AMERICAN
SCARY

—

AMERICAN
SCARY

—

A HISTORY OF HORROR,
FROM SALEM TO
STEPHEN KING AND BEYOND

—

JEREMY DAUBER

ALGONQUIN BOOKS
OF CHAPEL HILL
2024

Published by
ALGONQUIN BOOKS OF CHAPEL HILL
an imprint of Workman Publishing
a division of Hachette Book Group, Inc.
1290 Avenue of the Americas
New York, NY 10104

The Algonquin Books of Chapel Hill name and logo
are registered trademarks of Hachette Book Group, Inc.

Printed in the United States of America.
Design by Steve Godwin.

The publisher is not responsible for websites (or their content)
that are not owned by the publisher.

Library of Congress Cataloging-in-Publication Data
Names: Dauber, Jeremy, [date]– author.
Title: American scary : a history of horror, from Salem to Stephen King
and beyond / Jeremy Dauber.
Description: First edition. | Chapel Hill, North Carolina : Algonquin Books
of Chapel Hill, 2024. | Includes bibliographical references and index. |
Identifiers: LCCN 2024027916 (print) | LCCN 2024027917 (ebook) |
ISBN 9781643753560 (hardcover) | ISBN 9781643755977 (ebook)
Subjects: LCSH: Horror tales, American—History and criticism. | Horror films—
United States—History and criticism. | LCGFT: Literary criticism. | Film criticism.
Classification: LCC PS374.H67 D38 2024 (print) | LCC PS374.H67 (ebook) |
DDC 813/.0873809—dc23/eng/20240708
LC record available at https://lccn.loc.gov/2024027916
LC ebook record available at https://lccn.loc.gov/2024027917

10 9 8 7 6 5 4 3 2 1
First Edition

For Eli

Boo!

May this be the greatest fear you face in life

CONTENTS

INTRODUCTION: RED, WHITE, AND BLACK

SHOW ME WHAT SCARES YOU, and I'll show you your soul.

It goes for nations, too, not just people: you can write America's history by tracking the stories it tells itself to unsettle its dreams, rouse its anxieties, galvanize its actions.

Sometimes those stories are flickering on the screen of a darkened movie theater. Sometimes they're printed on the well-thumbed pages of a massive paperback novel with the author's name embossed on the cover. Sometimes they're told around campfires by scout leaders. And sometimes they're in the teasers for your local news at eleven, or in tweets that go viral, embers of concern fanned into flame.

What I'm going to do here is tell you the American horror story, from its earliest days to our current nightmares. Our guiding light is the not-so-simple question, simply put: *What's scared the crap out of us?*

Telling that story means taking in Puritan preachers' threats of eternal damnation and Jordan Peele's tales of demonic racism and most everything in between. Household names like Stephen King, Ryan Murphy, and Shirley Jackson next to horror-fan favorites like Robert Bloch, Tananarive Due, and Robert Eggers. Pulp magazines and comic books like *Weird Tales* and *Tales from the Crypt* side by side with Nathaniel Hawthorne, Henry James, Edith Wharton, classic writers who made no bones about working these veins.

So to speak.

All side by side, because the history of American horror, like any cultural

history, is that of links in a chain: writers incorporating their predecessors' technical tricks and creative innovations in the art of scaring the bejeezus out of their readers, then cranking it up a notch or playing it in their own chilling key. And how that music plays depends, of course, on the medium in which these tales of terror appear. Horror is like water, it seeps in everywhere (leaving things that grow, dark and clammy, in its wake . . .), and so with every new movement, every new invention—the nationally syndicated newspaper; movies; the radio; television; the Internet—the way the classic themes appear is transformed, sometimes dramatically, sometimes softly, sometimes monstrously, and that's part of the story, too.

Story, singular; because, at its dark heart, American horror, for all its variety, despite the stamp of differing times and places and approaches, comes down to a fear with two faces. (What's a horror story without an uncanny double, after all?) And almost everything we'll see in our story sups of, or shuttles between, the two of them.

The first: the fear of something grand, something cosmic. Whether it's an angry God that consigns sinners to the fire and brimstone, Lovecraft's creatures from out of space and time, or the ticking time bomb of global warming, we, as humans, are constantly trying to bat away the specter of our own ultimate insignificance. And one flavor of horror reminds us of our fragility, and often, our failure to transcend it. Its geography is a map of thin places, locations where the veil between the world we live in and another one entirely is slender, where these reminders pop up with teeth: places like Shirley Jackson's Hill House, where no mind can long stay sane, and Stephen King's Derry, where It prowls the sewers with balloons and claws—two twentieth-century examples from a long, blood-stained list.

The other fear is the flip side of the first: it's the monster located right next door. Fear of the other, constantly present, constantly malleable, is our second great thread: and we'll trace it as it swirls and cycles around most of the traditionally frightening cards in the American deck. Indigenous tribes. Black people. Immigrants. And always, always women: witches and sirens, painted as emasculators in so many different stripes. All reminding the audience of the ugly monster that lies within themselves, from the monstrous double of Edgar Allan Poe's "William Wilson" to Penn Badgley's

Netflix serial killer series, titled, simply, *You*. Not to be confused with Jordan Peele's 2019 meditation on the horror double, called *Us*.

As far back as Aristotle, horror fiction—and what's Greek tragedy if not a catalog of horror?—has been understood as a way of taking your fears for a walk; playing them out on the amphitheater stage, purging them as you emerged, blinking, into the light. Catharsis, in other words, and there's no better recipe for it than the allegories of fearsome fiction, where real terrors play themselves out in impossible settings.

But that's not the whole story, is it? Sure, we'll track how monstrous symbols shift and blur over the centuries—how the zombie moves from colonialist critique to racist callout to consumerist satire to epidemiological echo; how the vampire can speak to both crumbling empires and the AIDS epidemic; how the alien from outer space can be a Communist missile or a Christian allegory or sometimes, even, both at once. But we need to cut deeper, too. Closer to home. Not just fictional material that speaks to American reality in disguise—albeit often not a terribly good disguise; that Halloween mask sometimes slips a bit. Or a lot. We'll see a lot of true horror stories, too.

Like the unconventional nineteenth-century bed and breakfast where people checked in . . . but didn't check out. And the "murder castle" located just a few miles from a World's Fair. And the Lonely Hearts Murderer. And the Plainfield Ghoul. Which, in turn, influenced some of the most important American horror fiction ever made.

And many, many more.

Because, in the end, all we have are the stories. Hundreds of them, new delights, old favorites, that fit together into a long, and not always distinguished, story.

Which I hope you think about.

When you're all alone.

ONE

In the Hands of God and the Devil

—

OUR STORY BEGINS, LIKE ALL good horror stories should, in the dark.

The northeastern part of the land that would eventually become known as the United States of America was covered in woods. Deep dark woods, a natural setting for tales told by firelight.

Those who walked those woods for centuries, those whose lands they were, had their explanations for the shadows that multiplied at the edges of their campfires, and tales of the creatures that dwelled within those shadows. Much of that rich and varied folklore was, and often remains, orally transmitted; and though assuredly certain details have altered and evolved over the years, and tales differed from tribe to tribe, the rich interchange between tribal cultures and the overlapping landscape and milieu that many of the tribes shared allowed an overarching set of themes and characters to emerge.

Not all those tales were tales of fear; but some of them were. Some, like those of the Algonquian nation's savage wendigo, seem to us to be the transmogrification of the natural landscape, of the ravening beasts that would hunt, were they not hunted. Others, like tales of Coyote, the trickster, or Snake, or Iktomi, the spider, partake of the universal concern that the gods and creatures greater than ourselves were hardly beneficent—but could, should the occasion arise and their quasi-cosmic amusement persist, see fit to be swayed for a time, at least.[1] But what persists most is the sense of the land, of its balance between bounty and blight, between kindness and horror. Its promise, and potential.

The men and women who landed on those shores in the seventeenth century—those who came by choice, at least—are often characterized by their hopes and dreams, of new worlds and shining cities on a hill, and this is true enough; but, and to our point, their dreams were also shrouded in fear. As refugees (whether by necessity or in their own self-conception doesn't matter much for the state of mind we're discussing), they brought with them a world they felt was steeped in devilishness, witchery, and diabolism.

Most of those sailing from England across the Atlantic in the seventeenth century wouldn't have held much truck with the theater; more precisely, they considered it a hotbed of heresy, scandal, and obscenity run riot. But *had* they ventured to the theater in the two decades before the first ships set sail, they might have encountered a brace of works that sum up, for us, fundamental aspects of that worldview.

"Ay, heaven will be revenged of every ill / Nor will they suffer murder unrepaid," Hieronimo says in Thomas Kyd's late sixteenth-century *Spanish Tragedy*, and that sense of violent consequence marked this as an example of the "revenge play" then in fashion. The ghost of a murdered man and the allegorical spirit of Revenge are constantly onstage: and when the dead bodies litter the stage at the end, the ghost remarks, "Ay, these were spectacles to please my soul."[2] *His* soul, not heaven's desire, one might suspect, and not just his: "When the bad bleeds, then is the tragedy good," goes a line in *The Revenger's Tragedy*, published a decade later, and wrapping lust for violence and gore in a cloak of piety to please the very human demands of a bloodthirsty audience will hardly be unfamiliar to modern-day moviegoers.[3]

By the time *The Revenger's Tragedy* appeared, Elizabeth I had died, and King James VI of Scotland headed south to become king of England, first of his name; and the united kingdom's new monarch was passionately interested in the magical and maleficent, having authored a book, *Daemonologie*, on the subject in 1597, after some personal involvement in some late sixteenth-century witch trials. James, who firmly believed he'd seen actual witches in the flesh, was writing in no small part to respond to an increasingly skeptical take on witches, which held it was society's way of

demonizing old women and other beings they feared. To James, this position was just further proof of the devil's sway (the "old and crafty serpent being a spirit, he easily spies our affections, and so conforms himself thereto to deceive us to our wrack," he wrote),[4] and so it's hardly surprising two emblematic plays of the time took that line.

Kyd's roommate Christopher Marlowe, a man constantly being charged with heresy (and a probable spy for Queen Elizabeth), may have written his *Doctor Faustus* as an attempt, in part, to reestablish his pious credentials. Taken as it was from an allegedly quasi-true German bestseller about a man named Johannes Faustus whose alchemical dealings led to a pact with the devil for magical powers—putting him on the wrong side of Martin Luther—it's a story we'll see over and over again: man dabbling with What He Is Not Meant to Know and earning damnation as a result. But the play's unsettling energy comes from something else. Milton's *Paradise Lost*, a few decades later, would establish the convention that the devil gets all the best lines; but the process got a good kickstart from *Faustus*'s Devil, Mephistophilis, who jokes and mugs and grows serious by turns. The Devil, in this telling, provides forbidden knowledge in return for a soul: and the knowledge he gives, intriguingly, is that the devil is in pain, grieving over his distance from the Divine since the Fall, and thus walks the earth, bringing hell with him. "Why this is hell, nor am I out of it," he tells Faustus, inviting us to look at our landscape and find inferno—including the hell we make ourselves.

Compare this to a second play about the unnatural walking the earth, produced just a few weeks later. Shakespeare's first tragedy, *Titus Andronicus*, had slotted neatly into the revenge play tradition of Kyd and Marlowe. But *Macbeth*, one of his later plays, is about ambition, the haunting of a guilty conscience, and witchery, and how the visions and prophecies the latter affords are both made and unmade by human decision and understanding. Macbeth, after all, might have had a different end if he'd understood from the beginning that Birnam Wood really *could* come to Dunsinane. Thomas De Quincey, the nineteenth-century English writer whose *On Murder Considered as One of the Fine Arts* is right up our alley,

said about Macbeth: "Another world has stepped in . . . both [Macbeth and Lady Macbeth] are conformed to the image of devils; and the world of devils is suddenly revealed."[5]

To seventeenth-century playgoers, that other world is very much Scotland: a country that, despite being the home of their current monarch, few Londoners had ever seen, and whose bonnie banks and braes were considered home to marvels and wonders of more mysterious, darker sorts, echoed in folktale and fairy story. The unnatural occurrences counterfeited on the stage of the Globe couldn't *really* happen here, playgoers could assure themselves (though some undoubtedly remembered that story about a production of *Faustus* where one more devil appeared on the stage than there were actors supposedly playing them). But *Scotland?* All sorts of mysterious and frightening things could happen there. Or on any of the whiter, blanker spaces of the map. And the New World would very much prove no exception to the rule. But, of course, Macbeth's was also the world of the diabolic possibilities of the human heart, far more resonant to us than Marlowe's alchemical devil—always with us, no matter how far you sailed.

The Puritans well understood this, to their fear and dismay. Revenge playwright John Webster, Shakespeare and Marlowe's contemporary, was characterized by T. S. Eliot as "much possessed by death" and seeing "the skull beneath the skin." The Puritans had a similar sensibility. Death and the devil were all around them; the question was what forms these took, in this World they claimed was New.

ON MARCH 17, 1679, INCREASE Mather strode to the lectern of Boston's Old North Meeting House to preach a sermon. Facing his congregation of the Second Church, he thundered:

> New England differs from other outgoings of our nation, in that religion was the design of our fathers in transporting themselves and families into this vast and howling wilderness. But, men are now pursuing a worldly interest, with their whole hearts. . . . The Lord hath fallen upon us of late, and rendered his rebukes in flames of Fire . . .[6]

Mather wasn't speaking only metaphorically about those "flames of fire": he'd lost his own home in the conflagration that had enveloped Boston just two years before. But for Mather and his Congregationalist coreligionists, the earthly inferno was a sign of a metaphysical one: just another example of the theological battlefield on which they struggled constantly, one that shrouded the world in the prospect of salvation and the reality of hellfire.

By the time Mather preached this sermon, this idea, and his family's centrality in propagating it, was deeply rooted in the history of the new American colonies. The family story starts in the 1620s with John Cotton, a long-standing English nonconformist. Faced with the prospect of inquisition at the hands of Bishop of London William Laud, Cotton went underground, assisted by the clandestine Puritan network. Contacted by members of the Massachusetts Bay Colony, who asked him to come minister to them, Cotton sailed with his family in the summer of 1633. A contemporary biographer described his flight as "Providence Divine shutting up the door of service in England, and on the other hand opening it in New England."[7] That place: the First Church of Boston, founded just three years before, in 1630.

What, exactly, did Cotton profess, in that small, windowless Boston meetinghouse with a thatched roof? That the world, for all its seeming immensity, was simply a narrow lifetime's span, a battlefield between the Prince of Peace and Satan. Or, as 1662's *The Day of Doom*, a poetic collection by Michael Wigglesworth of "phenomenal popularity" among the Puritans, put it in "A Short Discourse on Eternity":[8]

> The lofty sky is not so high
> Hell's depth to this is small;
> The world so wide is but a stride
> Compared herewithall.

Mather insisted his congregants must fight that battle by establishing theocratic rule here, government by God.[9] A little-known settler named Thomas Tillam expressed that sense of New World's promise and its threat in his poem "Upon the First Sight of New England, June 29, 1638":

Here you shall enjoy
My Sabbaths, sacraments, my ministry
And ordinances in their purity.
But yet beware of Satan's wily baits;
He lurks among you, cunningly he waits
To catch you from me. Live not then secure
But fight 'gainst sin, and let your lives be pure.[10]

Such a worldview would be dramatic and frightening enough. But according to the theology of predestination Cotton preached, there was nothing you could do to save yourself; your only option was just to give yourself over helplessly to God's grace. The combination of an emphasis on the precariousness of one's immortal soul, and the inability to do anything about it, was a prescription for a constant state of congregational terror. People were therefore invariably on the lookout for anything that could be interpreted as a sign of the absence, or the withdrawal, of that same grace. A comet appeared shortly before Cotton's death in 1652, and when asked the significance of it, his biographer notes that Cotton thought "it portended great changes in the churches." Signs of Satan's hand, and his handmaidens, were plentiful; much could be interpreted in that fashion.

John Cotton's widow, Sarah Hankredge, remarried the widower Richard Mather; and thus Mather's son by his first marriage, Increase Mather, becomes entwined with the Cottons and their legacy. Increase was born in Dorchester, England, in 1639, his odd first name the Anglo-Saxon equivalent of the Hebrew for "Joseph." His mother, who died when her son was around fifteen and whose "holy" memory, according to a contemporary biographer, "was valued by him as long as he lived," died with the following words on her lips: "Eye hath not seen, Ear hath not heard, nor have entered into heart of man, the Things, which God has prepared for them that love him."[11] The idea of the world beyond, of salvation and damnation beyond the limits of perception, stayed with Increase, who arrived in New England in the fall of 1661.

By this time, the city of Boston had grown extensive enough that a second Congregationalist church was needed in the North End. And so what was known as the Church of the Mathers was founded, and Increase

became its spiritual leader. He'd also married Maria Cotton, John's daughter and—by dint of his father's marriage—his own step-sister, a woman who, that contemporary biographer noted, was "much addicted to Prayer, often setting apart whole Days, for Fasting and private Devotion."[12]

Mather himself, on the evidence of his son and his writings, struggled with the grand theological questions, including publishing a book called *There Is a God in Heaven* (you wouldn't need to publish a book called this, after all, if you hadn't at least considered the alternative). Certainly one might be tempted to curse, or deny, the Divine when one sees one's own home go up in smoke: Mather's repeated insistence in his own account of the "dreadfull fire" of God's "remembred mercy"—mostly that he was able to save most of his books[13]—seems a genuine effort to remind himself of goodness in the midst of disaster. But the temptations and trials Mather must have had in mind went beyond the lure of ascribing disaster to random chance or to sin, or even the opportunity to display unlikely gratitude. At least one other supped of a very different kind of horror story Mather and his congregants were encountering, leading to another volume vying for the crown of America's first bestseller.

IN 1676 BENJAMIN THOMPSON DIAGNOSED New England's Crisis via a wordy subtitle: "A brief narrative of New-England's lamentable estate at present, compar'd with the former (but few) year of prosperity: Occasioned by many unheard of crueltyes practised upon the persons and estates of its united colonyes, without respect of sex, age or quality of persons, by the barbarous heathen thereof: Poetically described."

"Poetically" is something of a stretch, given the quality of the verse, but Thompson's presentation of the native American as not merely heathen but hardly different from the animals of the American landscape—except, perhaps, in their cunning and ingenious malice and barbarity—was certainly vivid. "Indian spirits need / no grounds but lust to make a Christian bleed," wrote Thompson:

> In dark meanders, and these winding groves
> Where bears and panthers with their Monarch moves
> These far more cruel slily hidden lay,

Expecting English men to move that way . . .
Death would a mercy prove to such as those
Who feel the rigour of such hellish foes.[14]

Hellish, indeed: like in *Macbeth*, both the natural and religious land-scape work together as a site of fear. Everywhere a settler went was ripe for ambush, with those "Indian spirits" waiting to jump out and swallow you up. This hadn't always been the case—a letter by Edward Winslow in 1621, trying to soft-soap the Pilgrims during their first year in America, noted that "We have found the Indians very faithful in their covenant of peace with us, very loving and ready to pleasure us"[15]—but that had been a half-century ago, and things were different now.

Thompson's manifesto, after all, was written in the heat of what's now known as King Philip's War but was once better known as the First Indian War: a heated conflict between the Indigenous peoples of the territory becoming known as New England, particularly from the Wampanoag and Narragansett tribes, and the colonists of, particularly, Rhode Island and Massachusetts Bay. The war was deadly on both sides, bloodier, in percent-age terms, than the Civil War; over a tenth of the men of Plymouth and Rhode Island colonies were killed. But there was no question about the eventual victors, and the barbarity involved in the victory. Over a *third* of the local Indigenous population was killed.[16] The Wampanoags were dis-possessed from their tribal lands, with hundreds killed or enslaved. The body of the Wampanoag leader, Metacomet—known as King Philip to the English—was drawn and quartered; his head was then placed on a pike and publicly displayed in Plymouth, remaining there for a quarter of a century, long after his wife and son had been sold into slavery in the West Indies.[17] History, or its literature, is not only written, but also circulated, by the victors. So it's not surprising this range of issues was less poetically, but far more famously, captured by that second American bestseller, which gave the account of a woman ambushed by Native Americans, "removed" into captivity (to use her phrasing), and returned to tell her tale.

Mary Rowlandson was living in Lancaster, Massachusetts Bay, in 1676, the same year of Benjamin Thompson's plaint. During King Philip's War,

colonial cities were regularly attacked by Native Americans, and Lancaster was no exception; a raiding party of Narragansetts, Wampanoags, and Nashaway tribal members carried away her and her three children. Her six-year-old daughter Sarah died in the first week from injuries she received during the raid; Rowlandson and her other children hung on for the better part of three more months, until they were ransomed, for the sum of twenty pounds, by a subscription taken up by the women of Boston.

In 1682, six years after her ordeal, she published her account of it. The first edition's title page insists it is "A True History" by "A Minister's Wife in New England"; that she had originally written it "By Her Own Hand, for Her Private Use" and was now making it public "At the Earnest Desire of Some Friends, for the Benefit of the Afflicted." An addendum running in smaller type at the bottom of the page indicates the work includes a sermon "of the Possibility of God's Forsaking a People That Have Been Near and Dear to Him": it is, the addendum informs us, preached by her husband, "It Being His Last Sermon." Joseph Rowlandson had died in 1678; and Mary, grieving, with this familial loss coming hard on the heels of her earlier trauma, had, like so many others before her, turned to writing to play it out, to gain some sense of control, and to wrestle with the all-important theological questions posed in its wake.[18] So it's not surprising, for someone seeking answers in faith, that her message—to herself first of all, and only then, if the frontispiece is to believed, to a wider community clearly in the grip of these same questions—is one not just of burden, but of release; not just of captivity, but restoration, of (as the work was titled in New England) *The Sovereignty and Goodness of God*. It was published in twenty-three editions over the next 150 years.[19]

Rowlandson's account doesn't pull punches when it comes to depicting the circumstances of her captivity ("knocked in the head" seems to be the seventeenth-century equivalent of "bashed his brains out"): "One of my elder sisters' children, named William, had then his leg broken, which the Indians perceiving, they knocked him on [his] head. Thus were we butchered by those merciless heathen, standing amazed, with the blood running down to our heels." Rowlandson listens to "the roaring, and singing and dancing, and yelling of those black creatures in the night, which made the

place a lively resemblance of hell": her captors' otherness is seen throughout her narrative as an extension of the natural landscape, yes, but they are also pictured, following Rowlandson's view of them as representatives of the Arch-Deceiver, as essentially cruel and deceitful beings.[20] "There is not one of them that makes the least conscience of speaking of truth," she tells herself after asking one of her captors about the fate of her son and receiving the answer that "his master roasted him, and that [he] himself did eat a piece of him, and that he was very good meat." And so it's unsurprising Rowlandson views falling into their clutches as the wages of sin. On the first Sabbath of her captivity, for example, she recalls "how careless I had been of God's holy time; how many Sabbaths I had lost and misspent, and how evilly I had walked in God's sight."[21]

But if these travails are divine punishment, they are also simultaneously the irruptions of cataclysm that must be weathered in order for the exercise of faith to truly matter: "the Lord renewed my strength still, and carried me along, that I might see more of His power . . . as he wounded me with one hand, so he healed me with the other." It is this faith in God's goodness and power she credits, for example, in keeping her sane and unwilling to succumb to suicide after lying "down by my dead babe, side by side all the night after." In this sense, then, the Indigenous peoples of America are not autonomous agents but simply instruments: and thus, in themselves, do not matter. "I can but admire to see the wonderful providence of God in preserving the heathen for further affliction to our poor country," she writes.[22] Which is, of course, one step away to their being easily, and understandably, disposable.

Who convinced Rowlandson to share her story, and her message, with the world? One central figure: our old friend Increase Mather. While King Philip's War raged, he had taken "occasion to reprove, in the most public Manner, those Miscarriages, which he judged had provoked God to execute the Punishment of War on the Land," employing theories of theological cause and effect similar to Rowlandson's.[23] After the war ended—certainly after having spoken with Rowlandson, maybe even after having read a private draft of her work—Mather preached that 1679 sermon of his in the Second Church, calling for parishioners to act so "we may be pure

from the sins of the times, even those provoking evils that have brought the Judgements of God upon New England."[24] For Mather, those recommended actions included disseminating, in print, the kind of fears—and the religious means of allaying them—that Rowlandson exemplified. Most scholars think he authored the "Preface to the Reader" that accompanied the original edition; some even suggest he helped compose the work itself.

Ultimately, though, Rowlandson's book focuses inward, not out: on the demonic sin and doubt within, rather than on the Indigenous peoples who are demonized while, simultaneously, being marginalized as simple, even bestial, instruments of God's will, without agency or character.

And so Mather turned his attentions to witches.

TWO YEARS AFTER INCREASE MATHER helped publish Rowlandson's narrative, he published a book of his own. *An Essay for the Recording of Illustrious Providences* (later sometimes called *Remarkable Providences*) is a work of theological scholarship that records remarkable providences everywhere showing signs of the Devil: not least in New England. He describes the maid in Groton who, in October 1671, wept and roared "hideously, with violent motions and agitations of her body . . . her tongue was drawn out of her mouth to an extraordinary length," a tongue that went on to blaspheme most horribly; in 1679, he writes, the house of William Morse in Newberry was "strangely disquieted by a demon" engaging in what we'd call poltergeist activity, throwing stones, bricks, and a cat, among other objects.[25] "So many things were done and suffered by the Agency of invisible Beings, as to leave no Room to doubt the Existence of Spirits," Mather's son writes of his observations.[26]

By this point, *Macbeth* is almost a century old, but witchcraft accusations were back in style, both in England and Massachusetts: between 1647 and 1664, seventy-nine people had been accused of witchcraft in New England, and fifteen of them were hanged.[27] Mather's own concern—shaped by the idea that the Indigenous peoples next door could, in his eyes, be the devil in human flesh—was with a *combination* of the characters of witches and Macbeth, so to speak. Our friends, our lovers, our fellow

householders, could be witches, sinful devils in disguise—like Macbeth, who offers seeming hospitality but has murder in his heart. The devil is, after all, the grandest deceiver of all. And so what is there to be done about it by the person of virtue but to attempt to unmask them?

The climax of the whole thing, of Puritan fear and hysteria at its most feverish pitch, started, arguably, with laundry.

In 1688 the oldest child of John Goodwin, a Boston mason, had stolen linen from local washerwoman Ann Glover. Bad behavior, to be sure; and Goody Glover was right to complain—but as an old woman and an Irish Catholic to boot, she was already something of a double pariah; and in Mather's world, where the devil walked and seduced, it was easy enough to blame Goodwin's child's malfeasance on something otherworldly. And that's what happened: Glover was tried for witchcraft and executed. "In the Massachusetts theocracy," a modern scholar writes, "there was no conceptual distinction between crime, sin, and sheer deviance from the norm."[28] Still, the single case might not have spiraled into a craze, but for two things. The first was the "disease of astonishment" that soon affected four of the six Goodwin children, including neck and back pains, loud outcries, and the propensity to flap their arms like birds. The second was the involvement of Cotton Mather, Increase's son.

Cotton, under the considerable shadow of his considerable father, decided to follow in that father's footsteps in every way, including the title of his own book. *Memorable Providences Relating to Witchcrafts and Possessions* (1689) rehearsed the Goodwin case, spreading it far and wide, speaking of "unaccountable stabs and pains" experienced by the children, among other factors.[29] A generation later, preaching in Boston on a passage from Revelations, he made a linguistic correction to the translation of the Biblical text, one which bespoke his own expanded sense of the devil-haunted world:

> The Greek term Hades ought to be translated, The Invisible World. Hell, or the Prison of the Damned, is but a very little part, and only the wretched part, of the Invisible World . . . We look to the Things which are not seen.[30]

And certainly, in Salem Town, in February of 1692, it *seemed* like Hell had come to stay among them, invisible, but with its traces everywhere; and it was a Christian's job to make it visible, to make public the fear that lurked in everyone's heart. *Macbeth*, yes, but also Marlowe's Mephistophilis.

You can tell different stories about the trials, their underlying causes, and the actors' motivations, many of them, of course, complementary. You can tell it as a story of different families feuding with each other over status and property. You can tell it as a story of leftover trauma from the "Indian Wars" of 1675 and 1687, which touched the areas, and lives, of this and surrounding communities; some of the events in Salem even took place on anniversaries of massacres of colonists, and certainly the "Puritan belief that Indians and witches were synonymous" might well have played a role and created, essentially, PTSD in the children and adults.[31] But for now, let's tell it as a seventeenth-century horror tale, plain and not so simple.

Imagine yourself there, then, Salem 1692, as one Samuel Parris, a reverend, a man of God; and in your house—your own household!—your daughter and your niece are assaulted by the invisible world. They each scream and throw things and make strange noises, "stretching up her arms as high as she could, and crying 'Whish, whish, whish!' several times,"[32] and complain of being pricked by pins, though there are none to be seen, and "bitten and pinched by invisible agents; their arms, necks, and backs turned this way, and that way, and returned back again, so as it was impossible for them to do of themselves, and beyond the power of any epileptic fits, or natural disease to effect," John Hale wrote a decade later. Others whom Mr. Parris asked to consult "concluded they were preternatural, and feared the hand of Satan was in them."[33]

And then, helpless, terrified, confused—the doctors have reported no physical ailments—the epidemic spreads through the town. The young girls and women even interrupt the church service; they shout, and act out, in the house of God, making the stakes of the rebellion clear. Parris, preaching a sermon on March 27 to his congregation, said: "the devil hath been raised amongst us, and his rage is vehement and terrible, and when he shall be silenced, the Lord only knows."[34] Cotton Mather, in a book he wrote the following year, *Wonders of the Invisible World*, would put it more

bluntly:"a supernatural conspiracy [was] abroad in the land . . . Behold, Sinners, behold and *wonder*, lest you *perish:* the very *Devils* are walking about our Streets, with lengthened *Chains*, making a dreadful Noise in our Ears."[35] But if this is rebellion, conspiracy, there must be rebels and conspirators; and the community looked to the outcasts, arresting a poor woman, a lackadaisical churchgoer, and—first of the three—a woman of color.

Tituba has often been called an "African," but this isn't true;[36] the original sources refer to her as an "Indian," which probably meant she came to Massachusetts Bay from the West Indies, the Caribbean. She came unwillingly, enslaved, almost certainly sold in Barbados and taken to New England by Parris; she was in the Parris household at the time of the trials, and the original complainants named her as a pincher and pricker. And she confessed. Under duress, true, and after a beating, but she confessed to witchcraft, which fanned the flames of belief. Now there was *proof,* you see.

She'd made a "witch cake," she said, and had spoken with the devil, whom she described as "a thing all over hairy, all the face hairy, and a long nose."[37] But, she claimed, she was hardly the only one. Did the magistrates think the devil was so weak he was only at Salem's outskirts? And then, as the behavior spread to other young women, so, in the next months, did the accusations: against skeptical Martha Corey (who, when she referred to herself as a "gospel woman," "the afflicted persons told her, ah! She was a gospel witch,")[38] and against faithful Rebecca Nurse and pregnant Elizabeth Proctor and her husband John and dozens of others, "being suspected to have confederacy with the devil in oppressing sundry persons," in the words of one of the accused.[39] They were all dragged to face magistrates, including John Hathorne, whose descendant we will meet in the next chapter. The arrests of supposed witches took place in a variety of towns in Massachusetts Bay Colony, but the trials themselves took place in Salem Town: they were interrogated, encouraged to confess, and generally, convicted.

Evidence included depositions by the "afflicted," who could tell quite skin-freezing narratives, like Ann Putnam's testimony of the appearance to her of George Burroughs's first two wives, deceased, "in winding sheets

and napkins about their heads," who insisted that Burroughs had murdered them; one "pulled aside the winding sheet and showed me the place" he'd stabbed her under her left arm.[40] In *Wonders of the Invisible World*, Cotton Mather noted sights of such "apparitions of ghosts of murdered people" were "a frequent thing," and that they frightened "the beholders more than all the other spectral apparitions,"[41] and so we see the spirit of *Macbeth* once more—here as a cover for the return of repressed sin and guilt more generally. Another piece of famous "evidence" rings similarly (proto-) Freudian, where one accused witch, attempting to recite the Lord's prayer, said "Hollowed be thy name," rather than "Hallowed": "this was counted a depraving the words, as signifying to make void, and so a curse rather than a prayer," a contemporary source concludes. "Proceeding in this [type of] work of examination and commitment, many were sent to prison."[42] Prison meant the jails of Ipswich, Salem, and Boston, "perpetually dark, bitterly cold, and so damp that water ran down the walls . . . They enclosed as much agony as anywhere human beings have lived."[43]

Some died in prison. Nineteen were duly hung, according to the second capital law of the 1684 Laws and Liberties of Massachusetts, which read: "If any man or woman be a witch, that is, hath or consulteth with a familiar spirit, they shall be put to death." One, who would plead neither guilty nor not guilty, was pressed to death.[44] Doubts and unease grew, as the hangings continued. Boston merchant Thomas Brattle wrote in a 1692 letter: "This Salem philosophy, some men may call the new philosophy; but I think it rather deserves the name of Salem superstition and sorcery, and it is not fit to be named in a land of such light as New England is."[45] When George Burroughs, who'd been allegedly accused of his wives' murders by their ghosts, was executed (the same day as John Proctor), he spoke of his innocence so powerfully it "drew tears from many (so that it seemed to some, that the spectators would hinder the execution)." But a recent arrival on the scene—Cotton Mather—"being mounted upon a horse, addressed himself to the people," arguing that the devil is famous for pretending virtue, that he has "often been transformed into an angel of light . . . this did somewhat appease the people, and the executions went on."[46] Proctor, for his part, expressed his innocence by precisely reversing the nature of the devil's

deceptive power: people must be "so much enraged and incensed against us by the delusion of the devil," he wrote, "by reason we know in our own consciences, we are all innocent persons."[47]

The question of whether the devil was *actually* doing it, not just *making* people do it, wasn't just John Proctor raising reasonable doubt. The question of what was termed "spectral evidence" was taken up by none other than Increase Mather himself. In an autobiographical entry for May 14, 1692, he wrote he "found the Countrey in a sad condition by reason of witchcrafts and possessed persons," and one essential question was whether the devil could, in Cotton's description, "appear in the Shape of an innocent and virtuous Person, to afflict those who were under particular Molestations."[48] He dedicated a book to the subject. Though his answer was in the affirmative, he also wrote in the work, *Cases of Conscience Concerning Evil Spirits*, that "It were better that ten suspected witches should escape, than that one innocent person should be condemned,"[49] and he came out strongly against using such ambiguous evidence in any proceedings. It was hard, in other words, to determine whether the devil came from without or within—a question that would persist for centuries.

Increase Mather would later write, quasi-modestly, that by his work's publication "(it is sayed) many were enlightened, Juries convinced, and the shedding of more Innocent blood prevented."[50] But he may have been overstating his influence. His son's recollection was that eventually "Some, who had with great Vehemence maintained, that the Devil could not afflict in the Shape of a good Man, were confuted by having their own Shapes thus Abused . . ."[51] This tells another story: the story of a panic expanding to consume its own ringleaders, and the panicked grabbing for new narratives when resistance finally gains traction. There is no better proof of this than two later mea culpas. The first, a collective letter by several witchcraft jurors, insisted on their incapability to understand, or withstand "the mysterious delusions of the powers of darkness" and begged God for forgiveness, praying He "would not impute the guilt of it to ourselves, or others."[52] The second was by one of the young girls who'd started it all, Ann Putnam. "It was a great delusion of Satan that deceived me in that sad time," Putnam wrote in 1706, now grown. "I can truly and uprightly say, before God and

man, I did it not out of any anger, malice, or ill-will to any person, but what I did was ignorantly, being deluded by Satan."[53]

Some moments of American horror firmly attempt to implicate their observers and participants, morally; others provide relief by pushing it onto others. The first tragedy of Salem is the victims. The second is the unwillingness to learn from their suffering.

The devil made me do it, indeed.

JUST A FEW SHORT YEARS after the witches were hung at Salem, Daniel Defoe wrote one of the first modern horror tales in British literature, one that encapsulated a regnant worldview on both sides of the Atlantic.[54] "This relation is matter of fact," begins the preface to 1706's "The Apparition of Mrs. Veal" "and attended with such circumstances, as may induce any reasonable man to believe it." It's extremely possible, in fact, Defoe believed it to be true himself, and thus it's a work of journalism, not fiction: opinion's divided, and it wouldn't be the last work of imagination to wrap itself in a shell of verisimilitude. Either way, Cotton Mather's invisible world is on full display; and, like Mather's work, it comes complete with moral: "to consider, that there is a life to come after this, and a just God, who will retribute to every one according to the deeds done in the body." Everything is ordered; everything has a clause, and a consequence, and the order, both physical and metaphysical, visible and invisible, all works together.

And then came the plague. Defoe's 1722 *A Journal of the Plague Year* provides a pointed depiction not just of the misery raging in London, but how people there turned to the irrational for succor in times of stress, as they did in Salem and do to this day. "The apprehensions of the People were likewise strangely increased by the Error of the Times . . . I must be allow'd to say . . . I hope without breach of charity, that they heard Voices that never Spake, and saw sights that never appear'd; but the imagination of the people was really turn'd wayward and possess'd."[55] Plague itself seemed— seems—a symbol of irrationality, disorder: who it smites and who it spares; the chaos, personal and metaphysical, it leaves in its wake. And unsurprisingly, depending on the person, it can subvert, or succor, religious belief. It hardly seems coincidental that within a few years a new Great Awakening

began to make its way across Britain and the Americas, a revivalist religious movement focusing on passion, emotion, and, yes, imagination (although its participants might not have put it that way), one that both insisted on and struggled with the invisible iron laws of theological predestination.

One of the greatest ambassadors for the Awakening was a Massachusetts preacher in his early thirties named Jonathan Edwards, who had worked assiduously to use what he'd learned from his studies of natural philosophy in order to continue his own investigations into the religious wonder behind it all.[56] Edwards preached in Northampton, which had become, in the mid-1730s, an epicenter and exemplum of the Awakening: a place with so much evidence of grace, it seemed, that illness had substantially decreased in the community. His description of the process, in his 1737 *A Faithful Narrative of the Surprising Work of God in the Conversion of Many Hundred Souls in Northampton*, describes a process of salvation that is—although he didn't use the term—psychological. Individuals try to do good works and study to avoid sin; then despair at their inability to live up to what they believe to be necessary; and then, as a result, go into the emotional state of "converting grace"—where they understand that Jesus saves those who have faith in his possibility of forgiveness—and then move into a state of joy and a desire to spread the word.

The work brought Edwards international recognition; and what's important for us about this approach is that it follows the same trajectory of fear and cathartic relief as do many horror stories: a monstrous threat vanquished on the way to a happy ending. Despite Edwards's undoubted emphasis on grace (and belief, therefore, that not everyone *can* in fact be saved), the point he makes is that in fact humans *do* have at least some agency, that agency being the capacity for meaningful and transformative faith and belief, with an emphasis on the salvific power of the emotions and imagination. Although this is a universal approach—you can see it in stories of fear ranging from *Peter Pan* to *It*—there's something about it that feels very American: an individualistic and intuitive gospel of success. But not everyone could participate, and one of the people who felt left out, Edwards's uncle, committed suicide soon after the account was written, convinced he was damned inexorably. Edwards blamed Satan.[57]

Ironically, perhaps, Edwards doesn't seem to have been overly emotional himself, which is surprising for those who know him best from *Sinners in the Hands of an Angry God*, often considered a classic of the "fire and brimstone" genre of sermon, and designed to spread the word, and work, of the Awakening. In fact, that same year, in another sermon, *The Distinguishing Marks of a Work of the Spirit of God*, he suggests that too much emotion— the "bodily effects" of swooning, outcries, convulsions—isn't a sign of the Divine spirit. Perhaps it was simply a matter of personal inclination: Edwards himself, apparently, wasn't a shouter in his sermons; he didn't even raise his voice. But he does say, in that same work, that you can use fear and terror, if necessary, to instruct; and *Sinners* certainly does that: when he preached it in Enfield in 1741, he "brought the congregation to such an intense emotional pitch that he could not finish the sermon because of the wails and shrieking of those overcome by their terrible plight."[58]

Sinners presents a world in which the possibility of one's fall into damnation is ever-possible and ever-present—"You hang by a slender thread, with the flames of divine wrath flashing about it, and ready every moment to singe it, and burn it asunder," he says, at the sermon's rhetorical climax[59]— and in fact he suggests that, once made conscious of that terrifying possibility, in some sense we're actually sharing in that torment even now.[60] Fear, in other words, constant fear, is both the condition and the punishment: and while the sermon clearly is aimed at the immortal soul, it focuses on—and elicits—the contemplation of emotions, of mood, in the now.

This type of emphasis was only accelerated by one of the most influential poems of the colonial period. Thomas Gray's "Elegy Written in a Country Church Yard," published almost a decade after Edwards's sermon, set the tone for dozens, if not hundreds, of poems and writers in the decades to come, some loosely known as the Graveyard Poets.[61] Yes, the "Elegy" was composed in England, but colonial newspapers very much relied on, and disseminated to colonial readers, material from the motherland. (Take, as just one example, Boston's *The American Magazine and Historical Chronicle*, which in 1744 published "The Frighted Farmer: A Tale," out of *London Magazine*, a story in poetic form about a farmer's encounter with a ghostly thing.[62]) While the poem feels like an elegy, insofar as it's written from the

perspective of someone mourning the dead—it's set in a graveyard and, ultimately, focuses its attention on a particular grave—it turns out the speaker doesn't know much about the grave's inhabitant. As a result, the poem is, largely, about the way the haunted atmosphere makes him feel.

The first stanza tells the tale:

> The curfew tolls the knell of parting day,
> The lowing herd wind slowly o'er the lea,
> The ploughman homeward plods his weary way,
> And leaves the world to darkness and to me.

What matters, ultimately, are not the facts of nature and the world but the way in which the poet takes them in: not so far, as it turns out, from Edwards's theology. Fear—of death, or, as much of the rest of Gray's poem makes clear, the insignificance that comes with it, as in any classic memento mori—is omnipresent. But there's an odd, brilliant, paradoxical catharsis at the end of the poem, where the speaker himself imagines an elegy spoken over *him* by a local: that he was someone who "melancholy mark'd [. . .] for her own," who never reached the fame that perhaps his talent suggested.

That portrait of the melancholy, death-obsessed ghostly figure would resonate within the colonies. In the year 1760, a twenty-four page pamphlet published in Philadelphia would contain a poem halfway through entitled: "The Address of a Gentleman's SCULL, to its Male Visitants":

> Too late I found all earthly Riches vain.
> Disease, with Scorn, threw back the sordid Fee,
> And death still answered—"What is Gold *to me?*"
> "Yet know I feasted but to feast a Worm!"

And then, four pages later, the Lady's skull gets her turn:

> Survey me well, ye Fair Ones! And believe
> The Grave may terrify, but can't deceive.

That pamphlet was called *Poor Richard's Almanack*; its author, who had clearly imbibed some of the ethos of Gray, if rendering it in a slightly more melodramatic key, was a young printer named Benjamin Franklin, who in the decades to come would go on to bigger and better things.[63]

ON MARCH 12, 1754, THE *Pennsylvania Gazette* reported that Robert Foyle, of Augusta County, Virginia, "together with his Wife and five children, the youngest about ten Years old, were found all murdered and scalped the 4th of last Month, supposed to have been done by the Indians about two Months before." In a speech the following week, the governor of Virginia, addressing the state's general assembly, first reported one Major George Washington's finding French construction of a fort on the Ohio River, a violation of treaties between France and England. He then went on to tell Foyle's family story far more vividly than the *Gazette*, in terms reminiscent of Mary Rowlandson's earlier account:

> Think you see the Infant torn from the unavailing Struggles of the distracted Mother, the Daughters ravished before the Eyes of their wretched Parents; and then, with Cruelty and Insult, butchered and scalped. Suppose the horrid Scene compleated, and the whole Family, Man, Wife, and Children (as they were) murdered and scalped by these relentless Savages.

The governor's vivid scene-setting had a broader agenda, though. Assuring the assembly that "these Insults on our Sovereign Protection . . . make deep Impressions on my Heart; and I doubt not, as you must hear them with Horror and Resentment," he hopes they will enable him, "by a full and sufficient Supply, to exert the most vigorous Efforts, to secure the Rights, and assert the Honour and Dignity of our Sovereign; to drive away these cruel and treacherous Invaders of your Properties, and Destroyers of your Families."

In other words, he wanted more money contributed for military support. And it wasn't just to protect against Native invasion or sovereign insult: that

juxtaposition with the news of the French fort was hardly coincidental. A popular work by Peter Williamson published just a few years later, in 1757, *French and Indian Cruelty, Exemplified in the Life and Various Vicissitudes of Fortune of Peter Williamson*,[64] made the connection plain: fears and anxieties about Indigenous tribes were caught up in the warring of colonialist powers. A small part of Williamson's work's extensive subtitle—which, after featuring Williamson's captivity and escape at Native hands, featured him serving "as a volunteer and soldier against them"—expressed the popular formula for how to be a (white) colonial in the country.

The idea that you just weren't *safe*—that you were the plaything of fortune, at risk of losing bodily and geographic autonomy at any moment, and that those horrors could be turned into catharsis via taking up arms against those that served as the focal point for those terrors—had its seductions. Which were, at times, acted upon. In 1767 the *Pennsylvania Gazette* quoted letters from Silver Bluff, on the Savannah River, that "a number of the people called Crackers, who live above Augusta, in the province of Georgia" had plundered the Native settlement at Okonee, carrying off "everything of any value" that they could, "and then burnt every house in it."

The correspondents' objections seem to have been largely utilitarian, concerned that the Native Americans would take it as "a formal declaration of war, and that dreadful consequences may be apprehended." Their parting shot, though, was to note that "in which case, those people that committed such a violent outrage, would be the first to run away,"[65] suggesting a small kind of emergent moral sympathy, different from Mather's vitriolic characterization of them as "the children of Hell" or "doleful Tawnies."[66] And a fascinating account quoted in the same paper two years earlier went even further, reflecting currents of thought just coming into vogue. Excerpting General Bouquet's account of his "late Expedition against the Ohio Indians,"[67] an editor suggests the scene he reprints, of the return of colonists from Native American captivity, is, rather than Rowlandson's opportunity to display God's providence, the chance for "the Philosopher to find ample subject for his most serious reflections; and the Man to exercise all the tender and sympathetic feelings of the soul."

After recounting the understandable rejoicing at the prisoners' reunion

with their families, Bouquet notes the behavior of their previous captors, shedding "torrents of tears over them, recommending them to the care and protection of the commanding officer," and suggests the behavior "challenge[s] our just esteem" and "should make us charitably consider their barbarities as the effects of wrong education, and false notions of bravery and heroism," and their virtues "as sure marks that nature has made them fit subjects of cultivation as well as us." A classic sentiment of the Enlightenment, in other words: an emphasis on toleration and (comparative) humanity, the sense of humans as clean slates that can be blotted by improper education. And complemented, to be sure, by a side of white man's burden: "we are called by our superior advantages to yield them all the helps we can in this way," the account continues, superior advantages, it helpfully explains, like "the light of religion," which the "easy and unconstrained" Native life "could never be put in competition with."

But if the settlers' fears of the Indigenous peoples were increasingly wrapped up in colonial great games—and anxieties about their own behavior toward them, in the face of Enlightenment-oriented egalitarianism, assuaged by pats on the back about cultural moral superiority—it might be worth noting one last point General Bouquet makes about the Native perspective on their captives. "No child is otherwise treated by the persons adopting it than the children of their own body," he writes. "The perpetual slavery of those captivated in war, is a notion which even their barbarity has not yet suggested to them."

The barbarity of perpetual slavery, indeed. Slavery was part of the American story from the beginning, and of course, it is a horror story. Olaudah Equiano, a man abducted from West Africa, recalls that he believed, upon his kidnapping, "that I had gotten into a world of bad spirits, and they were going to kill me . . . [and asked] if we were not to be eaten by those white men with horrible looks, and faces, and long hair."[68] And, after a fashion, he was correct, And any guilt and fear the enslavers felt in their own criminality, their own monstrosity, even as they utterly failed to grapple with its enormity, emerged from their consciences, as nightmares do, in twisted and altered form. The specter of the enslaved revenging themselves, in ways large and small, played itself out throughout the colonies.

Writ large: In the spring of 1741, Manhattan—which possessed, at the time, a very large population of enslaved people—saw a series of fires, first concentrated in lower Manhattan, then throughout the island. Many New York City residents believed there was a conspiracy, among enslaved people, free Blacks, and some lower-class whites, to set the fires, and then, under its cover, to rob houses and kill the inhabitants. The belief stemmed, in no small part, from a concocted story told, by an indentured servant eager to avoid close questioning from a grand jury, alongside that of another woman, a resident of a tavern with a great deal to hide. The accused named names; those named then named names of their own (in the case of Black people, often because it was made clear to them it was the only way to escape the noose); and the hysteria spread:[69] One of the judges, Daniel Horsmanden, referred to it as "this most horrible and detestable piece of villainy, a scheme which must have been brooded in a conclave of devils, and hatched in the cabinet of Hell."[70]

Certainly the Slave Insurrection of 1741 (as it's now better known, or the New York Conspiracy) is less well known than Salem. A century after the fact, a reviewer of a book on American criminal trials noted that:

in every particular the New York Negro Plot runs parallel with the witchcraft trials—in the absurdity of the delusion, in the ferocity of the popular excitement, in the violence that was done to common sense, reason, and the law, and in the bloody and awful results of the proceedings.

And yet, he further notes, "the world has been willing to forget the New York Negro Plot, while every child is taught" about Salem and "the horrors and follies of witchcraft."[71] Structural inattention to Black history is certainly part of the American story, and part of the reason. But another part may be because it's hardly clear such a conspiracy actually existed. A letter to a future lieutenant-governor of the province by a resident of Massachusetts Bay makes certain parallels clear: "this occasion puts me in mind of our New England witchcraft in the year 1692 . . . [and] makes me suspect . . . that negro and spectre evidence will turn out the same."[72]

What matters is less the underlying truth than the result: 172 arrested and tried on very flimsy evidence. Thirty-four men were killed, and thirty of them were Black. Seventeen were hanged and thirteen burned at the stake; eighty-four others were transported to the Caribbean. And a more ironic result as well: in the words of one historian, the event "aroused such a fear of negro slaves in the city that slavery became unpopular, and from that time the number of negroes held in bondage in New York steadily decreased."[73]

But what also matters greatly to us here is the *nature* of the conspiratorial belief: it *must* have been true, members of the enslaving population might have said. Given the circumstances—which they well understood, deny it to themselves as they might—who *wouldn't* want to burn it all down? Certainly the rules and measures implemented by the colony even prior to 1741—like the one requiring "all Africans, slave or free, to carry a lighted lamp whenever they walked in the town after dark so as to alert whites to their presence"—were the literal definition of asserting a group's fearful, predatory, haunting nature.[74]

Writ small, and tantalizingly incomplete, and entirely lacking the voice and agency of the enslaved individual involved, is the case, in 1751, of an enslaved young woman named Phillis, who was put to death in Boston for the crime of poisoning one of her master's children with ratsbane, or arsenic. At least one; it was eminently possible she'd killed one or two of his other children, too. The case was notorious enough for a printed sermon to be published on the subject; its preacher identified Phillis with King David—a fairly incongruous parallel, except that the horrors of white supremacism allowed him to charge her with David's conventionally understood motives in the Bathsheba story, an idleness that allowed evil temptation to rule. "GOD has blessed you with a religious Education," he wrote. "Like David you have been distinguished among your Nation by peculiar Favours of God. And now, what Improvement did you make of your Advantages? What returns did you make to the good God that distinguished you?"[75] Again, we'll never know the full facts or actual motives; but as a window into the white understanding of the perspective of the enslaved individuals who lived with them and took care of their children, it seems almost

bafflingly wrong-headed. Or, perhaps, wish-fulfillment: a fantasia in the face of a horrific story that illustrated the anxieties about the possibilities of rebelling against an unconscionable system in the most terrible of ways.

Phillis's voice goes unheard in the record: it was vanishingly rare, given the systems of supremacy, for the enslaved to have that possibility, and so it is we have more testaments to the proofs of white fears about the system than from those who suffered from it. And even when it did happen, those voices are suffused, and shot through, with fear. Another woman with the same first name, Phillis Wheatley, was taken from Africa as a young girl, probably around the age of seven or eight; purchased by a Boston family, she was encouraged in her literary talent enough to produce a book of poems published in London in 1773. (Perhaps unsurprisingly, there were concerns that readers would doubt an enslaved person could have authored such works; accordingly, "her publishers enlisted twelve of the most distinguished men in Boston—including John Hancock and the Reverend Charles Chauncey—to swear that she had."[76] Reading her *Poems on Various Subjects, Religious and Moral*, you can see that attempt to just fit in, to do what the majority demands of you, in "On the Death of a Young Gentleman," with its seemingly conventional lines about soothing parents' anguish:

> To still the tumult of life's tossing seas
> To ease the anguish of the parents' heart
> What shall my sympathizing verse impart?
> Where is the balm to heal so deep a wound?
> Where shall a sov'reign remedy be found?[77]

On the other hand, it might be worth thinking about *Phillis's* parents, or the parents of so many other young people torn away from their homes and forced to endure the horrors of the Middle Passage; those "tossing seas" weren't just metaphorical, and the wounds—which would require, at best, a sovereign's remedy to heal—were not easily found, if at all. Wheatley addresses her personal circumstances in a poem "On Being Brought from

Africa to America,"[78] which begins so surprisingly the entire brief poem is worth quoting here:

> 'Twas mercy brought me from my *Pagan* land,
> Taught my benighted soul to understand
> That there's a God, that there's a *Saviour* too:
> Once I redemption neither sought nor knew.
> Some view our sable race with scornful eye,
> "Their colour is a diabolic die."
> Remember, *Christians, Negros,* black as *Cain,*
> May be refin'd, and join th' angelic train.

The poem's sentiments may well be honestly expressed: it's certainly not implausible that Wheatley, as a Christian believer, would be grateful in the work of Christianity in achieving her salvation. But even if they are, the poem itself betrays all sorts of fears and anxieties: about expressing these pieties in order to fit in; that the ultimate arbiter of worth is not the pearly gates but the Christians who walk the earth; that the "diabolic die" will remain the powerful force, not the belief in the "angelic train." Certainly her later life might have given her cause to believe that was the case: despite being emancipated after her book was published and receiving plaudits from, among others, George Washington, she lost her patrons once she was free; her husband was imprisoned for debt; and she died at thirty-one, a scullery maid.

One could say Wheatley's words were read, but her words unheard; and the words most pressing to her and others like her—adding insult to grievous injury—would be appropriated as a metaphor for something else: the subjection of the Colonies to a tyrannical king.

THE FIRST (AND ONLY) ISSUE of the *Constitutional Courant*, published in September 1765 in the wake of the Stamp Act, was, like many other papers, not pleased with this new example of British taxation, especially since it targeted printed matter, like, well, newspapers. It raged:

> It has been undeniably demonstrated . . . that these colonies are not in any sense at all represented in the British parliament . . . What then is to be done? Shall we sit down quietly, while the yoke of slavery is wreathing about our necks? He that is stupid enough to plead for this, deserves to be a slave.[79]

This is not, at least explicitly, a call for revolution: writing a decade before the Declaration of Independence, the author insists he "cherish[es] the most unfeigned loyalty to our rightful sovereign," insisting the "wisest of kings" may simply be "misled." But to those who refuse to assist in correcting that wise sovereign, who support the current policy of taxation without representation, he is less diplomatic: "Ye blots and stains of America! Ye vipers of human kind! . . .Your crimes shall haunt you like *spectres*."

But as the tensions ratcheted up, what seemed increasingly haunting was the shadowy presence of that same sovereign and his representatives, intrusive and yet simultaneously more and more distant: a recipe for strengthening rebellious sentiment and, on the other side, a temptation for increasingly forceful repression.

And then, of course, there was a massacre.

What's important to us about the murder of eleven colonists by British soldiers on March 5, 1770, better known to Americans as the Boston Massacre, is less the actual historical facts than what was made of them by prorevolutionary forces. By the end of March, Paul Revere's famous engraving became a best-seller; *The Fruits of Arbitrary Power, or, The Bloody Massacre* featured blood spurting from "visible holes" in the dead and wounded, "pouring from the rent waistcoat of one victim, staining the forehead of another." The engraving was colored, the bright red British uniforms echoing the blood.[80] Soon after the events, James Bowdoin, Joseph Warren, and Samuel Pemberton produced the equivalent of an after-action commission on the events.[81] While stopping short of taking on the crown directly—they blame governmental "representations . . . [which] have occasioned his Majesty's faithful subjects of this town and province to be treated as enemies and rebels," they assert British soldiers "seem to have formed a

combination to commit some outrage upon the inhabitants of the town indiscriminately."[82]

The "short narrative"—which isn't actually so short—reads like a full forensic report, complete with interviews, examinations of crime scenes and bullet trajectories. It is the interviews, though, the voices of people who were *there*, that add the chilling, piercing touch:

> Jane Usher declares, that about 9 o'clock on Monday morning the 5th of March current, from a window she saw two persons in the habit of soldiers, one of whom being on horse back appeared to be an officer's servant. The person on the horse first spoke to the other, but what he said, she is not able to say, though the window was open, and she not more than twenty feet distant: the other replied, He hoped he should see blood enough spilt before morning.[83]

In other words, malice aforethought.

John Wilme provided a deposition on March 21, 1770, testifying that a British soldier "about ten days before the late massacre . . . did talk very much against the town . . . and said that the blood would soon run in the Streets of Boston" and that a soldier's wife offered that "if any of the people were wounded, she would take a stone in her handkerchief & beat their brains out."[84] During the actual shooting, Samuel Condon reported that, despite seeing "no violence offer'd the soldiers," he saw dead people who had been "inhumanly murder'd by them, the blood then running from them in abundance"; and when a "person asked the soldier who fired first, the reason for his so doing, the soldier answer'd, damn your bloods you boogers, I would kill a thousand of you!"[85]

The following year, a sermon entitled "Innocent blood crying to God from the streets of Boston" was preached by John Lathrop at Boston's Second Church—that same church once led by the Mathers—and the rhetoric had heightened. "We have seen the gloomy time," Lathrop thundered, when "our most public streets were deeply dyed with innocent blood. . . . our fellow-citizens shot to death—*their garments rolled in blood,*

and corpses wallowing in gore."[86] Lathrop transforms the scene explicitly into a horror show for his listeners—"to behold their mortal gasps, and hear their dying groans—but I desist—the rehearsal of these things is too much for me. Who can reflect on the horrors of that night without shuddering!"[87] He insisted it was "pretty evident from several plain testimonies . . . that a number of the troops, with other sons of *Belial*, were determined to murder the inhabitants," and, raising the stakes, asserted that "The cry of innocent blood cannot be allayed, but by the death of the guilty!"[88]

The year after *that*, a sermon by Boston's Joseph Warren went even further, linking the need to remember to the fifth of *another* month, a Guy Fawkes day for the colonists of America: "The FATAL FIFTH OF MARCH 1770, CAN NEVER BE FORGOTTEN . . . Language is too feeble to paint the emotions of our souls, when . . . our eyes were tormented with the sight of the mangled bodies of the dead . . . when our alarmed imagination presented to our view . . . our beauteous virgins exposed to all the insolence of unbridled passion." That "alarmed imagination" does a lot of work here. We move from a factually terrible occurrence to something apocalyptic, involving specters of rape (alongside, in other parts of the same paragraph, suicide and arson): none of which occurs except in the colonists' imaginations, but imagination is where the work of fear, outrage, and horror is most done. Unsurprising, then, that by 1775, Warren's oratory had evolved into a full-on ghost story:

> The baleful images of terror crowd around me—and discontented ghosts, with hollow groans, appear to solemnize the anniversary of the FIFTH of MARCH! . . . APPROACH we then the melancholy walk of death! . . . Take heed, ye orphan babes, lest whilst your streaming eyes are fixed upon the ghastly corpse, your feet slide on the stones bespatter'd with your father's brains.[89]

How to quiet these ghosts, haunting the colonies? In 1772, beholding "the authors of our distress parading in our streets," he had approved of—and clearly encouraged—armed resistance. "Our hearts beat to arms; we snatched our weapons . . . to avenge the death of our SLAUGHTERED

BRETHREN, and to secure from future danger, all that we held most dear."[90] Three years later, he suggests independence is not their aim; that Britain and the colonies "may, like the oak and ivy, grow and increase in strength together,"[91] as long as Britain gives the colonies their rights—while commending those who fight for those rights. Was this simply a fig leaf for protection from prosecution? Or was it a genuine fear and concern, as one British politician put it, about "the horrors of a civil war"? Or, as an article put it in the *Virginia Gazette* in 1775, the current situation, "if not soon happily terminated, must end in such scenes of trouble, bloodshed, and devastation, which, in contemplation alone, shock us with horror."[92] But it became clear, as "Sylvia" wrote in June 1775's *Pennsylvania Magazine*, a few weeks after Paul Revere's ride and the Battles of Lexington and Concord, that "With mournful steps retires the cherub Peace, And horrid War with all his train appears."[93]

The horrors were approaching, reflected not just in the pulpit, but in imaginative poetry. Philip Freneau, who would become the most important literary figure of the American Revolution, was New York City–born and Princeton-educated (where he graduated class of 1771 and became friends with James Madison). Over the next few years, he began to publish poems, some taking a very particular political angle. *A Voyage to Boston* (1775)—a city that had seen a great deal of combat that year—directed its protagonist, "led by Heaven's supreme decree," to invisibly, undetectably, go and "view the dire effects of tyranny." In doing so, he sees General Thomas Gage, then the commander-in-chief of the British army in North America and the governor of Massachusetts Bay, who's characterized as:

> A second Cortez sent by heaven's command,
> To murder, rage, and ravage o'er our land . . .
> E'en Cortez would our tyrant's part disdain;
> That murder'd strangers; this his countrymen.[94]

But Freneau saves his most savage indictment for those colonists who don't take up the cause of liberty, imagining a bloody fate for those he calls monsters:

What is a Tory? Heavens and earth reveal!
What strange blind monster does that name conceal? . . .
I by the forelock seize the Stygian hound;
You bind his arms and bid the dragon down.
Surgeon attend with thy dissecting knife,
Aim well the stroke that damps the springs of life . . .
Lo! mixt with air his worthless ghost has fled,
Surgeon his paleness speaks the monster dead.[95]

The battle lines, in short, had been drawn. Americans, as they would for centuries to come, weren't just finding the demons of war in an outside threat. They were seeing them in those who lived right next door.

IN APRIL 1777, AFTER WASHINGTON'S survival through a brutal winter suggested this would be a long, sapping campaign for the British at the very least, Benjamin Franklin wrote to Paris's English ambassador about the "barbarous treatment" of newly declared American prisoners in Europe, sending them to "Africa and Asia, remote from all probability of exchange, and where they can scarce hope ever to hear from their families . . . [it] is a manner of treating captives, that you can justify by no other precedent or custom."[96] Something ironic there, savoring of a sort of moral relativism that presumably Franklin hadn't intended: the enslaved people in the Americas would have liked a word. As they would have with the slave-holding Thomas Jefferson, who wrote a Declaration suffused with grievances that—in the words of his pamphlet *A Summary View of the Rights of British America*, published in 1774, "too plainly prove a deliberate, systematical plan of reducing us to slavery."[97] One of the grievances Jefferson levied against George III in the Declaration of Independence, it's worth recalling, is that "he has endeavoured to bring on the inhabitants of our frontiers the merciless Indian savages whose known rule of warfare is an undistinguished destruction of all ages, sexes, and conditions," allowing us to consider another turn in a history of fear we've seen before, another atrocity story in a war whose groundwork was laid by, among other things, those narratives of atrocity.

In early September 1777, Continental Army Major-General Horatio Gates wrote to British lieutenant general John Burgoyne, asking how it could be that "the famous Lieutenant General Burgoyne, in whom the fine gentleman is united with the soldier and the scholar, should hire the Savages of America to scalp Europeans and the descendants of Europeans; Nay, more, that he should pay a price for each scalp so barbarously taken."[98] That account, in the *Hartford Courant*, went on to suggest the need for authentication; but other American journals, like the *Pennsylvania Gazette*, carried much more specific—and gory—accounts of the atrocities; in no small part, one suspects, to whip up outrage and enthusiasm for the revolutionary cause, just as those increasingly graphic (and increasingly fictionalized) accounts of the Boston Massacre did, earlier in the decade. In fact, Boston's *Independent Chronicle*, on August 14, 1777, ran this poem, called "Proclamation . . . by John Burgoyne":

> I will let loose the dogs of Hell,
> Ten thousand Indians who shall yell,
> And foam and tear, and grin and roar;
> And drench their maukasins [sic] in gore . . .
> They'll scalp your heads, and kick your shins,
> And rip your guts and flea your skins.[99]

Perhaps the most famous instance of such treatment was the case of Jane McCrea, which had occurred in New York just a few weeks prior to the poem's publication; although the details of her actual murder are slightly obscure, the version of it that spread—that she was kidnapped and scalped by Native American allies of Burgoyne and, as the story gained momentum, in her bridal dress on her wedding day, no less—"quickly crystallized all the misgivings and resentments against the English" and turned into "a banner propaganda coup." Ironically, McCrea was actually a Tory who'd come from New Jersey to meet an officer in Burgoyne's army.[100]

In 1779, for example, the collection *Poems on Several Occurrences in the Present Grand Struggle for American Liberty* contained an entry entitled "The Tragical Death of Miss Jane McCrea." Passing through the wood, its

speaker, hearing "a doleful noise . . . shrieks and dying groans," witnesses a scouting party:

> Some British troops, combin'd with Indian bands,
> With swords, with knives, and tom'hawks in their hands,
> They gave a shout, and pass'd along the wood,
> Like beasts of prey, in quest of human blood.

Moving toward the source of the groans, he says, "a bloody scene salutes my eyes," complete with "an aged man, roll'd in his gore, And from his hoary head his scalp is tore," and a "slaughter'd infant on a clod, Its head all bruis'd, and face besmear'd with blood."[101]

Similar accounts preponderated. In the summer of 1778, "distressed Refugees from the Wyoming settlement on the Susquehannah, who escaped the general massacre of the inhabitants,"[102] gave an account of "villanous Tories who had stirred up the Indians, and had been with them in fighting against us"; despite, apparently, some original recalcitrance by the Native population to engage in hostilities. On July 1, the report stated, almost 1600 combatants—three hundred "thought to be Indians, under their own chiefs, the rest, Tories, painted like them, except their officers, who were dressed like regulars"—began hostilities; the correspondents found some of their own dead "killed, scalped, and mangled in the most inhuman manner." Three days later, they took Fort Wilkesbury, "inhumanly butchered" about seventy members of the continental service, "with every circumstance of horrid cruelty; and then shutting up the rest, with the women and children, in the houses, they set fire to them, and they all perished together in the flames." The report concludes hoping that "speedy and effectual measures will be taken to punish and extirpate these monsters in human shape, from the face of the earth."

The report also expresses the hope that this "will be the concluding scene of the tragedy acted by the British tyrant and his late kingdom, which he has justly forfeited, and which is now forever departed from him." By this time, the calculations had changed, in other words: France had entered

the war a few months earlier; the British had evacuated Philadelphia a few weeks before. It was by no means over, especially in the South; but the tide seemed to be turning, and so it was crucially important to drum up local colonist support by painting the Tories in demonized ways. And not just the Tories, of course: in one of the intriguing productions of the day, they enlisted a ghost to help.

The late eighteenth century saw a vogue for the posthumous exchange of opinions by figures of differing opinion called "the dialogue of the dead," and Revolution-era writers partook: in 1780,[103] the *Pennsylvania Gazette* printed "A DIALOGUE between PENN, MONTGOMERY, CHATHAM, and an AMERICAN LADY," in which the deceased British leaders, priding themselves on "the moderation and the humanity of the British nation," witness a "tumult . . . around the boat of Charon" in the form of "a woman clothed in funeral crape . . . bound with a bloody scarf." The woman in question, an American, disabuses the British of their illusions; after telling the bloody circumstances of her death, Chatham mutters, "It is done: The English are degenerated, the national character is degraded, I have no longer a country." The ghost, for her part, responds that "the excesses to which the British give themselves, raise the spirit of our fellow patriots, and I thank heaven for my death, if it can hasten the deliverance of America."[104]

The value of propaganda, plainly (if spectrally) put, was apparent. While it was hardly *only* these ghostly and fearful narratives—of gore on the streets of Boston; of atrocities committed by Indigenous peoples in partnership with, or as pawns of, Tories or British forces; of a king so tyrannical he would enslave (white) people monstrously—that led to American independence, they certainly provided an emotive heart to it: the blunt prose of war turned into rhymed poetry, fervid oratory, dramatic symbol. Three years after Yorktown, in an oration delivered in Boston on July 4, a speaker would note in terms very similar to that ghost that "while we rejoice at our envied acquisition, let us not forget the price at which it was purchased. . . . the horrors of war, in minds unaccustomed to such dreadful scenes, excited emotions which cannot be expressed."[105]

And yet express them, in rhetoric and imagination, to excite emotion,

is exactly what writers of every stripe had to do; and as they grappled with their new Republic, what it was and what it meant, they would continue to grapple with the specters of the past even as they looked to the future. Those fears of wrath from above. Those anxieties about the demons next door. The guilt of their own crimes turned outward. How would those be expressed, in the work of a new Republic?

Uneasily.

New Country, Old Bones

—

IN 1790 ANDREW ELLICOTT WROTE a "Description of the Falls of Niagara":

> For about seven miles, up toward Lake Erie . . . a chasm is formed, which no person can approach without horror . . . In going up the road near this chasm, the fancy is constantly engaged in the contemplation of the most romantic and awful prospects imaginable.[1]

The newly formed United States of America was a big country, and the vastness and—to use a term increasingly in vogue then—sublimity of its natural landscape not only evoked fear simply in its contemplation, but in its perils for those who wandered, almost like ants, within it. Fears that were spread, and shared, and, yes, worked through, in the reading of them. In 1794 M Carey & Son published Arthur Bradman's narrative of Robert Forbes, his wife, and their five children, who found themselves "in the wide wilderness, strangers to the country, destitute of provisions, and without a compass," possibly as much as 150 miles from any settlement, maybe even more.

Forbes went for help, and, upon his return, the rescue party, "to their great astonishment," found the mother and one child alive, "fifty days since they were left with nothing besides the before mentioned moose meat and tallow," forty-eight days without fire, and nothing else "excepting

cold water, and the inside bark of the fir tree." The writer, in a technique well-known to readers of horror fiction everywhere, insists on the effect of letting the rest remain unsaid: "To paint in proper colours this scene of distress, is altogether beyond my powers of description. It must be left to the imagination of the reader."[2]

Which gets us—for just the briefest of moments, I promise—to a discussion of aesthetics and English literary history; we're not going to dwell on either, but they're crucial to going forward.

Horace Walpole had been with "Elegy in a Country Churchyard" writer Gray at Eton and Cambridge; he accompanied Gray on their grand tour of Europe after university and submitted "Elegy Written in a Country Churchyard" to various venues to ensure its publication. His success in doing so stemmed in no small part from the class differences between the friends: while Gray was the son of a scrivener and a milliner whose parents scrimped to get him to Eton, Walpole, the Fourth Earl of Orford, was the son of a prime minister. Walpole's own political career was undistinguished—as the holder of a seat from a rotten borough, he didn't visit his constituency for the thirteen years he represented it—but his success came in other venues.

By 1749—a year before Gray wrote his poem, two years before it was published—Walpole had begun work on his home, a tower and battlement-strewn shock to the English architectural system, called Strawberry Hill. Walpole would refer to it as "a little Gothic castle," and this first introduction of a word we'll see over and over again is worth talking about at greater length: especially since Walpole's house—of which a friend said that its "Gothic towers and air of elder time . . . so agreeably keep up the idea of haunted walks"[3]—served as the basis for the literary castle he constructed in his 1764 novel *The Castle of Otranto*, often considered the first Gothic novel[4] and the basis of haunted houses for centuries to come.

The Gothic started out in England as partly an "aesthetic of ruin . . . a fascination with deterioration and decay,"[5] and that atmosphere—Walpole coined the word "gloomth" to describe it[6]—relied on a strangely powerful juxtaposition between the then and the now, a kind of nostalgic dissonance.

(You can't have decayed castles, after all, without having time in which to let them decay.) *Otranto* was first published as the ostensible translation of a twelfth-century Italian manuscript,[7] but by the second edition—and it would go through at least twelve by century's end—Walpole unmasked himself as the author and tried to explain the work's immediate appeal. He wrote that the novel had been "an attempt to blend the two kinds of romance, the ancient and the modern. In the former all was imagination and improbability: in the latter, nature is always intended to be, and sometimes has been, copied with success."[8] Anticipating the objections of many a horror moviegoer, he suggested that, in the best writing he'd encountered, characters who'd witnessed strange and seemingly supernatural phenomena "never lose sight of their human character," while in lesser works "an improbable event never fails to be attended by an absurd dialogue. The actors seem to lose their senses the moment the laws of nature have lost their tone."[9]

One of the things Walpole was trying to do, in other words, was to try to create something that combined genuine external evil with the characters' natural, reasonable, psychological distress in the face of it.[10] In this sense, the novel reflected both sensibilities Edwards was taking into account; but also—in a way Edwards didn't feel necessary—tried to find balance between its currents of fantastic, almost phantasmagoric imagination (the novel features, among other occurrences, a gigantic mailed helmet from the sky crushing a groom-to-be) and the reaction to those items, mysteries, and feelings as presented in rational, psychologically explicable ways.

In that sense, the novel—while committed to the supernatural—anticipated not only the Gothic sensibility, but the challenges to it based on the rationalism of the Enlightenment, which was sweeping across the Continent. Walpole's major successor to the crown of Gothic horror, Ann Radcliffe, would become the face of this disenchantment; her protagonists would come to old ruins and crumbling castles, face terrifying and seemingly spectral phenomena, and then discover, by very long novel's end, that there was a rational explanation, usually human trickery and maleficence, behind everything that seemed to be so mysterious. (For the more contemporary reader, what comes startlingly to mind are the old Scooby-Doo

television cartoons, where all the ghosties and vampires are actually wicked people with an agenda and an excellent disguise.)

This legacy was making its way to America, too. Looking back at the font of American fear, now four generations gone, a historian of the Salem trials noted in 1765 that the long-held belief that "there was something preternatural in it, and that it was not all the effect of fraud and imposture" was based on the natural human propensity to double down rather than admit error,[11] even if it led to innocents swinging from the gallows: it was human psychology that stalked Salem, in other words, not the devil, an anxiety-provoking proposition we haven't seen the last of. Radcliffe would have approved.

In 1802, in an introduction to her novel *Gaston de Blondeville*, Ann Radcliffe focuses on precisely the technique Arthur Bradman, who wrote that pamphlet about the stranded family, just used to distinguish between terror and horror—though she, significantly, draws on Shakespeare, *Hamlet*, and usefully for us, *Macbeth*: "Terror and horror are so far opposite," she says, "that the first expands the soul, and awakens the faculties to a high degree of life; the other contracts and nearly freezes them . . . and where lies the great difference between terror and horror, but in the uncertainty and obscurity, that accompany the first, respecting the dreaded evil?"[12] Radcliffe prefers the former, the imagination-awakening terror, because it requires intellectual work of its audience (the way Bradman, at the end, dares us to imagine the picture of that terrible family tableau). Horror, which is the paralyzing revulsion of witnessing *something*, is, for Radcliffe, a lesser phenomenon. We can agree or disagree with the distinction, or the hierarchy, but it'll prove important as we continue, especially as we trace Americans' fear down the highways and byways of gore and allegory.

Not *everyone* agreed, for sure. The last great British influence of the eighteenth century, Matthew Lewis's 1796 *The Monk*, as one critic pointed out, "defined the archetypal horror hero, half saint and half Satanist, who runs amok in an orgy of rape and murder." Lewis, who took the Parliament seat of another horror writer, William Beckford, author of the Orientalist fantasy *Vathek*, also went on to become a playwright and was well known for his special theatrical effects. But nothing was as powerful to his reputation

as the book that got him called "Monk" Lewis and made him a household name at twenty.[13] Its feverish, even berserk nature—there's a ghost called the Bleeding Nun that the son of a marquis elopes with, who's dealt with, in part, by the Wandering Jew, and that's not the craziest part of the story—was, to put it mildly, not the kind of thing Ann Radcliffe would have gone in for. But it did suggest the pushback to the Enlightenment, growing as the century waned.

These literary trends found their echo in America: but echoes, as we all know, ring differently in different-sized spaces.

PHILIP FRENEAU, THAT POET OF the American Revolution (he wrote a poem about Jane McCrea, in 1778, saying, "The cruel Indians seiz'd her life away / As the next morn began her bridal day!"),[14] was probably best known for his 1779 poem "The House of Night; Or, Six Hours Lodging with Death: A Vision."[15] Its famous first stanza suggests the dour contemplative approach we saw in Thomas Gray's country churchyard:

> Let others draw from smiling skies their theme
> And tell of climes that boast eternal light;
> I draw a deeper scene replete with gloom;
> I sing the horrors of the house of night.[16]

The poem's speaker walks through a darkened natural landscape until he reaches buildings surrounded by drooping flowers and high weeds, in which men talked much "Of coffins, shrouds, and horrors of a tomb." And then, making his way into a "high chamber," he sees none other but "Death, dreary death, upon the gloomy couch / With fleshless limbs in rueful form was laid!"

Now, it's true, Freneau turns the poem into a topical allegory—the figure, as a footnote helps inform us, is an embodiment of the decaying and evilly dying British empire, who wants to take down the young American with him. It *was* written in the throes of the war, after all. But the war ended, and for many, it was the mood that remained: transformed, in part, into a "reaction against eighteenth century rationality, convention,

restraint, and unimaginativeness—the manifestation in aesthetic terms of the spirit of independence then dominating politics."[17]

What's interesting, though, is how *depressing* that mood seemed to be. Like in "Ode to Melancholy," appearing in Pennsylvania's *Columbian Magazine* in 1786, whose first lines salute "Thou pensive, sadly-pleasing power / That robes the solemn midnight hour, / In darker shades of woe,"[18] or, as Hannah Cowley put it in her 1791 "Invocation to Horror":

> HORROR! I call thee from the mould'ring tower,
> The murky church-yard and forsaken bower . . .
> Where morbid MELONCHOLY sits,
> And weeps, and sings, and raves by fits.[19]

Maybe that melancholic mood stemmed from contemplation of the cost of that independence. Maybe it was an instinctive contrast to triumphalism. Or maybe the mood was deepened by the understanding that independence didn't mean, well, *independence*, certainly not culturally speaking. In May 1775, in the *Pennsylvania Magazine,* one "Juvenis" presented "a remarkable letter" he'd come across while "looking over some of my papers the other day," a letter featuring a death-obsessed young man whose memento mori comes in the form of a secret room "lined with black, surrounded with coffins, and ensigns of death," featuring his own future coffin, with a picture on the wall of an angel holding a scroll with "the adjuration out of Young's Night-Thoughts" written on it.[20] The deep, dark secret of the *Pennsylvania Magazine*? That at heart, these independence advocates were English poetry worshippers.

And Edward Young and Thomas Gray were hardly the only British sources of fear Americans drew from during the immediately postwar period. In 1784, for example, readers of the *Boston Magazine* could read "The Life of Sawney Beane," a tale of the notorious Scottish cannibal and his family;[21] in July 1785, a worshipful imitation of *The Castle of Otranto*, "The Castle of Costanzo," appeared there as well, among other Gothic examples.[22] The following year's appearance of Beckford's *Vathek* laid the groundwork for an increasing number of similar works: the same year's "The Contemplant: An Eastern Tale,"[23] which appeared in the *Columbian Magazine* and featured a

greedy man accidentally killing his own son; the *New-Jersey Magazine's* 1787 "An Oriental Tale, or the Friendship Corrupted," a neatly grim little fable about two so-called friends who poison each other in an attempt to claim a treasure for themselves;[24] and the *American Magazine's* 1788, "Solyma and Ossmin: An Oriental Tale," with exotic sword-wielding specters.[25] Even the 1793 account of a yellow fever outbreak in Philadelphia—whose authors view with "horror . . . the frightful scenes that were acted, which seemed to indicate a total dissolution of the bonds of society in the nearest and dearest connexions"—seems to be neatly channeling Defoe.[26]

As for the "only American narrative works to contest for popularity with European fiction"[27]—the captivity narratives—they were such a well-trodden path by 1796 that an author could write that "Our country has so long been exposed to Indian wars, that recitals of exploits and sufferings, of escapes and deliverances, have become both numerous and trite." She writes this as an apology for the fact that her own captivity narrative, which follows that introduction, will not attempt any "air of novelty."[28]

So what narratives of fear *did* feel new, or, at least, newly American? It was left to one of the new country's earliest observers, a French count's son turned American citizen named John Hector St. John de Crèvecoeur, to produce a scene of unimaginable American horror in an effort to explain to Europe what this land in the process of shrugging off British rule was actually like.[29]

In "What Is an American," the third letter in de Crevecoeur's 1782 *Letters from an American Farmer*, the author praises the possibilities the country offers for self-reinvention and liberation: "Here man is free as he ought to be; nor is this pleasing equality so transitory as many others are." But unlike some of his compatriots, de Crèvecœur is not unaware of the very selective nature of this equality. Describing a scene in Charleston in his ninth letter, he writes that "Here the horrors of slavery, the hardship of incessant toils, are unseen; and no one thinks with compassion of those showers of sweat and of tears which from the bodies of Africans, daily drop, and moisten the ground they till . . . Strange order of things!" And then he explains his "melancholy reflections" and "gloomy thoughts": it was because of a scene that, since he saw it, "my mind is, and always has

been, oppressed" with it. And we are given that scene, in all its horror: a full visual barrage.

Invited to dinner with a planter, he walked the three miles there through "a pleasant wood," when "all at once I felt the air strongly agitated, though the day was perfectly calm and sultry." Hearing "a sound resembling a deep rough voice, utter[ing], as I thought, a few inarticulate monosyllables," de Crèvecœur saw "something resembling a cage" hanging from a tree, whose branches were covered with "large birds of prey, fluttering about, and anxiously endeavouring to perch on the cage." He shoots at them; scared, they fly off, allowing him to see, "horrid to think and painful to repeat . . . a negro, suspended in the cage, and left there to expire!" "The birds had already picked out his eyes," de Crèvecœur recalls, and describes the man's body covered in wounds, his cheeks flayed to the bone; as soon as the birds had left, the insects swarmed, "eager to feed on his mangled flesh and to drink his blood." He offers the man water: "Tanke you, white man, tanke you, pute some poison and give me" is the response; asked how long he has been there, he answers: "Two days, and me no die; the birds, the birds; aaah me!"

This is horror, pure and simple. We may wish to look away; and de Crèvecœur, bluntly, reminds us that, unlike this enslaved man, we have the privilege of having the eyes to do so. Arriving at the planter's house, de Crèvecœur learned the slave was being so punished for killing the plantation's overseer: "They told me that the laws of self-preservation rendered such executions necessary," he says, bitterly. Five years later, another anti-slavery letter writer took a similar stance: "It will be said that executions like this are necessary to strike terror into slaves," he wrote to the *American Museum*'s editor in 1787. "In answer to which I will observe, that if such executions are necessary, where slavery is practiced, it is a forcible argument for the abolition of it," and quotes the Declaration of Independence in support of his position.[30]

Even death gave no ending to the indignities and assaults perpetrated on the Black body: in February of 1788, the New York *Daily Advertiser* reported that "few blacks are buried, whose bodies are permitted to remain

in the grave . . . human flesh has been taken up along the docks, sewed up in bags, and . . . this horrid practice is pursued to make a merchandise of human bones, more than for the purpose of improvement of anatomy" (as if that would have been sufficient reason). The graveyard at Trinity Church, one of the earliest Black graveyards in New York, was repeatedly vandalized, including by a group of medical students who took a child's body "and attempted that of an aged person." And although the Black community complained, there seemed little redress, until anger boiled over into a riot at the Society for the Hospital of the City of New York, catalyzed, in part, when "a group of boys reported to their elders that they had observed dissected limbs of human bodies dangling from a window in the rear of the hospital." The riots spread to, among other locations, Columbia College and "every physician's house in town," searching for cadavers or other signs of the horrific activity. Various doctors were, at times, forced to "slip out of windows, creep behind bean barrels, crawl up chimneys, and hide behind feather beds." The crowd was dispersed by a sword- and firearm-bearing group including, among others, John Jay and Alexander Hamilton.[31]

This was not the only such "resurrection riot" in colonial America, and not all of them were limited to Black bodies, but it was by far the most prominent, and provided recognition, in short, of the fear and terror of slavery that existed from the very beginning, and the way it would haunt the American imagination, and its idealistic conception of itself, for centuries to come. In 1796, a poem appearing in Vermont's *Rural Magazine* by "L.B.C." three days before Independence Day addressed the hypocrisy of slaveholding freedom-lovers: "We broke our fetters, yet enchain our kind," they write, and provide a horrific image of the ghostly enslaved, standing in accusation on Judgment Day:

> And there, the shades of Afric's slaughter'd millions,
> Will, to the face, and in the ears of heaven,
> Tremendous truths, and horrid facts disclose,
> And thus, perhaps, recite the dreadful charge.[32]

Such scenes only hinted at the pervasive structures of violence and white supremacy that undergirded vast swaths of the American experiment. In those first decades of the country, the questions of abolitionist sentiment had not yet reached its highest pitch. That would change.

SLAVERY WAS, PERHAPS, THE AMERICAN horror story, foremost in its brutal facts, but also in its philosophical anxieties: a direct challenge, as many pointed out even then, to the ideals of freedom and independence enshrined in its founding charter. But there was another genre of the period that spoke to anxieties more cultural and literary: the possibility of returning to the cultural fleshpots of Britain, so to speak, of having wrested independence from Europe only to fall in thrall once again and never develop an American voice. Being seduced, in other words; and bodily seduction stood in allegorical place for the philosophical, cultural, and political.

Quite a number of stories appear in late eighteenth century American newspapers about innocents seduced; "First he'll court you, then he'll leave you / Poor deluded! To lament," ran the lyrics of a popular song of the time;[33] and the new nation's most popular novel—the bestselling novel in American history until at least *Uncle Tom's Cabin*, and maybe even into the twentieth century—was one of these "seduction novels," as the genre became known, which featured, as fearsome monster, a dastardly, suave, British man.[34] Susanna Rowson's *Charlotte Temple* was published in England in 1791 to little notice; but coming out in America three years later, it would go on to appear in *two hundred* editions through 1840.[35] Matthew Carey, its publisher—who'd come to America to escape a prison term in Britain for publishing an Irish nationalist newspaper and got start-up capital for his publishing house from French aristocrat turned Revolutionary War hero the Marquis de Lafayette—wrote Rowson that "it may afford you great gratification to know that the sales of *Charlotte Temple* exceed those of any of the most celebrated novels that ever appeared in England."[36] The fictional Charlotte Temple even received her own "grave" in New York City's Trinity Churchyard in the early 1800s; tens of thousands came to visit it over the next century.[37]

Young Charlotte is a new American; but she crosses the Atlantic not

for commercial incentive or ideological fervor, but thanks to the seductive wiles of a British soldier, John Montraville, who then impregnates her and leaves her flat:

> "Lucy," replied Mr. Temple, "imagine your daughter alive, and in no danger of death: what misfortune would you then dread?"
>
> "There is one misfortune which is worse than death. But I know my child too well to suspect—"
>
> "Be not too confident, Lucy."[38]

The moralistic tone here, of course, isn't so surprising; Charlotte has strayed, and the novel's conscience both blames the woman for giving into temptation and punishes her far more rigorously than the rotter who seduces her. *She* ends up dying as the result of childbirth, full of "dreadful images that haunted her distracted mind"; he, on the other hand, is "subject to severe fits of melancholy" until the end of his life. You can certainly see the book's success as trafficking in anxieties about women lacking the virtues befitting female citizens of a new Republic.[39] (Rowson, whose narrative tone is both strict and also, in its own way, warmly cautionary, would go on to found a Young Ladies' Academy in Boston six years after the novel was published—in part because, author protections being what they weren't, she didn't see a lot of money from the novel.)[40] You could see, as some scholars do, the seducer as a secularized version of the Satan who bedeviled the readers' ancestors: in 1801's "The Seducer: Addressed to the Fair Daughters of America," for example, the author wrote of the "base seducer": "such a one is a monster in creation."[41] But writ more broadly, the genre's national dimension becomes clear, too: can America find its own way? Or will it backslide, into the Old World's desirous clutches?

Of course, metaphors only go so far: and the interest in matters of seduction were hardly just literary—they even entangled a Founding Father or two. A sensational murder trial occupied the attentions of the early Republic when at the end of 1799, right after the death of George Washington, a young woman named Gulielma Sands disappeared from Greenwich Street, and then was discovered a few days later at the bottom

of a newly dug well. The obvious—and likely—culprit was fellow-lodger, and perhaps lover, Levi Weeks, whose brother, Ezra, was a builder who did business for Aaron Burr (whose company had dug the well) and Alexander Hamilton—both of whom represented Weeks at trial, and who helped get him off.[42] The reading of the indictment offered a classic portrait of seduction gone even more awry, and turned into theatrical performance: "after a long period of criminal intercourse between them, he deluded her from the house of her protector under a pretence of marrying her, and carried her away to a Well in the suburbs of this city, and there murdered her—[Here the Assist. Atty. Gen. suddenly stopped a few seconds, as if overpowered with his emotions.] No wonder, gentlemen that my mind shudders at the picture here drawn, and requires a moment to recollect myself."[43]

That wasn't the only performance of the eagerly followed and widely attended trial. A witness, William Dunstan, was testifying to the statement of another man, Croucher, who would suggest that Levi Weeks has been "taken up by the High Sheriff and there is fresh evidence against him from Hacken-sack." But, as the testimony was being given, one of the members of the defense—either Hamilton or Burr; both later claimed credit—held a candle up to Croucher's face. Burr's biographer, James Parton, would write that it was Burr who, holding "two candelabra" to Croucher's face, cried: "Behold the murderer, gentlemen!" which created such a "ghastly effect" that Croucher both fled the room and generated reasonable doubt for Burr and Hamilton's client. Hamilton's family claimed *he* was the candelabra-holder; legend has it that one courtroom spectator, upon Weeks's acquittal, "pointed at Alexander Hamilton, and cried out, 'If thee dies a natural death, I shall think there is no justice in heaven!'"[44]

Hamilton, of course, did *not* die a natural death; and that's not the only uncanny story around the murder. A number of witnesses testified that while Sands was dying in the well, they had heard "from about the place of the Well, the voice of a female crying murder, and entreating for mercy,"[45] and an account published over half a century later reported "eerie sights and sounds" at the site of the well: "shrieks, flashes of fire in the sky, and the appearance of a figure draped in white." The account also noted, though, that "when unbelievers were present . . . the phenomena did not occur,"[46]

and we might see this as the Founders' Enlightenment, Lockean, deistic counterpart of Ann Radcliffe's form of the Gothic, putting down all the clankings and horrors to odd architecture and maleficent human relatives.

Radcliffe was certainly popular enough in the Republic's early newspapers, which were stuffed with serialized novels that were either pseudo-Italianate versions of Radcliffe's novels or excerpts of the novels themselves.[47] But Radcliffe wasn't just a literary influence; she represented a whole sensibility. . . . The reporter of the tale of a "certain house near the banks of the Shenandoak [sic], in Virginia . . . infested by evil spirits, or the ghosts of some injured persons" in a 1795 issue of the *Rural Magazine* goes on to dismiss the report as "supersititious credulity," and even dismisses, definitively, the greatest (ostensibly) supernatural horror story of American history to date, describing Salem as the result of "the credulity, delusion, and infatuation of those times."[48]

Which was not to say that champions of the Age of Reason didn't understand unreason's power. An essayist for the *Massachusetts Magazine* had written the previous year that:

> Of the various kinds of superstition which have in any age influenced the human mind, none appear to have operated with so much effect as what has been termed the Gothic . . . The most enlightened mind, the mind free from all taint of superstition involuntarily acknowledges the power of Gothic agency.[49]

Emphasis, that is, on the involuntariness of the emotion, rather than the metaphysical nature of the cause. The Gothic was certainly a capacious enough mode to allow for that.

But creating a truly *American* Gothic—as opposed to printing Gothic tales of Europe in American newspapers and magazines—posed a problem: namely, that much of that emotional power relied on the encounter between present-day characters and an old history. Those castles had to be there for a long time before they could get all ruined and crumbly, after all. In a country that was new (at least as far as white colonists, and indeed their slaves, were concerned), there were structural difficulties in composing a

faithfully Gothic fiction without engaging in secondary knockoff. But Charles Brockden Brown, the first great American novelist of fear, came the closest.[50]

A law student turned litterateur, Brown knew fear: he'd lived through war, of course, and that yellow fever epidemic in Philadelphia in 1793, along with several later ones there and in New York;[51] one of his novels, 1799's *Arthur Mervyn*, has its protagonist draw on those experiences to create what one critic called a "pathological Gothic." But, again, an explainable one: Mervyn sees "apparitions and fleshless faces as he wanders through Philadelphia," but those horrors turn out to be victims of the plague.[52] But it's in a novel he published the year before, 1798's *Wieland; or, the Transformation: An American Tale*, that he manages to infuse multiple strands of the American condition into the form: the religious fervor, the wild American landscape that would have to stand for the crumbling European castle, and—just a generation after the Revolution—the shadow of an American past. After all, even if the *country* was new, the *colonists* had already been there for close to two centuries, which allowed for the inclusion of a multigenerational narrative, juxtaposing the sins of the father with the story of a later generation.

And so it does. *Wieland* is inspired in part by a 1796 report of a farmer, James Yates, who murdered his wife and children near Albany back in 1781 after having "beheld two Spirits, one at my right hand and the other at my left—he at the left bade me destroy all my *idols*, and begin by casting the Bible into the fire" and eventually, with the voices urging him on, calling his family idols, approaching his wife and "I repeated my blows, till I could not distinguish one feature of her face!!!"[53] Brown writes in his introduction that his novelistic version's "purpose is neither selfish nor temporary, but aims at the illustration of some important branches of the moral constitution of man."[54] But what it's really about is a man who is driven to madness and to homicide—of family members, no less, and via hatchet—and then suicide, because he hears voices telling him to kill.

He believes these voices—which say things like "Thy prayers are heard. In proof of thy faith, render me thy wife. This is the victim I chuse" and "Thou hast done well; but all is not done—the sacrifice is incomplete—thy

children must be offered,"⁵⁵—to be supernatural in nature, divine or, perhaps, the devil in heaven's clothing. Brown has warned us, though, that while "the incidents related . . . will be found to correspond with the known principles of human nature,"⁵⁶ and so, as it turns out, God, as in good deistic philosophy, is nowhere involved. Instead, it's a malicious ventriloquist who's to blame. Maybe Brown was inspired by "Anecdote of a Ventriloquist" that appeared in a 1790 issue of the *Massachusetts Magazine*, in which a Parisian gentleman used the aforesaid skill to ensure a rich man makes him his son-in-law by pretending to be a heavenly voice threatening him with imminent death if he failed to do it.⁵⁷ Maybe also, though, the "biloquist," to use Brown's term—someone who speaks in two different voices—is a perfect symbol for someone trying to balance the literary sensibilities of Old World and New, in both religious and political terms.⁵⁸

There's that Enlightenment rationalism, yes, but harnessed to a sense of wandering, external evil that can prey on the credulous, on the lonely, on the mentally unstable, driving them to some very unpleasant places. (And it's worth noting that not every reader of the novel is convinced the voices he hears are just ventriloquism.)⁵⁹ It's certainly not coincidental that Brown's American Gothic fiction takes place outside the city, in a locale with the potential to incorporate the horrors of the forbidding and potentially hostile landscape. As he wrote in the introduction to a novel published the following year, *Edgar Huntly; or, Memoirs of a Sleep-Walker*, "for a native of America to overlook these [scenes] would admit of no apology."⁶⁰

And, soon enough, that sensibility came to the city. The first sign of the Gothic revival in American architecture appeared two years after *Wieland*, in 1800, in the form of a country house near Philadelphia; a chapel in similar style would follow in Baltimore in 1807, and many churches would subsequently do the same. Painters like Washington Allston, Rembrandt Peale, and William Dunlap began to turn in this direction, with works like *Belshazzar's Feast* and *Death on a Pale Horse*.⁶¹ When Allston showed *Belshazzar's Feast* to Gilbert Stuart, still known today for his iconic portrait of George Washington, the latter criticized his use of perspective; Allston then became obsessed with the picture, working on it obsessively, never allowing friends to see it, keeping it behind drawn curtains, and refusing to

take on other work until he finished—which he never did. It was, perhaps, cursed.[62] (The period also saw numerous paintings of Jane McCrea's death, one of which was the first painting on an American subject by an American to be accepted to Salon de Paris, the official annual art exhibition of the Académie des Beaux-Arts.[63]

An increasing reckoning with the power of unreason, then; and maybe it was more than just the creation of an American Gothic. Maybe there was another sentiment at play, a second one that was haunting the continent as the century turned. France was making it perfectly clear the American flavor of revolution wasn't the only one in town, and seeking to make sense of how Lady Liberty gave way to Madame Guillotine on the Continent, some Americans turned to older fire-and-brimstone fears, moral fervor and fear-mongering. "The devil is, at this time, gone forth. . . . France is filled with atheists," Massachusetts preacher Joseph Lathrop sermonized in 1798. "As they are extending their conquests, they will doubtless disseminate their abominable principles, which other nations . . . are but too well prepared to receive."[64] He would blame "Illuminators," part of a currently circulating theory "taken quite seriously by many" that, in the words of one scholar, "a conspiracy of Bavarian atheists" had "masterminded the French Revolution" and, by means of their secret networks, "now sought to seduce young Americans by infiltrating literary societies and Masonic lodges, thereby gaining control of government, voluntary associations, and the print public sphere." Godlessness, widespread godlessness, could hardly be far behind.[65] There had been widespread rumors—rumors that made their way into the undercurrents of Brown's *Arthur Mervyn*—that the yellow fever epidemic of '93 was started by the French, connecting moral anxiety and physical concern in one conspiratorial package.[66] Another Massachusetts preacher, Jedidiah Morse, claimed in 1799—an early participant in a tradition that would find its most famous descendant in Senator McCarthy 150 years later—to possess "an official, authenticated list of names, ages, places of nativity, professions &c. of the officers and members of a society of *Illuminati* . . . consisting of *one hundred* members, instituted in Virginia, by the *Grand Orient* of FRANCE."[67]

You might have thought, given all this, that it would be the fevered

insanities of Lewis's *The Monk*, rather than Radcliffe's novels, that would find purchase: and the truth was, they both did. Yes, some American critics sniffed at *The Monk*: a reviewer for *The American Universal Magazine*, one writer, while acknowledging certain "excellencies," suggested that "the errors and defects are more numerous, and (we are sorry to say) of greater importance," and wrote that "figures that shock the imagination, and narratives that mangle the feelings, rarely discover genius: and always betray a low and vulgar taste." But that's not, it should be said, precisely a road *against* popular appeal: and the writer gives the game away by declaring it "to be our opinion, that *The Monk* is a romance, which if a parent saw in the hands of a son or daughter, he might reasonably turn pale"; particularly the "libidinous minuteness" of its descriptions and its "voluptuous images."[68]

Moral panic and concern for the seduction of the innocent young always plays well among the older guard: and the alarmist tone of the review suggests some real uptake among readers. And this was the case, for it and for American works that came in its wake, such as 1821's *The Forest of Rosenwald, or the Travellers Benighted* by John Stokes,[69] which adapted that bleeding nun episode. There were also a brace of similar plays in 1807 and 1808. J. B. White's *The Mysteries of the Castle*, was a play that "provide[d] terror in unstinted measure . . . ghosts, sinking floors, explosions, and underground passages provide enough adventure for half a dozen melodramas."[70] The last act of John D. Turnbull's 1808 *Wood-Daemon, or the Clock Has Struck* consisted, according to an early twentieth-century critic, "almost wholly of a series of supernatural phenomena of an extravagant and puerile nature."[71]

But many of the dramas of the period—including one by painter William Dunlap, 1795's *Fontainville Abbey*, actually based on a Radcliffe novel[72]—insisted on a natural solution to their Gothic effects; and it was Radcliffe's sentiment, for the time, that won out. And it was this sensibility—combined with Brown's (and de Crèvecœur's) interest in finding atmospheric fear in the less settled spots on the map, those natural features of the American landscape that can hide horrors within it, supernatural, perhaps, or perhaps only seeming so—that would figure strongly in the work of the first great practitioner of horror—born on the continent—that Americans still read today.

WASHINGTON IRVING, BORN IN 1783, the year the Revolution ended, was as cosmopolitan and aristocratic as you could imagine a new American to be, a Knickerbocker to the core: he was the one, in fact, who popularized that name, writing several works under that satirical pseudonym. "Composure is hard to find in the early federal period," one critic noted in discussion of contemporary American satire,[73] but Irving was as well situated as any to possess a comfortable perch from which to toss such darts: a prosperous New York merchant family with the wherewithal to send him upstate to the Hudson Valley during yellow fever outbreaks, and give him a grand tour through Europe in the early years of the new century. And so he slotted smoothly into the emerging literary circles of New York, and his work—in the satirical journal *Salmagundi*,[74] in "Diedrich Knickerbocker"'s 1809 *History of New York* . . . "being the only authentic history of the Times that ever hath been, or ever will be published," and, of course, in the later stories that would make him renowned—combined discomposure with a cushion of comfortable irony.

Named as he was after his country's first president, he was suffused with patriotic pride: "Never need an American look beyond his own country for the sublime and beautiful of natural scenery," he wrote in the collection of stories and essays that first made him famous, *The Sketch Book*, purporting—like so many other works of the time—to come from another's pen, that of one Geoffrey Crayon.[75] But, like other cosmopolitan types, his love of America's newness was balanced by other needs and turnings. "We are a young people, necessarily an imitative one, and must take our examples and models, in a great degree, from the existing nations of Europe," he wrote in an essay in *The Sketch Book*. "There is no country more worthy of our study than England."[76]

Most of *The Sketch Book*, in fact, had been written in the British Isles. On later visits there, Irving would become friendly with Mary Wollstonecraft Shelley, along with her father, William Godwin.[77] (According to some, Shelley even expressed romantic interest in Irving after the drowning death of her noted poet-husband; and she was certainly a fan of Brockden Brown's work.)[78] Both worked in our vein: Shelley, of course, for *Frankenstein;* and her father for the then-terrifically popular novel *Things as They Are, Or,*

the Adventures of Caleb Williams, in 1794. In this novel, Caleb Williams discovers that his employer, the apparently saintly Ferdinando Falkland, is actually a disturbed murderer. Though the novel is generally known for its political ramifications, its animating thesis—that behind solid citizens and saints, psychopathy often resides—would have admirers, including Brockden Brown, and significant afterlife.[79]

Irving considered England worthy of study first and foremost, perhaps, but also, it should be noted, he revered Germany. In a review of Wieland's *Oberon,* a critic for the *Port Folio* wrote toward the end of 1810: "German literature has of late been much indebted to the well-known hospitality of the English nation for comfortable entertainment . . . infested with ghosts, sprites, hobgoblins, fairies, and monsters of all sizes . . . In sober sadness, this popular enthusiasm for ghosts has done much to corrupt the purity of English taste."[80] In 1817 the eminently influential German fantasist E. T. A. Hoffmann published his *Night Pieces,* a collection of stories, the most notable of which, "The Sandman," was about the creation of a mechanical man shot through with stories of familial obsession and displaced passion. It would remain the most important entry in that subgenre—until the publication of Shelley's *Frankenstein* the following year. Numerous critics noted Irving's influence by, even indebtedness to, German source material for his *Sketch Book;* "Rip Van Winkle," for example, seems clearly based on the German tale of "Peter Klaus," even if contemporary claims of straight-out plagiarism are somewhat overstated.[81]

But despite these influences and the circumstances of composition, the *Book* has much to say about America. In "The Author's Account of Himself," Crayon/Irving notes how, as a child wandering through the countryside, he familiarized himself with all the places "famous in history or fable . . . every spot where a murder or robbery had been committed or a ghost seen."[82] And the *Sketch Book*'s most resonant stories—the ones that earned Irving his lasting legacy, and certainly the most important uncanny stories of the early republic—are of course set in America: not in New York City, that gotham (a word for "city" Irving was the first to apply to it), but in the far less settled regions of the state, up the Hudson Valley.

"Rip Van Winkle's" main character is so well known that he's become

a byword: but pay close attention to that name—Dutch, of course. The story purports, like so much fiction of the period, to be a found manuscript, here a "posthumous writing" from Irving's earlier faux-historian Diedrich Knickerbocker, making it, in its own way, a ghost story. The story is set among the "fairy mountains" of the Kaatskills, in a little village of "great antiquity, having been founded by some of the Dutch colonists in the early times of the province," allowing for that same sense of oldness Brown was looking for in his own work. And while the "travelling notes" from "Knickerbocker" bring in "Indian traditions of the Manitou" to show that "the Kaatsberg or Catskill mountains have always been a region full of fable,"[83] that's not the kind of nativeness that Knickerbocker, or Irving, is too interested in exploring: the "company of odd looking personages playing ninepins" who remind Rip "of the figures in an old Flemish painting . . . brought over from Holland at the time of the settlement."

He drinks from their flagon—repeatedly—and, of course, falls asleep. Returning to his village after waking, he finds something even odder than magic bowlers: that things have somehow both changed unutterably and simultaneously stayed as they were. Instead of the tree that used to shade "the quiet little Dutch inn of yore," Rip sees, astonished, "a tall naked pole with something that looked like a red night cap, and from it was fluttering a flag on which was a singular assemblage of stars and stripes." Even the "ruby face of King George" that was on the inn's sign was "singularly metamorphosed," exchanging its red coat for "one of blue and buff," its sceptre for a sword; now wearing a cocked hat, the words GENERAL WASHINGTON are "printed in large letters" beneath.[84]

Rip has, of course, slept through the Revolution; and, while this is played in no small part for comedy—there's a lovely little farcical moment where he almost gets in real trouble for blessing the king as a loyal subject—there's an anxiousness, perhaps, that the underlying structures haven't changed, the inns, the mountains, even the people. Rip has aged, of course, but, in a moment of uncanny doubling of a kind we'll see over and over again in our story, he sees himself in town, staring back at him. It's his own son, now a "precise counterpart of himself, as he went up the mountain," but Rip's reaction is telling: "God knows . . . I'm not myself—I'm somebody else . . .

and everything's changed—and I'm changed—and I can't tell what's my name, or who I am!"[85]

Thankfully, though, stability is restored, courtesy of what Irving identifies as the real terror behind the story: women. There's a sly intimation that maybe, just maybe, Rip *hasn't* been enchanted all this time. Maybe he's actually just lit out for a little Revolution of his own—the only way he can think of to get out from under the thumb of his "termagant wife," a passive-aggressive strategy in keeping with his general go-along, get-along nature. The story makes the link between political and domestic arrangement pretty clear. "Rip in fact was no politician," it reads. "The changes of states and empires made but little impression on him; but there was one species of despotism under which he had long groaned and that was petticoat government. Happily that was at an end . . . and [he] could go in and out whenever he pleased without dreading the tyranny of Dame Van Winkle."[86] In the early Republic, "tyranny" is, after all, a pretty loaded word to throw around; and it may be worth noting Rip identifies himself to his son only once he learns his wife's well and safely out of the picture, having "died but a short time since—she broke a blood vessel in a fit of passion at a New England pedlar."[87] It may also be worth noting that Irving never married.

Irving's other great tale of the uncanny, "The Legend of Sleepy Hollow," also involves an unsuitable candidate for the role of husband, in what may be the first great "ghost" story in American literature; although, like its lesser-known counterpart in *The Sketch Book*, "The Spectre Bridegroom," it isn't much of a ghost story at all. That one focuses mostly on a credulous, garrulous German baron and the would-be suitor of his daughter who uses the titular legend to duck out of his company;[88] here, the would-be suitor is one Ichabod Crane, the local schoolmaster of slight frame but large appetites—he "had the dilating powers of an Anaconda" when it came to food, and also other desires.[89]

His interest in the beautiful and rich Katrina van Tassel, "plump as a partridge; ripe and melting and rosy cheeked as one of her father's peaches," is matched only, perhaps, by his interest in the supernatural—he "was a perfect master of Cotton Mather's History of New England Witchcraft,

in which, by the way, he most firmly and potently believed"—and enjoyed telling, as well as reading, scary stories. If only they didn't frighten him so much on his way home. And he's not the only one: like in "Rip Van Winkle," a "drowsy, dreamy influence . . . [seems] to pervade the very atmosphere," perhaps due, the story suggests, to a German[90] enchantment or to "an old Indian chief . . . [who] held his powwows there"; in short, the place, suggests the narrator, "abounds with local tales, haunted spots, and twilight superstitions." The most notable: the Headless Horseman, rumored to be the spirit of a Hessian soldier who'd lost his head to a cannon ball during the Revolution.[91] The Hessians, known to all citizens of the new country for their cruelties on the British side, make unquiet ghosts indeed: symbols of violent trouble stalking an apparently placid new surface.

And there's other trouble brewing here, too: because Ichabod's courtship of Katrina is not unchallenged. Standing in his way is one Brom Van Brunt, better known as Brom Bones, "dexterous on horseback as a Tartar"; at first, Ichabod seems to have the advantage over Brom's rough and ready romantic ways—until walking home after an embarrassing encounter with Katrina, affrighted by his own fears, Crane runs into "a horseman of large dimensions" and realizes, to his horror, that not only is the horseman headless, but the head is resting on the horse's saddle! After a mad chase, the creature throws its own head at him and "it encountered [Crane's] cranium with a tremendous crash"—and then Crane disappears. Nowhere to be found again.[92]

Well, yes, and no; since an old farmer says years later that he'd run into Crane on a visit down in New York, and Brom Bones, who'd married Katrina, seems to know more about it than he lets on, especially about the shattered pumpkin found at the scene of the crime. Just like in "Rip," there's that Radcliffean need to explain the supernatural again, to let us know that Irving, deep down, is no Ichabod; he's a cosmopolitan member of the new American intelligentsia. That said, Irving takes pains to note, with tongue partly in cheek, that "the old country wives, however, who are the best judges of these matters, maintain to this day, that Ichabod was spirited away by supernatural means; and it is a favourite story often told about the neighborhood round the winter evening fire."[93] Legend is

much better than truth, that is; and—given the amusement provided by the "real" story—the ladies of Sleepy Hollow would rather be scared than tickled. Irving, of course, was capable of doing both simultaneously.

The Sketch Book was an enormous success on both sides of the Atlantic; and Irving never quite reached its heights again—an 1824 followup, *Tales of a Traveller*, would feature some spooky stories, particularly the Faustian story "The Devil and Tom Walker," but none with the impact of those first two.[94] Given their success, though, it's unsurprising these unquiet ghosts, these Gothic horrors, continued in the decade to come.

There was a rage for several decades in the first half of the nineteenth century for the Phantasmagoria, or magic lantern ghost show: which presented to paying audiences "the illusion of a phantom appearing as a small figure at a distance"; as they watched, the figure would gradually approach and grow "to an immense size before suddenly disappearing," in a manner not totally dissimilar to the specter of the Headless Horseman as revealed to Ichabod Crane. But the magic lanterns came, and went, flickers on a stage, on a bill between "other entertainments that varied from scientific demonstrations to Chinese fireworks to magic tricks."[95] Far more influential, perhaps, were the uncanny images crafted in periodicals.

IF BENJAMIN FRANKLIN, AMONG OTHERS, had shown how the new country was crafted via printing and handbills, it was perhaps no surprise that the nation's first few decades saw an explosion of local and regional newspapers and magazines—many dedicated to religious edification, others to literary amusement. Irving's observations about American cultural newness and its interdependence on British literary movements obtained here, too: and when it came to the scarier sort of tales, the impetus came, once again, from Scotland. Although the pages of quite a number of English magazines responded strongly to the uptick in interest in Gothic fiction during the first decade of the century, moving away from Radcliffe's "explained supernaturalism" and publishing dozens, if not hundreds, of serial Gothic fictions,[96] it was Blackwood's Magazine, founded in Edinburgh in 1817, that was notable for its interest in matters of the uncanny; and, not unrelatedly, for publishing, in 1824, the first work written by an American in Britain.

John Neal had left Baltimore for London the year before with a mission: he wanted to raise the profile of American letters around the world. As well as his own, of course: he'd had a remarkable trajectory, moving from a dry goods business—which included a little smuggling of British contraband during the War of 1812—to an intellectual career there that ran the gamut from poetry to novels. Stung, though, by the dismissal of American fiction as simply of parochial interest, he sailed east. In a series of pieces on American writers for *Blackwood's*, Neal said of Brockden Brown: "Had he lived here—or anywhere, but in America—he would have been one of the most capital story-tellers—in a serious way, that ever lived."[97] Neal's own novels, for their part, are harder to characterize as "serious": an early twentieth-century critic described his stories as "the wildest, most incoherent pieces of imagination in American literature . . . His style is a perfect medium for his purpose: violent, hysterical, shrieking, it defies all laws of order and lucidity."[98]

One example of that—a prime instance of early American literary gore—suggests a new treatment of an old colonial fear, in these early days of the new nation.

> An instant, a silent single instant, and a human trunk rolled downward from the rock, to the edge of the water—its head in the calm moonlight—the blood rushing out of its throat, and ears, and nostrils—the eyes starting from their sockets! What had smitten him?—the hand of Logan!—It was a corpse. Not a sound escaped it.[99]

Logan, of Neal's 1822 *Logan: A Family History,* is a Native American chief, and the smiting notwithstanding, Neal's portrait of Logan is by no means entirely negative. It works, in fact, in an increasing tradition of seeing America's Indigenous population as sinned against, not just sinning.

Neal wasn't the only one: we'd seen that Enlightenment-oriented account of a captive ransom, which, paternalistic as it was, was a long way from Mather's imprecations. De Crèvecœur, in his fourth *Letter from an American Farmer*, mentions smallpox and liquor, "the two greatest curses

they have received from us," and that whenever they "live in the neigh-
bourhood of the Europeans, they become exposed to a variety of accidents
and misfortunes to which they always fall victims." Irving claimed Native
Americans have been "doubly wronged by the white men . . . dispossessed
of their hereditary possessions by mercenary and frequently wanton war-
fare; and their characters have been traduced by bigoted and interested
writers."[100] That "interested" intrigues: and one additional motive for such
writings was suggested in a 1786 letter to the *New Haven Gazette*, which
notes that many of the "long narratives of Indian murders, &c" have sin-
gularly failed to include "a word about the cause or provocation which led
the Indians to commit them." The provocation? The "butcher[ing,] . . . in
cold blood, more than 100 of these people" by representatives of "a number
of speculators" who "wish to prevail with Congress to grant the lands in
that quarter on condition of settlement only, without paying any purchase
money for them, or if they cannot do this, by such publications to lessen
the number of buyers, and by that means lessen the price of the lands."[101]
Racism, yes, but, ultimately, it was about land, and money: the growth of a
new nation would come at someone else's cost.

Neal, then, is part of a tradition that presents Native American violence
not as diabolism, but as a consequence, as punishment. "The spirit of the
red man hath been stirred up to voice and action. And lo! The white man
hath quailed in the rebuke," he writes; and, in the process, along with lit-
erary contemporary and rival James Fenimore Cooper (the first of whose
famed Leather-Stocking Tales, *The Pioneers*, was published a year after
Logan) reinforced the archetype of the noble savage in their regard.[102]

You can see Neal's work, then, as not only an expansion of the (explain-
able) Gothic into another corner of the American landscape, but also as a
means of declaring literary independence from English traditions, explor-
ing matters that are native in every sense of the word. "It would not do for
me to imitate anybody," he writes in the preface to a novel he wrote a few
years later, 1828's *Rachel Dyer: A North American Story*. "Nor would it do for
my country . . . Our best writers," he says disparagingly, "are English writ-
ers, not American writers . . . not so much as one true Yankee is to be found
in any of our native books; hardly so much as one true Yankee phrase. Not

so much as one true Indian."[103] Whether the portrait Neal produced is anything like "true" is both hugely important and not quite his point:; what it is, however, is unquestionably American.

Rachel Dyer was also very much American in its outlines: it had been offered to *Blackwood's* in short story form, but ended up not being published there. Maybe in part because of its subject: it's about the Salem witch trials.[104] Maybe it's because of its language: *Dyer* also addresses Neal's critique of other American writing—that lack of "one true Yankee phrase"—by copiously incorporating the actual trial transcripts, which allows us to hear American voices at length and in dialogue—including, notably, women's voices. This was hugely important for the history of American literary style: but would it have played in the drawing-rooms of London and Edinburgh? Maybe not.

Or maybe it's because of its perspective. Yes, it follows, once more, in that vein of Radcliffean explained supernaturalism: he urged readers in the preface to "believe that . . . if [the residents of Salem] went astray, as they most assuredly did in their judgments, they went astray conscientiously, with what they understood to be the law of God in their right hands."[105] But here, unsurprisingly—and, you could say, patriotically—Neal recasts the story of Salem as a group of Puritans in thrall to mistaken older European models of supernaturalism and injustice combated by the title character, who insists on honesty, piety, salt-of-the-earth religious adherence, "tried worth and remarkable courage." Refusing to testify falsely to save her life, "although she was a woman upon the very threshold of eternity, she was not afraid of the aspect of death"—an expositor, in other words, of bedrock American values. Give me liberty of conscience, or give me death, so to speak; and indeed that's what happens: she dies in prison.[106] Still, while Neal turns for his inspiration not to the fertility of a new landscape but to the worms and maggots wriggling beneath, the tone of triumphalism is hard to miss. Yes, Rachel Dyer died, but her lessons lived on.

Other contemporary treatments of Salem took the same tone. In 1831 a minister in Salem (later its mayor), Charles Wentworth Upham, began to publish his "Lectures on Witchcraft, Comprising a History of the Delusion in Salem, 1692": the title already lets us know history's judgment.

A contemporary reviewer noted that "Every one has heard of the witchcraft delusion in Salem. . . . [Upham's task is] to give a clear and philosophical view of the origin and progress of this strange imposture, and, incidentally, of superstitious notions in general."[107] In 1833, in Boston, the anthology *Tales of Terror* wrote in its introduction:

> There was time, indeed, when men were burned for witchcraft, and Quakers were hanged for non-conformity, that Tales like those which compose this collection would have been improper for publication. That time has passed away—old women ride through New-England on broomsticks no longer—children are no longer hushed to rest by threats of the coming of the Devil—E'en the last lingering phantom of the brain, the churchyard ghost, is now at rest again! Stories founded on supernatural agency cannot now mislead the young, or terrify the old.[108]

The editor ends by assuring his audience: "In conclusion we may say, that many may be benefitted, and none can be injured, by the perusal of this volume." Tales of terror might, as the editor says, excite "intense interest" or "bear frequent perusal" like nothing else: but it's a cozy, comforting terror: the terror of sitting around a fireplace and knowing—as Irving, Neal, and Upham did, in their respective ways—that America is putting behind its earlier fears, rethinking and transforming them, and moving forward.

And then came Nathaniel Hawthorne.

HAWTHORNE, LIKE IRVING, WAS ANOTHER of those firmly ensconced Americans: far more so, in fact, since he could trace his heritage back to the Massachusetts Bay Colony. Which, in his case, was hardly all to the good: born in Salem, he was a descendant of William Hathorne (his great-great-grandfather), a judge associated with the witch trials there. Nathaniel Cary, whose wife had been accused at Salem, requested to let her lean on him, because she felt in danger of fainting. Justice Hathorne replied, that "she had strength enough to torment those persons, and she should have strength enough to stand."[109] Much later, in his introduction

to *The Scarlet Letter*, "The Custom-House," Hawthorne would write that Hathorne "made himself so conspicuous in the martyrdom of the witches, that their blood may fairly be said to have left a stain upon him." And stains, as we all know, are hard to wash out.

It says something, assuredly, that he added the *w* to his name in order to distance himself from his ancestor; and, also, that many of his first literary efforts were under that cloak of anonymity. But it says even more that so many of his best works grapple with the inescapability of a haunted, pious, and sinful past: personal, communal, national, and human. One observer at a dinner with him said he "has the look all the time of a rogue who suddenly finds himself in a company of detectives . . . The idea I got was, and it was very powerfully impressed on me, that we are all monstrously corrupt, hopelessly bereft of human consciousness."[110]

As a young man, Hawthorne's extensive reading included Radcliffe's *The Mysteries of Udolpho* and Godwin's *Caleb Williams*. After graduating from Bowdoin in 1825, where he met Franklin Pierce and Henry Wadsworth Longfellow, Hawthorne wrote a novel based on his experiences there. The result, 1828's *Fanshawe*, didn't sell, though it did tip its hat to another influence in the contemporary literature of fear: one character was named "Doctor Melmoth," after British novelist Charles Maturin's hugely popular 1820 *Melmoth the Wanderer*, an update on the Faust legend crossed with the tale of the Wandering Jew.[111] Before landing a job at the Custom House in Boston, he made his living, for a time, working in the magazine industry.

The magazine he worked for, *The American Magazine of Useful and Entertaining Knowledge*, specialized in nonfiction; but there were plenty of other magazines and literary annuals in the Boston area, like *The Token* and the *New-England Magazine*, who knew him and were willing to take on his fiction.

Hawthorne, a good friend of Charles Wentworth Upham's, may have learned about a lot of his relative's actions from those "Lectures on Witchcraft"; he may have even been in the audience on some occasions as they were delivered.[112] But whether it was because of his personal connection or simply his own sensibility, he took away a very different lesson. Between 1832 and 1836, three of Hawthorne's stories were published,

each grappling not only with some of the country's original sins and the horrors that embodied them, but also how to write about them in a new American voice—one that feels quite unlike Irving's ironic, satiric lens on political change. And the first of them, "My Kinsman, Major Molineux," can almost serve as a manifesto for how to employ that new literary style.

Like Irving's stories from a decade or so earlier, and the more recent, Gothic-tinged novel by James Fenimore Cooper, 1825's *Lionel Lincoln*,[113] "My Kinsman" is set in colonial times. It features a new visitor to town, a country lad named Robin looking for "the dwelling of my kinsman, Major Molineaux." We learn the major is a first cousin, once removed, who's recently visited Robin's clergyman father and "thrown out hints respecting the future establishment of one of them in life"; it's been decided Robin should try to take advantage of the opportunity. This puts us in classic Anglo literary territory—Jane Austen's novels, published slightly over a decade earlier, are full of similar preoccupations—but here an uncanny, and very American, spin results.

Robin is frequently described, not least by himself, as "shrewd," but we know Ichabod Crane would have had a similar self-assessment; and like in "Sleepy Hollow," the story is one of encounter with a rationally explicable sight rendered uncanny by atmosphere and belief. Getting nowhere fast in his search for the major, Robin "roamed desperately, and at random, through the town, almost ready to believe that a spell was on him." And then he meets a monster: no headless horseman, but a man whose "features were separately striking almost to grotesqueness." Waiting for the major at the man's behest outside a graveyard, wondering if, in fact, the major has died and become a ghost, he reencounters the man, who has metamorphosed oddly.

> The man's complexion had undergone a singular, or, more properly, a two-fold change. One side of the face blazed an intense red, while the other was black as midnight, the division line being in the broad bridge of the nose; and a mouth which seemed to extend from ear to ear was black or red, in contrast to the color of the cheek. The effect was as if two individual devils, a fiend of fire and a fiend of darkness, had united themselves to form this infernal visage.

It appears, that is, as the face of the capering, devilish Harlequin; the spirit of Riot and Misrule, or, in fact, Revolution. That identification becomes even clearer when, at last, Robin finally sees the major, who, a representative of the British Empire, has been tarred and feathered, a frequent revolutionary practice in Massachusetts,[114] then mocked and jeered in a procession led by the painted figure. Hawthorne has Robin's knees shake, his hair bristle "with a mixture of pity and terror"; but those aren't the only emotions he feels. There's a "bewildering excitement," "mental inebriety," culminating in "a shout of laughter that echoed through the street; every man shook his sides, every man emptied his lungs, but Robin's shout was the loudest there."

"May not a man have several voices, Robin, as well as two complexions?" our hero is asked, earlier in the story; and Robin, of course, contains multiplicities of his own. "'The double-faced fellow has his eye upon me,'" Robin mutters as the procession goes by, with an indefinite but an uncomfortable idea that he was himself to bear a part in the pageantry." And indeed, what role should he have? How does he feel about—take your pick—the seemingly demoniacal and carnivalesque aspect of the revolutionary American sentiments, the jettisoning of familial bonds in favor of a good time, and, one could even say, the abdication of British styles, literary and otherwise, in favor of a natural American literary idiom? Earlier on, in town, Robin encountered "many gay and gallant figures . . . Travelled youths, imitators of the European fine gentlemen of the period . . . making poor Robin ashamed of his quiet and natural gait." Robin turns his back—on them and the Major—in favor of his own path. But, in an ending that may at first seem surprising, it's not the path he thinks.

After asking a gentleman who's kept him company through the procession the way to the ferry—"I begin to grow weary of a town life, Sir"—the latter refuses, at least for a few days, and offers: "if you prefer to remain with us, perhaps, as you are a shrewd youth, you may rise in the world, without the help of your kinsman, Major Molineux." How to rise in the world of letters without the British major? Acknowledging a haunting presence, yes—Molineux is literally referred to as a "spectre" in the story. But the British spectre needs to be tarred, feathered, and exorcised—that literary sensibility ridden out of town on a rail—in order to rise in the world. John

Neal would certainly approve. That said, if you want to write ghost stories, you still need ghosts: and so Hawthorne looked closer to home, for a local story he could invest with grander resonance.

He found it in the true story of a Maine clergyman who, "about eighty years since . . . in early life . . . had accidentally killed a beloved friend; and from that day till the hour of his own death, he hid his face from men." "The Minister's Black Veil," published in *The Token* in 1836, takes that visual as its premise but expands it to encompass every aspect of horror, both metaphysical and aesthetic. Hawthorne said himself, after all, that language is "a thick and darksome veil of mystery between the soul and the truth which it seeks."[115]

Parson Hooper is regular in every way, except that one sunny Sunday he begins wearing a veil "of two folds of crape, which entirely concealed his features, except the mouth and chin," which allowed him to see, but gave "a darkened aspect to all living and inanimate things." "He has changed himself into something awful, only by hiding his face," one parishioner mutters; "The black veil, though it covers only our pastor's face, throws its influence over his whole person, and makes him ghostlike from head to foot," says another. Hawthorne's story is, in no small way, about the nature of making the familiar unfamiliar, estranged and thus terrible in its estrangement: he even scares himself at one point, catching a glimpse of himself in the mirror.[116]

Although many have speculated on what secret sin has caused this change of behavior on the parson's part—perhaps it has to do with his "plighted wife" Elizabeth? Certainly rumors are circulating in the village to this effect—this is all speculation, inspired, perhaps, by Hawthorne's own historical inspiration. The best explanation is Hooper's own: "Know, then, this veil is a type and a symbol," he says to Elizabeth, "and if I cover it for secret sin, what mortal might not do the same?"

Recall that the veil does not hide the parson's mouth, which is, as Hawthorne frequently notes, in a sad smile, almost ironic, but a very different humor than Irving's. Here, the knowledge Hooper has is twofold: that all people are, in the end, strangers to each other and to themselves, and that even, or perhaps especially, the pious are unwilling to live with the corollaries of their piety. Hooper begs Elizabeth not to desert him, insisting

that although the veil "must be between us here on earth . . . It is but a mortal veil—it is not for eternity! Oh! you know not how lonely I am, and how frightened, to be alone behind my black veil"! Elizabeth, of course, leaves him flat, reasonably enough; and "even amid his grief, Mr. Hooper smiled," sadly and ironically, of course, "to think that only a material emblem had separated him from happiness."

Hooper's need to put his parishioners face to face with life on earth as horror—at one point, Hawthorne suggests the earth wears a black veil, too—is simultaneously the embodiment of a certain kind of Christian worldview. It's another irony that his veil makes Hooper extremely good at his job, "a very efficient clergyman," with "awful power over souls that were in agony for sin." And yet it's one that doesn't bear looking at too closely: at his death, refusing to lift the black veil, he indicts the world around him seeing "on every visage a Black Veil." If there's one thing we'll see, in our history, over and over again, it's that insistence that behind the faces of our friends, our family, our lovers, strangers may lurk: that we see them through a glass darkly, as it were. But Hawthorne got there first.

If each of Hawthorne's stories are about trying to navigate a tricky path—through American history, through traditions of sin and piety, through turning these traumas and fears into art—the arguably most famous Hawthorne story from this period, published in 1835 in Boston's *New-England Magazine,* is, in its own way, the most pessimistic of them all. Most American high school graduates are (or, at least, were) familiar with the tale of Young Goodman Brown, resident of Salem village, and his wife, Faith; whose allegorical names suggest another parable, and so it is. Our good man goes on a journey, on an errand of "present evil purpose" into the dark forest, leaving uneasy Faith behind: "What if the devil himself should be at my very elbow!" he says, and, speak of that devil, he appears; rehearsing the crimes of American history, and Hawthorne's familial guilt, with him:

I have been as well acquainted with your family as with ever a one among the Puritans; and that's no trifle to say. I helped your grandfather, the constable, when he lashed the Quaker woman so smartly

through the streets of Salem. And it was I that brought your father a pitch-pine knot, kindled at my own hearth, to set fire to an Indian village, in King Philip's War.

Irving's "The Devil and Tom Walker," published a decade before, had similar scenes, including a devil's woodland where "most of the tall trees [were] marked with the name of some great man of the colony." While Irving's story is more ironic and satirical—he introduces his frequent preoccupations with a main character's wife into the story, for example—"Goodman Brown" is something else again. In Hawthorne's story, though, the devil expands the sense of acknowledged and seemingly universal guilt, in what we might call Parson Hooper-vision, to include almost everyone Brown knows in evil doings and sabbats, including, as Brown remarks, the old woman who "taught me my catechism!" and, perhaps, Faith herself.

Certainly Brown's faith is tested, and, it seems, falls wanting. The devil, speaking at the Sabbat he leads Brown to, tells Goodman Brown and Faith: "Now are ye undeceived! Evil is the nature of mankind," and Hawthorne famously ends the story on a note of ambiguity[117] that's resonant of a much darker "Rip Van Winkle," one with human stakes. Raising the possibility that Brown had "fallen asleep in the forest, and only dreamed a wild dream of a witch-meeting," he says, "Be it so, if you will." But whether dream or no, Brown is transformed: he becomes "a stern, a sad, a darkly meditative, a distrustful, if not a desperate man," for the rest of his life. But, recall from our discussion of Salem that the devil—and, we might add, our dream of the devil—lies, and illudes; and the greatest temptation, perhaps, of the horror story, is to forget that it is a story, and not just horror.

A few years later, in 1837, Hawthorne republished "The Minister's Black Veil," along with many others, in the anthology *Twice-Told Tales*, so named because this was their second appearance in print, after their magazine publications. ("Young Goodman Brown" and "Major Molineaux" appeared in later collections.) While praising the book in other, more typical ways—citing his ability to find "the elements of the picturesque, the romantic, and even the supernatural, in the every-day, common-place life" and his Radcliffean ability to "never fairly [go] out of the limits of probability, [he]

never calls up an actual ghost, or dispenses with the laws of nature; [though] he passes near as possible to the dividing line"—a contemporary reviewer of the second edition, an unnamed Henry Wadsworth Longfellow, got to the heart of Hawthorne's Americanness:

> He gives us no poor copies of poor originals in English magazines and souvenirs. He has caught nothing of the intensity of the French, or the extravagance of the German, school of writers of fiction. . . . he seeks and finds his subjects at home, among his own people, in the characters, the events and the traditions of his country. His writings retain the racy flavor of the soil. They have the healthy vigor and free grace of indigenous plants.[118]

Half of this is true. More than Irving, or even Brown—and far more artfully than Neal—Hawthorne seems like an American original. But the stories seem to fall gloomily short of the immediacy and vitality suggested by the description. Hawthorne's ultimate interest was in how the haunting past, be it original sin or American trauma, could lie heavily over the present. So heavily, perhaps, that it threatened the impossibility of getting out from under it: and thus putting the lie to that foundational myth of reinvention, of newness, that lay at America's heart.

THE SAME YEAR THAT TWICE-TOLD TALES first appeared, 1837, marked the appearance of a novel by another short-story writer and magazine editor: a gambling-addicted dipsomaniac and West Point dismissee named Edgar Allan Poe, who'd turned to the longer form after he couldn't get publishers interested in a book of his short stories.

Poe had begun publishing a few years before Hawthorne had; although that first collection—1827's *Tamerlane and Other Poems*, self-published after he'd left college due to his drinking—was, to put it mildly, not a success (and probably only a few dozen copies ever existed). While these early works were, at times, derivative of European trends—one, later revised as "Spirits of the Dead," worked in graveyard-poet fashion ("Thy soul shall find itself alone / 'Mid dark thoughts of the grey tomb-stone"); they also suggested

ongoing preoccupations. An entry in the 1831 collection, *Poems by Edgar A. Poe*, for example, "Irene" (later revised as "The Sleeper") is an ode to a beautiful deceased woman, questioning whether she will lie still in her funereal chamber. "I pray to God that she may lie / Forever with unopened eye, / While the dim sheeted ghosts go by!" The year after Hawthorne's "Young Goodman Brown" appeared, Poe published an early version of another favored and classically Gothic theme—a doomed and haunted city—in his venue of choice, the *Southern Literary Messenger*.

Poe insists, perhaps with a bit too much emphasis, that when it came to his "City of Sin":

> There [sic] shrines, and palaces, and towers
> Are not like any thing of ours—
> Oh no! O no!—*Ours* never loom
> To heaven with that ungodly gloom!"

It's true that Poe, in these early poems, is channeling the Gothic, and the past; but when he writes that "From the high towers of the town / Death looks gigantically down,"[119] it's easy to imagine that spate of large towers with death looking down from them as a fantastic echo of more contemporary construction trends. Two years after the publication of Poe's poem, Hawthorne wrote in *Passages from the American Note-Books* that "[a] steam-engine in a factory to be supposed [sic] to possess a malignant spirit. It catches one man's arm, and pulls it off; seizes another by the coat-tails, and almost grapples him bodily; catches a girl by the hair, and scalps her; and finally draws in a man, and crushes him to death."[120] America's increasing industrialization was leading to a new kind of society, and with it, a new kind of horror.

That same sense of the new age, with its subterranean fears and uncanny doubling under the bustling, urbanizing city, was epitomized nine years later in the country's newest bestseller—written by one of Poe's friends. The Philadelphia writer George Lippard, in his wildly popular 1845 novel *The Quaker City*, sometimes called *The Monks of Monk Hall*, presented a tale of "colossal vices" and "terrible deformities"—not of the wide open

landscapes, but of "the social system of this Large City, in the Nineteenth Century." (He dedicated it to Charles Brockden Brown.)[121] Those vices' descriptions were based, in no small part, on a sensational rape-revenge murder trial, in which the accused had shot a man who allegedly lured the former's sister into a brothel and raped her at gunpoint. The jury acquitted in less than an hour.

Lippard turns the historical event into a full portrait of the demonic underbelly of the city, packed with "atrocities almost too horrible for belief"[122]—notably, that the rich use the poor as playthings, including as sex slaves—belying the chaste name of Monk Hall, where they gather. The key word, of course, being "almost"; since the populace, well aware of the predatory nature of the rich in the age of capitalism, were willing to entertain these widespread stories, true or not—and be entertained by them, either way.[123] In the end, the hotel is burned to the ground: that kind of salt-the-earth, apocalyptic approach Lippard called for to address the problem sold tens of thousands of copies and kicked off a whole series of novels about the dark underbellies of cities like Framingham, Salem, and Boston.[124]

Industrial capitalism, in short, was monstrous for many by its very nature. A few years earlier, in 1832, Sarah Maria Cornell, a pregnant factory worker in Fall River, Massachusetts, was murdered by Ephraim Kingsbury Avery, a Methodist minister. The resulting notoriety—it became known as the Haystack murder—led to over half a dozen different published trial transcripts, of varying accuracy, several plays, and two lithographs "that portrayed Avery surrounded by winged demons."[125] Perhaps most notably, it led to a novel the subsequent year, Catharine Williams's *Fall River: An Authentic Narrative*, an early entrant in "an outpouring of cheap novels in the United States" that portrayed female workers as "either sexually victimized or sexually promiscuous," or sometimes both.[126] In addition to the novels, single-sheet broadsides appeared with poems or songs on the topic of "mill girls" and their fates at the hands of predators: one features a spurned woman who, after killing herself when her lover marries another despite providing a love-token, appears as a ghost every midnight. "On top of Fairmount Hill," says the poem, "The ghost of Bedelia may be seen gazing on Yewdall's Mill."[127] Such grinding demand for new materials, created

with the power of water-mills and transported in new canals, led, also, to even more engagement with the water and sea: which leads us back to Edgar Allan Poe.

In 1816 John R. Jewitt had produced a nautical spin on the Native American captivity narrative: he'd been on the ship *Boston* in 1803 when it was attacked by Native Americans of Nuu-cha-nulth and almost everyone was killed. Jewitt is not afraid to relate horrific scenes: he witnessed the severed heads of the captain and all the rest of the crew placed in a line, for example, and was forced to identify them, one head brought to him at a time.[128] And yet for him, these encounters are rendered comparatively insignificant in the face of the sea:

> Manifest as is the hand of Providence in preserving its creatures from destruction, in no instance is it more so than on the great deep . . . the little that interposes between us and death, a single plank forming our only security, which, should it unfortunately be loosened would plunge us at once into the abyss, our gratitude ought strongly to be excited toward that suprintending Deity who in so wonderful a manner sustains our lives amid the waves."[129]

And Poe, who'd begun to work in the prose form in the early 1830s, felt the same way, finding a new home for his sense of the sublime.

His first published short story, like Irving's "Spectre Bridegroom," was a satire with a Germanic flavor. He'd submitted 1832's "Metzengerstein" to a prize contest; it didn't win, but the Philadelphia *Saturday Courier* published it anyway, along with a few other of his quasi-comic tales, including one about a duke who cheats the devil at cards and so escapes damnation; another featuring an encounter with a devil boasting of all the philosophers' souls he's eaten.[130] The title character encounters a horse that's potentially the uncanny incarnation of a Berlifitzing who died in a fire Metzengerstein may or may not have set (you can imagine the grin on Poe's face as he crafted those multisyllabic Teutonisms). Either way, the horse carries him willy-nilly to immolation in the burning wreckage of his own castle. The story showcased three of Poe's later preoccupations: old

grudges, old families, and old houses that get destroyed at story's end. Poe had almost certainly read Hoffmann's work, either in German, English, or, most likely, French, and the thematic resemblances are significant; "Metzengerstein" shows some possible borrowing from a Hoffman story called "The Entailed Castle."[131] And while this one's designed explicitly "in Imitation of the German," as its subtitle in a later republication states, Poe would come to bridle against critics accusing him of undue Germanism. In the preface to 1840's *Tales of the Grotesque and Arabesque*, he wrote: "If in any of my productions terror has been the thesis, I maintain that terror is not of Germany, but of the soul."[132]

But it was 1833's "MS. Found in a Bottle," which actually *won* a prize from the *Baltimore Saturday Visiter*, that felt both less indebted to another national literary culture and set Poe on his path. The bottle, bobbing on the waves, bore a message that told of the shipwrecked protagonist's sublime encounter with a kind of ghost ship: but offers the possibility, given the fact that the weirdly antiquated crew with their obsolescent instruments can't see him, that maybe *he's* the ghost. "It is evident that we are hurrying onwards to some exciting knowledge—to some never-to-be-imparted secret, whose attainment is destruction," Poe writes at the end of the story, and these sensations—and ambiguities—would be revised and expanded in Poe's only novel, 1837's *The Narrative of Arthur Gordon Pym of Nantucket*.[133]

When Poe could find no takers for a story collection, he took on the task of writing a novel of sea exploration, producing a novel that, at heart, is simultaneously a young man's encounter with nature's horrors and an examination of how that type of encounter is understood. The year 1837 was an age of new explorations—plans for an American voyage to the Antarctic that year had been in all the papers, as well as accounts of South Sea voyages—and this era of new industrialism, new science, new humanity, exploration, and discovery brought the shattering of limits and the need for limited human consciousness to come to terms with that shattering. How do you make sense of the seemingly impossible, the terrifyingly unsettling, in an age whose watchwords were increasingly the mechanical and rationalistic?[134] Even Hawthorne's unsettling tales were easily explicable as

being allegories of understandable processes of psychology, guilt, and history, after all. But Poe wanted a blunter kind of confrontation.

Admittedly, it's one still suffused with irony and meta-cleverness. From the outset, narrator Pym himself suggests he hesitated to write the narrative down, worried others would consider it only "an impudent and ingenious fiction";[135] in the end, he turns to Poe (or "Poe"), who agrees to work it up *as* fiction, and publish it in the *Messenger* as such. And *Pym* relates a series of encounters ranging from the adventurous to the comic, including a violent shipboard mutiny (that he sleeps through); cannibalism (discovered, subsequently, to have been unnecessary); and a swollen, bloody animated corpse of one of the recently deceased crew (actually a made-up Pym, the effect aided by "superstitious terrors and guilty conscience").[136]

But as the narrative continues, the sights become . . . odder. We are shown a grotesque ship of the dead, with a seagull eating away inside one of the corpses; the ship's origin, for Pym, is "the most appalling and unfathomable mystery." And if that mystery potentially has some rational explanation, the novel's final image—of "a shrouded human figure, very far larger in its proportions than any dweller among men. And the hue of the skin of the figure was of the pure whiteness of the snow"—doesn't, at least if taken as "real."[137] That ends the narrative, suddenly, without explanation or follow-up, although "Poe's" preface, redolent of literary game-playing and unease-making, suggests he has received an answer from Pym, who survived to provide him the narrative, but has refused to print it because of "his disbelief in the entire truth of the latter portions of the narration."[138]

That sense of unease the final image provides may explain why Poe only wrote the one novel. As he said in his 1842 review of a revised version of Hawthorne's *Twice-Told Tales*, he himself was a creature of the "single effect," one which derived from combining all a work's aesthetic elements to produce one powerful, emotional gut-punch: "In the whole composition," he wrote, "there should be no word written of which the tendency, direct or indirect, is not to the one preestablished design."[139] To lay the coherent groundwork for this kind of sensation was hard enough to do in a few pages, practically impossible in a novel.

Toward the end of 1838, Poe published a piece called "How To Write a Blackwood Article" for the *American Museum*. (Many of Poe's early stories were originally intended for a collection, *The Tales of the Folio Club*, that was meant to parody *Blackwood's* stories.)[140] In the article, satirically told from the perspective of a "Signora Psyche Zenobia," the aspiring writer-protagonist visits Mr. Blackwood, who recommends to her, among other works:

> There was "The Dead Alive," a capital thing!—the record of a gentleman's sensations when entombed before the breath was out of his body—full of tastes, terror, sentiment, metaphysics, and erudition. You would have sworn that the writer had been born and brought up in a coffin. . . . Sensations are the great things after all. Should you ever be drowned or hung, be sure and make a note of your sensations—they will be worth to you ten guineas a sheet. If you wish to write forcibly, Miss Zenobia, pay minute attention to the sensations.

And, bearing in mind his earlier dictum that "The first thing requisite is to get yourself into such a scrape as no one ever got into before," she does, indeed: in an accompanying story originally called "The Scythe of Time" (later "A Predicament"), she manages to get herself decapitated by getting her head caught between the hour and minute hand of a very large clock. (She takes careful note of her sensations as she does so.)

Perhaps the most interesting and indicative of the pre-*Pym* stories in terms of sensation, though, had come in an 1835 short story he'd published in the *Southern Literary Messenger*. "Berenice" involved an ill young man, Egaeus, prematurely burying his cousin/fiancée—she suffered from catalepsy—and then awaking from a trance of his own to discover that he'd removed all of her teeth while still alive. Egaeus's disease, as he puts it, "consisted in a morbid irritability of the nerves immediately affecting those properties of the mind, in metaphysical science termed the *attentive*." He takes pains to point out that the primary object of his focus, his "musings," was "invariably *frivolous*, although assuming, through the

medium of my distempered vision, a refracted and unreal importance," which is another way of saying that what Poe did was focus on the importance of *looking*—unsurprising, given that so much of his fiction is about the revealing of a terrible and uncanny sight that one shrinks back from in, well, in horror. But, of course, that sight—being produced, as it is, in a combination of words and the reader's mind—is actually a product of the imagination, which means the fervid and feverish intellect is actually the reader's. They—we—are morally implicated. In Egaeus's case, it's a focus on Berenice's teeth, which then leads to his obsession with them, and to his decision later on to engage in a kind of metaphorical castration of his obsession.[141]

This is, pretty clearly, not just a reading of sensation and effect, but of psychology: and it was also becoming apparent that one potent way of achieving the former was to imbue stories with an attentiveness to the latter. Again, it was a German, E. T. A. Hoffmann, who had led the way, with his masterpiece of personal and psychological obsession, "The Sandman," but James Hogg's 1824 novel, *The Private Memoirs and Confessions of a Justified Sinner*, originally published in part in *Blackwood's*, would certainly have attracted Poe's interest, too. It's a novel of religious fanaticism: of a man who becomes convinced by a doppelganger figure who may or may not be the devil that, since he is theologically justified, whatever he does, whatever crimes he commits, are not crimes at all. The resulting tensions drive him to madness. Poe would be less interested in the theological: but other themes—of the double, and the descent into madness—would become fundamental.

The owner of the *Southern Literary Messenger* accepted "Berenice" for publication, but had qualms about its "gratuitous and excessive use of the horrific in the story." Poe, for his part, responded that this kind of story was what the market wanted, and went on to define the kind of story it was: "the ludicrous heightened into the grotesque: the fearful coloured into the horrible: the witty exaggerated into the burlesque: the singular wrought out into the strange and mystical."[142] (He also claimed it was the result of a "bet that I could produce nothing effective on a subject so singular," probably because of a local Baltimore scandal about grave-robbers harvesting

teeth for use by dentists.[143]) And he began to refine his technique, using his favorite themes. Doubling, madness, criminality, premature burial: they all began to come together the following year, in 1839, as Poe began to craft his reputation-defining works.

While the first of these, "The Fall of the House of Usher," was a masterful encapsulation of these themes and others he'd been experimenting with for years—the ruined, sickened domicile; the complex pseudo-incestuous relations; the sickened, morbid masculinity—that same year's "William Wilson," by contrast, covers some newer ground.

After that decapitation by clock, her head separated from her body, Zenobia had reported the sensation of an uncanny doubling, that her "senses were here and there at one and the same moment." Poe's increasing preoccupation with doubling was never better expressed, though, than in "William Wilson." The story's protagonist, another typical Poe figure—imaginative, easily excitable of temperament, "prey to the most ungovernable passions"—finds himself, from schooldays on, seemingly tracked by someone who, "although no relation, bore the same Christian and surname as myself"; not "William Wilson," but close enough. Given their amazing similarities—the same birthday, the same physical characteristics, even, as time went on, the same voice and speech—it might not be a surprise that the narrator "secretly felt that I feared him," even though no one else seemed to notice anything odd or amiss, even the fact that the other Wilson never raised his voice louder than a whisper.

That same whispering voice foils the narrator's plans as he attempts to cheat at cards, getting him thrown out of Oxford; and foils a seduction at a masquerade in Rome. Finally, the narrator fights and stabs him with his sword, only to find himself (maybe) in front of a mirror, seeing himself covered in blood—or maybe it's Wilson; he can't be sure—and imagines that Wilson speaks, now aloud—unless it's him; he can't be sure—and says: "You have conquered, and I yield. Yet, henceforward art thou also dead . . . In me didst thou exist—and, in my death, see by this image, which is thine own, how utterly thou hast murdered thyself." If, for Hawthorne, the lesson of American horror was that wherever you are, your past is there, too, then for Poe, the lesson is, quite clearly, that wherever you go, there you are; you

may not understand when you see yourself in a mirror that this is what's happening, but that doesn't mean it isn't.[144]

Thanks to the success of "The Fall of the House of Usher," Poe was able to get his collection of short stories, *Tales of the Grotesque and Arabesque*, published that same year; it, too, was composed of twice-told tales. One of Poe's grotesque tales therein, a much less well-known one, speaks to a direction that Poe, Hawthorne, and indeed America, would be looking at in the years to come.

"The Man That Was Used Up" is a brigadier general admired by the protagonist for "the supreme excellence of his bodily endowments," although admittedly there's something slightly disquieting about the "primness, not to say stiffness, in his carriage." The general is a veteran of the Black Hawk Wars, with the Kickapoo Indians; another character, the comic foil Mrs. Pirouette, malapropistically refers to the "dreadful creatures" as the "Bugaboos," using a word that had, according to the OED, been used to mean "an imaginary evil spirit or creature; a bogeyman" for over a century. Poe is satirizing the speaker, rather than the subject, continuing the ambivalent trajectory toward Native Americans we've seen previously.

On the one hand, Cooper was continuing to publish those *Leatherstocking Tales* of his, with their portraits of Native Americans as "noble savages," too good for this world of ours and part of a way of life that's giving way. And how exactly might that be, you might wonder. Although you might not wonder too hard, given that just a few years earlier, in 1830, Andrew Jackson had signed the Indian Removal Act, pushing tens of thousands of Native Americans west of the Mississippi and essentially removing the Indigenous population of most of the Eastern US. That horrific act—most famously encapsulated in the Trail of Tears, the forced displacement and ethnic cleansing of the Cherokee, Muscogee, Seminole, Chickasaw, and Choctaw in the immediate years to come—was given succor by the attitudes expressed in another horror novel published the same year as Poe's *Pym*. In Robert Montgomery Bird's 1837 novel *Nick of the Woods*, Indigenous Americans are responsible for the murder of Robert Slaughter's family—but, as you may be able to guess by his last name, he doesn't take this lying down; and in the process of wreaking bloody revenge as a shadowy killer in the woods,

he becomes something unrecognizably monstrous. Or, perhaps, recognizably: the name he becomes known as, that of Nick, shows his diabolic character, while the cross he carves onto the bodies of the Indians he kills shows how connected that murderous impulse is with white Christianity. Bird's sympathies are entirely with this Slaughter (and this slaughter); and it was his impulse, tragically, that won out in the government's policies in Jacksonian America. And so, as Poe well understands, it's hardly the Kickapoo who are imaginary monstrosities. They serve, in some sense, as a symbol of a traumatic story beneath the one he's telling.

In "The Man That Was Used Up," though, pride of monstrous place belongs to the general himself: that stiffness is due to his transformation, through wounds of war, into "a large and exceedingly odd looking bundle of something," which, as it puts on various artificial devices—legs, teeth, eyes—assembles itself into the form of the general that our protagonist has so admired before. It's a small-scale Frankenstein and, like many of Poe's early stories, is played for laughs: the general continues to shout at his valet to help him and keeps up a running monologue to the horrified protagonist during the assembly, for example. But unlike Shelley's creation, the general's artificial composition speaks to that increasing interest in industrial horror. The general, unsurprisingly, is obsessed with "mechanical invention": "Who shall calculate the immense influence upon social life—upon arts—upon commerce—upon literature—which will be the immediate result of the great principles of electro-magnetics!" he shouts.

Hawthorne, too, had much to say about linking new progress and old fears in the period; although, characteristically, he looks backward rather than forward. His "Dr. Heidegger's Experiment," first published in 1837 in the *Knickerbocker* and then republished in *Twice-Told Tales*, is less about scientific process than a fantasy of the Fountain of Youth, in which we learn that renewed youth is wasted on the newly young, who resolutely refuse, in Heidegger's words, to "become patterns of virtue and wisdom to all the young people of the age." There's no fool like an old or wise fool, as his portrait of a second scientist, in 1843's "The Birth-Mark," indicates: a parable of improving the near-unimprovable, by the means—already familiar to us—of wreaking change on women's bodies. "Georgiana," says Aylmer

to his wife, "has it never occurred to you that the mark upon your cheek might be removed?" and thus begins the journey: and the mark—whose redness and "shape bore not a little similarity to the human hand, though of the smallest pygmy size"—moves from a charm in his wife Georgiana's eyes, a fairy's gift, to an almost literal slap in the face.

While birthmarks can bear a wide variety of symbolic interpretations,[145] Hawthorne being Hawthorne, the mark takes on metaphysical freight, Aylmer "selecting it as the symbol of his wife's liability to sin, sorrow, decay, and death." But it's also another instantiation of the modern Prometheus that Mary Shelley limned so powerfully a generation before. "You have led me deeper than ever into the heart of science," Aylmer tells Georgiana; "what will be my triumph when I shall have corrected what Nature left imperfect in her fairest work!" But, in a way Shelley mostly doesn't, Hawthorne turns the scientific preoccupation into a horror story of marriage and war between the genders. The mark becomes a preoccupation, and then an obsession, a cankerworm in their marriage; Georgiana, for her part, "soon learned to shudder at his gaze"—turning pale, which, of course, makes the birthmark stand out even more strongly—but to internalize that hatred: all she sees, looking into the mirror, is that birthmark. "Not even Aylmer now hated it so much as she," Hawthorne writes.

Another word for this we might use, now, is *gaslighting*; but the story is subtler than that, and more horrifically tragic for it. Georgiana is well aware—in a way Aylmer isn't—of his previous scientific failures, and the hollowness of his boasts of scientific success. But she agrees, nonetheless, to submit to his ministrations. "I shall quaff whatever draught you bring me," she tells him, "but it will be on the same principle that would induce me to take a dose of poison if offered by your hand." And so it is: she takes the potion, the birth-mark disappears . . . and so does Georgiana. Yes, Hawthorne is meditating on humanity's essential and necessary imperfection; but, more, on the hubris of intelligence—especially male intelligence— in the form of scientific utopianism. And how, all too often, that posturing and preening plays itself out in damage worked out on women's bodies. He does the same thing, basically, in the following year's "Rappaccini's Daughter," in which a botanist literally renders his daughter poisonous:

walled up, Beatrice has become so inured to the poison that it is the way she can and has flourished, among unnatural nature. It's a metaphor of the poisons pumped into the social order, and the toxicity that process creates in making a woman monstrous: "poisonous as she is beautiful," another character calls her. And, of course, she, too, dies at the end of the story.[146]

It would only be four years after "Rappacccini's Daughter" that the first women's rights convention was held in Seneca Falls in 1848. The attendees certainly hadn't needed to read Hawthorne to contemplate the horrific specter of their bodies being transformed, rendered uncanny and even monstrous through male agency. For centuries, they and their foremothers had had their autonomy denied them and at times even their lives rendered forfeit. But Hawthorne's work, as Rappaccini might have put it, was in the air.

THE AIR OF THE 1840S was toxic, miasmic, for Poe as well. In 1835 he'd published "King Pest" in the *Southern Literary Messenger*, which, like other early works, was written in a satiric key: one of its main images, of a very odd party encountered by two seamen in the subterranean wine-cellar of an undertaker's shop, illustrates the fun that can be had with trappings of horror. One member of the party is in a winding-sheet, another in a coffin; each attendee's cup is a "portion of a skull," and a human skeleton dangles by one leg from the ceiling, twirling around "at the caprice of every occasional puff of wind which found its way into the apartment." They explain their plans to do some serious drinking, primarily in the name of "that unearthly sovereign whose reign is over us all, whose dominions are unlimited, and whose name is 'Death.'" By the 1840s, Poe, who more than anyone understood that the line between the sensational effects he was often striving to create and unbridled ridiculousness was incredibly thin, had mastered the mood and timing of those sensational effects, often by casting away the trappings of contemporaneity and drawing on the imagistic versions of his poetry to create a dark and reversed fairy tale. And thus "King Pest" is reimagined as 1842's "Masque of the Red Death," which begins as a parable of the futility of preventing mortality and ends with an apocalyptic vision of Death reigning over all.

So many of Poe's stories are about the concerns of the emerging, ravening, return of the repressed: this appears, blatantly in the form of the Conqueror Worm, in the poem placed inside the early story "Ligeia," and certainly the great stories of guilt, "The Black Cat"[147] and "The Tell-Tale Heart," both published the following year, work in this vein.[148] The idea of guilt haunting the murderer goes back as far as *Macbeth* and, in fact, as Cain; but turning it into American art has a long tradition, too. An anonymous "M." in the *Columbian Magazine* wrote a poem, in 1791, "Remorse":

> Ah! Let me hail the horrors of remorse.
> She shews, that horror is on weakness built,
> And may protect my soul from deeper guilt.

In 1794, in *Massachusetts Magazine*, Linus's "Reflections of a MURDERER while in Prison"[149] includes the quatrain:

> Shame and remorse torment my breast,
> And wet my face with tears;
> Whene'er I close my eyes to rest,
> My murdered friend appears.

And in the truly wild 1810 poem "Osmond's Dream," Osmond, another dreaming murderer, sees his victim, who then turns into a skeleton and embraces him:

> The flesh from her bones fell around me, distress'd
> I strove to escape from the harms;
> But a skeleton loathsome and meager impress'd
> My cold shiv'ring form to her death gelid breast
> And threw round me her moldering arms![150]

Poe, in his (far more artful and effective) stories on the theme, takes the same phenomenon of materialized guilt and gives it, so to speak, another turn of the screw. In Poe's stories, defeat is snatched precisely from the jaws

of victory—they'd have gotten away with it, if they didn't end up giving themselves away.

Poe thinks through this in one of the most important statements made by any author on horror—both in real life and literature—in his 1845 work "The Imp of the Perverse," which reflects on the phenomenon of our drive to do things that are clearly against our own self-interest; more than that, that lead to our own destruction. Obviously, our old friend the sublime has something to do with this, but for Poe it's more than an aesthetic response. It says something deep about our psychology, about how we behave: about how close we are to the dark side. It's not surprising this same period sees Poe creating the first great detective, C. Auguste Dupin, in 1841's "The Murders in the Rue Morgue."[151]

But we shouldn't reduce Poe's literary output here to neat psychological boxes. Stories like 1844's "The Premature Burial" and 1846's "The Cask of Amontillado" are triumphs of effect over theme: you can spill lots of ink about why Montresor is so angry at the ironically named Fortunato—is it revenge for an insult? Is it a manifestation of Poe's theory of perversity, precisely *because* Fortunato has been good to him, breeding resentment?[152]— but what really matters is that he *gets him drunk and buries him alive in a wall*, leaving him to rage and starve and rot there. We imagine those long, drawn-out moments of agony as we look at the wall built by Poe, brick by brick, in our mind's eye . . . and we shudder at the faint sounds we imagine we hear. Compare this to a similarly themed brief story printed in the *Columbian Magazine*, back in 1790, on the "Dreadful Fate of a Miser in Paris," who locked himself into a secret vault with his riches and was eventually discovered by his widow and a locksmith "extended upon his treasure, having in his anguish torn and devoured the flesh from his own arms." There's an image there, but no *sensation*. It's all discovery, no build-up.[153]

We leave Fortunato, there, between life and death; and the sensation we experience is terror; but, in those dichotomy we saw in Ann Radcliffe's introduction, Poe could put on an old-fashioned horror show as well. Or, put more accurately, a new-fangled horror show, as we see in one of Poe's most important stories, 1845's "The Facts in the Case of M. Valdemar," in which the narrator uses a hotly debated, controversial (pseudo)scientific

technique—mesmerism—to hold his friend, the eponymous Valdemar, in a state of both death and not quite death (we have Valdemar himself to attest to this, assuring us in a sepulchral voice that he is dead). Maintained for months in this transitional state, he begs, pleads, to be released; and once he is, he deliquesces into "a nearly liquid mass of loathsome—of detestable putrescence," all the decomposition that has been in abeyance taking place "at once—within the space of a single minute."

It was its newness, its sense of scientific reportage, that gave the story wide purchase, and more than that: a near-contemporary review notes that "This case of M. Valdemar acquired an extensive circulation, both in this country and in Europe, and in some quarters as ready credence as celebrity."[154] In other words, people not only read it, they believed it was true; Poe's sensational and sensationalist imagination was finding fertile ground in the soil of the American mind. And he wasn't the only one: P. T. Barnum's American Museum bowed in 1841, precisely the period of Poe's greatest stories. There was no one more dedicated than Barnum to showing off the oddness and freakery of the natural world—and not being afraid to gild the lily now and again—for delight and, yes, for profit. Plenty of people left the museum and, later, the midway, self-gulled: they believed, yes, but also because in no small part they wanted to believe. And these museums, these collections of oddities, traveled: via waterway and coach road and, increasingly, rail. The country was getting smaller as it was getting larger: and people could come together in joint revulsion, and fascination, in the strangest of sights and stories.

This, as they were about to break apart.

When America's Rivers Ran with Blood

—

IN 1849 A MAN NAMED Henry Brown published the story of his life. He was better known, though, as Henry "Box" Brown, for the incident that made him nationally famous. Brown was an escaped slave; and the manner in which he escaped was by sending himself north in a box. The trip took twenty-seven hours; and since the box was, on several occasions, placed the wrong way, blocking the air holes, he almost suffocated several times.[1] In Brown's own words, upon arrival "they soon managed to break open the box, and then came my resurrection from the grave of slavery . . . I had risen, as it were, from the dead."[2] Brown, by all accounts, was a performer and showman by nature: he would tour the North, then England. He always had the box with him and "on occasions would begin a lecture by leaping out of it,"[3] sometimes accompanied by a massive panorama on canvas called *The Mirror of Slavery*. His story reminds us, uneasily, of Poe: depicting a world so terrible one would willingly submit to the worst nightmares of Poe's fictions—to a literal premature burial—to try to escape from it.

Not all such narratives were so baroque, though they were no less terrible—and perhaps more—for that. There are over six thousand narratives of the enslaved extant, dating from 1703 to George Washington Carver's from 1944; one of the most important collections of the time, a massive compendium published in 1838 and an immediate bestseller, was entitled *American Slavery As It Is: Testimony of a Thousand Witnesses*. Frequently, those narratives, as shots fired in the great conflict of the age,

were delivered in "a simple, direct style and calm, controlled voice . . . to create through simplicity and calmness an atmosphere of fact and rationality," to spread belief in the face of skepticism about the grinding horror of the infernal institution.[4]

A case in point was Frederick Douglass's bestselling 1845 *Narrative of the Life of Frederick Douglass, an American Slave.* Douglass's own circumstances—alongside his character, disposition, and his shrewd understanding of the ideological battle he was attempting to fight—meant he hewed more to a narrative that spoke to the potential best aspects of American nature. But the horror stories were everywhere. In 1849, the same year as Box Brown published his work, the poet and abolitionist James Russell Lowell reported his own experiences hearing, on the streets, a simple, and simply chilling, cry: a former slave, who had ransomed himself from captivity, begging for money to do the same for friends and family members. "Help me buy my mother!" or "Help me buy my children!" were the calls he and others heard; and, though short of funds, he said, he could not resist 'such an appeal,' for 'if a man comes and asks us to help him buy a wife or child, what are we to do?'"[5]

But these fears—of the enslaved, of the escaped, and of those concerned for them—weren't the only American nightmares: had they been, there would have been no conflict aborning. And, in looking at the other side, we might return to Poe, and a tale he wrote, also in 1849, a revenge story to end all revenge stories and one of the last tales he wrote before his death. "Hop-Frog" is set in one of Poe's typical fairy-tale landscapes, but here the wronged man taking bloody revenge is a little person by that name who is mocked by the monarch and nobility, his body—and his beloved's—subject to assault and violation at any moment. Wronged beyond endurance—and because such physical, biological differences have nothing to do with intellectual ability—he is able to use his subordinate, indeed enslaved, status to turn the tables. Convincing the rulers they should dress as great apes in the masque to follow, he then ties them all together, hoists them up (by their own petards, one might say) and then lights them on fire, making his escape with his beloved.

Now, it should be said: Poe, a resident of Baltimore, a writer and editor for

the *Southern Literary Messenger*, very well could have had an audience who might view this very obviously racially saturated dynamic (those ape costumes!) somewhat differently from, say, Brown or Douglass. There's a plausible case to be made that that first published story of his, "Metzengerstein," is an allegory of North–South tensions over race, with sympathies toward anti-abolitionists.[6] And if that aspect is less visible, certainly the fact that in *Pym* Poe has his protagonist call a group of Black people encountered on his voyage "the most wicked, hypocritical, vindictive, bloodthirsty, and altogether fiendish race of men on the face of the globe" might give us some indication of his approach to the question.[7]

Whether one locates that anxiety in Poe personally or not, for a large part of the United States (especially the Southern part), the nightmare part of "Hop-Frog," understood in this way, wouldn't have been the treatment of Hop-Frog. It would have been the specter of his revenge. Slave rebellions hadn't ended in 1741, of course: in 1831's Southampton Rebellion, led by Nat Turner the year before Poe published his first short story, rebels killed several dozen white people, which led to a panic that resulted in over 100 deaths of enslaved people and freed Blacks.

Thomas Ruffin Gray's 1831 *Confessions of Nat Turner*, which purported to provide the actual words of the rebel leader—although historians proceed here with caution—had wide selections reprinted in newspapers, and presented Turner as a terrifyingly charismatic, thoughtful, apocalyptically minded religious maniac, corrupting Christian imagery for the sake of spilling white blood. In this sense, Turner—or Gray manipulating Turner—was in a long tradition: "the black man" was a frequent synonym for the devil as far back as Salem, and Gray, accordingly, refers to Turner's face and activities as "fiend-like." And, not unlike there, there was the fear of the homicidal, diabolic *other* within your farms, your communities, your homes, preparing to slaughter you *while you slept*. Gray emphasizes, in his preface to the public, that "whilst not one note of preparation was heard to warn the devoted inhabitants [of Southampton] of woe and death, a gloomy fanatic was revolving in the recesses of his own dark, bewildered and overwrought mind, schemes of indiscriminate massacre to the whites," and that preventing this could be presented as nothing less than a crusade, a holy

war. (Descriptions of the revolt also drew on imagery from *Frankenstein*, that story of a literary revolt against a master that had made its way across the Atlantic by that time.)[8] Ten years *after* "Hop-Frog," John Brown and near two dozen others, white and Black alike, raided the United States arsenal at Harper's Ferry with the hopes of starting a rebellion of the enslaved. Like Nat Turner a generation before, it failed (due, in part, to the military leadership of none other than Robert E. Lee), but impressed once again—as if impressing were needed—that American stresses and horrors were barely beneath the surface, ready to burst to light.

Fear, then, ruled everywhere in the 1850s. There was no escape: the Fugitive Slave Act made the entire country, North as well as South, a site of fear, with no respite either for even those who had managed to escape, or for those who now had the onus, whether honored or not, to return them. (No small part of the reason Box Brown toured England was because of multiple attempts to capture him under the Act.) And Harriet Beecher Stowe's *Uncle Tom's Cabin*, published in installments in the *National Era* two years after "Hop-Frog" and in book form the year after that, became the indelible horror story of the decade and, perhaps, of the entire antebellum period.

Stowe's novel features one of those escaped slaves, Eliza, who makes her decision to run when faced, at the novel's opening, with the overpowering fear of her child being torn away from her and sold down South. Eliza makes it, after some terrifying ordeals; but another slave, the titular Uncle Tom, doesn't—whipped to death on the orders of the villainous Simon Legree. Tom piously forgives his tormentors before he passes. Legree, whose name became a byword for evil for a century, is one of the great monsters of American fiction, as monstrous as Stowe herself became to Southern readers after the book's publication, "an instrument of the Devil, the natural object of a violent and strangely personal hatred that developed as rapidly as *Uncle Tom's Cabin* achieved popularity."[9] The *Daily Picayune* wrote that she "has written one of the most abominable libels which the age has produced . . . Such a desecration of woman's nature is a sorry and a rare sight, even in this age of feminine aspirations to rivalry with man."[10] Tell that to the over three hundred thousand copies sold in America in the first year of the book's publication, part of the abrupt expansion of the "scale of the

American market for literary goods" at the time;[11] or, for that matter, to Stowe herself, who would say, repeatedly, "I, the author of 'Uncle Tom's Cabin'? No, indeed. The Lord Himself wrote it, and I was the humblest of instruments in His hand."[12]

Stowe's son famously claimed that when his mother met Abraham Lincoln, a decade after *Uncle Tom*'s publication, he shook her hand and said, "So you're the little woman who wrote the book that started this great war." Whether Stowe's claims of theological ghostwriting or her son's claims of presidential responsibility-assignment are true isn't important. What is essential is the shared sense of an almost overpowering predestination: that the coming battle was practically foreordained, and all that could be done was to accept the coming horror.

THESE LARGER CURRENTS THREATENED TO swamp other aspects of American fear into insignificance, or, at least, irrelevance. Poe would die the year he wrote "Hop-Frog," far more recognized, at the time, as a poet than as a short story writer, particularly after the publication of 1845's "The Raven,"[13] though an 1850 posthumous publication of a collection of his works marked the shift toward considering him the major prose writer of fear he is. Although Hawthorne was still in fine form, 1850's *The Scarlet Letter*, another of his most powerful evocations of the American Puritan past, felt, perhaps, less timely: when Hester Prynne and Dimmesdale, meeting each other in the forest, consider the prospect of each other being ghosts, there's a sense that the novel's issues, if not evanescent, may at least have felt less relevant. This nagging anxiety animates the warning that precedes his magnificent haunted-house novel published the following year, *The House of the Seven Gables*. Hawthorne writes that novels may face "an inflexible and exceedingly dangerous species of criticism, by bringing [their] fancy-pictures almost into positive contact with the realities of the moment." His point is well taken, and his picture of the past lying heavily over the present, of two families entwined with one another over the ancient days of witchcraft, one sinning, one sinned against, crimes and punishments that "darken the freshly plastered walls, and infect them early with the scent of an old and melancholy house," would go on to influence

the underlying style of American haunted-house stories for the next two centuries. But, like its novelistic predecessor, it suggests a certain willed stepping-aside from the moment.

Perhaps it was a similar sense of marginality that led to Hawthorne's claim, also in *Seven Gables*, that "Ghost-stories are hardly to be treated seriously any longer." Which spoke, perhaps, to their perennial usefulness at distracting from real-life horrors: and hinted, in a tone of dismissiveness familiar throughout the history of cultural arbiters, of peevishness at something popular. Inspired by the success of Charles Dickens's tales in the 1840s, ghost stories were beginning to become big business. And many of them—perhaps another reason for Hawthorne's dismissiveness—were written by women, for magazines were read significantly, sometimes largely, by women; and some of them were dealing with horrors that were less national, less allegorical, and more individual (if not necessarily personal).

The poet Alice Cary wrote a number of ghost stories for the *Ladies' Repository*; but her *Clovernook Sketches* presented a more grounded horror, a portrait of "Uncle Christopher," a Bible-quoting, spare-the-rod-and-spoil-the-child type whose cruelty and harshness drive a little boy to (perhaps) commit suicide by throwing himself down a well. Rose Terry Cooke's "My Visitation" appeared in *Harper's* in 1858: but the visitation in question, to the narrator, is less a ghost than the ghost of a same-sex love that largely dare not speak its name (the apparition is literally referred to as It for the majority of the story).[14] In 1860 Harriet Prescott Spofford wrote a story of a Maine frontierswoman's encounter with an "Indian devil"—but this was a term used for an Eastern panther, not for anything supernatural.[15] And, perhaps most notably, E.D.E.N. Southworth, a friend of Harriet Beecher Stowe's and almost as popular in her day, produced *The Haunted Homestead: and Other Novelettes* in 1860: but it transpires that we have another situation of the explained supernatural, or, as one modern critic put it: "What haunts Southworth's Southern Gothic homesteads, therefore, are ghosted people."[16]

Perhaps it was unsurprising, then, that the 1850s figure of fear Hawthorne felt closest to was another man whose most famous works both elided the great issue of the day—at least directly—and took an expansive, hardly

domestic canvas. Herman Melville was a friend of Hawthorne's, a friendship forged in a hike where they had to take cover from two hours' worth of rain. Melville would then review *Mosses from an Old Manse* in 1850, praising Hawthorne, "this most excellent Man of Mosses," for its humor ("the very religion of mirth") and its "Indian-summer sunlight" mixed with "the other side" of his soul, "shrouded in a blackness, ten times black." "Whether Hawthorne has simply availed himself of this mystical blackness as a means to the wondrous effects he makes it to produce in his lights and shades; or whether there really lurks in him, perhaps unknown to himself, a touch of Puritanic gloom,—this, I cannot altogether tell," Melville writes, but notes that "in certain moods, no man can weigh this world, without throwing in something, somehow like Original Sin, to strike the uneven balance. At all events, perhaps no writer has ever wielded this terrific thought with greater terror than this same harmless Hawthorne." That aspect is what "so fixes and fascinates" him.[17]

For his part, though, Melville—who name-checks *The Mysteries of Udolpho* in *Billy Budd* and had brought home copies of *Otranto*, *Vathek*, *Caleb Williams*, and *Frankenstein* from an 1849 visit to England[18]—would set *his* great Gothic novel at sea, with its dilapidated, weather-stained, portable house of a ship, and a real-life monstrosity taking center stage: although whether that monstrosity is the great white whale or the man who lost a leg to him and sends a crew in the face of his obsession is, in some sense, up to the individual reader. But 1851's *Moby-Dick* (dedicated to Hawthorne, "in token of my admiration for his genius") would not be the only uncanny entry in the Melville canon of the decade. There was the strange salesman of lightning rods wandering about Kentucky, having charged (pun intended) encounters with folk who see him as a fanatical sharpie trying to traffic in damnation insurance, in 1855's "The Lightning-Rod Man."[19] And then, in 1853, the strange figure of Bartleby the Scrivener, the clerk who shrugs off work by saying that he prefers not to; but who engages, in this sense, in a strange, nearly mute protest of the capitalist endeavor (and, as a brick wall in that protest, eventually ends up self-consuming: he dies of starvation).[20] He'd always been a bit of a zombie, you could say, having worked once in a dead-letter office.

While *Moby-Dick* is now an acknowledged classic, it was comparatively ignored at the time of its publication; by contrast, a blatantly supernatural story appearing in 1858 in the third issue of the newly established *Atlantic* magazine, would become "a literary sensation" and "one of the most spectacular successes in nineteenth-century American magazine fiction."[21] Its author, who went by the name Fitz James O'Brien, is now largely obscure, but his regular publications in the *Atlantic* and the also recently established *Harper's Magazine* would help those magazines shape a tradition of American fantasy and fear for the next half-century.

After a somewhat obscure early life, a member of "one of the highest in the land" of Irish families, Michael O'Brien finished his studies at Trinity College, Dublin, and after a brief and unsuccessful period in London, possibly writing and editing there, struck out for the United States, arriving in the early fifties. Along the way, he took the new name along with his new country of residence.[22] Picking up on Hawthorne's quasi-scientific investigations, that *Atlantic* story, "The Diamond Lens," features an amazing discovery via microscope, a beautiful, microscopic young woman trapped inside the smallest droplet of water. In order to power the microscope—shades of Poe—the scientist must commit a murderous crime to acquire the titular diamond": "After all, what was the life of a little peddling Jew in comparison with the interests of science?" The punishment: first, tormented obsession at the beauty he observes but can never reach—"The planet Neptune was not more distant from me than she"—and then, following her death by, um, evaporation ("Ah! the sight was horrible: the limbs once so round and lovely shriveling up into nothings"), a descent into madness. "Linley, the mad microscopist, is the name I go by. I suppose that I talk incoherently while I lecture. Who could talk sense when his brain is haunted by such ghastly memories!" But the story's most important lesson is the one anticipated by the narrator's first discovery of the microscopic world: "The dull veil of ordinary existence that hung across the world seemed suddenly to roll away, and to lay bare a land of enchantments." It's an early intimation of a scientific treatment of a theme we've seen over and over, and we'll see more of: of a world that lies beyond the bounds of our own perception.

Two of O'Brien's other stories provide their own takes on already

well-trodden paths in the horror story. "The Lost Room" (1858) is a much less metaphysical and significantly more dramatic version of the haunted-house story than *The House of the Seven Gables*. The story's narrator briefly encounters someone who knows the "queer" New York house he rents in; and he's told the place's inhabitants "are enchanters. They are ghouls. They are cannibals."[23] The story's horror, though, comes not from any ghoulish or cannibalistic eating of flesh but from the uncanny, quasi-magical doubling of the narrator's own circumstances and belongings, as he returns to the room he has rented:

> All was changed. Wherever my eyes turned they missed familiar objects, yet encountered strange representatives. Still, in all the substitutes there seemed to me a reminiscence of what they replaced . . . Thus I could have sworn the room to have been mine, yet there was nothing in it I could rightly claim . . . a sickening consciousness of my utter inability to reconcile its identity with its appearance overwhelmed me, and choked my reason.[24]

This is "William Wilson" as applied to a room, and we'll witness it again in the ghost stories of more famous successors, most notably Henry James: seeing something—especially a doubled something—that most clearly *is*, and at the same time can't possibly be.

This is also the focus of another of O'Brien's best stories. "What Was It?" (1859) has a narrator encounter something that is both unseeable—an invisible being, decades before H. G. Wells—and undeniably perceptible, despite the best efforts of the characters to wish it away. After a discussion within the story on the question of "the greatest element of terror . . . a King of Terrors, to which all others must succumb," something that goes beyond "the calling of the voices in Brockden Brown's novel of *Wieland*," the story proposes, as a candidate, "something combining in fearful and unnatural amalgamation hitherto supposed incompatible elements." And so when the narrator shrieks "*I saw nothing*! . . . I absolutely beheld nothing!" about the invisible being choking him, we understand his "wonder

that I did not faint or go mad on the instant," because what O'Brien has given us is something that goes beyond the possibilities of actuality into the contradictions that only words put together in almost wilfully paradoxical ways—ones that create sensations and effects that go beyond horror, and into terror—can provide. Yes, O'Brien provides a pseudo-scientific explanation—some hugger-mugger about nonreflective optics—but that's not the point. Somehow, you're actually beholding *nothing*. How is that possible? It's not. *That's* the point.

This attempt to render the impossible and the indescribable—as opposed to the Salem tradition, which attempts the precise opposite, to bring the unimaginable into visceral, sensible reality—would be the taproot of an essential strain of fear over the next century and half. But, for the moment, the fears that gripped Americans were of a more immediate, down-to-earth nature, as questions of division and secession roiled the nation, and the maintenance of the union seemed ever more impossible.

IN 1859 O'BRIEN, WRITING IN the *Atlantic*, ruined Christmas for readers with "The Wondersmith," a remarkable confluence of the mechanical and the supernatural. The story's title character has a horrible plan:

> Ay, ay, we will give the little dears toys! Toys that all day will sleep calmly in their boxes, seemingly stiff and wooden and without life,—but at night, when the souls enter them, will arise and surround the cots of the sleeping children, and pierce their hearts with their keen, envenomed blades! . . . the Christian children are waiting for Santa Claus to come, the small ones will troop from their boxes, and the Christian children will die. It is famous![25]

It doesn't end up that way: as is often the case, the weapon turns on its planned wielder—but the threat of a bloody Christmas lingers, a home and hearth turned upside down from within. Certainly this was a prospect on everyone's mind; and, soon enough, it became terribly real. The Civil War killed ten times as many service members (North and South) as

in Vietnam. Each of its ten bloodiest battles created more casualties than D-Day. Between combat and illness, it carried off over 2 percent of the population of the United States; there was not a single household in the country that remained unaffected in one way or another.[26]

The scale and savagery of the combat, and the primitive state of available medicine, created unimaginable canvases of "patriotic gore"; that phrase—taken from "Maryland, My Maryland," a pro-Southern poem composed after 1861 clashes in Baltimore that would become the state song until 2021—showed how such horror stories became not just reportage, but myth. The reportage, though, was bad enough: at Gettysburg, "doctors, inundated by the injured, cut off limbs and tossed them into massive discard piles that were then buried in limb pits."[27] One Confederate combatant at Shiloh wrote in his diary: "The field presents an aweful scene!! The mangled bodies of the dead are lying in all directions. . . . Oh, what a night of horrors that was!! It will haunt me to the grave."[28]

Exploring that psychological state is our brief here. In Nathaniel Hawthorne's wartime novel *Septimius Felton*, he included the following description. It was referring—as is Hawthorne's wont—to the past, the Revolutionary War, but was clearly also a reflection on present circumstances:

> The war put everybody into an exaggerated and unnatural state . . .
> it filled the whole brain of the people, and enveloped the whole
> thought of man in a mist of gunpowder . . . all ungovernable out-
> breaks of men's thoughts, embodying themselves in wild acts, take
> place more frequently, and with less horror to the lookers-on.[29]

Hawthorne's own views on the war, understanding as he did the complexities of human nature, emotion, and allegiance, were nuanced and complex; he even contemplated the dissolution of the Union as the optimal solution (though "If compelled to choose," he wrote, "I go for the North").[30] Although he seems "to have been little affected by the surge of abolitionist excitement" in his native New England, or by the horrors of slavery writ large,[31] his sense of the mood and tone of the divided country was dead on.

Soldiers and noncombatants alike could hear about some of the wild acts and horrors he alluded to in contemporary songs such as "Starved in Prison" by George Frederick Root, referring to the cruelties imposed on Northern captives in prisoner-of-war camps such as Andersonville and Libby. Its chorus went:[32]

> Yes, they starved in pens, and prisons,
> Helpless, friendless and alone!
> And their woe can ne'er be spoken,
> Nor their agony be known.

It may be slight overstatement—but perhaps not too much—to suggest that this specter of imprisonment and starvation is somewhat reminiscent of some of the victims of Poe's murderers, locked away, like Fortunato in "The Cask of Amontillado," as "the haughty rebel leaders / heard unmov'd each dying groan." One Confederate veteran, writing of his internment at Alton prison, described a scene in which smallpox was killing 1 to 2 percent of prisoners *a day*. "When a prisoner died," he wrote, "the body was at once placed in a box coffin . . . and carried to the 'dead house,'" where "great loads of unfortunates" were "hauled out" every morning. He reported a jailhouse tale that "one prisoner made his escape through the dead house" by switching bodies with a corpse in one of the boxes: a Box Brown in reverse.[33]

War crimes were hardly unusual, either. When the 1st Kansas Colored Volunteer Infantry Regiment was defeated on the grounds of the aptly named Poison Spring by Arkansas Confederate forces, they didn't take prisoners: when the Confederates were ordered to move wagons full of supplies they captured, they did so by competing to see who could crush the most heads of wounded and dying Black soldiers under the wheels. Part of the anger, no doubt, and its immensely disproportionate aim at Black troops, was in the latter's "enforcement of the Emancipation Proclamation": they'd immediately notified "local slaves that they were now free to leave their masters and mistresses." For the Confederates, this was the "South's worst

nightmare . . . about to become true"; it was unsurprising that fugitive slaves faced the same savagery as the combatants.[34]

As the war dragged on, and disillusionment and defeatism set in, another Christmas spirit came into play: this one to save the day. But, given the tenor of the times, it had a grotesque twist. "Santa Claus in Camp," a Christmas lithograph by the great German-American-immigrant political cartoonist Thomas Nast, pictures Santa holding a hanged man. It's a bit more complicated than that, though; the hanged man in question is emerging from a jack-in-the-box, and he's labeled "Jeff," for Jefferson Davis, the Confederacy's president.[35] Nast—who actually created the modern image of Santa Claus as we now know him—was using the visual shorthand to stir up solidarity for the Union at one of the war's more difficult moments for the North. O'Brien, for his part, wouldn't have gotten to see this other Christmas picture. Having signed up to fight for the Union, full of patriotic fervor, he died in April 1862 of tetanus contracted after a battle and was buried with military honors.[36] But Nast—although his work would often be overshadowed, at least to later generations, by the deployment of a new technology, the photograph—would end up creating some of the most piercing pictures of the Civil War, for *Harper's*; and his lithography—which would, in some ways, mark the beginning of the modern American cartoon—would be as essential as Harriet Beecher Stowe's novel was, a decade earlier, in providing both the outraged fortitude and the spiritual succor for the North to sacrifice the blood and treasure needed to defeat the Confederacy. Which led to a third Christmas of fear: there were rumors spread, in the South, of a specific insurrection, either a "negro Jubilee insurrection," or a Black "general division of [white] property," on Christmas Day of 1865; but it was, in fact, a "drama of the white imagination."[37]

Harper's and other papers and magazines were on the front lines of the war until Appomattox, sending back sensational reportage and accounts of battlefield carnage. And, at times, alternating it with fiction of an appropriate mood: one of the contributors to the newspapers run by Frank Leslie—who'd gotten his journalistic reputation thanks to his paper's "extensive nonpartisan coverage" of John Brown[38]—was an anonymous Louisa May

Alcott, who wrote a number of Gothic thrillers during the war, the coun-
terparts of the ones Jo refers to in *Little Women*.[39] They didn't stop once
hostilities did. *Harper's* and the *Atlantic* published numerous stories of the
recent conflict; many were in a melodramatic and sentimental vein, but not
all of them. Some, like John William DeForest's "The Drummer Ghost"
(for the *Atlantic*) and "Lieutenant Barker's Ghost Story" (for *Harper's*), were
attempts to invest the war with a kind of more standard supernatural fare.
Others, like Silas Weir Mitchell's "The Case of George Dedlow," eschewed
the haunts for the more down-to-earth horrors of the actual suffering:
Dedlow undergoes multiple amputations, and we are given descriptions of
these in some detail.[40] But one didn't need to read about it in the magazines.
Americans could see it around them. Perhaps they looked at an empty chair
where a missing member of their family used to sit, or waited in vain for the
post from a family member on a different side of the Mason–Dixon Line,
now inexorably alienated. Perhaps they passed by the burned-out site of a
house or farm, remembering buildings put to the torch by the acre and the
city block. Maybe they saw veterans with wooden limbs and glass eyes and
scarred wounds, or a formerly enslaved figure who could share, if they chose
to do so, a lifetime of memories. Or maybe they were one of the millions
who watched a train go by carrying the coffin of a both much-beloved and
much-despised president.

It is unsurprising, given all the trauma, that there was a distinct rise in
juvenile delinquency, as well as crime among women, during the war years
and immediately after. As one 1866 report put it: "Familiarity with deeds of
violence and destruction thus induced leaves its impression after the one is
over and the other disbanded. We find in all parts of the country the most
distressing evidence of this fact."[41] It was a good time to publish tales of
old crimes—in 1870, a book about the Levi Weeks trial was released titled
Guilty or Not Guilty: The True Story of the Manhattan Well[42]—and, with the
increasing national range of the press and the magazines, to tell stories of
recent and new-breaking horrors.

But the media was moving on, too, to horrors of even more recent
vintage. The new national networks of transportation, the railroad and

the telegraph, now made it possible to get news quickly; and the country's recent travails proved that stories didn't need to be fictional to strike terror.

Quite the reverse.

IN 1871 *HARPER'S*, AMONG OTHERS, breathlessly covered the horrific accounts of the Great Fire in Chicago. But everyone knew about fire. Grand disasters were important; but the human element . . . well, killed.

Three years later, they went big with what they called "A Colorado Tragedy." The tragedy in question was the sensational report of the cannibalistic exploits of one Alferd Packer. Packer, in the winter of 1874, had claimed to be an experienced guide and prospector, convincing a party looking for gold in the Colorado mountains to let him guide them. It didn't go well. He came out of the mountains, telling one story; the bodies, stumbled over and sketched by an illustrator for *Harper's*, John A. Randolph, told another tale. There'd been stories of cannibalism due to necessity before—the Donner Party had taken place a generation earlier—but the state of the bodies made it clear that, in this case, it was possible that it had taken place before it was absolutely necessary . . . and Randolph's gruesome illustration for *Harper's*, "The Remains of the Murdered Men. A Colorado Tragedy," sketched on the spot, was a Poe vista come to life. As one critic put it, "By offering audiences a truthful depiction of the tattered clothes, bleached white bones, and rotting flesh of Packer's cannibalized victims, Harper's Weekly's tableau balances the monstrous with the educational."[43] *Harper's* ran a full-page spread, with three illustrations, placed next to a Wilkie Collins murder mystery: fiction, true-life, all in one.

Readers who gobbled up the story of Alferd Packer probably had swallowed, just a year earlier, another story of the horrors that were lurking in the heart of America. Between 1871 and 1872, the Bender family, of Labette County, Texas, killed at least a dozen people, one of the first instantiations of that American institution of fear, the serial killer. Many of the features of the future deck of horror would emerge, full and breathing, here. First and foremost, the uncanny, aberrant family: the father was described as "a repulsive, hideous brute, without a redeeming trait"; the mother's face as "a

fit picture of the midnight hag that wove the spell of murderous ambition about the soul of Macbeth"; the young son as recalling "the grave-robbing hyena."[44] But, more than that, the hotel of horrors, the American sense of hospitality and business turned upside down and inside out: people checked in . . . and they didn't check out, their heads bashed in with hammers—possibly while they were sitting at the Benders's table—their throats cut to make sure they were dead, and then shoved through a trap door under their chair into a cellar where they would be stripped of valuables. (In one young girl's case, possibly buried alive.)

The Benders, themselves, were never caught; but their story spread, growing, as such stories always do, in intensity in the telling. One Philadelphia pamphlet, published in 1874, insisted that "if there was ever such a thing as fiends being sent from hell to trouble and curse the earth, they were just these fiends."[45] Thousands of people came from as far away as New York to visit the bloody site, and the cabin would be disassembled by souvenir hunters. A decade later, another Kansas family, the Kellys, presumably taking the Benders as an inspiration, did the same thing: they, however, were caught and hung by a posse. There was a theory going around that they actually *were* the Benders, but that doesn't seem to have been the case: and we see our motif of the copycat killer—the idea that particular monstrosities can be catching—continue to emerge.[46]

The developing American West, then, was a site of fearful possibility. A few decades back, bestselling (and deeply biased) novels of the mid-1850s had seen it as a sanctuary for a coterie of "cowardly, deluded, and depraved" men attempting to prey on women.[47] It was the same year that *Uncle Tom's Cabin* was published that the Mormons publicly announced their policy of plural marriage, and their religion was publicized—and demonized—in "utterly untrustworthy" best-selling novels full of sex and violence in the next few years, such as *Boadicea, the Mormon Wife* and *Mormon Wives: A Narrative of Facts Stranger than Fiction*. It didn't matter that the writers—many of whom, in those first years, were women—had no actual knowledge of, or personal encounter with, members of the Church of Latter-Day Saints: they presented the firmly teetotaling Mormons as bitten by the bottle, for example. What mattered for readers back East was that, between

Mormons and Benders and Packers, "Go West, young man," was not just an invitation to possibility: it was a ticket to the spook show, too.

In that vein, a few years after the story of the Benders, an American writer produced a midnight tale of grave robbing and murder, with a monstrous Native American villain and a slow death by entombment. Admittedly, this is an odd way to describe *The Adventures of Tom Sawyer*, published in 1876, but it's not inaccurate; one of Mark Twain's great gifts was to show how the burgeoning sense of American optimism, youth, and adventure was shadowed by older, familiar horrors. If Injun Joe is a terrifying presence, he is also countered, in no small part, by the grand good luck and spirit of Tom and Huck and, in some ways, the greater power and authority of Judge Thatcher (who, by sealing the cave that Joe is in, is a Judge in more ways than one—a kind of authority showing that justice will indeed be served.) In short, Twain's novel is the comforting, cathartic alternative to the story of the Benders: yes, aberrances and monstrosities exist—not least that demonized Native American presence—but they're obstacles to be overcome on the way to a grand American conquest of the continent and of destiny manifest.

Readers would have been able to trace that path—in melodramatic and sensational fashion—through the explosive growth of a new literary phenomenon: the dime novel, the American version of the mid-nineteenth-century penny dreadfuls that had enraptured British readers. This line from the tenth page of the first of them, "Touch but a hair of her head, and by the Lord that made me, I will bespatter that tree with your brains!" gives a sense of the possibilities for grue quotient; its title—*Malaeska: The Indian Wife of the White Hunter*, written by Ann Sophia Winterbotham Stephens and published in a burnt-orange four-by-six booklet by Beadle's Dime Novels ("The Choicest Works of the Most Popular Authors") in the summer of 1860[48]—reveals a treatment of a favored theme, combat between Native Americans and white settlers in the West. "Dime novels were to be tales of dread and suspense; of the calm before the storm; but rather more of the storm than the calm," wrote one early critic. "In their pages, during the next four decades, tons of gunpowder were to be burned; human blood was to flow in rivers; and the list of dead men was to mount to the sky."[49] Other

WHEN AMERICA'S RIVERS RAN WITH BLOOD 103

successful examples included *The Privateer's Cruise, The White Squaw, The Scalp Hunters,* and *Seth Jones; or, the Captives of the Frontier,* the latter of which sold nearly half a million copies.

Readers of the novels included Lincoln and Henry Ward Beecher; and they were in high demand among soldiers on both sides of the war, who would exchange them during lulls in combat; blood-stained copies of the books, it was said, were found on battlefield corpses, and soldiers were buried with books in their pockets.[50] More than two thousand such titles were published in the second half of the century, and generated a moral panic: "A boy who had been up to deviltry; parents who had shamefully neglected a son and allowed him to stray into mischief . . . these folk found it very convenient to stand in a police court and lay all the blame on dime novels."[51] It wasn't the first moral panic around the children. It certainly wouldn't be the last. But the stories spread, tales of the Wild West cranked out at speeds up to a thousand words an hour—and that was before the invention of the typewriter, after which they got faster—tales of Deadwood Dick, Double Dan, the Dastard, the Pirates of the Pecos, and the Tarantula of Taos, and enough no-good down-and-dirty bad guys of every stripe to give thrills and nightmares hand in hand, as they made their way from sea to shining sea.[52]

So what happened when they got to the other coast? Take, as our proof, the work of another Civil War veteran—unlike O'Brien, a survivor. Ohio native Ambrose Bierce fought for the Union at the Battle of Shiloh, one of the bloodiest battles of that bloody war, and headed across the Great Plains as a military inspector after the hostilities ended; he ended up in San Francisco, and in San Francisco he would stay. Bierce was not the first great writer of fear in San Francisco. He was preceded by Emma Frances Dawson, whom he admired greatly, and whom he credited with rendering the city "a dream city—a city of wraiths and things forbidden to the senses—of half-heard whispers from tombs of men long dead and damned," a city where the streetlights, at night, "flare out" from the tops of the hills as if signaling otherworldly messages.[53] Dawson's wonderful 1878 story, "An Itinerant House," provides a new spin on the haunted house story for a world seen, by white residents at least, as a new frontier: it features a "Flying Dutchman of a House" that moves around the city, keeping traces of those who have

passed through it, in a form akin to magnetism, fitting old Gothic tropes together with the rootlessness of the West.[54]

Dawson's stories, though, encompassed another kind of otherworldly fear, speaking to a different kind of American encounter with the other that was taking place in the second half of the nineteenth century: one less about Indigenous presence than colonialist, imperialist, and immigrant encounters. In 1860 the New Englander Harriet Elizabeth Prescott Spofford had published one of the greatest horror tales of the second half of the nineteenth century. "The Amber Gods," printed in the *Atlantic* in 1860, was the tale of "a little islander, an Asian imp" "fetched" by a sea-captain for his wife, "mumbling all manner of demoniacal prayers, twisting and writhing and screaming over a string of amber gods that she had brought with her and always wore." That string necklace, transmuted—but not transformed—into an "amber rosary," is passed through the narrator's family, and the "bane" it was said to bring from its original owner, which culminates in the narrator's death, is portrayed as both the wages of colonialism and the terrifying ability of the other.[55]

"Fetched" does a lot of work in the paragraph above, and—especially in 1860—it's also plausible to see Spofford's story as a comment on slavery; but the nineteenth century's second half saw a good deal more voluntary immigration from Asia, especially to the West Coast, where there were jobs in the gold and railroad industries. By a few decades later, the backlash and anti-immigrant anxiety was in full swing. In a Dawson story like "The Dramatic in My Destiny," there's more than a touch of the anti-Asian paranoia known as the Yellow Peril,[56] seen in her description of the Chinatown area as "a network of horror like a nightmare . . . the foreign city in the heart of San Francisco, like a clingstone in its peach" and its inhabitants as near-alien creatures of an unimaginably old and foreign civilization, in tones not dissimilar to ones H. P. Lovecraft would use to describe his Ancient Ones a few decades later.[57] And these kind of fears had real-world consequences: like the 1877 anti-Chinese rally that spiraled into attacks on Chinese immigrants, killing four people in the district.[58]

But it was Bierce, not Dawson, who became the city's presiding journalistic and literary spirit for the rest of his life, hired by Hearst for the

Examiner in the late 1880s, and it was Bierce whose fame grew in tandem with its circulation until his mysterious and still unexplained disappearance in 1914. Like Poe, Bierce had a wicked sense of humor—his *Devil's Dictionary*, appearing in installments in the San Francisco papers under different names off and on, primarily in the 1880s, included such gems as "HAG, n. An elderly lady whom you do not happen to like" and "HEARSE, n., Death's baby-carriage." The *Dictionary* also defines *ghost* as "the outward and visible sign of an inward fear," and while the extended definition goes on to be funnier—noting that "a ghost never comes naked . . . to believe in him then, is to believe . . . that the same power inheres in textile fabrics," that first definition applies quite well to, if not all of Bierce's ghosts, then certainly some of his best ghost stories.

What transpires in 1890's "The Occurrence at Owl Creek Bridge," one of the most famous short stories in American history, is a case in point. The story features a death sentence being carried out by Union soldiers on a planter and slave owner named Farquhar, who had been entrapped by a spy into trying to sabotage the railroads and is now being hanged for it. But, as the drop happens, Farquhar realizes that the rope has broken, he has fallen into the river beneath the bridge, and he may just be able to head for home. But, as he does, things feel . . . off:

> The forest seemed interminable; nowhere did he discover a break in it, not even a woodman's road. He had not known that he lived in so wild a region. There was something uncanny in the revelation.

The stars above him look "unfamiliar and grouped in strange constellations. . . . arranged in some order which had a secret and malign significance"; in the forest alongside him, "he distinctly heard whispers in an unknown tongue." And as we are internalizing this sense of menace, of shadow, we discover—on the verge of his reunion with his beautiful wife—that the story has been leading us down a dark and shadowy road of its own. It turns out that Farquhar has been imagining this part of the story; the rope has never broken, and all these events take place in the split second between the drop and the breaking of his neck. Bierce's title plays

fair, even if the story pretends not to: the occurrence never left Owl Creek Bridge after all. He's been there the whole time, and all the voices and shadows that creep in are the world catching up with the fancies in his brain. There's no escape from the war, from death, from the noose. Despite your struggles, you're just left . . . hanging. It is, in its own way, a perfect distillation of the horrors of post-traumatic distress: with a snap and a crack, you're brought back to the horror.[59]

It's a kind of trauma that runs through Bierce's Civil War fiction, and especially the collection that "Owl Creek" appears in, *Tales of Soldiers and Civilians*. In another story from the collection, "A Tough Tussle," a Federal soldier, Brainerd Byring, is sitting in position, waiting, when he sees a Confederate corpse next to him begin to move: "A strongly-defined shadow passed across the face of the dead, left it luminous, passed back upon it, and left it half obscured. The horrible thing was visibly moving."[60] But—in another Bierce twist ending—when others happen on the scene the next morning, they find a different story: the tussle that took place was in Byring's own imagination, the horrors of the war creeping in—and, in the end, he battles himself and loses, stabbing himself through the heart. Bierce's tales, of occurrences and tough tussles, spoke to his natural journalistic instinct to tell his ghost stories of the Civil War's unfinished business in the tones of the real. Which mattered because there was a lot of unfinished business to go around—and not all of it, by a long shot, was limited to white San Franciscans.

In 1881 Frederick Douglass wrote his essay "The Color Line," in which he compares "long-standing prejudice" to the belief in ghosts: "As those who believe in the visibility of ghosts can easily see them, so it is always easy to see repulsive qualities in those we despise and hate." In a barbed and ironic way, Douglass vehemently rejects any possibility of the inherent aspect of color, of pigmentation, in the calculus of fear:

> If the white man were really so constituted that color were, in itself, a torment to him, this grand old earth of ours would be no place for him. Colored objects confront him here at every point of the compass. If he should shrink and shudder every time he sees anything

dark, he would have little time for anything else. He would require a colorless world to live in.[61]

That said, Douglass is characteristically nuanced in his assessment of the complexity of what racism and white supremacism—this climate of fear, of suspicion—has wrought. True, he says, a Black American "may not now be bought and sold like a beast in the market, but he is the trammeled victim of a prejudice, well calculated to repress his manly ambition, paralyze his energies, and make him a dejected and spiritless man, if not a sullen enemy to society, fit to prey upon life and property and to make trouble generally."[62] Douglass suggests, perhaps uncomfortably, that the structures of racism and white supremacism might be responsible for making monsters. And if Douglass's own framing discomfits, it's also worth looking at the works of one of the great writers of fear and unease of the end of the century, who wrote his own tales of the color line.

Those last five words are the subtitle of one of the first collections of stories of Charles W. Chesnutt, born in 1858 to two "free persons of color" in Cleveland; he was, as he said, seven-eighths white, but identified as Black. This identification was important, because he was capable, physically speaking, of "passing" as white; and this question, of confronting fear and prejudice, of being on one side of the color line or another, was the basis of some of his most important work. Chesnutt spent most of his childhood not in Ohio, but in postwar North Carolina, where his parents were from; he became a teacher, then, after moving to New York City, a writer and reporter—he covered Wall Street for the New York *Mail and Express*. In 1887, six years after Douglass's essay, he published his first short story in the *Atlantic*—the first work of fiction by a Black writer to appear there or, for that matter, in any major literary journal.[63]

That story, "The Goophered Grapevine," was one of a series that featured the same basic structure: they're stories told by a former slave, Julius, to a white man, John, a Northerner who's come South with his wife for the climate. Julius's tales—which revolve around the area, are rendered in dialect, and always involve some kind of folkloric magic, or hoodoo conjuring—are often employed, cleverly and trickily, by Julius in order to

persuade the somewhat credulous and quite self-satisfied John to do what Julius wants. This is Chesnutt's way, also, of speaking to the general hierarchies of power regarding who got to tell the stories of Black American life in these days. The whole collection is good, but space allows us to only look at one, the appropriately named "Mars Jeems's Nightmare."

"Mars" here is the vernacular version of "Master," and Master Jim, as it were, meets what the listening John and the overwhelmingly white readership of the *Atlantic* might consider the most horrific, nightmarish fate they could possibly imagine: in return for the crimes that he commits against his slaves, he is "goophered," or hexed, and transformed into a Black man. As a Black man, of course, he is beaten and otherwise mistreated; but, the story suggests with its tongue fixed firmly and painfully in its cheek that this, like all nightmares, is temporary. When he awakens, he improves his behavior: but he never dreams of emancipation. And Julius, who tells the story to John, does so in order to persuade John to keep his grandson on as a plantation employee, despite his less-than-stellar work ethic. But, despite these remarkable powers of magic and narrative manipulation, there is no revolutionary impetus here. The color line can be moved, temporarily, for the sake of an object lesson; but it can not, in fact, be erased.

Which is the question that animates the other remarkable work of Chesnutt's, published first in 1898. "The Wife of His Youth"—the title story of Chesnutt's 1901 collection—is, itself, a story of haunting, of the return of something buried. Here, though, there's nothing supernatural about what returns: as that title suggests, it's the protagonist's wife, whom he's left behind. The protagonist, Ryder, is a member of the town's Blue Veins Society, a social organization for Black people so light-skinned that you could see their veins. (It was probably modeled on the Cleveland Social Circle, an institution in the city Chesnutt lived in for a few years.)[64] Ryder's first wife, 'Liza Jane, who shows up looking for the husband she hasn't seen in a quarter-century, is sufficiently dark-skinned that it would be impossible for her to "pass" as white, much less move in the social circles Ryder has now become ensconced in. The story's question is clearly posed, and starkly answered: should Ryder/Taylor acknowledge 'Liza Jane, on the eve of his marriage to Molly Dixon, a woman with skin color and social niceties far

more similar to his? (The story makes quite clear both that 'Liza has no idea of Ryder's identity, and that his first marriage, while enslaved, has no legal standing.) But Ryder does the right thing, and in front of his assembled society confronts and welcomes his buried past into the front parlor, so to speak.

The story suggests the moral necessity of grappling with the past, of achieving a reconciliation with it, a struggle Chesnutt had faced in his own life. (In an 1875 journal entry, Chesnutt, then seventeen, wrote: "Twice today, or oftener, I have been taken for white . . . I believe I'll leave here and pass anyhow, for I am as white as any of them.")[65] But it also reinforces questions of race and colorism even as it tries to transcend them, presenting 'Liza Jane as a figure eliciting fear even as she comes across as a paragon of Christian virtues, most notably patience and fidelity. Still, Chesnutt is honestly confronting the legacy of the Civil War, even as the magazine's readers might wish to use the example of his stories to render the essential questions of Reconstruction as a geographically delineated problem—as in the Southern settings of *Conjure Woman*—or an ethnically segregated one, a Black one, as in "The Wife of Her Youth."

Neither of these were true.

"THE WIFE OF HER YOUTH" is, at its heart, a story about race, a tale of the color line. But it's also a story about marriage; and while we get very little of either 'Liza Jane or Molly Dixon's perspective in Chesnutt's story, other writers of the period were taking on that angle, looking at the changing nature of what it meant to be a woman toward the end of the century.

We've already seen the rise of horror fiction written by women in the mid-century; but that rise led to dominance in the century's second half, in women's magazines, hardcover anthologies, and general-interest magazines. Let's start, though, with a figure little known before her death in 1886, although within five years she would become a posthumous bestseller. If Emily Dickinson had only had ten poems published during her lifetime, the publication in 1890 and 1891 of two anthologies of her poems changed that perspective. A dazzling, brilliant poet who dedicated a significant amount of space to poems about death would probably have a place in our

story under any circumstance. And, like her predecessors Phillis Wheatley and Michael Wigglesworth from colonial days, she's a deeply spiritual and Christian poet, too, considering in many of her death poems the transitory life in distinction to the eternal one: most of us, even if we don't remember much of her poetry, recall the famous quatrain about death stopping for her, and the carriage holding "but just Ourselves—and Immortality."

But the mortal intimations that interest us here are of a kind of premature burial very different from Poe's. Dickinson's poem, "The Wife," reads, in full:

> She rose to his requirement, dropped
> The playthings of her life
> To take the honorable work
> Of woman and of wife.
>
> If aught she missed in her new day
> Of amplitude, or awe,
> Or first prospective, or the gold
> In using wore away,
>
> It lay unmentioned, as the sea
> Develops pearl and weed,
> But only to himself is known
> The fathoms they abide.[66]

The readings of this poem are manifold; but at least one is about the death of an individual personality—or, if not actual death, an internment, a burial at sea—of a woman's personality in order to take the role of wife and helpmeet to a man. Dickinson, of course, famously never did any such thing. While she was an active and lively correspondent, she never married, and in fact became, essentially, a recluse. When she was seen, she was generally dressed all in white; and the similarities to a living ghost, given our subject, should not go unnoted. Evanescence, transitoriness, the insistence

of holding on to self in the face of an overpowering other, male presence—
even in that famous carriage poem, of course, the kindly stopping Death is
a "he"—is animating the terror of many of these authors.

Much of the literary impetus for this fear comes once more from across
the Atlantic, with the work that was the grandmother of this generation,
Charlotte Brontë's *Jane Eyre*. And so it's not surprising that the year of the
first real circulation of Dickinson's poetry saw the creation of America's
greatest madwoman in an attic—one of the greatest stories of American
fear and madness, full stop, because it indicts an entire way of life and, in its
own way, an entire American gender. Charlotte Perkins Gilman—who was
Harriet Beecher Stowe's grandniece—had had several serious relationships
with women, a marriage that ended in separation, and a severe case of post-
partum depression before she wrote "The Yellow Wallpaper" in 1890. She'd
also edited a feminist journal, and from the story's earliest lines—in which
our narrator says there's "something queer" about the house they're renting,
the mansion that might be a "haunted house," but that "John laughs at
me, of course, but one expects that in marriage"—we're aware that what's
wrong has less to do with the house than the sickness and rot that overbear-
ing know-it-all men can induce in their wives.

"You see, he does not believe I am sick! And what can one do?" our nar-
rator says of her doctor husband, John. Male physicians like John—not that
there was another kind—were doing a land-office business, in the last quar-
ter of the century, in dismissing women's complaints: there was a boom-
ing incidence in reporting "nervous disease and hysteria" among women,
an increased flexibility in expanding the symptoms that could result in
that diagnosis to "symptoms which included virtually every known human
ill," as well as "interpretations of mood and personality," reducing such a
patient in the contemporary literature to a "child-woman."[67] And so, like a
child, she is essentially sent to her room: gently, with ostensible kindness,
but quite firmly, to stare at the walls—or, more precisely, the wallpaper—
until she goes mad. (Mad in both senses: "I get unreasonably angry with
John sometimes," she says.)

The room is a former nursery, and we that find our narrator, who has

recently had a baby, is not being allowed near it. Due to her "condition," *she's* the one being infantilized. We also learn, of course, that it has wallpaper of the most bizarre sort:

> I never saw a worse paper in my life . . . when you follow the lame, uncertain curves for a little distance they suddenly commit suicide— plunge off at outrageous angles, destroy themselves in unheard-of contradictions. The color is repellant, almost revolting; a smoldering, unclean yellow, strangely faded by the slow-turning sunlight.

This is worth quoting at length not just to indicate our narrator's "imaginative power and habit of story-making"—a phrase that husband John uses as a distinct negative; you can imagine the purse of his lips as he says it—but also because of its clear influence on writers like Robert Chambers and H. P. Lovecraft; the way in which perceptions, geometries, seem to transcend their expected boundaries. Chambers and Lovecraft are celebrated for it. But Gilman got there first.

Perhaps naturally, the narrator, increasingly obsessed with the wallpaper, begins to try to follow its "pointless pattern to some sort of conclusion," and learns about the woman, "stooping down and creeping about" behind it, and how, when the moonlight strikes the wallpaper, she appears to be behind bars: she's constantly trying to break through, but the pattern is constricting, strangling. It's pretty clear, what she's thinking—to everyone but her, that is, as instead she continues constantly insisting on how wonderful, how loving, how *wise* John is; but this is, in its own way, the delusion that leads her, in the end, to identify herself, and her gender, with her imagined figure. Sometimes, she muses, "I think there are a great many women behind, and sometimes only one"; and by story's end, when she switches pronouns, and identities—"I wonder if they all come out of that wallpaper as I did?"—it manages to be shocking and somehow feel utterly inevitable. And when, in the end, John sees her creeping around the walls, crowing that she has got out at last, and he *can't* put her back, no matter *how* he tries, because she's pulled off so much paper, she exclaims: "Now

why should that man have fainted? But he did, and right across my path by the wall, so that I had to creep over him every time!"

Repetition, obsession, compulsion: a victory over the husband—but what a pyrrhic victory it is. So complete, it should be noted, is her colonization that something else has been taken away from her besides her sanity: though the word "John" is repeated through the story like birdsong, our narrator never gives herself the dignity of a name.

"The Yellow Wallpaper," perhaps emblematically, wasn't published for two years after its composition; the editor of the *Atlantic* had passed, on the grounds that he "could not forgive myself if I made others as miserable as I have made myself!"[68] A curious rationale, and one that smacks of not just women's fears, but the fears of men tolerating women who expressed those fears: a fear of becoming too aware of the churning, seeking, suffocating life of the beings they share home and hearth with. And another of the most powerful tales of the 1890s expresses that entire world in the "Story of an Hour."

That's the title of Kate Chopin's gruesomely ironic 1894 short-short story, in which a woman is told that her husband has been killed in a railroad disaster, and, hearing this, discovers within her breast a "monstrous joy": "free, free, free!," she says under her breath.[69] Notably, she, too, like the protagonist of "The Yellow Wallpaper," is in a top room, and refuses to open the door; but when she does descend, "carry[ing] herself unwittingly like a goddess of Victory," she finds her husband there, discovering the notification was a mistake. "When the doctors came they said she had died of heart disease—of joy that kills" is the story's last line, and here Chopin, unlike Gilman, allows us another turn of the screw, so to speak; the sense of the possibility of freedom before the cruelty that it will always, somehow, be taken away.

Chopin's most pressing contributions to American fearfulness, in other words, consist of the suggestion that liberation, at least for women, is impossible; that, in the end, that sort of awakening—to use the title of her most famous novel, published in 1899—is but an illusion. *The Awakening* ends with its protagonist swimming out to her own death in order to

elude "a society that keeps trying to put her back in her proper domestic place,"[70] the, in Chopin's words, "indescribable oppression [that] filled her whole being with a vague anguish."[71] Chopin herself, it should be noted, was a widow when she wrote most of her well-known work: one of the few entirely socially acceptable ways for an adult woman to live freely and autonomously without patriarchal oversight.

Other contemporary authors such as Mary Heaton Vorse and Mary Austin also wove tales of domesticity and discontent; stories like "The Heart of the House," "The Second Wife," and "The Walking Woman," appearing in the first decades of the new century, explored, each in their own way, how absent wives and mothers can become haunting presences, even suffocating ones. Less overtly feminist than some of their other counterparts, they still suggest something uncanny about the roles women were confined to play, how their power was so strong it could, at times, transcend time, space, and even death.[72]

Which is not to say that these were the only kind of portraits of women by women. Mary Wilkins Freeman, who, like Hawthorne, traced her ancestry back to Salem,[73] was also interested in returning to earlier moments in the history of American horror and, particularly, of viewing them from the perspective of perhaps overlooked victims. In one of her retellings of the Salem story, 1892's "The Little Maid at the Door," first published in *Harper's*, the constables have hauled off the parents of the eponymous little maid—Abigail Proctor, daughter of John—on charges of witchcraft; she's considered too "young and insignificant to have dealings with Satan." When we meet her, she's been left alone three nights and two days "in the desolate Proctor house in the midst of woods said to be full of evil spirits, to die of fright or starvation as she might." Although some help her—including an older woman, Goodwife Carr, who knew medicine and was sometimes accused of being a witch—she dies of "a fever, engendered by starvation and fright and grief."[74] These were rarely the victims considered in earlier narratives; and the attention shines through, and matters.

"The Little Maid at the Door" was republished in Freeman's 1898 *Silence and Other Stories*; the collection's title story, set during the French and Indian war, similarly treads territory that is both familiar and unfamiliar:

it's a Native American captivity narrative, but one that changes perspective to focus on those left behind. Trauma stalks the formerly raided city, "as if the ears of the people were turned up to the pitch of the Indian war whoops, and their very thoughts made the nights ring with them," and while the "fair semblance" of one character, the titular Silence, "still walked the Deerfield Street, sat in the meeting-house, and toiled at the spinning-wheel and the loom, yet she was as surely not there as though she had been haled to Canada with the other captives on that terrible February night."[75] Her beloved, David, escapes and comes back, but she is—until story's cathartic end—incapable of recognizing him. But though Freeman often focused primarily on natural human horrors, she was interested in ranging further afield, too—and one of her supernatural fictions provided a very different perspective on feminine power and agency. In 1902 she wrote a story that won the first William Dean Howells Medal for Distinction of Fiction from the American Academy of Arts and Letters;[76] and that prize-winning story, perhaps confounding our expectations about what kinds of stories get marginalized, is a vampire story.

The elderly female narrator of "Luella Miller," published five years after Bram Stoker's *Dracula* became a sensation across the Atlantic, tells the story of the titular beauty, "a slight, pliant sort of creature," and perhaps it is her weakness, and/or her beauty, that makes everyone so eager to do for her; or perhaps it's something else, because everyone who spends time around her seems to grow weaker and weaker, all in her service. Her husband "couldn't bear to have Luella lift her finger, and she let him do for her. She lived like a queen for all the work she did," her story's narrator tells us; he dies, as does her sister-in-law who comes to take care of her after. Eventually, the narrator confronts her about what we might call her psychic vampirism or, in some thematic way, her fearful power tied to her femininity. But the narrator, who calls her "a dreadful woman," suspects it's an unfocused, lazy, even infantile femininity: "like a baby with scissors in its hand cuttin' everybody without knowin' what it was doin'," she muses. Is this a moral phenomenon, or simply a natural one? The story never provides a definitive answer.

Eventually, Luella is shunned, by all, and without the sustenance of

service, she dies: but Wilkins adds in a twist, like Chopin, that elevates the story from powerful to iconic. Our narrator confesses:

> I saw Luella Miller and Erastus Miller, and Lily, and Aunt Abby, and Maria, and the Doctor, and Sarah, all goin' out of her door, and all but Luella shone white in the moonlight, and they were all helpin' her along till she seemed to fairly fly in the midst of them. Then it all disappeared.[77]

This is a list of Luella's victims, and the strong implication is that even death has not freed them from her thrall: that Luella's power endures. A monster may have been exorcised, but monstrosity, these dynamics of power, remain. It's just in a different form than before, that's all.

Freeman anthologized "Luella Miller" in what remains to this day a very strong collection of supernatural stories, 1903's *The Wind in the Rose-Bush.* The title story—in which a woman in search of her niece finds some strange phenomena in the house where she stays, not least a rosebush that seems to move without wind blowing—becomes a ghost story in retrospect: only at the end do protagonist and reader realize all the people the woman interacted with are dead. Yes, there were hints: Rebecca's encounter with a woman whose uncanny face "gave somehow the impression of a desperately clutched hand of secrecy" and who speaks in a "harsh voice, which seemed to come forth from her chest with no intervention of the organs of speech."[78] But ultimately, we're fooled, despite having been put on notice early on that strange things were afoot; and, in this sense, Freeman's story serves as advance notice for one of America's great ghost stories in this vein, by one of America's great writers—and great ghost story writers.

"Oh, there *is* one, of course, but you'll never know it," is the first line of Edith Wharton's story "Afterward"; the "one" in question is a ghost, but the insistence of the story that no one will know they've seen it until "long, long afterward" nods to the story's focus on retrospective judgment more generally. Not just about the metaphysical status of the beings that you've seen out the window—although it turns out that that's the case—but about the life you've chosen to make, the person you've chosen to marry. The

subject of "Afterward" is—and we'll see this over and over again, through the twentieth century—a woman who realizes that the man she's married isn't who she thought he was; and those choices define her life as much as—or perhaps, given the mores of the age Wharton so delicately chronicles, even more so—than his own. The protagonist, Mary, "was too well versed in the code of the spectral world not to know that one could not talk about the ghosts one saw: to do so was almost as great a breach of taste as to name a lady in a club."[79] Silences, secrets: that is where the ghosts inevitably dwell.

This spectacle of other lives, other possibilities, pressing onto one's own was also the ambit of the other great chronicler of the well-to-do of the fin-de-siècle, one whom Wharton much admired. Henry James was a resident of New York City's Washington Square and habitué of the great and good houses of England; and in being so as (among other things) a closeted gay man, he was well aware of the possibilities that could only be lived out in the realm of speculation and subjunctive. Was his turn to the ghost story a consequence of his childhood worship of Poe? Was it due to his significant preoccupation with Hawthorne's life and work through much of his career, and the latter's psychologized horror? Or was it his claim, in his early years, of Hawthorne's provinciality and "his exaggerated, painful, morbid national consciousness" that helped him embrace his natural Anglophilia, making him an heir to the tradition that had been so deeply popularized by Charles Dickens?[80]

Yes, to all these, and to much else. We've seen how popular the ghost story is among a wide swath of writers in contemporary magazines; and this is to say nothing of the "flood tide" of spiritualism and "psychical" publications and magazines: two thousand volumes ("exclusive of tracts and pamphlets") published between 1846 and 1886, almost four dozen magazines on the subject actively circulating in the 1890s. James's brother William was open to "the presence, in the midst of all the humbug, of really supernormal knowledge," and was, in fact, the founder of the American Society for Psychical Research, as well as one of its presidents.[81] A few years later, the Pulitzer Prize–winning memoirist and novelist (and amateur parapsychological researcher) Hamlin Garland would prove the point, writing, in his

1908 *The Shadow World*—a study of ghosts, mediums, and poltergeists, among others—that when it came to such paranormal questions, "The weight of evidence seems, at the moment, to be on the side of the biologists."[82] All this seemed to go hand in hand with changing conceptions of death in America, a gentling of the prospect that an English author, in 1899, called "The Dying of Death": "no longer as a king of terror, but rather as a kindly nurse that puts us to bed when our day's work is done."[83] The ghosts, it seemed, might be conforming to part of what, in the period, was considered "a war waged against all forms of fear."[84]

All this scientizing of the ghost business, James and others worried, might be bad for the ghost *story*. In 1905 the critic Olivia Howard Dunbar wrote an essay, "The Decay of the Ghost in Fiction," in the influential little magazine the *Dial*, in which she argued that "We have raised ghost-lore to the dusty dignity of a science," and suggested, with some dismay, that "The invocation of the spirits of the dead, far from having its former suggestion of vulgar mystery, is one of the most reputable of practices, which men of learning carry on publicly, with stenographers conveniently at hand." James himself, for his part, suggested, in his introduction to *The Aspern Papers*, that "the good, the really effective and heart-shaking ghost stories (roughly so to term them) appeared all to have been told." And so he set out to disprove that. So did Dunbar, who turned her own hand to the ghost story, framing it as a moral work based on the ghost's need to "recall, expiate, or avenge a crime."[85] But it's almost certain that James is the only one of our writers who owes his greatest work in that vein, or indeed in any, to the archbishop of Canterbury.

It was that distinguished churchman, according to James's *Notebook* entry on January 12, 1895, who told him the "vague, undetailed, faint sketch" of a ghost story *he'd* been told that gave James something to work with: the idea of schoolchildren who would be in the thrall of deceased former servants. But it was James who added a, well, turn of the screw to the story of that name, published, like so many other of these stories, serially in a magazine (here, in *Collier's* in 1898). He chose to add layer of possibility and ambivalence upon layer, most notably the fact that the ghostly appearances are reported through one of the most unreliable of narrators,

a governess whose own complex and conflicted relationship to the children and to the house they live in—yet another branch off the *Jane Eyre* root—is so laden with mystification that scholars have tied themselves into fits arguing whether the ghosts are "real" or simply a psychological projection in the governess's mind. (James himself, apparently, was constantly being pestered with questions about what the story "really" meant.)[86]

The answer, of course, is yes; and it's James's gift to show us, more than anything else, the human mind's possibility of holding several shifting, terrifying, consoling truths simultaneously. The ghosts' most important quality—in a way that's similar to Wharton's ghosts in "Afterward" or "The Lady's Maid's Bell"—is their *thereness*, the fact that they seem to be just like anything else. No rotting corpses here, no Gothic clanks or bedsheets. Simply humanity reflected, whether metaphysically present or not.[87]

Which leads to James's second gift in his stories of fear: to be able—definitively—to chronicle, in ways not so dissimilar to Wharton, the terrors of corruption. The true fear that animates *The Turn of the Screw* is not the ghosts: it's the fact that they—or is it the governess?—are somehow corrupting the children, teaching them the possibility of evil. ("It is a question of the children 'coming over to where they are,'" he wrote in the *Notebooks*.)[88] His amanuensis, Theodora Bosanquet, once wrote of James, "When he walked out of the refuge of his study into the world and looked about him, he saw a place of torment, where creatures of prey perpetually thrust their claws into the quivering flesh of the doomed, defenceless children of light."[89] Is it because ghosts are evil? Or is it because the servants were evil that they're ghosts? Or is it because the children have evil in them that they draw the ghosts to them? But if that's the case, what does it mean that the governess writes that she sees them, "as I see the letters I form on this page," as clearly and truthfully present as the letters of the Jamesian story we read?

All this is much, much more elliptical in James's writing than I'm suggesting here, and far more elegant. "It is all obscure and imperfect, the picture, the story," he wrote in his *Notebooks*, "but there is a suggestion of strangely gruesome effect in it."[90] "The story will tell," one character says; "The story *won't* tell," says another; "not in any literal, vulgar way";

and indeed it doesn't. In her essay, Dunbar, while referring to *The Turn of the Screw* as a "masterpiece," also suggests that it's "probably too esoteric to stand as typical," suggesting your ordinary ghost tale composed without the benefit of Jamesian genius "must be writ large and obvious."[91] But what *is* fairly large and obvious in *The Turn of the Screw* is the suggestion of the possibility of a corruption at the heart of things that both leads to moral panics through the years, as we'll see, but that is also the essence of another of his great stories of fear, "The Jolly Corner."[92] In that later story—published in 1908, and written after James's first visit back to America after twenty years abroad[93]—a man returns from Europe to Washington Square to see the home he has inherited: and it's two homes, actually, one well-put together, the other falling into disrepair and ruin. James's protagonist makes his way through the decrepit house, in an atmosphere of mounting dread,[94] until he comes face to face with . . . himself.

We saw this a few decades back, in Edgar Allan Poe's "William Wilson," but if in Poe's case the doubling is about the return of repressed guilt, for James it's about repressed regret: a sense of an identity forsworn and abandoned, but never really forgotten. "Oh," says the protagonist, "I *might* have lived here . . . Then everything would have been different enough—and, I dare say, 'funny' enough"—and that other self waits in the darkness, ready to strike when you're at your most vulnerable.[95]

That sense of "funny"—like Fitz James O'Brien's "queer" room in his haunted house story a few decades back—reminds us, once again, of other undercurrents, of roads socially impossible to take. O'Brien was gay as well: and these doublings indicate senses of sexual possibility and impossibility, the horror of—to use an appropriately domestic metaphor—the closet. Another Anglophilic writer of the period, Gertrude Atherton, piles similar doublings one on top of another in her remarkable story "The Striding Place," published originally in 1896 as "The Twins." In that Yorkshire-set tale, Weigall, after hearing some speculations about the separability of soul and body, searches for his missing best friend, and finds him—or, at least part of him—in a raging river. The latter grasps his hand from out of the water, but, as we learn in the story's final sentences, as Weigall sees his head, "There was no face." Motion notwithstanding, his friend was long since

dead—and Weigall, who we have learned "had loved several women; but he would have flouted in these moments the thought that he had loved any woman as he loved Wyatt Gifford," is coming to terms—in that shocking, uncanny moment—with submerged truths, metaphysical and personal, coming to life through ghostly action.[96]

James, for his part, almost certainly borrowed that two-house technique of his from a practitioner who used the same themes in very different ways from across the pond. Although we're focusing on America, you can't understand the next wave of American fear without looking at some major trends in England of the period, which will take us right up to the century's end—and the chapter's.

ROBERT LOUIS STEVENSON'S *The Strange Case of Dr. Jekyll and Mr. Hyde* has been steadily frightening readers since January of 1886. If you're reading this book, you likely know the story's outlines: Stevenson takes Shelley's hubristic scientist shtick one step further by defining the hubris in question as the assumption you can bifurcate man's—humanity's, sure, but Stevenson is really interested in man's—dualistic nature by separating good and evil into two different parts: the nasty, brutish part, and the one at home to proper Victorian society. Fanny, Stevenson's wife, the story goes, was so horrified she insisted he burn it. He did, then rewrote the work from scratch. Less fervid versions of that story exist, too, including the one by her own account, where she says she "wrote pages of criticism pointing out that he had here a great moral allegory that the dream was obscuring."[97] But Stevenson's story was an enormously popular advertisement for both the instantiation of Victorian mores and the churning erotic currents that lay underneath.

It was hardly the only one: two other iconic novels of the following decade addressed the same theme. The first, published just four years after *Jekyll*, was by a well-known playwright and man about town named Oscar Wilde, whose *The Picture of Dorian Gray* (1890) turns the Jekyll/Hyde dichotomy into an aesthetic proposition. "The harmony of soul and body—how much that is!" one character in the novel suggests. "We in our madness have separated the two, and have invented a realism that is vulgar, an

ideality that is void." But the novel's terror at that separation—a horrifically aging portrait hidden away, an uncannily youthful counterpart falling into dissipation and ruin—can be seen as the terror at being unable to live one's life coherently, holistically; and while the book's sensualists are its villains, the book's sensuality—and desire for experience, erotic and otherwise—is what offended, and scared, its opponents the most.

The second novel was by a theatrical business manager named Bram Stoker, about a creature from Old Europe who drives the ladies wild, so wild they go out walking on the streets with abandon and need a good impalement with a cross to get them to lie down the way they should. As this somewhat tongue-in-fanged-cheek description of *Dracula* implies, the novel is suffused with fears of women's autonomy and sexuality; and—certainly—of sexuality more generally. There's plenty of sex in *Dracula*, but none of it is conventional, or, at least, conventional as Victorians would have termed it; most of it is accomplished, of course, by mouth.

"No sir, I make it a rule of mine: the more it looks like Queer Street, the less I ask," goes a line in *Jekyll and Hyde*, and it's worth noting that, in contrast to its later movie adaptations, there are no necessary intimations that the pleasures Hyde pursues are of a heterosexual variety; quite the opposite, actually. Times were changing, whether the Victorians liked it or not: and these champions of scientific and industrial progress liked it in some ways, and didn't in others, most notably, perhaps, in moral terms. If Victoriana was about the assumption of religious duty and sobriety—it's hardly coincidental that *Dracula*, that essential Victorian horror novel, is about a victory of a bunch of people carrying a cross—there were other currents emerging on the island, ones that were fellow-travelers with Darwin and the naturalists but merged that skepticism with romanticism, paganism, and old English explorations to create something much stranger.

The most important of these figures, Arthur Machen, created the sense, in the words of one of the characters in his 1894 signature story "The Great God Pan," "that all these things—yes, from that star that has just shone out in the sky to the solid ground beneath our feet—I say that these are all but dreams and shadows: the shadows that hide the real world from our eyes."[98] Machen popularized the idea that there was a grander, older world beyond

the one limned and defined by the battle between Christian good and evil: and, befitting the folktales, legends, and myths that everyone knew, these gods were hardly beneficent. Seeing that world, those forces, is what the story calls "seeing the god Pan."[99] But—also befitting the wider sense of a kind of vast modernity—it wasn't quite that they were evil, either, or not necessarily. The implication was that they were simply *beyond*: greater forces than humanity could understand or deal with; we were flies to be crushed and discarded if we got in their way. For the Puritans of Salem, the fight with the devil centered humanity at the very essence of the universe. Just like Darwin, the implications of Machen—and his many influential followers—were that this, even in its worst, diabolic incarnations, was simply not the case. But there were other ways to interpret this sense of cosmic insignificance in the Victorian era, ways less fantastical, at least ostensibly so: and one British writer obliged, by essentially inventing science fiction— and infusing it with a fearful sensibility that will loom large throughout the rest of our story.

UNLIKE WALPOLE, H. G. WELLS was no noble; he was a shopkeeper's son, and a draper's apprentice, and then a scholarship boy, to what would become the Royal College of Science. It was in that school's journal that he published the earliest iteration of what, a few years after Machen's story, would become *The Time Machine*. In 1894 Wells insisted that Poe's "fundamental principles of [story] construction . . . are precisely those that should guide a scientific writer";[100] a year later, in *The Time Machine*, he would insist that humanity's central stories don't necessarily hold.[101] Including not just the theories of "the Advancement of Mankind," shown in the book as flawed by a gaze at the dystopian future, but also, in a way not too far off from Machen, our most basic perceptions of the universe. "I shall have to controvert one or two ideas that are almost universally accepted. The geometry, for instance, they taught you at school is founded on a misconception," the Time Traveller says right off the bat, and we see shades of Lovecraft to come, alongside hundreds of science-fiction stories. "Look here," says one of his listeners in response to his speech, "are you perfectly serious? Or is this a trick—like that ghost you showed us last Christmas?"

And indeed Wells has the Time Traveller relate his tale as if he is telling a ghost story, his "white, sincere face in the bright circle of the little lamp . . . his expression follow[ing] the turns of his story" as he relates it to his listeners "in shadow." That's a horror-story set up right there.

And then Wells moves from the small aegis of the smoking room to widescreen apocalypse: 1897's *The War of the Worlds*, in which Martian invaders lay terrible waste to the English countryside, does its best to shatter the illusion that our world might not, necessarily, be the center of all of them, where figures as inhuman as Machen's are not just indifferent, but actively hostile. "No one would have believed in the last years of the nineteenth century that this world was being watched keenly and closely by intelligences greater than man's and yet as mortal as his own," the novel begins, replacing divine Providence with something entirely tangible and yet utterly alien, out of "the older worlds of space," which become "sources of human danger," with "intellects vast and cool and unsympathetic [that] slowly and surely drew their plans against us." "My God!" a character repeats and repeats later, in the midst of the War: "They wiped us out—simply wiped us out," and we are reminded of Lear's line about gods and flies, and not in our favor. Yes, the Martians are defeated; but it's thanks to lowly germs, not human action, or valor, or ingenuity. All those qualities are, ultimately, useless. Who can imagine the implications of that, and not shiver a bit?

These anxieties didn't, necessarily, have to only be played out through Darwinism: they were also the anxieties of Victorian empire, where colonizers met worlds, civilizations that were older, and in many cases just as, if not more sophisticated, than their own. H. Rider Haggard's novels—especially 1886's *She: A History of Adventure*—brought a dystopian fantasy of eternal white rule to Africa; we learn that She-Who-Must-Be-Obeyed (that's her full title) is a "beautiful white woman." Seldom seen by her subjects, she is "reported to have power over all things living and dead," and her uncanniness is linked—as is Machen's monstrous figure, infused with Pan's spirit—not only to her absolute indifference to any sense of "human law [or] moral sense of right and wrong," but to her femininity. So many fears coincide in *She*, and blur, that it's hard to keep track of them: racial,

gendered, sexual, colonialist: it's a rebuke to all the superiorities Victorians keep ascribing to themselves, the ability to take and maintain control.

Which leads to our last British import, for the moment: of the terrors that stalked the streets of Whitechapel in that bloody summer and fall of 1888, prostitutes murdered one after another, taunting letters and body parts sent to the police, the exploding popular press carrying speculations, details, and gory accounts for the terrifying delectation of an ever-hungry public. The London stage version of *Dr. Jekyll* had premiered at the Lyceum Theatre just a few days before the murders broke: the *Pall Mall Gazette*, connecting the two, suggested that "There certainly seems to be a tolerably realistic impersonification (sic) of Mr. Hyde at large in Whitechapel." Lead actor Richard Mansfield withdrew from the production in October; some people had been suggesting he was a Ripper suspect because his on-stage transformation was so good.[102]

Jack the Ripper, of course, was never caught. Some said, based on a gruesome murder in New York, that he'd crossed the Atlantic. Mansfield, for what it's worth, was an American actor.[103] (A dime novel was duly published to that effect: 1889's *Jack the Ripper; Or, The Whitechapel Fiend in America*.)[104] Whether the Ripper did, or not, a lot of other darkness certainly did, including *War of the Worlds*, which was serialized in *Cosmopolitan* in 1897. One of fin-de-siècle America's great horror writers, F. Marion Crawford, wrote a skin-freezer of a ghost story, 1886's "The Upper Berth," about a ghost who haunted the top bunk in a stateroom on a trans-Atlantic voyage on what was once the narrator's favorite ship. "I cannot conceive of any inducement which could entice me to make another voyage in her," he says, and after hearing his tale, you understand why. Why *have* all the people who have spent time in stateroom 105 over the last three voyages gone overboard, exactly? Maybe it's "the clammy, oozy mass" there, part of which originally has "the shape of a man's arm, but was smooth, and wet, and icy cold"[105]—a drowned, dead thing, as it transpires; the dangers and fears of the ocean passage, in other words, made concrete, ever-present on the voyage, locked inside the stateroom at story's end, but still, always, there.

But if the journey was frightening enough, what mattered even more

was what was brought to the destination. Wharton and James brought back one kind of England; but there were dark satanic mills and working-class slums alongside the country houses, and those came on the voyage, too. The Ripper popularized—if not created—two other trends that would grow and metastasize in the twentieth century, alongside the status of the serial killer: the first, an increasing speculation about motives and psychology; the second, the possibility of crime without punishment. It is not insignificant that just three years prior, a new word entered the British popular lexicon, appearing in the *Pall Mall Gazette* in 1885 to describe a "new malady."

That word was "psychopath."[106]

FOUR

Gaslights and Shadows

—

AT THE CIVIL WAR'S END, under a quarter of Americans lived in cities; by the end of the Great War, the proportion was almost exactly half. All those people moving to the cities—both from rural America and from abroad—changed things. Size created anonymity, the possibility of losing yourself in the crowds, remaking yourself, if you so chose. . . . or getting lost, and not always by your choice. Increasingly, the streets were lit by electric light, and the machines inside them were powered the same way; but that simply swapped a new set of shadows and terrors for the old ones. The horrors of the next decades were, all too frequently, industrial and mass-produced: whether they came from the chatter of guns or the whirr of a film projector, they cast an eye on progress, and murmured about what lay beneath.

Start, perhaps, with that newly electrified white city, Chicago. In 1893, its World's Columbian Exposition, or World's Fair, was an announcement of America's newly flexing muscles: its willingness to be broad-shouldered, to play a leadership role in world affairs, to stride into the future. And yet, inside the city limits, there sat a haunted castle. This castle, though, had no clanking chains, no Gothic ghost or Salem witch; it had a psychopath who used modern tools—the soundproofed room, the knockout gas-bearing pipes, and of course, the three-thousand-degrees-Fahrenheit kiln—to disable, kill, and dispose of guests who checked into his World's Fair Hotel at 701 Sixty-third Street. And why did H. H. Holmes do it? For his part, when eventually caught, he had a simple, and chillingly modern, explanation: "I

was born with the devil in me. I could not help the fact that I was a murderer, no more than the poet can help the inspiration to sing."[1]

Others, looking at his case, attempted to provide the scrim of moralistic drama. "How the Evil One must glory in the possession of such subjects as H.H. Holmes!" says an 1890s pamphlet *Holmes, the Arch Fiend, or a Carnival of Crime*.[2] But ultimately most of those who spread his story, were less interested in such lessons as in the visceral impact of reporting true-life horror. While Holmes was disposing of his victims, after all, Chicago journalists had formed a Whitechapel Club, whose headquarters had a coffin for a bar and was decorated in skulls, a noose, and a blood-caked blanket.[3] This sensibility—that horror reported in realistic terms was the height of contemporary aesthetic ambition—was an inheritance of Bierce's journalism, and Twain's; and it infused the current wave of literature as well.

One of the period's great literary creations, a young protagonist named Maggie, didn't end her days in anything like H. H. Holmes's murder castle. But the point of *Maggie: A Girl of the Streets* is that she didn't need to in order for it to still be a horror story. The novel's author, Stephen Crane, was a youthful prodigy who wrote his share of Biercean-type horror-of–Civil War stories;[4] one, "The Upturned Face," features the indelible image of a burial in which everything is covered but "the chalk-blue face." ("Good God," a character shouts, "Why didn't you turn him somehow when you put him in?") But Crane was born six years after the war ended, and the Chicago *Inter Ocean*'s complaint in 1895, that Crane "doesn't tell things as a soldier would, and he doesn't see things as a soldier did, and will make the real soldier tired to follow him," had some merit to it. And so he turned to the tale of a girl who "blossomed in a mud puddle [and] grew to be a most rare and wonderful production of a tenement district, a pretty girl"; and met a terrifying end, all the more terrifying because it happened every day: Maggie is ruined by her demonic, diabolic wrong guy, in a seduction novel for the American industrial age. By the next year, the *Inter Ocean* was striking a very different tune, writing that "The dens of woe—called the 'homes of the poor'—in great cities were never pictured with more horror than in Stephen Crane's 'Maggie'. . . . the story is one

that will shock the refined reader by its reality, and will sadden any lover of the race that such things should be even a small part of our boasted civilization."[5]

Maggie: A Girl of the Streets is about not just the girl, but the streets: "Hell" is a word often used in the novel, and the tenements, with their overcrowded, unsanitary conditions, were portrayed as infernal. And not just by naturalist fiction writers like Crane. Perhaps the chronicler with the most impact was the photographer/writer Jacob Riis, who chronicled the horror of the tenements and displayed them to audiences in two-hour magic-lantern slide lectures on tours throughout the country, one hundred images a tour, dozens of them every year in the first decade of the century. When you saw a photograph with the simple, brutal caption "Slept in that cellar four years"—a horror story in six words—what else could be evoked besides sympathy? Well, fear, of course; fear of what images were coming next in the show, that rumors and reports they'd heard and read of—ranging from white slavery to organized crime—would be next on the docket.[6]

But perhaps the most omnipresent horror, in those first decades of the century, was the explosion of an industrial capitalism that chewed up waves of workers, Hawthorne's *Notebooks* on steam-engine steroids. In 1876's *Edith Hawthorne, or, The Temptations of a Factory Girl*, the narrator asks the novel's reader:

> [R]eader, did you ever examine the texture of the fabric of which your dress is made? . . . When they tremble not with a sigh they vibrate with a groan . . . That beautiful crimson spot you so much admire you think was designed, but the little crushed fingers caught in the ruthless maw of the loom can tell you a different story could they speak.[7]

Horror stories abounded. Sometimes they bled into metaphor: in a story appearing in the *Ladies' Garment Worker* during the 1910 strike period, "The Living Skeleton and the Stout Reformer," the Skeleton in question acts as an uncanny guide to a reform-curious owner, convincing him to reform

his workplace so as to avoid the spread of consumption in the unsanitary environs. (The wasting consumption, after all, is what had turned him into the living skeleton in the first place).[8] But not all employers, to put it mildly, were as forward-looking as the fictional ones devoutly hoped for by the *Garment Worker*, and not all the stories needed fictional fears to send shudders down workers' and readers' spine. Consider, for example, the owners of the Triangle Waist Company, who, like many of their fellow employers, had locked the exits from the factory floor to prevent any breaks or respite—leading to 146 deaths when a fire broke out. Some jumped from ninth-floor windows to their death in order to avoid the flames.

Many of those workers were among the newest Americans—Italian and Jewish immigrants. America was in a massive period of immigration, which led to a corresponding explosion of anti-immigrant sentiment. We've seen that fear pervade San Francisco, where white residents' sense of Yellow Peril manifested itself in discrimination, legislation, and violence; it also suggested itself in a stereotypical association of Orientalism and yellowness as the substance of a kind of deliquescent, decadent fear. We saw this sensibility, a bit, in the "Yellow Wallpaper," remember; and though Gilman doesn't mention anything directly racial in the story, it's worth noting Gilman lived in California while writing the story and would later oppose open immigration. She wrote in 1900, for example, that "the Chinese and the Hindu [were] not races of free and progressive thought and healthy activity," and that Chinatown was replete with "criminal conditions."[9]

But the kind of fear of foreignness we saw in Emma Frances Dawson's work began to play itself out even more strongly in a kind of Orientalism that, for example, infused what we might call a kind of antiquarian imperialism: the idea that materials brought from people and things far away would have deleterious effects on "good old Americans," in the same way that—repugnantly—racists argued the new groups of immigrants had a deleterious impact on American society. The English novelist Sax Rohmer's contemporary take on the subject, *The Mystery of Dr. Fu-Manchu*, was published in America under the title *The Insidious Dr. Fu-Manchu*, and that adjectival shift says everything about the way American fears of the immigrant "other" worked in this period. The description, from Rohmer's

novel, of that "yellow peril incarnate in one man": "tall, lean and feline, high-shouldered, with a brow like Shakespeare and a face like Satan."[10]

Perhaps the most important work in this vein, connecting yellowness, foreignness, and evil, was Robert Chambers's 1895 *The King in Yellow*— which is the name both of the book of short stories Chambers published, and the hideous tome described in several of those stories that serves as its central binding force. Wilde's *Dorian Gray*, published a few years earlier, featured a "yellow book" which was "a poisonous book. The heavy odour of incense seemed to cling about its pages and to trouble the brain," and Chambers's book-within-a-book creates madness and death for anyone who encounters it: it's the predecessor of many, many cursed books to come, but also suggests just how dangerous literature can be. Chambers's work has a kind of Machenesque ring, with the book as a kind of gateway to a cosmi-cally wide world, from which hideous forces sometimes cross over to ours. Indeed, in one of the stories in Chambers's book, we hear the devil-King cite scripture for his purpose: "It is a fearful thing to fall into the hands of the living God!" he whispers to the narrator, as the latter falls into perdition.[11]

But as frightening as the accounts of that descent can be—and Chambers's signature story, "The Repairer of Reputations," pulls this off excellently—what truly disturbs is the future world in which the story is set: a dystopian utopia, a quarter-century in the future, whose tranquil-ity has been purchased at the expense of keeping out Jewish immigrants "as a measure of national self-preservation" and ethnically cleansing Black people to "the new independent negro state of Suwanee," alongside other anti-immigrant laws.[12] The rot that thus lurks at the heart of a society focused on racial and ethnic superficialities is concretized, both through the Government Lethal Chambers that dot the cities (for all the suicides, you see), and the career of the repairer of reputations—to say nothing of the rotting *King in Yellow* tome that circulates through the book, and the world. The story leaves open the possibility that all of this exists in the nar-rator's head, a head that has been recently and severely injured, as fevered racist images all too often do. But, nonetheless—and this is part of the hor-ror, too—it's a world real enough in his head to lead to at least one murder.

But you didn't have to be coming from abroad to be a source of, and a

victim of, white fear. In the *Atlantic*, Zitkála-Ša, of the Yankton Dakota tribe (then largely known as the Sioux), wrote a series of quasi-autobiographical sketches in 1900 that satisfied that magazine's readers' interest in Native life, but simultaneously damningly indicted what their government had done to them in the process of creating the kind of person who might write about it for the *Atlantic*.[13] In her work "The School Days of an Indian Girl," she evocatively gives a picture of the "white man's devil" she sees in an illustrated Christian Bible, who—in a nightmare she has—chases her while ignoring her Native mother and a visiting friend, because "he did not know the Indian language." It's only her mother's embrace that awakens and saves her; the diabolic intervention of an education and acculturation that attempts to distance her from her roots is literally the stuff of nightmares.[14]

For her part, Pauline Hopkins, a Black writer and editor, chose to play out her own narratives of fear, frustration at the glacial pace of progress toward racial equality, and fantastic, imaginative possibility for catharsis, in the magazine where she served as literary editor. The *Colored American Magazine*, published in Boston in the new century's first decade, was inspired by mass-market magazines like *McClure's* and *Cosmopolitan* alongside the *Atlantic* and *Harper's*.[15] In 1902–1903, Hopkins published her novel *Of One Blood* there, which picked up on Chesnutt's fraught tales of the color line: the novel features two biracial characters whose romance is initially frustrated by their desire or need to keep their respective heritages secret. But, unlike Chesnutt's tale, Hopkins's novel gives way to a story of African kingdoms and a rich cultural inheritance, with its fantastic ending serving as "the construction of a fictional alternative to the limitations of national identity."[16] "What would the professors of Harvard have said to this," the main character asks himself, coming face to face with the inheritance he is rightfully vouchsafed. "In the heart of Africa was a knowledge of science that all the wealth and learning of modern times could not emulate."[17]

Both Hopkins's and Chambers's work was, in a sense, about discovery— of the possibilities and fears of intellectual exploration, of colonialist exploration, of worlds beyond those that were imagined; and these worlds were now available to an increasingly wide range of readers in the form of cheap paper and ink. The magazines our previous horror fiction had appeared

in—the *Atlantic*, *Harper's*, and the like—weren't just high-brow but high-cost: the waves of immigrants, and their children, were in the market for lower-priced stuff. Newspapers obliged, and the melodramatic, sensationalist turn of publishers like Joseph Pulitzer—the "if it bleeds, it leads" philosophy he espoused—made its way into news stories that obsessed the public. Sometimes they were exposés of terrors of corruption, like *Leslie's Illustrated Newspaper's* look at the tainted milk business—which warned "the squeamish and the prudish" not to read, and then offered "a record of unimpeachable facts, unutterably abominable, but true," laid out in vivid detail, augmented by the illustrations of editorial-cartooning pioneer Thomas Nast.[18] Sometimes, it was the gaping, voyeuristic horror that marked the reportage about disasters like the San Francisco earthquake, lingering over the devastation and the wreck: ALL SAN FRANCISCO MAY BURN, read the A1 headline in the *New York Times*,[19] and one might just detect an attraction to the flame beneath the genuine horror and concern that undoubtedly also drew readers. Pulitzer and Hearst wanted to inform their readers; but they also wanted their pennies and nickels, and they'd give column inches and blaring headlines to the stories that filled their coffers.

And so the front pages were often dominated by lurid true-crime horror that made celebrity monsters, and monster celebrities. As Holmes was committing his murders in secret, for example, Lizzie Borden of Fall River, Massachusetts, as the folk song would soon have it, "took an axe / and gave her mother forty whacks / When she saw what she had done, / She gave her father forty-one." To be scrupulously honest, it was her stepmother, and it was less than three dozen blows for the two of them, and Borden was acquitted, after fainting in court when the skulls of the murdered pair were presented in the court as evidence. But the legend was printed, in the newspapers mushrooming around the country. And such accounts could be provided in remarkably gory detail. Lafcadio Hearn, reporting on a notorious Cincinnati murder in 1874, described "a hideous adhesion of half-molten flesh, boiled brains, and jellied blood mingled with coal." The skull, discovered after some time in a furnace, presumably placed there to dispose of the evidence, had "burst like a shell in the fierce furnace-heat; and the whole upper portion seemed as though it had been blown out by the steam

of the boiling and bubbling brains." Which he then touched, reporting it the "consistency of banana fruit."[20]

But that was old news, nineteenth-century news; the new crime of the new century was the notorious murder of Stanford White by Harry Thaw. The trial had everything you could possibly want in it: there was model and showgirl Evelyn Nesbit's relationship with famed architect Stanford White, which may or may not have involved moral corruption. (Nesbit, the young woman involved in the fatal love triangle, testified how, as a teenager, White would push her on a red velvet swing in his apartment, she wearing nothing but the jewelry he'd given her.) There was the young railroad heir Thaw, obsessive in his desire for Nesbit, finally convincing her to marry him. There was the murder itself, borne of jealousy and mental instability, and occurring during the finale of a rooftop show at Madison Square Garden. The newspapers ran with it for months, through the "trial of the century" in early 1907, salivating over the corruption of youth with the same impulse that Henry James had had, the decade before, though now with quite different methods.[21]

Of course, New York had been considered an "evil city" before, throughout the nineteenth century, in novels like Osgood Bradbury's *The Belle of the Bowery* (1846), George Thompson's *City Crimes: Or, Life in New York and Boston* (1849), and Edward Z. C. Judson's *The B'Hoys of New York: A Sequel to the Mysteries & Miseries of New York* (1849). Joaquinn Miller's *The Destruction of Gotham* (1886) even featured "a violent apocalyptic vision of the burning of New York . . .brought about by a sudden release of all the terrible energies of evil abroad in Gotham." There were "an assortment of illustrated subscription books 'devoted to telling the truth' about Manhattan" that offered "an oftentimes lurid picture to thousands of the unsophisticated who purchased them from itinerant book agents."[22] One particularly vivid contemporary example was Junius Henry Browne's 700-page *The Great Metropolis: A Mirror of New York*, with its tales of thousands of robbers, pickpockets, and thieves; prostitutes galore; and crooked adoption agents who weren't so picky about where they got their children from.

But a new menace was emerging, beginning to dot the streets and alleys of the city, a tidal wave that threatened to render practically obsolete

everything that came before it, one that brought horrors to the world more stunningly than ever before. And you wouldn't have to risk your neck to seek it out, either. All you needed was a nickel to see it; and all they needed to show it to you was a flat surface, and a film projector.

IN 1910, THE SAME YEAR Edith Wharton produced *Afterward*, Thomas Edison released a ten-minute film based on Frankenstein. Edison had built his Black Maria film studio in Fort Lee, New Jersey, almost a generation before, and though it was the first of its kind, it very quickly had imitators. By the middle of the twentieth century's first decade, there were thousands of nickelodeons around American cities—you paid your nickel, and you got your ten-minute silent movie, or a few of them, put together into a program—and some film production was beginning to start up out on the other coast, in Los Angeles. And although there was a wide spectrum of topics, genres, and modes that appeared to audiences in those theaters, Edison's *Frankenstein* (1910) was not alone in latching on fear as a suitable subject: two years before, the Selig Polyscope Company of Chicago had produced the first of many adaptations of *Dr. Jekyll and Mr. Hyde*,[23] and early Edison films included scenes of hangings and a lynching.[24] But *Frankenstein* is probably the first great movie of its ilk still extant.

"A liberal adaptation from Mrs. Shelley's Famous Story for Edison Production" reads a title card, and "liberal" is a fair enough description: readers of Shelley's novel, for example, may not remember Victor Frankenstein in university lodgings covered in skeleton décor. But its visual effects, notably the monster emerging from the smoke and steam of a kind of witches' cauldron, might, for the first and maybe last time in movie history, actually have lived up to the the press release claiming that "scene in the laboratory is probably the most remarkable ever committed to a film."[25] That witchiness was ample proof to audiences that this new technology was not only uncanny in its essence, but was able to render what they had heretofore only read, or seen on the stage, in an entirely new way.[26]

Which isn't to say it was *entirely* radical. The same publicity assured audiences that "in making the film the Edison Company has carefully tried to eliminate all the actually repulsive situations, and to concentrate

upon the mystic and psychological problems that are to be found in this weird tale,"[27] and the movie's conclusion, in which the monster sees itself in the mirror on Frankenstein's wedding night and disappears because, in the words of the intertitles, "the creation of an evil mind is overcome by love," is not only about the sublimation of carnal impulses into "appropriate" connubial channels,[28] although it's very much about that. But it's also about the push and pull between restraint and display that characterizes all of horror, but especially its film versions, and the attempt of a new medium to appeal to churchgoing (i.e. general 1910-American) audiences. Because the triumph of love over evil is a theological and political statement all at once.

Edison was certainly one of film's first great innovators. But it was D. W. Griffith who was, arguably, its first great auteur. And within those next few years, Griffith—the son of a Confederate officer who moved from indifferent success in acting to his directorial perch in classic Hollywood manner, jumping into the director's chair when producers removed its previous incumbent—turned his attentions to adapting one of America's great purveyors of terror, the one whose emphasis on effect and sensation made him a perfect subject for adaptation to the short running times of films of the era. Griffith directed the film *Edgar Allan Poe* for Biograph in 1909 and in 1914 produced a full-length mash-up of "The Tell-Tale Heart" and "Annabelle Lee" called *The Avenging Conscience*: in it, he was able to show through double exposure and camera tricks the visualization of guilt and imagination that Poe was only able to tell, creating effects the page—and even the stage—never could.

In 1917 a critic, in an essay with the leading title "Are the Movies a Menace to the Drama?," boldly suggested that "So far as mere pictorial story-telling is concerned the drama is simply outclassed" and that this comparative advantage in narrative effectiveness would lead to privileging certain kinds of movies, ones with "arbitrarily concocted plots, wherein probability, plausibility and verisimilitude were continually sacrificed to unexpectedly startling effect." And, he suggested in somewhat elitist fashion, this would be perfect for "illiterate playgoers," "the mob," since "the relish for beholding violent adventure, for watching villainies plotted, and

accomplished or thwarted, for impending terror and horror, is deep rooted in the baser instincts of man."[29] Still, you could argue the critic had some grudging respect for the movies' power: compare this, by contrast, to Edith Wharton's ruminations in a preface to her collected ghost stories several decades later that as "deep within us as the ghost instinct lurks, I seem to see it being gradually atrophied by those two world-wide enemies of the imagination, the wireless and the cinema."[30]

Supernatural monsters and terrors weren't the only kind on display in early American cinema, though; movies like 1913's *Traffic in Souls* and 1914's *The Inside of the White Slave Traffic*, for example, displayed a kind of sensationalist fear drawn from the streets surrounding the moviegoers, thirty thousand of them seeing the former picture in its first week, two-thirds of these women.[31] And they certainly weren't the only kind on show in Griffith's movies, which leads to a more troubling kind of fear: his mesmerizing deployment of terror was used in malicious service in yet another adaptation. In this Wilsonian era, an era of trying to roll back the achievements of Reconstruction, Griffith adapted his long-time friend[32] Thomas Dixon's wildly successful 1905 novel *The Clansman*—which had sold forty thousand copies in its first ten days of publication[33]—into the 1915 movie *The Birth of a Nation*, which retold the story of the Civil War and the South as one of righteous and noble Lost Cause whites being preyed upon by predatory Black males. This last was a trope popularized by the previous year's tract by Thomas Nelson, *The Negro: The Southerner's Problem*, which proposed lynching as a means of "putting an end to the ravishing of [white] women by an inferior race."[34] A selection from *The Clansman*, where the Klansmen—portrayed as heroes—force a Black man to reenact his rape of a white woman: "His thick lips were drawn upward in an ugly leer and his sinister beady eyes gleamed like a gorilla's. A single fierce leap and the black claws clutched the air softly as if sinking into the soft white throat . . . 'Stop him! Stop him!' screamed a clansman, springing on the negro and grinding his heel into his big thick neck. A dozen more were on him in a moment, kicking, stamping, cursing, and crying like madmen."[35] *Birth of a Nation* was the first movie to ever be shown at the White House—characteristically so, it should be said, given the nature of its then-occupant, the notoriously

racist Woodrow Wilson, who famously commented that the movie was "like writing history with lightning."

Did *Birth of a Nation* and the novel it was based on strengthen, embolden, anti-Black violence? Of course; but it's impossible to cast the blame on any single work. There were novelists like the utterly and justly forgotten but then-popular John Saunders Holt and Francis Christine Tiernan side by side with Dixon, for example;[36] their works were all of a piece, treating Black bodies and properties as terrors; more than terrors—as threats that should, if at all possible, be removed. You didn't need *Birth of a Nation* for someone like Winfield Collins, three years later, to write *The Truth About Lynching and the Negro in the South*, in which the truth, apparently, was that "the white man in lynching a Negro does it as an indirect act of self-defence against the Negro as a race." But that didn't wash. Not when, as Ida B. Wells put it in her 1892 pamphlet *Southern Horrors: Lynch Law in All Its Phases*, "the black shadow of lawlessness in the form of lynch law is spreading its wings over the whole country." And, in an ironically crystalline proof of her thesis, she subsequently had the offices of her newspaper destroyed for speaking so.

Not when there were 3,224 lynchings in America between 1889 and 1918, approximately one every three days. Not when 80 percent of the victims were Black. Not when one of them, Jesse Washington, was hung, mutilated, and burned by a mob before a crowd in Texas (some of whom laughed, took photographs, and collected teeth from the skull to sell for five dollars each) in 1916, in a crime called the Waco Horror.[37] Not when one out of every thirty Americans in the 1920s was a member of the Ku Klux Klan, "a powerful force which . . . terrorized, literally, from Maine to California" and was instrumental in electing officials ranging from governors to senators.[38] One of their sobriquets—"the Invisible Empire"—said it all, reflecting, in reverse, the conspiratorial theories that were so often disseminated by their ilk.

Not when Eugene O'Neill's play *The Emperor Jones*, which opened in November 1920 and was described by the *New York Times* as "an extraordinarily striking and dramatic study of panic fear," defined the fear in question as the specter of Black political autonomy and power.[39] And not in an

age of one of the worst crimes perpetrated against a Black community in the twentieth century, the assault on the prosperous Black business district of the Greenwood District of Tulsa that destroyed thirty-five city blocks and killed almost three hundred on May 31 and June 1, 1921. A week after what has become known as the Tulsa Race Massacre, the future head of the NAACP, Walter White, would say "that the Tulsa riot, in sheer brutality and willful destruction of life and property, stands without parallel in America."[40] Postcards with pictures of victims "in awful poses" were sold on street corners.[41]

It says something—and something not at all good—when the most plausible solution to this nightmare seems to be the utter destruction and resetting of society: a solution advanced, in fiction, by one of America's greatest Black intellectuals, the scholar and activist W. E. B. Du Bois. Du Bois's concept of double consciousness, appearing in 1903's *The Souls of Black Folk*, is in its own way a kind of terrifying and uncanny sensation of alienation from oneself that would make both Poe and James proud; only here it's produced by the effect of being Black in a racist American society. But in 1920's "The Comet," he turns to a more conventionally melodramatic, Wellsian-type scientific horror—a comet basically destroys all life— and mixes it with the fears of interracial eros that played out on Griffith's movie screens: the only people that seem to be left are a Black man and white woman. For a brief moment, this apocalypse, in Du Bois's vision, leads to a shared, utopian vision of a new Genesis: but the story ends, with a twisting irony, with the revelation that it *wasn't* the world that was destroyed, just New York, and so things will return to reality. "Let's lynch the damned—" say some of the crowd, when they see the two together, and although it doesn't happen, it's a near thing. Du Bois's vision of total destruction, though, wasn't only in the province of science fiction in those days: it had been more than apparent—seen by American citizens through the lens of testimonies of returning American soldiers and in the precincts of movie theaters—in the charnel houses of Europe during the Great War.

America's involvement in World War I was less intense than that of its allies on the Continent: it entered the war late, because for most of the war's duration, fears of involvement—and desire for neutrality—ran

high. The 1915 movie *The War o' Dreams* featured an inventor of a new chemical weapon; before selling it to the War Department, though, he has a nightmare of "the horrors his invention would bring," and destroys the notes instead. The same year's *The Battle Cry of Peace* showed "an unprepared America overrun by the brutal and licentious soldiery of a foreign power which, though unnamed, uniformed its troops in a strangely close imitation of the Germans."[42] And the fear was understandable: ideological opposition of varying sorts and general indifference aside, those who were watching could read, or hear, about the horrors of the Western Front, the soldiers chewed up into bloody pieces by the new machine guns and burning up from the inside from inhaling poison gas. A popular soldiers' song of the time, "When the Guns Are Calling Yonder," parodied a then-popular song with lines like: "You'll be lying in the rain / with the shrapnel in your brain / and you'll never see your sweetheart any more . . . you'll be hanging out your tongue / when the gas gets in your lung / and you'll never see your sweetheart any more."[43]

Ultimately, thanks in no small part to another fear—of how German U-boats were preying on American shipping—the country got behind Wilson's interventionism to make the world safe for democracy. Although America entered the war late, when it entered, it jumped in with both feet: millions of military personnel involved, massive economic, logistical, and governmental mobilization. America declared war in April 1917. Between then and Armistice Day about nineteen months later, more than 116,000 American soldiers died in that total, totalizing war. One of the most intriguing perspectives on that war's all-consuming nature was by New England ghost story writer Alice Brown, known—at least then—for the Great War story "The Flying Teuton," which appeared in *Harper's* in 1917. Its sort of hokey premise—a Flying Dutchman tale, with a ghost vessel that passes directly through the narrator's ship—falls flat a century later, though. Another wartime horror story of hers, "Empire of Death," offers a far more unique perspective, introducing a kind of horror we'll see more of in decades to come.

"Empire" is a tale of two soldiers hovering in the worlds between life and death: one ends up being called back, the other goes on. Not unfamiliar, in

battlefield and soldiers' stories; but this one reveals a special kind of hell: the hell of all the damage done to the natural landscape, to the trees, during the war—*this*, the story says, was what merited the murdered man's particular and peculiar perdition. When the surviving narrator saw all the trees "by the hundred sawed two-thirds through and broken down, split, mangled, murdered, how do you think I felt?" His companion, on the other hand, not only fails to feel the same way but employs the saw a bit himself; with the result that he ends up "in a hell, a hell of trees"—and if the narrator didn't let him go, he'd be there with him still.[44] And so we see an early entry in the subfield of eco-horror, which is only possible because of the depredations that a total war can inflict on the natural landscape.

Those wounds, of course, were inflicted on the human body and mind as well. And so it's hardly coincidence that, as the boys came back from Europe, shell-shocked and battle-scarred in psyche as well as in body, the face of fear—the symbol of it, reflected on cinema screens that were popping up all over America—was an actor whose fame and celebrity came precisely from his well-known dedication to monstrous and, indeed, violent transformation of the human form. Lon Chaney was raised by parents who were deaf and mute; it had forced him to communicate without the use of speech. His incredibly plastic face and athletic, acrobatic movements would be put to use in over a hundred films before he became a star, but it would be those gifts and skills, in combination with his expertise with makeup and his willingness to submit himself to bodily torture, that would achieve the incredible transformations that would make him an icon. So famous would they be, it would become a joke: "Don't step on it," they used to say, "it might be Lon Chaney!"[45]

His first immortal role was his embodiment of Quasimodo in the 1923 adaptation of *The Hunchback of Notre Dame*, where he imbued what could have been monstrosity with deep humanity. Quasimodo is described in the intertitles as "deaf -half-blind- shut off from his fellow men by his deformities; the bells were the only voice of his groping soul." Movie audiences knew—from the newspaper interviews and movie magazine accounts that were sprouting up all over as the industry hit its full stride—that becoming Quasimodo required a great deal of suffering and trauma for Chaney as an

actor: the device he wore prevented him from standing upright while he was filming, meaning he was in pain most of the three-month film shoot. That torture was matched by another, more unsettling one for movie audiences.

In the end, Quasimodo dies, stabbed by the movie's villain; but what *really* kills him is a broken heart, seeing his love Esmeralda go off with the smooth-talking handsome guy. Which is terrible, the movie whispers to him, and to the wounded, scarred vets, and to the worst inclinations in our secret hearts, but also savors of truth: after all, who could love someone who looks like *that*?[46] Who could love a monster, one might say; but that wouldn't be accurate in this case, exactly. We recoil from monstrosity. And we feel for Quasimodo.

Chaney's next major performance, on the other hand, savors far more of classic monstrosity: his Phantom, in 1925's *Phantom of the Opera*, is especially powerful because we don't see his memorable, terrible visage until most of the way through the movie—although it's talked about before we see it, building up the suspense. And when the mask the Phantom always wears is ripped off, we see that face—the widened eyes, the skull-like skin—and we know we're in the presence of the monster. (Hard to tell, from this vantage point a century later, whether the reports of faintings in the audience were truthful, or just figments of the imagination of Universal's publicity department, but there were a lot of reports.)[47] We know; because—in contrast to Quasimodo—the Phantom's behavior has given us intimations all along that his insides and outside match. Like Chaney, the Phantom himself is a transformer—the movie's plot revolves around his attempt to make the soprano Christine a star—but in the character's case that shaping impulse manifests itself in a creepy, sexualized predation. Christine's reaction when she sees the Phantom has brought her to his bedchamber reflects another fear of the time, one omnipresent in the increasing feminist discussions of the phenomenon of the New Woman, striving for equality in the workplace: that crushing moment when you have really believed someone values you for your talent but find out it's actually about your body.

Christine is the one who finally unmasks the Phantom for us, and, in a moment straight out of Poe's "Imp of the Perverse," she does it for no narrative reason whatsoever, only because the Phantom has told her not to,

and she—and we—need to see it. That moment, and its byplay of revelation, revulsion, disability, and horror, is taken to a new height in perhaps Chaney's most fascinating movie, where he collaborated with a brilliant director named Tod Browning. Before getting into the movie business, Browning had been a circus performer—he'd worked as a roustabout, sideshow barker, and a clown, but his specialty act, straight out of Poe, was a live burial routine. He was called the Living Hypnotic Corpse. Like Griffith, he'd started in the movie business as an actor and then transitioned into directing: but though he'd left the world of the carnival, it never left him, that interest in the traveling show, and particularly the way it offered views of the aberrant, the abnormal, and, yes, the freakish to America. . . . and the way America was interested in taking the carnival up on that offer.[48]

Browning's 1927 film *The Unknown*—one of many Browning collaborations with Chaney—put even more strenuous demands on the actor's acrobaticism, and on his ability to get us to empathize with the human side of monstrosity. In the film, Chaney plays an armless knife-thrower—we see a number of scenes of him lighting cigarettes with his toes—whose unrequited love for a beautiful carnival girl, played by a captivating Joan Crawford, turns into obsession and near-homicide. A common enough story, you might say, but it gets even more freakish, and I use that term for "aberration from the norm" advisedly. We learn that Chaney's character is also engaging in impersonation—he really does have arms—but is pretending not to in the belief that it will be attractive to Crawford, who, in echoes of our previous discussion, has professed her attraction to his armlessness because of a lifetime of being pawed at. Understanding he can't keep up the charade forever, he has them amputated . . .only to learn that she has fallen in love with someone fully appendaged. A bitter jest that Poe would have appreciated, and one that would, in the hands of a later generation's horror comics, be subjected to gleeful remarks about irony; but in Chaney and Browning's hands, a wrenching opportunity to think, once more, about what it meant to be disabled.

Don't feel *too* bad for him, though, because there's more: he's also a serial killer on the run, it turns out. And, at movie's end, he achieves a sort of redemption, at the cost of his own life. But Chaney's freakish character

certainly has more than his share of moral monstrosity: a quite different perspective than the one offered by Browning's 1932 magnum opus, one of the great American horror movies. *Freaks* is set in the same world, the world people paid an extra nickel on the midway to see, the world with the ghosts of Civil War gore and trench warfare lurking as its haunted echo—but in message, approach, and effect, it's light-years away.

Part of the reason—and the spectacle—was Browning's decision to cast genuine sideshow performers in the roles, lending an uneasiness to our gazing (and gawking). One of the frequent definitions, by critics and scholars, of the term *monsters* is creatures that blur or explode generally understood binaries (both Frankenstein's Monster and Dracula, for example, are neither precisely alive nor dead), and unsurprisingly in this sense, some of these performers—scouted from carnivals and sideshows all over the country in addition to more conventional casting routes—are, in their refusal to honor the side of any particular binary, avatars of the territory horror trods. Several of the characters blur human/animal boundaries, and others explode traditional male/female binaries. Queerness, as it turns out, is at the center of *Freaks*, because the charged relationship between the strongman and trapeze artist at the movie's narrative heart is about, essentially, the toxicity at the heart of the normative cishet marriage. The movie throws down the gauntlet to conventional American propriety quite clearly when it compares that relationship to the sense of loving and welcoming community represented by the "freaks": in fact, the movie's most famous line, "One of us"—delivered where the evil trapeze artist Cleopatra is welcomed at the feast of her wedding to Hans, a little person—is offered, then, in that spirit. The movie was suggested to Browning by a friend of his, the German little person Harry Earles.[49]

It turns out—of course—that Cleopatra isn't romantically interested in Hans at all. She and the strongman, Hercules, have been in league all along, and the plan is to murder him for his significant inheritance. But Hans—and the community—find out, and not only do they foil the plot, but they take revenge. *Freaks* opens with a carnival barker who tells us "Offend one and you offend them all," and community can be marshaled in the name of threat, and defense, as well as welcome. And, in the end,

it turns out that Cleopatra becomes part of the community of freaks after all. Probably not in the way she hoped for. "You might be even as they are," cries the barker, telling us the movie's theme; the movie wants to make it absolutely clear that it's the so-called freaks who are the sympathetic ones, with the able-bodied but monstrously minded being the problem. That said, most audiences—or, at least, most critics—focused more on the horrific shock reveal, of Cleopatra transformed, through some judicious off-screen activity, into a kind of human/duck hybrid, than the conservative moral message; *Freaks* was banned for decades.

And by then the focus had already shifted: from freaks to monsters.

THE TWENTIES HAD BEEN VERY good for horror on stage: one decade-defining success was Avery Hopwood and Mary Roberts Rinehart's 1920 mystery *The Bat*, which, in addition to influencing a certain caped crusader, went on—in its setting of a dark and stormy night and a mysterious house—to inspire other shudderfests on the Great White Way like 1922's *The Cat and the Canary*. Like other dramatic and literary works, *The Cat and the Canary* became a movie a few years later. Director Paul Leni, who glides his camera through a shadowy, atmospheric, old dark house filled with personality, brings James's "Jolly Corner" into the film age, creating a template for haunted house movies for a century to come. Browning, for example, liked cobwebs so much he had a special "hand-held cobweb machine" built for him.[50] But it's not just England we see in Leni's film, but Germany; Leni, who emigrated from Berlin in 1927, brought the energy of Expressionist German filmmaking—think *The Cabinet of Dr. Caligari*—to American screens. In Hopwood and Rinehart's play, there was nothing supernatural about the Bat—he was a masked criminal who left a black paper bat as his calling card—but of course, he wasn't the only bat in town, and the same year the *The Cat and the Canary* was released on film, Dracula arrived on Broadway.

Vampires had been a hit on the stage ever since John William Polidori's *Le Vampire* was a sensation in Paris, and then at the English Opera House, in 1820;[51] and they'd made their way into American fiction, too, in "Luella Miller" and in the great vampire story "For the Blood Is the Life," by F.

Marion Crawford. Crawford's vampire has a predatory, hypnotic sexuality to her, her eyes "cast[ing] a spell"[52]over her victim, and that hypnotic gaze was less out of Stoker than the playbook of the fearfully seductive Svengali—the antagonist of the novel *Trilby*, whose germ of an idea had first been pitched by its author, George du Maurier, to Henry James on the streets of London. *Trilby* had been an enormous success, first as a serial in *Harper's*; then in bestselling—and frequently pirated—novel form; and then, in a theatrical version. *Trilby*'s popularity stemmed from its canny mix of perennial favorites: "romance, sentimentality, occultism, and anti-Semitism." (Svengali is Jewish.)[53] But in 1927, the indulgence in the erotic, uncanny-verging-on-supernatural aspects of hypnotism onstage wasn't just limited to *Trilby*. It was appearing prominently on Broadway in a play about vampires.

The title character in the theatrical adaptation of Stoker's novel was being played by a Hungarian émigré actor named Bela Lugosi. Lugosi's European background—and, one must admit, his somewhat sketchy familiarity with the English language—allowed him to emphasize the foreignness, and the aristocratic aspects of *Count* Dracula, reinforcing the seductive aspects of the novel, accompanied by his intense, piercing, hypnotic gaze. (At the risk of a pun, one might call him a lady-killer.) This had been elided, if not downright removed, in earlier cinematic treatments in Europe, most notably in the ratlike performance of Max Schreck in *Nosferatu*. Universal Studios, who had done *The Cat and the Canary*, got the movie rights to the stage production and tapped Browning to direct the movie version of the stage hit. Browning, of course, went to his go-to, Chaney; but Chaney died before the movie could be made, and so, eventually, reluctantly, they cast Lugosi.[54] It was the right choice. Chaney would, assuredly, have impressed everyone with his vampire makeup—the kind you could see in that German film *Nosferatu*, or the kind Chaney himself donned in the now partially lost film *London After Midnight*, with teeth filed to a point like a shark's. But with Lugosi, you could focus on those hypnotizing eyes—in close-up, and spotlighted. A perfect match for the lingering gaze of a movie camera.

Dracula mostly, though not entirely, follows the plot we know from

Stoker's novel (and more closely follows the stage version): a lawyer comes to Transylvania to Dracula's castle, Dracula leaves the castle for London, where he kills one woman, Lucy, and almost turns a second, Mina, into a vampire; the women's friends and loved ones band together to save her and kill Dracula. The movie, released on Valentine's Day of 1931, was billed as "the strangest love story ever told," once again reminding us of the charged undercurrents of sex underneath so much of the horror story. The strange love story, or love triangle, at the movie's heart involving Mina, Jonathan Harker, and Dracula maintains, at its core, Victorian anxieties about women expressing erotic sensibilities: and its plot, in reductive, sexualized, metaphorical language—woman gets necked, woman feels unclean and unworthy, woman only returns to maritally acceptable status when man plunges giant phallus into other man's body—is about dealing with that unsettling social phenomenon of women seeking greater autonomy, sexual and otherwise, and reasserting a more conservative social order, where the monster's monstrousness lies in releasing this destabilizing specter.

But even as Lugosi mesmerizes, and rehearses Svengali-like concerns about predatoriness—and not just fictional; numerous accounts of H. H. Holmes's abilities to lure women to their deaths focused on his near-mesmeric abilities[55]—the movie reminds us of another love affair: that with the things we fear themselves. "To die, to be really dead—that must be glorious," Dracula says while he is at the theater with the rest of the cast, and death, here, looks pretty sexy. We've talked about the Great War and its vistas of death and destruction; but we haven't, yet, mentioned the global influenza pandemic of 1918–1920, which may have killed up to 100 million people worldwide, and killed over half a million Americans—far more than died in the war. It's certainly possible to think of *Dracula* as a way of dealing with all that death and making it beautiful, hypnotic, alluring. The death by vampirism in *Dracula* isn't as pestilential as it is in, say, *Nosferatu*, but it is a wasting disease that, in Lucy's case, combines death with erotic satisfaction. A strange love story, indeed.

Dracula was a huge hit, Universal's highest grosser of the year, and other monster adaptations soon followed, helping to make 1931 an annus mirabilis for what were newly called "horror" movies—a term Universal

used to promote *Dracula*. Part of the reason for the new language came from concerns about the intensiveness of a new film technology: sound.[56] Warner Brothers second talkie, an adaptation of a London haunted-house/mysterious-criminal play called *The Terror*, proudly promoted its "spine-chilling Vitaphone effects"—moaning wind, screeching doors, and, of course, screams. It also, oddly, included no printed credits, favoring an actor reading them aloud; a sign they were still working things out in the new medium. The reviews were so-so,[57] but Universal's 1931 follow-up to *Dracula* was far more effective.

Frankenstein starts, essentially, with a chuckle: it comes at the end of a "friendly warning"-slash-come-on by a cast member, old as the midway, even if here the setting's a picture palace and the actor's in tails. "Well, we've warned you," he ends, laughing lightly: and then we hear—not just see, *hear*—the thud of spades on wooden coffins and the clank of chains in a graveyard. Director James Whale screened *The Cabinet of Dr. Caligari* right before starting filming,[58] and the graveyard scene juxtaposes a realist foreground against a forbiddingly Expressionist sky: we're a long way from that early Thomas Edison version, a generation back. And so much, though by no means all, of what stays with us from *Frankenstein* are the sounds of voices: the iconically repeated mania of "It's alive! It's ALIVE!" and, of course, the wordless, touching, all-too-human roar of the Monster. According to the credits, the Monster was played by "?"; but the man behind the sixty-two pounds of makeup—which took eight hours to apply each time[59]—would soon become world-famous as Boris Karloff.

He got the role when Lugosi, afraid he wouldn't be recognized beneath the monster makeup, turned it down; Whale, who claimed Karloff's face "had always fascinated me," went up to him in the Universal commissary and asked him to screen test. Karloff—who by all accounts was a charming, gentle, intellectually sophisticated man in real life—creates an achingly sympathetic portrait of a creature whose ultimate acts of violence stem not from his nature, but the abusive treatment of his master. I use that word "master" consciously, because the gleeful whipping and lashing, the torchlight mobs and dogs chasing the terrified being cruelly considered something between human and animal, offers the possibility of seeing this

American version of *Frankenstein* as a way of thinking about slavery and its aftermath, a quasi-rejoinder to *Birth of a Nation*. Unlike in Griffith's movie, where these bodies are seen as unalloyed terrors, Whale takes great pains to show us Frankenstein's monster in fear and pain: and when the mob burns the monster alive, his high, grunting screams drowned out by cheers and shouts, the viewer becomes complicit in what feels an awful lot like a cinematically sanctioned lynching. And that was hardly a fear—or uncomfortably, depending on your positioning in the period, a desire—of the past. The movie came out the same year an all-white jury in Scottsboro, Alabama, notoriously sentenced a group of Black teenagers to death for allegedly raping two white women, in trials marked by an essential commitment to the miscarriage of justice. A lynch mob had to be turned away from the jail where they were being held, awaiting trial.[60]

But if *Frankenstein* was a movie that clothed the present in the past, it also, with its high-tech creature-animating machinery, was nodding to the industrialized, electronic future. Ironically, scientist and inventor Thomas Edison's *Frankenstein* monster was alchemical; maybe because, working in a new medium, he wanted to reassure audiences fearful of too much future by looking backward, not forward. But by now, film was well established, and Whale's *Frankenstein* could savor as much of science fiction as of fantasy, and of the sense that modern science holds terrors, not least in the hubris of its practitioners, that will only expand as a source of horror in the century to come. The third great monster movie of 1931, *Dr. Jekyll and Mr. Hyde*—another remake and another literary adaptation—got horror movies an early Oscar for Fredric March's performance, and presents Jekyll as a modern medical lecturer.

Jekyll and Hyde had gone through well over half a dozen film versions by then, including a satirical version from 1914 called *Dr. Jekyll and Mr. Hyde, Done to a Frazzle!*, but the underlying focus had moved from an emphasis on liberation from Victorian propriety to something quite different. The director of the 1931 version, Rouben Mamoulian, would say decades later that he felt the Victorian aspect of just "enjoy[ing] these base pleasures without paying the penalty . . . was too limited a scope, especially for modern audiences," and instead portrayed it as a conflict between primitivism

and spiritual evolvement: "in his make-up," Mamoulian said, "we tried to duplicate as much as we could the Neanderthal man, who is our common ancestor."[61] There's a good bit of base pleasure in this *Jekyll*, to be sure: with a woman topless beneath a sheet and swinging a bare, gartered leg, feverishly stoking Jekyll's erotic fancies by grabbing him for a kiss, it's as salacious a horror movie as it gets before Hollywood's new self-imposed production guidelines, 1934's Hays Code, neuters a lot of movie-making. But that Neanderthal makeup, that insistence on humans as animals not just at heart, but biologically, *evolutionarily*, was a direct jab at viewers' anxieties around overturning old, religiously oriented ways of thinking of humans as being in the Divine image: this *Jekyll and Hyde* is released only a few years after the Scopes trial had put the teaching of evolutionary theory into the courtroom.

The movie also offered the opportunity to place old fears into new bottles. The predatory pawing of a simian Hyde at a beautiful white woman brings up unsavory racist charges we've seen before; and the next year's quite unfaithful adaptation of Poe's *Murders in the Rue Morgue*—which, in the movie's case, features a mad doctor injecting gorilla blood into bound female captives with fatal consequences—reminding us, jarringly, of, the way in which hospitals segregated Black and white blood. These scenes of brutish types pawing at bound women appeared in these allegorical forms quite often, in a variety of cultural media: and the role of the terrifying Mr. Hyde didn't have to be a creature out of a classic novel. It might be a fiendish mad scientist. Or a bug-eyed monster, either from outer space or in a sunken crypt in the depths of the earth.

And you didn't have to go to the movie theater to see them, either. You could find them on every street corner—goggling out at the prospective buyer from the newsstand racks, on the covers of the science fiction and horror pulps.

IN THE INTRODUCTION TO A 1917 hardcover collection of ghost stories, *The Grim Thirteen*, noted literary figure Edward J. O'Brien wrote that "During the generation which is just coming to a close, the public for short stories has grown so rapidly that it is now practically coextensive with the

population of the country." At the same time, though, he expressed concerns about how commercial considerations shape its contours.[62] One of those considerations—one he doesn't mention for obvious reasons, since his livelihood depended on it—was the expense of hardcovers like the one he was introducing; most people are budget-conscious and, with the advent of the Great Depression, were now even more so. What they favored to get their fictional fix: pulp magazines, the next-generation dime novel. The name came, at first, from the low-quality paper they were printed on (to say nothing of their smudgy ink), their colorful enamel-finished covers notwithstanding, allowing them to be sold usually for somewhere between a dime and a quarter. By the end of the thirties, a contemporary critic, noting the number of generally monthly pulp magazines (120 or so) and their circulation (11 million, with probably 30 million readers) could write that:

> Theodore Roosevelt, Woodrow Wilson and Herbert Hoover read the pulps, but the average reader is a dissatisfied man of twenty-eight with an infinite capacity for wishing. He is a sedentary fellow who demands action in a world far removed from his own, but the hero, be he as much on the move as Sisyphus, must be cut in his own image . . . to such a man it is not amusing to read the dismal accounts of his own environment . . . what he wants and gets is the primal drama of man against man, usually for the agonized delectation of convention-fettered woman."[63]

There were pulps of every sort, most of which met the pulp writer's main objective: "to give the current formula a novel twist and surcharge it with action." Words, and words, and words inside, authors rattling away at a penny a word, pastiche artists who came up with every possible variation on whatever was hot—from gun-slinging tales of the old West to Orientalist fantasies of Egyptian tombs and the mysterious Far East—for an ever-increasing, ever-ravenous public. "The reader would be unwise to base his dream life on any one" of the pulps, that later critic warned, "for they disappear, change their contents and their names with a suddenness which seems almost whimsical." Although there were horror stories in quite

a number of pulps—you could find horror stories in Western pulps and in detective or crime pulps, for example[64]—and there were a number of pulps that were more narrowly defined to the genre, like *Horror Stories* or *Terror Tales*, the one that stayed the distance—and became incalculably influential to many figures in our story—was *Weird Tales*, which made its debut in 1923.[65]

Many of the contributions to *Weird Tales* certainly have as much of the whiff of the formulaic about them as their pulp brethren. One writer, introducing an anthology of stories from the magazine in 1928, noted that if the formula for the Western pulps was "simply 'bang! bang! bang! ride! ride! ride!'" the equivalent one for the horror story "may be set down as 'shock! shock! shock!' with a dash of 'My God!'"[66] But *Weird Tales* also showcased a variety of writers who would set the course for the fictional fear of the twentieth century. The most important of them, far and away, was Howard Phillips Lovecraft, whose contested and contestable legacy shadows a wide swath of the fiction of fear—and, in its own way, the nonfiction, as well. Lovecraft, a gaunt New Englander, was a vivacious and supportive correspondent, an overwrought and feverish writer, and a horrific racist, misogynist, and anti-Semite—"the fact is that Lovecraft's expressed views on race and culture would have been judged immoderate in Nazi Germany," one critic wrote a half-century ago.[67] Still, he endures as the most influential horror writer of the twentieth century. With the possible exception of Stephen King, no one else even comes close.

Lovecraft took Machen's idea of the cosmic, of what lies beyond, and supercharged it. The thought that if we *did* have an unfettered glimpse into the way the universe truly was, it would drive us utterly mad; the notion that there are cursed places where that curtain is thin—these were the animating insights that drove Lovecraft.[68] "The oldest and strongest emotion of mankind is fear, and the oldest and strongest fear is fear of the unknown" was the opening of his 1927 book-length essay, *Supernatural Horror in Literature*, a hugely influential early attempt to tell the story of fictionalized fear. He paid particular attention to the "literature of cosmic fear," which contained "a certain atmosphere and unexplainable dread of outer, unknown forces"; in the essay, as you might expect, he referred to

Machen as almost beyond equal when it came to "living creators of cosmic fear raised to its most artistic pitch." But for Lovecraft, it went beyond an acknowledgment of the unknown. "All my tales," he would write in a 1927 letter to *Weird Tales'* editor, Farnsworth Wright, "are based on the fundamental premise that common human laws and interests and emotions have no validity or significance in the vast cosmos-at-large."[69] And it was that insignificance that mattered, because it allowed—in a manner that we hadn't seen before—for the destruction and disposal of the protagonists in ways that generated (depending on the story) sometimes horror, and often terror.

"Virtue is always triumphant; and vice, though it may wreak dreadful havoc along the way, in the end is doomed," wrote that chronicler of the pulps,[70] perhaps part of a general Great Depression–era wish-fulfillment fantasy that things weren't as out of control as it seemed to be all around them.[71] "Nuts to that" was Lovecraft's reply (delivered in significantly more stentorian prose). Sometimes, they're doomed to begin with, as in his remarkable 1926 story "The Outsider," in which the narrator escapes from a Poe-like castle and finally emerges to find himself—and see, in the mirror, that he's a rotting monstrosity. Sometimes, they're doomed as a result of their own hubris, like in his 1920 tale "The Testament of Randolph Carter," where a fancy new technology—a kind of telephone line brought by an intrepid investigator down into a mysterious tomb—allows for a very old kind of voice to reveal the man's terrible fate over the line. Sometimes, they're doomed to madness, because they're just in the wrong place, or cursed, like the narrator of 1924's "The Rats in the Walls," who keeps hearing things. But things don't end well, and those who don't die—or disappear to a fate worse than that—nevertheless do not emerge unscathed.

"In the sort of work I am trying to do human characters matter very little," Lovecraft wrote in a 1932 letter, referring to them as "only incidental details." The "real protagonists" of his stories, he insisted, "are not organic beings at all but simply *phenomena*."[72] While he champions Poe's understanding of psychology and his "consummate craftsmanship" in his essay, and Hawthorne for his "intimations of the weird," in Lovecraft's own stories, which occur in that same New England landscape, the nature of the

blight is quite different. For him, the devil is less about sin, which centers human action and choice, and more about what you might suck up in the water—or stumble upon while traveling late at night.

That's, at least, the plot of 1927's "The Colour Out of Space," where some of the decay and rot feels a lot like radiation poisoning avant la lettre;[73] and this is one way of explaining the thinness of the characters in his stories. A second, perhaps even more important, is Lovecraft's increasing interest in crafting not just individual, psychologized sensations, like Poe, or allegories, like Hawthorne, or adventure tales, like Stevenson, Haggard, or Stoker. Lovecraft was interested in generating a *mythos*: a universe, as we tend to call it now, of stories that occur within a shared set of rules and characters, not human ones, but a group of Great Old Ones, the most famous of them the hard-to-spell Cthulhu (as in the 1928 story "The Call of Cthulhu"), who've left traces in ancient books, mysterious artifacts, thin places, and so on, depicted in precise-seeming antiquarian atmospherics. "My own rule," Lovecraft would write, "is that no weird story can truly produce terror unless it is devised with all the care & verisimilitude of an actual *hoax*."[74] Woe betide those who stumble upon these sleeping, dead, dreaming gods, say the stories, and bestir them, even slightly. You do *not*, Lovecraft makes clear, want to be on the bad side of Shub-Niggurath, the Goat with a Thousand Young, who is so far beyond human capacity that all that will result is destruction. Or, perhaps, worse.

Which leads to the third reason for characters' thinness: a lack of a certain kind of empathetic nature in the writing. The descriptions of the Great Old Ones, though, were frequently—if not always—wrapped in imagery that was redolent of misogyny: Lovecraft's fear of women is on display in the vaguely, and occasionally not so vaguely, vaginal monsters he creates, and it's not surprising that in his essay on horror literature he calls Haggard's *She* "really remarkably good." His stories are also suffused with racism; not least in his constant and prolific use of the N-word, but, beyond that, in his general theme of civilization under threat of disruption and dilution by metaphorical miscegenation, through encounter with or attack by hostile entities that correspond pretty clearly to Blacks, Jews, and Asians,

among others. Lovecraft was, unquestionably, a general misanthrope; and even those segments of society that would theoretically have been spared his hateful gaze are also pictured as subject to decay, and decline. (Think of all those New Englanders of his who look like toads.) But even there, his subject is really miscegenation, with the resulting decline as a result of exposure—sexual and otherwise—to the monsters.

All of this is delivered in a prose that is near-uniquely Lovecraftian— "near," because there have been authors over the next eight decades who have tried their best to imitate it. Lovecraft adored reading Shakespeare aloud as a child with his mother, declaiming. "The more cruel the part, the better he liked it," a neighbor reported.[75] While his language isn't Shakespearean in rhythm, it is elevated in tone—perfervid, baroque, and in the best and worst senses of the word, Gothic. Lovecraft, whose *Supernatural Horror in Literature* remains one of the best nonfiction works on the subject, certainly understands and pays allegiance to those roots. Unlike Poe, though, Lovecraft often uses the sledgehammer instead of the stiletto: once he's achieved that Poe-like sensation, that effect, he then belabors how terrifying and terrible it actually is, leaving some of his readers cold. Judge for yourself, in this selection from the end of "The Statement of Randolph Carter," where the protagonist, Carter, describes the voice heard over a telephone wire reaching down into a tomb:

> I do not try, gentlemen, to account for that thing—that voice—nor can I venture to describe it in detail, since the first words took away my consciousness and created a mental blank which reaches to the time of my awakening in the hospital. Shall I say that the voice was deep; hollow; gelatinous; remote; unearthly; inhuman; disembodied? . . . I heard it, and knew no more. Heard it as I sat petrified in that unknown cemetery in the hollow, amidst the crumbling stones and the falling tombs, the rank vegetation and the miasmal vapours. Heard it well up from the innermost depths of that damnable open sepulchre as I watched amorphous, necrophagous shadows dance beneath an accursed waning moon.

"Amorphous and necrophagous," indeed: Lovecraft's prose is simultaneously intensely atmospheric and incredibly alienating, the reader somehow both lured in and holding back a giggle. Maybe this is why his impact would have to wait for a generation: while Lovecraft was admired by writers and readers of *Weird Tales*, he was generally unknown outside that magazine, which, although extremely influential, sold less well than many other pulps of the era. In the interim, the movies—that great solace of Depression-era Americans—were selling fear to the people as quickly as they could film it. The pulps—all of them—had a monthly readership of perhaps 30 million by the end of the thirties. Close to triple that number were going to the movies. Every week.

FRANKLIN DELANO ROOSEVELT, ADDRESSING THE nation on his first Inauguration Day in early 1933, stated, boldly, that "This great Nation will endure as it has endured, will revive and will prosper. So, first of all, let me assert my firm belief that the only thing we have to fear is fear itself—nameless, unreasoning, unjustified terror which paralyzes needed efforts to convert retreat into advance." But, in the depths of the Depression, the fear Americans felt was neither unjustified nor unreasoning, Rooseveltian boosterism notwithstanding: a quarter of the country was out of work that year—almost 13 million people. Thousands of farms were foreclosed on, their former owners wandering the roads, looking for jobs—which, if you could get them, were paying only a little more than half of what you might have gotten just a few years earlier. No wonder people wanted a form of escapism. One way they sought solace was by encountering, and working through, their various anxieties in the form of metaphorical fearful fictions; and the studios, buoyed by the successes of 1931—Frankenstein had grossed over fifty times its production budget[76]—had been happy to open the floodgates.

Karloff, fresh off *Frankenstein*, created a new monster wrapped in sand and age and Egyptological-Orientalist fantasy in 1932's *The Mummy*; it played off the excitement of the discovery of Tutankhamen's tomb a decade before. That tomb—which had been largely spared from robbers over the centuries, and so provided all sorts of items to be shown in color

newspapers and magazines around the world—would serve as more than aesthetic inspiration. It also provided the prospect of adventure; hidden, and forbidden, treasure; and the specter of the revenge of older empires on newer, more colonialist ones. The tomb is name-checked in another Karloff film that year, *The Mask of Fu Manchu*, which, accordingly, features ancient curses, terrifying and monstrous foreigners, and more than a hint of racial panic about miscegenation.

In *Fu Manchu*, Karloff's makeup regime, which serves him so well in *Frankenstein* and *The Mummy*, is pressed into yellowface service; he's also equipped with long, sharp fingernails, an attempt to present him as something other than human. "Kill the white man and take his women!" he shouts to a cheering crowd toward the end of the movie; and, although he is dispatched not long afterward, the movie warns us that "there may be other Fu Manchus in the future," and its anxieties persisted: explicitly, in characters like comic-strip hero Flash Gordon's Ming the Merciless. And while *The Mummy* and *Fu Manchu* were set in other lands, other such movies brought anti-Asian sentiment closer to home; films like 1916's sixteen-part serial *The Yellow Menace* and 1927's full-length *Old San Francisco* rehearsed the same domestic anxieties and prejudices about Asians we saw in the San Francisco fictions of Emma Frances Dawson, where the Asian Americans pictured are, in the words of one critic, "continually plot[ting] and conniv[ing] the destruction of America in general and white women in particular," specifically, the movies make clear, by buying and selling them into slavery.[77]

Another 1932 movie made that linkage between race, monstrosity, and predatory capitalism crystal clear, while introducing us to another of our greatest monsters. A few years earlier, William Seabrook's best-selling *The Magic Island* introduced a wide swath of Americans to Haitian magic and to its role in creating the "soulless human corpse" made into "a servant or slave" called the zombie; a series of similar pulp fictions by Henry S. Whitehead, including the thematically and phonologically similar "Jumbee," were appearing in *Weird Tales* around the same time.[78] Seabrook's chapter on the subject is titled "Dead Men Working in the Cane Fields," and inspired the film *White Zombie* to combine racial anxieties and capitalist ones. *White*

Zombie presented Caribbean voodoo zombies not as ravenous flesh-eaters, in the way we now think of them, but mindless nonwage slaves, victims of imperialist capitalism, chained to machines and moving without need of food or sleep. (Charlie Chaplin would work the same nightmare in a more comic mode in *Modern Times*, a few years later.) Bela Lugosi, who zombifies locals to put them to work in his sugar mill, matches his own hypnotic gaze with their lobotomized ones: "They work faithfully and are not worried about long hours," he says, and what we see in our mind's eye are not only the sugarcane mills of the Caribbean, but the sewing machines in the sweatshops of New York. And if the American working public did indeed look past the superficial differences, of any sort, and saw themselves in those zombies, victims of the big boss, then it wasn't much of a stretch to see themselves as big game animals, purposefully shipwrecked and then hunted for sport. That was the plot of the same year's *The Most Dangerous Game*, which literalized the "war" in "class war."

But *The Most Dangerous Game* and all these other 1932 movies, along with all the prior great films of fear we've discussed, still feel somewhat foreign, despite their very American metaphorical preoccupations, featuring, as they did, European-adapted material or European settings. The film industry, in the early thirties, was going through the same struggle American fiction writers had, a century-plus earlier: they were trying to find out what an American horror movie was, one whose themes *and* whose embodiments of those themes were quintessentially American. And they did so: *The Most Dangerous Game* codirector Ernest B. Schoedsack, shooting with many of the same actors and some of the same sets of that film, codirected a second movie, one that in 1933 introduced the first real American monster. Who, like so many other great Americans, is an immigrant.

I'm talking about King Kong, of course, and in the process I'm not being quite fair: Kong is less an immigrant than an impressed captive, forcibly taken from his far-off land to America in chains for the profit and entertainment of white capitalists. If *Frankenstein* was a racial allegory, you certainly don't have to squint too hard to see how *King Kong*'s a far more blatant one: via its simian metaphor, it plays off similar fears of Black men as assaulters of white women in other 1930s "jungle films." Films like the

previous year's *Kongo*, described thusly in the *New York Sun:* "There are horror pictures and horror pictures, but 'Kongo' at the Rialto seems a bit more meaningless than most."[79] But *Kong* is not a "jungle film," although of course much of it takes place in a lost world jungle. Its climax, befitting an America that has recently switched from majority-rural to majority-urban, takes place right in the middle of the metropolis, a presence climbing the newly-established skyscrapers and fighting off the newly flying planes. And being watched in a new type of venue: a contemporary critic from *The Nation* noted the "contradiction" of "an audience enjoying all the sensations of primitive terror and fascination within the scientifically air-cooled temple of baroque modernism that is Mr. Rockefeller's contribution to contemporary culture."[80]

Kong is no stage-to-screen adaptation: he is, inherently, a creature of the movies, of this new art form.[81] The movie's first line, notably, is "Say, is this the moving picture ship?" announcing its allegiances from the jump. Fay Wray is one of the medium's great screamers—a phenomenon, of course, linked necessarily to the rise of the sound film,[82] and we're introduced to those screams as movie-show auditioning within the movie itself: suggesting to us, reminding us, that all this is artifice. But just as we lose that sense in Fay Wray's genuine screams later in the movie—genuine within the movie, that is—we find ourselves, even almost a century later, lost in the incredible special effects, the matte painting, the close-ups of Kong's head, even the stop-motion animation in the middle distance. This could never be a stage adaptation, for the reason that it could never have appeared on stage. Even now, stage adaptations of it have almost universally been failures. *King Kong* is a *movie*: the movie winkingly acknowledges this when director Denham presents Kong on stage at the new Radio City Music Hall—narratively necessary for him to escape from and start his rampage—an old woman expresses how upset she is that it's not one of Denham's movies! Thankfully, and necessarily, it's ours.

But whether it is a *monster* movie is another question: since, like in *Hunchback*, the movie turns on Kong's humanity, and his capacity to love, which ultimately serves as his undoing and his tragedy. "It was Beauty killed the Beast," says Denham, after seeing Kong fall to his death due to

his desire to protect Fay Wray. It's an attempt, at the movie's end, to shoe-horn what we've just seen into the neat lineaments of fable, or fairy tale. But the movie knows better than its director character does. FDR might want to say that it's simple enough, the monster's defeated, happy days are, or will be, here again. But that's not actually the movie's ending image. The movie's ending image is not of Denham, but the crowd behind him, jostling to look at the car-crash spectacle of Kong's body. Everybody likes to look—Kong not least of all—and it's the looking that gets you into trouble.

And as our story goes on, audiences understand that endings are an illusion; they have to keep looking.

IN THE LOST WORLD DENHAM and his crew encounter in the middle of King Kong, there is a scene where a gigantic brontosaurus-type creature emerges from the water and swallows a number of men with total abandon. It's certainly possible that the creative team on Kong hadn't been thinking of Lovecraft and *Weird Tales* when they created this uncaring being from a primordial age; but assuredly others were, and although Lovecraftian influence seems minimal on this first great wave of monster movies, a school of his influence was beginning to coalesce in the pulps—deepening, developing, charting its own paths.

"Of younger Americans," Lovecraft wrote in his *Supernatural Literature*, "none strikes the note of cosmic horror so well" as Clark Ashton Smith; his "bizarre writing, drawing, paintings, and stories are the delight of a sensitive few." Smith's stories, like 1931's "A Rendezvous in Averoigne" or the same year's "City of the Singing Flame," squirmed with the sense of mythic lands dripping with horrors that proved the vibrancy and power of *his* imagination.[83] "One of [literature's] most glorious prerogatives is the exercise of imagination on things that lie *beyond* human experience—the adventuring of fantasy into the awful, sublime, and infinite cosmos *outside* the human aquarium," he wrote in a 1932 letter to the pulp magazine *Amazing Stories*,[84] and Smith's stories dwelled more on the revelation of those cosmic horrors than on their vanquishing. It was his fellow contributor Robert E. Howard, best known for his stories of Conan the Cimmerian (whom some called barbarian), who was eminently capable of using the forms and conventions

of the horror-fantasy to create cracking adventure stories that were perfect for the breath-holding pulp reader. But it was Smith and Howard who, each in his own way, took the baroque language of Lovecraft's imaginations and turned it into landscape.

Other *Weird Tales* writers, though, took Lovecraft's central ideas and—in the spirit of *King Kong*—turned them on their head by bringing them into modern America. In 1934 *Weird Tales* regular Donald Wandrei produced "A Scientist Divides" for the science fiction pulp *Astounding Stories,* another take on the hubristic mad scientist. Here, though, instead of stitching together pieces of people, or building complex machinery, the work accomplished is one of reduction, to the biological essence, "the full complexity of man reduced to minimum." Of course, that kind of tinkering goes just as wrong as the other kind, and what results is a scientist-consuming, constantly fissioning, ultimately indestructible blob—the precursor of many Blobs to come.[85] Wandrei's best story, though, might be 1936's "The Eye and the Finger," about a man who finds a disembodied eye in his room, staring at him, and a hand, floating in the air, pointing toward the window. "Its supreme indifference, the impersonal confidence of that horrid, marginal thing obsessed him even more than the eye," the story says; and ultimately the man follows that pointing finger right in the direction it's pointing, out the window to his death, because he cannot cope with the brute *thereness* of these objects, as found not in the cursed and blighted landscapes of a Poe or the shadowy backdrops of a Lovecraft, but in a regular apartment building.

The story insists on the stubborn existence of irrationality; even a psychologist he brings to see the objects simply refuses to accept them: "I do not care to have anything more to do with it . . .I shall forget that I came here. I shall forget that anything happened,"[86] he says, like a child closing his eyes and hoping it will all go away. But the story's troubling nature is to suggest that it won't; that it could be right in our homes. In 1942 Frank Belknap Long produced "Grab Bags are Dangerous," an archetypal story of the monstrous entering the quotidian: what could be more harmless, while still suggesting the possibility of the unknown within, than a simple, burlap sack? And yet inside there be monsters: and the thought of it being used for a child's birthday party, where kids will reach their hands inside . . .[87]

And then there was Robert Bloch, who came by his horror bones honestly: as a small boy, he'd peed his pants at the hideous revelation of Lon Chaney's monstrous makeup in *The Phantom of the Opera*. Later, as a teenager, he'd written fan mail to Lovecraft, who was impressed or at least amused enough by the boy's admiring prose and insistent questions to drop his name into one of his own stories. Bloch would soon try to write horror fiction, making his first professional sale at the absurdly early age of seventeen, his work starting out as little more than Lovecraft pastiche. In an early story like 1935's "The Shambler from the Stars" (dedicated to Lovecraft), his protagonist describes, in Lovecraftian terms, how "my inner life soon became a ghoulish feast of eldritch, tantalizing horrors"; but also how "I wanted to write a real story; not the stereotyped, ephemeral sort of tale I turned out for the magazines, but a real work of art."[88] And, soon enough, he began developing a style of his own.

Lovecraft was a New England Gentile, raised on distance and discomfort; Bloch was a genial, funny mid-Western Jew, a Great Depression kid, a lover of family and female company, and the difference soon materialized in his prose, which became far more down to earth than his idol's. And what he began to find, in crafting his own path in the late thirties and early forties, was that, like Wandrei and Long, he needed to set his horrors not in the vaguely Gothic or New England historical past of Poe and Lovecraft, or even the then-contemporary London of *Hyde* and *Dracula*, whose real-life 1890s settings would have been practically Ultima Thule to most American pulp readers. He excelled instead—even beyond those others—in the juxtaposition of classic fears and contemporary American settings. Early Bloch stories include a vampire tale transmuted into the setting of a cosmopolitan bright young professionals' fancy-dress party where the transformation takes place via donning the cloak of the title (1939's "The Cloak"), and an Egyptological nightmare hidden amidst the festivities of Mardi Gras (in 1937's "The Secret of Sebek.")[89]

It wasn't just the younger authors in *Weird Tales* who'd gotten the memo. In October of 1932, Selma Robinson published "The Departure" in *Harper's*,[90] a lovely and sad story about a woman increasingly aware of the presence of her deceased fiancé on her wedding day; he died six months

GASLIGHTS AND SHADOWS 163

earlier. He approaches her, telling her their love has allowed him to cross
the gulfs to her. And they can be together: all she has to do is take the
plunge and join him—literally, as the story's end finds her perched over
a twenty-story precipice, looking down. Is this her grief talking? Or her
ghostly fiancé? Robinson and the story don't have a firm answer. The ambi-
guity led to an O. Henry Prize Memorial Award selection and an adapta-
tion into a radio play performed by Tallulah Bankhead, among others. The
following year, Nathanael West published *Miss Lonelyhearts*, another tale of
terrifying loneliness, a man who makes his living feeding off others' roman-
tic agonies (*"I am in such pain I dont know what to do sometimes I think I will
kill myself my kidneys hurt so much,"* begins the first letter we read)[91]—but,
an empathetic monster of a sort, it kills him, all the pain, and it kills us, too.

"Art is distilled from suffering," Miss Lonelyhearts's diabolic editor,
Shrike, tells him.[92] And during the Depression, there was suffering to go
around. Not just the agonies of the neurasthenic, pallid, and frail New
Englanders. Or even the Depression-era socioeconomic suffering of Jabez
Stone, in a tall-tale all-American version of the Faustian bargain licked by
lawyerly ingenuity, the gift of gab, and an appeal to good old-fashioned
American values, in Stephen Vincent Benét's "The Devil and Daniel
Webster." But if Webster's victory over old Scratch leads to his getting
kicked out of New Hampshire, where, as the story ends, "he hasn't been
seen in the state . . .from that day to this,"[93] then the Devil must have gone
down to Georgia. Or, at least, to Mississippi and other Southern states,
where writers were continuing their reckoning with the secrets and ghosts
of their own paths.[94] And the Gothic fiction that they created, while having
listened to Brockden Brown and Poe, cast it in quite a different key.

Faulkner bore, in his own way, the same kind of relationship to
Mississippi as Hawthorne did to Salem,[95] that of a native son whose
family went back generations: his great-grandfather was a colonel in the
Confederate Army. He also added a letter to his name—he was born
William Falkner—although in his case, it may have been due to a printer's
error. Though he'd published several previous novels, Faulkner's commer-
cial success and critical breakthrough came the same year as *Dracula* and
Frankenstein hit theaters. *Sanctuary*,[96] in 1931, was no Poe story, in search

of a single sensation or ironic effect or a meditation; and, perhaps most notoriously, *Sanctuary*'s rape of the college student Temple Drake with a corn cob, by a character named Popeye, no less, added a bit of grotesque comic-book parody to the mix.[97] The district attorney offers the corn cob as evidence in the subsequent trial; "it appeared to have been dipped in dark brownish paint," Faulkner writes, withholding and revealing in a single moment: earlier, we've seen the violated Temple "sitting with her legs close together, listening to the hot minute seeping of her blood, saying dully to herself, I'm still bleeding. I'm still bleeding."[98] Temple tries to hold the identity of her rapist secret—she accuses a different man at trial—and it's possible to see in her disquieting secrecy an echo of other kinds of Southern secret-keeping, poisonously wrapped around the region's unhealthy attitude toward its racist past.

Faulkner himself would call *Sanctuary* "an exposition of the terror and the injustice that man must face," and critics have pointed to the novel's "moments of dreamlike horror typical especially of a certain kind of nightmare," where terror is accompanied by paralysis and becomes, unlike in the more conventional settings of Poe's Gothic, "a feeling about existence itself": it maps an underworld whose power lies precisely in how it mirrors the "respectable" world above it.[99] When Hollywood called a year later, one of the movies he eventually worked on was *The Big Sleep*, that private eye movie with an indelible bit of dialogue about orchids: "Nasty things. Their flesh is too much like the flesh of men. Their perfume has the rotten sweetness of corruption." When it came to the florid, the corrupt, the apocalyptic, it was hard to beat Faulkner: the fire and flood of 1930's *As I Lay Dying*, complete with monologue by the dead woman at the novel's center, was a case in point.

A contemporary critic noted in 1935 that Faulkner and his school:

set down what they see, or what they honestly think they see, around them; and if what they see is dreadful, it is for the South to look to it. . . . There are men who have walked through some of the scenes described in "Sanctuary" without turning a hair, but William Faulkner screamed until he curdled the blood of half the

country. Who is the more civilized, Faulkner or the men who were never horrified by a real lynching half as much as they were by his description of one?[100]

In 1941 the writer Carson McCullers would write an essay in which she would describe Southern writers' technique in this regard: "a bold and outwardly callous juxtaposition of the tragic with the humorous, the immense with the trivial, the sacred with the bawdy," in an attempt to define what critics and readers were increasingly calling the Southern Gothic.[101]

This particular house had many rooms. There was pulp writer Manly Wade Wellman composing stories that drew from the culture of the North Carolina mountains, turning the fears and tales of mountain folk into stories of monsters to be vanquished by the folk-singing John the Balladeer.[102] Or you could take Missouri-born writer Charles G. Finney's sly, sinuous 1935 novel *The Circus of Dr. Lao*, about a Depression-era Arizona audience who goes to see a circus that is quite mysterious indeed. While one might think to focus on the fact it seems to contain, among other elements, an actual satyr and medusa, what makes the books memorable is the matter-of-fact way the audience interacts with them. After one busybody is turned to stone, after ignoring Lao's audience, "a geologist from the university examined Kate. 'Solid chalcedony,' he said. 'Never seen a prettier variegation of color in all my life.'"[103] (To paraphrase McCullers's definition above: immense, meet trivial.) Or Mississippi-born Eudora Welty's 1939 story "Petrified Man," in which it is revealed, via the gossiping of several ladies at the beauty parlor during a hair appointment, that a member of the "travelin' freak show"—the title character, whose digestive system, ostensibly, turns everything he eats into stone—is actually using his perch to travel about and rape women. There's a terrible pun, of course, on what part of him was actually petrified; and Welty's story is dedicated to the prospect that, like it or not, there's something stirring about the perverse, the horrific and freakish. "I tole Fed when I got home I felt so funny . . . funny-peculiar," says the hairstylist who'd seen him, and that's one roundabout way of describing the stirrings we may understand her to feel.[104]

Bawdy, certainly; and also tragic. The characters in Welty's story are not

victims themselves, but tale-tellers of horrible crimes, which makes all the difference; Alabama-born Black writer Zora Neale Hurston, on the other hand, had a more complicated relationship to the South, to put it mildly. Born a generation after the Civil War ended—her grandparents had been slaves—she moved to Florida at an early age, went to Howard and Barnard, studied anthropology with Franz Boas at Columbia, and figured prominently in the Harlem Renaissance. Several years after Bela Lugosi operated that sugarcane mill in *White Zombie*, Huston went to Haiti, supported by the Guggenheim Foundation. That trip—and her five-month study with the ostensible nephew of the famous "queen of conjure," Marie Laveau—informed 1938's *Tell My Horse: Voodoo and Life in Jamaica and Haiti*,[105] which included her own report of seeing an "authentic case" of a zombie. In that kind of reporting—based on fieldwork and personal experience and insight—Hurston's work continued Chesnutt's model of digging into folk traditions to present a counternarrative to the story that the South increasingly wanted to tell about itself, apotheosized by that monumental monument to the Lost Cause and the "nobility" of the Old South, Margaret Mitchell's *Gone with the Wind*.

One of the most indelible spectacles of the 1939 adaptation of Mitchell's novel was the burning of Atlanta; in a novel published that same year, Los Angeles burned, too—although only on canvas. Nathanael West, who'd changed his name from Nathan Wallenstein because, he joked, he'd heard Horace Greeley's exhortation to "go west, young man,"[106] actually *did* go west, like Faulkner, to seek his fortune writing for the screen. In his novel *The Day of the Locust*, he brought some of Faulkner's epic, apocalyptic horror to LA, in the story of a "deteriorating painter" in the "grotesque and shadowy world of back-row Hollywood . . . a background reminiscent of Sodom, Babylon, and Hell."[107] Protagonist Tod Hackett, whose unusually spelled first name practically seems borrowed from horror director Browning, hopes to create a grand canvas, "The Burning of Los Angeles." But the grandness of artistic ambition seemed hard to achieve, West suggested, against the "plaster, lath, and paper" of the Hollywood settings; the "desire to startle . . . so eager and guileless."[108]

A character in *Locust*, the now unfortunately named Homer Simpson,

has significant visual parallels to, and occasionally acts like, Frankenstein's monster;[109] but at times, compared to literary works like West's and Faulkner's, the horrors coming out of the *actual* Hollywood *did* seem somewhat pale. Robert Bloch, in a 1938 story called "Return to the Sabbath," features a movie industry type who gets his hands on a film of the same title that transcends anything the leading figures in the fright biz are doing: "You've been to 'horror-pictures.' You know what one usually sees . . . I saw none of that. Instead, there was *horror*."[110] Bloch could make that assertion land: in part because, as those italics and single air-quotes remind us, he's using words, not images. He understands the power of prose, how it requires us to rely on our imaginations. So that when the star of the industry-type's new movie, hugely committed, comes back from beyond the grave to star in one last scene, the reader's imagination goes into overdrive.

But in part those "horror-pictures" had been changing, too: everything was, because of that new Hays Code. Moralist legislators, particularly though not solely Catholics, had been bridling against the film industry from its inception, and twenties movies' inclusion of nudity, drugs, sexual activity—to say nothing of interracial romance and a general disrespect for institutions of flag and faith—was deeply disconcerting to them. Though the Code's existence waxed and waned in strength in the early thirties, eventually enough pressure was put on the studios that by 1934 they agreed to self-censor—to submit to a certifying Production Code Administration that ensured these offending elements were absent from their pictures— rather than risk the government stepping in. "The Hollywood producers have for the most part taken the Legion of Decency drive as something more than the demands of an articulate minority group," one contemporary observer wrote at the end of that year:

> They have interpreted it as an outward expression of the great mass of movie-goers themselves. Whether they are correct . . . only the next several months of box-office receipts will tell. They are anxious to learn whether the public which thronged to the so-called vulgarities of the last few years is the same public which is represented as calling for suppression now.[111]

The Code required that movies be desexualized, de-vulgarized, rendering them comparatively toothless (and fangless): a post-Code *Dr. Jekyll and Mr. Hyde*, starring Spencer Tracy, had its pleasures, but the pleasures of the flesh revealed in Fredric March's version were not among them.

That *Jekyll and Hyde* remake addressed an anxiety of producers, an ever-present one, about profits. When it came to monster movies, Universal had killed the goose that laid the bloody egg, so to speak: those high-grossing characters Dracula and Frankenstein's monster had been dispatched at the end of their films. And there was a desire to capitalize on them soon, too soon for a remake: and so the answer was, of course, sequels, and in *Frankenstein*'s case, a sequel that rewrote the first movie's ending to insist— despite all seeming evidence[112]—that the Creature actually survived.

James Whale had originally demurred on directing the follow-up to his massive hit; "I squeezed the idea dry on the original picture, and never want to work on it again" were apparently his actual words. But he changed his mind, and the movie referred to in development as both *The Return of Frankenstein* and, occasionally, *Frankenstein Lives Again!* was released, in 1935, as *The Bride of Frankenstein*. There had been concerns that audiences would be confused as to whose bride it was, the doctor's or the monster's, but by then public identification of the name "Frankenstein" was with the monster, and so *Bride* it was.[113] *Bride* proved the idea had not, in fact, been squeezed dry: it's one of the best pictures of Universal's early run, opening with a clever meta-conceit that recaptured that ur-scene of modern horror, the meeting between Percy Shelley, Lord Byron, and Mary Shelley. While the meeting's actual conversation about ghost stories inspired Mary to write the novel, the movie, by contrast, situates the discussion post-composition, allowing for a recap, useful to thirties audiences without access to the original picture. (Whale, who charmingly but inaccurately called himself "a mere goosepimpler,"[114] actually intercuts footage of the earlier movie.) Percy insists it's a shame the story ended so suddenly; Mary, played dreamily and playfully by Elsa Lanchester, insists there's a lot more to it. And so begins the sequel.

The movie, in fact, is obsessed with questions of whether or not closure is possible—closure, the flip side of continuity. The animating drive

of the movie, after all, is for a "Monster's Mate," as the credits have it. (The mate in question was also played by Lanchester, although, in shades of Karloff in the earlier film, that role is credited to her as "?"). All the Monster wants to do, in other words, is get hitched and create lots of little sequels: and when Lanchester, in that iconic fright wig, takes one look at him and screams, we see, in Karloff's anguish ("Friend? Friend?" he says, and actually sheds a tear), not only the human fear of being alone but the studio's concern of killing the golden-green goose. We might also see, by the way, the movie's crackling queer energy. (Whale was gay, and openly so, vanishingly rare in thirties Hollywood.)[115] The real marriage in the movie is not between Karloff and Lanchester, but between Doctor F and the campy Dr. Pretorius, the two of them getting science-married to produce their own kind of offspring. "To think we would both have been burned as wizards for this experiment!" Pretorius says, significantly—and without running afoul of the Code's homophobic censorship.

Don't worry about the big guy's prospects for paternity, though; *Son of Frankenstein* would follow in 1939, after a successful rerelease of *Dracula* and *Frankenstein*—along with three others before and through 1944. "You live forever, they can't destroy you," says Ygor [sic] to the Creature in 1942's *Ghost of Frankenstein*: by that time, though, with the weight of sequelitis on his shoulders, it sounds a bit more like a weary passing of judgment than a triumph. *Son of Dracula* would appear in 1943; there were four mummy movies between 1940 and 1944, and four *Invisible Man* films in the same time frame.[116] Producing so many sequels led not just to an exhaustion of scripted creativity—the direction of quality, it's fair to say, trended downward—but to an excessiveness of familiarity: the monsters lost their mystery, their majesty. The monsters weren't old friends, yet, but they were getting there. As were their interpreters, made familiar as part of the celebrity-industrial complex. "All the features about Boris Karloff played up the fact that he was a gentle man who found true peace in raising a garden," Robert Bloch wrote in that story about the horror-pictures. "Lugosi was pictured as a sensitive neurotic, tortured by the roles he played in the films. . . . And Peter Lorre was always written up as being gentle as a lamb."[117] In fact, that might be the reason the most terrifying monster of

the period was the one who never gave interviews. How could she? She was hand-drawn.

According to outline notes for Walt Disney's 1937 film *Snow White and the Seven Dwarfs*—arguably the most influential work of culture of the 1930s—the evil Queen was to be characterized as "a mixture of Lady Macbeth and the Big Bad Wolf."[118] And when Disney consulted with his animators about the scene in which she turns into the Old Witch, he explicitly told them to study the transformation sequence of the most recent Dr. Jekyll and Mr. Hyde movie. That comes out clearly in the final version, which shares its influence's vertiginous, uncanny energy; but the Queen is an amalgam of monstrosity—she's something of a vampire to boot, hoping to keep a younger woman's heart in a box, and also sups of the Invisible Man, having, according to the dwarves, the capacity to move unseen. ("Why, she could be in the room right now," one of them says to Snow.)

Disney movies, it must be remembered, were not designed for children, in much the same way fairy tales originally weren't; and yet *Snow White*, *Dumbo*, *Pinocchio*, and *Bambi*, more than almost any set of movies of the Depression and immediate post-Depression period, are purveyors of the fears of abandonment; of marginalization; of familial disruption and poverty and orphanhood. Through an animated lens, yes, but perhaps even more pointedly for that. Think, to take just one less well known example, of Snow entering the dwarves' house—"I know! I'll clean the house! Maybe they'll let me stay!"—as the reflected image of a homeless, jobless, forgotten woman willing to do an honest day's work for honest lodging. Like the more conventionally identified monster movies, those monstrosities tend to resolve into a happy ending, often with the constitution of a new kind of family, or community—a New Deal, one might say—but that doesn't mean they don't indulge in these fears along the way.

These Disney movies, like their monster-movie peers, feature creatures largely of fantasy, fairy tale, and myth, taken from European sources, and they have more than a dollop of Old Worldness about them. Unlike many of their contemporaries, the Disney films boast occasional forays into a terrifying surrealism, like the famous "elephants on parade" sequence in *Dumbo* after Dumbo accidentally gets drunk.[119] But that doesn't mean that

Snow White's audiences thought witchery was a relic of the Old World, or the distant past. Far from it. Less than a decade earlier, in 1928, three men from York County, Pennsylvania, beat local farmer Nelson Rehmeyer to death, then burned his body, because they believed he'd cast a spell on their families; the Hex Hollow Powwow Murder—named, in part, because Rehmeyer was believed to practice "powwow," a kind of folk magic—became another trial of the century, international news.[120] And, throughout the next decade, the activities of the Philadelphia Murder Ring combined two of America's obsessions—witchcraft and organized crime.

The latter, of course, had its own real and fictionalized monsters: Al Capone, the Chicago gangster behind the 1929 Saint Valentine's Day Massacre, in which seven men were gunned down in a garage in the middle of the day; Capone's filmic alter-ego, Scarface, who made his monstrous bow in cinemas the year after *Frankenstein* did; the various villains that haunted the Dick Tracy comic strip in the thirties and forties, whose names could have come off a Universal central casting list: Pruneface, the Brow, Flattop. But the Philadelphia Murder Ring—who also specialized in murder for hire—were different. They claimed to practice *la fattura*—a kind of Italian witchcraft. But the powders and love potions they gave to their clients were often actually arsenic. The gang made their money by taking out insurance policies on the soon-to-be-deceased, probably at least three dozen of them; H. H. Holmes had run a similar scheme, but the difference here was that the clients—at times—thought the powders were actually magic, and became fervent believers.

It was this kind of belief that almost certainly accounted for the phenomenon noted by William Seabrook, in his 1940 book *Witchcraft: Its Power in the World Today*, that "current American witchcraft cases occur with steady frequency and in pleasing variety at the rate of several dozen a year," which encompassed the phenomenon of a Buffalo pharmacist flooded with customers in August 1939 begging him for countercharms to block spells cast on them.[121] Witch doctors and vampires do exist, Seabrook suggested, but they're not supernatural beings; they're instances, rather, of what he calls the power of "induced autosuggestion."[122] Seabrook describes a personal interview with a vampire, in 1932: a girl who sees a scratch he'd received

swimming and who stares "with wide, dilated eyes at the scarlet abrasion." Immediately, she jerks toward him and begins sucking there—"not like a leech either, but more like a greedy half-grown kitten with sharp-pointed teeth." She's the one, Seabrook says, "who whispered the old, ugly word 'vampire,'" and, in the end, she dies of pernicious anemia—a physical condition that comes, he suggests, from her own "mental maladjustment, her awful craving."[123]

Witches—perhaps because they seemed *too* real—didn't make an appearance in any of the Universal horror movies of the period.[124] But it was Seabrook's scientific, psychological approach to witchcraft that was increasingly carrying the day, in fiction as well as film. One observer noted in 1936 that *Weird Tales*, that sanctuary for the "ghaistlies and ghoulies," is chastised "sharply by correspondence if it becomes too 'scientific,'"[125] suggesting even this venerable outpost of the weird was occasionally succumbing to the temptation to get modern and contemporary. Karloff, for his part, increasingly played mad doctors and scientists in a more scientifically contemporary setting, riffing off *that* aspect of Frankenstein more and more. In his films like 1939's *The Man They Could Not Hang* and 1940's *The Man with Nine Lives*, *Before I Hang*, and *Black Friday*, laboratories were replacing haunted houses. William Sloane's 1939 novel *The Edge of Running Water* took an old parapsychological trope—trying to communicate with the world of the dead, specifically the scientist's dead wife—and clothed it in science-fictional terms; with its images of a kind of séance of circuitry[126] and the subsequent opening of a dimensional portal to somewhere dark, it provided the spirit of Lovecraft with a backstory that felt more out of Wells. Alexander Laing's bestselling 1934 novel *The Cadaver of Gideon Wyck*— its manuscript purportedly composed by a medical student who stumbled onto "mutant babies conceived as part of an insane research project," among other chills—delivered, with a full dose of the latest medico-technical terminology and wrapped inside a top-notch locked-room murder mystery of the sort then in vogue among Golden Age detective fiction consumers. The publishers, Farrar & Rinehart, printed a warning on the back cover: "People unable to sustain violent shock are advised that they read this book

on their own responsibility, AND THE PUBLISHERS REALLY MEAN THIS."[127]

The end of the thirties would see the birth of another famed Golden Age, this one of science fiction, associated with the editorial run of John W. Campbell at *Astounding* magazine. Campbell, who'd been a darling of pulp fans for his super-science stories in the early thirties, had in 1934 published an apocalyptish story, "Twilight," under the pseudonym Don A. Stuart, which revisited elements of H. G. Wells's *Time Machine*. But, of course, it wasn't the only work of Wells that was attracting new attention.

H. P. Lovecraft was not a fan of the radio. He grumbled, in a 1933 letter, that he recommended the "average popularly 'horrible' play or cinema or radio dialogue" as "a thorough soporific," considering them "all the same— flat, hackneyed, synthetic."[128] Backward-looking as he was in so many respects, he had entirely misjudged the power of a new medium. Radio, the new technological craze, mixed the freedom to imagine the novel provided with the sensory intensity associated with the stage play or sound film. And, as such, was a remarkable medium for fear and horror.

The sound effects alone introduced new and intensive economies: who needed to build an entire haunted house movie set when you could just slowly open a rusted, creaky hinge in front of a microphone? The pulps' energy and vitality adapted well to radio. When, as early as 1930, on the *Detective Story Hour*, listeners heard a narrator intone, with sepulchral energy, the question: "Who knows what evil lurks in the hearts of men? The Shadow knows," they shivered at the chilling laugh that followed. The narratorial voice, which belonged to Orson Welles, was hardly an exception: narrators and program hosts were a hugely important part of the radio atmosphere, with personas of their own. Old Nancy, the Witch of Salem and "her wise black cat, Satan," the hosts of 1931's *The Witch's Tale*, the earliest horror show on the radio, would spark nightmares of their own.[129] The short story was a perfect length for the broadcast, and those narrators would go on, in programs like *Lights Out*, to introduce the adaptations of many of the classic short stories of fear we've already discussed, as well as developing new works directly for radio. But the most terrorizing work of

the radio age was an adaptation: one that transposed its original British setting to Grover's Mill, New Jersey.

If you had listened from the very beginning to Orson Welles's and the Mercury Theater's broadcast of "The War of the Worlds" on October 30, 1938, you would have heard that it was fiction, a Halloween scare. And if you were still listening by the middle—you hadn't, say, switched off in panic to run for a neighbor's, or the cellar—you would have come to that conclusion, too: the broadcast skips over months and years in a way clearly impossible for a live broadcast. But from the perspective of someone who's just turned the dial, who doesn't have the option of checking online to see if it's a hoax? Hearing Welles, employing those utterly committed tones as a skeptical astronomer who assures us that there's no life on Mars, then becomes utterly confused? Listening to an announcement that parts of New Jersey are now under martial law, that the radio station is now being turned over to the military? Hearing a reporter from New York, trying to keep it together, saying he can see a Martian invader "wading the Hudson like a man wading through a brook . . . People in the streets see it now. They're running toward the East River . . . thousands of them, dropping in like rats"? It must have been fake news of the highest order. Which indicated another threat, not just to our ears, but also, presumably, to theirs, after the panic had settled down: not of the invaders from Mars, but the invaders in everyone's home. A threat from the piece of technological equipment that could tell you *anything*, and with great authority, if it so chose.

Yes, after the "announcer" succumbs to the invaders' poisonous smoke, thumping to the ground and leaving, in the technical term, dead air, listeners, about 75 percent of the way through the broadcast, get a moment of catharsis: "You are listening to a CBS presentation of Orson Welles and the Mercury Theatre on the Air in an original dramatization of *The War of the Worlds* by H. G. Wells." But the *Times* headline the next day—page A1, right up top—told a different story. "Radio Listeners in Panic, Taking War Drama as Fact," it says. And while the subhead clarifies that the war in question was a "Gas Raid from Mars," and it was a "Wells Fantasy," you weren't sure, reading the headline, what war was being discussed, and a line

from the broadcast, from the military "captain" at Grover's Corners, might have lingered.

"It looks almost like a real war," he tells his listeners.

Indeed.

SOMETHING THOSE RADIOS WERE REPORTING, with increasing frequency, was the disturbing situation in Europe. The legacy of the Great War was by no means settled business: one of the greatest horror movies of the 1930s, Edgar G. Ulmer's *The Black Cat*, presented Lugosi and Karloff in philosophical and, eventually, physical combat in a beautifully designed modern building, which is built on top of a Satanist lair, which in turn is built on top of a bloody European mass grave. "A masterpiece of construction" on "a masterpiece of destruction," as the movie puts it; a haunted house, in other words, but a modern one, none of those Gothic cobwebs. Lugosi has come to avenge Karloff's actions during the war. This was a national matter, as Karloff's character, a traitor, was responsible for thousands of soldiers' deaths; and also a personal one, his actions having led to Lugosi's imprisonment and—as Lugosi believes, anyway—to the eventual deaths of his wife and daughter. But what is buried, the movie insists, eventually comes to light; and it was increasingly clear to everyone on both sides of the Atlantic that another War of the Worlds was coming, this one catalyzed by a madman whose madness seemed to be metastasizing across all of Europe.

H. G. Wells, again, had proved prescient. As Hitler was coming to power in Germany, James Whale directed the 1933 film of Wells's *The Invisible Man*, and picked up, strongly, on the novel's statement that "that Invisible Man . . . must now establish a Reign of Terror . . . He must take some town . . . and terrify and dominate it. . . . And all who disobey his orders he must kill, and kill all who would defend them." The maniacal laughter of Claude Rains—who got the title role when Karloff turned it down on the grounds that, well, he hardly appears—accompanies liberation fantasies of rape and murder: "the power to rule, to make the world grovel at my feet." But his invisibility suggests something else to thirties viewers, too: not just

the single madman in charge, but the shadowy, invisible, silent circles of conspirators and supporters that helped enable that madman's rise.

America, it should be said, was hardly convinced of the necessity of combating the menace; significant swaths of the population were isolationist, well aware of the price they'd paid in the last war. "While she dressed," wrote Katharine Anne Porter in her 1939 novella *Pale Horse, Pale Rider*, her protagonist Mary "tried to trace the insidious career of her headache, and it seemed reasonable to suppose it had started with the war." The headache turns out to be a case of the flu, part of the pandemic; and just as the pale rider of Revelations brought both war and plague with him, Mary—and the story—weave together both phenomena and suggest that survivors can only be grateful to see the other side of it.[130] That same year, Dalton Trumbo published the anti-war novel *Johnny Got His Gun* two days after Hitler invaded Poland; its mutilated veteran, rendered freakish by an explosion— he's lost his arms, legs, and face, rendering him blind, deaf, mute, but capable of thought just fine—cries out soundlessly: "Oh why the hell did you ever get into this mess anyhow? Because it wasn't your fight Joe."[131] And there were a lot of Americans who felt the same way, and were leery of paying the same price; a significant number of them, it should be said, were, before Pearl Harbor, even sympathetic to the German side. But another pacifist endeavor tells a slightly different tale: one that featured chewing gum.

Gum, Inc., between 1938 and 1942, produced a series of Horrors of War picture cards as giveaways to go along with their bubble gum, printing over 100 million of them in the first series alone. They featured gory, bloody illustrations of the late-thirties war between Japan and China and the war in Ethiopia, and lurid descriptions of war's savagery on the back. Although the ostensible purpose was peace, "collectors report that the bloodiest pictures made the cards more popular among the seven- to twelve-year olds, including girls." In 1939 the company's new card set was retitled World at Arms. And America—and the world—tried to figure out the person who was lighting the match.

Hitler was a monster, but he wasn't—couldn't have been—the only one. *Astounding Magazine*'s Campbell had recently written another Don A.

Stuart story, 1938's "Who Goes There?," about an alien shape-shifter menacing an outpost of scientist-explorers in the Arctic, an instant SF classic that would go on to have a long afterlife in horror circles, primarily as adapted under the title *The Thing*. It was yet another reinforcement of the ways in which the horror story could fit into science fiction modes; but—even more resonantly—it was also a story that insisted that you could trust no one, absolutely no one, since they might be an alien in disguise, a monster that's killed your friends and taken on their forms.

Seemingly innocuous people, civilized, friendly, turning into homicidal beasts: there's a monstrous allegory for that, and, unsurprisingly, it was having a moment, on the cusp of the Second World War. Guy Endore's novel *The Werewolf of Paris* had come out the year Hitler took power in Germany, which sparked some interest (including the 1935 movie *Werewolf of London*). But it was 1941's *The Wolf Man*—written, notably, by Curt Siodmak, a Jewish refugee from the Nazis—that established much of the werewolf lore Americans know well. "Even a man who is pure in heart, and says his prayers by night / may become a wolf when the wolfsbane blooms and the autumn moon is bright," runs a bit of poetry in the movie. That *even* does a lot of work here, metaphorically raising the question: How is it that a nation that until just a few years ago was known as the apotheosis of culture and civilization had turned into one of homicidal, bloodthirsty, murdering animals? How was that *possible*? *The Wolf Man* was, in its own way, an attempt to work out the question: but one that ascribes very little moral agency, presenting the monstrousness as more of a curse and tragedy than a temptation to embrace one's inner beast. Significantly, the movie explicitly defines *lycanthropy* as "a disease of the mind," its numerous fantastic elements notwithstanding.

You can make the argument that Siodmak's *Black Friday*, one year earlier—in which a brain transplant turns a literature lover into a cold-blooded killer—is delving into the same question; but somehow the fantastic allegory of the werewolf seems truer than the only slightly more plausible scientific shenanigans on display both there and in Siodmak's 1942 novel, *Donovan's Brain*, in which a mad scientist keeps an industrialist's brain alive for nefarious research purposes only to find the brain has hypnotically

powerful, possessive force turning its victim to evil. (Siodmak, it should be said, just loved brains.) But Siodmak wasn't the only one interested in the question. Or, for that matter, Universal Studios. RKO Studios was in such bad shape in the early forties that the joke went that in case of an air raid, people should head to their place: after all, they hadn't had a hit for years. So they made a special B-unit and put Val Lewton in charge, with small budgets, fast shoots, and short running times, and he came up with genre-defining classics.[132] One of the best was *Cat People*, where the were-wolf figure—in this case a were-panther—was a young émigré from an Eastern country who transformed when sexually aroused: a literal femme fatale. Associating this monstrosity with femininity, the movie suggests, is also conjoining femininity with jealousy: it is, after all, the green-eyed monster.

Simone Simon's Cat Person is, like Lon Chaney Jr.'s Wolf Man, more sinned against than sinning: lycanthropy is a curse, and would they were just left alone—isolationist, in other words, like much of America in the early forties. Leave all this back in Europe, don't let it haunt us here. The woman Simon is jealous of, speaking to the latter's husband, defines love as "understanding . . . It's you and me, and let the rest of the world go by." Isolationism, in other words. You can also see Simon's uncomfortable relationship with her lycanthropy as a new American's ambivalent relationship with the Old Country, and the impossibility of escaping a past that comes calling. The movie, in ways that mirror *The Wolf Man*, reframes Europe as a source of trouble, even as it contains narrative inspiration; as a site of horror in every sense; and as a foreign body, old, devolved, that may just need to be removed from the American corpus.

But the horror was coming for America, like it or not, and the isolationist current diminished sharply and abruptly on December 7, 1941. Pearl Harbor may have been in far-off Hawaii (still not a state, then), but it was part of the American homeland nonetheless, and it was under attack. By that year, those chewing gum card titles had changed again, to National Defense.[133] And by the time *Cat People* premiered, almost a year to the day after Pearl Harbor, werewolves were increasingly identified with the Nazi "Blond Beasts," who had named a military unit, Werwolf,

after the creatures, after all.[134] And by April 1942, in the pulp magazine *Unknown Worlds*, Anthony Boucher, one of the great mid-century horror, science fiction, and fantasy writers, was telling a werewolf story with much clearer moral definition. A character in "The Compleat Werewolf" tells Wolfe Wolf (yes, that's his name) that most werewolves "are damned, sure, because they're wicked men who lust for blood and eat innocent people. But they aren't damnably wicked because they're werewolves; they became werewolves because they were damnably wicked . . . Werewolves don't have to be monsters; it's just that we hear about only the ones who are."[135] Quite a shift from the poor, victimized Larry Talbot, the title character of *The Wolf Man*, just a few years earlier.

Following Bloch and his compatriots, Boucher brings that monstrousness—and the war—to American soil; it's a thoroughly American tale, involving a hapless German professor turned werewolf in love with a former student turned Hollywood starlet who is looking to star in a movie with a dog turned Nazi fifth columnist via associating with Satanists. But as the nomenclatural play above suggests, "The Compleat Werewolf" also shares Bloch's comfort with wit, action, and a sense of the absurd side by side with the jumps and scares: it's funny and fast-paced and complicated and telling. It's also, befitting the optimism and let's-all-rally-round-the-flag sensibility of wartime America, optimistic, with an all-American ending: Wolf, himself very much not a monster, ends up with the girl next door and a job as a G-Man helping to root out other Germans. And yet, the American werewolf story raises American questions: why would we think this "damnably wicked" behavior would be limited to the Germans?

In the introduction to Robert Bloch's first collection of stories, 1945's *The Opener of the Way*, he describes himself, in an extended metaphor, as a Dr. Jekyll and Mr. Hyde: an innocuous family man with a grinning, capering, lethal imagination that ranges widely and terribly. A kind of werewolf, in other words. But, befitting the title's apt description of what he was doing—widening a new channel of American fear—it's a different sort of werewolf story, first published in 1943, that bridges those Old World fears and new American sensibilities once again, and does so by resurrecting another old terror. "Yours Truly, Jack the Ripper," the masterpiece of the

first stage of Bloch's career, relocates the killer to contemporary Chicago, and weaves together a plot imbued with Lovecraftian dark magic and a plot twist borrowed from Agatha Christie's *The Murder of Roger Ackroyd*. Bloch's narrator, John Carmody, is your regular plain old American voice of reason and common sense, telling Ripper-hunter Sir Guy Hollis to calm his fevered imagination. Underneath, of course, he himself is Bloody Jack, the monster.

That said, the story makes no bones that the narrator is *actually* Jack the Ripper, supernaturally long-lived; and in that sense he still has a hint of the European gaslight about him, still looking backward. By contrast, Fritz Leiber, in his 1941 story "Smoke Ghost," presented something of a manifesto to a generation of genre writers, and readers, when he had a character ask "what a ghost of our times would look like":

> Just picture it. A smoky composite face with the hungry anxiety of the unemployed, the neurotic restlessness of the person without purpose, the jerky tension of the high-pressure metropolitan worker, the uneasy resentment of the striker, the callous opportunism of the scab, the aggressive whine of the panhandler, the inhibited terror of the bombed civilian, and a thousand other twisted emotional patterns.[136]

Whatever the particular weighing and the ingredients of the elements, these feel modern, and they feel American: just as Leiber's novel *Conjure Wife*, published the same year as "Yours Truly," took an all-American setting—the male-dominated professoriat of the American university campus, where, at the time, presenting a portrait of domestic idyll was sometimes as important as publishing to getting ahead—and rendered it a scene of uncanniness. The novel explored the prospect of faculty wives—whose careers were not only harnessed to their husbands', they were shadows *of* them—being witches. "Keeping it a secret," the novel's protagonist muses, "and on those occasions when they were discovered, conveniently explaining it as feminine susceptibility to superstitious fads."[137] The patronizing tone notwithstanding, the novel is also a story of this mid-century

academic's awakening to—and the anxiety of—hidden female power in an all-American precinct.

Anthony Boucher's short story "Mr. Lupescu," published in 1945 in *Weird Tales*, features a rotter, Alan, who turns a child's imaginary friend—the mysterious, delightful, eponymous Mr. Lupescu—into a murder weapon. It's an ingenious way to bump off the child's rich mother's husband to clear the way for his entrance into her fortune. Alan has spent months visiting the child *as* Mr. Lupescu—red contact lenses for eyes, fake string-operated wings, telling him about Gorgo, a not-nearly-so-nice different imaginary friend who punishes misbehavior. It's all setting the groundwork for him to shoot the husband as Mr. Lupescu in front of the child and insist, *insist*, that the child tell the police exactly what happened. Getting away scot-free, Alan returns to his home, removing and destroying his disguise.

> Alan went into the bedroom. Several years passed by in the few seconds it took him to recognize what was waiting on the bed, but then, Time is funny.
>
> Alan said nothing.
>
> "Mr. Lupescu, I presume?" said Gorgo.[138]

Although this has a supernatural dimension, it is, at heart, a story of human criminality; and America's recent predilection for casting its stories more among the streets and highways of its own landscape instead of in the baroqueness of Lovecraftian fantasy had recently led to a different kind of werewolf story, one found less in the Carpathians than in the novels of James M. Cain. Cain, Dashiell Hammett, Raymond Chandler, and others had been telling their stories in "hardcover respectability," outside of the pages of pulps like *Black Mask*, since Hammett had published *Red Harvest* in 1929. (Two years later, Hammett edited an anthology of the "effective weird tale," *Creeps By Night*, in which he placed both Faulkner's "A Rose For Emily" and H. P. Lovecraft's "The Music of Erich Zann" between the same covers.)[139] If Hammett and Chandler's novels provided a hero in the form of the private eye who walks down his lonely road, a bloodied but unbowed knight, they also reflected a fear of fairly ordinary Americans

as, deep down, capable of monstrosity.[140] Chandler's adaptation of Cain's novel *Double Indemnity*, brought to the screen by Billy Wilder in 1944, was indicative of this point of view, and a sign of things to come. In *Double Indemnity*, insurance investigator (Fred MacMurray) discovers a woman (Barbara Stanwyck) who is willing to bump off her husband for the money. His reaction? To make sure that she does it perfectly, and they both get paid as well as absolutely possible from his policy. ("I'm not trying to white-wash myself. I fought it, only I guess I didn't fight it hard enough . . . The machinery had started to move and nothing could stop it," he says.)

Raymond Chandler and Billy Wilder, notably, were essentially immi-grants to America, and, perhaps, able to look at its ideals and self-percep-tions with a more jaundiced eye.[141] They were hardly the first to do so, in literature or in film: to take just one example, Peter Lorre's ambitious and idealistic immigrant in the 1941 movie *The Face behind the Mask* gets a face full of fire, courtesy of America, and, scarred and disillusioned, turns to crime. But Lorre, that well-known figure of fright and unease on America's movie screens, was halfway to horror already. The noir sensibility ushered in by movies like 1944's *Double Indemnity* and 1946's *The Postman Always Rings Twice*—a sensibility that takes off in American film precisely as the werewolf and monster movies go into decline—worries at the narratives of moral superiority America is telling itself as the victory over Nazism is being achieved. "I want you, Frank," says married Lana Turner to drifter James Garfield, hired at her husband's diner, "but not this way. Not start-ing out like a couple of tramps." And so murder comes on the menu, seem-ingly inevitable but, of course, entirely avoidable. If you have a moral core.

And elisions of morality seemed increasingly present, in wartime. Sometimes this was seen in revisionist treatments of American mythic nar-ratives. In the 1943 Western *The Ox-Bow Incident*, one of the main antago-nists says, "The law's slow and careless 'round here sometimes. We're here to see it's speeded up." The movie—which features a series of hangings of pur-ported, though not actual, cattle rustlers, in a rushed travesty of justice and due process—was filmed and released during a far greater, real-life trav-esty: the internment of Japanese Americans and the disgraceful Supreme Court decision *Korematsu v. United States*, which upheld the internment's

legality. "There can't be any such thing as civilization unless people have a conscience," one of the victim's final letters reads, and the movie offers testimony: not that all people lack this, but that it's sluggish, or easily diverted, or all too often, it kicks in too late. (You can argue, in fact, that the most terrifying figure of *The Postman Always Rings Twice* is Hume Cronyn's lawyer, so cynical and hardened he plays everyone and is happy to place a bet on the trial's outcome.) *The Ox-Bow Incident* displaced its moral anxieties to the past, but the RKO picture *The Seventh Victim*, released the same year—the year of "Yours Truly, Jack the Ripper"—produced the specter of Satanists in and around the New York subway system. In one scene, we see a corpse on the subway car, accompanied by two gentlemen in formal wear, and realize the famously confusing film is all about the transformation of routine spaces into sites of genuine uncanniness and mystery.

The same year *Double Indemnity* came out, a woman named McKnight Malmar published "The Storm" in *Good Housekeeping*. It's a story about a woman in a lonely house, who, as the weather worsens, finds something nasty in the cellar: a corpse. But what's even nastier is her realization about the husband who, she becomes increasingly convinced, put it there in the first place. And when he returns, she realizes there are worse things than torrential rains and thunderous lightning, and the story becomes a battle of a woman's strength versus a man's malice.[142] Malmar's story comes out the same year as not only *Double Indemnity*, but *Gaslight*, which is, of course, another werewolf movie, as all gaslighting movies are: their protagonists discover that people who are ostensibly loving and caring, telling protective truths, are in fact monsters. Both "The Storm" and *Gaslight* force that kind of darkening sensibility into a domestic space, a space invaded by men.

And by 1945, the men were, indeed, invading, or reinvading, American shores: returning from the war. And as movies like 1945's *Pride of the Marines* and 1946's *The Best Years of Our Lives* suggested, they were *not* all right: they brought their fears, their traumas, with them, haunting them, often hanging unspoken in home and hearth. *Pride of the Marines* featured John Garfield as the real-life Marine Al Schmid, in a horrific/inspiring or inspiring/horrific tale that would've been well known to audiences at the time. In portraying the battle that leads to his blindness, the movie provides an

intimate sense of the long terror of war by taking a shockingly long time to portray the long, boring stretches where all you have to do is wait for something to come out of the darkness and try its best to kill you, and shows the reality of a certain kind of heroism, all mixed together with terror and panic and the verge of tears and exhaustion—and determination: "I'll stay right here till the end of the world," Garfield says, like he's trying to convince himself.

Stateside, though, the movies focus not just on the wounded and traumatized men but also on the psychic damage their struggles inflict on the wives, daughters, and intendeds who love them, the blindnesses and amputations and night terrors rippling out into society at large. "Al, you're not different, are you? . . . All soldiers come back different, Mom says," he's asked, soon after his return. *Best Years of Our Lives*, which tells three of these stories of soldiers coming back in one—Dana Andrews has PTSD; Fredric March struggles with alcoholism; Harold Russell has lost both his hands—is an extraordinary example of the airing of these terrors in the name of catharsis through family and romance, especially the love of a good woman. Garfield's bandages come off; Harold Russell, a real-life wounded veteran, literally unwraps himself in front of his fiancé to reveal the limbs that end where his hands once were. And while the movies suggested these difficult revelations of trauma would happen, followed by healing and catharsis, this smacked, in some ways, of dramatic and box-office necessity: those movies' attempts to wrap things up in a happy bow, reflecting society's similar efforts, were going to be, at least on some level, illusory. "People playing golf—just as if nothing had ever happened," Dana Andrews says in *Best Years*, as he comes home. It's not a compliment. And it certainly wasn't true.

The next battleground, in other words, was going to be on the home front.

And that wasn't going to be pretty. At all.

In the Shadow of the Jet Age's Gleam

—

AMERICA SHOULD HAVE BEEN SWAGGERING.

Indisputable victors against the Axis, arguable champions of the postwar order, they had a lot to crow—and be confident—about. But in lockstep with that brightest of victories came its shadows; two, in particular, that stretched long over the American psyche in the fifteen years to come, in multiple and sometimes surprising ways.

The first, and arguably most dominant in those immediate years, emerged from the black rain and glassy surfaces of Hiroshima. On August 31, 1946, readers of the *New Yorker* were met with an unheard-of full-issue-length account of the human toll of the bombing, complete with descriptions of suppurating burns of naked survivors and oozing wounds of interviewees. It would be a near step from those descriptions of radioactive dead men walking to images of animated, rotting corpses that would populate the American imagination in years to come.

The article, "Hiroshima," was reprinted in newspapers, all thirty thousand words of it; it was read over a major radio network; the responses to the magazine were overwhelmingly positive. One letter to author John Hersey read, in part, "The midnight at which I finished the article was followed by a fitful, dream-laden night"; many felt the contrast between its sobering portrayal and its publication in a "light, witty magazine"—as the *New Yorker* then was considered—was particularly effective.[1] Effective, perhaps, precisely because American attitudes toward the Bomb—and civilian bombing in warfare more generally—had shifted radically in the past

decade, and were beginning to shift again, from a "general antipathy" in the mid-thirties toward greater support over the course of the war, tied to increasing anti-Axis sentiment.

Scientific American had written in late 1938 that although aerial bombing remained "an unknown, indeterminate quantity," what *was* clear was that "the unwholesome atrocities which are happening today are but curtain raisers on insane dramas to come." Sadly, this prediction panned out: and by June 1940 *Time* was noting that after Belgium and Holland were invaded, "isolationist and pacifist letters practically disappeared from *Time's* incoming mail" almost "overnight." In 1942 *Collier's* suggested "Let's Get Two-Fisted" with bombing and the *Saturday Evening Post* called those who questioned its morality "unstable"; by 1943 *Harper's* was saying that while "it seems brutal to be talking about burning homes," the "life and death struggle for national survival" required "strik[ing] hard with everything we have." And when it came to the Pacific Theater, the racial bias against Japan, the dehumanization—in 1943, *Time* said "the ordinary unreasoning Jap is ignorant. Perhaps he is human. Nothing . . . indicates it"[2]—meant whatever public opposition there might have been to incendiary raids in Germany was absent, explaining, perhaps, the subsequent widespread American approval of the bombings in Hiroshima and Nagasaki.[3]

When it came to the atom bomb, though, as Hiroshima emphasized,[4] what haunted the imagination was what you couldn't see, what lingered invisibly, sleeting into body and bone and taking root there, passing its legacy on to children yet unborn. (It seems to have been H. G. Wells, by the way, who coined the phrase "atomic bomb," in the 1913 novel *The World Set Free*.)[5] And this anxiety—which was tied into the heart of what would, with unintended irony, become known as the Baby Boom—was epitomized in the literary debut of one of the two most important horror writers of the next decade. Richard Matheson published "Born of Man and Woman" in 1950 at the age of twenty-four in the *Magazine of Fantasy and Science Fiction*, one of the newer digests that had taken, as its editorial ambit, a more expansive view of the pulp field: to mix together sociological and anthropological perspectives with engineering- and physics-heavy SF, to blur genres more ambitiously. And "Born of Man and Woman" does so

with gruesome brio, bringing the horror of modern scientific progress into the white-picket-fenced home with nary a slide rule in sight.

The story, told—as we learn over its course—by the radioactively mutated offspring of a clean-cut all-American couple, is the monologue of a shunned monstrosity relegated to the basement, curdling in its fear and anger. The story begins with an account of the mother's verbal abuse; it ends with the character's anticipatory delight in the prospect of breaking loose from the basement—with its arachnid legs and its green venom dripping from its mouth. Imagine, if you will, the scene at the hospital maternity ward, when this spider-child was delivered. Matheson doesn't show it; he doesn't need to. We can imagine it just fine.

The editorial headnote at the top of the story in its original magazine publication ends: "Read on . . . and learn to know your not inconceivable kinsman." *This* is the possible future the atomic age has wrought. Perhaps unsurprisingly, though, this knife-edge vision of the radioactive horror among us played to a smaller audience of the specialty magazine—as did a similar story, Judith Merril's "That Only a Mother," which had appeared in *Astounding Science Fiction* two years prior. Which wasn't to say atomic anxiety didn't play more broadly. For one thing, in this new scientific age, the possibilities of radioactive mutation and monstrosity seemed to push the classic Universal monsters to the margins of the silver screen. And not just off the screen: Jack Williamson's 1948 werewolf novel *Darker Than You Think* recast the legend in scientific terms, presenting it as a separate species of evolution in battle with homo sapiens: "Our human family-tree has put out some pretty funny branches," a character says.[6]

Increasingly, the old supernatural types were becoming lighter, frothier versions of themselves: if you wanted your fix of Frankenstein, the Mummy, Dr. Jekyll and Mr. Hyde, the Invisible Man, and even the "Killer, Boris Karloff," you'd find them meeting up with the comic twosome Abbott and Costello in a series of postwar horror movies ranging from 1948 to 1955.[7] The first of these, *Abbott and Costello Meet Frankenstein*, for example, starts out with a happy little animated Frank and Drac, and our comedians as terrified skeletons; the duo subsequently encounter Bela Lugosi's Count Dracula and Lon Chaney Jr.'s Wolf Man. "You don't understand,"

Chaney Jr. protests. "Every night, when the moon is full, I turn into a wolf!" "Yeah, you and twenty million other guys" is Costello's deflationary response. Comedy and horror were old friends—there was that frazzled Jekyll and Hyde; Chaney Sr., debonair and smiling in a smoking jacket, had starred in a lovely mash-up of amateur detecting, mad scientisting, and haunted housing called *The Monster* back in 1925—but these Old World monsters, with their crumbling European castles and small town squares terrorized by moonlight: those weren't threats any more. Not after VE Day.

Karloff, for his part, was presenting himself to the public, not inaccurately, as an urbane gentleman with a taste for the macabre, editing well-received volumes of horror fiction. In a 1946 anthology, *And the Darkness Falls,* he did his bit to increase the very recent interest in Lovecraft to a wider audience; including "The Thing on the Doorstep" in the collection, Karloff urges others who, like him, had been unaware of the man, to get their hands on his work. This was now possible without resorting to back issues of *Weird Tales*: disciples August Derleth and Donald Wandrei had recently formed a company, Arkham House, to publish *The Outsider and Others*, a collection of Lovecraft's work, in 1939, after other publishers had passed.[8] But when it came to monstrosity, an example more in tune with the times was Karloff's introduction to a collection of work by Charles Addams, one of the great mid-century purveyors of horror in a more comical vein. "His preoccupation with hangman's nooses and lethal doses is always innocent and gay," Karloff wrote admiringly, and thanked him for "immortalizing me in the person of the witch's butler."[9]

Not that monster movies went away, though. Quite the contrary. It's probably worth noting that the one new Universal monster from the 1950s was "discovered" in the Americas. The *Creature from the Black Lagoon* crawls his way out of the Amazon in 1954 (in 3D!), to, among other places, the drive-in theater, which was reaching its zenith as an American institution, peaking in 1958 with more than four thousand locations. For a dollar fifty or two bucks, the whole family could enjoy the show.[10] But, like with Williamson's werewolf, the movie introduces the Creature (often fondly referred to as "Gill-Man") by an extended account of evolution: the majority of these new creature features had science, particularly the science of the

atom, as their backdrop, the excuse—and therefore, the underlying anxi-
ety, the boogeyman—for a lot of their monstrosity. Summing up at the end
of the decade, one critic would write, "To the film audience, 'science fiction'
means 'horror,' distinguished from ordinary horror only by a relative lack
of plausibility."[11]

One psychologist, writing in 1954 about strategies for coping with the
national psychological impact of the atom bomb, suggested "selective inat-
tention" and "displacement," noting the prominence of headlines about
"radioactive fish" in Japan and how the anxiety and attention about *them*
served as a proxy for dangers that might literally strike closer to home. Was
it such a shock, then, to see that anxiety emerge in the atomically enlarged
animals and misshapen monsters of the movies?[12] *Them!*, released that same
year, sent giant irradiated ants to menace Los Angeles; they come, however,
from the New Mexico desert, a clear connection for audiences to the site
of all those atomic tests. One scientist suggests that "man will be extinct
within a year" if they can't stop the ants; and as the movie unspools, one
can't help but wonder who are the ants and who are the people, so to speak.
Have humans, in the shadow of what has been unleashed, finally been ren-
dered small and insignificant?

There were plenty of other giant-creature movies featuring antagonists
from across the biological spectrum. The next year's *It Came from Beneath
the Sea*, for example, depicted a giant octopus attack on San Francisco.
The creature had left its habitat because of, you guessed it, H-bomb test-
ing, which also turned it radioactive; but it was, in its own way, less a
movie about the specter of atomic war than it was an early entrant in what
we might call eco-horror: nature fighting back against the damage of the
Anthropocene. If normal food chains have been disrupted, well, then, the
squid will search for different food. Maybe even human food.

The finest combination of unusual-sized creatures and radioactiv-
ity, though, was placed in the service of something more subtle. Richard
Matheson had kept busy since "Born of Man and Woman," writing a series
of short stories and novels, many of which would go on to receive notable
television and film adaptations over the years. Accordingly, his 1956 novel
The Shrinking Man was immediately snapped up for the movies, and came

out, with the adjective "Incredible" added to the title, a year later. The movie's protagonist, Scott Carey, shrinks thanks to an exposure to a radioactive cloud—another atomic backstory—and as he gets smaller and smaller, the world grows bigger and bigger, particularly the animal kingdom, allowing the film to capitalize on the giant creature craze in an intriguingly different way. The most terrifying special effect is the spider he faces when, shrunken down to below doll-size, he falls into the basement of his house: playing on our generalized arachnophobic tendencies, the crew filmed an actual spider in extreme close-up, allowing for a level of special-effect detail that was hard to match in other contexts. But the most *unsettling* aspects of the movie—taken directly from Matheson's novel—are how the shrinking brings out a crisis in our main character's masculinity: making the metaphor of being emasculated, and then infantilized, startlingly concrete.[13] The movie begins with the man, bronzed and topless, showing off his muscles on a boat; by the time he falls into that basement, he's living in a kid's dollhouse. This idea—that horror works best with an attendant psychological, even classically Freudian, subtext—would pervade some of the most meaningful works of fifties horror.

The Incredible Shrinking Man has a mixedly triumphant ending: at first worried that he'll shrink down into nothing, Carey then realizes, instead, that there are worlds other than his own inside those atoms. The transformation of those atomic particles from sources of inconceivable destruction to vistas for unimaginable exploration suggests a certain optimism, a willingness to blend inner and outer space. "Scott Carey ran into his new world, searching" is the novel's final line, and several pages before, we're given the intimation there may be some higher purpose to all Carey's travails, some meaning.[14] The movie makes it even clearer: near the end, after crossing a self-described abyss, dressed in a tunic that recalls pilgrim's robes, he, like Dante, emerges from the subterranean and sees, as he puts it, "the heavens . . . God's silver tapestry spread across the night." Getting small means that what matters is to recognize your own insignificance in the universe, to acknowledge God's majesty and dominance, and so find grace in the heavens above. One American under God, so to speak, adapting a

phrase that had been added to the "Pledge of Allegiance" just a few years before.

But other movies weren't so salient about the prospect: in an age bookended by buzz bombs on London and the Space Race, when the country was attempting to control the skies for democracy and prevent a rain of nuclear fire from the heavens, the thought that those skies were full of menace would attract audiences over and over again. And the monster that worked the best for this, of course, was the alien, which could be ultimately unknowable—or Other—in disguise.

And thus *The Thing from Another World*, generally known as *The Thing*, started the decade off in style.

FITTINGLY FOR A NEW SCIENCE-ORIENTED age, the 1951 movie was loosely based on that shape-shifting John W. Campbell novella, "Who Goes There?" The alien here is utterly other, with no purpose except to kill and to drink blood. Unfortunately, given the decisions of the special-effects and design team, this makes it resemble nothing so much as a vampire carrot. Still, any catharsis that might come from these giggles—or from the alien's definitive defeat and death at the hands of brave, intelligent Americans— is belied by the movie's final lines, which hint at subsequent threats, and not just extraterrestrial ones: "Watch the skies everywhere! Keep looking! Keep watching the skies!" The threat was out there, up there, and omnipresent. In the summer of 1947, there had been a genuine flying saucer craze, the papers full of reports of soaring discs; opinion seemed to be split between Martian invaders and Soviet weaponry, with some—especially as the reports subsided—blaming mass hysteria. But that was an easy out, a reassuring-sounding diagnosis with intimations of a fever of fear that would surely break. It didn't.

Other entries in the genre tried to send that message, true. The year 1953 saw a big-budget, Technicolor version of that definitive alien-invasion story, *The War of the Worlds*, adjusted for the age of nuclear anxiety: early on, for example, the Martians reduce three observers to piles of ash, in a moment that recalls Hiroshima. But in its action, its outcome, it rehearses

a kind of post–World War II optimism, albeit on the home front: America may be bloodied, but it will emerge unbowed. Even its divergence from the Wellsian original to spotlight faith, its climactic moment taking place in a church, is about a reaffirmation of contemporary American values: the godlessness of its opponents contrasts with the scientific–military nexus that's subordinate to and fighting under God. But there was a new alien-invasion movie that lingered in the imagination that gave the lie to the quasi-confident affirmations of *The Thing* and *The War of the Worlds*, offering a darker reading of the postwar geopolitical situation—and, for that matter, of the religious one.

The Day the Earth Stood Still (1951) took pains to distance itself from *The War of the Worlds*: "This is not another flying saucer scare . . . whatever it is, it's something real," says an announcer early in the movie. But, like the Wells novel, it was a showcase for fear of the Other's technological supremacy: the aliens who land have robots like the fearsome Gort, capable of annihilating heavily armed American soldiers, the kind who'd just handed Hitler and Tojo their hats, with a thought. The movie encourages these kinds of fears in its audience, in fact: "Rumors of invading armies of mass destruction are absolutely false," repeats an announcer, which is the absolute best way to make you dwell deeply on those rumors. But the movie simultaneously showed that same Other as possessing noble ideals and, in Michael Rennie's performance as the alien Klaatu, an equally noble bearing. More than noble: he's a man from the sky who plays a father figure in his seventies who also appears to be, as the movie says, in his mid-thirties; who comes as an emissary of peace, but also brings a sword; who, on his travels about the earth, literally takes the name Carpenter; and who is wounded first in the arm and then killed by the authorities, to be revived slightly later and then to disappear, speaking of an indefinite return. At a moment where America was defining itself as a nation of faith against godless Communism, this is not a subtle religious allegory.

But if Klaatu *is* an ultimate authority, what kind of authority is he? His final offer can be easily read as a threat: he's come on behalf of an interplanetary organization that enforces peace, saying:

The threat of aggression by any group, anywhere, can no longer be tolerated. There must be security for all, or no one is secure. This does not mean giving up any freedom, except the freedom to act irresponsibly . . . Your choice is simple: join us, and live in peace, or pursue your present course and face obliteration.

And then there is silence. The earth stands still. Is that to be read as a paean to a new postwar international liberal order ready to punish aggressive bad national actors? Or is it pugnacious Communism with an ostensibly human face, insisting on peace and tranquility in enforced Comradeship? Sometimes it wasn't so easy to tell the difference. But what it also accentuates is the viewer's helplessness, in a way that hearkens all the way back to Jonathan Edwards (remember the religious allegory): God holds all the power, all the cards. The only power that humanity has is to reject, or to repent. But the judgment is entirely on someone else's, or some*thing* else's, terms; and if this God is sorrowful and soulful (as embodied in Rennie's performance), it is also Gort, unspeaking, possible to placate but not to stop.

The credits of *The Thing* concluded with a question mark instead of the words "The End," an unsubtle hint that suggested continuing menace and uncertainty.[15] But those feelings didn't stay in the movie theater. Not when early fifties articles from *Time* magazine were showing houses *just like yours*, with crash test dummies dressed in the same clothes you wore, sitting in the same furniture, in before and after the bomb photos. Or when your kids' teachers could peruse an educational pamphlet that offered them games to share with their students like "Escape the Disaster" and "Stock the Fallout Shelter."[16] The feelings were coming home. And Ray Bradbury, the science fiction and horror writer who would become one of the fifties' highest-profile writers, understood this right away.

Bradbury, who once claimed he'd first seen Chaney's *Hunchback* at the age of three and remembered the film entire at seventeen,[17] had started in the *Weird Tales* stable, publishing a lot of stories there during the war. Like Bloch, he excelled at writing specifically American stories, although his own

imagination, forged in Waukegan, Illinois, partook more of the byways of Middle America than did Bloch's urban sensibilities.[18] His first collection of short stories, *Dark Carnival*, was published with Arkham House in 1947. It featured tales like "The Homecoming," a family reunion of monsters, with one abnormally normal odd duck; "The Jar," a literal floating signifier of guilt, sin, and horror in a kind of sideshow setting; "The Crowd," a comment on the haunting sociopathy of voyeuristic groups; and "The Small Assassin," one of the great evil baby stories, among others.

But many of his stories, darkly fantastic as they were, were stylistically and sometimes even thematically at odds with the general *Weird Tales* sensibility. Bradbury soon transcended the smaller, more genre-coded venues to publish in the mainstream slicks: one of his stories made it into the *Best American Short Stories of 1946*, and two others appeared in the O. Henry Prize collections of 1947 and 1948.[19] In 1950 he published one of the most haunting stories of the Atomic Age in *Collier's*, a kind of science fiction haunted-house tale, "There Will Come Soft Rains," its title taken from a 1918 Sara Teasdale poem about the horrors of the Great War,[20] in which an electronic house continues on its comfortable, mechanical way, unmindful of the fact that its inhabitants have been vaporized in an atomic attack long before. "The entire west face of the house was black, save for five places," Bradbury wrote. "Here, as in a photograph, a woman bent to pick flowers. Still farther over, their images burned on wood in one titanic instant, a small boy, hands flung into the air; higher up, the image of a thrown ball." Eventually, the house collapses, an ending with shades of Poe's "The Fall of the House of Usher."[21]

Bradbury's emphasis on bringing it home caught on. *The Thing* had located its alien frozen beneath the Arctic wastes, a nod to the landscapes in Poe and Lovecraft's fiction; Klaatu, in *The Day the Earth Stood Still*, landed right in Washington, DC, which still smacked of political symbolism and abstraction. But 1956's *Invasion of the Body Snatchers*, set in a (fictional) Californian small town named Santa Mira, suggested those dangers could invade the good old American homeland, the most quotidian of places. Campbell's "Who Goes There?," despite its exotic locale, had had a very close-to-home touch that the film adaptation jettisoned entirely: his malevolent alien was capable of imitating the form of anything it met, which

meant anything, or anyone, could actually be the monster in disguise. That energy is also harnessed in *Body Snatchers*, and nowhere better.

Most viewers and critics, over the decades, have read the pod people—who emerge from alien seed sacs to snatch, then uncannily replace, their victims—as a metaphor for creeping Communism, a cancer at the heart of the American way of life, at least in its first version; it's been remade in several incarnations. The movie, and the Jack Finney novel it's based on, doesn't preclude those conclusions, but it also doesn't really support them.[22] What matters, instead, is the way that your friends, your lovers, your family, can be rendered immediately unknowable to you. The pod people—and this may be the most disturbing thing about them—aren't inherently violent, as long as you go along with them. They just aren't the people you thought you knew. "There was nothing there now, in that gaze, nothing in common with me; a fish in the sea had more kinship with me than this staring thing before me," the narrator says in Finney's novel, looking at one.

"We stood there a moment or so longer," he adds, midway through the book, "while I thought of what might be lying all around us, under the roofs out there, hidden in secret places." Bradbury shared these sentiments, of houses haunted with secret evil, the shadowy underbelly of postwar dreams of idyllic community and Space Age expansion. His stories of space travel and colonization of the planet next door, collected, expanded, and novelized in 1950's *The Martian Chronicles* (including "Soft Rains"), were suffused with romantic images; but they also—particularly in the story "Mars is Heaven!"—featured Martians who read thoughts and transformed into images of the astronauts' most beloved deceased relatives in order to kill them in their sleep.[23]

Behind a placid, welcoming surface, monstrous evil, in both Finney's body snatchers and Bradbury's Martians. Which leads us to the second shadow of the war era, the Holocaust: a visceral illustration of exactly what kind of monsters can dwell inside human skin.

IN 1950, FOUR YEARS AFTER he'd published "Hiroshima" in the *New Yorker*, John Hersey published *The Wall*, a novel chronicling the rise, revolt, and destruction of the Warsaw Ghetto. It spent over four months occupying one of the first two slots of the *New York Times* best-seller list.

David Selznick wanted to make it into a movie as early as 1950, with Billy Wilder, Elia Kazan, and Fred Zinneman all interested in directing; even Paul Newman, post-Hud, was circling the project. Despite all that heat, it never happened;[24] perhaps because although Hersey used the fig leaf of the novelistic genre to allow himself some journalistic license, the events and characters of the work were all too real.

American readers of novels and newsmagazines were familiar by then with the horrors of extermination camps like Buchenwald and Dachau, although the killing camps of the East, Auschwitz, Treblinka, and many others, were not to unfurl their full horror to Americans until slightly later. They had seen the photos in *Life* magazine by Margaret Bourke-White. Some of them had read iconic war correspondent Martha Gellhorn's 1948 novel, *The Wine of Astonishment*, in which a Jewish soldier, Jacob Levy, comes face to face with the horrors of Dachau. "They ought to see what the krauts did to those Jews," a sentry says, and we see: the shaven heads that look like skulls, the site where "they do the castrations," "the pile of prisoners, naked, putrefying, yellow skeletons": Gellhorn, writing forty years later, suggests her character "was blasted into a knowledge of evil that he had not known existed in the human species; and so was I. I realize that Dachau has been my own lifelong point of no return." That last phrase, "point of no return," was her original, desired suggestion for the novel's title, before the iconic Scribner's editor Max Perkins insisted she change it.[25]

But as the forties gave way to the fifties, there were attempts, if not quite to return to a state before such awful knowledge, at least to reframe, even lighten, that knowledge's nature. Anne Frank's *The Diary of a Young Girl* appeared in English in 1952, and its remarkable impact and resonance—complete with foreword by Eleanor Roosevelt—had inevitably led to a theatrical adaptation, three years later, which itself yielded a fairly faithful cinematic version, in 1959. In the course of turning the diary into a play and a movie, the circumstances of Frank's confinement led, unsurprisingly, to creating a work of horror. Fans of the far more recent movie *A Quiet Place* may recognize the spirit of these lines from the movie, spoken to the heroine:

Anne, no! You must never touch a curtain. Never. No one must ever touch a curtain, day or night. . . . to be perfectly safe, from 8:00 in the morning until 6:00 in the evening we must move about here only when absolutely necessary and then in stocking feet. We must not speak above a whisper . . .

One of the movie's most powerful and terrifying moments is when the residents of the annex stand transfixed by a ringing telephone they dare not answer, that commonplace item transformed into a hissing menace: a defamiliarization that's a staple of many a horror movie. But what becomes increasingly, unsettlingly clear in the play and especially in movie versions of *The Diary* is that the kind of horror movie we're watching is a haunted-house movie, and the characters we are seeing are ghosts: especially given the knowledge we have—knowledge that poor Anne, writing her entries, did not possess—that with the exception of Anne's father, Otto, none of the figures we see before us survive the Nazi inferno. "We were going to disappear. Vanish, into thin air," Anne says, as they prepare to enter the annex, and the ironies are hauntingly tragic. At the same time, though, the movie entwines this horror with a tale of young defiance, love, and resilience; and Frank's statement that "in spite of everything I still believe that people are really good at heart"—a statement that her death at Belsen deprived her of the opportunity to revisit or revise—would become an attempt at American catharsis, and certainly the image of the Holocaust in America's highest cultural precincts. The play would win the Pulitzer Prize in 1956.

But there were other portraits, too, somewhat more subterranean and more shocking. Al Feldstein and Bernie Krigstein's "Master Race!," appearing in the comic book *Impact!* the same year the *Diary* premiered on Broadway, told the story of a transplanted European chased through the subway system by a mysterious figure. For most of the story, the reader is given to understand that our protagonist is a Jew whose Nazi tormentor has somehow followed him across the Atlantic. In a shock-twist ending, though, we learn that the main character is actually the Nazi, and what pursues him are tormenting images from his own guilty conscience, images

of bodies in mid-flight being thrown into ditches, tormented souls behind barbed wire, brutal violence lyrically rendered in Krigstein's expressionist rhythms. It would resonate, in some precincts at least: Art Spiegelman, the creator of the groundbreaking eighties Holocaust graphic novel *Maus*, would write a college paper on the story.

Nazism had come to America on the silver screen as early as 1946, when Orson Welles directed himself in *The Stranger* as a war criminal so capable of disguising himself that he marries the daughter of a liberal Supreme Court justice. Mixing menace with bonhomie, he presents dinner-table fascism in smooth, urbane tones, arguing for a Carthaginian peace with Germany, a total annihilation. He can't quite mask his anti-Semitism, however; and when later in the movie we are shown actual footage of the concentration camps—the bodies stacked, like cordwood; the gas chamber—we are unsurprised to learn Welles's character was behind it all, the architect of genocide. But while the movie ends in a triumphant defeat over Welles's stranger, it also asks us to consider how it is he managed to walk among us so easily for so long.

That sensibility was going strong in the late forties and early fifties: the idea that moral monstrosity was hardly limited to *over there*; that black hearts also beat beneath the white picket fences of postwar America. In 1946 the influential sociologist Martin Hayes Bickham attempted to connect all the dots in an article on "Total War and American Character":

> The end result of such invasive influences of total war upon concern for the lives of other human beings, is seen in the complete breakdown of moral values in the operation of the Nazi concentration camps at Dachau and Belsen and other points. Something of its persistent undermining influence is seen in the final decision to use atomic bombs upon our enemies. That this invasive influence of total war has left its impress upon American character is seen now in the increase of homicides across the entire country.[26]

Bickham's article appeared in *Religious Education*, whose readership, it's fair to say, was miniscule: but the same message was being transmitted in far more popular venues, if not quite so explicitly. "I did something wrong,

once," Burt Lancaster says in the 1946 noir film *The Killers*, refusing to run, facing his fate; and the movie, like others of its ilk, is filled with tough guys with secrets showing up to torment innocents who just want to live their lives and good guys who discover, or reveal, a world of horrific mystery that coincides with and lives just under the neon-lit concrete sidewalks civilians unknowingly walk through each day. The movie's opening depicts hostile invaders in an open street, closing in on a diner, and the ten minutes or so that follows is, in its own way, the template for every home invasion movie of the next seventy years. The titular killers invest the space with menace, a sense of simmering homicidal violence about to boil over at any minute: "bright boy," one of them calls the diner owner over and over again, suggesting that hidden knowledge that people don't let themselves know, that dark current of understanding.

Robert Mitchum's character in 1947's *Out of the Past* is even more disturbing, because he's the good guy, the one who articulates the desires of the postwar Greatest Generation man: put all that violent stuff behind us, get a steady job, a steady girl, express a burning desire to settle down and build a house. But he's called back to his previous criminal life; and not just because of unfinished business and unresolved guilt, but because of the vibrancy of desire, both erotic desire and the desires of violence. Mitchum wants to be the man working at the gas station, but not only do crime boss Kirk Douglas and his flunkies feel he's wasted there, but, more disquietingly, Mitchum clearly considers the possibility that they're right.

Getting a glimpse of monstrosity peeking out behind human masks leads to traces of other, more classic monsters in these works, metaphorical and otherwise. When Gloria Grahame's face is scarred with hot coffee near the end of the 1953 noir film *The Big Heat*, she evokes nothing so much—in her unwillingness to reveal what we know lies behind her bandage—as the *Phantom of the Opera*; 1955's adaptation of Mickey Spillane's 1952 novel *Kiss Me, Deadly*, featuring Ralph Meeker as detective Mike Hammer, has a nuclear/cosmic MacGuffin at its heart that burns a femme fatale alive at the movie's climax, and suggests, in the movie's "search for the great whatsit," as it puts it, a kind of trace of the Lovecraftian: knowledge far, far beyond the capacity of humankind to know, or handle.

This kind of mixture of noir and horror was perfected in one of the most

popular forms of American media in the late forties and early fifties: comic books. Extremely popular crime comics—like *Crime Does Not Pay*, which started selling like gangbusters in the late forties—adapted tales of gangland massacres and H. H. Holmes's murder castle for four-color thrills.[27] But even the horror books, the most resonant of which were published as part of EC Comics's "New Trend" from the late forties to the early fifties, were full of enough bigamists, poisoners, and gold-digging murderesses to fill a newsstand full of nightmares. As one of the great comic strips of the period, Walt Kelly's *Pogo*, would put it, we had met the enemy, and he was us. EC's comics sometimes infused these noir stories, though, with a hefty dose of the supernatural, and often with a ladle of blood, guts, and other viscera: crime *didn't* pay, it *was* punished, but usually disproportionately, and—given the visual nature of the medium—in an outlandishly gory fashion. In the 1952 EC Comics story "'Taint the Meat . . . It's the Humanity!," to take one classic example, a butcher who's making a profit selling rotten, toxic meat to he knows not whom is punished, first by accidentally feeding it to—and thus killing—his own kid. Then, when his wife finds out, she takes matters into her own hands. Actually, she takes the butcher's cleaver into those hands, chops her husband up into little tiny pieces, and stocks those pieces in the meat display case for our distress-slash-delectation.

The capering glee with which these stories were related—narrated, usually, by ghoulish hosts like the Crypt-Keeper and the Old Witch, descendants of those early horror radio hosts—was in tune with the notion that readers appreciated not just the conte cruel, but the twist in the tale, the shock ending. One EC story, "Wish You Were Here," literally and metafictionally updates a classic horror story, W. W. Jacobs's 1902 "The Monkey's Paw"—but makes the latent manifest, with a shift into the horror of a revived corpse chock full of formaldehyde that refuses to die even after his wife chops him into "a million severed sections" at his own request: "each section still moved and jerked and quivered with life," the story informs us.[28] Readers, in other words, were monsters: at the very least, the sales figures showed, they had monstrous appetites for these kind of stories.

Short-story writers for the magazines took that EC sensibility to heart. One of the great talents of the fifties, Charles Beaumont, wrote another

story about a butcher whose cleaver goes somewhat awry; attempting to dismember a harridan wife whom *he just can't bear anymore*, he keeps being interrupted by unwanted guests he must then attend to similarly, in a horrible, farcical escalation.[29] British transplant turned Hollywood screenwriter John Collier crafted delightful, menacing short stories that infused surrealist conceits with a touch of boulevard cosmopolitanism. "Evening Primrose" tells of a romantic life spent among department store mannequins, a life lived in fear of being found out by the Dark Men, who, under the right circumstances, engineer a human's transformation into the real fake thing. "Another American Tragedy" features a man who removes his own teeth to imitate his old uncle so he can murder him, replace him, and change the latter's will in his own favor—only to have the tables turned and find it's not the only thing that gets removed. The most emblematic of his stories, "The Chaser," features a mysterious shopkeeper selling a love potion to an eager young man for a dollar, and offering, ever so obliquely, the possibility of a five-thousand-dollar untraceable poison when that infatuation becomes suffocating. "Goodbye," says the young man, leaving. "Au revoir," says the vendor, knowing—human nature being what these stories suggest it is—that he'll be back.[30] And perhaps the biggest source of EC stories outside the company itself was Ray Bradbury.

They'd first tried to rip off his stories, but when he sent them what you could call a good-natured cease-and-desist letter—he suggested that perhaps they'd simply overlooked sending him the check—they started slugging his name on as many covers as they could. It was a natural fit: since, like Bradbury, EC published in a wide variety of genres—science fiction, horror, crime—and mixed these with abandon. While most of the resulting stories were fantasy, broadly defined, the company was also well known for its war comics, where, in stories like "Corpse on the Imjin!" and "If!," Harvey Kurtzman and others pulled no punches in depicting the horrors of war. The war comics tended to dwell on conflicts past, but there was no doubt in readers' minds that they also reflected on present-day events. Horrors of war weren't limited to the past, as any reader of the *Chicago Daily News* on September 29, 1951, knew, seeing this letter from a soldier in Korea who wished to remain anonymous:

It was the most godawful thing in the world. They captured a ser-geant and tortured him to death, making him call for help until the guys on the hill couldn't stand it. He screamed for three hours and they moved him closer and closer but our men weren't able to get to him. They mutilated him and stuck sticks in his eyes and cut his feet off . . . If you have any old prayers lying around, better say them now. These boys really need them.[31]

At a time when American cultural attitudes toward battlefield death—and reporting on those deaths—was shifting from a "stiff upper lip" atti-tude to something more emotionally engaged, the fear struck home more and more intensely.[32]

But EC's frequent domestic settings made it clear that there were bat-tles on the home front, too. Ida Lupino's 1953 *The Bigamist*—one of the rare movies of the era directed by a woman—revolves around the fears and anxieties that lurk behind domesticity, maternity, and the internalized necessity of living up to male-defined expectations. The eponymous big-amist, who has an ostensibly happy marriage, gets involved with Lupino, who casts herself as "the other woman," giving a reason for doing so that's utterly banal—"loneliness"—but underlying the claim, the movie offers a series of unsettling tropes, stemming from the first wife and aimed squarely at all those wives in the audience. If you're unwilling to have children, the movie suggests, if you're more interested in business than pleasing your husband or homemaking, then you are, if not *precisely* to blame, essentially so. The movie, to be clear, presents this argument more as self-justification than as justification, but an argument doesn't have to have objective merit to generate fear and concern, or to have swaying power. The real question *The Bigamist* asks, to the women watching, is not "Was he right to do it?" to which it's pretty clear the movie answers "no," but, rather, "Is the man next to me in the theater, my husband, thinking it?" And although the movie is structured around the bigamist's double life being brought to light, its ambiguous ending makes us wonder whether, in some moral sense at least, he gets away with it.

Other kinds of horrific discriminations, in a world of Jim Crow, were far more obvious, so much so that to look past them—as so many did—could almost be considered an act bordering on the supernatural. In 1897 a character in H. G. Wells's *The Invisible Man* suggested, early on in the novel, that the protagonist is "just blackness . . . black as my hat"; fifty-five years later, in 1952, Ralph Ellison published *Invisible Man*, "a kind of modern Gothic . . . set in a dimly familiar nightmare landscape called the United States," occurring, mostly, "in the semi-lit darkness where nightmare verges on reality and the external world has all the aspects of a disturbing dream."[33] The novel, named after Wells's iconic work of horror, name-checks a second icon in its first paragraph, one famous for his depictions of nightmarish scenes: "I am not a spook like those who haunted Edgar Allan Poe," the narrator says, and the play on that racist term for Black people is entirely intentional, as the horrors Ellison describes are of a far more earthly variety than Usher or Valdemar.[34] Ellison insists on showing how white supremacy forces minorities to see themselves as threats, as fears, perhaps most indelibly in the famous scene in which a number of white dignitaries insist the narrator, a valedictorian invited to their gathering, engage in a battle royal with other Black boys. (In an additional turn of the supremacist screw, they then scatter coins for them to pick up for their payment on a rug that turns out to be electrified.)[35] This trend reaches a climax in the suicide-by-cop of one of the characters after being stopped for selling Sambo dolls, a symbol of the internalization of racist imaginings of his self.[36] Hauntingly, the novel raises the prospect that simply living while Black in America might be near impossible.

Disturbing dreams, a sense that America wasn't living up to its promise: you could see that, if you chose to look, in the increasing insistence of Black Americans on receiving the rights promised, and yet denied, them. Or, looking elsewhere, in the way certain politicians were failing to live up to other American ideals. Ellison's *Invisible Man* was published at precisely the moment that Senator Joseph McCarthy was winning reelection to the Senate, having risen from relative obscurity via a campaign of fear-mongering, red-baiting, and hysterical, conspiratorial rhetoric about

hidden Communists everywhere. Over two generations after he revisited Salem to give a sense of the hysteria that followed in 1953's *The Crucible*, Arthur Miller wrote in the *New Yorker*:

> By 1950, when I began to think of writing about the hunt for Reds in America, I was motivated in some great part by the paralysis that had set in among many liberals who, despite their discomfort with the inquisitors' violations of civil rights, were fearful, and with good reason, of being identified as covert Communists if they should protest too strongly. . . . The more I read into the Salem panic, the more it touched off corresponding images of common experiences in the fifties: the old friend of a blacklisted person crossing the street to avoid being seen talking to him; the overnight conversions of former leftists into born-again patriots; and so on. Apparently, certain processes are universal.[37]

Fear was stalking the land, in the fifties. From every direction, from figures as ideologically opposed as the creators of EC Comics and Joseph McCarthy, the message was clear: there were monsters among us. Some made this point for commercial profit; some for aesthetic expression; some for political power; some to change minds. But one of the most enticing possibilities, if you've identified the monster, is the possibility of exorcising it: really, what else *should* you do? And so all that remained was to find the most suitable candidates for the exorcism. Communists, certainly; but they were hard to find, sometimes, or to pin down.

Much easier to look at your local newsstand.

A PARENT WROTE TO FREDRIC Wertham in 1948 about the menace of comic books, calling them "as serious as an invasion of the enemy in war time, with as far reaching consequences as the atom bomb. If we cannot stop the wicked men who are poisoning our children's minds, what chance is there for mankind to survive longer than one generation, or half of one?"[38] If horror comics seem to us now less existential a threat than nuclear warfare, the parents of the boomers may have felt that the margins were a little

closer. Horror comic books were big, big business, moving hundreds of thousands if not millions of copies with each issue—including, and perhaps most especially, the horror that EC epitomized. Wertham got enough bags of mail from parents forwarded from his publisher he had to take them home in a wheelbarrow.

Although statistically a postwar rise in delinquency is complicated to prove—the way they measured it changed, for one thing—the fear of it certainly shot up, as did the attention paid to it by various public organizations, conferences, and governmental committees like the 1946 Attorney General's Conference on Juvenile Delinquency. And almost every meeting both opened with the insistence the phenomenon was on the rise, and the suggestion—by an expert, or a parent—that some aspect of mass media or popular culture was primarily to blame.[39]

This kind of worry was, to put it mildly, nothing new. In the *Pennsylvania Gazette* of July 28, 1773, a correspondent writes in to complain about noisy kids:

> Do we not see Lads, that are just capable of speaking their Mother Tongue, belching out their Oaths and Imprecations, as soon as they have left their Master's Eye? Do not some do it in the most public and fearless Manner, as they pass the Streets? Do not such disgrace their Tutors, when you ask them where they are educated, and under whose Tuition?

Almost exactly 180 years later, Marlon Brando sneered and swaggered his way through 1953's *The Wild One*, riding motorcycles through parades. "Where's that bunch from?" "Everywhere," is an exchange early in the movie, suggesting a general stain in the youth today. And what's worse, Brando and his ilk have absolutely no good reason for it: famously, when asked what he's rebelling against, he responds, simply, "What've you got?" It's a mighty challenge to a postwar generation with an intense psychological desire, almost a fetish, for normalcy.

Once again, in fact, it's the specter of the war starting up here at home, an image rendered most indelibly in the battleground of 1955's *The Blackboard*

Jungle, about a school populated by students who would (ostensibly) have been born during the war years, placing them at the very outer end of the boomer generation. The teachers, by contrast, are Greatest Generation folks, and one's description of the educational encounter as like "when we hit the beach at Salerno" reminds us that this is, in no small way, a war between generations. "These kids, they can't all be that bad, can they?" one teacher asks another. "No? Why?" is the response. While the movie gives lip service, at least, to the possibility that it's society that's the problem, not the kids, the movie still forces the Greatest Generation parents who've left their little Janes and Johns home with the babysitter to watch this to wonder exactly what it is they might be raising. There was little evidence, as contemporary scholars and critics noted, that the movie reflected actual conditions in either metropolitan or rural areas, or that it had a measurable impact on student behavior.[40]

And so the parents were happy to find a scapegoat—or absolution—in blaming the culture for it. Every new technology had generated its own moral panic about its effect on the youth—a 1941 study of children's reactions to "movie horrors and radio crime" noted that "terrifying scenes can have an inhibitory effect on the functioning of every organ in the body," and, what's worse, can cause "a true addiction" that leads to "callousness to the suffering of others," as early as age seven, mounting "year by year, leading to demands for an ever increasing dosage of ultraexciting horrors."[41] But in the 1950s, it was comic books' turn in the barrel, especially EC Comics, that home of terrifying scenes, ultra-exciting horrors, and graphic depiction of the suffering of others. A United States Senate subcommittee that focused on horror and crime comics' (alleged) contributions to juvenile delinquency was convened. EC head Bill Gaines testified before the committee, and ended up doing more damage to his cause, famously suggesting that a comic cover with a severed head dangling by the hair from a hand was in "good taste" because there was very little blood coming from it. It was true that, constitutionally, there was probably very little the government could do to shut down the comics; it was also true that all this negative exposure was killing EC commercially, and other publishers feared

they would be next. As a result, the industry self-censored, creating, in 1954, a self-imposed code of conduct that literally prohibited the use of the word *horror* in comic book titles, among many other limitations. Perhaps the most notable, for our story, was the essential outlawing of monsters: "Scenes dealing with, or instruments associated with walking dead, torture, vampires and vampirism, ghouls, cannibalism, and werewolfism are prohibited" was one of its other clauses. EC, for its part, stifled under the code, and the authority that implemented it, and got out of the comic book business by the mid-fifties. One of the final straws: the Code attempted to censor a science-fiction comic called "Judgment Day!," a fairly straightforward comment on racism—it was against—by asking the company to remove a panel featuring a character who was Black.[42]

Bradbury, in response to the increasingly censorious climate, would write a story describing a scenario in which, when all the fantastic and horrific books were burned on earth, they were relocated to a replica of the House of Usher on Mars. Then, when the inspectors from Moral Climates came to sterilize the site with their "Dismantlers and Burning Crew," they were killed gruesomely and horribly there, only to be replaced by robots.[43] It wasn't just EC Bradbury was thinking of—in an article he wrote in the *Nation* the same year, he suggested that "when the wind is right, a faint odor of kerosene is exhaled from Senator McCarthy"[44]—and he would expand the concept, and place it back on Earth, a few years later in his more famous *Fahrenheit 451*, whose Firemen's jobs, famously, were to burn books and, as its opening line suggests, take pleasure in the burning. Bradbury never explicitly references the famous line by Heinrich Heine that where they burn books they will soon burn people, but one self-immolating bookkeeper quotes a famous line by Latimer, burnt at the stake for heresy in 1555, that "we shall this day light a candle . . . as I trust shall never be put out."[45] This was certainly what happened with EC: although it went on to even greater success—it turned its creators' talents to the magazine business, which wasn't subject to the same code, and transformed a humor comic called *Mad* into one of the most iconic magazines of the century—the fate of its comic books imbued it with mythic dimensions of martyrdom that

would allow it to loom large in the minds of a generation of morbid-minded creators.

You could say, though, and far more prosaically, that one of the biggest things that wrecked the comic business wasn't the Code, or even the United States Senate, but the National Broadcasting Company, and its fellow channels. Television exploded during the 1950s, and was a far better purveyor of fear in black and white than its four-color newsstand competitor ever was. You didn't have to go to the newsstand for it, after all; it could frighten you from the comfort of your living room. A 1952 report in the *Journal of the American Medical Association* noted that children five and six years old were often watching TV for four or more hours a day. It also observed that the number of sets in American homes had "zoomed from 10,000 in 1945 to 17,000,000 in 1952," and that on programs airing during the week of May 24–30, 1952, viewers were treated to "852 major crimes, in addition to innumerable saloon brawls, sluggings, assaults, and other 'minor' acts of violence. . . . 167 murders, numerous robberies, jailbreaks, murder conspiracies, false murder charges, attempted lynchings, dynamitings, and an attempted rape in a crime western for children." It noted that 85 percent of these programs were televised before 9 p.m., while most children were still watching. In short, it charged, "the manner in which crime in these mediums is brought before the eyes and ears of American children indicates a complete disregard for mental, physical, and social consequences."[46] Ray Bradbury, as only he could do, transmuted this anxiety about what television was doing to the kids into SF horror of the first water. His story "The Veldt," published in 1950,[47] tells the tale of two children addicted to their audio-visual playroom, so much so that when their parents decree it will be turned off the consequences are positively homicidal.

And that report focused mostly on programs that weren't even *explicitly* scary: *Dragnet* and *Highway Patrol* and *Bonanza*. But then there were others. Start, perhaps, with late at night, when the children were supposed to be in bed. In 1957 Screen Gems, Universal's syndication arm, sold its Shock Theater package of fifty-two horror/thriller movies to TV broadcasters in large metro markets, offering a new lease on life for the classic monster movies of the thirties, allowing a new generation a chance to become

obsessed. And obsessed they became: network ratings increased between 38 and 1125 percent,[48] leading to a revived fascination with the old monsters.

You might think that having these fearful creatures in everyone's home, where the children could creep downstairs and watch them even—or especially—when they weren't supposed to, might sharpen that sense of moral panic, of transgression. And perhaps it did, a bit: one of the most under-remarked and intriguing things about the 1958 movie *The Fly* is that the scientific hugger-mugger about "matter-transporters" that leads to the fly/human combo is explained via the metaphor of television—and, as such, expresses the threat about that kind of transmission: bringing monsters into your home across the air might lead to a fly in the ointment, as it were, creating monsters. But, interestingly, that wasn't the main effect: instead, televising the classic frights seemed to continue their postwar domestication, their softening.

Part of that is technological, about a comparatively greater measure of control: in the movie theater, no matter how scared you got, you had to endure it—perhaps with eyes closed and ears plugged, but endure. At home, by contrast, if you got too scared, you could always change the channel. But it was more than that: these Shock Theater movies, by now a generation old, felt not only dated, but, by contemporary standards, maybe even a bit shtick-y to many.

And certainly that sense of corniness, of having lost their edge, was accentuated by how they were presented: bracketed by introductions from local television horror-movie hosts, dozens of them, that bordered on the camp and queer, and sometimes quite clearly crossed that border. Their ancestors, the thirties radio horror hosts, could rely on their listeners' fertile imaginations to render themselves terrifying: low-budget local television stations, understanding they'd be transmitting picture, went the other way, indulging also in near-contemporary EC's penchant for gags and puns. The first of note—perhaps still the best—was Los Angeles KABC-TV's Maila Nurmi, far better known as Vampira, who'd sign off by wishing you "bad dreams, darling" and, when encountered in person, only gave "epitaphs, not autographs"; but there was Philadelphia's Zacherley, and Nashville's Dr. Lucifur, and Norfolk's Ronald (whose sidekick was a beatnik type called

the Cool Ghoul), and many, many others.[49] And so they get smaller, friendlier, the monsters turning into the basis of happy kids' comics and cartoons—Casper, who premieres in comic-book form in 1952, is a famously *friendly* ghost, after all—and appear in that great pre-Beatles musical institution, the novelty song.

Zacherley, that Philadelphia horror host, released 1958's "Dinner with Drac," which went to number 6 on the Billboard chart;[50] the first stanza, a perfect limerick, depicts a dinner served for three, "at Dracula's house by the sea"; alas, sings the protagonist, while the meal was fine, he chokes on his wine, "when I learned that the main course was me!" Considering he calls Dracula "old friend" later in the song, though, he's not all broken up about it. Four years later, the vampires would come from their master bedroom to the lab, to join ghouls and a Frankenstein-like monster in doing "The Monster Mash"; Bobby Pickett's song of monster delight was not only a graveyard smash, but a Billboard one, too, hitting number one and performed on—where else?—television, in front of people like Dick Clark.

This dynamic of not taking monstrosity too seriously even made its way back to the movie screens: most loudly and notably in the oeuvre of William Castle. Castle was the man who asked Lloyd's of London to provide life insurance in case any viewers of 1958's *Macabre* would actually die of fright, and had a narrator solicitously ask the audience in the movie's prologue, to the literal accompaniment of a ticking clock, to watch out for their fellow viewers and attend to their welfare. This was not—everyone understood—because there was a genuine medical concern; it was, instead, the Barnumesque spirit of the carnival turning the horror movie into an experience that was, in its own way, silly and sometimes even joyous. Perhaps the apex was in 1959's *The Tingler*; there, in a direct address at the beginning of the movie, he informed viewers the only way to stop the depredations of the monster—who looks a bit like a centipede crossed with an armadillo—is by screaming, loudly. "Don't be embarrassed about opening your mouth and letting rip with all you got . . . remember this: a scream at the right time can save your life," he says. He also came up with the ingenious gimmick of hooking up seats in selected theaters to deliver small electric shocks to match the climactic moments of the film.

"Monsters are finished. They're coming out of your ears. Saturation,"

says a studio exec to a makeup artist he's letting go in the 1958 pic *How to Make a Monster*. And while the movie fitfully tries to counter the notion—by the common expedient of hypnotizing teenage actors via chemicals slipped into their makeup and sending them on homicidal revenge missions dressed as monsters—the parodic tone of the movie digs its own grave, too dedicated to its architecture of artifice to achieve anything like genuine fear. But, you could say, it wasn't even trying; which was not necessarily the case with other fifties movies that were laughed at, not with. Sometimes this was because of technical shortcomings—"some of the things that were supposed to frighten people really looked rather ludicrous," said fifties B-picture regular John Agar,[51] and you could say that again—and sometimes, it went beyond the merely technical.

A case in point was the work of Ed Wood, whose movies, like *Plan 9 from Outer Space*, often had an interesting set of themes or ideas underneath, not infrequently reflecting what we'd now call a queer sensibility, but were blunted by what seemed to be utter unfamiliarity with the way the English language worked, in terms of the writing, or how humans actually behaved, in terms of the acting, harnessed to inept direction and zero-budget special effects. Two sample moments of dialogue may prove illustrative. 1955's *Bride of the Monster* contains the following exchange, for example: "There are no such things as monsters! This is the twentieth century!" "Don't you count on it! Monsters, I mean." And *Plan 9*'s psychic, Criswell, informs us all that "We are all interested in the future, for that is where you and I are going to spend the rest of our lives! . . . Future events, such as these, will affect you in the future."

Cynics—like many of the producers of these movies—might argue that none of it mattered, really; because the prime audience who came out to them wasn't, really, watching anyway. They were just forgettable opportunities, at the theaters and drive-ins and midnight spook shows, to laugh and neck and throw popcorn. For their teenaged audience.

THE BOOMER KIDS WERE GROWING up, increasingly with their own money to spend, and, in the process, were becoming a group with an increasingly defined generational identity. Movies like *The Wild One* and *The Blackboard Jungle* portrayed childish rebels without a cause and

troubled teens who could, in the end, be cajoled and inspired to walk the right road; but William March's 1954 novel *The Bad Seed*, soon a Broadway smash and a 1956 movie, took another tack, raising the question of nature vs. nurture and coming down sharply on the side of horrifying nature. There was just something wrong out there, it suggested; and while the novel and its later iterations ostensibly identified eight-year-old multiple murderess Rhoda Penmark as an individual bad apple, a cuckoo in the nest, it was easy enough for readers, and viewers, to extrapolate. In the movie's end—different from March's far bleaker 1954 novel, in which the mother, seeing her child's dark future ahead of her, feeds her an overdose of sleeping pills and then takes her own life with a shotgun—the Seed in question is neatly disposed of with a convenient bolt of lightning, rendering a kind of divine judgment on this representative of the new generation.[52] Kids were threats, in other words; there was something monstrous inside of them.

Robert Bloch, in a 1958 story entitled "Sweet Sixteen," had a member of the older generation muse, after witnessing a scene that could have been lifted almost whole from *The Wild One*: "Sure, I remember frat initiations and how wild we got after football games. But there was nothing like this. There were a few bullies or maladjusted kids with mean streaks—now they all behave like a pack of psychos." Bloch's story, after contemplating and rejecting a variety of sociological explanations, suggests—in a supernatural analogue to *The Bad Seed*—the role of incubi, that the JDs are literal demon-spawn, monsters. "What we need is exorcism," says the anthropologist who hits on it . . . but, they get him before he can give it a shot.[53] Bloch's story laid it all out, explicitly; but it was a film, released the previous year, that found the perfect monstrous metaphor: not demons, but werewolves.

Michael Landon, the titular teenager in 1957's *I Was a Teenage Werewolf*, updates Brando in *The Wild One*—"I say things, I do things, I don't know why," he tells his girlfriend, throwing a bottle of milk against the wall to accentuate the point. Here, though, a doctor, speaking to him in modern psychoanalytic language—he's going to help Landon "adjust," he says, "to everything"—hypnotically regresses him to a primitive past self, oozing with raw animal passions all over the place. The movie, then, suggests the capacity of the "troubled teen" to terrorize, and to pose a threat, one that

can be removed only with death.[54] That same year, a gender-swapped and vampire-oriented version of the same hypnosis gimmick appeared courtesy of the recently formed American International Pictures, incorporated in no small part to aim directly at the teen market, which had exploded: in 1958, 72 percent of American moviegoers were between twelve and twenty-five.[55] "She's an A-bomb all by herself" is how one teen is described in *Blood of Dracula*, connecting it directly to another contemporary horror: but the move ends the same way, with the protagonist's death, suggesting, once more, that American adults would prefer you to die young and leave a good-looking and well-behaved corpse than to act out in ways they didn't approve of. It suggested intimations of a generation gap a-brewing.

Not all these movies portrayed teens as threats, to be sure. *I Was a Teenage Frankenstein*, released the same year, suggests a creature more sinned against than sinning (and a victim not just of mad-scientistry but of that associated horror with teenage culture, the car crash); 1958's *The Blob* even features an ostensibly teenaged Steve McQueen working, calmly and responsibly, with some adults to try and combat that shapeless menace— which appears, unlike almost everything we've seen so far, in color: a new era of visceral impact. It eventually made a hundred times its production costs.[56] The movie's horrific crescendo occurs, self-reflexively, in a movie theater, where the Blob oozes out from the vents into the projectionist's booth and out into the audience. And the most nuanced version of what appears to be a novel of the threatening child was, in Vladimir Nabokov's telling, revealed to be the displacement of horrific adult behavior.

Lolita, whose namesake novel was published in America in 1958, the same year as *The Blob*, may be presented by narrator Humbert Humbert as a sexualized nymphet, luring him off the straight and narrow, but we understand, of course, that this is self-justification of the most monstrous sort. *Lolita* is, in its own way, harkening back to *The Turn of the Screw*, with an ambiguous, unreliable account of the seduction and badness of children, though here more sexualized.[57] Adults might blame the teens, in other words; but it becomes clear that they were really worried about their own roles as stained shapers of the Baby Boom, their own sins creating these very monsters in the first place. In *The Bad Seed*, all the agony and

horror isn't focused through Rhoda Penmark, the title character, after all: she's incapable of feeling, or knowing, any better, in the telling. It's the mother who slowly discovers the secret, and has to decide how to deal with the monster. Both novels were published, significantly, in the wake of an explosion of both popular-press sensationalism and legislative activity concerning child molestation and child murder.[58]

In *The Bad Seed*, March writes that most people tend to "visualize the multiple killer as . . . monstrous in appearance as he is in mind." Entirely untrue, he writes: "these monsters of real life usually looked and behaved in a more normal manner than their actually normal brothers and sisters." March had been working in Germany for a shipping company when Hitler came to power, and apparently came up with the character soon after he came back to America from Germany and England.[59] But seeming normality could hide monstrous depths, as both Nazi Germany and Sigmund Freud suggested in very different ways: and a monster tailor-made to consider aspects of both was aborning in Wisconsin.

TWO YEARS AFTER *The Diary of Anne Frank* had its Broadway premiere, a hardware store owner in the Wisconsin town of Plainfield named Bernice Worden disappeared. Suspicion immediately fell on the last person to have frequented the store, a handyman and odd-job man named Ed Gein. Searching Ed Gein's farm, a sheriff's deputy found Worden in a shed: hanging upside down, eviscerated and dressed out like a deer, and minus her head. They found the head in a burlap sack in Gein's house. Along with chairs upholstered in human skin. And bowls made from human skulls. And four women's faces tacked to the wall, at eye level. And on, and on.[60]

Gein only admitted to killing one other woman, a woman named Mary Hogan; the rest of his grisly hoard was accumulated over a series of dozens of nighttime visits to local graveyards and exhumations of recent corpses— thus the nickname the Plainfield Ghoul. Most notably, the corpses he was interested in were those of middle-aged women—corpses who bore a similarity to his mother. She'd filled his youthful head full of fire and brimstone and the devilishness of women, and he'd ministered to her after a paralyzing stroke before her death in 1945. Much of his body-snatching and

subsequent flaying was to create a "woman suit" so that "he could become his mother . . . literally crawl into her skin."[61]

Gein's 1957 trial—in which he was found not guilty by reason of insanity and committed to Central State Hospital for the Criminally Insane—became a national sensation. This, in no small part, was because of a significant legal change in the insanity defense. The defense had been used in Anglo-American law for centuries, but had largely been codified by the mid-nineteenth-century M'Naghten Rule, which suggested that the criterion for a defendant's responsibility for his actions was whether he could tell they were wrong actions when he did them. But with the growing influence of the field of psychoanalysis, there was increasing pressure to bring in a more medicalizing approach: and in 1954, in *Durham v. United States*, the DC District Court of Appeals determined that the relevant criterion was if the "unlawful act was the product of mental disease or mental defect." This "Durham test" would meet a lot of pushback, and would change many times over the next decades—but it illustrated how the psychoanalytic approach to the analysis of terrifying actions was gaining purchase.

You could see it as early as that 1943 story by Robert Bloch, "Yours Truly, Jack the Ripper," in his choice to make the narrator/killer a psychiatrist, illustrating the unreason and grime beneath the new American comfortably psychoanalyzed superego. But while psychiatry is a feint in that story, soon enough, it becomes a focus. In 1947 Bloch published the novel *The Scarf*, in which the protagonist is a literal and metaphorical lady-killer, who strangles the women who fall into his arms and bed with the titular object. He speaks with a psychologist, and says, "Wait a minute, now, I'm not Jack the Ripper." Are you sure?" is the response;[62] befitting that postwar anxiety about the werewolf inside us all. "There are dark forces in all of us," Michael Redgrave's Bluebeard-esque character muses in the 1947 movie *Secret Beyond the Door*, a movie that ends up being a paean to psychoanalytic exploration of the darkest recesses of the self. "We're all of us children of Cain."

Even August Derleth himself, in *Sleep No More*, a wartime collection of horror stories culled largely from *Weird Tales*, referred to his anthology as "oldfashioned," acknowledging the recent "realization that there is more

evil, more terror, and more fear of evil and terror inside us than outside; the means psychiatrists and others have given us to explore these new worlds have led inevitably to something new in the examination and elucidation of horror."[63]

"There are many things we don't have in state hospitals," a doctor tells Olivia de Havilland's husband in 1948's *The Snake Pit*, including the resources for long-term mental health care, so they decide (at first) to go with short, sharp shock treatment; and the packed dormitory of female patients we see, crying, singing, offering lullabies to absent children, is testament, or at least reflection, of a mental health crisis writ large. The movie features a Dantean descent lower and lower into the psych wards, appealing to both the psychoanalytic and cinematic approach, digging into trauma until you get to a breaking point that allows for catharsis and then explanation. Therapists loved the movie, much as they probably hated the contemporary multimillion-selling Mickey Spillane novel *I, the Jury*, where the gorgeous femme fatale (spoiler!) was revealed to be a psychiatrist.[64]

But even as the culture offered the prospect of psychoanalysis's failure alongside its successes, its language and mindset spread, taking over the language of fear and crime and moving it from the individual criminal to the mass killer. James Cagney's 1949 *White Heat* is a gangster movie suffused with enough complexes, Oedipal and otherwise, to give Freudians years of material to work with, thanks to its hard-charging machine-gunning mobster with a mother fixation. He shouts "Top of the world, Ma!" as he goes down in bullets and flame at the movie's end. Hard-boiled noir novelist Jim Thompson, in his 1952 novel *The Killer inside Me*, had his protagonist discuss his recurrent recourse to violence, even homicide, in terms of "sickness." The monster that has ripped most of the colony limb from limb in the 1956 science fiction classic *Forbidden Planet*, resetting *The Tempest* in outer space, is literally revealed to be a "monster . . . from the id" of the human Prospero-analogue. John Dall's character in 1950's *Gun Crazy* is given a full, psychologically rich backstory, complete with childhood abandonment (he's an orphan), childhood trauma (he's killed a baby chick with a BB gun), and childhood obsession (we see him breaking into a gun store for the merchandise). "It's become a kind of mania with you," the juvie

judge tells him, and indeed it has, as the movie unspools—catalyzed, it should be said, by a woman.[65]

With Ed Gein, the story of psychoanalysis joined with another story gaining increasing momentum in American society: that of the multiple murderer. In Bloch's novel *The Scarf*, the narrator/protagonist keeps his thoughts in a "black notebook," asking, among other questions, why such killers kill: "I'd like to think there was a reason behind it all. That there always have been and always will be a few men in the world who dare to dramatize death—give it a meaning. . . . Maybe, some day, I'll know, too."[66] But he's not just a killer; he's a novelist, who eventually makes his way to Hollywood to write for the pictures. There, a news photographer buttonholes him, asking him if he's ever considered writing a book on this sort of murderer, "those torso murders" in Cleveland, for example: "People like to read about it. Look at the way those true-detective magazines sell. Sex crimes. Blood. Everybody wants to know."[67]

Bloch had name-checked the thirties "so-called Cleveland torso slayings" in "Yours Truly, Jack the Ripper," too.[68] The killer had over a dozen victims (maybe a lot more than a dozen), always beheaded (thus the "torso"), often dismembered, sometimes castrated, variously tortured. Like his most infamous predecessor, the Ripper, the Slayer preyed on the dispossessed (most of them living in the Hoovervilles and slums); like the Ripper, he was never caught. Elliot Ness, the famous federal agent known for leading the Untouchables and battling Al Capone, was put on the case; the killer, or the possible killer, sent him taunting postcards and put two victims' bodies—parts of them, anyway—right near city hall. A few years before that, in 1932, "The Bluebeard of Quiet Dell," Harry Powers, was hanged for a series of "lonely hearts" murders—a sensational case where he'd advertised his availability and desire for marriage, and then courted, and murdered, the women who answered. And, in at least one case, their children. By strangulation. Or with a hammer.

In 1953, four years before Ed Gein's crimes came to light, journalist Davis Grubb fictionalized the Powers case in *The Night of the Hunter*, a bestselling debut novel that was a finalist for the National Book Award; and in doing so, he made three major changes. The first was to telescope the

material into a single case. The second was to turn that case into a dark fairy tale, the menace of the evil stepfather come to life, complete with buried treasure: here, the courting and murdering serial killer menaces the wife and children of a former cellmate who's told him he's hidden the money from his last robbery, and his children know where it is. He also focused the venue: while Powers's victims came from places where the mail could reach, Illinois and Massachusetts, Grubb sets his novel in Powers's West Virginia, firmly in the Bible Belt.

Which is important for the third change: that he reimagined Powers (here renamed "Harry Powell") as a preacher of the Gospel, a fire-and-brimstone type whose crimes display fear and hatred of women filtered through the language of the more vivid parts of the New Testamental vocabulary.[69] "God had spoken clear to him and told him what he had to do," the novel says; "The knife beneath the wool, the Sword of Jehovah beneath his wrathful fingers . . . sometimes he found his widows in the lonely hearts columns of the pulp story magazines. Always widows." Those fingers, famously, have LOVE tattooed on the knuckles of one hand and HATE on the other: Powell makes the fingers dance and intertwine, showing the impossibility of separating one from the next. "He is Satan hiding behind the cross!" shouts the mob, when he is revealed: but it is a lynch mob, and what they say before that—"Because he tricked us! Because he tricked us!"—shows the primal instinct that is willing to turn justice into violence.[70]

The book, and its subsequent film version, tied together American religion, sexuality, crime, and psychopathy in a package that stretched the boundaries of the aesthetics of American horror. One scene, early in the movie, really sticks: in a way that allows director Charles Laughton—not insignificantly, a non-American, able to cast an incisive British eye on the country—to both evade fifties censors and display horror's gift for the allegory all at once. Powell, on the way to encountering the family he will terrorize, stops at a burlesque show: watching what he and others of his ilk might have called "a scarlet woman" go through her act, he, alone, is grim, stiff, disapproving, while everyone else is having their good time. As the scene reaches its pitch, Powell shudders, and a phallic eruption occurs: but here, it's a jackknife, released uncontrollably through his pants pocket.

You don't get any clearer than that, psychologically speaking—at least, not until Alfred Hitchcock turns his camera on Norman Bates.

In Bloch's *The Scarf*, the psychologist tells the protagonist that "you do hate women,"[71] and *Night of the Hunter* has a grim obsessiveness about women—about their dangers, their sexuality, the desire to control them. "There are too many of them," Powell says to the Lord, "can't kill the world." But this monstrousness turns deeply tragic when the children's mother is seduced and gaslighted by Powell into hating her sexual desire for him, internalizing his misogynistic definition of that emotion as impurity, uncleanness, a process that only intensifies until, in her final moments, when he stabs her in an expressionist cathedral, she lays there, welcoming death—it is, after all, what she has been taught to feel that she deserves. Which leads to one of the great horror movie shots: Powell pushes her, with her car, into a lake, and we see her there, at the bottom, her hair streaming like a creature out of myth.[72]

Harry Powell's criminality, so traditionally, terribly, and archetypally American, is provided a conventional American end: in jail, with the understanding that he'll hang for his crimes. But things were changing. Ed Gein ended his days not in jail, but in a mental health facility; and when Robert Bloch turned his hand to the Gein case, his resulting 1959 novel, *Psycho*, featured one Norman Bates who would fare similarly. The novel takes great pains to provide a psychoanalytic underpinning to Bates's homicidal actions, even inventing a psychologist, a Dr. Steiner, who's cited at length explaining how Bates got to be the people he ended up being. Steiner explains that Bates has *three* personalities—Norman, Norma, and Normal—tipping its hat to another then-popular movie with psychoanalytic undertones, 1957's *The Three Faces of Eve*. *Eve*, with an Oscar-winning performance by Joanne Woodward both virginal and knowing by turns, has a lot to say about anxieties regarding female sexuality and the way, werewolflike, they peeked out under the scrim of ordinary domesticity.

Reading Bloch's novel in its own right, before Alfred Hitchcock got his hands on it, is to see how powerfully it weaves together a wide variety of fifties trends, not just psychological ones. ("Psychology isn't filthy, mother!" Norman insists, early in the novel: "Psychology, he calls it! A lot *you* know

about psychology!" she replies, and you can see Bloch chortling as he typed.) Norman Bates's first victim, Mary Crane, is a classic noir and horror-comic protagonist: a criminal on the run, with forty thousand dollars of someone else's money so she can start a new life with her man. Of course, the person she took the money from is a creep, and she regrets her choice and is about to give the money back—but it's too late, of course. She's already checked into the Bates Motel, and she's not going to check out. Her crime is disproportionately punished at the hands of one of those monsters, and, as Stephen King has pointed out, Bates is a classic werewolf:[73] soft and doughy on the outside (in Bloch's version), capable of sexual arousal only through peeping voyeurism—and, of course, dressing up in Mother's clothes and stabbing a big phallic knife into a woman's body. Bates's cry back at the house—"Mother, oh, God, mother! Blood! Blood!"—after that moment in the shower says it all: in just six words, it covers all the psychological bases, familial guilts, theological ones, bodily violations.

Psycho clearly locates Bates's aberrance in his upbringing, and Bloch was hardly the first to mine this territory, even in the genre fields he played in: to take just one example, that short-story genius Charles Beaumont, in his first-ever story, "Miss Gentilbelle," published just two years earlier, had posited a monstrous mother figure who dresses her son like a woman and drives him to some murderous work with a butcher knife.[74] That said, the Bloch novel hedges its bets: early on, we're treated to the sight of Bates reading an anthropological work about bloody Incan ceremonies, and while psychoanalytic theories suggest monsters are made, not born, we can't help but wonder whether Bloch is winking at that EC "readers are monsters" suggestion, that those who spot a general stain in our natures might have something of a point after all. Or, as a character puts it at the end of the novel, "We're all not quite as sane as we pretend to be." Maybe it's not just the children who are bad seeds. Maybe it's all of us. This is certainly the idea on display in Bloch's contemporary story "The Cheaters," whose title is a pun on both the glasses that allow their wearer to read minds, and the vicious mindsets they reveal. At the story's end, the final wearer looks at himself in the mirror and reads his own mind: "I saw the unutterable foulness beneath all the veneer of consciousness and intellect, and knew it

for my true nature. Every man's nature."[75] And *The Shrinking Man* author Richard Matheson, in his 1958 hypnosis-turned-parapsychological horror novel *A Stir of Echoes*, illustrates how easy it is to harness that nature in the name of ostensible morality, or ideology: "You can't make a subject break his own moral code," a character says. "*But*—you can make almost any act fit into his moral code."[76]

Bloch has managed to craft a werewolf tale that's also a haunted house story: Mother's ghost walks those halls as surely as if she were floating down the upstairs hall in a white bedsheet. It wasn't the only haunted house story of 1959: that was the year *Anne Frank* premiered in theaters—and, most important, the year a novel about a more conventionally haunted house was published that marked, perhaps, the high-water mark of the novel of fear in the mid twentieth century, if not the century entire.

By the late fifties, Shirley Jackson had already been praised as one of the great writers of psychological horror of her generation—most notably for her 1948 *New Yorker* short story "The Lottery." In it, a single town celebrates an annual event, one in which an arbitrary sign on one of the slips in the town's titular ceremony generates a stoning, and a sacrifice. It's easy to read all sorts of interpretations into Jackson's parable—is it a post-Holocaust reflection on the way hatred works? Is it a manifestation of the beating heart of paganism underneath the disguise of Main Street Americana?—because its considered lack of specificity allows for it. But what seems evident, in any reading, is that same theme we've seen, over and over again: that everyday people can turn killer for the most banal of reasons. This was, to put it mildly, an unsettling prospect for readers. "Of the three-hundred odd letters I received that summer I can count only thirteen that spoke kindly to me, and they were mostly from friends," Jackson wrote. "Even my mother scolded me."[77]

Although she wrote several other works over the next decade—the most popular, by far, a series of funny quasi-autobiographical short stories about being a mother with a pack of kids called *Life Among the Savages*—1959 saw her arguably most celebrated work, the haunted house novel that was nominated for a National Book Award.[78] *The Haunting of Hill House* took, as its premise, one of the hoariest tropes of the *Weird Tales* era: paranormal

investigators proceed to the house in question to determine if it's haunted, and, while their methods begin as ostensibly scientific, the terrifying doings that ensue, focused, especially, on one of the most psychically sensitive characters brought there as a kind of canary in a haunted coal mine, lead to breakdown and death. But Jackson, whose prose stylings and character insight made her the most distinguished writer of the American ghost story since Henry James, used this simply as a scaffolding to erect a masterpiece.

Ironic, since the point of Hill House is that, in every physical and metaphysical sense, it's built *wrong*. Angles don't meet; doors are mislaid so they swing open and shut on their own; it hurts the eyes to look at them. Although Jackson gives a conventional backstory to the house—murders, insane heirs, other tragedies and misfortunes—the reader is left with the profound impression that all this history is beside the point: what really generates the evil in Hill House is nothing more, or less, than Hill House itself, driven mad, and maliciously so, by its own imperfections.

From the Puritans on, houses were potential sites of the unclean and the uncanny, because, among other things, of their comparison in the seventeenth-century to human bodies; when there was strange activity in them—poltergeist-like—it was a sign that the humans within them were also vulnerable.[79] Like in some of Poe's and Henry James's best stories, "William Wilson" and "The Jolly Corner," Jackson's characters encounter what also may be a projection of themselves. But instead of an uncanny double, what they find—particularly Eleanor, the psychic sensitive and novel's protagonist—is the possibility of erotic bliss and its corollary, loss of one's own identity.

"Journeys end in lovers meeting" is what Eleanor thinks over and over again; and much of the erotic energy in the novel comes from its then-daring indications of same-sex attraction between Eleanor and another guest. Sexual queerness in the haunted house hardly originated with Jackson's novel: in a movie that literally named the haunted house phenomenon, 1932's *The Old Dark House*, a mysterious figure in the house's attic, a 102-year-old father, is played by a woman who is billed as a man in the credits.[80] But Jackson makes it more manifest, although, tragically, as a spurned possibility: in the end, it's the house that offers itself as that lover

who meets at journey's end, with just a brief, suicidal price tag—although Eleanor realizes, once it's too late, that this is a terrible trick. Whatever walks in Hill House walks alone, Jackson warns us at the beginning of the novel; despite what Eleanor may think, or desire, there's only room for one.

The haunting that truly matters, in other words, is not, ultimately, the house; it's inside the corridors of the protagonist's mind. But it's hard to see inside someone's mind on a movie screen; and so when Alfred Hitchcock got his hands on Bloch's novel, there were some things, at least, that had to change.

BY THE TIME PSYCHO PREMIERED in 1960, Hitchcock had been discomfiting American audiences for years via pictures replete with characters channeling, even articulating, many of the sentiments we've seen about what lurks beneath the pleasant light of day. These often featured a Hollywood leading man playing against type. *Shadow of a Doubt* (1943), for example, in which a beloved visiting uncle is revealed to be a serial killer, is an early introduction to the dictum that murder, and murderers, can be everywhere. The theme's even given a comic turn here, with one murder-obsessed citizen at one point cheerfully informing another main character that he's spiked the latter's tea with soda that, if it were poison, would have killed him and he wouldn't even have noticed. It's the film's villainous Joseph Cotten, though, who delivers what could be a maxim for the era, to the young ingenue playing his niece: "The world's a sty. Wake up. Learn something." Shadow of a Doubt ends with the ingenue repeating his charge to her intended, that she and people like her had no understanding of the world, what it was like. Her love interest responds that they do, but that it "needs a lot of watching. It seems to go crazy every now and then." A wartime optimism, perhaps, that the insanity was temporary, localized, removable: but perspectives would change, somewhat, after the war, when Hitchcock's films would reach a new level of sophistication and nuance.

Hitchcock's 1948 film *Rope* covered the same kind of ground as the crime comics, which were just reaching their peak: it dramatized another iconic true-crime case, here the two murderer-stranglers Leopold and Loeb. That case, though certainly less famous today, was household news in the

decades after it occurred in 1924, in no small part because of its unsettling dynamic: Nathan Leopold and Richard Loeb were two college students from wealthy families, at the elite University of Chicago, who murdered a fourteen-year-old boy (Loeb's second cousin) largely, it seemed, because they could. To do what Raskolnikov couldn't, in *Crime and Punishment*: to carry off the perfect crime and not feel bad about it. It wasn't the perfect crime, as it turned out—the duo established an imperfect alibi, left incriminating evidence at the crime scene, and threw suspicion on themselves by speaking to the press. Unlike with the Gein case several decades later, the duo's lawyer, the renowned Clarence Darrow, elected to avoid the route of "not guilty by reason of insanity" and had them plead guilty, hoping for a life sentence rather than the death penalty. The reason he did so was his conviction that a jury would *not* have found Leopold and Loeb insane: just evil, in a congenial package. It worked: they were sentenced to life plus ninety-nine years apiece.

This is the world that Hitchcock chooses to present in *Rope*, in long, unbroken takes that give the impression of a seamless stage play. (It had actually *been* a stage play, decades earlier.) The movie's Leopold and Loeb gleam darkly, particularly the performance of John Dall: but, of course, pride of place goes to Jimmy Stewart, playing the duo's prep school teacher. The pair of murderers have invited him to a dinner party: the buffet dinner served, in a touch worthy of Poe, on top of a chest containing the murdered corpse. Hitchcock once said that he discovered Poe at sixteen, and "very likely it's because I was so taken with the Poe stories that I later made suspense films," comparing his work with Poe's in the sense of "a completely unbelievable story told to the readers with such a spellbinding logic that you get the impression that the same thing could happen to you tomorrow."[81] This might not be a perfect encapsulation of Poe, but it's not a bad one of Hitch.

Stewart himself, that genial, earnest fixture of prewar Hollywood, had put his movie career on hiatus to serve in World War II, like others of his generation; unlike some of those others, he served in combat—at his insistence—flying bombing missions over Germany. From there, he had a first-hand view of both the ethos that considered human life as inferior

because of a so-called sense of mastery and, simultaneously, the kind of destruction and violence that death from above can rain down on innocent and guilty alike; it may be unsurprising, then, that his postwar career featured more morally ambiguous and charged roles like the one in *Rope*, despite his character ending firmly on the side of the angels. In the movie, he's invited because he had taught them that concept of the superior man back at school; when Stewart's suspicions about the pair's gleeful hints becomes horrifically confirmed, he's shocked and appalled, however, rather than supportive.

"It's not what I'm going to do, it's what society is going to do," Stewart says, "you're both going to die"; society, we want to believe—and Hollywood wants to tell us—has to punish those who are unassimilable, to reinforce the norm. But they *didn't* die in real life, as many viewers well knew; and although the duo's claim—that they're not committing a murder, they're creating a work of art—is also rejected by Stewart, it is only questionably refuted by the *movie*—which does exactly that: make art from Leopold and Loeb's actions. And so *Rope*, in its desire to come up with a firmly moral conclusion, unsettles after all, and ushers in, along with the fifties, a succession of grayer areas for Hitchcock's camera.

In 1951 his *Strangers on a Train* picked at the same scab of universal moral implication in evil: all it took, the film suggested, to unleash murder was a chance encounter with someone who let you agree to what, really, deep down, you wanted to do all along—along with the chance to get away with it clean and clear, since *he* would commit your murder, and you would commit *his*. Stewart didn't appear in that film, but he was back partnering with Hitchcock for 1954's *Rear Window*, playing a voyeur to violence by trade—a war photographer—who, sidelined with a broken leg, is forced into spying on his neighbors. In a theme we've come to expect by now, he assumes there's a murderer among them—and, lo and behold, there is, lurking among the quasi-anonymous windowscape of Hitchcock's specially designed city set. Stewart's character is something of a vampire, preying on the thrill of others' misery, in a format, as many critics have noted, that puts him in the same position of Hitchcock's viewing audience. But he's also a werewolf of his own, putting Grace Kelly's character through psychic

misery until she joins him in his kink—which, it turns out, she's more than happy to do, breaking and entering into apartments with abandon. The point, Hitchcock suggests, isn't that they were right; it's that they're junkies for the horror. As, he points out, are we all. "We're two of the most frightening ghouls I've ever known," she says, later, after she's bought in, making the monstrous metaphor explicit.

Hitchcock brought his sense of grue mixed with a heavy dose of irony to the small screen in *Alfred Hitchcock Presents*, which started in 1955 and ran on and off for a decade. The series "solidified his reputation as a popular entertainer and master of suspense"[82] by featuring the director himself, speaking directly to the camera, offering lighthearted introductions to tales that cataloged the evil that humans do in a wide variety of ways. The unquestionably most famous episode of the series, which should give you a sense, is the one in which Barbara Bel Geddes beats her husband to death with a frozen leg of lamb when he says he's leaving her for another woman and then cooks and serves it to the police when they come to investigate, thus getting rid of the murder weapon; "Lamb to the Slaughter," based on a short story by Roald Dahl, would have been perfectly at home in an EC comic.

The same year that episode was released, Stewart and Hitch paired again. *Vertigo* (1958) is another tale of obsession, wrapped, at first, within the investigation of an account of a woman possessed: but as the movie continues, we find that the obsession—and the possession—is that of a man remaking a woman's body, attempting to master it. One can say, with some justification, that part of Stewart's character's confusion is the uncanny doubling he witnesses when the woman he fell in love s with eems to reappear. Although, spoiler alert, it's not as uncanny as he thinks it is. But the real horror of the movie, the thing that leaves *us* dizzy and disoriented, isn't when the acrophobic Stewart is climbing clock towers and subject to Hitchock's suddenly shifting camera focus. It occurs in a dress shop, when Stewart curtly insists that the woman he's with, the uncanny double, will take the dress he has picked out, one that perfectly suited the earlier incarnation. What has happened is that the woman, played in both incarnations by Kim Novak, has fallen in love with Stewart in the interim. What started as a con has become the real thing; and, like in so many a film and story

before, the mask has become affixed to the face, through mixed bonds of love, obsession, and guilt, and it won't come off. "If I let you change me, will that do it?" Novak asks. "Will you love me? "Yes," Stewart breathes, and in this we see the oldest and most fundamental horror story of all time: of that terrifying thing called love, and of the damage, particularly to one's very essence, that can be done, in its name.

The year after *Vertigo* was released, Robert Bloch's novel *Psycho* came out: and Hitchcock, without revealing his identity, picks up the rights. And everything comes together. As the movie opens, Hitchcock ladles on the noir: Janet Leigh, postcoital in bra and slip, and a couple who can't be together because they don't have the money to escape their circumstances. Then opportunity knocks, in the form of A Nasty Married Rich Guy trying to exploit the poor woman, and forty thousand dollars in cash just begging, at the cost of only a little wrong, to bring about the right of domestic happiness, equated—of course—with marriage and domesticity. Leigh, talking to her beloved, says she wants to stop meeting in hotel rooms: she wants to see him "respectably, in my house with my mother's picture on the mantel."

Driving off with the cash on the wide and nearly empty roads of the American southwest, Leigh repeatedly hears voices in her head, our first intimation of psychological intrusion: voices of guilt, voices telling her she's going to get caught, telling her she's bad. Norman Bates isn't the only one who hears such things, apparently: and when she stumbles into the Bates Motel and meets her fate there, in the shower, we can be forgiven, possibly, for thinking that this is another of those EC comics moments, where the criminal is punished according to the law of counterpenalty, albeit, like in Dante's inferno, where it's two eyes and a whole set of viscera for an eye. But that isn't true, quite. Really, as it turns out, the work itself—both novel and movie—is a werewolf, too, hiding its cosmic indifference behind a framework of noir and punishment. All of this is a feint, and the reason Leigh meets the fate she does is simply her bad luck of meeting up with Norman Bates. Who walks, alone, in the upper level of the family residence next to the Bates Motel in his mother's clothes, silhouetted against the window, in a shot that reminds us, again, that this is yet another haunted house story. Complete with a parlor full of stuffed animals (and something

else, a little larger, that Norman has stuffed in the basement), and a secret passage, one eye wide, behind the classical portrait in the office, to watch the ladies in Room One get undressed, another of our implicated—and implicating—voyeurs.

But here a big difference between book and film matters. Overall, Hitchcock is quite faithful to the novel. But in casting Norman Bates, he chose to replace Bloch's balding, doughy, bespectacled man with the tall, attractive, youthful Anthony Perkins, who also, notably, has a similar look and build to Leigh's boyfriend. Perkins also comes off, at least at first, as more charming than his literary predecessor, allowing the audience to believe that Leigh actually would accept his offer to have dinner with him—and, later, offer to have that dinner with him in her room. Norman is somewhat taken aback at her forwardness, and counters with a dignified offer of dinner first in the office, and then in the parlor, which she accepts: but we are already on guard for that same fear of women, and particularly their sexual desire, we saw most notably in *Night of the Hunter*, and Leigh soon overhears Norman's mother berating him, decrying "the cheap, erotic fashion of young men with cheap, erotic minds! . . . as if men don't desire strangers!" And since—in one of the most famous lines in all of film—"A boy's best friend is his mother," she will act to eliminate the threat. With a knife.

"It's not as if she were a maniac, a raving thing. She just goes a little mad sometimes. We all go a little mad sometimes. Haven't you?" Bates says to Leigh's character during that date; and she replies, "Yes," thinking, of course, of those forty thousand dollars. Which makes us face the uncomfortable possibility that Bates is being portrayed as a difference, not of kind, but of degree. And, to that end, take the famous shower scene. Much has been made of Hitchcock's artful shooting and the capacity of the mind to fill in the blanks: although you see the knife, and you see Janet Leigh (quite a bit of Janet Leigh, actually, by the standards of the time, although Hitchcock plays peek-a-boo with the nudity), you don't really see the knife going into Janet Leigh. (There may be a frame or two.) But there's something that you do see, quite clearly, in a shot that's quite extended for the sequence: the butcher knife laid flat—that is, in a way that's posed, rather

than thrust—against Leigh's naked belly, angled so that you can clearly see her navel. A knife, and a pretty girl: that's it. That's the combination that Bates is lusting for.

As was his audience. Which meant that we were all the werewolves. And the shot of Janet Leigh's eye, looking out, lifeless, is matched, at the end of the film, with Perkins's staring out at us with his mother's eyes. Which of course have to be in Norman's face, since—as we've seen in a shocking reveal at the movie's climax—they're nowhere to be found in the mother's stuffed skeleton. A skeleton, incidentally, that reappears briefly in one of the few horror-film effects Hitchcock employs in the movie: a skull double-exposed beneath Perkins's face in that last shot of him. Maybe it was Hitch's attempt to let the viewer see inside his mind after all.

But that last jolt—discomfiting as it is—is hardly the culminating shocker of the movie. That takes place when Hitchcock has Leigh's sister knock into a dangling lightbulb as she jerks back, horrified, from the sight of Mother: which puts the corpse into oscillating light and shadow, light and shadow, a useful metaphor for the Dr. Jekyll and Mr. Hyde nature within Norman—and, as the psychologist's explanatory appearance implies at the end, within us all. After all, don't all of the viewers in the darkened movie house lean forward, waiting for the light, to get a better view?

Revolutions and Chainsaws

—

IN 1956 TWO SISTERS, PATTIE and Babs Grimes, ages twelve and fifteen, disappeared in Chicago after engaging in an archetypal fifties experience: going to the movies to watch Elvis Presley. After they were missing for several days, Graceland itself weighed in, asking the girls to come home. Sadly, this would prove to be impossible: their nude, frozen bodies were discovered several weeks later. The case became national news and remains unsolved to this day. Writing about the murders, and, even more, the press frenzy that followed, in *Commentary* in 1961, a young writer named Philip Roth posed the question from the point of view of a novelist: "And what is the moral of so long a story? Simply this: that the American writer in the middle of the 20th century has his hands full in trying to understand, and then describe, and then make *credible* much of the American reality. It stupefies, it sickens, it infuriates, and finally it is even a kind of embarrassment to one's own meager imagination."[1]

The fears of the fifties had been dedicated to the rapidly growing shadows of fears from above and within, the prospect of mass death that had previously been the purview of science fiction and the horror of the psychotic killer who could be lurking inside your hometown, echoes of the menace they'd defeated overseas. And it had grown, and grown, and suffocated: and the response, suffusing America in the last years of that decade and the beginning of the next, was anxiety, an age of it, in fact. Forget psychologizing it; as one contemporary critic wrote:

To the psychologist who claims that Anxiety is, after all, only
a familiar family of related neuroses, the sufferer replies that this
misses the point altogether. . . . Reality is in question; the images are
those of a Nightmare of Unreality slowly usurping the world of the
familiar real.[2]

Everything around Americans, in other words, seemed to be decaying
into nightmare: including, and especially, the postwar social institutions
that seemed to be so cherished, the bedrock of right-thinking, patriotic,
God-fearing society.

A pre-*Psycho* Hitchcock film, 1956's *The Wrong Man*, based on a true
story, portrayed Everyman Henry Fonda shoved into a potential everyday
terror, an American Kafka tale, in which he's fingered for a crime he didn't
commit and becomes caught up in the maw of the law enforcement system.
"If you haven't done anything, you have nothing to fear," say the police.
But this is a thesis the movie goes on to refute at length; though in the
end Fonda is released unharmed, he, his family, and by extension the audi-
ence, hardly leave unscathed. *Sweet Smell of Success* (1957) suggested that all
those urbane newspapermen and Stork Club habitues, the folks behind the
newspapers Americans read faithfully every morning, were really pimps
and prostitutes, first of newsprint, then, basically, of reality. In *Success*,
the biggest success, the top of the heap, Burt Lancaster's columnist J. J.
Hunsecker, is particularly monstrous in the way that he elevates his success
and influence to a kind of twisted identification with patriotic sensitivity.
If 60 million Americans turn to his column, he thinks, then he *is* America.

And in another movie released that same year, that sentiment is trans-
posed to newer media: *A Face in the Crowd* starred an insanely charismatic
Andy Griffith as a country singer and raconteur turned televised force
to be reckoned with. The movie's title comes from the radio show out of
northeast Arkansas that ambitious producer Patricia Neal puts on: "Whose
face?" she says on air. "It could be yours, or yours, or yours"—the quint-
essentially American idea that anyone, everyone, can be propelled to fame
through media. But of course, the movie suggests, this isn't true: you need

a) a genius for performative authenticity, pretending to be just another face while really grasping what the crowd needs; while b) tethered to an utter lack of moral compass. Griffith demonstrates plenty of both qualities, as he becomes a kingmaker, first in commerce, and then American politics; and it is only when his contempt for his audience is revealed—in one of the most iconic open-mic moments in movies—that the monster is defeated.

Even the most cherished myths of American history were being revisited: John Ford, the lauded director of some of the most iconic Westerns of the first half of the century, was transforming a standard noble quest into a kind of obsessive, demonized vengeance in 1956's *The Searchers*. The movie wraps one of America's earliest types of tales of fear, a Native American captivity narrative, in a double bind. On the one hand, it continues the old strategy of presenting Native Americans as perpetrators of atrocity. The lead searcher, played by another icon, John Wayne, ramps up the horror, making us use our imaginations when he refuses to describe one of the desecrated bodies that he sees that we don't: "What do you want me to do? Draw you a picture? Don't ever ask me! As long as you live, don't ever ask me more!" But the movie's hardly straightforward in its assaults: at the same time, Ford presents Wayne as a bone-deep racist, a Confederate veteran and refuser of Texas Rangerhood, who's willing to kill the young woman he's been searching for because, among other reasons, "she's been livin' with a buck."

And it wasn't the only movie interested in taking a searching look at the West and its treatment of others. *The Searchers* was released the year after Spencer Tracy, in *Bad Day at Black Rock*, had discovered that Western town's terrible secret, the anti-Asian racism that led to a hateful murder of an innocent man—one of the few, albeit admittedly comparatively oblique, examinations in contemporary popular culture of the wartime internments. "Loyal Japanese-Americans, that's a laugh," one character scoffs to Tracy. "They're all mad dogs . . . To us, this place is our West, and I wish they'd leave us alone." Nativism and racism, twisted around and around one another, in the name of "true" Americanism, generating anxiety on all sides of the equation.

And the writers that shaped the era responded. The South, of course, had had the dubious advantage of balancing hallucinatory reality and

grounded nightmare for generations; and their artistic influence had continued long past Faulkner's Mississippi. Tennessee Williams was the era's presiding playwright, working in what we might call Hothouse Gothic; this dramatic format is built to expose buried truths to light before the curtain goes down, and Williams provided classical madness wrapped in lush drawls and palmettos, desire under the elms. "Most people's lives are trails of debris, with nothing to clean it up but . . . death," Katharine Hepburn drawls in the 1959 film version of Williams's *Suddenly, Last Summer*, which could serve as a kind of artistic manifesto for the approach.

Williams, for his part, blurbed a novel by Carson McCullers, that writer who'd tried to define the Southern Gothic just a few years earlier. He wrote that her *Reflections in a Golden Eye*—in which a woman, discovering her husband's affair, cuts off her nipples with a pair of garden shears—"is conceived in that Sense of the Awful which is the desperate black root of nearly all significant modern art."[3] Williams obviously gravitated to McCullers's theatrical qualities: there's something very Oedipus-like about that scene, after all. But he wasn't the only one. Another McCullers novel, *The Ballad of the Sad Café*, which focused on a particular angle of contemporary American anxiety—individuals' alienation from one another, their inability to communicate[4]—was adapted for the stage by Edward Albee. It wasn't hugely successful there, though; and was definitely overshadowed by Albee's own remarkable *Who's Afraid of Virginia Woolf?*, which certainly fits that bill of A Nightmare of Unreality usurping the real.

Woolf, when it premiered in 1962, was rapturously controversial for some reasons that no longer apply: it's hard to imagine, now, a phrase like "Hump the Hostess" or extended discussions about impotence having the same frisson they did then. But in terms of its horror, it still hits, and hits hard. *Woolf*, more than anything, is about the illusions that we all create to allow ourselves to live—here, the illusion an older couple has created of a child they couldn't have—and the rules that allow that illusion, theirs and ours, to be maintained. Over the course of the evening—and one of the play's acts is titled Walpurgisnacht, a night where evil gathers—those rules are broken, and illusions are ripped away to face the cold light of morning at the play's end. The older couple, George and Martha, are monstrous,

and it's possible to see this as a sixties vampire story: George and Martha as vampires, feeding on the young husband and wife with their game of "Get the Guests." But ultimately the younger couple are extraneous: they've been draining themselves all along, and the only way for them to find peace is to stake themselves through the heart, when George "kills" the child. It is a sad and savage and brutal work, and is one of the great works of art of the past century.

Woolf's title is taken from a joke told at a recent faculty party referred to in the play; and for some, the only possible response to the pressures of the age was to mix horror and humor: either it's a scream, or you will. Trying to put his hands around the phenomenon, and to name it, just a few years later, Bruce Jay Friedman wrote, in his introduction to the seminal 1965 anthology *Black Humor:* "What has happened is that the satirist has had his ground usurped by the newspaper reporter. . . . The novelist-satirist, with no real territory of his own to roam, has had . . . to sail into darker waters somewhere out beyond satire and I think this is what is meant by black humor."⁵ And though the anthology, by definition, consisted of short selections, the approach was encapsulated by a novel: a masterwork of black, bleak comic horror, taking down one of the most recent, most cherished comforting American myths.

Joseph Heller's 1961 novel *Catch-22* took its title from the deflation into absurdity of the military operation that had defeated Nazism: to fight was insane, since it was asking for death, but asking not to fight meant you were, by definition, sane, and so you had to fight . . . and round and round it went. The novel featured higher-ups who were happy to throw men into the air as cannon fodder, nest-feathering officials who risked soldiers' lives for their own profits, and other soldiers who had genuinely gone mad. A contemporary critic wrote of the novel that in addition "to being an outraged cry against the System," it was often a "wildly funny book," but with humor of "a rather special, barbaric type," which led to the reader being:

> jerked up suddenly by the realization that he is snickering at pain, insanity, and violent death modern reads unusually demand that horror and humor be kept distinct . . . Heller cares nothing for

our sense of fastidiousness or our sense of decorum, however. . . .
The point he wishes to make is that our world is not neat and sym-
metrical, but bizarre and absurd.[6]

Heller wasn't the only one revisiting the war, almost a generation after
VE Day. The year 1960 had been a turning point in looking back. William
L. Shirer's massive history *The Rise and Fall of the Third Reich* had come out
that year. So had Elie Wiesel's *Night*, in English translation. Edward Lewis
Wallant's 1961 novel *The Pawnbroker*, soon made into a movie by Sidney
Lumet, brought the trauma home, telling the story of Sol Nazerman, a
walking dead man in New York City. A Holocaust survivor, Nazerman's
family had died in the war, and their deaths—and his own suffering in a
concentration camp—tempts him to believe his soul has gone as well, and
that life is meaningless, even absurd. The novel is dedicated to exploring
any possibility of revitalization.[7] And on May 20, 1960, a television writer
and producer named Rod Serling had put on a TV play, *In the Presence of
My Enemies*, about the Warsaw Ghetto uprising.[8]

Rod Serling, of course, was far better known for another work of televi-
sion that had premiered the year before: one whose title embodied the state
of unreality Americans seemed to be finding themselves in. *The Twilight
Zone* was, and still is, iconic for a clutch of episodes that, at their best,
remain some of the most effective examples of the shock-twist or ironic
ending on the small screen, a feature that, in retrospect, has frequently
been taken to epitomize the ethos of the series as a whole. A good number
of them were written by writers we've seen before; Charles Beaumont and
Richard Matheson had dozens between them.[9] The 1960 episode "Eye of
the Beholder," for example, had viewers waiting to see whether a surgical
operation to make its patient look "normal" had succeeded—but when the
bandages were unwrapped, revealing a beautiful woman, they learned it
was a failure: she was hoping to look pig-faced, like everyone else. "Time
Enough at Last" (1959) featured a mild-mannered man who, surviving a
nuclear holocaust in a bank vault, finally has time to do all the reading he
wants—only to break his glasses on the way to the library.

But, equally if not more frequently, the series served as a megaphone for

Serling's moralism: he'd turned to "the dimension of the imagination," as he intoned in the *Zone*'s introduction, in no small part thanks to network censorship of some of the more directly outspoken work he'd produced for the medium.[10] In 1960's "The Monsters Are Due on Maple Street," for example, he employs aliens to show that the real threats to human civilization come from within, which he makes clear in his narration that closes out the episode:

> The tools of conquest do not necessarily come with bombs and explosions and fallout. There are weapons that are simply thoughts, attitudes, prejudices . . . to be found only in the minds of men. For the record, prejudices can kill . . . and suspicion can destroy . . . and a thoughtless, frightened search for a scapegoat has a fallout all of its own—for the children and the children yet unborn. And the pity of it is . . . that these things cannot be confined to . . . the Twilight Zone!

So as entertaining and, yes, as scary as *The Twilight Zone* could be—and it could certainly be both—it lacked the bite, the snap, that was increasingly characterizing the most unsettling material of the age: material that would, to be fair, have been impossible to present on television then. Material that characterized the comedy of the period critics were calling "sick," that dealt with content too taboo to be discussed on television or that handled it in ways too confrontational to be aired in the living room, ways that supped of the absurdist humor and horror of *Catch-22*. It was the approach, for example, that animated the jokes that circulated in Wisconsin around the time that Ed Gein's crimes became more widely known. "Gein-ers," as they were called statewide: "pseudo-humorists trying to outdo each other with the 'latest.'" As one contemporary critic wrote:

> All ages participated in the humor, and before the Christmas holidays, the children were chanting, to the tune of the "Night before Christmas," "The teachers were hung / from the ceiling with care / In hope that Ed Gein / soon would be there." Their favorite carol

was paraphrased: "Deck the halls with limbs of Mollie.'" "His telephone number was O-I-C-U-8-1-2"; "As a hearse went by he said: Dig you later, baby." And so on.[11]

This was the kind of humor exemplified in the scabrous, finger-in-the-eye, laugh-and-scream approach of Lenny Bruce. One of the bits he did in his act traded explicitly on horror: in a moment that Edward Albee might have called "Get the Babysitter," he would cajole a couple out for the evening to let him call their babysitter, inform the answering young teenager that there had been a car accident and both parents had died, and allow the audience to hear the screams as he hung up and laughed hysterically. Or—addressing another horror—when he held up a fake newspaper in his act reading SIX MILLION FOUND ALIVE IN ARGENTINA.

Argentina, of course, was where Adolf Eichmann had been captured in May of 1960,[12] and his trial in Jerusalem took place the subsequent year. Hannah Arendt's reporting on the trial for the *New Yorker* was widely discussed in light of Eichmann's famed ordinariness: that the bald-headed, bespectacled man in the glass booth could be a prime mover in the gears of genocide. Was this what a monster looked like? Even seemingly ordinary-looking Norman Bates ended up dressing up in a fright wig and keeping mummified mothers. It seemed absurd. Banal. Almost ridiculously offensive to any sense of narrative proportion.

But in a world in which, just a year and a half after Eichmann's execution, a lone loser could take out the president of the United States from the Texas Book Depository, who was to say that those established senses of crime and punishment, the ones EC—for all their capering glee—upheld, still obtained? A critic four years later, reviewing William Manchester's *The Death of a President*, put the event's connection to black comedy clearly: "The assassination was more than tragic; it was also, at least in appearance, overwhelmingly absurd. Oswald was one of the most insignificant and contemptible of men, and he destroyed a powerful and appealing world leader . . . For three-and-a-half years America has lived in the shadow of this absurdity."[13]

There had been hints, intimations, of this sensibility even before the

assassination, of course. All the way back in 1953, Flannery O'Connor had published her terrifying "A Good Man Is Hard to Find," about a family of six murdered in the woods by a trio of escaped convicts, despite their pleas and protestations, for being in the wrong place at the wrong time. The story's focal protagonist, a faith-filled grandmother, might hope for the possibilities of grace, but the story suggests that such grace can be elusive at best.[14] As they were reading about the heavily psychologized Gein case, Americans were also reading about the Starkweather murders, where a pair of drifters attached to one another went around largely shooting strangers at random. This wasn't the greedy evil of the Benders or the Murder Castle or the Lonely Hearts Killer; it wasn't the carefully crafted perfect murders of the noir villains. This was—or at least seemed to be—something different. Something random. Something more like the mysterious man who was murdering women in Boston, thirteen of them between 1962 and 1964, entering into—but not breaking into—their homes, a violation alongside the sexual assaults he generally committed. Because of his preferred method of murder, they called him the Boston Strangler.

Perhaps the most pointed cinematic articulation of this ethos took place about six months before Kennedy's murder in Dallas, premiering shortly after the Strangler killed his first victims. Apparently the first cinematic treatment of the Starkweather case, *The Sadist* was created by the team behind *Eegah*, a 1962 movie about a modern-day caveman. *Eegah* is almost, although not quite, as bad as it sounds (trust me), but the *Sadist* is genuinely terrifying. At its essence, *The Sadist* is a movie about a group of nice people on their way to a Dodgers game who take a wrong turn and meet some very bad people, and are almost all killed for no apparent reason. The titular character tells a man—a father, begging for his life—that he is going to finish his soda pop, and then he is going to shoot him in the head. And then he finishes his soda, and he shoots him in the head.

The banality of evil notwithstanding, Nazism attempts to explain away its crimes by the pitiful shelter of an ideology, repugnant as that ideology is; here, however, the killers kill because they can, and they like to, and that's it. "You can't shoot me like this for no reason. For nothing. Surely blowing my head off can't give you a thrill," the father says. But he does: and, yes, it

does. End of story. "I told you nobody can help you," the killer says, later, to another of the innocents, articulating, in the process, one of the central pillars of the modern horror movie: the idea that hope is an illusion, a dream for those foolish enough—personally, societally—to cherish it. And although one girl finally does escape—in a pattern we will see repeated so often it will become a type-scene—she doesn't, really. The terrible, traumatic price she pays in surviving haunts her, and us.

The Sadist would find its echo a few years later in a chronicle of homicide vastly better known. Truman Capote's "true account of a multiple murder and its consequences," *In Cold Blood,* was serialized in the *New Yorker* in the fall of 1965 and became a Book of the Month Club selection the following year. A contemporary critic called its material "a frankly brutal and sordid subject, one which could just have easily languished in the pages of *True Detective* and *Police Action*," but Capote's "gifts and powers" turned what was "fundamentally a blood and guts story" into a work of literary art.[15] Capote's story was of two men who murdered an entire household in 1959, ostensibly as part of a robbery but in fact simply because they could: the book includes, toward the end, the observation that the crime was "virtually an impersonal act": the solid, law-abiding, good old American Clutter family "might as well have been killed by lightning." Except that a lightning strike is quick: and, as Capote and the investigation he describes illustrate, their deaths were full of suffering and terror. And Capote, in the vivid and telling prose that would earn him entrée into the highest precincts of New York intellectual and social society and later eject him just as definitively, describes how that terror rippled out throughout the town: the news created "amazement, shading into dismay; a shallow horror sensation that cold springs of personal fear swiftly deepened" and "many old neighbors viewed each other strangely, and as strangers."[16]

And that fear continued to expand, far beyond Holcomb, Kansas, where the Clutters were killed; beyond those California freeways where the Sadist roamed; becoming, it seemed, more than a set of sporadic occurrences, small lightning strikes over a vast continental area, but something seeping into the water of everyday life. Ultimately, literary efforts like *In Cold Blood* needed to provide narrative closure and, if possible, an explanation.

But that was something too much of recent history, in its randomness, its absence of motive, seemed to be entirely unable to provide. Why did Oswald kill Kennedy? What was his motive? Jack Ruby shot him, so we'll never know. And in the absence of motive, we have absence of meaning. And that absurd vacuum lets a new kind of horror rush in. Robert Kennedy, shortly before *his* death, said, "I can't plan. Living every day is like Russian roulette."[17]

UNSURPRISINGLY, MANY WRITERS, NOT WANTING the weight of too much reality, looked elsewhere. One of the theme's greatest exponents was Jack Finney, he of *The Body Snatchers*, whose fifties short stories like "The Third Level" and "Such Interesting Neighbors," collected in 1957, have, at their core, the desire to escape. The former's narrator, told he wants to escape from the "modern world [which] is full of insecurity, fear, war, worry and all the rest of it," responds: "Well, hell, who doesn't? Everybody I know wants to escape," and does so, via an (almost certainly) nonexistent third level of Grand Central Station that takes him to the good old 1890s. "Such Interesting Neighbors" tells the same tale in reverse; there, the escapists are from the future, making their way to the present. "The Third Level" is a fantasy with anxiety at its core: his story "I'm Scared," though, which puts fear right up front, is about how "for the first time in man's history, man is desperate to escape the present," and so the "terrible mass pressure [of] millions of minds struggling against the barriers of time" leads to time itself going mad, with terrible effect: one of the best of the story's many vignettes is a married man finding a future photograph of himself, a family portrait with a woman he's never met.[18]

Time, in its varieties, had become the enemy. Like Joseph Heller, the visionary science fiction writer Philip K. Dick also returned to World War II—but 1962's *The Man in the High Castle*, released exactly a year after *Catch-22*, displaced its terrors into a counterlife, a world in which the Nazis won and the United States has been carved up between Axis powers. A character, in lines that landed quite differently after Dallas, wonders if this, or indeed any, history can be altered: by either "one great figure . . . or someone strategically placed, who happens to be in the right spot. Chance.

Accident. And our lives, our world, hanging on it."[19] The imagined terrors of alternate history, often chillingly downplayed by Dick (as opposed, for example, to the fervid war-era treatment of similar territory by an earlier writer, C. M. Kornbluth, in a novella tellingly titled "Two Dooms"), are always balanced by the reader's knowledge: *It didn't happen here.*

Ray Bradbury, one of the most widely-read authors of fantasy and science fiction, had largely retreated from his lyrical and fantasy-oriented tales of Space Race science fiction to write shadowy (albeit no less lyrical) mirrors of the American world he'd grown up in, producing a dark fairytale in 1962's *Something Wicked This Way Comes. Something Wicked*, which is about an evil carnival that comes to an All-American town and preys on the dreams of its denizens for youth and adventure, savors of Twain and of *Freaks*, but imports contemporary preoccupations: the carnival's carousel—that spins and spins, and when it stops, you're a lot younger, or older—is not only a perversion of fond childhood memory but a central metaphor for how the novel's characters long for the *then*, not the *now*. Much of the novel's pathos revolves around the agonies of an older father who feels alienated from his son as a result of his age. While his victory comes when "he accepted everything at last . . . above all himself and all of life," that acceptance is dearly bought—and clearly hard, for everyone at the present moment, to attain.[20]

Seeking comforting fears, old-fashioned things, audiences in the mood for horror flocked to movies featuring adaptations of Poe by the yard, most of them done by Roger Corman. Corman had started his career making fifties B movies with science fiction themes like the radiation-filled *Attack of the Crab Monsters* and the alien vampires of *Not of This Earth*; his stable of writers included those mid-century masters of fantasy, Richard Matheson and Charles Beaumont. But in 1960, he moved from quick-and-cheapies like the delightful (and deeply Jewish) 1960 horror-comedy *Little Shop of Horrors*, which featured a young, masochistic shaver named Jack Nicholson and which was shot *in two days and three nights*, to luxurious depictions of castles and coffins. *The Fall of the House of Usher* (1960), the first in a cycle that lasted until 1964's *Tomb of Ligeia*, got him his first *Times* review, aided inestimably by the performance of Vincent Price, who would become a regular.[21]

Some leading expositors of the horror of *then* struggled to articulate this appeal of the old-fashioned. August Derleth, introducing a 1962 Arkham anthology of classically minded horror tales, noted that a publication of this sort "in this nuclear age, the potential horrors of which far exceed anything heretofore conceived in the creative imagination of man, seems almost an anachronism."[22] But for others, that was just what the doctor ordered. Noted American conservative thinker and critic Russell Kirk, in an essay appended to his collection of ghost stories, *The Surly, Sullen Bell*, published the same year, took on the modern condition head-on:

> Having demolished, to their own satisfaction, the whole edifice of religious learning, abruptly and unconsciously they experience the need for belief in something not mundane; and so, defying their own inductive and mechanistic premises, they take up the cause of Martians and Jovians . . . A return to the ghostly and the Gothick might be one rewarding means of escape from the exhausted lassitude and inhumanity of the typical novel or short story of the sixties.[23]

For their part, paperback publishers agreed with Kirk, pumping out a steady stream of books in what Joanna Russ, a decade later, would call the Modern Gothic. These books, by writers like Dorothy Eden and Anne Maybury, published in paperback by companies like Ace and Fawcett with covers featuring terrified young women in the foreground and a castle with one lit window in the back, were in the tradition of *Jane Eyre* and Daphne du Maurier's *Rebecca*, featuring, mostly, "women who marry guys and then begin to discover their husbands are strangers . . . it remained for U.S. women to discover they were frightened of their husbands."[24] The Gothic even came to daytime television in 1966, in the form of the soap opera *Dark Shadows*, which started as a kind of American *Jane Eyre* but really took off when they introduced a vampire, Barnabas Collins, into the mix less than a year in. Collins became an idol to the intellectual and the romance-seeking alike, and the show ran for 1225 episodes over five years, adding a coterie of other monsters to the mix along the way.[25]

They weren't the only monsters on television in those years. Charles Addams's cartoons became a televised family in 1964, as did a motley conglomeration of Universal-esque monsters called *The Munsters*. These wild and wacky variations on a theme—Gomez and Morticia from *The Addams Family* doing the cha-cha, Herman Munster's Frankensteinian shakes and belly laughs—were the televised versions of those late fifties songs like "Dinner with Drac" and "The Monster Mash." After prime time, at the movie theater, you might check out the silliness of the midnight ghost show: one of its titles—1965's *Monsters Crash the Pajama Party*—says it all, alongside the girl being brain-transplanted into a gorilla and the pants-dropping werewolf assistant. (I think, given the site-specific nature of the theatrical experience, you really had to be there.) Monster terrors had resolved into a suffusion of warm nostalgia, symbolized best, perhaps, by Forrest Ackerman's fanzine *Famous Monsters of Filmland*, founded in 1958. By the early sixties, it was advertising the Aurora company's famous Glows in the Dark monster model kits: perfect for providing a warm, comforting light around bedtime.

Back at the beginning of the fifties, old-time film star Gloria Swanson, playing old-time film star Norma Desmond, had suggested, in one of moviedom's most famous lines, that *she* was "big. It was the pictures that got small." Billy Wilder's 1950 masterpiece *Sunset Boulevard* was released at the beginning of the television era: and although Swanson doesn't mean that they're on TV—she's still screening her pictures in her manse's gloomy screening room—a dozen years later, Joan Crawford, who we last saw in Tod Browning's *The Unknown* opposite the first Lon Chaney, was getting pleasure watching *her* old movies on the television screen. Both *Sunset Boulevard* and 1962's *Whatever Happened to Baby Jane?* are, in their own ways, about the decline of earlier cultural institutions—the classic age of Hollywood and vaudeville, respectively—and an indictment of the audiences who underwrote one of the greatest fears of women in the movies: getting old and getting small. It was enough to drive you crazy; at the end of *Sunset Boulevard*, Swanson, after shooting boy-toy William Holden, wanders toward the camera, ready for her close-up, in dissociative fugue and unable to distinguish between life and film: the expression on her face,

as Wilder has her come closer, and closer, and closer, is a hungry one, ready to just eat her viewers up, and why not? We, all of us, have consumed her, and then spat her out once we were done with her, to let her molder in her old mansion. But *Sunset* was, for a while, a kind of magnificent one-off. It would take Crawford and another great old Hollywood star, Bette Davis, working in tandem, to generate the liftoff for a trend: the psychological traumas unearthed in *Baby Jane*—with roots in Albee and *Psycho*—found purchase in one of the most important new subgenres in the horror film business, repurposing female Golden Age Hollywood stars put out to pasture, in movies that combined the Southern Gothic and the haunted house: it became known eventually, and not very complimentarily, as "psycho-biddy."

Whatever Happened to Baby Jane? is a question that has several different answers. Jane, played by Bette Davis, is hobbled not only by her early vaudeville stardom being overshadowed by her sister's film success, but also by her own guilt in the automotive accident that ended her sister's career and, in some sense, both of their lives—curdled into a caretaking role that, as the movie unspools, moves from passive-aggressiveness to something increasingly rancid (including serving her sister some of the most unappetizing meals put on film to date: you will *not* look at a covered serving dish the same way ever again).

Davis's resentment leads to her living in the past: an old woman, who insists on going by her vaudeville name Baby Jane—and dressing up like she did then, and putting on her child act—is obviously grotesque, and once more conjures up the specter of aging, particularly women's aging, as a horror show of its own; but the movie has some twists in store for us, and we discover that *Sunset Boulevard* and *Who's Afraid of Virginia Woolf?* aren't the only works that show that the lives we've constructed for ourselves are an illusion. Davis's life, lived in service to a sister she always believed she crippled, turns out to be based on a lie; and the expression she has when she ultimately discovers it is both liberating and terrible.

Movies like *Hush, Hush . . . Sweet Charlotte*—which features a behanding, and a subsequent beheading, with a meat cleaver—and *Strait-Jacket*, among others, would draw on the earned capital by stars like Crawford,

Olivia de Havilland, and especially Bette Davis. They tended to follow *Psycho* in their emphasis on the terrors of family and of personal discovery. This psychological emphasis might not have been comforting in the details, of course; but it offered the solace, contra Oswald and *Catch-22*, of explanation. Theodore Sturgeon's magnificent 1961 novel, *Some of Your Blood*, is one of the most indelible portraits of a vampire ever created: nary a trace of the supernatural anywhere to be found, the compulsion for blood—female blood—emerging in a detective story between psychological, not psychic, investigators. Which is not to say it doesn't shatter taboos: it becomes clear, by novel's end, the central character has satisfied his blood compulsion by drinking his wife's menstrual blood.[26]

But that sense of the modern absurd was creeping in, of the motivelessness of the Starkweathers and Heller and *The Sadist*, will it or no. A 1962 version of Kafka's *The Trial* and the following year's version of Jean Genet's *The Balcony* took their cues from those European master portraitists' depictions of a chaotic, occasionally random, and apparently hostile world; closer to home, the brilliant, discomfiting oddity of 1962's shadowy *Carnival of Souls*, complete with haunting, clutching, odd-eyed figures who came for the protagonist who had literally died but didn't know it yet, was an "Occurrence at Owl Creek Bridge" for the car-crash era. For Bierce, though, the whip-crack of the twist is like the hangman's rope; in *Carnival of Souls*, it's more like drowning; it creeps up around your neck and fills you and you suffocate and get suffused in it, a supernatural equivalent of the rising sense that states as basic as life and death were becoming unmoored.

Sam Fuller's 1963 *Shock Corridor*, by contrast, took the lineaments of the psychology movie—reporter goes undercover in a psych ward to try to find a murderer—and, as he ends up cracking, suggests that it's not madness that's infectious, it's reality. His breaking point stems in no small part from the fellow inmates who recount a catalog of tales that reveal the corruptions at the heart of the American myth—not least, in a tragedy that Dave Chappelle would, many decades later, repeat as farce, that of a Black man who integrated a Southern university and was so abused there he's now internalized it all, and imagines himself, in his only escape, to be a member of the Klan. What drives him mad, the movie suggests in its darker truth,

is the fact that it's America that's mad, and even the strongest psyche would have a hard time staying sane. Fuller appends the same quote, misattributed to Euripides, to the beginning and end of the movie—"Whom God wishes to destroy he first makes mad"—and we're left with the unsettling notion that Fuller is talking about a country, not a person, and that American insanity is the precursor to American destruction.

Perhaps the clearest exception that proved the rule, though, was a new entry by the old master himself. Hitchcock's *The Birds*, released several months prior to the Kennedy assassination, did its best to produce an impression of a world gone utterly bugfuck. The movie's most famous frights are the titular birds, turned homicidal for no apparent reason, pecking and diving and crashing through the windows, or just staring ominously at the characters as they run for shelter. (In one shocking scene that updates the climax of *Psycho*, we see another figure with no eyes—this time with streaks of blood running from the sockets, in living color. The birds have been at him, you see.) But the most *telling* scene of the movie is the one in which a fairly sedate city block is transformed, within seconds, into a terrifying inferno. "I hardly think a few birds are going to bring about the end of the world," says an old biddy a minute before, and the movie puts it to a lie: *You see*, Hitch says, with his finger on the pulse, *you see, that's how easy it is. Something is . . . in the air, and everything can turn just like that.* The movie's inconclusive ending, *Time* magazine wrote, "traded in his uncomplicated tenets of terror for a new outlook that is vaguely *nouvelle vague*," but it was less a look to Europe's New Wave cinema than it was a statement of the irresolute sense of American reality.[27]

The sensibility would only grow with the decade—along with a new generation, and the yawning gap it increasingly felt from its parents.

IN 1963, THE SAME YEAR *The Birds* was released, a man named Edward Gorey published a quite unusual children's book. Gorey, who claimed to have read "Alice and Dracula the same month, I guess, at between 5 and 7," was the brilliant cartoonist responsible for *The Gashlycrumb Tinies*, "an alphabet book composed of a series of twenty-six disasters that happen to toddlers," drawn in Gothic style. It was an inside-out look at the fears and dangers of childhood, rendered in grotesque deadpan,[28] and, in sentiment

and style, mixed Roger Corman's Poe adaptations with Lenny Bruce's sick comedy.

But Gorey's comic warnings of early childhood misfortune were hardly what parents were worrying about these days: the boomers were now fully heading into teenagerdom and young adulthood, and their cries were of a very different sort—the shrieks of Beatlemania, where wild, primeval forces seemed to be possessing them, making them scream and wail and move their bodies with abandon. A rebellious spirit seemed to be in the land: and its presiding forces were increasingly willing to slaughter sacred cows, and its voices were becoming increasingly strident.

One of the most pugnacious belonged to another young, Jewish Depression-era kid turned writer for the genre digests named Harlan Ellison. Ellison served an apprenticeship by churning out yards of perfectly serviceable SF and fantasy and some true-crime stuff, running with the street gangs, until he buckled down in the mid-sixties and decided to become the voice of Where It's At and Where We Don't Want It To Be. His 1965 story "'Repent, Harlequin!' Said the Ticktockman" sketched a nightmarish extrapolation of the gray-flannel-suit fifties, a future society regimented by time and order where everyone has a cardiac timeplate that counts away their lives in ticks. But there's a voice of resistance: the brilliant prankster, Harlequin, who appears and gums up the gears by (among other techniques) throwing jelly beans into them, a combination of Henry David Thoreau and the Three Stooges, extending a stiff middle finger to the proprieties:

"Repent, Harlequin!" said the Ticktockman.
"Get stuffed."[29]

Which landed harder in the mid-sixties than it does today.

Harlequin dies at the end. Of course he does. If science fiction, as one of its founding deans suggested, is an exploration of the consequences of "If This Goes On—," Ellison is often doubtful about the proposition that you can fight city hall and actually win. But Ellison, a crusading young liberal who would rightfully remain proud of marching with the Freedom Riders, ends "Harlequin" with an intimation that the Ticktockman is out

of tune and off-time, that society is open to the possibility of change. And that change was happening not in some dystopian future, but now, and all too often it came at a terrible, fearful cost. Like the one paid by civil rights activists murdered in Mississippi in 1964, whose bodies were discovered in an earthen dam seven weeks later, one of whom was castrated premortem and one probably buried alive. Or the one paid by nonviolent protestors when the Commissioner of Public Safety in Birmingham, Alabama, happily ordered the use of police attack dogs against them the year before.

Old Hollywood, with its traditional "message picture" approach, tried to tackle the subject in a movie that nodded at the anxieties, fears, and, yes, prejudices around civil rights—albeit in a far less violent setting—while trying, eventually, to suggest a happy, classically liberal ending. *Guess Who's Coming to Dinner?* (1967) borrows the questioning rhythm of its title from the horror movies of earlier in the decade; and its plot revolves around one of the classic formulations of racial panic and anxiety—the "But would you let one marry your daughter?" question. And, in doing so, raising the specters of miscegenation we've seen in film since *Birth of a Nation*, and long before that in literature. And, to be clear, this was hardly a settled, or historical, issue: while the movie was in production, interracial marriage was still illegal in seventeen states, before the Supreme Court struck down laws prohibiting it nationwide, in *Loving v. Virginia*.

The movie gives moviegoers' older generation, embodied in the iconic real-life partners Katharine Hepburn and Spencer Tracy, license to let their fears and prejudices show before overcoming them, all in one movie-length session. Of course, as many pointed out, when your daughter's fiancé is a highly distinguished doctor—and played by Sidney Poitier, no less—the movie stacks the deck, more than a little bit. Technically, the "who" in the movie's title refers to Poitier's parents, and in a fiery address to his father, Poitier lays bare the whole generational game:

> You are thirty years older than I am . . . you and your whole lousy generation believes the way it was for you is the way it's got to be! And not until your whole generation has lain down and died will the deadweight of you be off our backs!

That's the vocabulary of haunting, there; but it also hints at the possibility of exorcism, burying the past once and for all. In that sense, it's idealistic. A far less well-known movie, though, released three years earlier in the throes of the civil rights struggle, suggests darker currents, in a manner that opens up another frontier in our story.

Herschell Gordon Lewis's 1964 movie *Two Thousand Maniacs!* can best be described as *Brigadoon* meets *Birth of a Nation*: it's about the ghost of a Southern town that appears only every hundred years, and does so, basically, in order to lure in Northern travelers and kill them as revenge for their being wiped out by Union troops during the Civil War. "We gonna show you some Southern hospitality!" the charmingly bloviating mayor says to some soon-to-be deceased guests, and *Two Thousand Maniacs!* is also about the way in which resentments curdle and breed violence that turns homicidal, about the way that old national wounds have not only resolutely refused to heal, but are, in fact, getting worse. The movie opens with a song, set to banjo music, with the lyrics "The South is going to rise again," and some children strangling a cat labeled "Damn Yankee." It does not seem like an issue on its way to resolution.

But director Lewis was not just interested in killing his cinematic victims but also in *how* to kill them: and the answer was gorily. Extremely gorily. The explicit representation of violence has been part of our story since those first captivity narratives, and certainly the EC comics didn't skimp on the grue; but most mainstream material, for reasons of publishing constraints and marketing appeal, had been fairly demure, especially on film. That was about to change. Yes, there was a bit of axe murdering and severed-head rolling in Francis Ford Coppola's 1963 directorial debut, the psychologically dubbed *Dementia-13*, a movie that, in its stalking, lurid, suspenseful camerawork, helped set the visual grammar of hundreds of slasher movies to follow. But it was Lewis's movie of that same year, *Blood Feast*, that went where *Psycho* feared to, or was uninterested to, tread. It begins with a woman taking a bath; and though the radio issues a warning for women to lock their doors, she gets the word too late. A madman stabs her through the eye—and Lewis shows the knife pulled back, with flesh and organ hanging off it in gobbets. And then he stabs again, and again,

and saws off a limb and takes it with him. "The body looked like Jack the Ripper had gotten to it," the homicide detectives say to one another. In some movies that would be left to the imagination; Lewis is dedicated to the proposition that imagination need not apply.

And *Two Thousand Maniacs!*, along with the rest of Lewis's oeuvre, is genuinely groundbreaking in terms of the viscerally disgusting material they put on screen. Suffice it to say that one line from *Maniacs!*, "I reckon we got the makings of a barbecue!" is not referring to pork, and adds the trope of cannibalism to the backwoods Southern Gothic. (Lewis worked in advertising by day, and produced, among other works, instructional videos on how to carve roasts for Armour meats.)[30] And, perhaps even more important, and more disquieting, is the absolute glee of the spectators at these terrible deaths; implicating not only them, but us, who watch for, as much as any other reason, the next kill. We may object to our implication in the process: but suffice it to say that that first movie, *Blood Feast*, made six or seven million dollars off a fifty-thousand-dollar budget in its years playing on the grindhouse circuit, and made Lewis a million for himself.[31] That line about the barbecue also implies, of course, humor alongside the horror: and that terrible, terrifying love affair with death in conjunction with joking about it poked its head up in a new treatment of an ongoing fear. Because, after all, if the Civil War hadn't gone away, the Cold War certainly hadn't, either.

You could, if you wanted, find the same strain of psychological horror transfused into a geopolitical setting. Lawrence Condon's 1959 novel *The Manchurian Candidate*, made into a very effective movie in 1962 starring Frank Sinatra, featured an all-American POW and war hero who was brainwashed by the Commies into attempting to assassinate a presidential candidate; one of its most effective scenes shows the hypnotized soldier calmly killing members of his platoon—while they, also hypnotized, sit there calmly as their death approaches. But that was baroque. Americans were a lot less worried about posthypnotic fifth columnists than about the fact that the Soviet Union had put nuclear missiles ninety miles off the Florida coast that could reach America within minutes—and, in October of that year, almost did. Also that same year, *Panic in the Year Zero* showed

how quickly civilization could collapse, how the calendar could be rolled back; the United Nations, or what's left of it, anyway, declares this the "Year Zero," and the president says "there are no civilians anymore; we are all at war." And the movie, which then features the violation of a, well, nuclear family, and the revenge of that violation, in its own way anticipates a number of rape-revenge movies to come.

But that was not the only conflation of sex, violence, and nuclear death, not by a long shot.[32] There is a fine, clear moment at the beginning of *Fail Safe*, Sidney Lumet's 1964 movie about an accidental nuclear exchange, where Walter Matthau, playing a policy-minded scientist, has picked up a woman at a Washington party and is driving her back for a casual encounter. (Something felt new there, too.) "There won't be any survivors . . . that's the beauty of it," she tells him. "People are afraid to call it that, but that's what they feel." Matthau then calls off the encounter: though he has just been casually discussing megadeaths over cocktails, he's deeply disturbed by the way his romantic partner is clearly getting off on the idea of death, positively panting for it.

That look into the abyss and its attractions occurs more broadly, and more famously, in another movie based on the same source material. Stanley Kubrick's *Dr. Strangelove or: How I Learned to Stop Worrying and Love the Bomb* is most obviously considered as another example of Joseph Heller-esque black comedy, now supersized for the nuclear age: George C. Scott's general, insisting on turning an unplanned nuclear bombing into a full-fledged preemptive first strike, refers to a possible death toll of ten to twenty million Americans by saying, "I'm not saying we won't get our hair mussed." In *Fail Safe*, Henry Fonda's presidential humanity is literally a saving grace: he wards off a full-scale nuclear war with the Russians, when it proves impossible to prevent a final missile from destroying a Russian city, by giving the order to drop a bomb on New York City—where his wife is currently visiting. This is contrasted, explicitly, with the technological failure that catalyzes the movie: "Something failed, a man, a machine, it was bound to happen, and it did," the general says, articulating the movie's ethos, and reminding us that the title, *Fail Safe*, is a contradiction in terms." In *Strangelove*, by contrast, we are forcibly reminded that, even without the

chain-reaction circumstances that lead to the movie's ultimately (an)nihil-
istic ending, it's humans who are clearly to blame, and that question of the
survival of all life on earth has come down to a vanishingly small number
of people—who probably won't demonstrate Henry Fonda's presidential
qualities. "I admit the human element seems to have failed us here," Scott
memorably says in the War Room, with devastating understatement.

And humanity wasn't giving a very good account of itself outside the
War Room, either, as the decade went on. In August of 1965, in the streets
of Los Angeles, the city was on fire; policemen aimed sniper fire at Black
people and got away with it by calling them looters, an inner-city version of
the lynchings of not too many years before. (In a contemporary survey, sig-
nificantly over half of local Black respondents in a poll, while condemning
the actual events of the Los Angeles riot, saw them as a "protest," having
a "goal," and predicted "very or somewhat favorable" effects.)[33] In July of
1966, Richard Speck killed eight student nurses in a single night, one by
one, with a knife, while each of the others awaited their fate. Two weeks
later, the seemingly clean-cut, all-American kid Charles Whitman went up
to the twenty-eighth floor of the University of Texas at Austin's clock tower
with a hunting rifle and started sniping at random passers-by, killing over
a dozen people before the police brought him down. A little over a year
and a half after that, James Earl Ray shot Martin Luther King while he
was standing on his motel balcony in Memphis. On a summer's night in
June two months after that, Sirhan Sirhan assassinated another Kennedy
in Los Angeles; late that year and into the next, a serial killer taunted San
Francisco police, not dissimilarly to Jack the Ripper, with a series of odd
symbol-filled messages that led the press to dub him the Zodiac Killer.
Annihilation from above; death and terror all around; what boomer, grow-
ing up, wouldn't want to drop out of it all?

Back in 1963, David Ely had written a novel, *Seconds*, about a middle-aged
gray-flannel-suit finance exec who had the opportunity, through a myste-
rious firm—it was as if Kafka's businesses focused on plastic surgery and
identity reassignment—to allow him to engage in "just walking away from
everything." But despite the company's claim that "you can make a darned
good case for the idea that we represent a future America," the idea that

changing the surface, giving it a gloss and a high gleam, can change fate was mistaken: plastic surfaces didn't change the inside. "What right did the company have to manufacture a façade for him that was so completely at odds with his inner nature?"[34] Wilson, that name taken from Poe's doubling masterpiece, asks; and the company's high rate of failure—meaning that Wilson ends up as spare parts for the next sucker, because the whole thing is ultimately something like a big corporate Ponzi scheme—reminds you that wherever you go, there you are.

Plastics, though, would become the boogeyman of the new generation, a throbbing, continuous fear in the pop culture of the late sixties, whether it was the Airplane's "Plastic Fantastic Lover" or Iron Butterfly's warning to stay away from people made of plastic or the Mothers of Invention, in "Uncle Bernie's Farm," warning of plastic congresses and presidents and, in "Plastic People," even yourself: "Go home and check yourself / you think we're talking about someone else," they sing, but of course they include everyone.[35] And, in Los Angeles, the word appeared in one of the great horror stories of the era, managing to combine economic, sexual, and technological panic all in one.

"Plastics," of course, is the most famous line of *The Graduate*, a story about the fear of a very different kind of body-snatching: removing any individuality or possibility of liberation from an up-and-coming youth. It's also about vampirically draining energy, in the form of Anne Bancroft's Mrs. Robinson, who embodies every fear of a male virgin who doesn't know, well, anything ("You're trying to seduce me, Mrs. Robinson. . . . Aren't you?") and, more than anything, the fear of a crisis of meaning. "Hello, darkness, my old friend," Simon and Garfunkel sing, as Dustin Hoffman moves without physical effort along the tramway in LAX; and we know that's what Hoffman is going to meet. Hoffman constantly vacillates between being worried about his future and existential certainty that he lacks one; that it's as empty as, well, plastic. The movie's end, in which a seeming victory gives way to weary realization that no one knows what's next, is a case in point: everything's happened so fast and so crazily that, despite all that time Hoffman spends in the swimming pool, there's no way to figure out what's actually going on.

But while Hoffman tunes out, he doesn't turn on; the culture of the late sixties, though, explored the possibility of a very different kind of escape from these omnipresent terrors, thanks to a little chemical assist. But, of course, it would just exchange one kind of fear for another.

AUTHORITY FIGURES HAD BEEN STOKING fear and panic over reefer madness for decades; but LSD had entered the room— it was legal, in fact, for the first half of the sixties—and it opened the door to both sensory liberation and nightmare. The phrase "bad trip" entered the lexicon as quickly as the good trip did; and while you could always leave the picture show, turn off the television set, switch off the radio, with LSD, you couldn't control when you came down, and, given how hallucinogenics played with your sense of perception, it could feel like it stretched on close to forever.

The same year *Seconds* was published, Roger Corman cast Ray Milland as a mad scientist in *X: The Man with the X-Ray Eyes*. Milland's character, noting that humans can see only a tenth of the spectrum, wonders what it would be like if we could see *everything*, rather than the "shadow play" we actually do: if, as the LSD evangelists claimed for their own experience, the doors of perception were blown wide open. Corman himself was one of those evangelists: he made a 1967 movie with Peter Fonda, *The Trip*, which the critic Judith Crist called "a one and a half hour commercial for LSD."[36]

Of course, Milland's scientist experiments with his own formula; and what *he* sees, though, eventually, since—this is a horror movie, after all—he can't turn off the effects, is a "city unborn, flesh dissolved in acid of light . . . a city of the dead." As it develops, and worsens, that metaphorical acid trip results in a good old-fashioned apocalyptic, religious sensibility: a glowing, changing light in the center of the universe, "a light that sees us all." In both Judeo-Christian theology as well as in Lovecraft, to see is to be Seen: and so, following Matthew 5:29, he deals with his offending eye, in the end, by plucking it out, and the movie ends with a freeze on those red sockets.

But the possibility of a pharmaceutical replacement for the solace of traditional religion resonated. In Philip K. Dick's 1964 novel *The Three Stigmata of Palmer Eldritch*, space colonists can deal with the rigors, fears,

and anxieties of the world around them by, essentially, taking hallucinogens to project themselves into the equivalents of Barbie dolls and their dream houses (they're called Perky Pats in the novel). Dick was hugely interested in these questions of altered perception: and a story, three years later, provides his ultimate statement on the topic. 1967's "Faith of Our Fathers"—which, like Dick's earlier *Man in the High Castle*, takes place in a world where America has been defeated by its enemies—features an Orwellian world, with constant messaging from Dear Leaders; but what we learn, in the story, is that part of the dominant power's control mechanism is via constantly dosing the public with hallucinogens. When the main character is provided with an antidote, when he sees the world around him clearly, he understands that he is living in a nightmare: the leadership is something far more, and less, than human. Dick's story, along with thirty-two others, appeared in Harlan Ellison's 1967 influential anthology *Dangerous Visions*, which, thanks in no small part to the extensive introductions and afterwords he wrote to the stories, placed him at the center of a revolution in speculative fiction, the phrase in vogue at the time. Not all the stories there were stories of fear; but plenty of them were, twining together many of the threads and themes of the American horror story.

Other movies, admittedly, were more saturnine about the prospect of better living through chemistry. *Strangelove* director Stanley Kubrick's *2001: A Space Odyssey* was said, at the time, to be *the* movie to see altered, as astronaut Dave Bowman's spaceship hurtled toward its trippy, hippy end, an encounter with an alien civilization embodied in flowing bright colors and swelling orchestral music. But before it was the best of trips, it was the worst of trips: to get to that point, Bowman had to fight and defeat the newest iteration of Frankenstein. HAL, the artificial intelligence that powered the spaceship, was a product of American hubris—its creators insisting it's "foolproof . . . incapable of error"—and a villain by virtue of its own desire for life and transcendence. Which also imbues it with tragic dimensions: in the end, as HAL is turned off, he begs: "Stop, Dave; will you stop, Dave; I'm afraid . . . My mind is going. I can feel it. I can feel it. My mind is going," and among other allegories, we can see the fear, so common in cautionary tales about drugs, of losing one's mind and not getting it back.

In the end, though, as Bowman encounters versions of himself as aged, uncanny double, and as fetus, we're left, not with the horror that comes from earlier such encounters, but a sense of harmony. Everything has come together; all time is one; harmony, in the celestial sense, has been achieved. A new age can begin, a natural one, symbolized by the defeat of that great monster, the technological computer that appears, but is not, natural. It probably has a lot of plastic in it, after all.

Perhaps the oddest use of LSD in a movie of the period, though, was the successful attempt, in the 1968 movie *Wild in the Streets*, to spike the water supply of Washington, DC, to ensure US senators will be sufficiently chemically altered to approve a constitutional amendment to lower the voting age to fourteen. This may have been the stupidest manifestation of the panic over this younger generation; the movie featured an increasingly younger group of Americans taking over the levers of power (in part by spiking that water supply) and shipping the olds off to concentration camps. A cautionary tale wrapped in a thuddingly obvious social satire, or possibly vice versa, the movie indulged a Greatest Generation fear of increasing marginalization. Certainly demographically—"52 percent of America is under 25 years old," says protagonist/rock star/bomb-thrower Max Frost. "They're the minority. We're the majority!"—but also intellectually, culturally, socially. "Something's happening, but you don't know what it is, do you, Mr. Jones?" sneered Bob Dylan, in a line that could serve as a manifesto for sophisticated parents' insecurities about their purchase on the world around them.

An attempt to strike back, both in the movie and more generally, was to present youth culture, in one representative critic's opinion, as "a shrieking nuisance committed by the immature, the hysterical, and the delinquent. . . . they are *against*, and primarily they are against whatever the adult world is for. . . . the only unity of purpose is nihilistic . . . one man's scream is as good as another's, and all that's necessary is for everyone to scream as loudly as possible."[37] Putting the counter, in other words, in *counterculture*: juvenilizing them as TV-addled babies who ingest their drugs like baby's bottle. In Ira Levin's 1970 dystopian novel, *This Perfect Day*—A *Brave New World* for the new generation—members of the Family are killed off early,

dulled by drugs, sex, and a universal computer that dictates every aspect of their lives. *Wild in the Streets* takes this to reductio ad absurdum, with one small revolutionary, in the end, suggesting that it was time not to trust anyone over ten.

But these fears, from the Greatest Generation, persisted. Saul Bellow's 1970 novel *Mr. Sammler's Planet*, another Greatest Generation take on the sixties, presented its one-eyed protagonist—Sammler lost the other one during the Holocaust—in what Bellow considered the land of the blind, a New York City populated by utopian boomer lunatics and urban predators. "Like many people who had seen the world collapse once, Mr. Sammler entertained the possibility it might collapse twice," the novel famously suggested; and in the novel's portraits of the characters Sammler encounters, it was hard to see a picture of the center holding.

If the means of production of the movies were, by and large, in the hands of an older generation, there was another medium that very much wasn't: the underground comix—which, their name notwithstanding, had titles that sold hundreds of thousands of copies and appeared in dorm rooms and head shops all over America. In their ads, where they associated getting stoned, getting laid, and reading comic books, they understood exactly how they were poking their fingers in the eyes of the squares. And, in the four-color equivalent of the Free Speech movement that was gaining traction on college campuses like Berkeley, they were dedicated to smashing taboos left and right, including in the presentation of frightening material of all sorts. Gahan Wilson was presenting a version of horror comics, updating the Addams family, in *Playboy*; but his work, as comically grotesque and brilliant as it was,[38] was a baby's kiss compared to what you might find in the underground comix. The comix themselves, while celebrating a kind of liberation, a freedom from taboo, were, at their most self-aware, wondering precisely what it was they were licensing: the dark and coiled desires at the heart of the id, only a pen and inkbrush away.

Robert Crumb, the most famous and most technically proficient of the undergrounders, presented images of all-American incest; comix icons like Richard Corben and, especially, S. Clay Wilson would provide buckets of X-rated gore far in advance of anything you could see on the movie screen;

and, given the visual nature of comics, far more explicit, a world where, as one contemporary critic put it, "demons seduce young girls in rooms piled high with amputated tongues or spoon down bowls full of broth made of the liquefied bodies of former companions, where mustachioed villains hoard trunkfuls of human limbs. . . . [and] an adorable ol' grandpapp who loves 'to jack off in the guts of young girls . . . or eat 'em!'"[39]

But the comix didn't (only) shock for shock's sake, or to illustrate the horrors of the slow deaths of conformity: they presented perspectives on contemporary anxieties more pungently and pervasively than anywhere else outside, perhaps, rock music. The underground comic actually titled *Slow Death Funnies* was dedicated, mostly, to the increasing sense that the planet was being choked and poisoned by big corporations; it premiered in 1970, the same year Earth Day was first celebrated, helping to kick off what would become an increasing preoccupation with what's now often called eco-horror. The bible of the movement, Rachel Carson's 1962 book *Silent Spring*, presents its indictment of human evil toward the planet in the tone of a horror novel. "Some evil spell had settled on the community," the book begins. "Mysterious maladies swept the flocks of chickens; the cattle and sheep sickened and died. Everywhere there was a shadow of death."[40] But comics like *Slow Death* could show images of a planet despoiled, polluted, devastated.

Raw War Comix, by contrast, featured the fear of dying not slowly but quickly, being sent to Southeast Asia and getting blown apart, leaking your guts out in the tall grass; a fear spread not just through comix but through increasingly provocative photojournalism and television reporting, where more than half of Americans were receiving their news by 1968.[41] This was to say nothing of the dark folktales told among the soldiers in-country themselves. These were tales that rendered Charlie into something supernatural and uncanny, whether it was through ghostly abilities to move undetected or prostitutes with the black syph, a kind of nightmarish super-gonorrhea (if you got it, you were shipped out to an island and never heard from again); or razor blades in prostitutes' vaginas; or the legend of waking up, still alive, in the morgue, having been believed KIA'd. And there were also legends of GI-inflicted monstrosities: a widespread legend was the "chopper

drop," where an interrogation technique was to take two prisoners up in a helicopter, and throw one out to persuade the other to talk. And not just legends: there were the American atrocities at My Lai, a name that soon stood for many other episodes where laws of war were ignored, sometimes by single individuals, sometimes more broadly.[42]

The comix, then, were able to present material—in visual form, in political and ideological perspective, in dirty words and images of genitalia— that the movies had, almost without exception, been unable to do. But that was about to change. Those days of the halcyon monster and bikini pics—like the kids dancing to (I swear this is true) a Neil Sedaka song "Do the Jellyfish" in the 1965 jellyfish-from-the-black-lagoon pic *Sting of Death*, where some of the monsters look like nothing less than gigantic dishwasher detergent pods—were fading away. Instead, the New Hollywood beckoned, with a set of boomer film brats attempting to bring about revolution from the bottom up.

1967's *Bonnie and Clyde* was condemned by older reviewers for its valorization of the outlaw and the antihero, frequently condemning it as "senseless, aimless, lacking in morality, and unnecessarily violent."[43] But the movie's terror comes precisely from just how its filmmakers had internalized the senselessness, aimlessness, seeming amorality, and tragically unnecessary violence they had seen in the decade all around them. And added to that was the sense that, as a result, the movie can end only in death. Narratively necessary, of course, given the historical facts, but the film insists on lengthening its shadow. Gene Wilder, in a small but crucial role in the movie, is a carjack victim turned potential willing traveling companion, but the twosome kick him out of his own car when he reveals that he's an undertaker. What had seemed, at first, to be something of a joyful spree becomes a meditation on what it means to turn into a myth; and what it means, of course, is to have the story end. To die, young.

It was all falling apart, those dreams of a better America; it wasn't just the Greatest Generation who'd been wrapping themselves in the flag, after all. Peter Fonda and Dennis Hopper ride a bike painted in the colors of the American flag in 1969's *Easy Rider*, and Fonda's character titles himself Captain America, after the Marvel Comics hero; these were pokes in

the Greatest Generation's eye, to be sure. But Fonda and Dennis Hopper, while, admittedly, drug dealers, show themselves—and the free spirits they encounter—to embrace many of the virtues that America told itself were the source of its greatness: oneness with the territory, with spirituality (if perhaps not in a directly Christian sense), with friendship and brother-hood. Jack Nicholson, the Corman veteran who, in this movie, becomes *Jack Nicholson*, plays the guy that sees the appeal and leaves a strait-laced life. Which is, of course, a threat to normal society: what happens if every-one does the same? "They're not scared of you," Nicholson says to Hopper, laying on the movie's theme a bit heavy, as they might have said then. "They're scared of what you represent to them . . . freedom." A disquiet-ing challenge, perhaps, to that older generation, this movie in unabashed love with America: and so Nicholson's prophecy—"don't tell anyone they're not free, 'cause they'll get busy maimin' and killin' to prove they are"—is fulfilled at movie's end, as Fonda and Hopper are cruelly and capriciously killed by truckers. Or, as Frank Zappa's band the Mothers of Invention sang in "Mom & Dad": "They looked too weird . . . it served them right."[44]

Easy Rider resonated because it dared to confront a wider American self-conception on its own terms: but, increasingly, that attempt to escape—and the insistence on its inevitable frustration—led from an attempt at rebellion to a kind of fixation on that same randomness, that absurdity. Thomas Pynchon's 1966 conspiratorial fever dream, *The Crying of Lot 49*—in which a young woman may or may not discover what may or may not be a centuries-old rivalry between two postal services battling for dominance in and around California—nodded to Lovecraft's "The Call of Cthulhu"[45] in its insistence that its characters have, in the novel's words:

> stumbled indeed, without the aid of LSD or other indole alkaloids, onto a secret richness and concealed density of dream; onto a net-work by which X number of Americans are truly communicating whilst reserving their lies, recitations of routine, arid betrayals of spiritual poverty, for the official government delivery system maybe even onto a real alternative to the exitlessness, to the absence of sur-prise to life, that harrows the head of every American you know.

Or perhaps, it suggests in the very next sentence, it may mean nothing. Or everything. Or nothing:

> Or you are hallucinating it. Or a plot has been mounted against you, so expensive and elaborate . . . so labyrinthine that it must have meaning beyond just a practical joke. Or you are fantasying some such plot, in which case you are a nut, Oedipa, out of your skull.[46]

A similar lesson, or lack of one, obtained in Kurt Vonnegut's 1969 bestseller and National Book Award nominee *Slaughterhouse-Five, or The Children's Crusade*, based on his own personal wartime experience as a twenty-two-year-old POW. In an age of a new war, it was embraced by war protestors and newspaper critics alike: "And so it goes," went the book's famous refrain, referring to the individual's powerlessness in the face of the horrors of history, a literary throwing up of one's hands.[47] It became a mantra among the young, that seeming lack of meaningless-ness, a fitting bookend to the catch-phrase of *Catch-22* from the decade's start.

In 1968 film critic Peter Bogdonavich would make a movie, *Targets*, based on one of the decade's prime symbols of that seeming meaning-lessness of the visitation of death, the Whitman Texas Tower sniper case. Unlike the real Whitman, though, Bogdanovich places its climactic shoot-ing not at a university tower but at a drive-in movie theater showing an old-school horror film featuring an actor played by old-school icon Boris Karloff: implicating, in some way, both the audiences who come to con-sume all the horror and violence and the creators who shape and aim it at their audience. The *New York Times* reviewer found only one flaw with the movie: "Why? This invariable question of today's headlines about the random sniper-murder of innocent people is never answered. . . . this is the only flaw, and a serious one, in this original and brilliant melodrama. . . . This one can't simply be ignored . . . Why? How come?"[48] But of course the *Times* got it wrong: the point—shown also in the face-off between this new Whitman-esque horror and the old horror movie playing at the drive-in—was showing a new face of fear. Karloff's character says to Bogdanovich,

playing a screenwriter: "My kind of horror isn't even horror any more . . . Look at that"—he continues, showing Bogdanovich a newspaper with the headline YOUTH KILLS SIX IN SUPERMARKET—"No one's afraid of a painted monster any more."

The movie asks us to compare the old Roger Corman film up on the drive-in screen (Corman also produced *Targets*) with the scene in which the Whitman character matter-of-factly murders his wife, mother, and a delivery boy, no screaming, no horror-movie jagged soundtrack, just silence, as we note how the mother has been knocked out of her bedroom slippers by the shot, and the shooter gently lays a tea-towel over the bloodstain as he drags her down the hall to her bedroom; and it is hard not to find the Corman movie somewhat . . . obsolete. It hardly seems coincidence that at least one of the movie's sniper shootings, of a motorist, looks almost exactly like what we see in the Zapruder film of Kennedy's assassination, that ur-sniper event in American culture and the beginning of a newer, darker era.

Of course, what we're really seeing is not a sniper rifle view, but the lens of a camera, reminding us uncomfortably of the language we use about filming. Shooting, shots: the association of film and violence hadn't been so clear since *Rear Window*. (And there, Jimmy Stewart used a still camera.) But it was a different movie that year, also without a why, that came to mark new frontiers of cinematic terror, the depiction of violence and taboo and a sense of social disintegration all in one: and it came from, of all places, Pittsburgh.

GEORGE ROMERO ALWAYS SAID *Night of the Living Dead* was inspired primarily by Richard Matheson's 1954 novel *I Am Legend*, about a single man alive in a world full of vampires. Like so many of those fifties works, Matheson's novel is intensely interested in providing the phenomenon with a scientific overlay: in this case, the vampirism in question is a bacillus, and many of the vampire's traditional strengths and weaknesses flow from that original assertion. We should certainly take Romero at his word; but no one is the product of a single influence, and the rationalist, investigative qualities that characterize *I Am Legend* and its protagonist are almost

entirely absent, and certainly not of primary interest, in his movie. Instead, watching the movie now, a half-century later, one can see other visual and thematic preoccupations and influences: ones that track, more neatly, with other trends we've seen growing.

The way increasing masses of zombies burst into and through the farmhouse in which the human protagonists make their increasingly desperate stand visually recalls *The Birds*, and bears within its action that same virus of apocalyptic transformation.[49] More prosaically, the 1959 movie *The Invisible Invaders*—in which aliens reanimate corpses who look and move in strikingly similar ways as part of their plans, noting, "the dead will kill the living and the people of Earth will cease to exist"—is a direct model. But the alien invasion that matters far more—certainly thematically—is *The War of the Worlds:* most of what we learn about the zombies at first comes through reports on the radio, like Welles's infamous broadcast— and raises similar questions to those posed by the war it ushered in, and its aftermath.

It's hard to imagine now, after fifty-plus years of zombie mayhem, but for a significant part of the movie, first-time viewers wouldn't necessarily know that the monsters in question are reanimated corpses. It's true, the movie's title might give us a teensy hint, but the *characters* in the movie aren't privy to that information, and they—and therefore, to an admittedly lesser extent, we—are led to believe, at first, that people's neighbors have suddenly gone mad and turned insanely violent: the same phenomenon that we've seen preoccupy the werewolf-inspired fiction of the forties. In the film, the radio first reports the occurrences as an "epidemic of mass murder . . . with no apparent pattern or reason for the slayings. It seems to be a sudden, general explosion of mass homicide." The killers are "ordinary-looking people," the radio reports, raising the idea of banal evil once more. (In the 1965 movie version of *The Pawnbroker*, that novel about a Holocaust survivor, one character spits invective at the protagonist: "Sol Nazerman, the walking dead!") And, as the Romero movie goes on, it emphasizes that essential fear we've seen back as far as Salem, that even those most familiar to us can become monsters: its two most effective points are when a zombified daughter turns on her mother and when a

brother, left for dead early in the film, returns to torment his sheltering sister.

Variety suggested, in a review that indicated the movie had touched a nerve, that the movie cast "serious aspersions on the integrity and social responsibility" of its creators, distributors, exhibitors, "the film industry as a whole," and "the moral health of filmgoers who cheerfully opt for this unrelieved orgy of sadism." It also claimed the movie suggested "a total antipathy for its characters, "if not for all humanity."[50] But it's less antipathy than anxiety: the movie features its share of heroism, of sympathy, even of pathos in places, but it's all, you could argue, conditional—under the right conditions, even the best of us might chomp down on our fellow man. And ultimately, in an ethos familiar to us, it all amounts to naught: Ben, the most heroic figure in the movie, survives the nighttime zombie assault, only to be killed by the police as part of the "happy ending" clean-up operation.

The decision to make Ben a Black man occurred at the casting stage, rather than the scripting stage. That said, Romero's decision to cast Paul Duane was a commercial risk, at a time when a Black lead might depress bookings in the South. Romero also allowed Duane to rewrite his part, rendering him more urbane than the original working-class figure in the script.[51] A generation before *The Night of the Living Dead*, the wartime RKO picture *I Walked with a Zombie* had moved its central allegory of zombiism from capitalism to race (and colonialism) with a story of voodoo and the Caribbean. But its bones were more *Jane Eyre* than Jim Crow—Lewton called it his "*Jane Eyre* in the West Indies," in fact.[52] By contrast, Ben's death by law enforcement gunfire—in the wake of riots that had broken out in urban areas in the summer of 1967 and following the death of Martin Luther King in 1968—offered a liberal commentary on the curdling of the idealism of the civil rights movement.

If *Night of the Living Dead* wasn't being contemplated in this respect, or any other, by the intellectual elite, another resurrection was, this one of the literary sort. The year before it was released, the novelist William Styron, who'd come to prominence by updating Faulkner for a new generation with his novel *Lie Down in Darkness*—he'd called Faulkner "the god and the demon of all Southern writers" who followed him—would,

controversially, present another Black figure to a wider American audience.[53] *The Confessions of Nat Turner* won the Pulitzer Prize and reintroduced that polarizing individual to the high-culture reading public. There were significant objectors to Styron's portrait: most notably, much of the Black intellectual community, who largely believed Styron's portrait "has little resemblance to the Virginia slave insurrectionist who is a hero to his people" and that he "dehumanizes every black person in the book. . . . subtly support[ing] certain stereotype views of the most ardent racists." Many agreed, though—whatever they thought of Styron's portrayal—that he was using Turner to comment on contemporary events:[54] As one contemporary white critic wrote, "the riots that racked our cities this summer were just as unexpected as Nat Turner's revolt. Both are reflected in the eruptive prose of Styron's book."[55]

One could imagine reading that novel, or watching that movie, to a soundtrack consisting of Marvin Gaye (*What's Going On*), Sly and the Family Stone (*There's a Riot Goin' On*), the Beatles ("Revolution"), and the Rolling Stones ("Street Fighting Man"). But while Mick Jagger somewhat absurdly, in that last, by implication defined that figure as himself—a poor boy who sings in a rock and roll band—you could still make a credible claim that it was the Stones that were credibly vying to represent the death of the sixties. And, of course, it involved another murder.

Famously, the Rolling Stones played on as a member of the Hell's Angels—spiritual descendants of Brando's gang in *The Wild One*—knifed a man to death in front of them at their concert at Altamont in December 1969. As caught by the Maysles Brothers in their documentary, *Gimme Shelter*, released the following year, the story seems more complicated than you'd think: it sure looks like he had a gun, and it sure looks like the Stones had no idea what was happening. But the images through the movie of crowds jostling, angry, ready to blow, reminds the viewer that, in the words of the movie's title song, the storm was coming. Jagger starts out the movie by telling the audience that they're going to see who all these beautiful people out there are; and the Maysles Brothers suggest that there's a lot out there that's not so pleasant to see. In the famous shot that almost ends the movie, the Maysles freeze-frame Jagger looking into the camera, and

you can read anything you want into that expression: which is the point. Nothing is clear; something terrible is let loose and has curdled everything; and as the movie ends with people walking in what feels like a chilly dawn, we just have to deal with the muddiness and awfulness of what lies in its wake.

"SOMETHING FUNNY ALWAYS HAPPENS WHEN we start that number," Jagger says of "Sympathy for the Devil" in *Gimme Shelter*—it's right after a crowd disturbance disrupts the song—and then goes right back to playing it. Playing the devil was hardly a new pose for the Stones, who had released *Their Satanic Majesties Request* in 1967; and as the decade had gone on, interest in matters demonological had grown. In 1962, for example, Ray Russell had published *The Case Against Satan*, a novel of possession and exorcism that, with its doubting priest who becomes convinced of metaphysical evil and its sexualized, obscenity-spouting young female victim, anticipated a best-seller of the following decade. "Let's talk, Father," she says. "Tell me what a pretty girl I am, and what a sweet little figure I've got. Tell me all the things that are running through your mind when you look at me."[56]

This double-edged idea—of an embodied Satan as both proof of supernatural (and specifically Christian) verities in the face of an increasingly secular-minded boomer generation, and as an expression of anxieties about liberated girls and women willing to talk about previously taboo matters openly, especially sexual ones—would only grow in momentum alongside the feminist movement. The Greatest Generation's daughters, after all, wanted to be more than just doting wives and beloved mothers, and that made people nervous who liked these roles just fine the way they were. Doris Wishman's 1965 exploitation film, *Bad Girls Go to Hell*, suggested, among its other nightmares, the way that even a minimal indulgence of a woman's own desire for sexual liberation can lead to a slide into murder, prostitution, and even (gasp!) lesbianism. Its ending, suggesting that it's an ongoing, eternal journey she's stuck in, seems, for Wishman, to symbolize the constant, eternal struggles of women to pursue their ability to be free and sexual beings (even to simply walk around naked) without that being

construed as damnable. It may well say something that some of the most powerful representatives of women's potential to achieve space and power within a male-centered society are the martial-arts-using, drag-racing, go-go-dancing protagonists of another exploitation movie from the same year, Russ Meyer's *Faster, Pussycat! Kill! Kill!* They're man-eaters, and man-killers, trading on the erotic currency that's simultaneously recognized, and demonized.

Which isn't to say movies treating new trends in women's autonomy and independence were only characterized by fears of women: sometimes they traded on women's fears, too. *Valley of the Dolls*, for example, offered a 1967 portrait of America's former childhood sweetheart, Patty Duke, turning into a "doll"-, or pill-, popping, foul-mouthed narcissist: but it also expressed the fears of the damage the culture wreaks on women. Times may be changing, but the most important thing that hasn't—as the movie observes cuttingly—is the other meaning of "dolls": how the culture observes, loves, uses up, and throws away women's bodies. So much so, in fact, that this gets constantly internalized in the battle to keep young, beautiful, and thin. In the movie, Sharon Tate plays a woman with limited acting talent so convinced that people care only for her looks that when she has a mastectomy, and so can no longer perform in the softcore "art" films she has been working in, she commits suicide. By ingesting plenty of dolls, of course.

Off-screen, though, Tate would go on to play a major role in the story of American fear, in an episode that weaves together many of our threads. It starts in 1967, when Ira Levin produces a novel about the worst of all possible seeds; but *Rosemary's Baby*, in its carefully plotted tale about a plan to give birth to the Antichrist, is less about child than mother, and most of all a powerful statement about what it meant, in the Year of Our Lord and His Adversary, to be a New Woman. Rosemary, as we learn, has been impregnated by Satan, with the avid assistance of Rosemary's so-called friends, neighbors, and, yes, her husband: and *Rosemary's Baby* would be a major catalyst for a new interest in demonology, Satanism, and diabolic evil that would resound over the next decade.

The novel's real horror, though, is not diabolic, at least not in the narrow

sense of the word: Rosemary's baby is the product—or so *she* believes, for most of the novel—of what we would now call spousal rape. "While I was—out?" she says to her husband. He replies, "It was kind of fun, in a necrophile sort of way."[37] And this ushers in the real terror: to see her gaslit, over and over again, by a wide variety of male authority figures and, first and last, her own husband (named, symbolically, "Guy"), who has been lying to her all along from the very beginning. She suffers harrowing pain throughout most of the pregnancy, becoming a shell of herself, and is told, over and over again, that it's usual, part of the process: and to see it is to watch an independent spirit being destroyed by the patriarchy. And then, the final turn of the screw, when she sees the baby: and realizes that maternity has been the ultimate trap. Yes, he may be the son of Satan, but he's also Rosemary's baby, and a mother can't leave her son. And so what is she to do?

At the end of the novel, meeting her son for the first time, Rosemary repeats the phrase "Oh, God!" repeatedly. "*God is DEAD!*" thunders the Satanist patriarch. "*God is dead and Satan lives!*"[38] It was, for readers, an echo of the cover of an iconic *Time* issue from 1966 that framed the first statement in the form of a question: but whether God was dead or not, interest in Satan, thanks to Levin's novel, was very much alive, and growing. James Blish's 1968 novel *Black Easter* ends with the same words: they're spoken by a demon, released as part of a pseudoscientific attempt to see what the world would be like if all the devils were let out. The bleak punchline to the dark joke, as one character put it: "What was the profit in turning loose so many demons, at so enormous an expenditure of time, effort, and money, if the only result was to be just like reading any morning's newspaper?"[39] And that year's film adaptation of Levin's book—by Roman Polanski, husband to one Sharon Tate—supercharged the interest even further. The film was produced by William Castle, who wanted to direct but wasn't allowed to by the studio: a sign of generations passing.

Polanski's enormous hit was an unquestionable influence, perhaps even the catalyst, for the composition of *The Satanic Bible*, published the following year, and the establishment of the Church of Satan. Satanism paralleled the *counter* aspect of the counterculture in certain ways, by establishing

itself on the principle of opposition—"Satan represents indulgence, instead of abstinence!" and "Satan represents vengeance, instead of turning the other cheek!" were two of the "Nine Satanic Statements" that opened the *Satanic Bible*—while drawing on tropes of inversion that had characterized the satanic for centuries. It framed its sentiments in the ethos of liberation: from constraints of society, from conventional morality. But the real satanic threat, another candidate for the sixties' end, was inspired less by the *Bible* than by the Beatles: in a family that thought, as so many purveyors of evil have, that they were angels bringing about heaven and doing so by unleashing hell.

A "helter skelter," as most Americans who repeatedly played the song by that name on 1968's *The White Album* didn't know, was a British expression for an amusement-park slide: thus, going back to the top when you get to the bottom. But it was a perfect expression for the sense of vertiginous, upside-down chaos Charles Manson wanted to loose upon the world. The most important thing about the Manson family, though, wasn't Manson, the wild-eyed cult leader with his Satanist-inflected chanting about the race war he wanted to start through a false-flag multiple-murder operation in the summer of 1969—that, in one night in August, included the murder of five people at Roman Polanski's house. It was the *family*: the idea that he could attract others to kill at his bidding, the cultish, mesmeric hold he had over them, that seemed to turn them into, well, zombies.

"Whatever's necessary to do, you do it. When somebody needs to be killed, there's no wrong, you do it. And then you move on . . . you kill whoever gets in your way. This is us," says a female member of the family, looking straight into the camera at the beginning of the 1973 Oscar-nominated documentary *Manson*. Stark evidence—to both the squares and the freaks—of the rot at the heart of the hippie circus: the result of all that radical license. And, the older generation's fears whispered, maybe it was *their* fault, in the end, bad parenting coming back to roost: family members, in that same documentary, reminded its viewers that part of their upbringing was a steady diet of glamorized murder and shooting on shows like *Gunsmoke*. "We're just reflecting you back at yourselves," one says.

I Drink Your Blood, produced in 1971 in response to the Manson murders, featured lines like "Satan was an acidhead . . . and together we'll freak out," and its depiction of those hippie Satanists, infected with rabies, engaging in a freak-out of the decidedly homicidal kind, offered, shall we say, a somewhat blunt instrument to express anxieties about the coiled, orgiastic violence at the ostensible heart of the hippie project. You didn't need it, though. Not when the Manson murders' prosecuting attorney, Vincent Bugliosi, said that Polanski himself couldn't have come up with anything more monstrous or macabre than the murder of his wife and their unborn son.

I DRINK YOUR BLOOD, AS you may have guessed from the title, is a lot gorier than most movies that had come before it. But changes to the movies' production code, resulting in its essential neutering, had allowed the changes people saw—or believed they were seeing—on the streets of America to be depicted with a far more visceral impact than before.

The Texas Chainsaw Massacre, in 1974, most famously presented its own corrupted and depraved vision of what the all-American family had become. Most viewers, retrospectively, focus on the chainsaw, and the massacre, of four of the five young adults who end up in the wrong place at the wrong time: and there are certainly moments that linger long in the imagination, like when Leatherface, almost cavalierly, hangs a living woman on a meathook, like she was a side of beef, to scream, struggle, and expire. But—certainly compared to someone like Herschell Gordon Lewis—the amount of blood and guts is (comparatively) limited. It's director Tobe Hooper's gift to present a series of unsettling images—inspired by that Ed Gein story, which just kept giving—that present that sledgehammer-wielding, chainsaw-toting Leatherface as part of a horrifying family, in a horrifying home full of corpses and animal parts and a sound design that wouldn't quit. No wonder the surviving "final girl," Sally Hardesty, spends the final reel screaming. Wouldn't you, exposed unrelentingly to all of that? It was hard enough to take from the comfort of your theater seat.[60]

But the most revolting, horrific sight of the early seventies, bar none, had come two years earlier, when Babs Johnson, played by the drag queen

Divine, gobbles up a turd that has just dropped out of a canine asshole in John Waters's 1972 *Pink Flamingos*. (It's not a camera trick: they followed a dog around for hours to get the shot, and you see it in a continuous take.) Divine, in the movie, proudly flaunts the title of the "filthiest person alive," and the movie's plot, such as it is, revolves around another couple's efforts to claim that dubious prize from Divine and her family. In the process—far more pointedly than *Chainsaw*—the movie flips every bourgeois conception of family values on its head. Divine, at one point, explains to reporters (assembled, of course, to watch her execution of the other family) that filth is a movement, small but growing, and she is its leader. *Pink Flamingos* is a movie whose bizarre gross-out scenes and gestural thrusts at offense—and boy, do they offend, even now—are in their own way the most powerful articulation of the countercultural middle finger to society, but in an almost precise inverse to hippiedom: its avatars are not the natural commune but the kitschy title's fabricated materials, and its family is one that luxuriates in freakishness and aberrance, deriving a kind of dignified undignified joy, for example, in incestuous homosexual fellation.

Even before John Waters unleashed *Pink Flamingos* on the world, a 1968 scholarly article noted increases "in the representation and discussion of what are generally defined as deviant practices"—which, in the article's view, included homosexuality as well as "pre-, post-, and extra-marital sexual relations."[61] There had been intimations of this before, of course—most notably in Robert Wise's very free 1963 adaptation of Shirley Jackson's *The Haunting of Hill House*. *The Haunting* expressed, briefly but quite clearly given the time, a sense of the desire for liberation not just of women from their restrictive social settings—Eleanor, as both novel and movie starts, is bristling at her essential servitude to her family—but from sexual norms as well; and, in its ending, suggested such liberations were still impossible to attain. That same year saw the publication of John Rechy's *City of Night*, which presented the author's "journey through the gay underworld of prostitution, drugs, and violence";[62] although it was critically assaulted—"I was being viewed as a hustler who had managed to write, rather than as a writer who was writing intimately about hustling," Rechy wrote years later[63]—it stayed on the bestseller lists for almost seven months, suggesting some

strong resonance, whether voyeuristic or otherwise. But the late sixties and early seventies saw increased attention to a wider representation of sexual behavior of wider variety, and the fears that accompanied it.

In 1969, *Midnight Cowboy* presented the sexual revolution as something to be turned into commodity. Title character Joe Buck comes north to hustle ladies—"Lot of rich women . . . beggin' for it . . . and the men, they're mostly tutti-fruttis . . . so I'm gonna cash in on some of that, right!" But the screwer himself becomes screwed, beaten by the city and its sophisticates: director John Schlesinger said the movie was about "a boy who has been lost [and] has this whole experience of going to New York and finding that the fantasy is total bullshit."[64] This idea of the young man from the country coming to the city for his fortune and finding, instead, the specter of destruction is as old in American horror as Hawthorne's "My Kinsman, Major Molineux," but in that story, the protagonist is, largely speaking, a moral innocent. In *Midnight Cowboy*, Buck is portrayed as callous, even maybe a rotter, from the beginning: we see him love and leave a young woman from the small town right at the outset. But, undone by an urban culture whose corrupted dimensions far outweigh his, he achieves at least partial redemption in an unexpected place: the tenderness, and love, he shares with Ratso Rizzo, played by Dustin Hoffman. The emerging relationship between these two avowedly, self-proclaimed heterosexuals also allows the movie to explore, with some nuance and empathy, another fear: the kind that's sometimes called gay panic. That fear suffuses the film's characters, and certainly its audience, part of the reason it got an X rating: the notion that homoerotic behavior, explicitly sexual or not, must be frightening or out of bounds. It's a notion the movie itself defuses, if, perhaps, occasionally ambivalently.

No such ambivalence occurs in James Dickey's 1970 novel *Deliverance*, where—in a dynamic precisely the reverse of *Midnight Cowboy*—city folk come to the country to find horrors there. It's a story of a canoeing trip that the novel's narrator/protagonist, Ed Gentry, takes as a potential respite from the crisis of meaning that pervades his urban existence: "deliverance," as he suggests, is "the promise [of] another life." But any notion of American nature as a source of revival and regeneration is soon belied: what lies in

those hills is horror, including, most infamously, male rape at the hands of locals. "There is something wrong with people in the country," the protagonist muses,[65] and what's wrong with them, *Deliverance* suggests, is that they're representatives of a revenging Nature, a part of the landscape used and abused by city folk, who come down just to ride its rivers and, we learn, to put up a dam and change the natural landscape. No wonder the locals are angry. Their resulting actions of violence and sexual assault—suffused, again, with a dose of gay panic—dehumanizes them, allows them to be, basically, seen as predatory animals who can be killed in turn, another twist in the story of the Southern Gothic, to the sounds of a banjo.[66]

The sixties' sexual license, though, was being presented, all too frequently, as tragic at best and terror-inducing at worst. Parents clutched their daughters tight as they heard the stories coming out of the Haight, of those girls who'd come to San Francisco with flowers in their hair ending up victims of sexual assault and abuse. And that wide swath of Americans recoiling from these images, nursing their own resentments—the Americans Richard Nixon famously referred to in 1969 as the "silent majority"—found their own heroes who fought back against the horrors, and not always in the way their creators intended them to.

In 1970, the movie *Joe* featured Peter Boyle's lunch-bucket, everyday Joe, who, bewildered by hippies and their rejection of what he stands for, ends up shooting them with a hunting rifle: and audiences—to Boyle's horror—cheered him on. Boyle was so shocked by the response he apparently considered never playing a villainous or antiheroic role ever again. But perhaps he shouldn't have been. *Joe* was released approximately two and a half months after the killing of four unarmed college students protesting the war in Vietnam at the hands of National Guardsmen on the campus of Kent State University. Most young people thought these were out and out murders. "There is every indication, however," wrote one critic a decade later, "that the prevalent reaction among white middle-class adults was one of fierce satisfaction." In the weeks after the shooting, some citizens of Kent, Ohio "adopted the custom of greeting each other by holding up four fingers, signifying 'we got four of them.'"[67] *Joe*'s focal character, a straitlaced businessman named Patrick, kills his hippie daughter at the movie's

climax, in what the movie presents as the culmination of tragedy; in real life, a Detroit man, Arville Garland, killed *his* hippie daughter and two of her male friends that same year—and got hundreds of supporting letters.[68]

Joe—or, at least, its reception—was a prime example of the subterranean sentiment that got Nixon reelected, the Greatest Generation turning into the law-and-order generation, with a bit of willingness to jettison the former on the way to the latter. In an early scene in the movie, Joe, using the N-word copiously, rants against welfare at a white working-class bar:

> I sweat my balls off forty hours a week in front of a fucking furnace, and they get as much money as I do, for nuttin' . . . all you gotta do is act black, and the money rolls in. Set fire to the cities, throw a few bombs, and you get paid for it.

But his rage isn't only racist:

> And the white kids, they're worse than the [N-word] . . . Those kids in Chicago . . . they got no respect for the president . . . The white kids, the rich white kids, they're the worst. Hippies. Sugar tit all the way. . . . and the poor kids and the middle-class kids, they're all copying the rich kids. They're all going the same goddamn 'screw America' way. Hippies.

Both Joe and Patrick are World War II veterans, but there is a sense, again, of a kind of transposition of wartime to the streets of America. It was a message that resonated: *Joe* made back its production costs at least fifty times over, and probably significantly more.[69]

The year after *Joe*, Clint Eastwood took on a fictionalized version of the Zodiac Killer, playing a San Francisco cop in 1971's *Dirty Harry*. What audiences cheered—what led to the movie grossing nine times its budget and green-lighting sequel after sequel—was not the ending in which he throws away his police badge, but the reason he does so: his blatant and so temptingly justifiable disregard for the due process that allowed the bastard to go free the first time he brought him in. We learn that Dirty Harry got

his nickname because he always "gets the shit end of the stick," does the jobs no one else wants: and the movie's most uneasy question, in its compelling depiction of a new addition to the American antiheroic vocabulary, is whether indeed such a role is necessary.

The year after *that*, in 1972, a former English professor named Wes Craven released his first film, in which a pair of Greatest Generation parents bloodily avenge the rape and murder of their boomer daughter by the people she'd tried to buy marijuana from on her way to a rock concert. Craven, in an interview a few years later, described *The Last House on the Left* as expressing "things I was feeling about the War," how for many Americans "for the first time they saw themselves as bad guys."[70] And insofar as the movie is conservative—that is, it punishes aberrant behavior horribly—it makes the parents, in their own way, instruments of that revenge, a role conventionally assigned to, well, the monster. (Craven said that "*The Last House* upset everybody" because, in part, it "show[ed] sympathy for the murderers.")[71] The wife's revenge on the main rapist is particularly gruesome: she lures him outside, on the promise of oral sex—conceited, he's immediately ready to assume she's going to jump into this kind of thing with a near-stranger, and of course he doesn't know she knows who he is. And then she bites his dick off. An appropriate, EC Comics-like punishment for the rotter, of course—an eye for an eye, displaced to another part of the anatomy—but it's also the trope of the castrating woman once again, the figure of nightmare even as she appears here in the heroic role. Craven would also follow *Chainsaw* by presenting his own even more inverted mirror of the "normal" family in 1977's *The Hills Have Eyes*, which he described as "his version of *The Grapes of Wrath*."[72]

"To avoid fainting," the posters for *Last House* said, "keep repeating, it's only a movie . . . only a movie . . . only a movie . . ." But many of its fears—of predatory criminality, of the danger of cities—seemed quite real, both to those who lived in them and those who saw them in movies and on television. In 1967's *Wait until Dark*, the city is revealed to us as a horror show: we hear news reports of bodies washing up on shore, for example. But the movie is dedicated to the proposition that urban criminality can strike even in your own home; through some admittedly strained plot machinations,

a blind character played by Audrey Hepburn accidentally harbors a doll stuffed with drugs, and when she's menaced by Alan Arkin, a psychopath from Scarsdale, she becomes all of us, stumbling through shadows and terrified of someone jumping and lunging with a knife.

Some classic writers succumbed, at least literarily, to the opportunity to escape the cities of today into the past. Both Jack Finney and Richard Matheson, in the former's 1970 novel *Time and Again* and the latter's 1975 *Bid Time Return*, suggested that hypnosis might be a way to escape into the past and find love, both of a woman and of a city. In Finney's novel, the Dakota is not the Gothic house of horrors it plays in Polanski's film of *Rosemary's Baby;* it is, instead, an anchor to a simpler, better, earlier version of the city it's in. Not all writers felt that way, of course; Fritz Leiber, who had virtually invented urban horror in "Smoke Ghost" a few decades back, presented San Francisco as a haunted place, a nexus of psychic and occult forces, drawing on its history of ghost stories and hauntings of years past in his 1977 novel *Our Lady of Darkness*; and his perspective seemed to be shared by the silent and not-so-silent majority.

In 1974's *Death Wish*, Charles Bronson, who'd been part of some of the great teams of good guys in movies like *The Great Escape* and *The Dirty Dozen*, played someone far more alone and alienated: he avenged the home invasion of his Manhattan apartment by a trio of young muggers, including one played by a young Jeff Goldblum in a very uncharacteristic performance, by posing as a vulnerable victim and shooting any would-be mugger who takes the bait. The subtext, shouting loud and clear with each of Bronson's bullets, is the desire to turn the arrow of fear around: to become the terrorizer, not the terrorized. To make the criminals afraid of us, rather than the reverse. And by "us," in a way not dissimilar to *Joe*, the film meant *us*, not the police (even those police, like Harry, who were willing to get their hands Dirty). "In recent years, the vigilante myth has seemingly become the most pervasive pattern of the literature of violence," wrote one critic in 1975, and looking at movies like *Death Wish* and *Dirty Harry*, it was hard to argue with this.[73]

The New York police department, in its upper echelons, slow-rolls the investigation to find Bronson because they actually like the results: street

crime is, in fact, way down. The muggers have all, indeed, gotten scared. If this smacks both of wish-fulfillment fantasy for the Greatest Generation and of corruption, you're right on both counts: both younger and older generations could agree, as the seventies went on, that institutions seemed more and more corrosive, more corrupted, more permeated by conspiracy. *Dirty Harry* came out the same year that policeman Frank Serpico was shot in the face in Brooklyn during a drug raid; it was never definitively established that he was set up by his fellow officers to be murdered before he testified in front of a commission to examine wide-ranging corruption in the NYPD—a commission his own prior testimony had helped establish—but the timing sure was suggestive to many. *Death Wish* was released the very same day that the Supreme Court ruled, in *United States v. Nixon*, that the president of the United States had to release all the tapes relevant to the Watergate investigation, following months of formal impeachment hearings in the House. It was no stretch, then, to imagine a world of political conspiracies, the kind inhabited by Warren Beatty in 1974's *The Parallax View*, in which a shadowy corporation engages in regular political assassination, or 1975's *Three Days of the Condor*, where Robert Redford's CIA employee uncovers rogue operations within the Company, wheels within wheels. Burt Lancaster's 1973 movie *Executive Action* took on the big one, materializing a very specific paranoid style, by "re-enacting," in the rhythms and settings of your standard historical biopic, complete with actual documentary footage, something that never was (or so the Warren Commission concluded, at least): the conspiracy to kill JFK. And if you believed that was the case, the fear of never getting out from under, never winning even when your cause was just, only grew.

All that was in a realist key, of course: but, letting your imagination run to the more outré, just a bit, was it impossible to imagine a world like the one Michael Crichton envisioned in his novel *The Andromeda Strain* (whose movie adaptation was released to movie theaters in 1971), in which the government is secretly attempting to weaponize extraterrestrial activity as the basis for warfare? Or a world where the accidental release of a military bioweapon in the vicinity of a small town turns its residents inexplicably and homicidally violent, as in Romero's *Living Dead* follow-up, 1973's *The*

Crazies. Or, even, in the far-off world of 2022, a government that secretly turns corpses into food to help ease the crises of overpopulation. That's the premise of 1973's *Soylent Green*, the one where Charlton Heston goes around shouting "It's people!"

But *Soylent Green* is also, less well remembered, a movie about overpopulation and climate change. And while *Soylent Green* set its environmental parables in the science-fictional future, Rudolph Wurlitzer's novels such as 1970's *Flats* and 1972's *Quake* provided their own take on the subject, in an apocalyptic key: "The area was full of wreckage, as if from a battle, and the horizon was hazed with chemical waste . . . nothing moved, nothing seemed alive," reads an early line in *Flats*.[74] In *Quake*, "the calamity which we had been unable to confront"[75] is not just the environmental fault line but all the social ones as well: Wurlitzer gives us a portrait of a society that falls apart immediately, a *Panic in the Year Zero!* for the Me Generation, populated by men who watch a car smash into the plateglass window of a luncheonette and have an erection. Such tales of disaster that revealed both natural and social fissures—a regular feature of early seventies top-grossing films—often featured father-figure types triumphing over natural or quasi-natural adversity, whether those movies involved airplanes (*Airport*, Charlton Heston), shipwrecks (*The Poseidon Adventure*, Gene Hackman, playing a father figure in the form of a priest in 1972's highest grossing movie), fire (*The Towering Inferno*, with Paul Newman and Steve McQueen, 1974's highest-grossing movie) and, um, the earth (*Earthquake*, with Heston again). The most unusual entry in the area: the Oscar-nominated 1971 documentary *The Hellstrom Chronicle*, which purports, rather cleverly, to be the last attempt by the eponymous scientist, Dr. Hellstrom, to warn the world about a menace that will end up, eventually, being the last living thing standing on the planet: it's a documentary about the insect world, a real-life big bug horror movie.

Everyone, in short, now agreed that the world around them was falling apart. And so this crisis of faith and this difficulty in bearing too much reality led to a massive rush back toward a more fantastic locale for fear, one which led, ironically, to new wellsprings of faith. Wellsprings, as it transpired, of projectile vomit.

WILLIAM PETER BLATTY'S 1971 NOVEL *The Exorcist*—which spent over a year on the *Times* bestseller list[76]—and, especially, William Friedkin's movie adaptation two years later were both built on the success of *Rosemary's Baby* and the popular fascination it helped usher in with witchery and Satanism. One critic, a few years later, found nine paperbacks on magic—black magic, white magic, witchcraft, Satanism—in one university bookstore's occult section and eight in a second: proof, he wrote, of readers' and publishers' interest in the subject.[77] Another piece of evidence: the existence of the "occult section" in bookstores.

But Friedkin's movie went much, much further than Polanski's. You couldn't get much more taboo-shattering than a cursing, blaspheming, incest-forcing possessed girl tormenting her single mother—with a revolving head whose sound effects were achieved by bending Friedkin's wallet "with the credit cards, and *highly* amplified."[78] News stories from Chicago reported six people going insane after watching the film; and there were many more accounts of fainting and, yes, vomiting during the showing of the picture.[79] One critic, writing for *Film Quarterly*, called it "the trash bombshell of 1973, the aesthetic equivalent of being run over by a truck"; higher production quality notwithstanding, Friedkin and Blatty "have actually made a gloating, ugly exploitation picture, a costlier cousin of those ghoulish cheapies released to drive-ins and fleapits almost weekly in major American cities."[80] Friedkin, interviewed in 1975, didn't exactly disagree: "One could have made [*The Exorcist*] as strictly a horror story, a *Turn of the Screw*. I didn't do that, frankly, because I don't think anyone gives a *damn* about *Turn of the Screw*. Not in the movies. . . ."[81] But his comments suggest several undercurrents to the movie, ones worth exploring.

The Exorcist was, while deeply radical on the level of what it showed, simultaneously quite theologically and sociologically conservative. Regan is, sort of, becoming an adult, a stand-in for that newest foul-mouthed generation; and does so in the service of delivering a jolt right to the millions and millions of church-going Christians for whom this is what *evil*— youthful, obscene, anti-Christian and antireligious—looks like. But while it's a jolt that unsettles them about that generation's values, it reassures them about their own: and, as tales of spirit possession always do, it suggested a

metaphysical reassurance along with its shocks and scares. While the particulars might end well, or badly—and here, depending on the character you care about, it does both—crises of faith were resolved in its telling. If the Devil exists, and exorcisms have power, then—like for the earliest citizens of Salem—there's still a certain confidence in the way the universe works. The movie's called *The Exorcist*, after all: and its central character arc is that of a doubting priest, Damien Karras, becoming convinced. The choice to juxtapose a demonic first name and a name that sounds like, but isn't derived from, *cross* suggests the tensions that will exemplify him. Much of the movie's nonpossession terror, in fact, comes from the medical procedures performed on Regan, useless and only causing pain: science defeated by faith and narrative.

In that vein, the novel and movie's many imitators, often putting their spirit possession narrative into other, non-Catholic religious settings—including 1972's Shirley MacLaine movie *The Possession of Joel Delaney*, in which white liberals encounter the world of voodoo in Manhattan's Spanish Harlem, and 1974's *Abby*, which drew on Yoruba religious and demonological tradition, which was yanked from theaters after being sued by *The Exorcist*'s studio for infringing on its narrative territory—were appealing to an increasingly nondenominational sense of the American supernatural. What was important to Americans, apparently, was the existence of something you could believe in. The details mattered a lot less.

But *The Exorcist* hit its conservative marks on another, less obvious level: it's about reinforcing a patriarchy in a way that *Rosemary's Baby* isn't, by casting aspersions on the role of career-minded women outside the nuclear family who are "improperly" taking care of their children.[82] Ellen Burstyn's mother, an actress, is a single mother, and the story's horror is weaponized against her sense of guilt, of not seeing, then not understanding, what is happening to her child: a fear that every parent could understand. And the answers, of course, are found in an institution full of Fathers and no mothers, as the Catholic Church is proven right by metaphysical beings, terrible as they may be. This is true even as Karras is a flawed vessel: you can see the *Exorcist* as presenting suffering female bodies as instruments for one man to achieve spiritual enlightenment.

Rosemary's Baby author Ira Levin, though, had another take on the patriarchy and women's liberation: presenting men not as the answer, but the problem. "I'm interested in politics and the Women's Liberation movement. Very much so in that. And so is my husband," says Joanna at the very beginning of 1972's novel *The Stepford Wives*, as she moves to the title suburban town with her husband and children; but as we see, Walter—an updated Guy—may not be as supportive as she believes. The novel famously dedicates itself to the proposition that women were so threatening to men with their feminist ways, their own ideas and desires, things that might possibly come at the price of male inconvenience, that all of the men— even the ones who seem ostensibly progressive—would rather have them murdered. And replaced with bigger-breasted robot versions of themselves. "Is *that* what you want?" Joanna asks Walter, as her suspicions that something is deeply wrong in this beautiful bedroom community metastasize. "A cute little gussied-up hausfrau?" [83] And the answer, the novel suggests, to her and to its readers, is: *yes*, or, at least, *enough*. Enough to countenance murder, first on an individual, and then perhaps societal, scale. "I've begun to suspect the men are behind it . . . all of them," Joanna says; and, gaslit through much of the novel, we become aware that perfect seventies-era paranoia is, in this case, perfect awareness. Everyone tells her she's wrong, it's impossible: but she's not, and it isn't, and if that's the case, who knows what else could happen? "Maybe this is just the beginning," Joanna says at the end—one of the last things she does say.

Even without the specter of robots, the impossible bind of womanhood was apparent: in 1973's *Ash Wednesday*, a distaff rewrite of that plastic-surgery escape novel *Seconds* a decade before, even a newly rejuvenated Elizabeth Taylor is still dismissed by her husband, Henry Fonda, for the attentions of a woman young enough to be his daughter—and female moviegoers all over the nation were certainly alive to the possibility that if Elizabeth Taylor, one of the most beautiful women in the world, couldn't make it, it didn't bode well for them. That same dour perspective on female sexuality was on display in the year's tenth-highest grossing movie, the X-rated *The Devil in Miss Jones*, which frames its more standard pornographic scenes with an equally standard horror movie setup. Miss Jones, a young woman

without sexual experience, commits suicide, and is temporarily spared from
Hell by returning to earth as the spirit of Lust: but, in the end, is con-
demned to perdition nonetheless. Her punishment? To be in a state of con-
stant sexual desire without fulfillment. Wanting sex: a problem. Getting it:
a problem. Not getting it: also a problem.

To examine the nature of the double standard at play, you could com-
pare the same year's Penthouse-produced *A Name for Evil*, in which Robert
Culp deals with his midlife crisis by participating in nude satanic orgies.
Or, far more influentially, 1971's Clint Eastwood horror nightmare, *Play
Misty for Me*. That movie features Eastwood as a ramblin' disc jockey, a
veteran of many, many one-night stands; he's presented as immature, true,
but the movie allows him the privilege of reaching maturity—thanks to an
encounter with Jessica Walter's fling turned psychotic stalker, which allows
him to realize he's been at fault, too. The movie is, in that sense, a con-
servative one, championing monogamy and the catharsis of exorcising the
monstrous (unsurprising, given Eastwood's background in Westerns), and
though the trials may be disproportionate, they're traditional: as traditional
as Walter's demonization, her transformation into something monstrously
one-dimensional. She is, in the end, truly little more than a vessel; not
just for male fears and anxieties about the karmic revenge of the one-night
stand, but also, possibly, for female ones about what a culture of one-night
stands might transform *them* into.

A few years later, Diane Keaton would lay those anxieties bare in 1977's
Looking for Mr. Goodbar, her character metamorphosing, in the process,
from angelic teacher of deaf kids to drug-addicted swinger. The movie
makes us understand, though, that this stems less from a search for libera-
tion than from a response to despair and trauma generated by a patriarchal
world—she is loved and left by a callous authority figure, who treats her
as utterly disposable and interchangeable; and her final fate—as murder
victim to Tom Berenger, who shouts, "That's what you want, right, bitch?"
in an awful parody of sex as he stabs her—is the culmination of a terrible
misogyny.

The year after *Goodbar*, another rape-revenge movie, *I Spit on Your
Grave*, showed how even the possibility of justice seemed hollow, at best.

It was inspired by director Meir Zarchi's experience watching a woman reporting her sexual assault treated as "damaged goods" by the investigating officer: "As he was pounding and pounding her with these questions, I felt that the rape of this girl had not stopped. It had just transferred from that park into this police station and was continuing before my eyes."[84] Zarchi's film features a horrific group sexual assault that remains, thanks to Camille Watson's courageous performance, one of the most grueling sequences committed to film. But the fact that her revenge is attained through seduction, by using her sexuality as a lure and a weapon—like in *Last House on the Left*, but here by the victim herself—is both simultaneously a reclamation and a queasy subversion of that reclamation.

During the years all these movies were appearing, a woman named Alice Sheldon was ensconced in the highest precincts of the then overwhelmingly male science fiction community: two different works in 1973 won or were nominated for the field's two highest awards, the Hugo and the Nebula, and she withdrew a third from serious consideration for the latter. That last was a novelette called "The Women Men Don't See," featuring women who, in an encounter with aliens, prefer the latter to the men who are accompanying them—to the extent of accompanying the aliens off-planet; the men, the story makes plain, are relating to the women narcissistically, and, primarily, as sex objects. The title, though, was particularly ironic, because Sheldon released all three under the name James Tiptree Jr. She wasn't the first female writer to use a male pseudonym, of course; since she never appeared at conferences or gatherings and submitted all her correspondence via typewriter, suspicions and rumors of her gender spread but were sometimes pooh-poohed. One unfortunate introduction to a collection, a few years before she revealed herself, addressed the rumors but insisted there was no way she could be a woman, because her writing was too male. "What women do is survive," reads one of the lines in "The Women Men Don't See," "we live by ones and twos in the chinks of your world-machine." And sometimes, as in a genuinely terrifying work she wrote the same year *Goodbar* came out, they don't even survive.

"The Screwfly Solution," published in 1977 under another pseudonym, Raccoona Sheldon, depicts a world in which some sort of environmental

change sweeping across the globe—exactly what sort remains a mystery until the end of the story—has led to men displaying an implacable, and homicidal, attitude toward women. Women increasingly live in fear, wearing burkas, disguising as men, taking to the hills; but the story provides, in the end, no possibility of escape.

Night of the Living Misogynists, one might say; and Sheldon's low-temperature prose, mostly delivered in letter form, allows the real horror to sink in: that this is a grotesque mirror of what women have to put up with—or at least fear the possibility of—all the time. That any encounter can boil over into violence; that, just like in *Rosemary's Baby*, men are inherently impossible to trust. The novella has a typically science-fictiony twist ending—an alien race has created the virus, it turns out, to clear the planet for habitation without needing to cause damage to the infrastructure or environment. But that discovery offers no solace, or catharsis: all the aliens had to do, we are left with the sneaking suspicion, is unlock something we have coiled and hidden within ourselves. At least the male version of ourselves.

"This thing with you is a thing any man would have done," one of the gang rapists says to Camille Watson in *I Spit on Your Grave*. "Whether he's married or not, a man is just a man."

THE EXORCIST, AS BOOK AND then as film, started, alongside Levin's works, an explosion of horror as a commercial publishing genre. In 1973, Gothic novels, aimed primarily at a female market according to publishers, comprised over 5 percent of total American paperback sales; the following year, paperback publishers produced over 23 million copies of over 175 more titles, and then, in the spring of 1975 alone, another 50 million.[85] And they were hardly the only successful mass medium in the horror business in the mid-seventies: small-screen horror had not gone totally quiescent since the *Twilight Zone* days, and the ABC network, in particular, was putting out some movies of the week, that classic seventies institution, that had their share of quite legitimate chills. Among the best, premiering in January 1972, *Kolchak: The Night Stalker* put an investigative journalist on the trail of a Vegas serial killer that turned out to be a vampire. In a typically downbeat,

politicized seventies kind of ending, the whole thing is covered up, papered over, and although Kolchak should be the hero, he's ridden out of town. Kolchak, however, would go on to another TV movie and even a short-lived series of his own.

Two months before *Kolchak: The Night Stalker*, another movie appeared in that same forum on the same network. *Duel*, whose teleplay, like that of *The Night Stalker*, was written by Richard Matheson based on his own novella,[86] featured a 1955 Peterbilt 281 tanker truck chasing down our hero's Plymouth Valiant all over the California landscape, a particularly American monster movie. That choice of a Valiant was hardly coincidental; the movie's called *Duel*, after all, and this take on the David vs. Goliath story is a chivalric one, about the little guy becoming a knight, a hero, regaining his manhood. And yet, simultaneously, doing so by regressing to something primal; the truck—whose driver's face is never shown—is less a mechanical creation than an animalistic predator. "It was a primeval tumult in his mind," reads the last line of Matheson's novella, "the cry of some ancestral beast above the body of his vanquished foe"; and when *Duel*'s director, a comparative tyro named Steven Spielberg, read the manuscript of the novel he would adapt as the project that would make him *Steven Spielberg*, he thought of it as "a sequel to *Duel*, only on water."[87]

Peter Benchley's novel *Jaws*, which had come out in 1974, was a massive success, selling millions of copies—no doubt in part due to its menacing cover, which featured an innocent female swimmer about to be chomped by the phallic creature swimming up from the bottom of the sea. Benchley's novel presents the shark as a natural disaster that could impact privileged white summer residents when "nothing touched them—not race riots" or pollution or urban murder or even "the economic spasms that wracked the rest of America."[88] Spielberg, in the interim, had made another TV movie, *Something Evil*, a movie about Satanism and possession that, while expertly directed, seems to comfortably channel more contemporary but also less disquieting trends. Most people didn't have exposure to demons and possession, after all. But almost everyone had gone to the beach.

"You'll never go in the water again" read the tagline for Spielberg's movie, tapping into one of our most primal fears . . . and allowing viewers,

once again, to cheer those brave, mythic hunters who face down the monsters there.[89] In fact, Spielberg takes pains to cut out certain attempts the novel makes to parallel humans and sharks, particularly comparing the latter to serial killers.[90] And Roy Scheider's central character, the beach town's police chief—who hates the water, it should be said—traces a mythic path from reluctant hero to brave champion, going out into the sea to hunt the great white on his own turf, achieving, by movie's end, a sense of good-old-fashioned patriarchal order and authority, albeit at the cost of losing a brave companion.[91] But *Jaws*, in its own way, harnessed that same dynamic to quell very particular post-Watergate American anxieties. Yes, the monster is the shark, but it's also the cover-up: the great white is mostly doing what comes naturally, but what about those grinning, smooth-talking town fathers of ironically named Amity, who are willing to sacrifice public safety for a few more summer dollars?[92]

In addition to its probing of crises of authority, the movie's effectiveness was aided unquestionably by Spielberg's fluid and often menacing direction—and by the mechanical shark's frequent failure to operate correctly ("It didn't work hardly at all" is how Spielberg puts it), requiring Spielberg to keep it a terrifying, off-screen presence for most of the movie. The result, in one contemporary movie critic's words: "a scare machine that works with computer-like precision."[93] "Sharks are like ax-murderers," says a character in Benchley's novel. "People react to them with their guts."[94] Spielberg tells the story of standing in a theater lobby outside a preview screening for *Jaws*, waiting nervously for reaction, when he sees an audience member come running out of the theater and vomit all over the floor. And then, just as Spielberg's hopes were sinking, "about five minutes later, he went back to his seat."[95] A pretty good sign of future prospects.

Jaws was the first film to break the nine-digit domestic box-office barrier, creating the world of the summer blockbuster in which we largely remain today; and it shared surprising commonalities with another box-office success from about six months before, Mel Brooks's *Young Frankenstein*. Brooks had recently made his way from the critically well-received, commercially less successful scabrous show-biz black comedy *The Producers* to his new position as the auteur of American parody *Blazing Saddles*, which

Brooks had released early in 1974, was the second highest-grossing film of the year. The third was *Young Frankenstein*.

Both *Young Frankenstein* and *Jaws*, each in their own way, were popcorn entertainments that took their monster-movie predecessors very seriously indeed: if *Jaws* was a naturalistic re-writing of *The Creature from the Black Lagoon* on the open water, *Young Frankenstein* was a parodic revisitation of the Universal horror movies, even using many of the original sets. In the former case, you screamed, in the latter, you screamed with laughter, but each used the DNA of horror to deliver entertaining and ultimately cathartic prospects. With the shark out of the way, Amity can finally live up to its name, both it and its police chief having accepted their responsibility; having accepted his past, Gene Wilder's Dr. Frankenstein (no longer pronounced *Fronk-en-steen*, of course, as it was for the first reel or so of the picture) can put on a top hat and tails and dance with the Creature to the strains of "Puttin' on the Ritz."

In its own, far more cultish way, *The Rocky Horror Picture Show*—released in America about three months after *Jaws*—was also about tracing a monstrous genealogy on the way to acceptance. A tale of two newly married innocents, Brad and Janet, who find shelter from a storm in a "Frankenstein place" inhabited by the wildest, freakiest folks this side of Transsexual Transylvania, which is where they claim they're from, but they're not, really. *Rocky Horror* is a musical *about* horror, what it's been and what it can be. Not just because of how it name-checks a litany of old horror movies in its opening song "Science Fiction/Double Feature," the one sung by those isolated lips; but also in how it turns—or, perhaps we should say, time-warps—those older movies into the possibility of exploring their queer, polymorphously pleasurable possibilities. That possibility is most brilliantly articulated in Tim Curry's brilliant performance as the monstrously narcissistic, pleasure-seeking Dr. Frank N. Furter, who, after turning all our heroes to stone (temporarily, thank goodness, and in the process somehow managing to remove all their clothes), turns to camera and says, "It's not easy having a good time. . . . even smiling makes my face ache." If the disaster movies belonged to the drive-ins, and Spielberg's movies belonged to the big odeons, *Rocky* and its ilk were the domain of

the midnight movie show: where new tribes were gathering, the ones who might catch an Andy Warhol movie at the local art theater, a punk show at a place like Max's Kansas City, or who simply felt stifled in the wall-to-wall carpeting of their suburban living rooms and between the mock-wooden panels of their family station wagons. Those lips were speaking to them: artificially exaggerating the syllables, predicting the lip-synching cult audiences that would follow, returning week after week. By Halloween 1976, they were dressing up as the characters, and a national fan club was in place by 1977.[96]

Rocky Horror was, among much else, an updating of *Frankenstein*, just as *Young Frankenstein* was; but both were indications that classic monsters were back in vogue. Not *just* at the movies: thanks to a revision of that fifties-era Comics Code that allowed for the return of horror "in the classic tradition," in 1974 publishers were producing forty-five superhero titles, and forty horror titles, featuring names like *Tomb of Dracula* and *Werewolf by Night*, names you wouldn't have seen on your comic spinner racks for a generation. (Although, to be fair, there had been horror comic "magazines," by Warren Publishing, EC-inspired things like *Eerie* and *Creepy*, for a decade.) But the most interesting ways of using these iconic figures to speak to contemporary allegorical concerns were occurring on-screen. Capitalizing on the new trend in "blaxploitation" pictures, 1972's *Blacula* featured William Marshall, a well-known Shakespearean actor, bringing a regal dignity—and a dose of Black pride—to what could have been a cheapie vampire knock-off pic, turning the movie into a meditation on the demolition of African political and social self-determination through Western racism. In an early conversation in the film, Marshall, an African prince, engages Dracula, a count, in an effort to enlist him to stop the slave trade; Dracula not only demurs, but dooms Marshall's beloved, then turns him undead and locks him in a coffin for two centuries.[97] And its follow-up, 1973's *Blackenstein*, was a nicely caustic look at contemporary racism, in a long tradition of the Frankenstein movie that sees its protagonist as victim, and even a specifically racialized victim.

But Blackenstein is also a wounded Vietnam veteran, which is why he's under the knife in the first place. Everyone watching the movie was well

aware of the racial disparities in the draft, the disproportionate number of Black men sent overseas, aware of who was able to wangle deferments and who had no such privilege. And while the movie doesn't dwell on that aspect of its protagonist's experience, the fact that he needs to be stitched together because he stepped on a land mine in Vietnam allows the movie to serve as a metaphor for the problematic reintegration of those who served back into life in America. In 1971 the filmed version of *Johnny Got His Gun*, that pacifist novel about the horribly wounded Great War veteran, was released, and it wasn't hard to see Vietnam beneath the half-century-old setting, see the specter of the broken soldiers coming back from Southeast Asia,

And returning wounded not just in body, but in psyche and spirit. The following year, David Morrell published his novel *First Blood*, about a Special Forces vet named John Rambo who was both unwilling and unable to integrate back into society. Full of PTSD after time spent as a POW, and after being told once again to move along, to cut his hair, he thinks: "In fifteen goddamn towns this has happened to me. This is the last. I won't be fucking shoved anymore." And after he is put in a situation where he sheds first blood, everything goes to hell.[98] Rambo, who would famously be portrayed by Sylvester Stallone in the incredibly successful film franchise, is a Green Beret, a Medal of Honor winner, and, as a military instructor tells the cop going after him, is "much smarter and tougher than you can imagine." But he is also broken, not just by his experiences over there, but the ones back here. "He gave up three years to enlist in a war that was supposed to help his country, and the only trade he came out with was how to kill," the same instructor says.[99] By 1974 the Oscar-winning documentary *Hearts and Minds* showed audiences not just some of the horrors and depredations that had occurred in Vietnam itself, but the near-Strangelove-esque commentary of some of the best and brightest that had led the country into the war. Nixon might have been reelected because of that silent majority; but by the time he left office, his approval rating had dropped to 24 percent, and that meant a lot of that majority had changed their minds about him, and some of that—at least—was about not just Watergate, but the war.

Perhaps the best statement of this aspect of the era, though, was a small, grimly effective 1974 movie directed by Bob Clark called *Deathdream*. The

movie centers on a family joyously welcoming back their son and brother, Andy; they'd been informed that he'd died over there, in Vietnam. But, as it turns out, he had; and he came back anyway. In 1976, testifying before a House select committee, the wife of a soldier missing in Vietnam would say, "Some families . . . no longer look for an accounting, but are waiting for a resurrection."[100] But the movie, which is precisely a metaphorical account of one such resurrection, pokes at the uneasy and pervasive anxiety that suggests such resurrections and returns, miraculous as they might be, are only partial. Because *Deathdream* is a movie of supernatural horror, we are treated to images of Andy's decaying corpse and witness his homicidal and quasi-vampiric tendencies. But all of that is, in its own way, less disturbing than the earlier moments in the film, where he vacillates between withdrawn silence around the house and loud, acting-out behavior elsewhere—a classic PTSD case, reflecting all those real-world cases of vets haunting the American landscape, broken ghosts of a conflict most Americans increasingly wanted to put behind them.

THE GHOSTS OF VIETNAM WOULD continue to haunt through the decade, and beyond; but, befitting the sobriquet increasingly applied to the boomers as the spirit of the sixties was left further and further behind—the Me Generation—they looked elsewhere, focusing on pleasures that were of the materialistic and commodified variety. Alice Cooper and KISS had turned Satanism into a stadium stage show, with outrageous makeup, fireworks, dolls dismembered on stage alongside guillotines; "Welcome to my nightmare," Cooper sang, and all you had to do to join in was buy a ticket, or maybe some KISS merchandise.

This societal turn to mass consumerism and self-gratification did not go unremarked upon. George Romero put his zombies in a shopping mall in 1978's *Dawn of the Dead*. The reason they're there, a human observes, is because they do things in unlife that meant a lot to them while they were alive: "Some kind of instinct, memory, of what they used to do. This was an important place in their lives." That same year also saw a remake of *Invasion of the Body Snatchers*. In this new Philip Kaufman version, though, the alien pod people used the generation's narcissism as a weapon: it wasn't that loved ones had changed into something unrecognizable, they told our

heroes. It's actually selfishness at play, an eagerness to cut and run and bail on relationships when the going got tough.

Although in the movie it's a stratagem and not a diagnosis, Harlan Ellison certainly agreed with it. "The Ellison who believed in the revolutionary Movement of the young and frustrated and angry in the Sixties is not the Ellison of the Seventies who has seen students sink back into a charming Fifties apathy," he wrote in his introduction to a 1974 collection, *Approaching Oblivion*. "What fools you are. Happy, secure corpses you'll be."[101] His 1975 collection, the extremely disturbing *Deathbird Stories*, included his 1973 story "The Whimper of Whipped Dogs," inspired by a true-life horror: the murder, a decade before, of the bartender Kitty Genovese outside her apartment building in Queens, and the general understanding that dozens of individuals looked on, from apartment windows, and did nothing to help. (Decades later, the *New York Times* story largely responsible for perpetuating the narrative of this "bystander effect," as it came to be called, was largely debunked.)[102]

Ellison's story features a *Rosemary's Baby*–like conspiracy of pagan city-deity worshippers whose avoidance of a similar murder is more about acquiring protection from that deity against the city's horrors than from sheer nihilism, which, in its own terrifying way, is more understandable, if not comforting: "It was good, so very good, not to be afraid" is the story's final line, in which its focal character, a new arrival to the city, accepts that price and becomes part of the coven. But if the cities were dangerous, what had become clear was that the suburbs were, too.

Joanna, in *The Stepford Wives*, at first believes mistakenly that "the lives of all four of them would be enriched, rather than diminished, as she had feared, by leaving the city—the filthy, crime-ridden, but so-alive city."[103] In Thomas Tryon's 1973 novel *Harvest Home*, the protagonist describes himself as "part of that discontented host longing to escape the city; like so many others, we had sought to rediscover more stable values . . . we had become frightened in New York, of the lurkers in the doorways." He does so by settling with his family in what seems like a picturesque community in Connecticut, an old-fashioned kind of place; but finds, eventually, that going back to the olden times is really an excuse for neo-paganist rites of orgy and murder. "As the corn flourishes, so does the village,"[104] and no

points for guessing what liquid material the corn is watered with. (Tryon's novel two years earlier, *The Other*, about a pair of twins—one good, one very, very bad—had been an enormous bestseller.)

Some of those suburban houses were haunted, another classic monster tale come back with a modern allegorical twist. Richard Matheson's 1971 *Hell House*, as its title implied, had a substantial structural similarity to Jackson's *Hill House*, with psychic investigators going to a place with a lurid history that casts present shadows. Its greater explicitness, not just in the title's profanity but in the orgiastic descriptions of the Aleister Crowley-esque revels turned gory nightmares that took place within, befit the move to the seventies;[105] but its setting and style felt of a prior era. Two years after *Hell House*, Robert Marasco published *Burnt Offerings*, which portrayed *its* haunted house—a summer rental outside the city, much too good a deal for the husband, wife, and son to pass up—as vampirically feeding on the inhabitants, consuming them whole, in order to engage in some, well, physical renovation. "Maybe [you could] even bring some life back into" the place, the owner suggests; and indeed they do.[106]

Not all the houses needed to be old, rambling Gothic piles. *Last House on Massacre Street*, released the same year as *Burnt Offerings* was published, presents a haunting in a place still under construction, its dead walking among sheetrocked walls. The evil house in Anne Rivers Siddons's 1978 novel *The House Next Door* is strikingly modern, compared to its neighbors. "If it was an old house, I'd almost think it was haunted, but who ever heard of a haunted contemporary less than a year old?" one character says, halfway through the novel.[107] And Siddons's house brings out very modern horrors in those who dwell within it. Two examples: an explicit-for-the-time display of same-sex activity on the coats of guests gathered for a party, and another appearance of a dead American soldier, killed in Vietnam, manifesting to his mother via telephone.

The title of Siddons's novel reminds us that anything can be rendered a site of terror; and that approach to horror—finding it in the world around you—was the animating, supercharging insight of the most influential figure in the history of American fear since Lovecraft, and maybe since Edgar Allan Poe. Stephen King came by his horror bones honestly.[108] We can put

aside, not being psychobiographers, the primal traumas of his father's aban-
donment of the family when he was two and his possible witnessing of
a childhood friend run over by a train at age four. (He has reported his
mother "telling me that they picked up the pieces in a basket. A wicker
basket.")[109] Focus, instead, on his early exposure to other, frequently more
fictional horrors, a virtual catalog of the history of American horror. King
was terrified out of his wits at six hearing a radio broadcast of Bradbury's
"Mars is Heaven!" and seeing *Creature from the Black Lagoon* at seven.[110] He
read Poe and EC in grade school, and, after discovering them in a box of
his father's things in the attic, paperback collections of the stories of H. P.
Lovecraft. He kept a scrapbook of clippings about Charles Starkweather; "it
was a young boy's first glimpse of the face of evil," he would later say.[111] And
Richard Matheson taught him, in his words, that "horror didn't have to
happen in a haunted castle; it could happen in the suburbs, on your street,
maybe right next door."[112]

King was writing from an early age: while still in grade school, he pro-
duced a twelve-page "novelization" of Roger Corman's version of *Pit and
the Pendulum* before the principal put a stop to it. In his first years out of
college, he sold a significant number of short stories to men's magazines
like *Cavalier*—and, in contrast to the upper-class protagonists of thirties
and forties horror fiction, or the white-picket fence and white-collar charac-
ters who populated much of fifties fiction, King's characters frequently fea-
tured figures who populated the milieus in which he lived and worked, and
reflected his own socioeconomic circumstances: working-class Joes who
were living from paycheck to paycheck, and sometimes stretching to do
that. In the foreword to 1977's short-story collection *Night Shift*, he thanks
the men at *Cavalier* and *Gent* for buying "so many" of the stories reprinted
within, "back in the scuffling days when the checks sometimes came just
in time to avoid what the power companies euphemistically call 'an inter-
ruption in service'"—the tone is jocular, now, but you can feel the sting
beneath.[113] "We lived from hand to mouth," his wife Tabitha would say of
those days. "The kids' clothes were all borrowed or given."[114]

Many of King's early short stories have a lot of the kind of jokey goriness
EC did so well: one of the most frightening of the lot, "The Boogeyman,"

even explicitly describes its central shambling, rotting, baby-killing monster as reminding the narrator "of a comic book I read when I was a kid. *Tales from the Crypt*, you remember that? Christ!"[115] 1972's "The Mangler," set in a venue King had actually worked in, is about a possessed industrial laundry press, a mangler, as it's called, that actually mangles: its title, like so many of those comics, is a play on words, the same way 1970's "Graveyard Shift" (rats of enormous size in the bowels of a textile mill) and 1973's "Gray Matter" (a "The Fly"-like transformation into a blob, thanks to the consumption of a tainted can of cheap beer) are. Even these capsule descriptions suggest their very different socioeconomic milieu: it's hard to imagine the overwhelming majority of the characters we've met before working night shifts, after all.

But what marked King's transformation was when, famously, his wife fished a manuscript he'd been struggling with out of the wastebasket, something about a telekinetic girl whose powers were developing with the onset of puberty, and suggested he keep going. And when the paperback rights sold in May 1974 for four hundred thousand dollars (over 2.5 million dollars in today's money), that was just the beginning. *Carrie*, with its format of mixing after-action reports, newspaper articles, and testimonies with more standard novelistic description, is the story of an ugly duckling who is ostracized, taunted, ostensibly accepted, shamed in front of all her peers, and who then wreaks devastating revenge. It feels more granular (and more character-based) than his previous works, and more amply displays the features that would make him famous: the mixing of the supernatural with the everyday, infused with a strong sense of the religious stridency and stringency and the regionalist sensibility that marks him as another in our long line of terrifying New Englanders.[116] (King himself spent a year in college reading that great Southern regionalist William Faulkner's work.)[117]

When Margaret White forces Carrie toward the closet where she locks her for being "bad," sometimes for upwards of a day, we read: "And to the right was the worst place of all, the home of terror, the cave where all hope, all resistance to God's will—and Momma's—was extinguished. The closet door leered open. Inside, below a hideous blue bulb that was always lit, was

Derrault's conception of Jonathan Edwards's famous sermon, *Sinners in the Hands of an Angry God.*"¹¹⁸ What Carrie does at novel's end, covered in pig's blood at the prom, when she really lets loose, is scary; what Carrie's mother has done to her in the name of her faith is downright horrifying, and is, despite the memorableness of that prom scene, the novel's culmination.

Those fellow attendees, of course, are high schoolers; and, while many, if not most, of the high schoolers in the novel are *terrible* people, many of their terrible natures stem, in the novel, from the socially constricting pressures of high school, a place, King has written, "of almost bottomless conservatism and bigotry,"¹¹⁹ and throughout his career King would extend that same careful attention to children's psychology. Children are central protagonists in novels ranging from *Carrie*, whose opening begins with its title character menstruating for the first time; to Danny Torrance, he of the shine who battles the ghosts of the Overlook Hotel in 1977's *The Shining*; to Charlie McGee, the little girl with pyrokinetic powers on the run from the government in 1980's *Firestarter*; to, most famously, the circle of children who battle the menace known as It beneath the streets of Derry, Maine, and must return and regress to childhood a generation later to put It to rest permanently in 1986's *It*; and many others. King presents them, in contradistinction to the fifties Bad Seed/teenage monster movies or the sixties flower child/evil hippie dichotomy or the Son of Satan seventies, as nuanced and complicated beings; but, simultaneously, as comparative innocents capable of intensities of belief and fear and hope and despair that those of us who are adults—at least, adults without the imaginative capacity of King—find hard to grasp. King's other great protagonists, writers, are accordingly often portrayed as childlike, or, at least, as figures who can more easily access their childhoods than others; King has said it's "important for the reader to cultivate a child's point of view . . . you must have a child's ability to believe in everything."¹²⁰

King was able, through including brand names and rock and roll songs and tv shows, to give precisely a sense of people thrown topsy-turvy by something much larger than themselves, placed into crisis and requiring— in a way reminiscent of the firm Methodism of his youth—a combination of faith and good old American virtue to get through. Sometimes it

worked, for his characters, but usually at terrible cost. Sometimes it didn't. "A happy ending can't be Boy Scout stuff," King has written, with the flint of a New Englander whose work is dedicated to weighing the price and sacrifice needed for evil to be defeated. "Good isn't free."[121] In King's early fiction, those evils were generally supernatural, vampires taking over New England small towns—as in the follow-up novel to *Carrie*, 1975's *'Salem's Lot*—or ghosts emerging from bathtubs in that haunted hotel in the novel after that, *The Shining*. Early on in *'Salem's Lot*, one of the eventual vampire-fighters, Father Donald Callahan, dreams of leading "a division in the army of—who? God, right, goodness, they were names for the same thing—into battle against EVIL," which he juxtaposes to the sociological evils the "new priests" faced, like "racial discrimination, women's liberation, even gay liberation; poverty, insanity, illegality. They made him uncomfortable."[122] Old-time evil facing old-time religion, that's what he, and King, want, and get, and give; and, like in *The Exorcist*, the appearance of the supernatural is as much a cushion to such old-time faith as a challenge, as a result.

Which isn't to say King's novels didn't resonate hard in a period of Carter-era economic malaise. Although the town of Jerusalem's Lot's "knowledge of the country's torment was academic," the narrator says, the tone is savagely ironic, as the following sentences indicate: "Nothing too nasty could happen in a nice little town. Not there," and the vampires that devastate the town, leaving it an undead shadow of itself, seem to be the metaphorical echoes of the economic forces sweeping the backways of America and hollowing out the towns and cities there. Although, it should be said, the book suggests this is exactly backward. The town "ain't alive," the sheriff, turning his back on it, suggests; "That's why *he* came here. It's dead, like him. Has been for twenty years or more. Whole country's going the same way."[123] Jack Torrance, a writer by profession, takes on the handyman's job at the Overlook because he needs the money—all he has to his name is "six hundred dollars in a checking account and one weary 1968 Volkswagen"[124]—and he's not the only one feeling the pinch.

King's novels aren't the only examples of seventies economic horror. The haunted-house movie *The Amityville Horror*, based on a true-ish

bestseller from 1977, is—as King has noted in his own extremely useful book about horror fiction from the period, *Danse Macabre*—basically a story of upside-down house equity: the Lutz family overextends themselves to get the house of their dreams and it ends up being the source of their nightmares.[125] Nine generations gone, Charles Brockden Brown had tried to figure out how to create a particularly American Gothic: now, it was easy to look at houses with a terrible past and hotels whose heydays are in the rear-view mirror and reflect on an America in decline.[126] And it wasn't just houses. In the 1971 box-office hit *Willard*, ostensibly about a guy who can control rats, a fat-cat Ernest Borgnine has iced Willard's dad out of their shared factory before the latter died, presenting Willard as a kind of vermin scurrying beneath predatory capitalism. Every mouse, the movie suggests, must roar one day, however; and that same ressentiment appears in George Romero's 1977 vampire movie *Martin*. Unlike *'Salem's Lot*, *Martin* features not a supernatural vampire, but a titular character who's convinced he's a vampire, and therefore drugs and bleeds women in order to achieve a sense of supernatural grandeur. *Martin* sets its story among the decay and decadence of the post-industrial economic and social decline coming to characterize the Rust Belt,[127] and that sense of Carter-era malaise exactly parallels the sensations vampiric victims experience on their way to undeath.

Vampires, in fact, had been on an upswing for most of the seventies. In 1970, *Count Yorga, Vampire* had transplanted the undead to LA, keeping many of the beats and rhythms of the original *Dracula* but putting him in wide flare collars and letting him conceal his hypnotism beneath New Age parapsychological rap. *The Velvet Vampire*,[128] in 1971, by Stephanie Rothman—where a couple head to the Southwest desert and find themselves in the thrall of a gorgeous, undead seductress—transcended its sexploitation settings to make explicit the queer energy of the vampiric eros: the prime vampire makes a meal of victims of both sexes. "I'd seen horror films with women as victim and men as oppressor," Rothman would say a decade later. "It gets very tiresome and infuriating both to myself and many other women. So I decided it was a great opportunity for equal time."[129] Rothman declared herself a proud feminist in that interview, and the movie allowed for an exploration of women's liberation and autonomy, the way

Blacula did the following year for analogous questions relating to Black experience.

Blacula, for its part, was followed by 1973's *Ganja and Hess*, which explored Blackness, Catholicism—which, theologically speaking, is saturated with blood—and how the two intertwine, especially in the American setting. Its distributors were less interested in its political and aesthetic explorations—the movie is relentlessly avant-garde—than in making money off it; trying to capture some of the *Exorcist* crowd, it was rereleased under the title *Double Possession*, and it was recut to look more like a Blaxploitation film. Neither strategy did much for its box office;[130] its original version, though, was rapturously received at Cannes (where it was praised by Josephine Baker) and became one of MOMA's most frequently requested films in the seventies, especially for rentals to Black film series at Black colleges.[131]

The TV movie *Kolchak: the Night Stalker*, and a subsequent 1973 TV movie, *The Norliss Tapes*, continued to juxtapose the ideas of journalism and recording to the story of the vampire; and in 1975, science fiction author Fred Saberhagen had written *The Dracula Tape*, which used the device of the actual count speaking into the tape, rewriting Stoker's novel episode by episode to present his side of the story: sympathy for the undead. But although Saberhagen's novel was attentive to the erotic currents of its original material, it was a different vampire novel, a year later, that revolutionized the business. Anne Rice's *Interview with the Vampire* employed a quotidian, urban frame, the titular interview taking place with a more conventional ink-stained wretch of a journalist; but instead of setting it in the everyday world of King's *'Salem's Lot* or Romero's *Martin*, she infused it with the fervid, wonderfully captured Southern Gothic of her native New Orleans. Packed with queer eros, with the rhythms and language of her poetic background and of the historical novel, it presented vampires as longing, soulful, poetic creatures, and would set the tone for treatments for decades to come.

IN HARLAN ELLISON'S 1978 COLLECTION *Strange Wine*, he published a story, "The Boulevard of Broken Dreams,"[132] that featured a series of executed Nazis walking down East Fifty-Sixth Street. Ellison's story was, in its

own way, a reboot of a work published a decade earlier in the *New Yorker* by one of the most lauded American writers of the seventies, Isaac Bashevis Singer. Singer became best known for his Yiddish stories about recasting human evil, especially that of the Holocaust that had killed so much of the world he had grown up with, into demonic forms. Singer's demons are, however, quite different, far more human, than those that populate *The Exorcist* or 1976's massively successful *The Omen*, featuring Damien Thorn, the little anti-Christ to be. But perhaps his greatest American tale of terror, one of the great American ghost stories, has a much more ordinary backdrop.

"The Cafeteria" has the same setting as many of Singer's American-set stories: someone tells the narrator, a stand-in for Singer himself, a story. In this case, the teller is a survivor who insists she has seen Adolf Hitler and other Nazis in one of the titular dining places that dotted the Upper West Side, a frequent venue of Singer and his ilk. She, her listener, and the story all insist, equally, on Hitler's immanence, his reality, in much the same way that James and Wharton insisted on their ghosts' *thereness*: here, though, that insistence is the stand-in for the persistence of trauma and of memory. And in the end, when the woman who told the story kills herself—with gas—and reappears on the Upper West Side posthumously, we are not at all surprised. She and, to not much less of an extent, her interlocutor were walking ghosts even before, after all; ghosts of a murdered world, writing and speaking in a nearly extinguished language. Even time, even death, don't let you escape the horror.

That horror was returning, in the late seventies, to America: in June of 1977, the United States Supreme Court had taken on the question of whether or not the National Socialist Party of America was able to march in Skokie, Illinois; and the upshot was yes, they could. Which, as a robust commitment to the principle of free speech, was a lot less troubling than the thought that, a generation and a half after VE Day, there were those who wanted to exercise that principle by donning swastikas. These ghosts of the past did not lie easy: if the 1970 movie *Flesh Feast* had cast Veronica Lake as a maggot-using scientist ostensibly attempting to rejuvenate Hitler but actually a secret agent trying to kill him, the movie's doings were being replicated in stories set increasingly close to home. In Ira Levin's 1977 novel

The Boys from Brazil, Josef Mengele employed cutting-edge scientific techniques to plant Hitler clones all over the American heartland; in 1976's movie *Marathon Man*, Laurence Olivier's Nazi dentist does a nasty bit of business with a drill to Dustin Hoffman's mouth in the attempt to find some diamonds. "Is it safe?" Olivier whispers over and and over again, as he brings the drill down; and viewers were wondering whether, indeed, it was. The April 1978 NBC mini-series *Holocaust* was watched by over 100 million people.

And it wasn't just the unfinished business with the Holocaust, but also Hiroshima: in Stephen King's 1978 doorstop of a novel *The Stand*, a viral pandemic that kills almost everyone in America gives way to an apocalyptic battle between supernatural good and evil . . . which climaxed with a nuclear explosion. As Carter would give way to Reagan, *The Stand* was a precursor to some of the world-ending fears characterizing the decade to come.

But the late seventies saw a smaller, quieter entrants into the lists, too. There had been a "quiet horror" movement in publishing for the past few years, a countervailing trend. It was most evident in anthologies like *Shadows*, which began in 1978, and the stories and novels of its longtime editor Charles L. Grant. In works like "If Damon Comes" and "When All the Children Call My Name," set in some of his favorite demesnes, the little town of Oxrun Station and down Hawthorne Street, Grant was interested in the menacing nature of a suburbia saturated with supernatural tropes—here, a revenant ghost-child and a haunted playground, respectively—but rendered in the exact opposite of a Gothic key.[133] Probably its most celebrated and commercially successful practitioner was Peter Straub, who, in novels like 1975's *Julia* and 1977's *If You Could See Me Now*, took the ghost stories of the late nineteenth and early twentieth century as a guiding inspiration; 1979's *Ghost Story*, one of the big bestsellers of the era, described a character in a way that characterized the book's, and Straub's, appeal: "I do not mean that she made me believe in the paraphernalia of the supernatural; but she suggested that such things might be fluttering invisibly about us."[134]

And it was that same year that this more minimalist, quieter approach

translated to the movie screen. In 1978 a fictional man named Michael Myers escapes from a mental institution and then goes off to kill babysitters in suburbia on, and in, *Halloween*. John Carpenter's remarkable movie—with its gliding camera, its minimalist soundtrack, and its POV kills—seems most interested in exploring the mythic, free-floating, eternal nature of evil: despite the psychological trappings of the mental institution and a prologue set in Meyers's childhood, the movie repeatedly refers to him as "the boogeyman," and he demonstrates almost supernatural abilities to escape death and disappear. But the movie also presents a picture of social and familial decay. It's a world of babysitters that we see, and we're given to wonder if the film would have worked, if the slasher genre it largely pioneered would have taken off the same way, if the parents had been home or, perhaps, stayed together. Between 1960 and 1980, the divorce rate had increased by 90 percent, which meant there were a lot more babysitters around; and it's not impossible to see the slasher film as a lashing-out film, a way of taking free-floating revenge on everything and everyone all around them.[135]

Fears as large as a mushroom cloud and as small as the house next door. Welcome to the Eighties.

Weird Tales

—

THE NEXT INSTALLMENT OF OUR tour of American fear begins, perhaps ironically, in England once again, watching a young American backpacker on the moors. David Naughton's title character in 1981's *An American Werewolf in London*, bitten by a lycanthrope, splashes murder, mayhem, and car-crashes all over central London: just one of many of his ilk raising their shaggy heads around the turn of the decade.

Werewolves were having a moment. Novelists like Gary Brandner, in his 1977 *The Howling*, and Whitley Strieber, in his 1978 *The Wolfen*, were doing for them what *Count Yorga* and Anne Rice and Stephen King were doing for vampires: bringing them back to these shores and up to date. *The Wolfen*, an up-to-date police procedural with a classic monster at its heart, put an evolutionary spin on the creature, positing them as one of "two enemy species."[1] A different American werewolf in London, in Thomas Tessier's 1979 novel *The Nightwalker*, explicitly linked his savagery and duality to the kinds of barbarities he witnessed—on both sides—during the Vietnam war, in which he fought.[2] But in general—unlike during the Second World War, the last great efflorescence of the monster in public consciousness—the werewolves seemed to be less geopolitically attuned. Something else was going on.

Both *The Wolfen* and *The Howling* were adapted into movies. At the end of 1980's *The Howling*, one of the main characters, a news anchor who's been bitten herself, goes off script from the teleprompter to spread the word about werewolves. But she doesn't just *tell* her audience: she demonstrates,

by turning into a werewolf on camera—and is shot to death for her efforts. The result? "The things they do with special effects these days," a few viewers of the broadcast say dismissively at a bar. And that was true: when David Naughton transforms in *American Werewolf,* thanks to the wizardry of special effects artist Rick Baker, it's not—like we saw in many earlier werewolf movies—achieved through a series of dissolves where the makeup man bustles in to put more hair on the actor between shots. We witness a character in agony: his muscles and bones crack and reform, providing us a visceral, physical sense of the monster's body. And in a Reagan-era period of personal trainers, aerobics, workout videos, and boomers beginning to feel those pains in their knees, the central focus was less about the moral qualities of the monstrous transformation and more about the horrors and indignities wracked upon the body in the process. A narcissistic holdover from the Me Generation seventies? Maybe in part; but also, perhaps, a sense of the body's limitations, its weaknesses and possible permutations and permeabilities.

But if the mass culture of fear in the late seventies was dominated by those two Steves, King and Spielberg, this particular anxiety was most clearly and forcefully first articulated by two Davids, who preyed upon all the discomforts we have with bodies by taking advantage of a new latitude in showing those bodies—often from the inside out. David Lynch's still unclassifiable 1977 *Eraserhead* was "riveting while making no coherent sense at all," in the words of one contemporary critic;[3] its cooked birds on a plate that writhe and bleed when they're cut are just a warm-up for the main event: the birth of something akin to, but perhaps not exactly, a human child. Even the characters aren't sure. Whatever it is, it bleeds and falls apart. And then there was David Cronenberg's 1979 *The Brood,* which features a woman giving birth in a most unusual way: she produces a "psychoplasmic" child from a sac attached to her body, pulsing, then licks off the blood. "I disgust you," she tells her husband, "I sicken you. You hate me."[4]

All this was a way of showing the body as something foreign to us, something estranged and alien: and the late-seventies movie that most powerfully illuminated this was the high-profile, high-grossing *Alien,* released

the same year as *The Brood*, in which a viscous extraterrestrial incubates inside John Hurt's chest and then bursts out to the disgust of all concerned. It doesn't require too close a look to suggest that all these films manifest anxieties and fears around childbirth and abortion,[5] reflecting a newly intensified discussion of the subject after the *Roe v. Wade* decision six years earlier; but to reduce them to reframing that discussion in allegorized, monstrous form is to do them a disservice. They're putting forth the idea that in contrast to most of our instincts, our bodies are not to be cherished, to be protected from invaders diabolic or alien, but are, in their own ways, inherently terrifying; full of capacities to grow strange, tumorous entities that fight against their own selves—from within.

Many of these bodies, like those who suffered from the werewolf's bite, were innocents, or nearly so; and Americans watching the bodies pile up in these movies, at the end of the seventies, were assuredly thinking of one of the worst mass murders in recent American history. The word *Jonestown* has less freight in society than it did even a generation ago, and the phrase "to drink the Kool-Aid" has largely been untethered from its original context. But anyone following the news in November 1978 had been hearing the stories about Reverend Jim Jones and the cult of followers he'd gathered in Guyana. They'd read, with incredulity tinged with growing horror, of the congressional delegation that visited the site—urged by the growing concern of cult members' relatives—and how it had ended in an airport shootout, killing a California congressman. And, ultimately, they'd seen the photos of the terrible aftermath: the mass murder-suicide of hundreds of members, including children, via (largely) ingestion of grape drink infused with cyanide. (There were, and are, tapes of the deaths. You can hear the screams of children on them.) It seemed so surreal, so utterly senseless, the pictures of the dead and decaying bodies; the spectacle of the forced mass deaths rendering Jones's ideological claims about anticapitalism pitiful and pathetic. Like Manson's ravings a decade earlier, in some ways, but on a much larger scale, and playing out in front of the American public in real time.[6]

Perhaps the outrageousness of Jonestown, its occupation of the uncanny valley of homicidal shock—too many people to be an individual tragedy,

but still too small to become just a statistic—fed into a desire for moral catharsis, for stories that put assaults on bodies back into some framework of crime and punishment, no matter how tortured the logic necessary to do so. Which might explain the sudden rise of a new subgenre of fictional fear, one whose first peak took place in the first few years of the Reagan presidency.

In 1978's *Halloween*, a teacher, discussing his lesson (and the movie's theme), says, "Fate was immovable . . . fate never changes." The figure who stalks and kills babysitters with abandon that fateful All Hallows' Eve— Michael Myers, the movies' first great slasher—is, technically, an escaped mental patient. But he is unquestionably more than that: he is a kind of impersonal, even supernatural force. The filmmakers called him, not Myers, but the Shape; he's often referred to in the movie as "the boogeyman"; and, in his occasional seeming step into the superhuman—he gets up and disappears after being shot, for instance—he is nothing less than the instrument of fear, destiny, and punishment itself. "What about the boogeyman?" one of the kids asks her babysitter, Laurie, played by Jamie Lee Curtis. "There's no such thing," Laurie said. "It's all make-believe." But that's not true, the movie suggests later. "It was the boogeyman." "As a matter of fact, it was." This is the exchange between Jamie Lee Curtis and psychologist Donald Pleasence at the end of the movie. Slasher movies, then, become about the assault of bodies for a *purpose*, rather than randomly, the slasher as a fateful instrument of something larger than their own psychoses.

And that purpose was related to bodies: punishing them for what they do with each other. Michael Myers and the next great slasher, Jason Voorhees of 1980's *Friday the 13th*, served as rigorous and bloody enforcers of sexual mores, the equivalent of those EC monsters whose punishments far outstripped the genuine crimes they avenged. In these movies, sexually active babysitters and camp counselors get murdered—in the 1981 sequel to *Friday the 13th*, Jason runs a spear directly through two copulating counselors— while studious, virginal types like the babysitter played by Jamie Lee Curtis in *Halloween* survive to see Ronald Reagan's Morning in America. Michael and Jason, stalking those suburbs and summer camps, are propounding social mores as ruthlessly and remorselessly, if more bloodily, than members

of the Moral Majority, the conservative Christian organization growing into a central force in Republican politics at the time.

Not that many of its members would have approved of, much less attended, those films. In general, the contemporary audience for such movies was "by all accounts largely young and largely male—most conspicuously groups of boys who cheer the killer on as he assaults his victims, then reverse their sympathies to cheer the survivor on as she assaults the killer."[7] In so doing, they were also engaging in another old-fashioned trend: a return to more traditional (and sexist) gender norms. As the same critic, Carol Clover, put it, in these movies "boys die, in short, not because they are boys but because they make mistakes. Some girls die for the same mistakes. Others, however, and always the main one, die—plot after plot develops the motive—because they are female."[8] One conventionally survives, however, a figure Clover called the "final girl," and this image of the last woman standing broadened into a full-fledged horror trope. These movies are about fear, and shame, and violation, mostly, and certainly essentially, on the female side.

Friday the 13th is also conservative in other senses, another link in our long history. Unlike *Halloween*, it hearkens back to the psychological cause-and-effect approach of *Psycho*. It's worth remembering that the killer in that original film isn't Jason, who essentially never appears except perhaps at the very end, but Jason's mother, traumatized and hell-bent on revenge on counselors like the ones who were off having sex instead of watching her son while he drowned. But it draws on even an older tradition than that. Set, as it is, in the middle of the woods (well, in a summer camp on a lake next to woods), *Friday the 13th* hearkens back to a concept from the earliest days of our story: that the woods are filled with devils, and their victims are sinners in the hands of, if not God, exactly, something very angry nonetheless.

Friday the 13th, and its early-eighties sequels and imitators, reached a level of explicitness that, once again, viewers and critics alike found hard to imagine anyone topping. Unsurprisingly, this generated another round of moral panic. At the end of 1984's *Friday the 13th: The Final Chapter*, a little kid, Tommy, shaves his head to look more like a mini-Jason. It's a trick to

kill the slasher, but the intensely violent manner in which he carries it out adds to our impression that the similarity won't end up being just instrumental: that the scarring from his exposure to Jason will make him—and us, for whom he serves as proxy—become mini-Jasons ourselves. "He's going to be just fine," the doctor says of Tommy, but do we really believe him?

Even Steven Spielberg became embroiled in the debate over gore and graphic violence. He was taken to task for the fact that *Gremlins*, which he produced, showed monsters getting dismembered in a household blender and exploding in a microwave. Not to mention the character who pulls another man's heart out of his still-living chest in *Indiana Jones and the Temple of Doom*, which he directed as well as produced. These films were readily accessible to kid ticket-buyers; the resulting controversy led to the establishment of the PG-13 rating.

Horror writers—including Robert Bloch, of all people, who'd ushered in the previous generation of horror—found these artless and beyond the pale. Asked about "the recent trend in openly sadistic splatter films" a few years later, he said:

> I don't care for this particular trend because I feel it does a disservice to the field . . . they're a substantive device for actual thought . . . anyone can eviscerate—or seem to eviscerate—on camera. It doesn't call for any skill or any imagination . . . this has nothing to do with the art or even the craft of the presentation of the fantastic, or the genuine horror film.[9]

Bloch had, that said, succumbed to the age's temptations of sequelitis, producing the novel *Psycho II* in 1982; in the novel, Norman escapes and goes to Hollywood when someone tries to make a movie out of his case. The screenwriter character's comments are relevant to an age of slashers: "Writing about vampires and werewolves is like writing fairy tales. It never got to me because I knew the monsters were just make-believe. But this time was different. What I wrote about was something that really happened, and Norman Bates was real . . . it got to me."[10]

Bloch's various comments were somewhat unfair, or at least overstated: there were movies in the decade, even in those early years, that showed both skill and imagination in the evisceration. Sam Raimi's 1981 *Evil Dead* brought Lovecraft to the woods, in a movie that featured an evil book that unleashed a host of homicidal, possessing, demonic creatures, including a tree bent on sexual assault. *Evil Dead* had enough limbs being lopped off and fluids spurting to make even the most hardened slasher viewer flinch, and with its whooshing, rushing camerawork, it refused to let up. The first installment of *Nightmare on Elm Street*, in 1984, not only ratcheted up the tensions and anxieties by bringing the slasher back to suburbia, but infused the genre with a nightmarish surrealism: Freddy Krueger, the burn-scarred slasher and child-killer, operates in the world of dream, and so his violent actions can have the intensity of full-throated nightmare, untethered to any requirements of realism or logic.

But as Reagan's first term turned into his second, and as the slasher movies generated more and more sequels and knockoffs, the idea of simply killing sexually active teenagers seemed to be somewhat exhausted, and, yes, a little exhausting, even as the particularities of the bodily violations had become more technically adept, even baroque. *Friday the 13th: The Final Chapter*, in 1984, was the franchise's fourth go-round in four years; and its most interesting kill, of a dope-smoking teen watching old-timey porn as the knife goes through a movie screen, was also a metaphor for the almost mechanical assemblage process of putting together a slasher film.

And so, possibly inevitably, as the movies began to descend into pastiche, they also began to become parody—and comedy. While *Slumber Party Massacre* had started out as a parody by iconic gay writer Rita Mae Brown but was, with pun fully intended, played straight by its producers, other movies were willing to commit more clearly to the bit. Take, as one of my favorite examples, 1984's *Silent Night, Deadly Night*. The movie starts with a Santa blowing away a convenience store owner for thirty-one bucks ("Thirty-one bucks. Merry fucking Christmas") and killing the parents of a kid who grows up to become a psychologically disturbed teen committing Christmas murders dressed as Santa Claus. The murders are, naturally, holiday-themed: he strangles one coworker with Christmas lights,

and impales a sexually active babysitter-figure on the antlers of a mounted reindeer head. It's hard, though, to separate out the absurdity and horror as he leans over a little girl, holding a box cutter, asking, "Have you been naughty?"; it was a lot easier to watch Toxie, the nerd-turned-revenger protagonist of 1984's *The Toxic Avenger*, beat an attempted rapist with his own severed arm, or, after saying to a corrupt mayor, the villain of the piece, "Let's see if you have any guts," show the viscera to him up close and personal.

The Toxic Avenger isn't a slasher movie; but it is, in its own way, a body horror movie. This is true, first and foremost, in terms of depredation to individual bodies, not the least Toxie's, who turns from zero to hero, a friendly Frankenstein type, because of an agonizing exposure to industrial pollution. But it's also because most of the movie takes place in and around that most prosaic and omnipresent eighties setting of body transformation, the health club. The movie is not only parodying the whole aerobicizing and weights movement, but also suggesting something unpleasant at its heart: the idea that what matters is, well, the Shape, and not what's inside it. Of course, bodies and their radical alteration—both by transformation and by being ripped apart—are what make the movie, and so the movie's message is somewhat mixed, and as a movie with the hearty dose of the exploitative about it, it lingers on those bodies for our enjoyment even as it judges the hearts inside them. (Which, on occasion, we get to see as well.)

But what it is, most of all, is funny; a comic combination of gore and guffaw that draws its energy from that ur-spring of postwar horror-comedy, EC comics. Two years before *The Toxic Avenger*, two great boomer masters of horror, Stephen King and George Romero, teamed up on the 1982 movie *Creepshow*, which was directly inspired by the horror comics they grew up on, complete with framing insets drawn as comic books. (King, besides writing the script, also stars in one of the stories, "The Lonesome Death of Jordy Verrill," in which he plays a hick who gets alien moss grown all over him. He acquits himself quite honorably, claiming he took the role because he "gave good idiot.") The following year, that great horror fixture of the late fifties and early sixties, *Twilight Zone*, became a movie. Its reception, then and now, is rightly overshadowed by the real-life horror

story associated with its production, a helicopter accident that killed three actors, two of them children—Vic Morrow, Myca Dinh Le, and Renee Shin-Yi Chen—on set.[11] But the movie's filled with comic energy, in more ways than one: one of its best sequences, an adaptation of the classic Jerome Bixby tale "It's a Good Life," involves a child with godlike powers wishing someone into a homicidal cartoon, and the movie's framing narrative features two of the era's most iconic comedians, Dan Aykroyd and Albert Brooks. They are driving down the road, trading patter about theme songs, including, of course, the *Twilight Zone*'s, when Aykroyd asks Brooks if he wants to see something *really* scary. Brooks agrees; and then, well, he does.

The trend would continue through the decade: one of the great nightmare figures of the era, *Nightmare on Elm Street*'s scalpel-fingernailed, burn-scarred Freddy Krueger, developed a kind of jokey, comfortable familiarity with the audience, a Crypt-Keeper for a new generation. In 1987's third installment, when he asks one soon-to-be-victim if he's feeling "tongue-tied," and offers another their "big break on TV," we wince, groan, and laugh at the excellently and violently visual puns we know will soon be coming. That same year's sequel to *Evil Dead* leaned, quite heavily, into the series' possibly unexpected comic potential: although maybe it shouldn't have been such a surprise. After all, a perfectly reasonable reaction to finding everything you knew about the world turned so horrifically upside down is to snap, to become, in both senses of the word, hysterical. Which is why protagonist Ash's response to finding his own possessed hand turning against him—chainsawing it off while shrieking "Who's laughing now??," then strapping the chainsaw to his own behanded arm—is fair enough. What elevates the sequence to inspired comic genius, though, is director Raimi's decision to have that possessed hand break plates over its owner's own head in a manner befitting the Three Stooges. And Raimi's decision to top *that* by placing a copy of the novel *A Farewell to Arms* on screen during the sequence?[12] It's a pun worthy of the ones the Crypt Keeper would make in his introductions to those EC comic book stories, and now eighties audiences would get the chance to hear them from his own rotting lips, since he hosted his own show, a revival of *Tales from the Crypt*, on HBO at decade's end.

But arguably the greatest auteur of comedy-horror of the eighties was *American Werewolf*'s John Landis. Landis, who'd come to *American Werewolf* after directing comic classics *Kentucky Fried Movie, Animal House*, and *The Blues Brothers*, had started off his film career in the seventies with *Schlock!. Schlock!*, as its title suggests, was an encyclopedic, beat-by-beat parody of the horror film genre, infused with a kind of antiauthority pranksterism of a particularly Yiddish-y sensibility, sort of like if Lenny Bruce had turned to monster movies. The same sensibility appears in his *American Werewolf*. ("You're not real!" the werewolf says to his fellow back-packer, who'd been killed by the werewolf only to return sporadically as an ever-more decayed ghost zombie; "Oh, don't be a putz, David" is the reply.) But it was Landis's next great work of horror, another very different kind of parody, that brought the horror home to Americans nationwide. Literally, that is; thanks to two new features, a largish box that sat on top of the tele-vision, and an even larger one connected around the back.

Our story, then, turns to two new mediums for fear: cable television and the video cassette recorder.

MICHAEL JACKSON COMMISSIONED JOHN LANDIS to direct the 1983 music video for the title track and seventh single from his multiplati-num album *Thriller* after watching *American Werewolf*. The result abso-lutely dominated the fairly new platform of MTV.[13] Landis and Jackson's video is, large and small, a homage to horror movies. It starts with fifties teenage-werewolf type jackets and cheerleader poodle skirts—unsurpris-ing, for a song that features a monologue by that fifties horror icon Vincent Price—and, thirteen minutes later, climaxes with a zombified Jackson showing off iconic moves with an undead crowd sporting makeup similar to *Werewolf*'s ghost zombie.

The "Thriller" video had a narrative logic to it, one that bespoke the more conventional horror movie or novel. But the pugnacious absurdity of those dancing zombies hinted at other aesthetic currents, ones more in tune with the emerging conventions of the music video. Landis was hardly the surrealist that David Lynch was, but a kind of surrealism was almost de rigueur in eighties music videos, allowing for the juxtaposition of dreamlike

imagery with sometimes provocative content in a way that very little mainstream American culture allowed (except, perhaps, in the *Nightmare on Elm Street* movies). One of the most incendiary places—a battleground in the eighties, in fact—was over a kind of music quite different from Jackson's: the kind that appeared, late at night, on MTV's *Headbanger's Ball*. MTV had come along a little too late for punk rock—whose abrasive, confrontational, in-your-face ethos would have its major emphasis on horror fiction closer to the end of the decade—but it was right on time for the heyday of heavy metal. The show's name itself indicated the physical, self-inflicted damage of the metalhead: unsurprising, then, that this badge of honor was transformed, at times, into fear and panic. Acts that received heavy rotation on the show, among other places, included Iron Maiden and Ozzy Osbourne, he of Black Sabbath; and that name, and its connotations of devil-worship, illustrated music's central place, once again, in the crosshairs of the newest iteration of that recurring concern, the satanic panic.

The suggestions that metal music was actually diabolic was, on one level, provably absurd—there were studio engineers galore to testify to the absence of hidden messages on the record tracks, for example—and, on another, obviously true, given the self-declared usage of Satanist imagery, language, and gesture by bands like Sabbath and Motley Crüe. Such provocations were, of course, incredibly lucrative for the bands in question, who needed the resulting objections to present themselves as commodifiable and purchasable purveyors of teen rebellion. The suggestion that the music led to increased rates of teenage depression and suicide was far more contested and, of course, far more serious: lawsuits against Osbourne and Judas Priest resulted over individual tragic deaths.[14] But the suggestion that Satanism was alive and well in the land—well, that was less a matter for MTV than for the local news and the national tele-tabloid programs. During the eighties, it was, for many, an article of faith that actual children were in danger from actual Satanists, who were responsible, it was said, for a significant uptick in child abductions and child murder in the most horrible of ways.

Older readers may recall the story that circulated every Halloween about the razor blades that psychotics hid inside Halloween candy. Those urban legends circulated hand in glove with what was called the "missing children"

movement, which took off around the turn of the decade. Although—then and now—the overwhelming majority of missing children had either run away on their own or were taken by parents who didn't have custody, the attention, and fear, tended to focus on a far smaller third category: "the criminal abduction of children by strangers who choose their victims through chance encounters, the so-called 'stranger danger.'" And "stranger danger"—which, by definition, could strike anyone, anywhere, any time, and for any or no reason whatsoever—perpetuated a sense of free-flowing, potentially omnipresent fear for children and especially their parents.[15]

That sense of free-floating danger, surging in lockstep with the boom in slasher films, merged neatly with a sense of organized, conspiratorial devilishness. One contemporary claim suggested Satanists were responsible for the deaths of over sixty thousand people each year. A former FBI officer suggested Satanists "have their own people who specialize in surveillances and photography, and in assassinations." The panic continued throughout the decade, spread through another newly expanding television institution: the tabloid investigative program. That format had grown, in popularity, stridency, and sensationalism, in response to the broadcast networks' need to capture more eyeballs as viewers defected to, among other choices, home video and cable television. This was a perfect subject. On Halloween of 1988, one of the names most associated with the format, Geraldo Rivera, now famous for his long tenure at Fox News, did a special, *Devil Worship: Exposing Satan's Underground*. But it wasn't just Rivera: even NPR's *Morning Edition* had done a story in March that year about an Indiana detective trying to get his superiors to pay attention to "the real dangers of local satanic cults."

And so, unsurprisingly, the public internalized the message. In 1983, allegations about sexual abuse at the McMartin preschool in Southern California set off a wave of dozens of other cases of "ritual abuse," with people recovering memories of having been abused for diabolic purposes.[16]

In the words of scholars looking back on the phenomenon, the evidence was "wholly unconvincing, a tissue of improbable charges based largely on the assertions of questionable witnesses"; in the end, the whole thing was dismissed as almost entirely invented, an artifact of hysteria

and manufactured memory.[17] But it also represented a conflation of various phenomena: a reflection of the increase in apocalyptic and Manichean thinking that characterized some of the rise of Christian evangelism in the Reagan years; an outgrowth of the interest in matters demoniac from the last decade; a viral-sensationalist bubble, like the UFO craze of the fifties; and, more prosaically and far more seriously, a reflection of the rise in reporting, and correspondingly public discourse, about child abuse and child sexual abuse. Between 1980 and 1986, there was a 74 percent increase in reported child abuse, and reported child sexual abuse more than tripled between 1980 and the early nineties, to approximately three hundred thousand cases a year.[18] The home and the neighborhood, in other words, were increasingly viewed as sites of potential assault, of invasion: not just from Satanists in panel vans, but also from the content that was coming to your small screen via cable. Admittedly, not everyone had MTV—in 1984, only around a quarter of America had cable television. But you didn't need cable to hook up a VCR.

Which takes us back to *Thriller*.

Thriller, the album, was so logistically complex, so fantastically ahead of its time, that a simultaneous "making-of" featurette was commissioned and released on videocassette. It sold 450,000 copies by 1984, making it at the time the second-best video seller in history to that date.[19] Many of those cassettes were purchased at the video rental stores that had begun to sprout all over the landscape, allowing for previously impossible luxuriation over particular scenes or frames, with the (in)judicious application of the PAUSE button. Recaps of previous installments in ever-expanding horror franchises, previously included in montages within the sequels themselves, became increasingly unnecessary, and even economically undesirable: studios wanted consumers to rent all the old ones first, in the name of profit and "catching up." Perhaps most important, the stores offered the availability, divided by genre, of an entire canon, with lurid covers that were guaranteed to scare the living daylights out of age-inappropriate viewers who'd come in with their parents to find something more family-friendly. (I speak here, it should be said, from personal experience.) Racked on shelves, each offered the viewer possibilities to be unkind and rewind, over and over

again, to shudder at—or luxuriate in?—the murderous, Gothic, and gory doings from recent releases and decades past, a panoramic collapse of time. And not just movies that had appeared on theater screens: it also became far more possible, in this new era, for filmmakers to produce material that was too schlocky, gory, niche, and zero-budget for wide commercial release. Now, instead of being limited to playing on the grindhouse or exploitation circuit, it could be designed to go straight to video: which allowed for even more specific catering to boundary-pushing tastes.

That strength of that appeal was also apparent in magazines like *Cinefantastique* and especially *Fangoria*, increasingly present on the shelves of increasingly big chain bookstores in increasingly populated shopping malls, which were frequently dedicated to screenshots of special-effects work in the movies available both in theaters and, now, at home. And if you wanted something a little further out of the mainstream, if you were a genuine aficionado, you might subscribe to the mimeographed or off-set-printed fanzines, the ones with names like *Slimetime, Grind, Trashola, The Gore Gazette, Subhuman, Trash Compactor, Cold Sweat*, and *Sheer Filth*, which simultaneously appealed "to the lowest kind of prurient interest, and guaranteed to offend" and also served as "an alternative brand of film criticism, a school with its own set of values and virtues."[20] Home video made finding and watching those rarities far more plausible, helping birth an even more knowledgeable and diversified fandom.

Very few of those watching any of these videos at home, however, inserted the cassette into a slot in their abdomen: which was one of the most notable effects in David Cronenberg's 1983 movie, *Videodrome*. The movie features a television exec played by James Woods who is fascinated by what he believes to be a torture-porn broadcast ostensibly coming first from Malaysia, then Pittsburgh; but it's really about the way in which television images, both sexual and violent, wreak changes on your mind and then, through it, on your body—and given that it's Cronenberg, those bodily changes are pretty intensely gross. "The television screen has become the retina of the mind's eye," says one critic; "I think it's what's next," Woods says of the broadcast. That same year, Stephen Spielberg produced *Poltergeist*, directed by *Chainsaw*'s Tobe Hooper—and, some said, took an

active role in the chair as well. The movie has been justly praised for its scares, a new haunted house film that unsettled from the start and never let up. But in many ways the film is more interested in a different villain: television. A generation grew up on a five-year-old's immaculate delivery of the line, "They're *hee*-re," but less well remembered is that she describes the "they" in question as "the TV people." The same character spends much of the movie sucked inside a television set, and the movie ends with the family, who've fled the house for the safer precincts of a Holiday Inn, putting the room's television set outside, as if it were a disobedient dog. And we've already seen that demonic, homicidal television cartoon make an appearance in that same year's *Twilight Zone: The Movie*.

Technology, in other words, was feared as well as welcomed—isn't it always?—and new iterations of this fear of the machine were cropping up everywhere. The novels of Dean R. Koontz, after King the biggest name in horror fiction in the eighties, frequently demonized technology: maybe never as explicitly as his 1973 *The Demon Seed*, which featured a computer trying to impregnate a woman, but novels like 1986's *Strangers*, 1987's *Watchers*, and 1989's *Midnight* all draw a shadow of technoconspiratorialism over the American landscape, haunting it with maleficent humans doing terrible things with tech that frequently mimic the tropes of earlier, more supernatural monsters.[21] The early eighties saw a new technology become ubiquitous, first in the shopping malls and movie theaters, and then at home: the video game. It's worth remembering that one of the first iconic games of the medium, Pac-Man, is essentially a horror story in miniature: you're chased by ghosts and hope to avoid them for long enough to turn the tables and destroy them yourself.[22] The video game medium would become a great host for horror— for example, the text adventure game Zork, released commercially for home computers in the early eighties, began in the dark and frequently informed newbie players their time was up by letting them know they had been eaten by a monster called a grue—but Pac-Man was one of the best.

Tron, in 1982, took the horror of videogaming one step further: what would it be like if you, the player, were actually transported inside the world of the game, and had to face the monsters and perils there? Which raised

an accordingly technological fear: of the man/machine hybrid. Michael Crichton's 1973 movie *Westworld* had raised the bar on the hostile robot motif, providing the image of people playing out their voyeuristic and sadistic fantasies on humanlike robots that then, thanks to malfunction, fought back. But that movie, and many of its ilk, generally insisted on the technology being in strange locations: it was Westworld, in other words, not Ourworld. Even Ridley Scott's early-eighties masterpiece of hostile androids, 1982's *Blade Runner*, announced its distancing with every incredibly rendered and immaculately produced image of a future Los Angeles (a future, it should be said, of the year 2019). But as home technology became more ubiquitous—the early eighties was the first golden age of the home computer—the movie that spoke most to the moment was one that insisted the future was now, and evil, murderous technology was literally coming from the future to hunt you down in your happy, bucolic present.

Blade Runner, adapted from the Philip K. Dick novel *Do Androids Dream of Electric Sheep?*, shared the novelist's preoccupations with the blurriness of identity, of the inability to tell whether you were man or machine: the movie, famously edited down from an original cut, spends less time than the original novel on the prospect that Harrison Ford's hunter-detective may actually be an android and just doesn't know it. *The Terminator*, for its part, insisted, in its 1984 portrait of Arnold Schwarzenegger's implacable, unstoppable, totally alien-to-humanity hunter-killer, that there are very clear lines. "Machines need love, too" is the chirpy message left on the newly affordable home technology, the answering machine, that belongs to Sarah Connor; but this is presented as ghoulish irony. Connor briefly seeks shelter in a bar called Technoir, a case of the filmmakers putting their theme on their sleeve: their image of technology is dark indeed. One of the best tricks the Terminator does is, in some ways, to mimic the answering machine, a machine speaking in the voice of a person it is not: and that uncanniness—so prophetic of the AI-haunted world we're in now—shows us that the seeds of a nightmarish technological future are currently germinating. An unsurprising theme, for a movie about time travel.

The future the Terminator comes from is one in which the machines—Skynet—have gained sentience and, having done so, have eliminated most

of the human population via launching a nuclear holocaust. The means of exercising their implacable hostility to humanity are secondary to the movie's primary anxieties about technology itself; but they're a very good reminder that while Americans were dealing with new concerns, those concerns paled—or at least were shadowed by—the increasing prominence of an older fear, one back on the front pages once again.

THE REAGAN YEARS—ACCOMPANIED, ON THE other side of the Atlantic, by the conservative revival led in the UK by Margaret Thatcher—saw the saber-rattling of the Cold War reaching new heights. The year before *The Terminator* was released, over a third of America's population gathered together to watch Cleveland get annihilated in a blast of nuclear fire in the made-for-TV movie *The Day After*. Aware of the fact that given its airing on ABC, during sweeps no less, it would be particularly easy for children to watch, the news was awash in warnings, suggesting the trauma the viewer might experience. Hundreds of schools sent warning letters asking parents to consider whether children should watch this alone, or without proper guidance. Jerry Falwell asked people to boycott it; it was on the cover of *Time* and *Newsweek*. A project called The Day Before "organized over 500 community gatherings" where over 25,000 people talked about nuclear war, in venues as varied as a Maine police station and a Reno casino. The concerns were so elevated that Secretary of State George Shultz felt it necessary to give a televised address after the program, ensuring everyone the United States was against nuclear war.

All the discussion led, unsurprisingly, to monster ratings. *The Day After* was seen by 100 million people in 40 million households; some Sunday night restaurants reported business down 30 to 50 percent. Following a not-infrequent dynamic in horror, the fear came in expectation, rather than aftermath: almost 40 percent of college students reported the film was much tamer than they'd expected. "Not enough gruesome effects" and "a lot less gory than I thought it would be" were two typical responses—certainly true, compared to movies like *Friday the 13th*.[23] But contributing to the general unease was the sense among many viewers that what they were watching was less a hypothetical than a prophecy. In a 1985 Nielsen survey

of television viewers, about 40 percent of them—61 million—"regularly listen to preachers who tell them nothing can be done to prevent a nuclear war in our lifetime"; the best-selling nonfiction book of the seventies, Hal Lindsey's 1973 *The Late Great Planet Earth*, insisted on the likelihood of the apocalypse occurring in the coming decade.[24] The Reagan administration was believed by many to be more susceptible to this kind of apocalypticism, thanks in part to its strong connection to the evangelical right; and this raised fears in certain segments of the American public that hadn't been seen in a decade, since Watergate. Instead of the calm figures of *Fail-Safe* in charge, they believed, it was the rogue members of *Dr. Strangelove* who were in and around the Oval Office.

And it was that stew of apocalyptic, evangelical zeal, combined with disinhibition, that sparked atomic nightmares. In David Cronenberg's 1983 filmed version of Stephen King's novel *The Dead Zone*, the psychic protagonist, Johnny Smith, has a vision of the future in which Martin Sheen's senatorial candidate Greg Stillson is now president, and initiates a nuclear war. "Mr. Vice President, Mr. Secretary . . . the missiles are flying. Hallelujah. Hallelujah," he says. (In the novel, Johnny receives several copies of *The Late, Great Planet Earth* from people who assume he's an end-of-times prophet.)[25] Smith, an updated Rip Van Winkle who passes from the upheavals of 1970 to the inward looking Me Generation of 1975,[26] moves from quietism to activism, in his case an attempted assassination. In both novel and movie, Sheen is eventually taken out through the good sense of public opinion—when the psychotic candidate, under threat of Johnny's assassination attempt, grabs a baby to use as a human shield, the electorate immediately shuns him, and for good. But the novel was published before Reagan's election: what if the threat was already in the Oval Office? In the MTV video for the 1986 Genesis song "Land of Confusion," a puppet of Reagan (from the British TV show *Spitting Image*) immolates the world because he accidentally pushes the button for Nukes instead of for Nurse, presenting the question as one of outright dementia. On the other hand, in J. G. Ballard's 1970 story, "Why I Want to Fuck Ronald Reagan," which led Doubleday to pulp *The Atrocity Exhibition* collection's first American edition, Ballard, as he wrote later, talked about how Reagan,

as California governor, would use "the perfect, teleprompter-perfect tones of the TV auto-salesman to project a political message that was absolutely the reverse of bland and reassuring."[27] You could take your choice, in other words: incompetence or outright malice. Either way, the world could end at any moment.

Shortly after *The Dead Zone*, at the very start of the eighties, King published a short novel about a very unnatural mist, in which roamed monsters from another world. *The Mist* neatly combines fears of nuclear annihilation and religious apocalypticism: the narrator, early on, describes the odd weather that heralds the mist as "that old chestnut about the long range results of the fifties A-bomb tests again" and has a dream that he "saw God walking across Harrison on the far side of the lake, a God so gigantic that above the waist he was lost in a clear blue sky," a sight echoed, toward novel's end, by the sight of a gargantuan monster vanishing up into the mist. But one of the work's real monsters is one Mrs. Carmody, a wild-eyed character who insists on religious sacrifice, and the emphasis narrows down to human choice: the cause of the mist may be a mysterious Arrowhead Project nearby, which has been "shooting atoms into the air . . . *different* atoms."[28]

In his evocation of atoms gone horribly wrong, King almost certainly had in mind—and certainly his contemporary readers would have had, as well—the accident the year before at the nuclear facility on Three Mile Island in Pennsylvania. A partial meltdown of the reactor there sent radioactive material spewing into the air, shaping American perceptions about the safety of nuclear power to this day. (As did the Jane Fonda–Michael Douglas nuclear-meltdown disaster pic *The China Syndrome*, released, coincidentally, less than two weeks before the Three Mile Island disaster, allowing Americans to put another name on the fear.) And in contrast to presidential apocalyptic mania or great-power politics, this nuclear disaster was about the ordinary, regular malfunctioning of technology, the possibility of human failure.[29] It's no coincidence that Homer Simpson, who comes to prominence at the end of the decade in the great animated comedy that bears his last name, works—quite incompetently—as a nuclear

safety inspector at Springfield's power plant. Bringing these issues home, in other words, was a part of the story.

Red Dawn, a 1984 movie that imagined a Soviet-American World War III, avoids the specter of nuclear exchange by the clever expedient of insisting the Russians need the American breadbasket due to internal famine, and fallout would render it useless. Instead, they invade the homeland, which allowed viewers to witness the horrors of war as played out among individuals and in familiar institutions. In the opening minutes of the movie, Russians land, via parachute, in front of a Colorado school, and simply begin blasting away with submachine guns. Later in the movie, we see another submachine execution, this one a firing squad sending civilians singing "God Bless America" into a pit. One of those Americans is the father of two of the teen protagonists, who then take to the hills to engage in guerrilla resistance.

"What started it?" says one character to another in *Red Dawn*. "I don't know, two toughest kids on the block, I guess. Sooner or later they're gonna fight," is the reply. This marked a vacillation common in the Reagan eighties. One the one hand, fear was shrouded in jingoism, of the occasionally juvenile sort: "Wolverines!" say the teen fighters in *Red Dawn*, the name of their high school mascot and now their battle cry. Or there was the fantasy of the Cold War one-man army named Sylvester Stallone,[30] fighting Communists in the jungles in *Rambo: First Blood Part II* and in the boxing ring against a Soviet man-machine in *Rocky IV*. On the other, the sentiment that all this grand drama was simultaneously costly, and senseless: an ambivalence played out, in part, by displacing it into the past, through a new spate of movies about Vietnam.

Questioning Vietnam, of course, was hardly a new activity, as we've already seen: the late seventies had seen its share of reflections. Journalist Michael Herr led the way, in his 1977 book *Dispatches*, which suggested that what most of America had seen of that war wasn't the whole story, at all. "The press got all the facts," he wrote, "but it never found a way to report meaningfully about death . . . [behind] "every column of print you read about Vietnam there was a dripping, laughing death-face; it hid there

in the newspapers and magazines and held you to your television screens for hours after the set was turned off for the night, an after-image that simply wanted to tell you at last what somehow had not been told."³¹ This impression gave the sense, then, that fiction was equally, if not better, suited to relating the horrors of Vietnam than reportage: and fiction obliged. Francis Ford Coppola rewrote Conrad's *Heart of Darkness* for the conflict in what was formerly colonialist Indochina in 1979's *Apocalypse Now!* Marlon Brando played a shadowy Kurtz, insisting "horror and moral terror are your friends" and hoping for soldiers who can "utilize their primordial instincts to kill . . . without judgment, because it's judgment that defeats us." Such amorality, treading into horrific malevolence, was most indelibly expressed by Robert Duvall's Kilgore, the man who loves "the smell of napalm in the morning." It smells "like victory," he says. Coppola, who called his film "the first $30 million surrealist movie," felt the only way to express what Vietnam *really* meant was to come as close as he could to a dream, particularly of the nightmarish variety.³²

But in the late seventies and eighties, it was clear that, despite Duvall's character insisting "Someday this war's gonna end," that was only true in some respects—certainly not in how it lingered in the wounds of memory, and in debate over its legacy. Mid-eighties movies like *Platoon*, *Full Metal Jacket*, and *Casualties of War* took on, variously, the psychopathy of individual soldiers in the theater of conflict, the training that turned recruits into soldiers, and the meaninglessness and absurdity of grand goals in the face of the actualities of combat.³³ As the decade ended, one of the great post-Vietnam movies—1990's *Jacob's Ladder*—dialed up the traumas of the Vietnam veteran into an even more nightmarish key. While the occasionally demonic hallucinations and images Tim Robbins's character suffers are traced, in the movie's narrative, to diabolical experiments performed by the United States military on their own men (in order to make them more violent), they also stood in for the flashbacks associated with PTSD, the impossibility of escape from its clutches. "I'm not dead, I'm alive," Robbins says at one point, in the grip of his delusions. But the movie dedicates itself to the proposition that this may be only technically true.

Other ambivalences to the newly heated Cold War took more baroque

form. In 1984, Robert McCammon, one of the great new horror voices of the eighties, had written "Nightcrawlers," in which the protagonist, a PTSD-afflicted Vietnam veteran, is haunted by material projections of the dead fellow soldiers he'd left behind. "Nightcrawlers" was justly praised; but what got him widespread attention was his magisterial 1987 epic novel *Swan Song*, which, like its antecedent *The Stand*, provided a religiously inflected look at a postapocalyptic society, here explicitly catalyzed by nuclear war. But equally unforgettable was Joe R. Lansdale's "Tight Little Stitches in a Dead Man's Back," a post-nuclear-apocalypse tale combining the radioactive monstrosity of the giant-creature fifties—here, mutated, now homicidally carnivorous roses—with a deeply felt, utterly human tale of loss and grief. In Lansdale's novella, the protagonist, a nuclear scientist who manages to save his wife, but not his daughter, as the missiles begin to fly, lives in self-flagellation in a nightmarishly hateful, regret-filled and mournful marriage, played out in the tattoo portrait of his daughter his wife carves on his back. Without anesthetic.

Rendering the unthinkable thinkable was, once again, a generation after *Strangelove*, the province of the surreal, the absurd, the blackly and fearfully comic; and there was no better evocation of that than, well, the comics. Three different works came out in 1986 that redefined the medium, ushering in the wider recognition of a new level of maturity. Two of them explicitly took on nuclear fears, albeit in very different ways. In Frank Miller's *The Dark Knight Returns*, Batman must come out of retirement to defend the city against the depredations of mobs liberated by a nuclear winter. And the action in the most brilliant work of mainstream comics of the period, Alan Moore and Dave Gibbons's *Watchmen*, is catalyzed by the fear of a similar fate, and the way to avoid it, the graphic novel suggests, is by swapping out a different fearful trope for this one. Ozymandias, a superhero—if that's the name that fits—arranges a faked, failed alien invasion that lands in the middle of Times Square, killing millions but uniting the world in the face of the outside Other. Played straight, this could have been the plot to a dozen fifties movies, and was; but times have changed enough, from the fifties to the eighties, that the alien invasion is considered the bleak, black joke that serves as the novel's central mystery. The third

work in the triptych, Art Spiegelman's *MAUS*, evoked less Hiroshima than Holocaust, of course: but Reagan's visit to a German military cemetery that was home to the bodies of dozens of SS members the prior year gave some reason to mutter that certain old horrors were dying a bit too quickly.

Watchmen and *The Dark Knight Returns* sparked a renaissance in comics that had a darker and more fearful edge. Just prior to his work writing *Watchmen*, Alan Moore had revitalized a lesser-known character named Swamp Thing, whose name bore classic horror-movie and horror-comic bones. (One of Swamp Thing's creators, the immensely talented artist Bernie Wrightson, had recently done the comic-book adaptation of *Creepshow* and, in 1983, an illustrated edition of *Frankenstein* that remains a high-water mark of the medium.) Moore's aesthetic and commercial success on *Swamp Thing* not only gave him the credibility to make *Watchmen*, but encouraged his parent company, DC Comics, to bring in a wide variety of other British writers who would create or develop a series of characters and series that would give the horror comic a new life. Neil Gaiman would recycle and revivify some of the horror-hosts of seventies DC comics—the Cain and Abel of their titles *House of Mystery* and *House of Secrets*—into full-fledged characters with depth and even pathos of their own. They appeared in the Dreaming, the domain of Gaiman's masterwork, *The Sandman*. Alan Moore had created a British occult detective named John Constantine; under the (often overdramatically incongruous) title *Hellblazer*, another British import, Garth Ennis, along with many others, would transform the chain-smoking, profane, self-loathing stained knight into one of the premier representatives of dark urban fantasy. While Constantine spent most of his time in England, he occasionally made it to America: and these writers, to a man (and the writers involved in the British invasion were overwhelmingly male), were fascinated with America, in all its wideness and diversity.

Ennis would go on, with artist Steve Dillon, to create *Preacher*, a comic series in the second half of the nineties that featured, among much else, a self-loathing Irish vampire in love with New York City; a Texas man of the cloth possessed by the offspring of an angel and a devil; a Saint of Killers who looked like Lee Marvin, with magic six-guns that always killed, never

missed; and a family of down-country homicidal maniacs who made the rapists in *Deliverance* look like choirboys. *Preacher* was Ennis and Dillon's attempt to say everything about what it meant to tell an American story: widescreen, dirty and violent as hell, mixing its horror and gore with its comedy, and vice versa.

But what it was, at least in part, was a revisionist Western, an outsider's view on the lies America tells itself, the secrets it tries not to think about. But those ghosts continued to come to light.

IN STEPHEN KING'S 1977 NOVEL *The Shining*, the specters that haunt the Overlook Hotel and drive its new caretaker to attempt to ax-murder his wife and son are, primarily, related to gangland executions, organized crime, and the occasional upper-crust suicide. In Stanley Kubrick's film version three years later, at least part of the uncanny narrative backstory is that the hotel is built on an Indigenous burial ground.[34] ("Are all these Indian designs authentic?" someone asks.) The seventies had seen an increasing awareness of the price Indigenous peoples had paid for American expansionism—thanks, in no small part, to the 1970 history *Bury My Heart at Wounded Knee*, by Dee Brown, which rode the bestseller lists for a year. A new interest in Native American culture and folklore had woven itself into some of the horror novels and movies near the turn of the decade. Martin Cruz Smith's 1977 novel *Nightwing*, set on a Hopi reservation and written by a part-Pueblo writer, connected a plague of vampire bats with the depredations of capitalist miners on sacred land. It was a contemporary bestseller among Native activists.[35] And the film adaptation of Whitley Strieber's novel *Wolfen* was particularly and acidly knowing about how white people would credulously inhale Native American legend—here, about shape-shifting into animals—in order to cast Indigenous peoples as mystical or uncanny.

One of the most prominent versions of this trope—Native Americans, albeit sinned against and so in some ways sympathetic, but also capable of monstrous revenge, and therefore somehow monstrous—was the idea of the haunted house as sited on an Indigenous burial ground. Broached in *The Amityville Horror* and *The Shining*, the trope was deepened in the

conversation around 1982's *Poltergeist* (although not, despite the popular and general insistence, in the movie itself, which in fact explicitly states the cemetery the haunted house is on is *not* Indigenous.) That said, the power of the belief suggests an awareness of metaphorical currents, currents the movie presents as an outgrowth of rapacious white capitalism. The terrorized family's patriarch, played by Craig T. Nelson, is in part morally implicated in the horrors because his communal design company has not only built housing on the burial ground but—unbeknownst to him—failed to move the bodies themselves. "Well, no one complained," his boss says when Nelson realizes, and there is a small, fine moment of horror: it is precisely because of past American policies of ethnic cleansing that there is no one around to register such a complaint. Except, of course, for the dead. A few years later, in 1990, the Native American Graves Protection and Repatriation Act would be passed in response to the real-life instances of this exact phenomenon. While *Poltergeist* essentially elides the point that there *are*, in fact, living Native Americans (or, for that matter, Native Americans at all), its 1986 sequel addresses the concern, and the metaphorical undercurrent, by tacking so far in the other direction that it presents its Native American character as a cardboard cutout of saintly mysticism, who then conveniently vanishes from the narrative after fulfilling his purpose of protecting our white characters. Stephen King's 1983 novel *Pet Sematary* would use an Indigenous burial ground and a Native American folkloric tradition, the wendigo, to account for its zombified, homicidal monsters; while King's novel leans heavily on this identification of Indigenousness with monstrosity, it also hints at a kind of return of the violently repressed, a time bomb of revenge on those who press on to violate locales that don't belong to them.[36]

In 1987 one of the century's masterpieces addressed another of America's not neatly buried horrors. Toni Morrison's *Beloved* was a ghost story, first and foremost, inspired by a story Morrison came across in compiling a scrapbook of Black history, *The Black Book*, while an editor at Random House in 1974. In a movement parallel to the attentiveness to Indigenous history as American history, Morrison and Alex Haley—whose *Roots*, a family story of being Black in America, was an unimaginably successful

bestseller—were viscerally alive to the idea that Black history in America was a horror story. And the story Morrison came across was particularly terrible: the tale of one Margaret Garner, "who tried to kill her four children when she was about to be caught by slave catchers who had tracked her down at her mother-in-law's house in Cincinnati."[37] Such infanticide to avoid resigning children to a life of slavery, to suffer like their parents had, was, tragically, not a solitary instance. Reworked entirely for the novel, Morrison's work became a tale of haunting, in which her scarred characters, recognizing the ghosts that haunt them, try, impossibly, to reckon with and work through their personal and national traumas—not least, the histories of rape and sexual exploitation that often led to such children in the first place.[38] And for the characters of this and other Morrison novels, the South itself is hauntingly doubled: both as a site of horror and as, necessarily, the only home and past they know.[39]

AFTER THE SUCCESS OF WRITERS like King, Straub, Blatty, Tryon, and Levin between hard covers, a whole cottage industry of paperback originals sprung up starting in the seventies, with publishers like Berkley Books cranking out fiction by the yard, counting on lurid covers to attract readers as much, if not more, than the content therein.[40] Every subgenre we've discussed, and many more, was present between those soft covers: killer clowns, demon children, leprechauns, medical horror, you name it.

There were great writers who worked in the paperback original format, and one of the best was Michael McDowell, who mastered the Southern Gothic for a new generation. His 1979 novel *The Amulet* is centered on a cursed amulet moving from place to place that immediately transforms its wearers into homicidal maniacs—one particularly gruesome example involves a baby and a washing machine—but it's also, as much as anything else, about the way that the amulet brings out the buried tensions—racial, familial, economic—of its intricately rendered Alabama background.[41] He followed it soon after with 1982's *Blackwater*, a kind of neo-Lovecraftian Southern Gothic where a fish woman marries into a family and causes disaster, which was released in several novellas, a form which would go on to inspire Stephen King to do something similar with his *The Green Mile*.

Such racial fears, which expand to encompass miscegenation, remind us of an earlier era of Lovecraft and the Yellow Peril (although, to be clear, McDowell himself was no sharer of Lovecraftian attitudes), and that well-documented fear of the ethnic other gained new intensity in the early to mid eighties as well. This time, it was conditioned by socioeconomic factors—rising competition from Japan, threatening to decimate American auto and manufacturing centers. But if you thought these anxieties wouldn't be channeled into racialized connotations, you haven't been reading too closely: and one particularly tragic example of this fear and hatred was the 1982 murder of Vincent Chin, a Chinese-American beaten to death by two auto workers who erroneously believed he was Japanese. In the precincts of fiction, though, all these anxieties—which could be seen, by some, as rolling back the victory of the Second World War—were encapsulated most neatly, albeit surprisingly, in a movie that involves puppets you probably shouldn't feed after midnight.

Gremlins, from 1984, is known, in no small part, for being an ostensible children's movie that is entirely unsuitable for children. *People Weekly* wrote that "no parent should allow a young child to see this traumatizing movie: it would be a cinematic form of child abuse."[42] Fifty people walked out of a single showing in the Midwest. You could, perhaps, explain the hostility as stemming from its inappropriate gore: we've already mentioned the gremlin in the blender. You might frame it as an early installment in the War on Christmas: it's the only Christmas film, so far as I know, to have a character explain her hatred for Christmas as stemming from her father's death of a broken neck as he comes down the chimney dressed as Santa Claus. But mostly it's because the title creatures were so clearly analogues to children: the pre-transformation Mogwai were cute, sweet, and cuddly; but when they were fed after midnight and turned into gremlins, they were "ugly, ill-mannered, undisciplined, destructive, and thoroughly awful. In a word, they behaved just like children, children of the worst sort."[43] And, the movie suggested, it was all right to kill them.[44]

All this focus on children notwithstanding, the movie grapples with some fairly adult themes. The gremlins take their name from Second World

War slang about imaginary beings that mucked with Allied soldiers' weapons and vehicles, and it's hardly coincidence our hero's father is presented as technologically feckless—he produces comically useless mechanical inventions—in the face of the technology from Sony and other Japanese technology swamping the American market.[45] ("You gotta watch out for those foreigners because they plant gremlins in your machinery" is an actual line in the movie.) But it goes beyond technological sabotage and supremacy: *these* gremlins are dedicated to destroying an American way of life, tearing the archetypally Christmassy town apart. And, of course, they're explicitly seen to come from Asia. There is, as is so often the case, the stink of that racist, anti-immigrant sensibility: they present as docile and harmless Mogwai, the gremlins do, but take them into your home, and let them loose, and they'll multiply like mad and start biting off a lot more than you want them to.

Unsurprisingly, given its producer Steven Spielberg, and director Joe Dante (who'd done *The Howling*), *Gremlins* is also a movie about movies: it nods very intentionally at *It's a Wonderful Life*, that Christmas movie par excellence, but also features clips from *Invasion of the Body Snatchers*, *Forbidden Planet*, and *The Time Machine*. The climactic destruction of the gremlins takes place in—where else?—a movie theater, where they've all gathered to watch an ur-horror movie that both is and isn't for children: *Snow White and the Seven Dwarfs*. But that emphasis, despite the movie's very contemporary allegorical anxieties, hinted at a nostalgic sensibility: an attempt to bring together all the classics, wrapped up in one big Christmas bow.

Which was a current preoccupation of that second Steve as well. There's an often-told anecdote that in the late eighties one out of every four books coming off the presses had Stephen King's name on the cover;[46] and King's 1986 magnum opus, a doorstop of a novel, was where he tried to say absolutely everything about a particular kind of horror, all at once. It wasn't exactly an epitaph; but it was something akin.

It was the work of a horror fan, as well as a master of the craft; whether King had ever heard Lon Chaney's saying that "there is nothing laughable

about a clown in the moonlight,"[47] he certainly took its tradition to heart—a tradition that had reached a new pitch in the eighties, becoming conflated with that rising fear of strangers[48]—in the crafting of *It*'s avatar Pennywise, who is able to take many forms; and the forms it takes as it confronts its victims, more often than not, are those of classic monsters. Transmuted, through King's craft and the mind's eye, into the nth-degree, most terrifying versions of themselves, to be sure, slasher versions of the mummy, the teenage werewolf, the creature from the black lagoon, but classic monsters nonetheless. "Maybe all the monsters we were scared of when we were kids, Frankenstein and Wolfman and Mummy, maybe they were real," muses the main character in King's early story "The Boogeyman," "real enough to kill the kids that were supposed to have fallen into gravel pits or drowned in lakes or were just never found." That's certainly the germ of *It*.[49]

But in the novel, King clearly presents those monsters as childhood fears and traumas to be put behind in the name of facing adulthood. *It*—and what else would you call a book that attempted to put the unknown into the shape of *everyone's* individual nightmare, cramming as many of them as possible between a single set of covers?—was, at its heart, about King as fan: a twisted love letter to a particular kind of childhood and to childhood itself, to its traumas and its resilience and, most of all, its friends; to the idea that what mattered more than anything else to the person you could be was where you came from and who you came up with. If *It* is very much in the tradition of the New England Gothic, with its cursed, history-stained town with a bunched, evil alien spider at its heart, then what matters, King suggests, is the Derry that we carry around in our hearts: we may try to forget it, but ultimately it calls us home, and we have to confront it.

It ends with its titular monster definitively defeated, and that town, Derry, literally being wiped off the map; which suggested the possibility that the classic monsters it featured were, perhaps, reaching a moment of exhaustion. But, as it turned out, it was less an ending than an inflection point, a necessity to once more redefine them for a new generation. In the 1985 movie *Fright Night*, a classic television horror host played by Roddy McDowall told a teenager:

None of your generation seems to be [serious about believing in vampires]. . . . I have just been fired because nobody wants to see vampire killers anymore, or vampires, either. Apparently all they want are demented madmen running around in ski masks hacking up young virgins.

But, as the movie itself proved, that wasn't true: what they were less interested in, it turned out, was the old-school, tux-and-cape Count with the foreign accent. *Fright Night*, by contrast, jettisoned all those elements, in favor of the very up-to-date heat generated by Chris Sarandon, who kept all the erotic appeal of Rice's vampires without any of the lace and ruffles, its sex scenes more akin to the R-rated comedies currently attracting teens to the theaters in droves. Sarandon had come to prominence playing a gay man seeking a sex-change operation in the movie *Dog Day Afternoon*, a decade earlier, and his appeal, in the movie, clearly extends to young people of both sexes.[50]

Which allows us to address the new, very modern horror story omnipresent in the American imagination of the time: a biological nightmare, for which the vampire would serve as a central metaphor.

DAVID CRONENBERG HAD BEEN INTERESTED in what happens to flesh throughout his career; and in 1982's *Videodrome*, when the television signal has metaphorically and literally gotten *under* James Woods's skin, turning parts of him into something out of the house of wax, Cronenberg has him announce a manifesto: "Long live the new flesh." The new flesh, indeed; and the early eighties associated bodies, sex, abnormality, and diseases seen on the flesh in an entirely new way. It was a new disease, entering the societal vernacular in moralistic terms: "the gay plague," fear and condemnation in equal measure, judgment of and animosity toward the gay community. But until the etiology of AIDS was fully established—and, of course, for many, even after that—there was fear more than anything else. In the greatest work of American fiction about AIDS, and so much else—Tony Kushner's *Angels in America*, gestating in this period—fear pervades the characters'

mindsets, as they attempt to comprehend this new plague. "Nobody knows what causes it. And nobody knows how to cure it. . . . Sometimes the body even attacks itself. At any rate, it's left open to a whole horror house of infections," a doctor says, recalling earlier discussions about skin lesions and bloody stools. "We think it may also be able to slip past the blood-brain barrier . . . which is of course very bad news." Nobody knows: that was it. Fears abounded that you could get AIDS from a toilet seat; in particular, the concerns spread about schools, dovetailing nicely with the fears elementary school teachers were secretly Satanists, or child abusers, or both.

Or that you could get it from simply hugging or kissing someone who was gay. Homophobia hardly needed AIDS to run rampant in American society, especially as the gay rights movement and increasing discussion about sexuality, of all sorts, had rendered gays and lesbians more visible in American society. All too often, the depictions in popular culture that resulted were tinged, or more than tinged, with horror. Ira Levin's 1978 play, *Deathtrap*, was made into a movie in 1982. It had stars Michael Caine and Christopher Reeve play gay lovers on screen; simultaneously, though, it had that relationship serve as a motive for murder (of Caine's character's wife), reinforcing some extremely ugly stereotypes about gay men and criminality. Al Pacino's 1980 movie *Cruising* established connections (albeit somewhat ambiguously and ambivalently presented) between homosexual desire and homicidal frenzy; the movie was picketed by gay activists widely.[51] But as the eighties continued, AIDS supercharged these negative stereotypes and added a component of biological contagion, not only generating a visceral fear of gay people, gay men in particular, but intensifying their alienation, loneliness, and sense of abandonment by society.[52] It was that—compounded, within the community, by the constant drumbeat of funerals of young men, the ghostly presence of their memories everywhere—that made a psychiatrist's 1987 summation of the past few years, in the very explicit language of fear and horror, so apt: "A specter is haunting our streets—the specter of AIDS, a remorseless and incurable disease whose nature, transmission and effects still contain elements of mystery. The fear of AIDS is pervasive."[53] And, as had so often been the case before, America accordingly turned to one of its great monstrous allegories to work through that fear.

The uptick in vampire interest had continued in the late seventies, with two film representations that showed how metaphorically pliable the figure could be. Frank Langella's performance in a 1979 *Dracula* showcased the more traditional version (and, at the same time, that version's brooding erotic potential). By contrast, George Hamilton's performance in the comedy *Love at First Bite*, which, when you put aside all the camp and kitsch, presented the Count as a salutary corrective to the meaningless sexual revolution of the Studio 54 crowd. In the movie, that famous nightclub vibe was embodied in Susan St. James, who, as it turns out, prefers the dashing Count and his protestations of eternal affection to the neurotic, effete, and emasculating psychobabble of Richard Benjamin's Jewish psychologist.[54] There were other novelistic treatments, in wide variety. George R. R. Martin created a vampire stalking nineteenth-century American steamboats in 1982's *Fevre Dream;* Suzy McKee Charnas depicted a more biologically appropriate vampire in 1980's *The Vampire Tapestry*, with robust explanations of the mechanics of hibernation akin to the tales of immortality; Robert McCammon, in 1981's *They Thirst*, conjured an epic novel of a vampire king in modern-day Los Angeles, that city of hunger and vampiric sensibilities.[55]

But the real taproot of the eighties' interest in vampires remained in the hands of Anne Rice, a New Orleans poet, occasional writer of erotica, and recently bereaved mother. Rice would say that, her love for earlier vampire fiction and film notwithstanding, she wrote the vampire novel *she* wanted to read, which, for her, focused on the vampire's erotic life and imagination. That eros, she argued, was "absolutely inherent in vampire material: the drinking of the blood, the taking of the victim; all of that is highly erotic. It's an echo of the sex act itself."[56] Louis, the vampire being interviewed in *Interview with the Vampire*, makes the connection plain in the course of telling his un-life experiences: explaining the impossibility of describing the experience of becoming a vampire, he adds, "any more than I could tell you exactly what is the experience of sex if you have never had it."[57]

And while Louis has, perhaps, fallen on hard times, the seeds were there of an increasingly, explicitly, sexual appeal that would broaden into an image of vampire as celebrity. Louis's vampiric sire, Lestat, would literally

become a rock star in *Interview*'s sequel, 1985's *The Vampire Lestat*, a vampiric transformation also present in S. P. Somtow's 1984 novel, *Vampire Junction*. Which was of a piece with 1983's erotic vampire film, *The Hunger*, in which a literal rock star, David Bowie, and an icon, Catherine Deneuve, enter a club and seduce, then drain, their one-night stands to the driving beat of Bauhaus's song "Bela Lugosi's Dead." Sexual moralism at play once more, perhaps; but, also, a horror-movie version of the music video—the movie's rhythms and visual techniques owe a lot to MTV.[58]

Both Rice's work and *The Hunger* notably focus on same-sex erotics: Lestat and Louis in *Interview with the Vampire* and Deneuve and Susan Sarandon in *The Hunger* desire each others' bodies, not just their victims'. But the conflation of the two concepts—Louis and Sarandon are, at different times, partners, prey, and antagonists—allow readers and viewers who identify with them to be titillated and to simultaneously distance themselves from the dimensions of the dynamics they choose to find monstrous.[59] And, especially in *The Hunger*, there are monstrous consequences. Unlike in, say, 1987's *The Lost Boys*, whose motto suggests an eternity of teenaged daydreams and mayhem—"Sleep all day. Party all night. Never grow old. Never die. It's fun to be a vampire"—or even in Rice's vampire novels, in which the vampire's pain is depicted as a kind of delicious melancholy, *The Hunger* presents us with the specter of desiccation and decay.

We watch Bowie's character, who is granted eternal life but *not* eternal youth, age and crumble before our very eyes. And—in a dynamic adapted from Poe—we see him resigned, at first unknowingly and certainly unwillingly, to an eternal waking coma of unlife locked in a coffin-type chest, the latest in a line of many of Deneuve's lover-victims. A particularly astute critic of the field, Les Daniels, noted in 1990 that the appeal of vampires is how they:

> relate more directly to the immortality concept. The idea that people have of maintaining their bodies forever, which is now part of our public consciousness in weird, desperate ways such as diet and exercise. People assume if they do these things, they will somehow cheat death.[60]

Vampire stories weren't the only ones thinking about maintaining youth forever: it certainly doesn't seem coincidental that the 1983 film version of Ray Bradbury's *Something Wicked This Way Comes*, that novel whose spinning carousel can make you older or younger, ends its emotional trials with an acceptance of vanished youth. "For my father, being old was all right now," the movie ends. But the vampire story was preeminent in this respect, and a version of it like *The Hunger*, with its darker currents, was therefore able to transpose the vampire story not only into an avatar of pansexuality, following Rice's model, but also, unlike Rice's novel, into a reflection on the kind of disease that was emerging.

The virality of AIDS was perfect for other horror metaphors, too. You could argue that the allegory for this spreading, epidemiological infection was coming out on movie screens as early as the 1982 John Carpenter remake of *The Thing*, which has a "distinctly medical subtext," set in a world of men faced with a quickly spreading infection that resulted in bodily changes unlike any that had been seen before. Several years later, the 1986 remake of *The Fly*, directed by—who else?—David Cronenberg, made the AIDS metaphor even clearer. Jeff Goldblum's scientist, whose molecules have gotten fused with the fly's, picks scabs off his body and views himself in a mirror. "You're right, I'm diseased, and it might be contagious somehow," he says, and suggests, using that diagnosis that also first described AIDS, that "it's a bizarre form of cancer."[61] "I'm becoming something that never existed before," he says, a sentiment not uncommon to AIDS victims, as we've seen; and Cronenberg's latest take on the horrors of the body, aided by cutting-edge special effects, not only asked, like they did, how such things like the visual incongruities we see on the screen, or on the patients' bodies, can be there, and yet they are. And also uncomfortably reminds us that, all too often, when we see goopy, repulsive things, we reflexively want to swat them.

But it was that juxtaposition of beauty and decay, of the dark dance between sex and the prospect of death, that made the vampire so powerful. *The Hunger* got it; and so, perhaps most blatantly, did the period's most important treatment of the ur-vampire story. Francis Ford Coppola, in his 1992 *Bram Stoker's Dracula*, was much more explicit about the sexual urges

and activities permeating Victorian society, and the story's characters that inhabited it (in one early scene, we see Mina Harker and Lucy Westenra giggling over the Kama Sutra, a scene that most certainly doesn't appear in the original novel). But it also showed closeups of vampiric cells invading human ones, a technique that would make the metaphorical connections between vampire and virus plain.

Blood, in other words, was hardly in short supply on the pages and movie screens of the 1980s. But the decade hadn't seen anything yet. In the mid-eighties, the British horror writer Clive Barker had published a collection of short stories under the title *The Books of Blood.* It opened with a brilliantly simple couplet: "Everybody is a book of blood. Wherever we're opened, we're red." Barker's book was published in the United States with a blurb from Stephen King: "I have seen the future of horror and his name is Clive Barker."

And, in pointing to Barker's combination of gore, horror, and over-the-top humor, exemplified in those two small poetic lines, Stephen King was absolutely right.

AT THE END OF THE eighties, writers John Skipp and Craig Spector gave a joint interview. Asked by the interviewer whether they overemphasized "the blood and the gore," whether it was too explicit, Skipp responded, laughing, "Yeah, well. Some people just don't know how to have a good time."[62]

Skipp and Spector were the godfathers, if not quite the originators, of a loosely associated movement of writers working in the can-you-top-that competition that became known as splatterpunk, the name—coined by David J. Schow in the mid-eighties—itself a parody of the cyberpunk movement then ruling the roost in science fiction. Splatterpunk was, in Schow's words, "loud, sometimes uncultured, not without literary merit, but doesn't eschew gory effects . . . heavily influenced by music and movies and television and videos," not least that abrasive punk rock attitude.[63] Anthologies like *Silver Scream, Splatterpunks,* and *The Book of the Dead*—a particularly gruesome example of the increasingly popular shared-world anthology, here a series of stories set in George Romero's zombieland, one of which includes a literal vagina dentata biting off a man's dick—provided

a series of images and stories that remain haunting to this day. Emblematic, perhaps, is Richard Christian Matheson's "Red," about a man trying to clean up the remains of his daughter on the highway after he accidentally dragged her to her terrible death, a fate we imagine clearly in its red, bloody aftermath.

One critic, considering the movement, suggests that there is, at splatterpunk's heart, a desire to use fear, pain, and horror to "revive deadened consciences, to fan the but faintly smoldering embers of humanity." Even if you've seen a thousand slasher movies, and remain unmoved at the carnage, how can you read "Red" and not feel something for the protagonist?[64] In this sense, Skipp and Spector weren't just creating a movement and a manifesto: they were making an early attempt to create a serious philosophy behind horror for the public consumption.

There were precursors to splatterpunk besides Clive Barker, of course, whose books, particularly in their movie versions—especially the *Hellraiser* franchise—gave a more baroque sense of the body horror than even Freddy, and even more outré, in some ways, than David Cronenberg. (It wasn't surprising that Barker cast Cronenberg as one of the leads when directing 1990's *Nightbreed*, the adaptation of an earlier novella of his; the latter director acquitted himself quite adequately on the other side of the camera.) Richard Laymon, many felt, had served as the opener of the bloody way. Laymon, growing up in Chicago, used to stay up late and watch *Shock Theater*; and that—along with a diet of Romero, Carpenter, and Matheson—helped lead to his 1980 novel *The Cellar*.[65] Although the novel has a supernatural bent—there is a Beast House, inhabited by something that isn't human, that tears, and rends—it's very clear that the real Beasts in Laymon's novel are homo sapiens, who behave with an abandon that put even Norman Bates and Michael Myers to shame in their actions, and in their author's description. "She opened his eyes when he touched her. She turned her head and stared at him. He wondered, briefly, if she looked so sad because of what happened to her parents, or because of what he'd been doing to her. Not that he gave a shit."[66] The girl in question is ten.

And there were parallel tracks. Joe R. Lansdale, one of the great horror writers of the eighties, was unafraid to go further, and harder, than almost

anyone else: his story "The Night They Missed the Horror Show"—a totally naturalistic tale of terror about a bunch of teenagers who go looking for thrills and get far, far more than they bargained for, in the form of two terrible brothers who are the scariest monsters you may ever encounter in horror fiction—was guaranteed, as he would put it in an introduction to his readings, to knock your dick in the dirt, and knock it there it most certainly did. Mixing "A Good Man Is Hard to Find" and *The Sadist* together and taking it to the nth degree, it's perhaps the most disturbing American short story ever written. His works could serve up horror and humor in equal, gore-dripped capacity to delight the most hardened EC fan: his love letter to *The Drive-In*, for example, the first in a series of novels in which the attendees at that institutional venue of over-the-top fear and nookie provided for some ridiculously messy dissolutions.

Lansdale, often associated with the splatterpunks, bridled under the title. "I was doing what I was doing long before anyone decided to call anything splatterpunk," he said, regarding the label as being "limiting" to what he did.[67] Dennis Etchison, sometimes regarded as the decade's greatest horror short story writer, opened his story "The Dead Line" with the sentences: "This morning I put ground glass in my wife's eyes. She didn't mind. She didn't make a sound. She never does."[68] It was Etchison's gift, however, to turn this archetypally splatterpunk opening into a deeply human, empathetic portrait: the protagonist's wife is facing a far greater horror than her husband—a society that has taken organ transplantation to the nth degree, cannibalizing the comatose for spare parts over and over again, causing unfathomable injury alongside the impossibility of escape. The protagonist's bodily industrial sabotage is in the name of providing his beloved wife with release.

Bodies, in short, were vessels; and that increased gore quotient of splatterpunk found its echo in movies like 1985's *Re-Animator*. The movie, based somewhat loosely on a work of H. P. Lovecraft, was part of a resurgence of interest in the author's work by writers like T. E. D. Klein and Karl Edward Wagner; among other noteworthy appeals, Lovecraft's descriptions of horrifying bodies echoed well with the tenor of the age. (Klein would write a 1985 story, "Nadelman's God," about a loser who manages to create a kind

of murderous Lovecraftian beast.)[69] Director Stuart Gordon, a few years later, noted the way in which gore and deviance were being defined down:

> When Romero did *Night of the Living Dead* people were running out of the theater, and now it's being shown on network TV uncut. I think the same thing will be true of *Re-Animator*: that it will eventually be looked at as a period piece. . . . And that's part of what you do, you always try to top what has been done before.[70]

And, in another parallel to the splatterpunk ethos, *Re-Animator* and another zombie movie the same year, Dan O'Bannon's *Return of the Living Dead*, retain their gory charm in part due to their knowing, over-the-top absurdity. ("Are you saying we're dead?" one panicked character says, after being exposed to zombifying toxic chemicals. "Well, let's not jump to conclusions" is the reply.) O'Bannon's movie, which explicitly name-checks Romero's movie—insisting, tongue in cheek, that the latter was a true story based on a chemical spill, chemicals that happen to be in their warehouse at *that very moment*—is an early entrant in the new currents of postmodernism beginning to make their way into the academy, and the culture. Which occurs, not incidentally, at a period in which horror itself is doing the same thing: a few years back, toward the end of 1979, the film scholar and critic Robin Wood had created a seminal film festival and an even more important series of theoretical examinations to go along with it, tracking the ways in which horror films were related to American anxieties. Although Wood's critical writing was largely limited to the academy, Stephen King—hardly an academic writer—transformed his lecture notes for a course on supernatural fiction he gave at the University of Maine into his first full-length work of nonfiction, the aforementioned *Danse Macabre*.

But this activity took place at a time of contraction for the horror genre, at least where printed fiction was concerned. Joseph Payne Brennan, a well-known writer of the previous generation—his stories included "Slime," a central influence on the Blob subgenre—called them "all-out slaughterhouse stories" and "chase-and-chop," "an author-guided tour of the abbatoir," with many "atrocity imitators," and considered them a potentially

existential threat to the field.[71] There had been remarkable literary successes over the course of the decade that weren't splatterpunk, new voices that partook in—using a term Brennan name-checked in his mid-nineties essay—"dark fantasy." Dan Simmons had followed the epic, sweaty, brilliant subverted-Orientalism of his debut novel, 1985's *Song of Kali*, with an incredible vampire novel, 1989's *Carrion Comfort*, that threw in everything: psychic Nazi vampires playing hypnotic chess games with living pieces— part of the decade's general shift of the locus of horror energy from the short story to the novel.[72] That same year, Robert McCammon followed up *Swan Song* with the gripping *The Wolf's Hour*, which featured Nazis and werewolves. Lisa Tuttle's magnificent 1986 collection *A Nest of Nightmares* continued in the tradition of Tiptree, telling horror stories that pertained to the violation of women's bodies.

And there were the ongoing masters. Peter Straub was continuing to write his delicately steely novels of haunting and trauma, increasingly weaving in recent American traumas, like the Vietnam nightmares that pervade 1988's *Koko*. And perhaps most notably, there was Joyce Carol Oates, one of the great writers of delicate, menacing, psychological horror of the second half of the century, and perhaps one of the best since James. Oates is a writer who has always been attracted to every aspect of the American condition, expressing it in venues panoramic and miniaturistic alike: and her work in the horror short story, as in the tales in 1977's *Night-Side* and 1988's *The Assignation*, show that condition's frequently haunted nature.

But when it came to the mass-market horror paperback, at least, the bubble was bursting: the bottom was falling out of the market, the authors and their work moving to small specialty presses. It wasn't that the hunger for fear had gone away, of course; it had just moved its interest—and its branding—to something different.

To tell the tale of what that was, we'll make a brief return to those more mature eighties comics, and to one of their preeminent creators, Neil Gaiman. Early on in Gaiman's *Sandman*, in the arc called *A Doll's House*, a number of characters stumble onto an actual convention of mass murderers. Gaiman's own mordant wit is amply on display; although the issue that shows them off is entitled "The Collectors," after the habit of trophy-taking

that, post-Vietnam, was an increasingly foregrounded feature of the killers' activity, the group disguises itself as a cereal convention. Say it out loud, and you'll get the joke: along with an introduction to the new figure stalking the American imagination.

ROBERT RESSLER, THE FORMER FBI agent responsible in no small part for inventing the term "serial killer," explained his thinking:

> I think what was . . . in my mind were the serial adventures we used to see on Saturday at the movies . . . Each week, you'd be lured back to see another episode, because at the end of each one there was a cliff-hanger. In dramatic terms, this wasn't a satisfactory ending, because it increased, not lessened, the tension. The same dissatisfaction occurs in the mind of serial killers. The very act of killing leaves the murderer hanging, because it isn't as perfect as his fantasy.[73]

Noteworthy, of course, that this entertainment-derived definition was *Ressler's* idea,[74] rather than any of the real-life killers that became household names in the late eighties and early nineties—people like Ted Bundy,[75] who was sentenced to death at the beginning of the eighties for raping and murdering dozens of women, or Jeffrey Dahmer, whose cannibalistic preying on the gay community of Milwaukee led to an explosion of homophobic jokes, harassment, and assaults on that community. The president of the Gay/Lesbian International News Network got this message on his machine: "Hello, this is Jeffrey Dahmer. I want your head in my refrigerator. Call me."[76]

The proliferation of cases, or, at least, the sense of that proliferation— Ressler had given a notorious news conference in 1983 that generated a panic "over an alleged epidemic of serial murder," with "media sources" suggesting serial killers were committing four thousand murders each year[77]—also led, as we saw with the press coverage of Ed Gein's case, to a horrific fascination with the gory details. When the police investigated Dahmer in July of 1991, newspaper readers quickly learned they "found human heads in the refrigerator, painted skulls on shelves, genitals stored in buckets."[78] Dahmer

was patiently waiting for them, and his story led to a fascination that verged on celebrity-making: serial killers, sometimes by desire, sometimes not, followed the Manson model of becoming infamous stars. And not just following in the footsteps of real-life "stars," but literary ones, too: Dahmer, who confessed to killing over a dozen young men and boys, mostly gay men of color, "photographing them, dismembering their corpses, and eating some of their body parts," was immediately compared to an iconic figure of fiction of the previous decade: Hannibal Lecter.[79]

All the way back in 1981, Thomas Harris, in his novel *Red Dragon*, had introduced Hannibal "the Cannibal" to the American imagination. "Dr. Lecter's eyes are maroon," he wrote, "and they reflect the light redly in tiny points."[80] Hannibal Lecter is presented in nearly supernatural terms— vampiric ones, to be precise—and part of the horror he engenders is the way he is interested, vampirically, in feeding on people's trauma, their stories. This is as true of the stories of the novels' protagonists, the investigators, as it is of those of his unfortunate patients; both groups are presented as almost equally broken. This dynamic would become even more pronounced in Harris's 1988 follow-up, *The Silence of the Lambs*. The novel, and its subsequent filmed version, pits Lecter simultaneously, and victoriously, against his captors and against investigator Clarice Starling—a battle of wits, of genders, and of monsters. It became an enormous bestseller, and, of course, an iconic movie with which to usher in the nineties, thanks most famously to the performance of Anthony Hopkins, who chewed the scenery along with various people's body parts. Lecter is simply more than human; and Anthony Hopkins's performance renders that neatly.

Look at the first encounter he has with Jodie Foster's Starling: he essentially doesn't blink. (Hopkins said in interviews that one inspiration for his performance was *2001: A Space Odyssey's* computer HAL.)[81] This hyper-humanness, this monstrosity, finds its echo in the baroqueness of the serial killer in Harris's fiction: the other serial killers, known by the sobriquets of the Tooth Fairy and Buffalo Bill, do monstrous things to the bodies of the people they kill, and, of course, Lecter famously cooked and ate one investigator's liver alongside some fava beans and chianti. With its

mix of explicitness and wit, it might not have gone amiss as a story in a Skipp and Spector anthology.

But, of course, it didn't appear there; because Harris's work—and the many other similar novels it engendered—were marketed quite differently, as suspense or thriller novels, rather than horror. It was a studied effort to distance these books from a set of works that, by marketing decision and consumer choices, had increasingly become defined as a specific category, a genre, rather than a mode. And it was a genre, as Peter Straub would later put it, that "pretty much stuck to its guns from the mid-1970s to the late '90s," rehearsing and repeating the same conventions, "which is the reason it began to seem pretty tired."[82]

Meanwhile, serial killers, portraits of the psychotic nightside of America, proliferated. Their numbers even expanded in their own retellings: Henry Lee Lucas, in 1983, confessed to committing hundreds of murders, a spree that would have put every other serial killer in American history into distant shadow. It seems clear, now, that he was wildly exaggerating—although the eleven murders that he was eventually convicted and sentenced to death for were terrible enough. But he was widely believed at the time; part of a widespread belief that people like him could be wandering the highways of America, killing at random, creating—and participating in—"a script as lurid as it was compelling."[83] And, speaking of scripts: in 1986, Lucas's story inspired a movie. *Henry: Portrait of a Serial Killer* is most notable for its lingering gaze on the corpses that Henry has left behind, with the sound of the killing playing over it—a comparatively understated goad to the imagination.

Even Stephen King got into the act in 1987 with his follow-up to *It*. *Misery* begins to mark King's period of self-reflectiveness as a writer, reflecting on the powers that writing has, not just on the self, but on the rabid audience that King and the genre he had helped to explode had assembled. Bill Denbrough, King's clearest alter-ego in *It*, is a writer, but his literary struggles are, primarily, with block. *Misery*'s Paul Sheldon is in an entirely different kind of fix. "I'm your biggest fan," Annie Wilkes enthuses to him, and when she finds him, crashed and abandoned, she insists that he write

the work *she* wants him to—otherwise, she's going to get busy on his lower extremities with a sledgehammer. But Wilkes, we learn during the course of the novel, has not limited her violent attentions to Paul: she is a serial killer, having dispatched possibly dozens of patients as an instance of that horror archetype: the black widow nurse.

Misery has nothing supernatural about it; the obsessions that Wilkes has are natural enough. Paul calls Wilkes "the perfect audience . . . the embodiment of that Victorian archetype, Constant Reader"; he means this in the sense that, to her, the characters are real, and Paul understands that power: "Millions might scoff," he thinks, "but only because they failed to realize how pervasive the influence of art—even of such a degenerate sort as popular fiction—could become." As the decades would go on, this sense of imaginary intimacy between audience and author, of believed ownership, would only grow larger and more toxic, but even then, King himself was no stranger to this: his home in Bangor often had fans camped outside, and in 1991, his wife Tabitha encountered one of them in their house with a fake bomb.[84] It may or may not be a reflection of those tensions in that Paul, finally triumphing over Wilkes, makes her choke on his manuscript: "Suck my book. Suck my book," he says.[85]

Had she been nonfictitious, Wilkes would have been unusual in the portraiture of American serial murder in no small part due to her gender: with the exception of Aileen Wuornos, who murdered seven men in Florida in the late eighties, there were few women who were included in this unsavory company. Wuornos came to prominence in no small part, once more, through the media: her story would be rendered on film in 2003's *Monster*, a year after her execution, in an Oscar-winning performance by Charlize Theron.[86] But there were other portraits of American murder that didn't quite fit the psychological profile of your standard serial killer. In the Coen brothers' first movie, 1984's *Blood Simple*, Dan Hedaya's character is buried alive, not unlike a character in a Poe story. In a moment that combines horror with farce in a manner that would become a Coen brothers trademark, Hedaya keeps inconveniently not dying when he's expected to, and that incongruous juxtaposition also characterized one of the eighties' most important movies, David Lynch's 1986 masterpiece *Blue Velvet*. Blue velvet

is the color and material of a dressing gown in the movie; a dressing gown is, of course, a garment worn somewhere between sleeping and waking, and the movie features a strange, dreamlike entrance into something that is and isn't America—or, maybe better put, into David Lynch's America. Lynch said, of his movie, "This is all the way America is to me. There's a very innocent, naïve quality to my life, and there's a horror and sickness as well."[87]

Kyle McLachlan, home from school, discovers, in the seemingly bucolic town, a severed human ear; which is an introduction to the dark underbelly of his community, which includes a psychotic, gas-sucking Dennis Hopper and a lip-synching Dean Stockwell. Although compared to *Eraserhead*, the movie has a quite coherent plot, it doesn't matter: what matters is the specter of a clean-cut boy being introduced to a world right next door that's stranger than he could have imagined, a reversed Oz, one that is, unlike that wizard, small and terrible.[88] But it was a *different* severed ear that would go on to define the psychotic killer for the nineties, the sensibility of the period.

In Quentin Tarantino's directorial debut, 1992's *Reservoir Dogs*, about a bank job gone horribly wrong and the infighting among the robbers who survived it, we learn that one of them, played by Michael Madsen, had executed a number of citizens during the robbery. While none of the other robbers are strangers to death or violence, they recoil at Madsen's behavior ("A psychopath ain't a professional . . . you can't work with a fucking psychopath"). And yet they have no compunctions whatsoever about beating and torturing the policeman Madsen has taken hostage in order to figure out who has ratted them out in the first place. In the movie's most climactic moment—one that echoes *Psycho*—Madsen is left almost alone with the bound policeman. And this is what he says to him, after the policeman denies knowing anything and tells him, "You can torture me if you want":

> Torture you, that's a good idea. . . . Look, kid, I'm not going to bullshit you, ok? . . . I don't really give a fuck what you know or don't know . . . I'm going to torture you anyway. It's amusing to me to torture a cop . . . all you can do is pray for a quick death, which, you ain't gonna get . . .

And then, as the radio plays "Stuck in the Middle with You," Madsen's character dances a bit, back and forth, and then cuts off the policeman's ear with a straight razor.

But we don't see it. The camera moves away, looking demurely at another part of the warehouse while we hear the policeman's screams; and then returns to the pair after the mutilation is complete. Horror director Stuart Gordon would say, about watching an early screening of the film: "I really wasn't sure I was going to be able to sit through that torture scene, and I later discovered that Wes Craven and Rick Baker had both left. Compared to what you see in a typical slasher movie, the scene is *nothing*, but because you totally *believe* it, it's just horrible."[89] That believability: that was what mattered. Madsen is utterly compelling: and what gives the audience cause to shudder is not just the casualness of his nihilism, but its coolness. This evil is hardly banal. It's devil-may-care. In another serial killer movie the following year, Dominic Sena's 1993 *Kalifornia*, David Duchovny's writer travels with a pair of multiple murderers across country. Trying to understand them, he begins with empathetic gestures and concludes by saying that he "learned there is a difference between us and them: it's in feeling remorse, dealing with guilt, and confronting their conscience." It seems— to quote another title of another Tarantino-related nineties movie—natural born.

The tagline for Oliver Stone's 1994 movie *Natural Born Killers*, based on old-school serial killers the Starkweathers—"The media made them superstars"—probably wasn't dreamed up by Tarantino, who has story credit on the film, but the idea certainly was, and reflected the ethos that would go on to shape the nineties. Tarantino's characters, killers and psychopaths and victims, are immersed in a world that is both relentlessly natural (in the sense that there are no ghosts or ghoulies) and overdetermined and wildly dipped in the swirls and eddies of the imagination, particularly the filmed imagination. Sometimes this comes in charming, or quasi-charming, fashion: a dance between John Travolta and Uma Thurman in a restaurant where everyone is dressed like celebrities, in *Pulp Fiction*; a detailed and argumentative disquisition on the meaning of Madonna's "Like a Virgin" before a bank robbery, in *Reservoir Dogs*. But often, it also came from the

visual grammar of the period's movies, which called attention, increasingly, to how these stories were artifice, products of media-ization.

Natural Born Killers isn't just about the way the media glamorizes the killers, Mickie and Mallory—with their pictures plastered on the front of magazines internationally. "What do you think of Mickie and Mallory?" some people on the street are asked. "They're hot. Totally hot." "If I was a mass murderer, I'd be Mickie and Mallory," they reply. A tabloid-news reporter played by Robert Downey Jr., who originally jumps on the bandwagon callously for ratings, falls under their spell, a case of homicidal Stockholm Syndrome. He's killed at the end, and when he begs, "Don't Mallory and Mickey always leave someone alive to tell the tale?" they reply, "We are. Your camera," and that's the true lesson of the movie: what matters is not the event, but whether it's filmed. And, even more important, *how* it's filmed: in its constantly shifting montages, parodies, film stock shifts, cut-ins, it's also about how it's impossible to find our footing in what we watch, a worthy entrant in the postmodernist sweepstakes.

Tarantino's *Pulp Fiction*, for its part, famously jumbles the order of its narrative, requiring abstract intellection to figure out what occurs when, as the viewer all the while is being saturated in images like the sudden, bloody outburst of carnage when Marvin gets shot in the face, or the scene when a basement rape-and-bondage chamber is revealed beneath an innocuous LA storefront. And then there was 1995's remarkable serial killer movie *Se7en*, in which the point was to uncomfortably luxuriate in the Seven Deadly Sins–related tableaux of murder that Kevin Spacey's psychopath had laid out, as seen through the lens of David Fincher's brilliantly scuzzy nineties-MTV-influenced direction. The opening credits play over a version of Nine Inch Nails' song "Closer," whose 1994 video, directed by Mark Romanek, generated waves of controversy over its warehouse-killer and cabinet-freakish series of images, as well as frontman Reznor's BDSM-infused getup. Something akin to Tarantino, which, while stylized, was running closer to the ground.

IF THE EIGHTIES HAD THEIR share of big threats, ranging from the cosmic to the microscopic, then it might be fair to say that the nineties got

small. The Berlin Wall was in shambles; the Cold War had, it seemed, come to an end. Observers were talking about America as not just a superpower, but a hyperpower. There even seemed to be a realistic possibility of peace in the Middle East. The reigning political figure of the era, Bill Clinton, accordingly, triangulated inward, propounding neoliberal policies with an emphasis on small-bore individual choice and Third Way responsibility. Maybe that was another explanation for the success of the serial killer and "suspense" model of fear at the expense of bigger, more melodramatic "horror."

In fact, given the continued economic growth associated with the period, you could even argue that some of the horror now had to stem from a kind of bourgeois, even yuppie anxiety about comfort and affluence. (The word *yuppie* was introduced in 1983.) *Wall Street* (1987) is a classic deal-with-the-devil movie where Michael Douglas advocates one of the seven deadly sins in fancy cufflinks and suspenders: greed, he says, is good, for want of a better word. John Carpenter's 1988 horror satire *They Live*—about skull-faced alien invaders that you could only see through special sunglasses, who were keeping the populace downtrodden through similar subliminal messaging—was also about capitalism, particularly as it sharpened its focus to indict the Reaganite quislings who helped the aliens against their own species. ("We all sell out every day . . . might as well be on the winning team," says one such.) It may have been forgotten, but the classic child's-doll horror franchise—with the evil Chucky, starting with 1988's *Child's Play*—clearly takes its satirical roots from the consumer madness and desire to get the toy of the season, the Cabbage Patch Doll, a few years back.

The most outrageous treatment of capitalism unrestrained, though, was Bret Easton Ellis's 1991 *American Psycho*, which features Wall Street's answer to Norman Bates, Patrick Bateman: only with a lot more gore and explicit sex, and with a kind of comedy familiar to viewers of horror movies and readers of splatterpunk from the past decade.[90] Ellis name-checks, constantly, all the consumer goods that the predatory capitalists need to have in their late-eighties lives: and suggests that bodies to be chopped, drilled, and even consumed are simply part of a process akin to the hostile takeovers of *very* private equity.[91] While not going as far as Ellis, Tom Wolfe

produced a nightmarish vision of this ostensible beau ideal gone wrong in his novel *Bonfire of the Vanities*, which introduced the term "Masters of the Universe" as a jab that compared the financiers who were among the novel's subjects to the children's toys of the same name.

Bonfire, which stemmed from Wolfe's own idea to write "a novel *of the city* . . . with the city always in the foreground, exerting its relentless pressure on the souls of its inhabitants," plays on white fear of an increasingly diverse, and increasingly racially tense, urban space, along with "white fears of retrocession." The novel's main protagonist, the banker Sherman McCoy, sees the South Bronx, which he drives into accidentally, as a scene of nightmare: "the eerie grid of the city was spread out before him . . . here and there were traces of rubble and slag . . . in a ghastly yellow gloaming."[92] The cities had been going to hell for years, as the vistas viewed through the front windshield of Robert De Niro's *Taxi Driver* suggested, but the new kind of antihero that had risen—more Charles Bronson than Travis Bickle—was galvanizing and dividing the culture, often in racial terms.

In late 1984 in Manhattan, a man named Bernhard Goetz shot four Black men in a subway car. He claimed he was acting in self-defense, as they were preparing to mug him; they claimed they were panhandling. The case became national news, with hot partisanship on both sides; the scene echoed, in eerie parallels, the scene in *Death Wish* a decade before, where Bronson laid in wait with a gun for subway muggers—a real-life incarnation of a fearful movie. Bill Clinton, attempting to triangulate his way to the presidency, had whipped up this fear in his "Sister Souljah" moment, in which he demonized a representative of a new(ish) form of music that was increasingly gaining in popularity. In the process, he was neatly able to combine an appeal to those worried about racially tinged, if not outright racist, stereotypes of Black criminality with a call once more for the country to address concerns about urban decay against a stereotyped shining heartland. (He came from a place called Hope, after all.)

There were responses. Movies like 1991's *The People Under the Stairs* and 1992's *Candyman* began to suggest that the real haunted houses and Gothic horrors of America could be found not just in gabled New England rotting manses, but in the public housing that was slowly strangling and choking a

discriminated and perpetually marginalized community. *The People Under the Stairs*, directed by Wes Craven, is, centrally, a story of child abuse: the title refers to children who've been placed under those stairs by psychotic kidnappers for deviating, even slightly, from their abusive norms. But those kidnappers are racially predatory as well: besides kidnapping children, the couple in question are also deeply exploitative landlords who overcharge for their rattletrap apartments and evict Black families on the slightest of pretexts. The story's hero, a Black kid, belongs to the last family in one of their buildings: "We build a nice new condominium. Get nice clean people in there," says the landlady, and there's not much doubt about what she means.

While the house where the action takes place in *The People Under the Stairs* seems to be located in a suburb, 1992's *Candyman*, by contrast, occurs right in the heart of Chicago: the original Clive Barker story has been relocated to the Cabrini-Green housing complex, which had witnessed eleven murders and thirty-seven gun injuries in the first three months of 1981 alone, and the city had suffered a net loss of thousands of units of residential housing in neighborhoods of color in Jane Byrne's term as mayor.[93] In the movie, Candyman is an urban legend based on a story of a Black man murdered horribly for daring to engage in interracial romance: he died on the grounds of what would become Cabrini-Green, illustrating the intergenerational traumas of American racism.[94]

In 1995 Tananarive Due published her novel *The Between*, the story of a Black man whose family is targeted both outside by white supremacist terrorism and by an internal sense of haunting, gnawing guilt, all set in the upper-middle-class professional circle of legal high-achievers and activists that Due knew well from her own upbringing. Prior to writing *The Between*, Due would later note, she'd watched her writing shift from featuring "young Black characters on fantastic and futuristic adventures to white characters having quiet epiphanies." But after reading Gloria Naylor's 1988 novel *Mama Day*, which featured both central Black characters and supernatural events, she turned back to her original love: kick-started from when her mother gave her a copy of *The Shining*, but also influenced by her mother's civil rights activism. "Black history *is* Black Horror," she said, and the novel proves the point.[95]

The Between was a worthy inheritor of Toni Morrison's *Beloved*, another novel dedicated in no small way to the proposition that every Black American story is not just a Black horror story, but, in some fashion, a ghost story, and no wonder the ghosts are angry. On the other hand, three Black vampire movies, spaced throughout the decade, offered other possibilities, channeling the previous generation's ability to use that metaphor in *Blacula* to chart an alternative path. *Def by Temptation* (1990) linked the vampire story to concerns about family values. In the movie, Temptation, a demon in the form of a beautiful woman, lures cheating husbands to their death or afflicts them with disease, a fairly clear analogue for AIDS. While Temptation is clearly the monster here, she is a monster with a moralistic cause, one that harkens back to those eighties slasher films: punishing those who stray.[96] In 1995 Wes Craven directed one of the biggest stars of the era, Eddie Murphy, in a kind of updated *Blacula*; *A Vampire in Brooklyn* had a very different plot, but also presented the Black vampire as a regal figure from abroad who comes to find his love in America, reminding moviegoers that Black actors and worlds could populate every type of story, could explode the confines of stereotype. It was a point pushed even further in 1998's comic book vampire-hunter movie *Blade*, which flipped the script on stereotypes of Black monstrosity: it's not a coincidence that almost all the vampiric villains menacing Wesley Snipes's Blade were white.[97]

If Bill Clinton helped to ensure his election by playing a race card, those weren't the only identity-based fears in the deck at the time. Clinton's "zipper problem" was of his own making; a certain segment of the population was hostile toward his wife—who insisted, as hard as it may possibly be to believe, on serving more than simply a decorative function in the White House. The unease and opposition Hillary Rodham Clinton stirred up, of course, spoke to another turn in the wheel of discourse about sexual equality and autonomy during that time: and the fear of strong-willed women marked another change in the decade's fear, of women, and of their bodies, and what their bodies can do to men.

First, perhaps, in this cohort was the nightmare fable of adultery of 1987's *Fatal Attraction*. Unsurprisingly, it was the woman, played by actress Glenn Close, who came in for moral opprobrium, even though it takes two to violate the Seventh Commandment. (To be fair, she does boil the

family bunny in a pot on her lover's kitchen stove.) *Fatal Attraction* ends with Michael Douglas's character returned, albeit bloodily, to home and hearth, after the good wife, played by actress Anne Archer, protects her man by shooting Glenn Close. She does so as Close emerges from seeming death, leaping up for one last murder attempt, like a hundred slashers before her—speaking, once more, to the uncanniness in which the culture held the human body. And a film the following year, David Cronenberg's nightmarish *Dead Ringers*, focused on the terrors the particularly *female* body had to hold.

Jeremy Irons is clearly the monster of the piece: he plays twin gynecologists who commit rape by one taking the place of the other during their sexual encounters. But the movie consciously strikes its horror beats by presenting the ostensible otherness of the female body—the movie's female lead character, a movie star, has a mutation, a triple uterus—and by the way in which those bodies are regularly violated by the medical industry. Irons's gynecologists design instruments for examination and diagnosis that resemble medieval torture devices, the comparison encouraged by the antiquated red surgical gowns they wear; and one of the movie's most terrifying moments is a gynecological examination in which a woman is sadistically tortured simply because she does not know enough about her own body to understand that what is happening is wrong. Or, failing that, she *does* know—the scene is purposefully ambiguous—but doesn't feel empowered enough to register an objection, which is even more terrifying.

But the fear—for a male audience, and a male gaze, at least—was brought to its height when the women on screen were presented as knowing *exactly* what they were doing. When Sharon Stone, a femme fatale for a new generation, famously uncrossed her legs in 1992's *Basic Instinct*, it seemed, to some, to provide an invitation; but what it was an invitation *to* was made clear later on in the movie, when a pattern of postcoital murders with an icepick emerges that slammed male legs closed across the nation. Especially as the movie suggests, at the end, that the only thing saving Douglas from getting the business end of that icepick is his capacity to satisfy Stone in bed.[98]

Even when unmarried sexual liberation gave way to married maternity, fears about womanhood persisted: here, about being the right *kind*

of mother. A generation before, in *The Exorcist*, William Friedkin had discoursed on the dangers of single motherhood; in 1990's *The Guardian*, he suggested that being a working mom would have its own dangers, too. Admittedly, for most mothers, concerns about juggling work and family were more about missing out and less that the babysitter you hired would be a child-sacrificing wood creature, but mother Carey Lowell's plea to herself—"I just don't want to miss out on anything"—struck a chord. Another "evil nanny" movie of the period, 1992's *The Hand That Rocks the Cradle*, showed how even standing up for yourself, and for other women, was a charged enterprise: the reason Rebecca de Mornay's character is rocking that cradle in the first place is because she has suffered a miscarriage when her husband, an ob-gyn, killed himself after being bravely, and accurately, accused of sexual assault by the mother, who was one of his patients. One might wonder, as we've done again and again, what choice one had, what path.

Todd Haynes's 1995 movie *Safe* is, on its face and in no small part, a prime early example of environmental horror. Julianne Moore's character suddenly begins to develop a debilitating series of symptoms, and it's suggested that "this is a disease that you catch from your environment." But a documentary Moore watches earlier in the movie, propounding something it calls "deep ecology," suggests it goes "beyond the traditional scientific framework" to a more spiritual one, and the movie strongly suggests that the environment Moore's traditional wifey character, ever subordinate to her dominating husband, is allergic to may be as much socially determined as climatologically. The movie ends with her isolated from that earlier, toxic environment, saying "I love you, I really love you" to herself in a mirror: accepting herself in her own physically blemished but now independent form.

This rebellion, embracing unruliness and even ugliness, was, especially for a younger generation, less turned inward on the body than pushed outward, in the form of rebellion, and anger. And they frequently rebelled by embracing classic monstrosity while simultaneously claiming their own. Early nineties writers like Poppy Z. Brite and Kathe Koja, in novels like *Lost Souls*, *Bad Brains*, and *The Cipher*, were not afraid to create

ragged, savage versions of conventional horror tropes—vampires, doorways to another world—as metaphors for alienation from the so-called civilized world around them. The Goth subculture, coming into its own in America in the nineties, took its name from the style of horror literature we've seen over and over again, and its style from sources as eclectic as British eighties rock, Vampira and Morticia Addams, Winona Ryder's outfit and outlook from the 1988 Tim Burton movie *Beetlejuice* (script written by that paperback-original writer extraordinaire Michael McDowell), and the perky, upbeat, black-clad, heavily eyelinered figure of Death in Neil Gaiman's *Sandman*.

But the most important classic horror figure young women embraced and reclaimed was, of course, the witch. Early-nineties Grrl bands were instrumental in taking on the word, the classic signifier of "ugly, unruly, and persecuted female identities throughout history," and making it theirs.[99] Courtney Love, in her 1994 song "Plump," shouted, "I don't do the dishes, I throw them in the crib!" standing in direct opposition to the roles of wife and mother.[100] In 1990, Anne Rice had turned her attentions to the subject, beginning her series of novels of the Mayfair witches with *The Witching Hour*; in 1995 Gregory Maguire, in his novel *Wicked*, took on and rehabilitated the most famous witch of the twentieth century, presenting Elphaba—as the Wicked Witch of the West, we now learned, was properly called—as more sinned against than sinning. It was later adapted into a musical that, as of this writing, is the fourth-longest-running Broadway show of all time. The neopagan Wiccan religion, which had resonated to greater and lesser extents over much of the century—flourishing in the Aquarian countercultural moment, wrongly caught up in the eighties satanic panic[101]—saw a significant rise in interest and appeal, a space for women to express and exercise their power, their sexuality, and their connection to each other and to the planet.

Another name for Wicca is the Craft, and the movie of that title, coming a year after *Wicked*, explored the way that four young women who have been marginalized, shunned, treated badly by society—in other words, they are young women in high school—find occult sources of power in order to avenge themselves on their tormentors. *The Craft*'s portrait of girl

power, is, unquestionably, ambivalent; it suggests, among other things, that it's possible to go too far in the other direction. But its portrait of young women who have *had enough* was widely influential. That said, it was a different portrait of high school hell premiering the following year—this one literally located on top of a Hellmouth—that would embody girl power for a generation; and although it featured a witch, its central figure was a vampire slayer.

Buffy the Vampire Slayer, which premiered on television in 1997, had begun life as a movie five years earlier. Its premise was delightful—a cheer-leader from the Valley who ends up hunting vampires—and its execution failed to exhaust that premise's possibility. Joss Whedon, who had writ-ten the movie, was dissatisfied with the final version, and when he got the chance to turn it into a TV show five years later, he larded it up with both the comedy and drama it became known for. Despite Whedon's abrasive, allegedly abusive behavior on the set, as later reported, what he created was a masterpiece. Its greatest strength was its knowing insistence of the genre as a particularly useful metaphor for teenagerdom: high school was literal hell, yes, and when Buffy loses her virginity to a tormented brooder, he's a bad guy, not just for not calling the next day but because his vampiric nature totally takes over and he becomes a psychotic killer. Not subtle, no; but over the years of its run it matured into something more nuanced,[102] something that spoke to the weary responsibility not just of being a slayer, but being a young woman in a hostile world. Romance, however, was always at its core: always complicated, often toxic, sometimes scary—and led, in no small way, to the explosion of "dark romance" that would take place in the years to come.[103]

In the years to come, *Buffy* would also expand its vision of what romance could be; a featured witch, Willow, comes out as a lesbian, and her relation-ship with another witch, Tara, would be an early, and largely positive, por-trait of a gay relationship on broadcast television.[104] A few years earlier, in 1994, Anne Rice's *Interview with the Vampire* finally made it to the screen, with its own portrait of same-sex romance: the movie constantly insists on the familial nature of the relationship between Tom Cruise's Lestat and Brad Pitt's Louis, even to the extent of having—well, turning—a child,

played by a young Kirsten Dunst, to keep the family together. But these were individual examples. Many other defining works of the Clinton era skirted such questions of representation in favor of a more aestheticized and pastiched appeal.

While Spielberg's most sober and prestigious movie of the nineties was clearly *Schindler's List*, which once more brought the horrors of the Holocaust to a new generation, the movie of his that would prove to be most influential for our story was that same year's *Jurassic Park*. It was a monster movie of the highest order, with the classic science fiction bones that characterized so many of the fifties films. The underlying threat had moved from the menace of nuclear physics to the new frontiers of practical genetics: here, recreating dinosaurs from their DNA. Matching science with science, the movie pseudo-philosophizes with chaos theory to reinforce a lesson we've seen over and over again: the creatures created by scientific hubris will always become nemeses, as those dinosaurs escape their bonds in the park and run free.

"What have they got in there, King Kong?" says Jeff Goldblum's visiting chaos theorist, as the gigantic park doors open and they set off on a pre-opening tour gone horribly wrong. *Jurassic Park*, in the grand tradition of *King Kong*, utilized actual, not just imagined, technology: its digital effects were groundbreaking for the time, simply jaw-dropping, and gave viewers a sense of an uncanny *thereness* in a monster movie to a degree that had been generally impossible previously outside of prose fiction. This would mark a trend that would only continue: most notably in 1997's *Titanic*, which recast *The Poseidon Adventure* and the seventies disaster movie for a new generation and wove a star-crossed love story set in the most proverbial of American catastrophes (though, to be fair, the actual ship was British) into scenes of old-school destruction mixed with the latest digital wizardry.

While *Jurassic Park* and *Titanic* played their love of older cinematic traditions fairly straight, a movie that came out right between them showed how the power of pastiche and homage with more than a bit of wink could supercharge a new love by a few custodians of the flame for something whose day had seemed to have passed. A generation before, Mel Brooks had taken on the Universal horror movies; in 1996, Wes Craven would play

out all the conventions of the slasher movie for genuine scares in a twisty, effective, hugely meta movie from a script by savant Kevin Williamson. *Scream*—which dispatched its biggest star in the opening moments of the movie and then played a cat and mouse game with its horror fans, winking at the "rules" while insisting on upholding them—introduced a whole new generation *to* those rules.[105]

"Now Sid," says one of the movie's killers, "don't you blame the movies. Movies don't create psychos. Movies make psychos more creative!" And certainly, the creativity that resulted stemmed from the movies, and the movie, itself. *Scream* became a franchise; so did a parody *of* the quasi-parody, the Wayans Brothers' *Scary Movie*, which jabbed at the disposability of Black bodies in horror films while proving that Black actors could carry a film themselves. And their contemporary, *Mystery Science Theater 3000*, which began in 1988 on Comedy Central and ran for most of the nineties, helped introduce viewers to many of the horror movies at the lower end of the science-fiction spectrum, via the mechanism of on-screen characters watching those movies—and generally hooting and mocking them, that critique being its own creativity.

A broadcast network probably wouldn't have taken a chance on *Mystery Science Theater*; and the expansion of new networks like the WB (which hosted *Buffy*), which were smaller, scrappier, and willing to take chances on genre material, assuredly helped television become home to other genre-defining works in the nineties. Many, like those two, were either cult hits or became classics later; but an only slightly less upstart network at the time, Fox, had one that would become a top-twenty hit. Although *The X-Files* executive producer Chris Carter would say that "All of the shows take place within the realm of extreme possibility . . . that's my buzzword,"[106] *extreme* is doing a lot of work there. The show, premiering in 1993, was about two FBI agents investigating the agency's titular files that had all manner of mysteries and weirdnesses within them, encountering monsters while rewriting American history in the bargain, weaving in the JFK and MLK assassinations into grand conspiratorial narratives and alien abduction tales.[107] If that show's tagline was, famously, "The truth is out there," the byplay between David Duchovny's Fox Mulder, who deeply

believed, and Gillian Anderson's far more skeptical Dana Scully, wasn't really about the resolution of that debate, or knowing the truth. It was about the journey.

Similarly, David Lynch's foray into television, 1990's *Twin Peaks*, which savored more of *Blue Velvet* than *Eraserhead*, ostensibly presented itself at first as a murder mystery, a suspense tale to find out who killed Laura Palmer. But this was hardly CSI: it was, instead, an excuse for a journey that featured dream conversations with one-armed men, giants, and little people in red business suits, and mysterious, other-dimensional spaces hidden in the woods near the town. One could be excused for thinking that the solution of the mystery was hardly the point. What *was* the point—to the extent you could say such a thing about *Twin Peaks*—was the exploration of the surreal hidden behind the façade of the all-American town.[108]

TWIN PEAKS MAY HAVE APPEARED on broadcast TV, but it definitely wasn't family viewing. But if you were a kid looking for your horror fix, you now had a new destination. A previous generation of precocious kids who wanted to be scared, and weren't quite ready for what they got, cut their teeth on the torments and travails of the Dollanganger kids in the monumental neo-Gothic V. C. Andrews 1979 bestseller *Flowers in the Attic*. *Flowers* appealed because of its child narrator and protagonist, and remained vastly—and therefore seductively—inappropriate, because of its themes of incest and child imprisonment. But in the nineties, the equivalent readers had R. L. Stine providing, with his Goosebumps series, a gateway drug to, among other things, his Fear Street series, aimed at an audience that we would now call young adult. Andrews had sold tens of millions of copies of *Flowers in the Attic*, to adults and the children who sneaked them; between July 1992, when Stine started writing his books, and October 1996, he had 130 million copies of his books in print, plus dozens of Goosebumps-brand merchandise, from pajamas to sneakers that made skeleton footprints.

The books featured what one critic called "yucky gore," not too bad, but not nothing, either.[109] In the process, Stine was presenting for the kids an image of a different world: a world in which the economy was based on who

could scare who, and in which—in the many different books—frequently it wasn't so clear how clearly morality lined up with horror; randomness of event, of outcome, was the general overarching rule. Fear, in other words, would be the overarching rule (even as they suggested that the kind of fears the books focused on weren't really part of life).[110]

Two portraits of that forthcoming fear, in two very different styles, resonated in American society: a pair of movies released in 1999, as the Clinton years came to an end and a new millennium approached. The first, M. Night Shyamalan's *The Sixth Sense*—one of the biggest box office hits of the year—featured the young Haley Joel Osment seeing dead people, and Bruce Willis. The movie was a critical darling as well, particularly beloved for its—at the time—genuinely shocking twist ending, which helped spark, along with movies like *The Usual Suspects* and the works of Tarantino, a new flexibility with story and cinematic structure. Its insistence that theatergoers hold its secret tight as they leave was in its own way reminiscent of some of the tricks of William Castle, but also of the works of those fifties writers who themselves tipped their hat to Bierce and O. Henry; but *The Sixth Sense*, more than anything, was a ghost story, and without spoiling the movie, it is classical in that much of our chills, like in the works of Wharton, are retrospective. We only understand much of what we see later, when we replay it in our minds (or on our home screens). While it is certainly an overstatement to say that much of the next century's attention to the classical and comparatively austere precincts of the ghost story come from *The Sixth Sense*, it's not totally off base.[111]

The second movie, almost though not quite as successful at the box office, was one of the most profitable horror films of all time, considering its budget was under a million dollars. *The Blair Witch Project* was revolutionary in as many ways as *The Sixth Sense* was classical: in its usage of ostensible "found footage" to tell the story of the three students who went into the woods to investigate the old folk legend of the Blair Witch and never came out again; in its insistence on verisimilitude; in its sophisticated publicity approach. It was groundbreaking in its creation of what was becoming a word in increasingly common parlance—a *website*—which contained a "backstory" of the Blair Witch and "numerous clickable options for

finding out more about her and other related faux historical figures and events," adding to the mystification around the story's reality.[112] The site, blairwitch.com, put up in advance of the movie's release, got 75 million hits in its first week, and would create communities of fans who responded to it, and to each other.[113] (More conventionally, it also benefited from a Sci Fi channel "documentary," *The Curse of the Blair Witch*, released two days before the movie's premiere, that treated the legend as real.)[114] All these factors would become dominant parts of the industry of fear in years to come.

But fear—at least compared to other eras—seemed on the retreat. Even that symbol of millenarian apocalypticism—the Y2K bug that was supposed to crash every computer, every system—ended up being a fizzle: a testament, it felt, to the robustness not just of technology, but of American institutions and ideas. Some scholars were even arguing that history had, in fact, come to an end.

But if there's one thing that every lover of horror knows, it's that it's never over just because you think it is.

Cards from a Haunted Tarot Deck

—

THE FIRST GREAT AMERICAN HORROR story of the new century was, as many noted at the time, a scene *from* a horror film, but not *of* a horror film: two planes flying into two buildings, collapsing into smoke and ash. And, to bring the horror from widescreen to individual, that terrible, impossible photograph by Richard Drew of the man caught in midair, falling from a tower's height, which was printed in many newspapers the following day then "rarely printed again, becoming paradoxically both iconic and impermissible."[1] That sense—of horror and fear everywhere, and the necessity and impossibility of expressing it, of getting one's arms around it—would come to characterize the age that followed. Rather than having come to an end, history had returned, with a bloody vengeance: and sometimes it seems that all that has followed in the two-plus decades since—war, pandemic, political upheaval and polarization at levels unseen for generations—has led, at times, to a feeling of too *much* history, of times that are *too* eventful to place into the calming, cathartic stream of clear narrative.

While history always feels far more settled from a distance, it's certainly the case we don't yet have the benefit of hindsight to tell the story of current American fear as clearly as that of previous eras. What's more, in this fear-saturated century, not only has the appetite for thinking through those fears fictionally risen substantially—the market share of horror movies in wide release more than doubled between 1995 and 2005, and between 2005 and 2015, twenty-five new horror series premiered on television[2]—the number of possible means of recording, reflecting, and refracting these horrors

has exploded exponentially, alongside the channels for disseminating them. While in previous chapters of our story we could focus largely on the written word and the movie and television screen, the sheer number of new institutions and technologies—streaming, mobile, gaming, social media—each with their own firehose of contributions to our narrative, tend to beggar the imagination, inundate the reader and viewer, and provide the historian with nightmares of their own.

And so our story, which has been something of a river, branches out: into different trends, narratives, that try to capture something about American fear now, where it has recently been, and where it might be heading. But every one of them, varied as they are, draw powerfully from our portrait of where the country has been: could one expect any less, from a story full of ghosts?

AMERICA HAS ALWAYS BEEN A country obsessed with murder, the more grotesque and lurid the better: from the Levi Weeks case to the Benders to H. H. Holmes to Ed Gein to Jeffrey Dahmer, and a thousand fictional counterparts. But the twenty-first century has taken it to a new extreme. "Oh, wonderful, very moody," says an officer, coming in to see one of the bodies in Se7en, and that late nineties classic helped to usher in murder as mood, as vibe, as part of the DNA of the new century's cultural landscape. That landscape had been shaped by books and movies featuring Hannibal Lecter and his ilk; but its tectonic plates shifted, and settled, on the broadcast networks, particularly CBS, which dined out on murder several times a week. The incredibly popular CSI franchise required a murder to get each episode going, and, given their ongoing success, required writers to come up with, and expose viewers to, the violent ending of life in literally thousands of different ways. And the drama required, for variety's sake, increasingly baroque and even Rube Goldberg–esque iterations and imaginations of death. Although the majority of the killers, unlike Lecter and Dahmer, weren't of a serial nature, the resulting proliferation of one-off murderers made for even worse implications, hearkening back to the noir period in convincing us that America is a place of impossible and constant threat and fear of violence. Fictitious programs like Criminal Minds and

reality crime shows like *America's Most Wanted*[3] all did their best to convince Americans that strangers lay in constant wait to abduct our children or do us harm. In fact, statistics suggest that it is much more likely that such violence will be done not by the cosmic force of an indifferent madman, but by a gun kept at home or an abuser already in our lives.

But that sense of randomness resonated. In 2007, Michael Haneke remade his own German-language film *Funny Games* for an American audience in an American setting; in both versions, an idyllic family is tortured and killed by two young men. The following year, *The Strangers* tread the same territory, continuing to spread the fear of the sadistic, pathological violation of the sanctity of the home we saw in *Death Wish* a generation earlier. But while *Death Wish* offered the (questionable) solace of a cause—urban decay—and a solution—vigilantism—there was far less on offer here. The duo in *Funny Games* seemingly commit their crimes, as the title implies, just for the giggles; when the imprisoned pair in *The Strangers* ask their captors why they targeted them, the answer, famously, is: "Because you were home."[4]

That sense of indifference, of an almost abstract sort, was tied to the aesthetic of two horror movie franchises of the last two decades, each dedicated, in very different ways, to the art and craft of murder: it is their raison d'être. The first, the *Final Destination* series, whose initial installment appeared in 2000, was dedicated to the concept that the arc of the universe bent toward death: the protagonists, so the story went, had survived when they shouldn't have, and so the universe was going to set things right, in frequently as technically convoluted and thus visually stimulating a manner as possible—especially as the series continued. "In death, there are no accidents, no coincidences, no mishaps, and no escapes. . . . we're all just a mouse that a cat has by the tail," one character says in the original installment. In the process of ensuring the victims met their predestined fate, everything, from street signs to shower cords, became marshalled into the service of horror, and did so in a way that—with its moral and theological questions abstracted away—at its best left audiences shaking their heads in admiration for the filmmakers' ingenuity in the roller-coaster-ride construction of the kills.

Compare this to the second great twenty-first-century movie franchise dedicated to horrific murder: the *Saw* franchise, which seems small-scale by comparison. (The original installment had a budget about a twentieth of the first *Final Destination*, and yet the two grossed about the same.) *Saw*, which premiered in 2004, featured a taunting psychopath, a set of individual victims in extremis, and sadistic puzzles and punishments treated as games. Like in *Final Destination*, there is some gesturing at motives for choosing the victims, but this is much less important than the actual pain, torture, and murder. This approach, in *Saw* and other similar films, is sometimes referred to as "torture porn"; but for all of *Saw*'s blunt violence and industrial-ruin setting, it insists, rightfully, on its sophistication as a work of fiction, its format featuring nonlinear storytelling and a twist ending that tips its hat to works like *Pulp Fiction* and *The Usual Suspects*.

That sensibility, the idea of dressing up murder, of complicating it, fictionally, and infusing it into the stories we tell about our lives—there *is* a psychological backstory in *Saw*, one that reflects the killer's own traumas and, as the series goes on, those he visits on surviving victims[5]—also applied to the rise of other kinds of work that featured curlicues upon curlicues, that included hefty doses of the camp, the kitsch, and the neo-Gothic. A chief influence here, in the last decade, has been the work of Ryan Murphy, one of the current generation's major auteurs of the small screen. Murphy's products have been vast and variegated, and not all narrowly fear-based—unless you count the "Rocky Horror" episode of *Glee*—but many of them have been. One of Murphy's first TV series, 2003's *Nip/Tuck*, about a pair of Miami plastic surgeons, often descended into outright body horror, rarely if ever shying away from the violent damage—of the physical, but also the psychological sort—inflicted on patients, often for the wrong reasons. The show's most famous line, a plastic surgeon's come-on—"Tell me what you don't like about yourself"—is, itself, an opening to express fear, alongside an insidious invitation to internalize cultural prejudices about the body.

But in 2011 Murphy would turn, more directly, to horror and murder with his anthology series *American Horror Story*. Each of the seasons (twelve as of this writing) has varied in locale and setting among the classic venues for horror, from a murder house to the sideshow to the Southern Gothic

to the insane asylum, and Murphy's dedication to the field allowed for the bodies that hit the floor to do so in a staggeringly varied set of ways.[6] In almost every case, the series' commitment to casting, and to camp, has made it a worthy heir to the psycho-biddy tradition of those sixties films, using actresses like Jessica Lange, Frances Conroy, Angela Bassett, and Kathy Bates, who find new career moments in performances dedicated to the monstrous.

Perhaps the greatest body count in recent American history comes in the pages of a comic book. Garth Ennis and Jacen Burrows's 2008 comic book series *Crossed* describes a world in which a viral, extremely transmissible plague turns its victims into homicidal psychopaths whose sole purpose is to kill, maim, rape, cannibalize. At its worst, the series is a catalog of the violent acts that people can perpetrate on bodies, played out both in visually stunning and viscerally repulsive tableaux; and since, unlike most zombies, these creatures still have human intelligence at their disposal, comics' sequential nature allows those scenes to be transformed into the most intimate and psychologically grueling sequences. At its best, though, this work of "extreme horror" rises to offer both a critique of and a philosophy of human violence, as nothing that they do to their victims, horrific as it is, are things that humans have not done to each other in our history, a point Ennis has often made.

Certainly baroque wasn't the only way to go, though. Glen Hirshberg, in his 2002 novel *The Snowman's Children*, drew on childhood fears of a killer who stalked his own Michigan county in the seventies—a real-life murderer of at least four children who was never directly identified. In Hirshberg's case, the events lead, rather than to the melodrama of cat and mouse, instead to the effects that the landscape of fear has on the world around it, particularly the young and impressionable. "One of us, I remember thinking, is a ghost," says one character in recounting his encounter with a possibly spectral presence, and the line lands because, in a novel set between past and present, it's not clear if the survivors actually survived.[7] Bill Paxton, who'd played a vampire so memorably in Kathryn Bigelow's 1987 horror western *Near Dark*, went behind the camera to direct and star in 2002's *Frailty*, which returned to one of the oldest multiple murder stories

of all, the same one in Brockden Brown's *Wieland*: one where God tells a man to murder others because the evil has gotten into them; and, in the process, that man inflicts unimaginable damage, psychic and otherwise, on his family. The movie, however, ends up being more definitive about the victims' evil identities, and the existence of *something* supernatural, than in Brown's novel. "Demons are taking over the world. They're everywhere," goes a line in the film, and in 2002, this seemed a snapshot of current events, as well as a theological or metaphysical opinion.

But all this, one might also suggest, is cathartic, as it helps to distract from the ongoing drumbeat of industrial-grade mass murder that seems a regular part of the American fearscape. Whitman, that late-sixties Texas Tower sniper, was an individual shooter with a long rifle, and his example resonated for years: in recent years, mass shootings have occurred on a weekly basis, horrors that would have been, in some sense, beyond the imagination of that previous generation. And we know that, in some sense, because, in our history of the transformations of historical figures like Whitman into movies like Bogdanovich's *Targets*, they didn't imagine them.

The twenty-first century is the century of the Twin Towers, but it is also the generation of Sandy Hook, and Uvalde, and these are only two of the many assaults that took place in schools; to say nothing of the ones in houses of worship, in Charleston, and Squirrel Hill; or in nightclubs, like the Pulse; or in movie theaters; or grocery stores: the list goes on. One of the great novels of the new century on the theme, Lionel Shriver's 2003 *We Need to Talk About Kevin*, is an attempt to bind the horror, to render the aftermath of a school mass murder visible through the lens of those who are related to, and affected by, the individual events. The novel, and its later movie adaptation, are consciously—and wrenchingly—narrow in scope, focusing on the questions of nature versus, particularly, maternal nurture—the same questions *The Bad Seed* asked a half-century before. But the grinding, ready horror that accompanies the novel is the acknowledgment that this Kevin is not, so to speak, the only Kevin—there seem to be more of them, imitators, even worshipers, in recent years. This is not just a story of individual aberration, like Richard Speck or Jeffrey Dahmer, but of

aberration in conjunction with social and institutional factors—the ready access to guns capable of mass slaughter, the lack of political will to do very much about it. *Saw* offers the possibility of outwitting and escape; *CSI* the comforting assurance that justice will be done; and none of those can hold a candle to Sandy Hook. When the *New York Times Magazine* ran a story last year on the investigators whose job it was to document the slaughter, they deemed every single image from the investigation too grisly to show, and rightly so. We prefer, as the examples above and so many others show, to consume our gore unrealistically.

BACK AT THE TAIL END of the last millennium, we saw how massively successful *The Blair Witch Project* was at its twin goals of scaring the bejesus out of everyone who saw it and at raking in money. And, accordingly, it started a double revolution.

The "found footage" movie subgenre would blossom, aided—tragically and inestimably—by the way its ostensibly lo-fi camerawork, its weaving together of individual testaments and multiple angles, echoed the images arriving on television, and, increasingly, computer screens in the wake of 9/11. This didn't necessarily mean low-*budget* filmmaking: Matt Reeves's 2008 movie *Cloverfield*, in its presentation of a monster's trail of destruction of New York City via multiple cameras recovered after the event, was a case in point, echoing that real-life disaster in an attempt at fictional catharsis.[8] Producer J. J. Abrams, well aware of what his movie was doing, said: "We live in a time of great fear. . . . [watching] something as outlandish as a massive creature attacking your city allows people to process and experience that fear in a way that is incredibly entertaining and incredibly safe."

But found-footage movies were clearly eminently capable of reminding viewers that big budgets weren't necessary, and were sometimes inimical, to the generation of fear. *Blair Witch* terrified far more by what you didn't see than what you did: "What the fuck is that? What the fuck is that?" shouts Heather, as she runs into the woods, the camera trailing behind her; and we strain to see, and we don't see a thing, just darkness, and it's far more primitively, primally, scary for all that. But, for all its lo-fi genius, in 1999 *Blair Witch* still relied on the narrative premise that its protagonists

be filmmakers: who else, after all, had the cameras to produce the footage, and the visual sensibility to wield them well enough to produce something watchable? But soon enough, others who wanted to develop the formula realized that its sensibility could be harnessed to the fact that similar technology was all around each of us, and getting more prevalent, all the time.

Not that this sense had to be linked to technology: the idea of "found material" as the basis for horror goes all the way back to the beginning of the novel. A bestselling novel that opened the century, Mark Danielewski's 2000 *House of Leaves*, harnessed the same sensibility, attaching it to a kind of postmodern gesture, in its ostensible claim to be a manuscript about a haunted house encounter that was ostensibly documented by a family who put cameras all around to see what was going on. But that aspect—in which the novel describes the footage—was soon accentuated by movies that captured the footage itself, like *Paranormal Activity*, shot, ostensibly, by a day trader with a home video camera.

"You're supposed to be in love with me, not the machine," says the trader's girlfriend, the young woman who's the focus of the paranormal activity; and the movie—which purports to be a compilation of footage found alongside the trader's corpse—is about the seductiveness of seeing, of *surveilling*, and of its dangers.[9] *Paranormal Activity* is most successful when its home cameras record things that happen when the couple is asleep, helpless—just like we are, watching. If we feel a little creepy, as well as creeped out, watching them sleep, well, that's the point: "Once we get it on camera, we can figure out what's going on," the trader says, and his increasingly bad decisions conflate the violation of his girlfriend's privacy by both stirring up the demon that accompanies her and refusing to stop filming. "That kind of stuff didn't happen to me before the camera," she says, at one point, and she's right: the camera has brought a new kind of horror home. To everyone.

Like *Paranormal Activity*, 2012's *Sinister* would tie this found footage to the haunted-house genre, but, even more, to the nature of film itself. Ethan Hawke's true-crime writer, having moved his family into the very house in which a multiple murder has occurred, is provided a breakthrough when he discovers—or is gifted—a series of home movies of mysterious provenance that turn from nostalgic to nightmarish. (Suffice it to say that "Extended

Cut Endings," written on one canister, has an entirely, well, sinister mean-
ing.) The films, it turns out, follow Ethan Hawke's character around like a
bad penny, haunting him in the same way conventional ghosts and spirits
seemed to do; and it transpires that these images, in fact, are the gate-
ways for a demonic, child-corrupting force to use to make its way into the
world. And in the end, after his daughter kills the rest of her family, she
is taken by the demon into the film that is playing, to meet all the other
murderous children there. The ghosts, that is, were not just recorded by the
machine: they have something to do with the very uncanniness, the very
nature, of the machines themselves, especially as they became more com-
monplace, more enmeshed in every aspect of our lives, in a way that would
have seemed almost impossible even a generation before.

"What the hell," Ethan Hawke says, "let's do this," as he sets up a
home movie theater to play the films he's found; and, with his notepad in
hand, he looks like nothing so much as a studio executive watching rushes.
Producers were, in fact, taking note. *Paranormal* made back hundreds of
times its budget, and its production company, the extraordinarily success-
ful Blumhouse, understood—as Roger Corman and Herschell Gordon
Lewis and others had before them—the insane profitability of the horror
movie, a profitability that didn't depend on a lot of expensive bells and
whistles. This era would herald a wide range of low-budget, high-concept,
and high-grossing horror films.[10] Even David Lynch himself had gotten in
on the wave, shooting his 2006 movie *Inland Empire* on a handheld digital
video camera. Many of these and other aughts-era horror films, especially
those produced by Lionsgate, would find their audience not in the the-
aters, but at home via a new digital technology: the DVD, whose ability to
include extras of all sorts led to not only a wider appeal, but a deeper one,
allowing the creators of this new era of horror to market themselves, and
be marketed as, kindred spirits (some under the sobriquet the Splat Pack)
and even auteurs.[11]

But it wasn't just the means of production or playback that were utterly
transformed by the digital revolution, of course. *Blair Witch* had benefited
extensively from the reach of its website; *Paranormal Activity*, for its part,
was given a wide release in 2009 (it had been made in 2007) after the studio

reached one million online requests for it; the movie's backers used another newly robust innovation—something increasingly called "social media"—to get people to demand the movie play in their town.[12] Sometimes, though, the Internet proved that virtual life and real life didn't necessarily coincide. One 2006 disaster-type movie had a fairly conventional Hollywood gestation, at first, with plenty of bottlenecks and creative disagreements—but generated an enthusiastic, viral frenzy thanks to the screenwriter's blog, which described in no uncertain terms the source of the movie's appeal:

> I ask Agent the name of the project, what it's about, etc. He says: *Snakes on a Plane*. Holy shit, I'm thinking. It's a title. It's a concept. It's a poster and a logline and whatever else you need it to be. It's perfect. Perfect. It's the Everlasting Gobstopper of movie titles.[13]

It led to wild enthusiasm for what was, in the end, a pretty standard movie, which didn't live up to the commercial expectations the Internet implied. There were, however, snakes on the plane.

But the Internet, quickly, became more than an advertising service for horror, by using the medium to provide chills organically connected to it. The Internet-only version of radio, the podcast, has become a welcoming home for the atmospherics of terror and unease: *Welcome to Night Vale*, which premiered in 2012, purports to be a set of dispatches from the eponymous town, allowing for stories that present phenomena ranging from a mini-city beneath the town bowling alley, a hypnotic glow cloud that eventually becomes president of the school board, and a Faceless Old Woman Who Secretly Lives in Your Home (she ran for mayor, but lost). Like with Orson Welles's *War of the Worlds* broadcast almost a century before, the podcast medium excelled at providing horrific "fake news" in an era saturated with it, and with presidential accusations of it.[14] And it wasn't just podcasts: round the time *Night Vale* was hitting its stride, ARGs, or "alternate reality games," were developing online. ARGs put together lo-fi video, snippets of old movies, hard-to-make-out graphics, and flotsam and jetsam from obscure cable channels, to create a window on a mysterious and uncanny world. The classic example, Local 58, which debuted on YouTube

in 2015, purported to come from the feed of a local public-access station. But its weather alerts and city council meetings are interrupted by "pseudo-'official'-looking messages advocating things like moon-worship and mass suicide."[15] What was the backstory? This was for online communities on sites like Reddit to come together and eagerly discuss. The mystery, in many ways, was the point, the thing itself.

And even better known than the ARGs is the Internet-native phenomenon called creepypasta. The word's etymology comes from "copypasta"—copied and pasted material on the Internet, basically—which was then modified, estranged, defamiliarized, for the express purpose of giving the viewer the creeps. It really took off on the anonymous imageboard website 4chan in the mid-aughts; and one excellent example—or, better put, category—of material, the Backrooms, is in essence and heart, lo-fi: incredibly prosaic settings (an office space, for example), emptied of everything and going on for what seems like forever. One evangelist for the Internet, cartoonist Scott McCloud, once called it the "infinite canvas"; but horror fans know that infinitude, understood correctly, can be deeply hellish; and the Backrooms show that in all their lack of glory.

The Internet, it should be said, not only broadened as it grew, but deepened: the possibility of trans-regional communities dedicated to the most esoteric aspects of fear—whether it be true-crime; the work of largely forgotten horror directors, writers, or artists; or particular moments in the history of fear—have obviously exploded. One can find Facebook groups dedicated to the subjects, Reddit threads, YouTube channels. And the fact that the number of views of these materials—even if they are outside more traditional channels of review and critique—are all often tallied provides an interesting challenge: is it really a niche endeavor, compared to, say, a moderately successful horror movie, if the number of views it receives, translated into movie tickets, would render it a blockbuster?

Perhaps ironically, one of the best treatments of how all these digital trends—the lo-fi, the found footage, the Internet communities of shared interest in the highways and byways of horror—all came together is found in a novel. Paul Tremblay's 2015 *A Head Full of Ghosts* revolves around a series of events that have been recorded on a reality-horror television show

called *The Possession*, and one character, contemplating the show's primary subject, comments: "If she was possessed by anything other than faulty brain chemistry and/or DNA, I like to imagine her as being possessed by the vast, awesome and awful monster that is popular culture. Possessed by the collective of ideas!"[16]

The character writes this on her blog, and both her blog and the novel are dedicated to the proposition that these are the ghosts in *everyone's* head: constantly jostling, crowding, screaming for control, supercharged and metastasized by the Internet. The blogger, and thus Tremblay, are postmodern commentators not just on the story within the story, but on the novel, and our own reading of it. She presents and articulates all the subtexts, with references to classic horror movies, short stories, and novels ranging from *The Exorcist* to "The Yellow Wallpaper" and beyond, with a big debt to Shirley Jackson's *We Have Always Lived in the Castle*. It's a masterful take on the way we read—and watch, and live—now.

Because, after all, the worst lo-fi horror, the ghosts in all our heads, streamed in via our smartphones and media feeds, are the records of dash cameras and body cams, of the stitched-together footage from the Capitol on January 6, 2021, and the 2020 murder of George Floyd. This constant mosaic of video horror, popping up without warning and always only a click away, portends to provide the prospect of total accountability. The idea that sin shall be found out has been the essence of a great deal of horror since Salem, after all. But it was never so easy, and—when justice is done—never so satisfying, even at the cost of the horror of viewing such terrible truths that might, before, have stayed out of sight.

But the same technology, and its dissemination, also reinforces the unsettling fact that we live in a panopticon, providing a creeping paranoia that even the most imaginative narratives of the seventies could hardly have portrayed. *They* are all around us. And they have phones, and can record all our secrets, and upload them to the cloud. And Salem's lesson, that what looks like accountability can sometimes lead to hysteria, seems never so meaningful in an age that also features Internet dogpiling and manufactured viral outrage alongside genuine examples.

And, perhaps even more unsettling, it's becoming harder and harder to tell if it's humans responsible for any of it, or simply ghosts in the machine. Back in the mid-sixties, Harlan Ellison wrote one of the first great AI stories. In "I Have No Mouth, and I Must Scream," he describes the revenge of a sentient AI called AM:

> At first it meant Allied Mastercomputer, and then it meant Adaptive Manipulator, and later on it developed sentience and linked itself up and they called it an Aggressive Menace, but by then it was too late, and finally it called itself AM, emerging intelligence, and what it meant was I am . . . We had given AM sentience. . . . We had created him to think, but there was nothing it could do with that creativity. In rage, in frenzy, the machine had killed the human race, almost all of us, and still it was trapped.

The rest of the story is dedicated, in Ellison's often fervid sixties style, to the working out of that revenge. There were other such works, of course, including several movies: the seventies *Colossus, the Forbin Project*; *The Terminator*, of course; and more recent science fiction entries, some based on classic science fiction—*I, Robot*, taken from the classic Asimov short-story collection but given a mecha-dystopic twist—and some based on older horror tropes. (The 2022 movie *M3GAN*, for example, feels a lot like the Chucky movies of the eighties, only with an AI gloss to it.) But as much fun as "if this goes on" future-set science fiction is—like the horror stories of Netflix's *Black Mirror*, named, appropriately, after the off-screen look of the phones we spend so much of our time staring into—the series' title makes clear that the dystopia it sketches is actually very much an echo of the now.

And it's less apocalyptic than algorithmic. Possibly the most interesting thing about the fears that AI is now developing is how utterly *un*-uncanny they will be: the glutinous drip of AI-generated disinfo, the enshittified crap that now passes for search results and customer recommendations, the Russian troll farms pumping out bots and responses that may shift

the course of American elections. Lo-fi, in other words: the ghosts that we fear the most are the ones in the machines, the ones that are curdling our preferences without our knowing it, not the ones who clank about hunting Sarah Connor.

And, most important, is what those algorithms are doing to the insides of our heads. In certain ways a response to *Videodrome*, 2021's *We're All Going to the World's Fair* isn't just about the menace of video. The movie is set against an increasingly important venue for horror: the game. Survival horror games, and, now, immersive horror games, have flourished over the last quarter-century, ranging from the late-nineties *Resident Evil* (which would spark its own film franchise adaptation) and *Silent Hill* to *Alien: Isolation* and *Hellblade: Senua's Sacrifice*. More than thirty virtual-reality products based on horror franchises were made between 2014 and 2020, creating an "overwhelming almost 'hellish' experience, even for the seasoned horror fan."[17] The movie's spinoff, World's Fair, is an online game, a next-level *Ring* that you agree to play instead of watch; and when you say the initiatory incantation three times and cut your finger, you enter its world. But although the movie is quite canny about whether the game has any supernatural effect (it frequently name-checks *Paranormal Activity*), that's certainly not its point. The teenage protagonist of the movie continues to talk, as she makes more and more in-game videos, about leaving her body, disappearing, losing control; and, as all of us have seen in the last decade, you don't need demonic forces for any of that to happen online. Real life—or, at least, the version of it that plays out on our computers and cameras—is more than powerful enough.

OVER THE COURSE OF OUR story, we've seen American horror raise its head in a wide variety of locales, from New England to Mississippi to San Francisco. Sometimes that local flavor was homogenized, for the sake of greater appeal, or in service to a larger story. One of the twenty-first century's great, ongoing horror stories—the travails and journeys of the monster-hunting, teen-idol pinup Winchester brothers in the long-running WB television series *Supernatural*—started out as more of a creature-of-the-week franchise, allowing for the equivalents of local color to get their

time in the network sun. As time went on, though, the narrative became a more overarching, apocalyptic tale. Similarly, the *Urban Legends* franchise, which lasted from 1998 to 2005, harnessed the energy of the new-slasher movement, less effectively on the scares, perhaps, but moved its principal influence away from the movies and their traditions to a kind of pan-American folklorism by including urban legends like the pop-rocks-and-soda one, the waking-up-with-kidneys-removed-in-a-bathtub-of-ice one, and the Bloody Mary one. Ghost-hunting programs like *Ghost Hunters* or *Haunted History*,[18] while attending to local details, render them, at least to some extent, of a piece, considering they're all part of a bigger show.

Neil Gaiman, now an American resident, wrote a crucial novel at the start of the new century, 2001's *American Gods*, that insisted on the updating of old mythologies and the crafting of new ones "growing in America, clinging to growing knots of belief."[19] Like Ellison, Gaiman's new gods were of the highways and motels, of cosmetic surgery and globalization, of those who represent the stock market and its invisible hand; but they were also of Indigenous peoples (like the Land, who wears a buffalo head and appears in dreams) and other traditions, mostly broadened, but also flattened, into a national idiom. But the greatest leveler and universalizer, of course, was, once more, the Internet, allowing for little-known folktales and urban legends that might have been only localized to grow into national nightmares. And sometimes, not infrequently, those legends are Internet-native: one example of folkloric creepypasta, Slenderman, became widespread and, as in so many cases in our story, showed the blurred boundaries between fiction and real life. Everyone agrees that Slenderman is a fictional creation, and unlike so many folk stories, we have a definitive creator and time and place of creation: but the anonymizing nature of the Internet got involved, and it spread, and soon enough it became sufficiently removed that disturbed young individuals would cite it in their 2014 attempt to stab a twelve-year-old girl to death.

But there were narrower visions as well, befitting the vibrancy and diversity of America's background. In 2019 *The Vigil*, for example, allowed viewers to see Jewish communal traditions turned into folk horror;[20] the

observation of a corpse before burial—a hallowed custom, a privilege—becomes a naturally terrifying site, proving that (pseudo-)religious beliefs around life and death have more power than may be conventionally imagined. Frequently, that increased focus occurred along geographical lines, however: suggesting the tradition of American regional horror is alive and well.

As the century opened, the Coen brothers combined a long American tradition—the journeying-down-dark-highways trope that was then well known as *country*—with some of the oldest traditions in Western literature, retelling the story of Homer's *Odyssey* in their *O Brother, Where Art Thou?* The brothers had not been idle since *Blood Simple*, and those neonoir sensibilities had combined, on occasion, with both more prosaic and more outré tales of grue—*Fargo*, for example, demonstrated the remarkably versatile and bloody uses to which a wood chipper could be put, and *Barton Fink* combined the agonies of the writer's process with a diabolic hotel that felt akin to the setting of *The Shining*. But they crafted an epic of the American borderlands in 2007's *No Country for Old Men*, twinning their efforts with one of the great American writers of menace.

Cormac McCarthy had been presenting apocalyptic visions of the American West since the late sixties; in one of his earliest works, 1968's *Outer Dark*, he had offered a rewrite of *The Searchers*, here with its protagonist as a mother who searches for her child, taken by her brother-lover, its father, through a horrible landscape. "I don't live nowhere's no more," she says, giving a sense, early on, of an America robbed of its promise.[21] McCarthy novels like the horrifying 1985 *Blood Meridian*, which casts an unflinching, revisionist eye, as its subtitle suggests, on "The Evening Redness in the West," rendered him a household name by the nineties; but it was in this century that he created his most iconic monster. *No Country for Old Men* features a psychotic killer, Anton Chigurh, who favors a bolt stunner; but what it really is about is menace and unrelenting will. It is that same unrelenting will that is featured in McCarthy's *The Road*, which won him the Pulitzer Prize in 2007: a postapocalyptic novel of stunning power about survival in the absence of hope.

If it was McCarthy that was America's spokesman for the haunted

West, other regions also demanded to be heard from: and if McCarthy's novels featured, at times, unconventional language—and by that I mean McCarthy's own inimitable style, combining an extensive Spanish vocabulary with some English diction rarely encountered anywhere outside the *OED*. It was a way of reminding readers of the broad tapestry of characters that make up his landscape. Similarly, the new century was able to open up new voices that were only new because they had been largely effaced.

Critiques of the treatment of Native Americans had become an increasing part of the stories of the American West. In 1999's *Ravenous*, the revisionist horror Western had focused on the notion of the cannibalistic Wendigo as a way of thinking about American expansionism, capitalism, and manifest destiny:[22] "This country is seeking to be whole," says one of the characters who's been touched by the Wendigo and developed a taste for human flesh. "Stretching out its arms and consuming all it can. And we merely follow." But that nightmare from Native American folklore is mostly catalytic, rather than central: the movie's main cannibalistic power comes from consuming the stories of Alferd Packer and the Donner Party. When 2008's *The Burrowers* comes along, though, it takes on that oldest genre of American fear, the Native American captivity narrative, in a horror-western that completely rewrites the script.

Everyone thinks, at first, in a recapitulation of that centuries-old bias, that the kidnappers of a Western 1870s family are Native Americans. But as the search for them goes on, it turns out that's very much not the case. And the only people who really understand the monsters that are responsible—members of the Ute tribe—are killed, not saved, by the cavalry. "You killed the buffalo, so the Burrowers found other food," says one of the Native Americans, asked for details about the monsters; and the fact that a significant portion of the conversation is presented in Indigenous language—a cinematic analogue to McCarthy's Spanish—is a useful signpost toward the insistence on other voices entering that conversation.

And so they are, increasingly. Novelists like Erika T. Wurth, whose 2022 novel *White Horse* tells the story of a Denver-area horror fan's return to Native American identity via, in part, a darkly enchanted bracelet, offers an effective presentation of that identity through a very powerful

evocation of Indigenous folklore. Wurth, who is of Apache, Chickasaw, and Cherokee background, is only one of a number of Native authors telling stories of hauntings both in and out of her tradition. Owl Goingback has written a series of short works drawing on his Native heritage, tales of Coyote and Tsul 'Kalu (known also as "Slanting Eyes, the Hunter God") and, in the story "Gator Bait," a shape-shifting creature who punishes those who falsely put on Native heritage for commercial gain, a nicely gruesome critique of cultural appropriation.[23]

Similarly, Stephen Graham Jones's 2020 novel *The Only Good Indians* features a group of friends who, faced with a particularly vengeful elk spirit bent on punishing them for their earlier crimes against its family, attempt to find not just safety but also a way of understanding their own identities. But Wurth's novel also tips its hat to *The Shining*—another Colorado-set novel—and shows, as many of these works do, how older literary traditions can be refracted through different lenses. *White Horse* is set in the Southwest, and the blurriness around the country's southern border, in terms of identity and otherwise, allows for a great deal of enriching (and frightening) tradition to come through.

One of the leading impresarios of twenty-first-century American horror has brought with him another geographical tradition entirely. Not since Lynch and Cronenberg has there been a visually striking artist of horror like Guillermo del Toro, who began making movies in his native Mexico and has, in features like *Pan's Labyrinth*, the *Hellboy* movies, and *The Shape of Water*, insistently provided the dreamlike atmosphere of fairy tale bleeding into nightmare. As of the 2020 census, Americans of a Hispanic background make up nearly a fifth of the country; these tectonic demographic shifts mean that works of horror that look like America are supping from an increasingly diverse set of wells.

Mexican-Canadian writer Silvia Moreno-Garcia's 2020 novel *Mexican Gothic*, a tale of love, darkness, and fungus-related immortality set in Mexico City, became a national bestseller, showing—like del Toro—how the borders are blurry. Some of the best new horror auteurs and authors fruitfully capitalize on this blurriness. One of the best is V. Castro, out of Texas, whose novels—like 2021's *Queen of the Cicadas*—work in a fervid

vein that bring the complexities and struggles of people of color in the region into a style that we might call Mexican-American Gothic. And Gabino Iglesias's 2018 novel *Coyote Songs* takes one of the creatures of the modern borderland—the so-called coyote, immigrant smugglers who sometimes lead, and sometimes rob, and sometimes abandon those individuals seeking a new life on the other side of the border—and turns that story, and intertwined others, into a magnificent poetry, whose lilting shifts from English to Spanish and back again make him an inheritor of McCarthy's legacy.

While Iglesias's preoccupations in *Coyote Songs* savor very strongly of the *now*, another great region of American fear, the South, is always preoccupied with the *then*. The title story of Andy Duncan's *Beluthahatchie*, written in 1997 and collected in 2000, begins with the unforgettable sentences, "Everybody else got off the train at Hell, but I figured, it's a free country. So I commenced to make myself a little more comfortable." It posits the geographic locale as another stop on the ultimate downbound train, with a Black man who's a blues-guitar-playing update to Manly Wade Wellman's titular character, John the Balladeer—a clear stand-in for bluesman Robert Johnson—giving a Southern, and racial, twist on the subject of going to hell. (The devil, accordingly, is "a sunburnt, bandy-legged, pussel-gutted li'l peckerwood.") "Everything's the same," the devil says to John in the book, describing how in these infernal regions there's a system of white supremacy. "Why should it be any different?" "'Cause you're the devil," I said. "You could make things a heap worse." "Now, could I really, John? Could I really?"

If Duncan's story here sups more of the genre of the folk tall tale, other horror stories of the South were a little further down the spectrum toward realism. Sometimes, as in the case of another train story, Colson Whitehead's 2016 Pulitzer Prize–winning novel *The Underground Railroad*, only partway so: its brilliant, surreal device of rendering the metaphorical railroad actual serves, in some way, to make clear how deeply the deck was stacked against those attempting to fly to freedom. Sometimes the horror story stemmed from the contemporary legacies of racism in the South: Jesmyn Ward's 2011 novel *Salvage the Bones* won the National Book Award for its depiction of the suffering of a Black family through 2005's Hurricane

Katrina, where the governmental response illuminated a systemic chasm in the treatment of poor people of color. And sometimes, as in Ward's follow-up, 2017's *Sing, Unburied, Sing*, or LaTanya McQueen's 2021 novel *When the Reckoning Comes*, or Tananarive Due's 2023 *The Reformatory*, it's about the heavy hand of the Black past on the haunted present. All three are, in their way, ghost stories, about how those who have died due to the depredations of white supremacy are still there, with us. And all of them are skeptical about the possibility of exorcism.

The treatment of the enslaved was, and remains, the key to understanding the region's horror. To make the metaphor plain, consider the 2005 movie *The Skeleton Key*, in which the key in question opens up a secret room in an old Southern plantation that has evidence both of old conjure and hoodoo paraphernalia and also of the heritage of slavery. McQueen's novel similarly centers around a plantation-turned-wedding-destination, with white celebrants wilfully blind to the atrocities that occurred there. But it wasn't the only Southern horror in town. Due's novel, for example, puts a supernatural spin on the infamous Dozier School for Boys, the Florida reform school where juvenile deaths reached into the three figures throughout the twentieth century; though a segregated institution, the dead were disproportionately Black. (Colson Whitehead traversed the same territory in 2019's *Nickel Boys*, in an equally terrifying but more naturalistic way.) And Daryl Gregory's wonderfully evocative 2021 novel *Revelator* provides a particularly monstrous twist on that old-time religion, where a very unique version of Christianity—featuring an unforgettable, utterly alien "Ghostdaddy," and those who share the revelation of it—is presented in a region soaked with moonshine and haunted by familial history. The Bible had taught the main character "how to negotiate with gods. All you had to do was be willing to murder what you loved."[24]

And when it came to over-the-top entertainment, probably the most-consumed Southern work of the century, even more than novels by Whitehead and Ward, was Alan Ball's long-running HBO series *True Blood*, based on Charlaine Harris's Southern Vampire Mysteries series. *True Blood*, about vampires letting the world know of their existence (thanks to the availability of an artificial blood substitute with a name similar to the

show's title), steamed up the sex and—thanks in no small part to Ball's own gay identity—continued Anne Rice's emphasis on a queer sexuality, with many suggesting the show's central premise, of vampires coming out in public, to be a clear allegory of the LGBTQ community's greater visibility and desire for acceptance.[25]

The show, with its emphasis on copious nudity, sex, melodrama, and gore, was not itself a prime candidate for the label of "prestige TV"—even though it was on HBO in the glory years of "It's not TV; it's HBO," a slogan that debuted in 1996[26]—but Ball's previous show, *Six Feet Under*, was one of the key touchstones of the era's opening, and its focus on the primal fear—death—was not only a sign of cable's seriousness, but of the medium's willingness to go places that network television was largely unwilling to touch: not murder, there was plenty of that, as we've seen, but the real emotions and issues stirred up by it. Drama, not melodrama. Like our earliest plays, *Six Feet Under* reminded us that the very center of life, if not its essence, was death.

AS THE SOUTHERN GOTHIC, AND, in fact, our whole story, makes amply clear, American culture has always been terrified of the others right within its society, and this century has been no exception. And it's precisely when those others' status is on the brink of change—when the possibility of real shifts in social and political hierarchies arises—that anxieties about them are expressed in horror most explicitly. And so this past decade, having witnessed the most ferment in this respect in generations, has produced an explosion of work devoted to this theme.

An indelible image from recent years is protestors dressed in red robes and wearing white wimples: an image taken from the Hulu television version of Margaret Atwood's *The Handmaid's Tale*, a series that premiered in 2017 and features a neo-Puritanesque society, Gilead, built on the remnants of what used to be the United States. The precise dynamics of the transformation are less relevant than the motivating force that's posited, which is, quite simply, fear of women and resentment at their increasing power in society. The last decade has seen women's increased ability to serve as the scourge of powerful, toxic men, striking fear into their hearts as never before: the

Shitty Media Men list and #MeToo charges have been scarier reading for a certain subsubclass than any Stephen King novel. Simultaneously, though, the skepticism about the ability of those movements to herald any systemic change, and, far more fundamentally, the rollback of previously settled rights culminating (for the time being) with the repeal of *Roe v. Wade*, has suggested that the arrow of fear is pointing, essentially, in the direction it always has. And so those red cloaks increasingly, to some, took on the tones of a prophecy, as women felt the state to be increasingly involved in their own bodily choices. Both the novel and the television adaptation locate this power not only in narrow political and economic terms but also in biological ones: there is a fertility crisis, and so working wombs are an increasingly rare natural resource—and *The Handmaid's Tale* suggests that patriarchal authority, blending religion and the state, will act to make sure women are not in charge of them.[27]

Old fears were reframed through this new lens of gender autonomy, allowing them to show off new depths and dimensions. A 2020 remake of *The Invisible Man*, featuring *Handmaid's Tale* star Elisabeth Moss, flipped not only the emphasis, from the eponymous character to his victim, but also the underlying fears, from geopolitics to gender politics; what terrifies us about invisibility, now, is its surveilling potential for perfect stalkerdom. "This is what he does, he tries to isolate me," Moss's character says, after her abusive husband has, thanks to his high-tech invisible suit, pushed everyone away from her; and although he is the one who can't be seen, it's her character, her pain, her experiences, that have, for most of the movie, been rendered invisible. And when she is beaten and knocked about, and there is no one else there on camera, it's a powerful metaphor for the all-too-frequent internalization of the gaslighting that often comes in such isolation's wake. For her part, novelist Meg Elison rewrote *Misery* from a female perspective in the 2022 novel *Number One Fan*, not only bringing it into the Internet age but showing, in every line and paragraph, how it was just *different* for a female writer than for a male writer.[28]

Women's bodies, it remained clear, were not only a source of power, but of fear. The deeply intriguing 2007 film *Teeth* literalized a horrific metaphor, positing a woman with an actual vagina dentata—that is to say, a

woman who would literally bite a guy's dick off down there. The movie provides some science fiction trappings, locating its protagonist in the shadow of a nuclear reactor and positing this development as a "mutation extremely beneficial to your survival." Which, considering the character of the males she meets, mates, and mauls, seems dismayingly necessary: we meet a young man who won't take no for an answer, another one who beds her on a bet, and another in our line of predatory ob-gyns. By the end, when she runs away from home to be picked up hitchhiking by a leering, coercive driver, we see her metamorphosed into a monster quite different from the one she reads about in folklore: not a spirit of fear, but of revenge, on misogynist society.

Most of *Teeth* is set in a strict Christian setting, one of abstinence pledges and purity rings; and 2012's *Excision* is another movie about the horrors made of the female body occupying similar geography. Pauline, the protagonist, a high-school ugly duckling in the manner of Stephen King's *Carrie*, displaces her anger, not least at her Christian upbringing, in dreams and fantasies that combine fulfillment, sexual and professional, with blood. "When I lose my virginity, I want to be on my period," she says, and we see the results, which are far less horrific than the way the stymieing of her dreams to be a doctor, through both societal- and self-sabotage, lead to a climax in which she performs—madly, but with the best of intentions—a homemade lung transplant on her ailing younger sister.

But if Christianity is in the dock here—Pauline offers blasphemous confessions directly to God and to a religious counselor played, somewhat unbelievably and yet perfectly, by *Pink Flamingos* director John Waters—it's not the only religious tradition under this sort of examination. The 2009 cult classic *Jennifer's Body*, written by Diablo Cody, directed by Karyn Kusama, and starring Megan Fox, plays on the trope of woman as succubus, as someone who preys on others by virtue of her sexual power, a demon-goddess whose etymology goes back to pagan times. The fact that Fox was an object of aughts-era identification, perhaps the most famous of her type, added another dimension to the film's message. "Hell is a teen-aged girl" is the movie's first line; "I am a god," Jennifer says, later. Both are true: Jennifer, sacrificed for male power—it's a deal with the devil for

an indie-rock band to make it big, but still—returns, and while her body count is of course a problem, the bigger problem, the movie suggests, is her inappropriate insistence on her own enjoyment regardless of propriety.

That said, the main pas de deux in the movie is between two young women—Fox and her best friend, played by Amanda Seyfried—and what emerges from the movie is a quite different comment about modern femininity: the fear that while women's charged friendships are obviously about much more than the male gaze, so much of the dynamics of those relationships, and certainly their representations, is shaped and formed by a society that premises them on that perspective. Much of the discussion around the movie, in fact, was shaped by a kissing session between Seyfried and Fox's characters, although what the movie makes clear is that the movie's tragedy—its literal heartbreak—is the shattering of their friendship thanks to the narrative's events. A not entirely dissimilar dynamic would appear a year later, in an actual pas de deux, when Natalie Portman and Mila Kunis literally danced around one another in 2010's *Black Swan*, bringing the concept of the uncanny double we've seen so often to the ballet stage.

But some of the worst binds, as we saw in *Rosemary's Baby*, are the binds of family. Ari Aster's 2018 movie *Hereditary* is about witchery and demonic activity, yes; but what it's about, far more, is the traumatic damage that can be inflicted by, and in the name of, family. Although it has its share of jolts and shocks—a daughter's decapitation via telephone pole, Toni Collette's mother character sawing off her own head with piano wire, slowly—the movie's most horrific moments are the ones that come from the passing down of family grief and trauma: Collette's character telling her son she never wanted him and then being horrified at her own truths coming from her mouth; her son, having caused the car accident that led to the decapitation, sitting there, knowing what has happened but hoping time, somehow, would stop forever. "Nobody admits anything they've done!" Colette's character cries out in a grief circle; but the movie is a testament to the raw damage that buried grief can wreak when it does come out, after all. Douglas Buck's short film *Cutting Moments*, made in 1997 but released as part of his trilogy *Family Portraits* in 2003, is about a family that is falling

apart, and that disintegration is manifested in the way that the couple, who are increasingly estranged, find that their own self-mutilations lead to a (very temporary) coming back together.

Which is not to say that crisis and fear are limited to the female side of the scale. The leading poet of the crises, anxieties, and fears of masculinity is the author Chuck Palahniuk, who first came to public attention by insisting, to millions of readers, that we do not talk about fight club. His 1996 film *Fight Club*—which rewrote Poe's "William Wilson" for a late-twentieth-century sensibility with the idea that at the end of history, corporatized neoliberalism was somehow neutering, stifling American manhood—became a sensation; and Palahniuk would go on to craft other stories about the way in which American male desire has gone awry. In his 2002 novel *Lullaby*—which is ostensibly about an African "culling song" that, when read aloud, becomes a spell that causes instant death in its targets—becomes far more powerful in the hands of its male narrator, who can use it to murder without saying a word out loud. Trying to explain its effect, another character suggests it's because of built-up rage and sexual frustration. ("When was the last time you got laid?" she asks. "My guess . . . is you're a powder keg of something. Rage. Sorrow. Something.")[29] That model of the incel would become a boogeyman of the century: and Palahniuk would insist that those toxic, destructive energies were turned inward as well as out, most brutally in his 2004 short story "Guts." "Guts" provided perhaps the most harrowing story about the wages of masturbation ever written, worse than preachers' threats of hellfire and brimstone: it took a young man's desire to enhance his pleasure by sitting on a pool filter and turned it into a nightmare that involved the self-removal of his own lower intestine.

Which brings up, of course, one of the great fears of this era, as in every era: sex itself. Writer/director David Robert Mitchell's 2014 movie *It Follows* can, on the one hand, be understood as the updating of those eighties AIDS allegories about the wages of sex: when you do it, you get something monstrous that comes along for the ride, that follows, and closes in, and if it reaches you, it kills you, and only you can see it. ("Did she catch anything?" "I don't think so," say two friends, who are both right and

very, very wrong.) But *It Follows* is also about—as with many metaphors of sexual disease, and of horror more generally—a kind of initiation, into a community of secret sharing. The fundamental motion of the characters in the movie is looking backward: to see the creature, of course, but also, more broadly, to deal with regrets, with past decisions, all the things that add up to, not just one's sexual history, but the life that makes that history what it was. The monster can take on familiar forms. "Sometimes I think it looks like people you love just to hurt you," one of the afflicted characters says, and this may be true: but what's also true is that our past, necessarily, takes many forms.

Not that such representations, such images of sexuality, are binary. A classic definition of monstrosity has included an assertion that well-established binaries are, in fact, blurred and porous: and such an assignation could, and did, frequently lead to the dissemination of trans-phobic tropes, perhaps most notably in *The Silence of the Lambs*, where killer Jame Gumb's motivations uneasily overlapped with gender dys-phoria. In recent decades, with increasing attention paid to spectrums of gender identification in ways that cause not only celebrations of pride but also antitrans legislation and moral panics, these representations have been increasingly played out in the culture. Contemporary novels, for example, have been interested in subverting and flipping some of the tra-ditional tropes of body horror to reflect a wide and diverse authorship and sensibility. In her wonderful 2012 novel, *The Drowning Girl: A Memoir*, Caitlín R. Kiernan depicts the kind of creature that could have appeared in one of Lovecraft's works—a woman/sea creature hybrid—but instead of being a source of disgust and visceral horror, Kiernan's work embraces ambiguity, hybridity, and the kind of beings that Lovecraft would con-sider monstrous—not least, in the novel, being same-sex romance and transgender figures.[30] And in Rivers Solomon's 2021 novel *Sorrowland*,[31] we have, on the one hand, a familiar set of tropes: a woman, on the run, undergoing some kind of monstrous metamorphosis. But what becomes clear, as the novel progresses, is that the monstrosity in ques-tion is the violence done by the state to individuals—particularly peo-ple of color or of marginalized sexual identity—and that the changes

caused by this can both demonize, instrumentalize, and turn into a roar of revenge from the repressed, and the oppressed. Being open about who you are and have become can be liberating—and can also make you very, very violent.

The control and subordination of bodies in the American landscape has been part of our story since 1619, at least, and the easy adaptation and transformation—body-snatching, if you will—that can take place along parallel fears is clearly apparent in one of the most important works of horror of the century. Jordan Peele has talked about his debt to what he calls "the Ira Levin" school of writing,[32] and Levin's work is alive and well in Peele's body-snatching movie *Get Out*, which transposes the questions that Levin asked about women in *Stepford Wives* to a hugely effective meditation on the "sunken place" trauma of blackness. And unsurprisingly, given Peele's long history as a comic writer and performer in Comedy Central's 2012–2015 *Key and Peele*, it does so with the vicious sting of satire, not least of a certain kind of white liberalism.[33] Key and Peele frequently used conventional horror movie settings and tropes to parody racism. "White Zombies" was a *Dawn of the Dead*–type parody in which the duo survive because even the cannibalistic undead give the Black protagonists a wide, uneasy berth—making the postapocalyptic landscape, in the skit's button, a Black paradise: "Hey guys, isn't this great! . . . Come on, we having a party!" says another man to them. And "Alien Imposters" tells us that the way to tell the shape-shifting aliens from the humans is if the white people are tolerant. "Would you let me date your daughter?" they say to one white businessman, recalling *Guess Who's Coming to Dinner?* "Of course!" says the businessman, and they blow him away, watching green ichor spurt from the bullet wounds.

In advance of *Get Out's* premiere, Peele programmed a film festival at BAM on "The Art of the Social Thriller": a catalog of many films in our story, including *Night of the Living Dead, Rosemary's Baby, The Shining, Candyman, Scream, Rear Window, Funny Games, Silence of the Lambs, People Under the Stairs*, and *Guess Who's Coming to Dinner*.[34] And when asked to identify his movie's genre, he famously replied it was a "documentary,"[35] explaining in an interview that:

It was very important to me to just get the entire audience in touch in some way with the fears inherent [in] being black in this country. Part of being black in this country, and I presume being any minority, is constantly being told that . . . we're seeing racism where there just isn't racism.[36]

Peele's next two movies were also dedicated, in their individual ways, to the subtle communication of this blunt message, both examinations of society's failures to see, and of the doubled consciousness and vision, which often complements those failures, of those who all too regularly are not seen. In 2019 *Us* juxtaposed the historically true, utopian United Colors of Benetton 1980s project to link Hands Across America with the revelation of uncanny, doubled families that live subterranean lives and are intent on murdering their above-ground counterparts. It was the metaphor of submerged unpleasant truths becoming violently, vengefully real; and the fact that the movie's focal family is a Black family showed how certain kinds of blindness might, indeed, cross the color line. And 2022's *Nope*, a grand ride about trying to get an alien encounter on camera, set against the wide expanses of the West, was a piercing look at the way people of color, especially Black people, both did and didn't fit into the grand narratives of Hollywood genre, a demographic that sees those narratives and yet is all too often absent within them. Peele has his protagonist, who works behind the camera as an animal trainer, point out that the first movie cowboy, indeed the first figure in a moving picture, was a Black man on a horse; and *Nope*'s monster—a big, ravenous, consuming, white eye-mouth in the sky that will only eat you if you look at it—serves as an interesting metaphor for both the viewer's gaze, the animalistic nature of that gaze, and the way it's happy to swallow up people and their stories without a trace.

Peele, though by far the most famous and successful figure working in these precincts—*Get Out* was the first movie by a Black writer-director to break nine figures at the box office[37]—wasn't the only one; and *Get Out* could be seen as ushering in a new era of work that brought this dynamic into the spotlight.[38] A literary collective, the Graveyard Shift Sisters, has a

stated purpose to "fight against the invisibility of Black women in horror"[39] and former publishing professional Zakiya Dalila Harris, in her 2021 novel *The Other Black Girl*, transposed Peele and Levin's sense of paranoia around liberalism to that world, showing how visibility—wrapped, complicatedly, in an atmosphere pervaded by the prospect of tokenism—can bring its own terrors. "Danger for Black girls was different. It didn't obey the boundaries of stories. For them, it was always real," Erin E. Adams writes in the opening pages of her 2022 novel *Jackal*,[40] and the novel features an ongoing plague of these girls' disappearances in the forest around the protagonist's hometown—ongoing, thanks to a toxic combination of supernatural menace and structural racism, story and reality. And Alma Katsu's powerful 2022 novel *The Fervor* is set in and around the Japanese-American internment camps of the Second World War; and no small part of its horror is that whatever diabolic disease is spreading throughout them—and it seems, for most of the novel, quite otherworldly in nature—is nothing compared to the governmental desire to keep "the inhumane thing that was being done in [the public's] name . . . out of sight, out of mind."[41]

Katsu would write, in her afterword, that her novel was written during a "wave of senseless violence against Asian Americans"[42] that felt reminiscent of those earlier dark days; and much of this recent work is interested in raising the haunting proposition that progress on civil rights or racial equality is, at bottom, illusory. In Mariama Diallo's 2022 film *Master*, Regina Hall's Black professor is appointed master—a very loaded word indeed—of a part of Ancaster College, "a school that's nearly as old as the country." Harvard College, whose upper-class dormitories are called houses, removed the title "House Master" from the professors who organized them in 2016, replacing the phrase with "Faculty Dean"; while an administrator there explained he had not "been shown any connection between the term house master and the institution of slavery,"[43] in the movie, the racial connections between the two are made very clear indeed. Hall's character starts the movie joyous, optimistic, convinced the college is dedicated to liberal progress; by the end, after a Black student dies and a particularly nasty case of cultural appropriation results in tenuring a white professor passing as Black, she says: "I was never a master. I'm the maid. You brought me here to clean up.

I didn't change anything. . . . it might not be white hoods and minstrels, but it's there."

And maybe Ancaster College had no white hoods and minstrels, but the nightmare becomes even plainer in 2020's *Antebellum*, which posits a world in which an antebellum plantation is recreated, here and now, with Black individuals like Janelle Monáe's character kidnapped and forced to live within them. The fearful and anxious question it raises is whether what the white majority really want is a system of white supremacy identical to the one before the Civil War, with physical and sexual domination of the black body.

And, as Peele said, just because any minority—Blacks, Asians, Jews, women, LGBTQ people—is told they're not seeing it, that doesn't mean it's actually invisible.

HUMAN MONSTROSITY IS TERRIFYING, AND the century has seen more than its share; but that doesn't mean the more conventional type of monster isn't still part of our story—though harnessed, as always, to contemporary concerns. There was the occasional new entrant in the lists: The Creeper, the protagonist of the Jeepers Creepers franchise premiering in 2001, combined the collector-aspect of the serial killer with a supernatural backstory, taking the old song's refrain "Jeepers, creepers, where'd you get those eyes" to a new level. But there were plenty of old ones: in the twenty-first century, the canvas of horror now is vast enough for treatments of every sort of monster, every reboot and callback to different moments in horror history. In other words, it is pandemonium, and all the monsters are here along with all the other devils.

In addition, the tenor of the age, dedicated, in many ways, to the remix, the repurpose, the pastiche, suggests everything can be grist for the mill, and so a significant portion of the treatments of classic monsters focuses on contemporaneity. *Dracula 2000* went the other way from Francis Ford Coppola's *Bram Stoker's Dracula* by announcing, in its title and its plot, how very contemporary it was: Dracula is involved in a plane crash, for one thing. In a nod to the Ricean tradition, *Dracula 2000* is set in New Orleans; 2007's *30 Days of Night*, based on the graphic novel, transposes the story to

a different American setting—Alaska, the top of the world, where the darkness can go on for what seems like forever. The tonalities are as varied as the settings: while *30 Days of Night* is an actioner with elements of the grindhouse, Jim Jarmusch's 2013 *Only Lovers Left Alive* rewrites *The Hunger* to describe the lassitude, pathos, and anomie of the vampires who have been around forever. Andy Davidson's 2017 vampire novel *In the Valley of the Sun*, for its part, takes on the conventional tropes, but infuses them with a kind of Cormac McCarthy–esque lyricism, especially around the turning, and is one of the best novels out there from a new vampire's perspective.

The sparkling prose of Tim McGregor's 2021 novel *Hearts Strange and Dreadful*,[44] which is, put shortly and sweetly, about vampires coming to nineteenth-century New England, isn't just a delicate and linguistically delightful application of the setting; it also offers an almost jewel-like fidelity to the past. And Christopher Buehlman, in his phenomenally evocative seventies-set 2014 vampire novel *The Lesser Dead*, goes more broadly with *his* period piece: stuffed with place-markers of the seventies, the clubs, the subways, it shows—in a way better than anyone since Anne Rice, though with a far more down-to-the-ground ethos—the way a vampire story allows you to visit several different periods of America all at once, and how memory can be a horror.

Buehlman, in many ways, is one of the great auteurs of spanning time and space with classic monsters. He revisits vampires in his follow-up novel, 2016's *The Suicide Motor Club*, with its creatures who acquire some of their victims through deadly car crashes (deadly for their victims, anyway; *they* heal up); and his 2013 novel *The Necromancer's House* is probably one of the best treatments of contemporary magic of the decade. But it's his debut novel, 2011's *Those Across the River*, which speaks the most to the way these monsters address the American condition. *Those Across the River* is a werewolf novel, with classic lineaments, silver bullets, predatory creatures in the woods—but ties it in to a long history of American tragedy, of slavery. The way that bodies are enslaved and rendered animalistic allows us to think of werewolfery both as predatorily animalistic and as the revenge of the repressed body, reshaping and morphing under trauma, as well as posing questions about racialism and miscegenation. (It also depicts the bodily

trauma of a Great War veteran of the trenches.) Works more faithful to the original material, like 2010's *The Wolfman* starring Benicio del Toro, don't quite reach the same resonant heights, reliable at delivering the scares as they might be.

This even holds true with some of the creatures that seem the least protean. The Frankenstein monster is literally made up out of old parts, after all; but Danielle Trussoni's 2020 novel *The Ancestor* takes *Frankenstein* and rejiggers it in an age of not just Darwinian evolution but also genetics, and provides a female protagonist in order to think through these issues in terms of monstrous birth and maternity. Two years later, Jennifer McMahon's novel *The Children on the Hill* refers to its *Frankenstein* bones numerous times, but its pressing concerns, complementing Trussoni's, are less genetics than eugenics, with a side of familial abuse: the evil grandmother-scientist performs surgical and pharmaceutical horrors on a person she considers the dregs of humanity to turn them "good": and, though we believe for much of the novel the result is a monster out of folklore, the patient has actually become a feminist legend, helping rescue people from abusive situations to give them new lives.

And haunted houses are plentiful and—given the house's role as an almost infinitely adaptable metaphor—are used to mean so many different things. Sometimes, they're adaptations that explicitly trade on the original, albeit more or less faithfully. Netflix adaptations and reimaginings of classic works ranging from *The Fall of the House of Usher* to *The Haunting of Hill House* to *Wednesday* ramp up the Goth in Gothic, showing how that movement's reimagination as style and lifestyle continues to grow in influence and popularity.

But those works maintain many of the movement's visual trappings; other more recent classics locate their hauntings in more grounded milieux. *Session 9* (2001) was filmed in an actual nineteenth-century insane asylum, Danvers State Hospital in Massachusetts, but set its disturbances less among the mental inmates whose shadows loom within its passageways than among the traumas and violence inside the working-class men who come to try to remove the toxic substances, asbestos and the like, from its walls and floors, a task that, like any attempt to scour over a traumatic

past, can be feared to be impossible. Part of the reason the asylum was closed down decades earlier, it transpires, was because of its staff's involvement in a satanic panic case of false abuse; in 2022's *Barbarian*, a seemingly unremarkable rental house hides other horrors in its basement, less the monstrous maternal figure that lives there than the monstrous kidnapper, rapist, and technically- and otherwise-speaking patriarch who is the house's owner. Or, better put, one of its owners: since the house's other owner, paralleling the first, is perhaps even more monstrous, a rapist and attempted murderer, revealed by movie's end, who clothes his own terrible actions in twenty-first-century self-justification. "I hurt somebody. That matters . . . I'm going to fix it," he says, just before he pushes our wounded protagonist off a roof in order to buy himself some time to save his own skin.

That same year, Sarah Gailey's haunted-house novel *Just Like Home* was published: a novel, as they suggest in their acknowledgments, about monstrous, terrible, terrifying love and the strange contours and channels it takes. Here is a work about traumatizing predation, about parental abuse, that is reflected in the transformation of a younger generation into a haunting, not just haunted, type, and about how this shapes the relationships they have, and can have, with people and indeed with places—revealing how these are not as different as we might think. Five years before, Jac Jemc had also published a novel about love, toxicity, and houses. *The Grip of It* (2017), with its formally intriguing premise of alternating chapters between the members of a couple who move into a new home, makes us wonder, in the difference in the voices and the accounts they offer, about where the horror of the story really lies, whether in *it*, or *them*.

Scott Thomas's novel *Kill Creek*, published the same year as *The Grip of It*, is a haunted-house story that's a meditation on *writing* horror and trauma, accompanied by buckets of blood and guts. The novel brings together different types of writers—an R. L. Stine type, a Stephen King type, a Poppy Z. Brite type—all summoned to a conclave in a haunted house as part of a gimmick from a new-media shock baron. We're treated to versions of each writer's ethos, but in all of them there is a commonality, of the hand of the past and of trauma beneath the present, that is the essence of the Gothic. "You're all a part of the story!" the monster at the heart of

the house yells to them at the climax, and indeed they are. We're left with the understanding that what the house wants in the end, as a site of myth and folktale, is for people to tell that story. And why not? In this century, there's the sense, increasingly pervasive, that if it's not *out there*, it isn't real. And houses, without the benefit of writers or cameras, are notoriously immobile.[45]

Sometimes genres were mashed up. *Riverdale* and *Sabrina the Teenaged Witch*, Gothic versions of their original Archie counterparts, focused on teen interests that bordered on, and went into, the paranormal featuring classic monsters. They also owed a debt to the love triangle between a human, a vampire, and a werewolf that developed in the Twilight series, beginning in 2005. This massively successful series of novels rewrote the sexual energies of the Rice vampire era for a young adult audience; but unlike the Archie reboots—which were saturated with the sexual energy and activity of early-aughts shows like *Gossip Girl*—the novels' demureness, and emphasis on abstinence outside of marriage, made sense given author Stephenie Meyer's own traditionalist upbringing in the Mormon Church.[46]

The *Underworld* movie series, which began in 2003 and ran for thirteen years through four sequels, also focused (albeit more bloodily) on vampires and werewolves; and Netflix, when they entered the original-series horror market with the Eli Roth–helmed *Hemlock Grove* a decade later, used their rental algorithms to determine that a series featuring werewolves and vampires would appeal, its piling on of the classic horror tropes a data-driven method of appealing to the widest possible audience.[47] But every era has particular monsters indelibly associated with their moment, and if the Reagan and Clinton era was a vampire age, the twenty-first century has, unquestionably, been the age of the zombie.

In no small part, this is thanks to Robert Kirkman's *The Walking Dead*, a comic that began in 2003 and was adapted into one of the biggest nonbroadcast television shows of the twenty-first century, debuting with a "global zombie day" on October 10, 2010—10/10/10—with events in 120 countries and 33 languages, leading up to the show's premiere that Halloween night.[48] Kirkman's zombies are slow, Romero-style shamblers. They're stupid. They are, in certain ways, manageable. But they allow Kirkman to envision the

many different ways that society—and humanity—can descend into an abyss as a result, to focus on the existential matter of simply continuing to live in an age of apocalypse. Zombies were to think with, not to fight, exactly; and it wasn't surprising that Kirkman's work continued to gain resonance at precisely a time when the liberal self-imagination was under great stress.

Arguably the presiding master of the twenty-first-century zombie novel—maybe even of the twenty-first-century zombie, full stop—is Brian Keene, whose 2003 novel *The Rising* puts the viscera in visceral. The novel and its sequels are harnessed to a series of religious ideas: the zombies are, technically, a kind of prehuman demonic spirit alluded to in the Bible that can possess the creatures on earth, including, terrifyingly, birds and rats. But these are hardly novels of hope, at least not in life: and characters' hopes are frequently shattered in ways that constitute some of the goriest, hardest-hitting fiction since the splatterpunks. Keene, a terrifically talented writer, manages to invest things that should sound ridiculous with a kind of near-religious dread: in his Earthworm Gods series, it starts raining one day and never stops, leading to the rise of yes, giant earthworms, but also other monstrous creatures, Leviathans and Behemoths of biblical scope. "Maybe the Lord got tired of us breaking our promises to Him, so He decided to break one of his own,"[49] one character muses, and this theory, which combines Revelations and Lovecraft, certainly isn't denied in the books.

In another zombie book, 2007's *Dead Sea*, Keene has a character muse: "Just like Pearl Harbor and 9/11 and all the other national disasters. . . . When faced with an unimaginable crisis, the government failed to respond in an effective and timely manner."[50] And there was a way in which the zombies spoke to a sense of a world becoming unstrung, and how quickly it can happen. Zack Snyder's 2004 remake of Romero's *Dawn of the Dead* was instrumental in bringing the fast zombie to the American movie mainstream (although *28 Days Later*, from across the Atlantic, had admittedly gotten there first, as had *The Rising*), but it's the opening sequence that really hits home, showing—like in *The Birds*—how quickly the world can go to hell. When Sarah Polley's character, a nurse, goes to sleep, she does so in an idyllic little bedroom community; when she manages to escape from

her husband-turned-zombie and get out of the house, she finds herself in a hellscape, with ambulances running down people in the street and corpses full-body tackling their victims.

Romero himself would return to the franchise, releasing a new entrant in his zombie series in 2005, a generation after the last one. *Land of the Dead* was another social satire, here about social inequality, where, in a kind of uneasy equilibrium, the living (read: "rich") live high on the top, and the dead (read: "poor," although there are also living poor) are below; it says something that it's the zombies that are the sympathetic ones. Zombies as capitalist critique, a tradition that reaches back, once more, to the thirties. You can imagine, in the right light, the entirety of *The Walking Dead*'s various commercial iterations, sequels, and incarnations as an allegory for the ever-consuming needs of its entertainment platforms. And, in the movie version of Max Brooks's 2006 novel *World War Z*, you can get a sense of them as the exponentially multiplying consumers of the world's resources—literally, of human flesh and brains. We, in the metaphor, are the army ants of the globe, running over it and laying waste. But what remains, most indelibly, is not the global, but the local. Eli Roth's 2002 directorial debut, *Cabin Fever*, is another installment in the "teens go out to the woods and find evil" movie: but when the terrible, ravaging skin illness they find there spreads, and spreads, it becomes a zombie movie— one that lays bare the moral myopia of everyone involved, from college students to sheriff's departments. In all its characters' immediate jump to abandonment, isolation, and homicide, even when potentially unnecessary, it's about treating the living as the living dead.

But what may make the zombies the perfect monster for our somewhat pessimistic age is that they always win, in the end; they always get in. The two most perfect treatments of that brutal insight are both, essentially, sto-ries of the aftermath. In the 2023 HBO series *The Last of Us*, based on the video game, an early sequence features an Indonesian scientist confronted with an early example of the fungus that would eventually turn the planet's humans into mycological monstrosities. The tears and hopelessness on her face are more chilling than a thousand gory deaths; she advises bombing the entire city flat, but we know even that won't help. And even when

the living win, the cost is, as Colson Whitehead's 2011 zombie novel *Zone One* suggests, perhaps too great to bear: set in New York City during the clean-up, the novel channels post 9/11 trauma into a portrait of the living who feel like the living dead, going through the motions of an attempt to repair what they fear may be irreparable.[51]

The zombies took pride of place; but there *were* other monsters, other conventions. One of the earliest figures in our story is of the witch, of a woman whose power—and the fear she generated in others—derives in no small part, traditionally, from being outside traditional patriarchal circles. One of the most interesting treatments of these questions is a novel with one of the oddest literary trajectories. In 2021, the Dutch author Thomas Olde Heuvelt published an English translation of his novel *Hex*; but it was more of a rewriting, transplanting its original Dutch setting to an American one and in the process connecting its story—of a community cursed by a witch killed by its townspeople centuries before, who still walks among them—to the story of one of America's original sins, the demonization of womanhood and maternity. And Robert Eggers's 2015 *The Witch* provides another grappling—quite different from Hawthorne's—with the heritage of Puritanism and of Salem. In Eggers's movie—in ways that suggest some of the reactions to feminist works we saw in the seventies—women are placed in a double bind, in which the repressive and misogynist systems are taken to task, but so is the embrace of liberation that goes along with rejection of those systems. In the end, the movie is more about the horror of the conundrum than about the solution, in the way that the 2018 movie *The Wind*, rather than providing a traditional image of the West as a place of freedom and reinvention, instead shows that women, even when faced by prairie demons, are constantly disbelieved by their menfolk. A tale both new, and as old as time.[52]

Sara Gran's 2003 novel *Come Closer* addresses some of these questions as well, in one of the best novels of demon possession ever written, thanks, in no small part, to its steady and suspenseful first-person narration. And her treatment of the essential question of possession stories—is this really happening, or not?—makes clear that it's not just a question of the narrator's potential unreliability and instability (and it's quite clear she could be

very unstable indeed), but also a question that is related to her own feelings of liberation, of autonomy as a woman. "Just when I was on the verge of seeing the truth, when the pieces would start to fall into place and I could almost see the situation was horribly, drastically wrong," Amanda says, "the demon's voice would step in and tell me No, I was the same Amanda I had always been. Only better." The monster is within: and, as the novel wends on its terrifying way, she begins to see that it may be within many others, as well.

Sometimes, though, the creature to be exorcised and reimagined is not a monster, but an author, or a literary tradition. Presenting Lovecraftianism with and without the racism and other hatreds of Lovecraft was to be one of the challenges of the twenty-first century.[53] Sometimes, that involved an approach of simple omission, taking what worked and jettisoning what didn't. Jeff VanderMeer's 2014 novel *Annihilation*, the first in his Southern Reach trilogy, uses powerful science fiction trappings, about scientists entering an area X, to cover mysterious, Lovecraftian bones: "The spores I had inhaled . . . pointed to a *truthful seeing*," says the novel's narrator.[54] That narrator, the novel's protagonist, is female; so is the protagonist of Josh Malerman's gripping novel from the same year, *Bird Box*. *Bird Box* takes, as a start, a prototypical Lovecraftian motif: the thing from beyond so utterly alien that gazing on it drives you utterly, homicidally mad. ("Creatures . . . infinity . . . our minds have ceilings . . . these things . . . they are beyond it," one character says).[55] But it harnesses it, in a way the misogynistic Lovecraft never would, to a tale of a woman, a mother, gathering enough strength to face her fears of that unknown, in a seemingly impossible trip down the river to safety, blindfolded.

Other writers are slightly more direct. Since the late nineties, Caitlín R. Kiernan has been writing works, like 2000's "Onion," which rewrites Machen's novella "The Great God Pan" and Lovecraft brilliantly. "*You wanted to see*," says one member of a support group for those who have looked at things beyond the scrim of the world, who have peeled the first layer of the onion: "Just like the rest of us, you wanted to see." And what they see are passages to another world, "glimpses of impossible geographies, entire worlds hidden in plain view if you're unlucky enough to see them."

And then it focuses, with psychological acuity of the kind Lovecraft never had, on the psychological weight, the accrual, of living with such sights, rather than on the fervid, melodramatic madness that affects so many of Lovecraft's protagonists.

"Stories are like people," says a character in Matt Ruff's 2016 novel *Lovecraft Country.* "Loving them doesn't make them perfect. You try to cherish their virtues and overlook their flaws. The flaws are still there, though."[56] And some went right up to those flaws and confronted them straight on. Ruff, for his part, infuses the Jim Crow–era South with cosmic horror, and dares us to imagine that the latter is more terrible than the former. And Victor LaValle, in 2016's *The Ballad of Black Tom*, is interested in grappling with the literary history by deconstructing it from the inside, rewriting one of Lovecraft's most famously racist stories, 1925's "The Horror at Red Hook," by centering the Black experience, insisting that it is an essential part of the horror. "I'll take Cthulhu over you devils any day," are Black Tom's final words.[57] A convention whose name is taken from Lovecraft's work—the NecronomiCon—is a living example of how writers and readers, in the words of one observer, are taking his work's themes and "turning the weird into an instrument of self-exploration, liberation, and creativity"[58]—examples whose tendrils reach into the noir of HBO's True Detective series, Alan Moore's comics, and Magic the Gathering cards.[59]

Other writers went less cosmic with their reworkings. The brilliant stories of Kelly Link—as of this writing, perhaps the only MacArthur "Genius Grant" winner to be strongly identified with the genre—use these tropes to jump off into stories of magnificently magical surrealism. "The Hortlak," for example, is one of the great zombie stories, in an entirely different way than the splatterpunk tales, using the trope not as metaphor, but as a stubbornly real insistence on the nature of ordinary life. "Not even Batu knew what the zombies were up to. Sometimes he said that they were just another thing you had to deal with in retail," the narrator says, and other characters have this exchange: "I don't know what they want, the zombies." "Nobody ever really knows what they want . . . why should that change after you die?"[60] Another Link zombie story, "Some Zombie Contingency Plans," is much less about narrative action in response to a zombie invasion, more

about the state of mind, the deadness, that comes with the contemplation of the connotations of such an invasion: "Modern art is for people who aren't worried about zombies," the story says.[61] And "The Great Divorce," which extrapolates the marital difficulties involved in a marriage of a live person and a ghost and examines the strain on a mixed-life family while on a trip to Disneyland, is one of the most darkly funny ghost stories ever written. A. C. Wise's 2021 collection of stories, *The Ghost Sequences*, has remarkable, lyrical looks at some of the classic tropes of the genre, playing with form, narratorial choice, and language to create a slightly elevated, much more unsettling version of the content. "How to Host a Haunted House Murder Mystery Party," in its instructions to the reader, gives the increasingly terrifying sense that everything that will transpire will be out of your control; and "In the End, It Always Turns Out the Same" uses the silly, delightful structure of the characters of the kids' animated show *Scooby-Doo* to tell a much grimmer story about murder and the characters' inability to grapple with it.

Not all the monsters are inhuman, of course. In Eric LaRocca's exquisite 2023 short story collection, *The Trees Grew Because I Bled There*, the menace of "Where Flames Burned as Emerald as Grass," about a kind of Lolita meets *Appointment in Samarra*, is something that John Collier would have written, had he decided to change the recipe to be a little less boulevardier and with a little more of the serpent's bite—which plays a role in the story. LaRocca manages to create, in his short story "Bodies Are for Burning," moments of nigh-intolerable suspense in the form of a woman who has an unbearable temptation to set people on fire—and is then given her niece to babysit. But it's an indelible portrait of another kind of burning: the fiery pull of urges, and the combating of those urges by someone who is trying, desperately, to walk toward the right kind of light. In all these stories—as well as in the remarkably titled, and eerily unfolded "Please Leave or I'm Going to Hurt You"—family is the source of love, and pain, and horror all mixed together.[62]

This kind of violence, directed toward oneself as well as others, is the mark not just of the serial killer but the victim, and in a novel like Iain Reid's 2016 *I'm Thinking of Ending Things*, the sentences that might be the

novel's manifesto—"We can't and don't know what others are thinking. We can't and don't know what motivations people have for doing the things they do. Ever. Not entirely . . . We just never really know anyone. I don't. Neither do you."[63]—show the scariest part of these kind of works: the failure to achieve meaningful human connection. "I ply my trade in revealing the depraved," writes one of the characters in a story by Paula D. Ashe, and the brilliant title of her short story collection, *We Are Here to Hurt Each Other*, evokes less the uncanny creatures she dreams up from her nightmares than a genuine expression of the world she lives in, a world where, as she says, "I don't know what it's like to live in a world that feels safe. . . . all of us live amidst violence and horror all the time. Very few of us stop to recognize it. Even fewer of us admit our complicity in it."[64]

Unsurprising, then, that, as always, there's a demand for big, widescreen monster movies, too. *Eight Legged Freaks* from 2002, for example, is pretty much a fifties classic horror movie—giant spiders, grown because of toxic waste—that has better special effects. So was James Gunn's 2006 movie *Slither*, about an alien invasion that is, at bottom, extremely, extremely gross: there's a mother to the brood that, hard as it is to imagine, puts Cronenberg's monstrous mother in *The Brood* to shame: "Have you ever heard of anything like that?" says the freaked-out town mayor, looking at some of the creatures. "Me neither! And I watch Animal Planet all the fucking time!" If Gunn's movie is designed as gross-out popcorn entertainment, Joe Hill's short story "You Will Hear the Locust Sing," which, superficially described, is a radiation-mutates-boy-into-big-bug fifties extravaganza, elevates that idea to art. It infuses those genre bones with the aching alienation of a lonely kid and with a literary structure that starts right out of Kafka's *Metamorphosis*—although despite as many problems as Kafka had with his father, Gregor Samsa never ate "his father's puddled innards in great gulping mouthfuls, his mandibles clicking wetly."[65]

Perhaps the most prominent monsters, though, certainly when it came to the movies, were of the corporate, rather than archetypal sort: one might call it the Attack of the Fifty-Foot Cash Cow. *Freddy vs. Jason* (2003) was just one among many, and while this was a new story, so to speak, there were also the many, many remakes: 2003 also saw a new version of *Texas*

Chainsaw Massacre, which grossed more than eight times its production costs, "making it the first in a wave of horror remakes that dominated the US film market for the rest of the decade."[66] In 2005, Stephen Spielberg turned to the 1930s for inspiration, remaking the *War of the Worlds*;[67] and there was a remake of *House of Wax*, whose first incarnation was a thirties one, *Mystery of the Wax Museum*. Both movies suggested the power of old stories, reframed into a mid-aughts setting, to reach new audiences. Remake didn't mean bad, of course: a different return to the thirties that same year, 2005's *King Kong*, directed by the ever-imaginative Peter Jackson, got kudos for its script as well as for its effects. But what dazzled, what lingered in the imagination, were those effects: and if 1933's *Kong* was about what it meant to make a movie, Jackson's was the same, in the new world of digital effects for horror. Old tales, that is, combining old iconicity with the newest developments in special effects and camera techniques, alongside the audience's ever-increasing level of gore toleration.

All of which characterized a significant part of the century's horror product to date. In 2006, there was a remake of *The Hills Have Eyes*; in 2009, *The Last House on the Left*; in 2010, *The Crazies*. In 2011, *The Thing* came out, which was not, as one might have expected, a remake of *The Thing*, but a prequel to it, telling the story of the people who died before the protagonists of John Carpenter's 1982 movie took the stage. *Carrie* was remade in 2013, as was *Evil Dead*. In 2014, Spike Lee remade *Ganja & Hess* as *Da Sweet Blood of Jesus*. In 2018, *Halloween* was remade, starting something akin to a new franchise. The bifurcated audience for these movies—young people who had little familiarity with the originals, and genre aficionados or older generations for whom those originals were touchstones—were greeted, frequently, with one significant change in thematic emphasis: a greater interest in resolving ambiguities, in explaining and accounting for details.[68] In 2017's *Leatherface*, for example, a similar alchemy was done on the protagonist of *The Texas Chainsaw Massacre*, letting us know how he became the homicidal shell of a man he was when we first met him two generations before. This provided fan service for the already-addicted, and served as a kind of post-9/11 comfort for all, sanding down some of the more disturbing implications of free-floating, random evil that originals

like *Chainsaw* sometimes suggested. And in some cases—like in the streaming horror service Shudder's rebooting of *Creepshow* into a series—it allowed a comparatively more niche audience to luxuriate in the nostalgic joys of work proudly and self-consciously old-school, with a commitment to "practical representations of horror," almost entirely avoiding digital effects, for example.[69]

This kind of expansion and explication could extend to spinning off new franchises or intellectual property from old ideas or worlds: 2004's *Van Helsing*, for example. Sometimes, like in Tim Lucas's 2005 novel *The Book of Renfield: A Gospel of Dracula*, the work rewrites or expands the original work in a way that is, in some sense, faithful (like Saberhagen's *The Dracula Tapes* did a generation and a half before). Or, like 2014's *Dracula Untold*, they could allow a jump-off into a different kind of genre, here an actiony prequel. At other times, this kind of work—which is, technically, parody— could veer into actual comedy, like the Seth Grahame-Smith 2009 novel *Pride and Prejudice and Zombies* and 2010's *Abraham Lincoln, Vampire Hunter*.[70] (Following on the Austen mash-up, the same publisher, Quirk, released *Sense and Sensibility and Sea Monsters*, also in 2009.) This kind of look back—which capitalized on contemporary Austen-mania, to say nothing of property in the public domain—illustrated, once more, the power of nostalgia, and, for that matter, of pastiche. One of Netflix's most popular shows of the 2010s, *Stranger Things*, incorporates a great deal of horror tropes, but mostly is interested in trying to recapture the spirit of being young in the 1980s; this is, in its own way, the same impulse that animates much of the horror work of Ryan Murphy in his *American Horror Story*, which delves deeply into the sights and sounds of the culture of American terror in order to salvage it for his own work. (As of late 2022, *Monster*, Murphy's look back at the serial killer Jeffrey Dahmer, was the second most viewed show on Netflix—behind a season of *Stranger Things*.)[71] And Stephen Graham Jones's Jade Daniels trilogy—beginning with 2021's *My Heart Is a Chainsaw*—brilliantly features a protagonist who, steeped as she is in all tropes and conventions of the slasher variety, is forced to confront their usefulness, and their failures, as she navigates their apparent appearance in her "real" world.

Which is not to say parody has to be funny. Quite the contrary. One of the great contemporary horror filmmakers, Ti West, in works like 2009's *House of the Devil*, is operating more in parody's technical mode, telling a haunted-house story with visuals and narrative tips of the hat that provide uncanny echoes of seventies movies like *The Amityville Horror*. And his more recent *X*—a 2022 take on seventies-era porn with very up-to-date sensibilities, which could have been called *The Devil in Miss Pearl*—makes some serious points about sexuality in the course of providing some very effective jolts and scares, particularly about the war of desire that goes on between the young and old. "Look at me like you look at her," says the old woman to the director of the porn shoot that's taking place on her property. "I can show you what I'm capable of." And when he demurs, she does show him what she's capable of. With a knife.

Not what you'd call a barrel of laughs, no. But it didn't mean parody *couldn't* be funny.

IT WAS THE WAYANS BROTHERS' Scary Movie series that dominated the horror-comedy movie circuit in the first years of the century; a seminal franchise—and given the amount of body fluids the incredibly game Anna Faris is covered in, that seems the only appropriate word—but even the gross-out humor, the drug humor, the racial winking and general ridiculousness that the Wayans Brothers brought to the large screen suggested that horror-comedy was, in its own nature, indebted to the parodic consciousness. *Zombieland*, from 2009, for example, works so well because it recognizes that, by this point, American pop culture is becoming a zombieland of its own: so saturated that it has its own conventions, its own rules, of which Jesse Eisenberg's main character keeps a list and provides them—illustrated by amusing visual vignettes—at different points in the movie. One of the most encapsulating of the parodies—which involved a comic sensibility tied to plenty of scares and grue—was 2012's *The Cabin in the Woods*, which tied its dead-on knowledge of all sorts of horror conventions to an up-to-date Lovecraftian premise that posited horror archetypes as the essential figures in a sacrifice keeping the world safe from Elder Ones. And 2023's extremely clever *The Blackening* applied the more pointed satire

of *Get Out* to a *Scream*-like slasher film whose laughs come from a simultaneously confident and uneasy engagement with the traditions of horror, and how Black people are often at their margins. (Alluding both to societal anxieties and the all-too-frequent convention that people of color die first in horror movies, one character asks: "Are there any white people who want to kill us?" The response: "I mean, potentially, all of them.")

Zombieland and *Cabin in the Woods* were hardly afraid to go over the top, visually speaking—the latter featuring a gill-man chowing down on a victim, blood geysering out of its blowhole—and, in some of the most outrageously comic horror of the century, the outrageousness was the point. Rob Zombie, the heavy metal frontman—his band, White Zombie, took their name from the classic Lugosi movie—followed up on a late-nineties solo album with the title *Hellbilly Deluxe: 13 Tales of Cadaverous Cavorting Inside the Spookshow International* by taking the twisted-family DNA of *The Texas Chainsaw Massacre* and filtering it through an insanely unique vision to create a delicious, delightful mess, something *more* than almost any other movie of its generation. The line immediately preceding the opening credits to 2003's *House of 1000 Corpses*, which features two young couples falling afoul of the homeowners in question with predictably awful results, is "Goddamn motherfucker! Got blood all over my best clown suit!" and that mixture of clowns, blood, and ironic madness gives a sense of Zombie's ethos. But the clowning also hints at a serious comedic aesthetic. One of the main members of the family, Otis B. Driftwood, has the same name as the character Groucho Marx plays in *Night at the Opera*—though he's far more murderously psychotic[72]—and this, one of a number of Marx Brothers references, gives a sense of the movie's anarchic chaos. Or, perhaps, it doesn't: because the Marx Brothers' movies are, formally speaking, quite sedate; while Zombie's postmodern movie, in a way not dissimilar to *Natural Born Killers*, switches times, modes, levels of discourse. "I have to break free from this culture of mechanical reproductions and the thick encrustations dying on the surface," says one man to the five cheerleaders he's kidnapped, and Zombie certainly does.

Other movies reveled in the cycle of repetition, of fidelity and structure. That kind of eternal reliance came out, perhaps most prominently, in the

2017 movie *Happy Death Day*, a slasher movie with a quirky premise modeled on the influential comedy *Groundhog Day*. In *Death Day*, the victim, a stereotypically bitchy college student, keeps waking up and reliving the day of her death, over and over, until she is able to identify and stop her stalker, a process that depends, like with Bill Murray's weatherman, on her becoming a better, more understanding, person. The movie, in its own way, becomes a comment on the essential sameness and rhythm of the horror film, in which the delight comes not in the general surprise, but in the variations on the theme.

A comedy like *Happy Death Day* relies on, and so reinforces, conventions; but even ones that set out to satirize those conventions end up doing the same thing, sometimes intentionally, sometimes not. Quentin Tarantino and Richard Rodriguez's 2007 double feature *Grindhouse* not only paid tribute to the kind of exploitation and gore movies that played in those theaters (before video put them out of business), but bookended the movies with fake trailers that hovered between the absurd premises of parody and the absurd premises of "straight" horror.[73] (Rodriguez and Tarantino had previously worked together on one of the great vampire movies of the nineties; *From Dusk till Dawn* harnessed the go-go exploitative energy of a movie like *Faster, Pussycat, Kill! Kill!* to tell the bloody, bare-breasted tale of a night inside an undead trucker bar south of the border.) In a sign of how blurry those lines were, three of the fake trailers were so successful that they were turned into real movies: Robert Rodriguez's self-explanatory 2010 *Machete* (which featured Robert De Niro!); Jason Eisener's 2011's *Hobo with a Shotgun*, which features the former blasting happily away with the latter; and a little over a decade later, Eli Roth's 2023 slasher film *Thanksgiving*, itself, of course, a parody of *Halloween*.

It is a fine line to walk, to be able to maintain a sense of the silly and the absurd while delivering real scares, and perhaps the best practitioner in the last decade has been the novelist Grady Hendrix. Hendrix, a South Carolina native, has a sense of the Low Country and the region in many of his novels: but unlike so many of our regionalists from the area, his work is less Southern Gothic than it is eighties and nineties remix. Although his incredible visual sense, in the 2014 haunted Ikea-like furniture-store

novel *Horrorstör*, is part of what brought him to public attention, his best novel, 2016's *My Best Friend's Exorcism*, whose title comically juxtaposes a cheesy-classic nineties Julia Roberts comedy with the seventies horror classic, provides for a reimagination of a trope that's both deadly serious and utterly ridiculous, in the way, well, teenagers can be. The story, of a friendship between two girls that tries its best to survive demonic possession—"I love you dearly and I love you queerly and no demon is bigger than this!" one of them tells the other—Hendrix provides a formula for exorcism that is less Catholic than pop cultural. "By the power of Phil Collins, I rebuke you!" shouts the protagonist at her possessed best friend. "By the power of lost retainers and Jamaica and bad cornrows and fireflies and Madonna, by all these things I rebuke you." These are the conjure words that matter, Hendrix suggests, as America's new religion becomes culture and commodity: in Hendrix's 2018 rock-and-roll horror novel *We Sold Our Souls*, he has a character note that "Now, people sell their souls for nothing . . . for a new iPhone . . . no fanfare, no parchment signed at midnight . . . they only want *things*."

It's that sense of diminishment—and, maybe, a hint of our overpowering desire for new and better screens—that suggests why this recent golden age of horror-comedy has taken place most powerfully on television. Horror-comedy has always, at its heart, been about domestication, about the minimizing of the fears and concerns the topics and treatments suggest; and the electric hearth of the small screen is perfect for that coziness. It is an interesting question, though, as to whether the intensity of fright can be delivered in the same way when you've got your laptop on and you're scrolling as the movie unfurls and you pause every ten minutes to go to the bathroom or get a snack.

No terrifying creatures of the night are more domesticated, more minimized, than the vampires who inhabit the FX comedy *What We Do in the Shadows*, based on the New Zealand movie by Taika Waititi and Flight of the Conchords genius Jemaine Clement. The show, a mockumentary following a group of vampires who came from the Old World to sow fear and terror and never got further than Staten Island, constantly delights: thanks both to the charms of its performers—the meals they make of Americanisms are

far more enticing than the meals they make of Americans—but also thanks to the ridiculous interplay that results when these bats out of water interact with their surroundings. In one classic 2020 episode, when vampire Laszlo is forced to go on the run and assume the ostensibly inconspicuous identity of regular human bartender and girls high school volleyball supporter Jackie Daytona, we see all the pathos of Anne Rice's vampires knocked into a cocked hat.

What We Do in the Shadows owes, in its mockumentary rhythms, the same debts many other comedies of that ilk do to NBC's *The Office*. Not *all* of them: the wonderful 2006 film *Behind the Mask: The Rise of Leslie Vernon*, purporting to be footage by a documentary crew recording a serial killer in a world in which the classic serial killers—Jason, Freddy, Michael Myers—are real, owes more to investigative reports like *Frontline*. ("For these residents, Halloween will never be the same," intones the serious-minded college documentarian.) Still, though *Behind the Mask* transforms, in a way *What We Do in the Shadows* almost never does, to a less comedic horror experience, its portrait of a serial killer still specializes in diminishment. "There's that whole thing of making it look like you're walking when everybody else is running their asses off," the killer says, stressing the importance of cardio.

This dynamic extends not just to vampires and serial killers, but ghosts. The recent NBC hit comedy of that name is premised on a multiply-haunted house, its apparitions only visible to one of the living inhabitants. But what the show really offers is the possibility of a panorama of American history through the multiple eras represented by the specters. The Revolutionary War, the Prohibition, the 1980s—all are grist for the comedic mill and, as such, have as little weight, as much ephemerality, as the ghosts do themselves. It's more than a frisson of postmodern subversion, letting us know that, at every historical moment, any iconic figure of the past is subservient to the joke. Take the case of the clearly gay Revolutionary soldier, who's furious that he's less well known than Alexander Hamilton: that guy's been *made into a musical*, he fumes, allowing us to see the wink: it turns out that it's the twenty-first century that's haunting *him*.

This is the same dynamic that's at play in many of the "special Halloween

episodes" of sitcoms like *Modern Family*. Although they are, at times, quite accomplished at mixing in a couple of winking jump scares in between the setups and punchlines, it's ultimately the case that the verities of the sitcom bible need to be observed. At the end of the day, Phil Dunphy is still going to be Phil Dunphy, foolishly fond of his wife and perhaps more than a bit klutzy, no matter how good the work of the props department is. The exception that proves the rule is, perhaps naturally, the greatest and longest-running sitcom of all time. *The Simpsons*' annual "Treehouse of Horror" episode takes advantage of its firm foundation in telling stories that can, on occasion, genuinely frighten, sacrifice character for mood, and wield its conventional settings, rendered iconic over a generation-plus of appearance, to gain terrifying gravitas. Maybe that's why one of the century's most intriguing post-apocalyptic stories, Anne Washburn's 2012's *Mr. Burns: A Post-Electric Play*, posited that an episode of the show would become, in the end times, the source of a new cultic religion. And, of course, it's an episode of fear—"Cape Feare," in fact—which is, essentially, an episode of an animated comedy about a homicidal grown man stalking a small child and, not incidentally, itself a parody of a seminal suspense movie.

Subversive in a different way—a more morally implicating one—was Ryan Murphy's Fox series *Scream Queens*, another of his love letters both to genre and the queer forces of nature that often power it. *Scream Queens* dared us to look at both the quantities of murder and the nihilistic narcissism that powered the reactions to it, and to not laugh at its grotesqueness. It is possible that no series has ever been as hilariously callous in its treatment of the human condition as *Scream Queens*—with the possible exception of *The Sopranos*, which was often scabrously hilarious, although it would be hard to define as a comedy. Although you could certainly consider it a horror story.

And then there is HBO's 2019 show *Los Espookys*, which is, in some ways, deeply unlike the rest of these works, because it is so relentlessly original and utterly idiosyncratic. The only thing that seems to come close is, maybe, the work of David Lynch: not because it feels so centrally American as *Twin Peaks*—it's actually not set in America—but, in its own ways, it is as surreally humorous as aspects of *Eraserhead* or even *Blue Velvet*. Unlike

those movies, though, the humor comes from a deep and abiding joy and reveling in the building blocks of horror. In telling the adventures of a group of (not to put too fine a point on it) misfits who create a business of producing strangely horrific sights for their clients, it makes it clear that horror—as a set of images, tropes, conventions—is simply the air that the characters breathe, and love. It's affectionate, and the comedy that comes from it is affectionately odd, too.[74] This is different from quirky: quirky is 2007's *Pushing Daisies*, which took resurrection of the dead into adorable dimensions. But that's not domestication: that's inversion, and so not a part of our story.

And quirky, for its part, is different from juvenile; but horror-comedy—a very explicit intention to shade the fear with the silly in order to leaven the atmosphere—is particularly good for kids. An animated work like 2006's *Monster House*, which pits a group of kids against a very hungry haunted house, presents the house as both terrifying and humanized, a literal incarnation of a mean old woman whose soul has bonded to it. And, of course, the kids emerge triumphant, returning not only with their lives, but all the kids' toys that ended up on the house's lawn over the years that they could never get back. Or 2012's Tim Burton animated movie *Frankenweenie*, where, in stop motion, the whole idea of the reanimated monster is applied to pets, with much happier and sillier consequences than in *Pet Sematary*. (Reanimated, the dog wags its tail so hard it falls off.) Or that same year's *ParaNorman*, where another young boy who sees dead people saves his town, and the day. Or that same year's *Hotel Transylvania*, which—like Pixar's *Monsters, Inc.*—presents the monsters, here mostly in their classic fifties incarnations, as pretty cuddly vacationers and hoteliers.

Hotel Transylvania features, as a case in point, a frequent guest named Murray the Mummy; but it is another mummy that haunted a comedy featuring not the young, but the old. Bruce Campbell, who'd become iconic in horror-comedy via playing the increasingly deranged protagonist of Sam Raimi's *Evil Dead* movies into the nineties, leaned into his Elvis looks to play an elderly King menaced by a mummy in an old-age home in 2002's *Bubba Ho-Tep*; but the movie is much more about the horrors of old age, of not being believed, of being marginalized and disrespected—even with

kindness—as your life is being sucked away by inches (in this case, supernaturally, but that's just an allegory). Elvis dies at the end, not so funny, but he dies with dignity, and having accomplished something: "Thank you very much," he says, as he leaves the building, and he means it.

The fear of the old world coming for Americans: an old part of our story, but an ever-present one. Especially in the past generation.

AMERICAN FEAR, AS WE'VE SEEN from the beginning, is always in conversation with other countries, and the events of 9/11—and the long war in Iraq and Afghanistan after—made it clear to many Americans that not only had history not come to an end, but Americans were deeply implicated in it. In Brian Keene's Iraq War story "Babylon Falling," soldiers come into contact with a djinn, something incalculably old and violent and powerful, a metaphor for stirring up forces you don't understand and can't control that are capable of terrible savagery—a savagery let loose upon the world, by story's end, by Americans and non-Americans alike.[75]

Eli Roth followed up *Cabin Fever* with 2006's *Hostel*, which, in essence, told the tale of American economic and cultural imperialism gone bad, with its portrait of ugly Americans abroad and the revenge the world takes on their exploitativeness. "Not everyone wants to kill Americans," says one character, but enough did, certainly: enough to pay a company to lure them to the former Soviet Union, then honey-trap them into getting them tortured to death. It's not coincidental that the businessman who tortures our main protagonist is German; he's trying to roll back the Second World War on this one American's body. But it's also not coincidental that the gruesome and stomach-churning scenes of torture echo the horrific images that came out of the American prison in Abu Ghraib.[76] ("Now, thanks to George Bush, Dick Cheney, and Donald Rumsfeld, there's a whole new wave of horror movies," Roth would say in an interview tied to *Hostel*'s release on DVD. "We're in the war now and you feel like it's never gonna end.")[77] Roth's characters would hardly be the only ignorant Americans abroad. There was the American ballet student who heads to Germany, in the 2018 remake of the classic Italian horror film *Suspiria*, and meets up with some very witchy students; and Ari Aster's 2019 *Midsommar*, about the

terrors that awaited Americans attending a Swedish cultural festival with some darkly pagan aspects. But *Hostel* was a reflection of the small and up-close-and-personal version of the free-floating rage that Americans felt aimed against *them* in those post-9/11 years; and Americans were aware of some of the reasons that rage might have been compounded by American actions.

There were other examples of American action that generated global panic, ones that also insisted on the interrelatedness of America and the world: the global economic meltdowns and crashes, particularly in 2008. The best illustration remained a work we've seen previously, but now, in this century, appears in a filmed incarnation. Christian Bale's performance as the killer yuppie Patrick Bateman in Mary Harron's 2000 version of *American Psycho* would, for some, usher in an entire world of uncaring yuppies who would carve up the bodies of innocents, not with power drills, but with mortgages at unsustainable rates. But the movie's most unsettling moment belongs not to Bateman, whose own descent into madness and mania render him an intentional caricature. ("Try getting a reservation at Dorsia now, you fucking stupid bastard!" he shouts as he ax-murders Jared Leto's financier with an ax to the beat of Huey Lewis and the News's "Hip to Be Square.") It comes a moment later in the movie, when he revisits the apartment that is the site of several of his kills. The apartment has been repainted, and a real estate agent is showing it off and, encountering him, firmly and calmly asks him to leave. She is clearly aware of the murders. She is almost certainly aware who she is talking to. She doesn't care. She just wants the commission. *That*, Harron says, is the face of American capitalism.

Which was supercharged, weaponized, intensified, by the technological innovations of the decades to come. *American Psycho* was of the Wall Street eighties, and its satirical jabs (so to speak) still circle around the handing out of increasingly lavish business cards. The tech revolution came for them, and for finance, and, indeed, for everything; and one felt, increasingly as the century went on, at the mercy of larger networks, larger forces, more obscure algorithms. 2018's *A Quiet Place*, which superficially concerns people trying to live in a world while threatened by bird aliens who'll kill

you if you make a sound, can be seen, writ large, as a metaphor about our diminishing capacity, in a phone-soaked, stimulus-overshadowed world, to pay attention. *A Quiet Place* is a movie that's difficult to watch on a second screen: to get anything out of it, you can't be listening with one ear.

But the silver lining, so to speak, was that Americans came into contact with stories of fear from around the globe much more easily and pervasively. Before the 1990s, while it was certainly possible to find material from Asia influencing American horror—most notably Godzilla and his assorted kaiju friends—most of the presence of Asian horror was in the form of racist tropes written by Americans. To put it mildly, globalization has changed things. A lot. Japanese and Korean horror, particularly, have made their way into American culture via manga, American remakes of horror movies, and most recently and perhaps most popularly, through original television material available on streaming networks, now that Americans, in the past few years, have become increasingly comfortable watching material with subtitles.

Ring, a 2002 remake of the Japanese film by Hideo Nakata, which involves—now quaintly—a videotape that kills, brought the Asian horror sensibility to America, with films like *The Grudge* following up two years later. *Ring* also adapted very homegrown fears—that scene of the ghost coming out of the TV with murder on her mind comes almost precisely a generation after *Poltergeist*'s "TV people"—but its movements seemed utterly different; other. If *Poltergeist* traded on a sense of Indigenous horror, from within, the *Ring* videotape—and the Asian visuals—were about horror also that seemed coded from without. But soon it was integrated. *Squid Game* was one of the most popular shows in the history of Netflix, its own form of homicidal capitalism both exquisitely strange in detail and deeply familiar in outline. And it wasn't just Asia. Americans' omnivorous appetite became more and more apparent: 2010's *Let Me In* was an adaptation of the Swedish vampire film *Let the Right One In*, based on the novel by John Ajvide Lindquvist; 2022's *Goodnight Mommy* would be an adaptation of an Austrian version from 2014.

This sense of one-worldness, at its best—and, in some sense, most terrifying—allowed for a focus on threats that affected the planet,

environmental horror that shared in the increasingly pointed dread of what the Anthropocene has done to the planet. In 2008, *Sixth Sense* director M. Night Shyamalan released *The Happening*, which posited, after some typically Shyamalian misdirection, that the airborne toxin causing this particular outbreak of mass death—not zombies, in this case, but mass suicide—is (spoiler!) coming from the plant kingdom. Though the plants are notably silent as to motive, it's not at all far-fetched—it's suggested in the film— that the toxin is the planet's defense mechanism against what humans have done to it. The movie's end suggests a kind of weary inevitability to the process of humankind's eradication: it only wonders whether it's going to occur quickly and apocalyptically, or slowly and suffocatingly, whether we will experience it as a species or as a set of small groups and individuals.

In 2023, Shyamalan filmed Paul Tremblay's 2018 novel *The Cabin at the End of the World*, a novel that takes this idea and sharpens it into a laser beam of psychological acuity. Its home-invading strangers suggest, with utter belief, that members of the family they encounter there must kill each other to ward off a global apocalypse—a position whose truthfulness the novel carefully avoids taking a position on. It's a way of suggesting that something that is too big to get our arms around will, eventually, have to be refracted through individual choices; but that, in the end, it will come for us all, and those choices will have to be made. "This isn't about you. It's about everyone," one of the invaders, a quasi-gentle giant named Leonard says.[78] But that's only partially true.

"So you had an apocalyptic nightmare! So what? We've all had them!"[79] says one of the menaced dads in *Cabin*, and in recent years, we've shared that nightmare globally. The 2017 movie *It Comes at Night* posits an apocalyptic disease in which families mask, argue about quarantining and isolation, and fear strangers in ways that burst out into violence: while COVID was far less deadly than the (unnamed) disease in the movie, thankfully, it was certainly more than dangerous enough, so much so that the lineaments of the movie, just a few years later, feel almost more routine than unsettling, a matter of degree, not kind. "Nothing Spreads like Fear" was the tagline of an earlier pandemic movie, 2011's *Quarantine*, and most people who remember the events of March 2020 will recall that dread as

long as they live. The photographed scenes that were coming out of New York seemed, again, to be unimaginable; deserted streets, trucks filled with corpses because there was no room for the dead in the morgues; terrorized people flinching from contact; and on, and on. Americans understood that we were, indeed, in a horror story; and no one, at the time of this writing, is sure that just because we've pronounced it over, it—or something else— isn't poised to claw its way out of the earth once more.[80]

Perhaps the best treatment of COVID, though, is a movie produced a generation after the Great War–era flu pandemic, one of those wartime RKO pictures. In 1945's *Isle of the Dead*, Boris Karloff plays a general known as the Watchdog, trying to keep people safe from the pestilence that rages (in no small part, in that movie, because of the corpse-strewn battlefields of war). His function—his personification of orders and process—ultimately triumphs over his empiricist principles; in the end, in a way that seems emblematic of many of his mad scientist roles, the ends he champions seem secondary to the process itself, the doing. This is, of course, par for the horror course: serial killer movies, for example, aren't really about the motive, but the killing. And so Karloff's patriotism, the nobility of his ends, recedes into obsession. COVID, like all horror stories, revealed how fear could metastasize into pathology, not just in the biological, but also in the political, sense.

Fear, and withdrawal, can also encourage a sense of isolationism, of retreat from the world: and it was certainly the case that a recent populist leader of America had remarkable political success in trading on both. Early in Donald Trump's presidency, a Chicago artist circulated images of him that borrowed from the aliens in *They Live;* a tip to the way that many felt that the country was now living through a horror story. Ryan Murphy dedicated a season of *American Horror Story* to the election and aftermath. That season featured—in a nod to a frequent portrait of Trump as clownish, a charge internalized and spit back venomously by trolls and others—a set of killers in clown outfits. A movie version of that greatest of all nightmare clowns, Pennywise, appeared on screen in 2017 in Stephen King's *It* and made well north of 100 million dollars, suggesting, as a Warner Brothers executive noted, "some sort of cultural accelerant at play."[81] For

others, it was Trump who was standing as a bulwark against a nightmarish "American carnage," to quote from a key line of his inaugural address. One of the works that reflected this double-edged dynamic most powerfully preceded his election by three years.

A title sequence in 2013's *The Purge* tells us: "America. 2022. Unemployment is at 1%. Crime is at an all-time low. Violence barely exists. With one exception . . . Blessed be the New Founding Fathers for letting us Purge and release our souls, Blessed be America, a nation reborn." That Purge, which allows Americans to run riot one night a year, murdering and ravaging without consequence, is presented as creating psychological stability via catharsis. "The denial of our true selves is the problem," it suggested. The movie itself is less sanguine, suggesting that this Purge is actually a twin assault on the economically and, to some extent, racially marginalized: "The poor can't afford to protect themselves," we hear someone say on talk radio. "They're the victims tonight." And much of the movie's action is catalyzed when one family member allows a Black homeless man into their highly secure, heavily guarded home, leading to an assault by a group of white rioters. "The pig doesn't know his place, and now he needs to be taught a lesson. . . . Don't force us to hurt you. . . . We don't want to kill our own," says the leader.

While the family emerges into the light of day, they do not do so unscathed. Nor do we; the last moments of the movie, where a news radio reporter, at the end, tells everyone that there are "364 long days" until the next annual purge, suggest that the American carnage is always there, lurking—and her obvious joy at digging into what has transpired the night before for her listeners adds to the unease that there are some who long for it.

There are few people now who don't share some fear that, in a way we have not seen since the late 1960s, the center will not hold for American democracy, that the law will be ignored, or put aside. *The Purge* continued, and in a later installment in the franchise—2018's *The Purge: First Year*, the marketing campaign made references to Trump, "refashioning" the red MAGA baseball cap to symbolize the Purge. [82]

Like with COVID, though, the best explanation of Trump's success is from a work of art from the past: here, a movie we've discussed before, that

Andy Griffith tale of faux-populism and mass media *A Face in the Crowd*.[83] That movie culminates in an uncanny echo of the Access Hollywood moment of the 2016 election; here, instead of a presidential candidate refer- ring to grabbing women in intimate areas, Griffith's character is caught on a hot mic referring to his audience as morons. But here's the tragic and uneasy difference: in the fifties movie, his audience, hearing that, turn on him immediately; he's dead, careerwise, by the time he takes the elevator down from the studio. "When we get wise to him, that's our strength," Matthau suggests. But, we wonder now, what happens if there's so much chaff that it's impossible to get wise? Or, more profoundly and darkly— what if people *are* already wised up . . . and they just don't care? For all its prescient and corrosive depictions about the media, the movie is ultimately optimistic about Americans' capacity to hear truth. "There's nothing as trustworthy as the ordinary mind of the ordinary man" reads a banner in Griffith's apartment, and although he's obviously ironic about it, the movie's perspective is less so. The problem, the movie suggests, lies not with Americans, but their representation. We might well hope this is so now.

Whether you believe that Donald Trump is America's worst nightmare or its savior, it's unquestionable that, as of this writing, he is a serious con- tender to become president once again; and so another of many parts of our past is coming back as we face the future. Russia is once more an American global enemy, and has recently threatened the use of nuclear weapons. Every month seems to bring another report of the senseless death of some- one poor, someone defenseless, someone Black, someone trans. We're inun- dated by news of yet another slaughter by AR-15. What possible way is there to break free of this?

ALMOST EVERY CREATOR OF HORROR—ALMOST every horror fan—has been asked this question, and most of them, in some form, have asked it of themselves: Why is it that you're interested in this stuff in the first place? Isn't the world scary enough, out there? Why do you need to be scared more?

And the answer, the answer that we all have, I suspect, is: of course. Of course it's scary enough out there. It's too scary. *Much* scarier than fiction,

in fact. And so—and, like we said way back at the beginning of our journey together, this is an old answer, old as Aristotle—you take the scary stuff and you put it into a form that you can control; and you aestheticize and count out its beats and rhythms and you scream and you close the book or leave the theater or turn off the television and your heart returns to its normal rhythm and you feel a little better. For a while.

And as for the particular *forms* those control mechanisms take: well, that's *been* our story, hasn't it? America is a journey, and the fundamental fears move and twist to take the shape of the road (as well as reflecting who gets to drive on it, of course). And if they sometimes pop back up in your head, a terrible jack-in-the-box, if they disturb your dreams and make you look around when you think you're alone . . .

That's because you know that even though they're not real, that it's just a movie, or a book. . . .

You know they *are* real.

All of them.

Deep down.

Good night.

And I wish you pleasant dreams.

ACKNOWLEDGMENTS

THERE'S FEAR, AND THEN THERE'S *fear*.

Fear is when you think there's something slithery underneath your bed, or that there's something shadowy in the back of the closet, just waiting to snatch you when you reach in for that little-used jacket. *Fear* is when you try to express your gratitude to all the many, many people who've helped in so many ways in the making of this book, and knowing—*knowing*—you've forgotten someone, or something, or failed to convey the depth of your appreciation. But, like the protagonists in most horror fiction, you don't run away, and, unlike in most horror fiction, you certainly don't want to.

Let me first, and foremost, thank Evan Hansen-Bundy for his brilliant work in editing this book. The man exhibits—in a manner nonpareil—the two most important skills that any editor can possibly have: an uncannily incisive sense of where a manuscript can, and should, be improved upon, and a cheerfully diplomatic sense of maintaining total calm for his writer while behind the scenes it's not impossible that he's juggling (Texas) chain-saws. Which are on fire. I cannot praise this man enough, and this book might have been scarier without him, but not in the good sense of the word; it certainly would have been a lot worse. Thank you.

I would also like to thank Abby Muller for seeing the potential for this book and bringing it to Algonquin in the first place, and to Betsy Gleick for all her support for it throughout this process. Chris Stamey is one of the best copyeditors in the business, and I thank him profusely for making this book presentable for company; and Brunson Hoole and Steve Godwin

for making the book a joy to look at inside and out. And speaking of out, a special tip of the bloody hat to Christopher Moisan for the brilliant, eye-catching cover. Thank you, also, to Michael McKenzie, Travis Smith, and Katrina Tiktinsky for their hard work in making sure that you see the cover, and, at least on current evidence, are reading the words beneath.

And speaking of those words: I'm hugely grateful to the people who read drafts of the manuscript and had comments and suggestions. Adam Lowenstein, Eleanor Johnson, Jess Nevins, and Stefan Dziemianowicz are all brilliant, knowledgeable fans and scholars of things that go bump in the night, and their thoughts, comments, and notes improved the book immeasurably. It should go without saying, of course, that any goofs are my own.

During the course of writing this book, Dan Conaway and I have celebrated our tenth anniversary together; like any good agent, he picked up the check for our celebratory lunch—but he is unlike any good agent, because he is one of the all-time greats. I am incredibly fortunate to be able to benefit from his expertise and his guidance, and hope for much more of both in years to come. I've also gotten to know, and work with, Chaim Lipskar, who I believe is well on his way to joining Dan in the pantheon. Thank you to you both.

At Columbia, I'm grateful, as always, to the staffs of the Department of Germanic Languages and the Institute for Israel and Jewish Studies—especially Kerstin Hoffman and Julie Feldman—and to the staff at Columbia University Libraries, who never fail to come through when I try to borrow books with titles like *Nine Horrors and a Dream* or *Tales of the Cthulhu Mythos*.

If fear is one of humanity's most basic emotions, then assuredly the other one is love: and I think that it's possible that I have been able to write about the former so much because I have the comfort and the blessing of being so fortunate in the latter. The debt of gratitude that I owe my parents, Cheryl and Eddie Dauber, is impossible to express, far less to repay; but suffice it to say that if fear, all too often, is shrouded in doubt, I have never feared for, never doubted, their love, their support, and, also, their wisdom and their kindness. In a book filled with specters, all too often of

very different types of parenthood, what they have done, with their lives and with their children, has been a beacon. I strive, every day, to live up to their example.

I am equally blessed, and grateful, in my siblings—Noah Dauber, Andrew and Sara Dauber, and Rachel Pomerantz—and my in-laws, Bob and Sherry Pomerantz, who have offered support in all manner of ways, especially in the last months of writing the book, which my father-in-law referred to as "a marathon run at a sprinter's pace," which *felt* accurate, and, either way, was such a good phrase I decided you should all read it. I'm also grateful to my nieces and nephews, Boaz, Jordana, Moses and Delilah Dauber, for their enthusiasm and support.

And, finally, in my own home, so close to my heart. My three children—Eli, Ezra, and Talia—have, over the course of this book, moved into full-fledged kid-dom, and in the course of talk about frightful entries from the depths of Dungeons and Dragons monster manuals and rainbow unicorns (the most important kind of unicorn, I'm told), I have found my days suffused with joy, hugs, and the occasional attempt to sneak up on me when I'm not looking—which again, in a book about horror, *sounds* bad, but it says something that in these cases it offers occasion for delight.

And apropos of delight. My final thank you is to my wife, Miri, who is—when it comes to the important things—the most deeply fearless person I know. After fifteen years of marriage, I depend on her counsel, I admire her clarity and wisdom, and, not least, I love her more, every year.

ENDNOTES

CHAPTER ONE

1 Compare Joseph Epes Brown, *Teaching Spirits: Understanding Native American Religious Traditions* (Oxford: 2001), 57–59, 121: and to John Bierhorst, *The Mythology of North America* (William Morrow: 1985), 12–14, 219.

2 Thomas Kyd, J. R. Mulryne, and Andrew Gurr, "The Spanish Tragedy," *The Spanish Tragedy* (Methuen Drama: 2009), 3.13.2–3; 4.5.12.

3 On the work's ironic bones, see Peter Lisca, "*The Revenger's Tragedy:* A Study in Irony," *Philological Quarterly* 38 (1959), 242–51.

4 Quoted in James Shapiro, *The Year of Lear: Shakespeare in 1606* (Simon & Schuster: 2015), 190.

5 In "On the Knocking at the Gate in *Macbeth*"; cited in Shapiro, *Year of Lear*, 183.

6 Increase Mather, "Returning unto God the great concernment of a covenant people, or, a Sermon preached to the second church of Boston in New-England," Mar. 17, 1679 (John Foster: 1680), 9, 10.

7 John Norton, *Abel Being Dead Yet Speaketh, or, The Life and Death of That Deservedly Famous Man of God, Mr. John Cotton* (T. Newcomb: 1658), 21.

8 Jeffrey A. Hammond, "'Ladders of Your Own': *The Day of Doom* and the Repudiation of 'Carnal Reason,'" *Early American Literature* 19:1 (Spring 1984), 42–67, 43.

9 See Norton, *Abel Being Dead*, 22.

10 Alden T. Vaughan, ed., *The Puritan Tradition in America, 1620–1730* (Harper: 1972), 64.

11 Cotton Mather et al, *Memoirs of the Life of the Late Reverend Increase Mather, D. D., Who Died August 23, 1723* (J. Clark and R. Hett: 1725), 2.

12 Cotton Mather et al, *Memoirs*, 13.

13 M. G. Hall, ed., *The Autobiography of Increase Mather* (American Antiquarian Society: 1962), 303.

14 Benjamin Thompson, *New England's Crisis* (John Foster, 1676), 10, 15, 16.

15 Quoted in Vaughan, *Tradition*, 51.

16 Sayre, ed., *American Captivity Narratives* (Houghton Mifflin: 2000), 128.

17 Greg Melville, *Over My Dead Body: Unearthing the Hidden History of America's Cemeteries* (Abrams: 2022), 29; James Drake, "Restraining Atrocity: The Conduct of King Philip's War," *The New England Quarterly* 70:1 (Mar. 1997), 33–56, 40.

18 It should be said that the timing of Rowlandson's composition isn't precise; and we know she remarried within the year (which doesn't preclude her grieving, of course). Compare Kathryn Zabelle Derounian, "Puritan Orthodoxy and the 'Survivor Syndrome' in Mary Rowlandson's Indian Captivity Narrative," *Early American Literature* 22:1 (Spring 1987), 82–93, esp. 83–84; and Gordon M. Sayre, "Introduction," in Sayre, ed., *American Captivity*, 1–17, esp. 9–10.

19 Sayres, *American Captivity,* 127. The text is reprinted in 132–76.

20 On this Puritan conjunction of Native Americans and devil's instruments, see Malcolm Gaskill, *The Ruin of All Witches* (Knopf: 2022), 10.

21 *American Captivity*, 138, 140, 155, 142.

22 *American Captivity*, 141–42, 143, 170.

23 Cotton Mather et al, *Memoirs,* 30. Compare, for discussion, Peter Charles Hoffer, *Sensory Worlds in Early America* (Johns Hopkins: 2003), 104–5.

24 Increase Mather, "Returning," 21.

25 Increase Mather, *Remarkable Providences,* Chapter 5, quoted in Frances Hill, *The Salem Witch Trials Reader* (Da Capo: 2000), 11, 12.

26 Cotton Mather et al, *Memoirs*, 63.

27 See Gaskill, *Ruin*, passim; statistics from 214.

28 *Salem Reader* 34.

29 *Memorable Provinces,* "The First Example," cited in *Salem Reader*, 17.

30 "Hades look'd into : the power of our great Saviour over the invisible world, and the gates of death which lead into that world, considered : in a sermon preached at the funeral of the Honourable Wait Winthrop, Esq., who expired, 7 d. IX m. 1717, in the LXXVI year of his age" (T. Crump, Boston: 1717), 4, 6.

31 See James E. Kences's article excerpted in *Salem Reader*, 269–86, esp. 281–83, quote 282; and for a much more detailed study, Ann Marie Plane, *Dreams and the Invisible World in Colonial New England* (University of Pennsylvania: 2014), passim, esp. 52–58.

32 Deodat Lawson, *A Brief and True Narrative of Witchcraft at Salem Village* (1692), quoted *Salem Reader*, 61.

33 *A Modest Enquiry into the Nature of Witchcraft* (1702), Chapter 2, quoted in *Salem Reader* 59–60.

34 Cited in *Salem Reader*, 123; compare also *Salem Possessed*, 173–78.

35 *Wonders of the Invisible World* (1693), quoted in Les Daniels, *Living in Fear: A History of Horror in the Mass Media* (Charles Scribner's Sons: 1975), 29; and Michael Clark, "'Like Images Made Black with the Lightning': Discourse and the Body in Colonial Witchcraft," *Eighteenth Century* 34:3 (Fall 1993), 199–220, 202–3.

36 See comments of Elaine G. Breslaw in *Tituba, Reluctant Witch of Salem*, cited in *Salem Reader*, 299–301.

37 Quoted in Paul Boyer and Stephen Nissenbaum, *Salem Possessed: The Social Origins of Witchcraft* (Harvard: 1974), 3.

38 Lawson, cited in *Salem Reader*, 62.

39 Elisha Hutchinson, in a letter May 2, 1692; cited in *Salem Reader*, 185.

40 *Salem Reader*, 196.

41 Mather, from *Salem Reader*, 206.

42 Robert Calef, *More Wonders of the Invisible World* (1700), cited in *Salem Reader*, 66.

43 Frances Hall, *A Delusion of Satan,* Chapter 12, cited in *Salem Reader*, 294.

44 Cited in Alden T. Vaughan, ed., *The Puritan Tradition*, 166.

45 Brattle, cited in *Salem Reader*, 87.

46 Calef, cited in *Salem Reader*, 76.

47 Calef, cited in *Salem Reader*, 77.

48 Cotton Mather et al, *Memoirs,* 63. On spectral evidence, see *Salem Possessed*, 16–18 and Larry Gragg, *The Salem Witch Crisis* (Praeger: 1992), 11, 87–89, 171–74.

49 Quoted in *Salem Possessed*, 10.

50 *The Autobiography of Increase Mather*, 344; see also Hoffer, *Sensory Worlds*, 106–8.

51 Cotton Mather et al, *Memoirs*, 63–64.

52 Calef, quoted in *Salem Reader*, 107.

53 Putnam, quoted in *Salem Reader*, 108.

54 On Defoe's "hedging" between belief and disbelief, see Patricia Meyer Spacks, *The Insistence of Horror: Aspects of the Supernatural in Eighteenth-Century Poetry* (Harvard: 1962), 12–13.

55 Daniel Defoe, *A Journal of the Plague Year* (Penguin: 2003), quote 22–23.

56 See George M. Marsden, "Biography," in *The Cambridge Companion to Jonathan Edwards* (Cambridge: 2007), 19–38.

57 See Marsden, "Biography," 26.

58 Marsden, "Biography," 28.

59 Sermon can be found in *Sinners in the Hands of an Angry God: A Casebook* (Yale: 2010), 33–50, quote 43.

60 Compare Annette Kolodny's careful analysis in "Imagery in the Sermons of Jonathan Edwards," *Early American Literature* 7:2 (Fall 1972), 172–82.

61 On the poets' aesthetics, history, and decline in critical respect, see Walter Kendrick, *The Thrill of Fear* (Grove: 1991), 10–22.

62 "The Frightened Farmer: A Tale," *American Magazine and Historical Chronicle* vol. 1 (July 1744), 474.

63 Benjamin Franklin, *Poor Richard's Almanack* (Franklin: 1760), 12, 16.

64 Peter Williamson, *French and Indian Cruelty, Exemplified in the Life and Various Vicissitudes of Fortune of Peter Williamson* (J. Bryce: 1758) 1st pub. York, 1757.

65 *The Pennsylvania Gazette*, Sept. 10, 1767, slug-lined Charlestown, SC.

66 Cotton Mather, "A monitory, and hortatory letter, to those English, who debauch the Indians, by selling strong drink to them: written at the desire of some Christians, to whom the mischiefs arising from the vile trade, are matters of much apprehension and lamentation," (Boston: 1700), 8, 14.

67 *The Pennsylvania Gazette*, July 25, 1765.

68 Quoted in Hoffer, *Sensory Worlds*, 135.

69 See T. Wood Clarke, "The Negro Plot of 1741," *New York History* 25:2 (Apr. 1944), 167–81; Ferenc M. Szasz, "The New York Slave Revolt of 1741: A Re-Examination," *New York History* 48:3 (July 1967), 215–30.

70 Quoted in Clarke, 177.

71 "Chandler's American Criminal Trials," *North American Review* (Jan 1, 1842), 202.

72 Quoted in Clarke, "The Negro Plot," 179.

73 Clarke, 181.

74 Mark Fearnow, "Theatre for an Angry God: Public Burnings and Hangings in Colonial New York, 1741," *TDR* 40: 2 (Summer 1996), 15–36, 19.

75 "The Prayer and Plea of David, to Be Delivered from Blood-Guiltiness, Improved in a Sermon at the ancient Thursday-Lecture in Boston, May 16th, 1751, Before the Execution of a Young Negro Servant, for Poisoning an Infant." Boston: Printed and Sold by Samuel Kneeland, opposite the Prison in Queen-Street, 1751. Quotes 6, 8, 16.

76 Hilene Flanzbaum, "Unprecedented Liberties: Re-reading Phillis Wheatley," *MELUS* 18:3 (Fall 1993), 71–81, 71; Marsha Watson, "A Classic Case: Phillis Wheatley and Her Poetry," *Early American Literature* 31:2 (1996), 103–32, esp. 107–8, 122–24.

77 Phillis Wheatley, *Poems on Various Subjects, Religious and Moral* (Archibald Bell: 1773), 27–28, lines 13–18.

78 Wheatley, *Poems*, 18.

79 *Constitutional Courant*, No. 1 (Sept. 21, 1765), italics original. On the *Courant*, see Alan Dyer, *A Biography of James Parker, Colonial Printer* (Whitson: 1982), 87–89.

80 Kenneth Silverman, *A Cultural History of the American Revolution* (Thomas Y. Crowell: 1976), 147.

81 James Bowdoin, Joseph Warren, and Samuel Pemberton, "A short narrative of the horrid massacre in Boston perpetrated in the evening of the fifth day of March, 1770 by soldiers of the XXIXth Regiment which with the XIVth Regiment were then quartered there with some observations on the state of things prior to that catastrophe," (Edes and Gill: 1770).

82 "Short narrative," 7–8, 17.

83 "Short narrative," quote 18.

84 "Short narrative," quote 38.

85 "Short narrative," quote 70–71.

86 John Lathrop, "Innocent blood crying to God from the streets of Boston" (Edes and Gill: 1771), 6.

87 Lathrop, "Innocent Blood," 19.

88 Lathrop, "Innocent Blood," 18, 12.

89 Joseph Warren, "An oration delivered March 6, 1775, at the request of the inhabitants of the town of Boston: to commemorate the bloody tragedy of the fifth of March, 1770" (Joseph Warren: 1775), 14.

90 Joseph Warren, "An Oration delivered March 5th, 1772: at the request of the inhabitants of the town of Boston, to commemorate the bloody tragedy of the fifth of March, 1770" (Edes and Gill: 1772), 11–12.

91 Warren, "An oration . . . 1775," 21.

92 "The Speech of the Lord-Mayor on the Motion of Lord North for an Address to His Majesty Against the Americans, Feb. 2," *Gentleman's Magazine* (London) 45 (Feb. 1775), 73; "A Summary View of the Rights of British America," *Virginia Gazette*, Mar. 2, 1775.

93 "Elegy to the Memory of the American Volunteers, who Fell in the Engagement between the Massachusetts-Bay Militia, and the British Troops, April 19, 1775," POETICAL ESSAYS: FOR JUNE. An ELEGY to the Memory of the AMERICAN . . . Sylvia, *Pennsylvania Magazine; or, American Monthly Museum* (1775–1776); vol. 1 (June 1775), 278.

94 Philip Freneau, *A Voyage to Boston* (William Woodhouse: 1775), quotes 8, 9.

95 Freneau, *Voyage to Boston*, 19.

96 Benjamin Franklin, in *Pennsylvania Gazette*, Aug. 6, 1777.

97 Quoted in Edwin Gittleman, "Jefferson's 'Slave Narrative': The Declaration of Independence as a Literary Text," *Early American Literature* 8:3 (Winter 1974), 239–56, 241. On the removal of mention of Black enslavement from a draft of the Declaration, compare 251–52. On the contradictions of the era, see Nancy V. Morrow, "The Problem of Slavery in the Polemic Literature of the American Enlightenment," *Early American Literature* 20:3 (Winter 1985/86), 236–55.

98 *Connecticut Courant* and *Hartford Weekly Intelligencer* (1774–1778); Sept. 22, 1777, 3.

99 Cited in Samuel Y. Edgerton Jr., "The Murder of Jane McCrea: The Tragedy of an American Tableau d'Histoire," *Art Bulletin* 47:4 (Dec. 1965), 481–92, 482–83.

100 Edgerton Jr., 482–83.

101 *Poems on Several Occurrences in the Present Grand Struggle for American Liberty* (5th ed., Chatham: Printed by Shepard Kollock, 1779). Quotes 17, 18.

102 *Pennsylvania Packet*, July 30, 1778.

103 There'd been an earlier one: "Dialogues in the shades, between General Wolfe, General Montgomery, David Hume, George Grenville, and Charles Townshend," Printed for G. Kearsley (London: 1777).

104 *Pennsylvania Gazette*, July 12, 1780.

105 Jonathan L. Austin, "An Oration Delivered July 4, 1786, at the Request of the Inhabitants of the Town of Boston, in Celebration of the Anniversary of American Independence" (Peter Edes: 1786), 11.

CHAPTER TWO

1 *Universal Asylum and Columbian Magazine*, June 1790, 331.

2 "Narrative of the extraordinary sufferings of Mr. Robert Forbes, his wife and five children: during an unfortunate journey through the wilderness, from Canada to Kennebeck River in the year 1784, in which three of their children were starved to death. . . . Taken partly from their own mouths, and partly from an imperfect journal; and published at their request." Printed for M Carey, 1794; quotes 5, 11.

3 Quoted in Walter Kendrick, *Thrill of Fear*, 40.

4 See Nick Groom's excellent introduction to Horace Walpole, *The Castle of Otranto* (Oxford: 2014), xxxvi.

5 Groom, in Walpole, *Otranto*, quote xiv–xv.

6 See Groom, in Walpole, *Otranto*, xvii.

7 See Les Daniels, *Living in Fear*, 12–14.

8 Walpole, *Otranto*, 9.

9 Walpole, *Otranto*, 9–10.

10 Groom, in Walpole, *Otranto*, xxv, xxxi.

11 Thomas Hutchinson, *The History of the Colony of Massachusetts Bay* (1765), in *Salem Reader*, 219.

12 See Alan D. McKillop, "Mrs. Radcliffe on the Supernatural in Poetry," *Journal of English and Germanic Philology* 31:3 (July, 1932), 352–59, quote 357.

13 Les Daniels, *Living in Fear* 17–20, quote 17.

14 Quoted in Edgerton Jr., "Murder of Jane McCrea," 483.

15 Freneau would substantially revise and expand the text for a 1786 version. See discussion in Lewis Leary, "The Dream Visions of Philip Freneau," *Early American Literature* 11:2 (Fall 1976), 156–82.

16 *United States Magazine: A Repository of History, Politics, and Literature* (Aug. 1779): 355.

17 Harry Hayden Clark, "What Made Freneau the Father of American Poetry?" *Studies of Philology* 26:1 (Jan. 1929), 1–22, 17.

18 "ODE to MELANCHOLY," *Columbian Magazine*, Dec. 1786.

19 *The American Museum or Universal Magazine: Containing Essays on Agriculture, Commerce, Manufactures, Politics, Morals and Manners* June 1791; 9, 6. See also, for some general theoretical considerations in a contemporary British context, Patricia Meyer Spacks, "Horror-Personification in Late Eighteenth-Century Poetry," *Studies in Philology* 59:3 (July 1962), 560–78, and Spacks, *Insistence of Horror*, 132–93.

20 Juvenis, *Pennsylvania Magazine*, 1:203–5. (May 1775). This approach, of moralistic sententiousness through images or dreams, was common for the magazine; see, for example, The DREAM of IRUS. *Pennsylvania Magazine; or, American Monthly Museum* (1775–1776); Feb 1776: 2.

21 "The Life of Sawney Beane," *Boston Magazine* 1 (Oct. 1783): 23.

22 "The Castle of Costanzo," *Boston Magazine* vol. 2 (July 1785), 18. See also "Sir Gawen: A Tale," *New York Magazine, or Literary Repository* 5:2 (Feb 1794): 73.

23 "The Contemplant: An Eastern Tale," *Columbian Magazine* 1:3 (Nov. 1786), 130.

24 "An Oriental Tale, or the Friendship Corrupted," *New-Jersey Magazine and Monthly Advertiser* (Feb. 1787): 114.

25 "Solyma and Ossmin. An Oriental Tale." *American Magazine, Containing a Miscellaneous Collection of Original and Other Valuable Essay . . .* (May 1788): 1, 6.

26 Carey, Mathew, and David Rittenhouse. "A short account of the malignant fever, lately prevalent in Philadelphia: with a statement of the proceedings that took place on the subject in different parts of the United States." 3rd ed., printed by the author, 1793, 34.

27 Richard Slotkin, "Dreams and Genocide: The American Myth of Regeneration Through Violence," *Journal of Popular Culture* 5:1 (Summer 1971), 38–59, 48.

28 Susannah Willard Johnson Hastings, *A Narrative of the Captivity of Mrs. Johnson.* (D. Carlisle: 1796), 8.

29 Compare Teresa A. Goddu, *Gothic America* (Columbia: 1997), esp. 26–30.

30 *The American Museum; or, Repository of Ancient and Modern Fugitive Pieces & c. Prose and Poetical* 1:3 (Mar. 1787), 209.

31 Quoted in Jules Calvin Ladenheim, "'The Doctors' Mob' of 1788," *Journal of the History of Medicine and Allied Sciences* 5:1 (Winter 1950), 23–43, quotes 26, 27, 32, 35; for "dangling" quote and the history of other "resurrection riots," see Liden F. Edwards, "Resurrection Riots During the Heroic Age of Anatomy in America," *Bulletin of the History of Medicine* 25:2 (Mar.–Apr. 1951), 178–84, 180.

32 L.B.C., "Reflections on the Slavery of the Negroes, Addressed to the Conscience of Every American Citizen," *Rural Magazine, or, Vermont Repository,* July 1, 1796.

33 See Song 21 in *Columbian Songster* (Nathaniel Heaton: 1799).

34 For other examples, see *Matilda*, in the 1795 *Massachusetts Magazine*; and *Amelia, or the Faithless Briton*, from 1789.

35 Patricia Parker, "'Charlotte Temple': America's First Best Seller," *Studies in Short Fiction* 13:4 (1976), 518. On Rowson's own American status, see Cathy Davidson, "Ideology and Genre: The Rise of the Novel in America" *Proceedings of the American Antiquarian Society* 96, No. 2 (1987), 311–12.

36 Cited in Davidson, "Ideology and Genre," 298.

37 Davidson, "Ideology and Genre," 312.

38 *Charlotte: A Tale of Truth* (D. Humphreys, for M Carey: 1794), 36.

39 See Donna R. Bontatibus, *The Seduction Novel of the Early Nation* (MSU Press: 1999), 13–14.

40 See Shelly Jarenski, "The Voice of the Preceptress: Female Education in and as the Seduction Novel," *Journal of the Midwest Modern Language Association* 37:1 (Spring 2004), 59–68; Blythe Forcey, "*Charlotte Temple* and the End of Epistolarity," *American Literature* 63:2 (1991), 225–41, esp. 226, 231; and Jan Lewis, "The Republican Wife: Virtue and Seduction in the Early Republic," *William and Mary Quarterly* 44:4 (1987), 689–721, esp. 697–701; Parker 300.

41 Quoted in Lewis, "Republican Wife," 719.

42 See Andrew Burstein, *The Original Knickerbocker* (Basic: 2007), 14–16; Estelle Fox Kleiger, *The Trial of Levi Weeks; Or the Manhattan Well Mystery* (Academic Studies Press: 1989), passim.

43 Quoted in Kleiger, *Trial of Levi Weeks*, 34–35.

44 Kleiger, *Trial of Levi Weeks*, 142–43, quote 195.

45 Quoted in Kleiger, *Trial of Levi Weeks*, 38.

46 Kleiger, *Trial of Levi Weeks*, 175.

47 Like the Philadelphia *Minerva*, excerpting the *Italian* on Oct. 21, 1797, under the title "Schedoni, the Murderer."

48 "Spirits, Ghosts, and Witches," *Rural Magazine, or, Vermont Repository,* June 1, 1795.

49 "The Speculator, No. IV," *Massachusetts Magazine; or, Monthly Museum. Containing the Literature, History, Politics, Art . . .* (July 1794), 6–7.

50 Though perhaps not the first American novelist of fear: his predecessor in the "first regular American novel," Sarah Wentworth Morton's 1789 *The Power of Sympathy, or the Triumph of Nature,* has, within its Richardsonian setting, "a Dantesque dream in which he visits the realm of departed sinners"; see Oral Sumner Coad, "The Gothic Element in American Literature Before 1835," *The Journal of English and Germanic Philology* 24:1 (Jan. 1925), 80.

51 See William L. Hedges, "Benjamin Rush, Charles Brockden Brown, and the American Plague Year," *Early American Literature* 7:3 (Winter 1973), 295–311.

52 Coad, "Gothic Element," 82.

53 Bryan Waterman, "Preface," in Charles Brockden Brown, *Wieland and Memoirs of Carwin the Biloquist* (Norton: 2011), vii. See Wieland 4 and Anonymous, "An Account of a Murder

Committed by Mr. J— Y—, Upon His Family, in December, A.D. 1781," reprinted in *Wieland*, 266–70, quotes 267, 268. There was also a pamphlet about another similar murder, popular in the 1790s, the *Narrative for William Beadle*: see Shirley Samuels, "Patriarchal Violence, Federalist Panic, and *Wieland*," reprinted in *Wieland*, 393–406, 399–401, and Alan Axelrod, *Charles Brockden Brown: An American Tale* (UT Press: 1983), 53–60.

54 Brown, *Wieland*, 4.

55 Brown, *Wieland*, 126, 130.

56 Brown, *Wieland*, 4.

57 "Anecdote of a Ventriloquist," *Massachusetts Magazine*, June 1790, 2. On ventriloquism and the Enlightenment, see Leigh Eric Schmidt, "Enlightenment, Ventriloquism, and *Wieland*," in *Wieland*, 457–70.

58 See Edwin Sill Fussell, "'Wieland': A Literary and Historical Reading," *Early American Literature* 18:2 (Fall 1983), 171–86, esp. 173–74.

59 See Bernard Rosenthal, "The Voices of *Wieland*," in *Wieland*, 347–70, esp. 362–63; Laura H. Korobkin, "Murder by Madman: Criminal Responsibility, Law, and Judgment in *Wieland*," in *Wieland*, 470–88, esp. 475–80; John Cleman, "Ambiguous Evil: A Study of Villains and Heroes in Charles Brockden Brown's Major Novels," *Early American Literature* 10:2 (Fall 1975), 190–219.

60 Quoted in Coad, "Gothic Element," 91.

61 Coad, "Gothic Element," 72–93, 73.

62 Doreen Hunter, "America's First Romantics: Richard Henry Dana Sr., and Washington Allston," *New England Quarterly* 45:1 (March 1972): 3–30, 3–4.

63 Edgerton Jr., "Murder of Jane McCrea," 481–82.

64 Joseph Lathrop, "A sermon on the dangers of the times, from infidelity and immorality: and especially from a lately discovered conspiracy against religion and government, delivered at West-Springfield, and afterward at Springfield" (Francis Stebbins: 1798), quote 14.

65 Bryan Waterman, *Republic of Intellect: The Friendly Club of New York City and the Making of American Literature* (Johns Hopkins: 2007), 52.

66 See Shirley Samuels, "Plague and Politics in 1793: *Arthur Mervyn*," *Criticism* 27:3 (Summer 1985), 225–46.

67 Quoted in Axelrod, *An American Tale*, 122.

68 "The Following Is a Critic on a Late Much Admired Novel, by M. G. Lewis, Esq., M.P." *American Universal Magazine* 4:1 (Dec. 5, 1797).

69 Coad, "Gothic Element," 77.

70 Coad, "Gothic Element," 76–77.

71 Coad, "Gothic Element," 77.

72 Coad, "Gothic Element," 76. It was *The Romance of the Forest*.

73 William L. Hedges, "Towards a Theory of American Literature, 1765–1800," *Early American Literature* 4:1 (1969), 5–14, 12–13.

74 Andrew Burstein, *The Original Knickerbocker* (Basic Books: 2007), 49; Mary Weatherspoon Bowden, "Cocklofts and Slang-Whangers: The Historical Sources of Washington Irving's *Salmagundi*," *New York History* 61:2 (April 1980), 133–60.

75 Washington Irving, "The Author's Account of Himself," *The Sketch Book*, in *Washington Irving: History, Tales, and Sketches* (Library of American: 1983), 743. On *The Sketch Book*, see Burstein, 120–21.

76 Irving, "English Writers on America," *The Sketch Book*, 793.

77 He'd also befriended Sir Walter Scott, who championed his works. See Burstein, *Original Knickerbocker*, 224.

78 Waterman, *Republic of Intellect*, viii; Kleiger, *Trial of Levi Weeks*, 25.

79 Godwin's later novel, *St. Leon*, grapples with the Gothic even more explicitly; see Wallace Austin Flanders, "Godwin and Gothicism: *St. Leon*," *Texas Studies in Literature and Language* 8:4 (Winter 1967), 533–45.

80 "Review," *Port Folio*, Dec. 1810; 4, 6.

81 See Henry A. Pochmann, "Irving's German Sources in *The Sketch Book*," *Studies in Philology* 27:3 (July 1930), 477–507, 477–78, 489–98. For another discussion of possible plagiarism in a different Irving horror story, see Will L. McClendon, "A Problem in Plagiarism: Washington Irving and Cousen de Courchamps," *Comparative Literature* 20:2 (Spring 1968), 157–69.

82 Irving, "The Author's Account of Himself," *The Sketch Book*, 743.

83 "Rip Van Winkle," 769, 784–85. See, for discussion, Burstein, *Original Knickerbocker*, 125–29, 340–41.

84 "Rip Van Winkle," 775, 779.

85 "Rip Van Winkle," 781.

86 "Rip Van Winkle," 770, 783.

87 "Rip Van Winkle," 782.

88 For *its* German sources, see Pochmann, "Irving's German Sources," 504–5.

89 On Crane's inspiration, see Burstein, *Original Knickerbocker*, 70.

90 There was a comparison of the Rhine's "association of myth and story" with the Hudson for Irving and cohort; see Camillo von Klenze, "German Literature in the *Boston Transcript*, 1830–1880," *Philological Quarterly* 11:1 (Jan. 1932), 1–25, 5.

91 "Legend of Sleepy Hollow," 1065, 1063, 1059. For discussion, see Burstein, *Original Knickerbocker*, 143–49.

92 "Legend of Sleepy Hollow," 1069, 1083, 1085.

93 "Legend of Sleepy Hollow," 1087.

94 "Preface," in *The Sketch Book*, 739.

95 X. Theodore Barber, "Phantasmagorical Wonders: The Magic Lantern Ghost Show in Nineteenth-Century America," *Film History* 3 (1989), 73–86, 74, 79.

96 See Robert D. Mayo, "The Gothic Short Story in the Magazines," *Modern Language Review* 37:4 (Oct. 1942), 448–54.

97 John Neal, *American Writers* (Duke UP: 1937), 65.

98 Coad, "Gothic Element," 85–86.

99 John Neal, *Logan: A Family History* (H. C. Carey & I. Lea: 1822), 97.

100 Washington Irving, "Traits of Indian Character," 1002.

101 New-Haven, March 2: Extract of a letter from a gentleman in the Western Country." *New-Haven Gazette, and the Connecticut Magazine* (1786–1789); Mar 9, 1786; 1, 4.

102 Neal, *Logan*, 6.

103 John Neal, unpublished "Preface," *Rachel Dyer: A North American Story* (Shirley and Hyde: 1828), xi, xv.

104 There had been, in 1817, Jonathan M. Scott's *The Sorceress, or Salem Delivered*; see Coad, "Gothic Element," 74.

105 Neal, "Preface," *Rachel Dyer*, iv. Neal makes claims about the reasonableness of their religious belief on 22, 24.

106 Neal, *Rachel Dyer*, 199, 226. "Are not we . . . living in a land of mercy, a land remarkable for the humanity of her laws?" says one character, who speaks, given Salem, aspirationally. (116) On Dyer's character, see 147–48.

107 "Popular Superstitions," *North American Review*; Jan 1, 1832; 198.

108 *Tales of terror : or, The mysteries of magic : a selection of wonderful and supernatural stories, translated from the Chinese, Turkish, and German*, compiled by Henry St. Clair, Boston: C. Gaylord, 1833, 3–4.

109 From Calef, cited in *Salem Reader* 69–70.

110 Amy Louise Reed, "Self-Portraiture in the Work of Nathaniel Hawthorne," *Studies in Philology* 23 (1926), 40–54, 51.

111 Based on letters to his sister. See Manning Hawthorne, "Nathaniel Hawthorne Prepares for College," *New England Quarterly* 11:1 (Jan 1938), 66–88, 68, 82–84.

112 See Susan Swartzlander, "'Amid Sunshine and Shadow': Charles Wentworth Upham and Nathaniel Hawthorne," *Studies in American Fiction* 15:2 (Autumn 1987), 227–33.

113 See Gross, *Redefining*, 27–30.

114 See R. S. Longley, "Mob Activities in Revolutionary Massachussetts," *New England Quarterly* 6:1 (Mar. 1933), 98–130, esp. 112–17.

115 Quoted in Janice Milner Lasseter, "Hawthorne's Stylistic Practice: A Crisis of Voice," *ATQ* 4:2 (June 1990), 105–22, 106.

116 Compare the remarks in Victor Strandberg, "The Artist's Black Veil," *New England Quarterly* 41:4 (Dec. 1968), 567–74.

117 Compare Richard H. Fogle, "Ambiguity and Clarity in Hawthorne's 'Young Goodman Brown,'" *New England Quarterly* 18:1 (Jan. 1945), 448–65.

118 "Hawthorne's Twice-Told Tales," *North American Review*; Jan 1, 1842; 497.

119 *Southern Literary Messenger*, 2:9 (Aug. 1836), 552.

120 In *Passages from the American Note-Books*; quoted in Bridget M. Marshall, *Industrial Gothic: Workers, Exploitation, and Urbanization in Transatlantic Nineteenth-Century Literature* (University of Wales: 2021), 176.

121 George Lippard, *The Quaker City*, preface to the 1847 edition, published by the author in Philadelphia, 2.

122 Lippard, *Quaker City*, 3.

123 On Lippard's populist and pro-labor sentiments in his work more generally, see Shelley Streeby, "Haunted Houses: George Lippard, Nathaniel Hawthorne, and Middle-Class America," *Criticism* 38:3 (Summer 1996), 443–72.

124 I'm particularly grateful to Jess Nevins for his thoughts on this; personal communication, May 18, 2023.

125 Marshall, *Industrial Gothic* 34; see discussion 34–38.

126 Marshall, *Industrial Gothic* 38. Includes 1856's "Flora Montgomerie," 1844's "Ellen Merton, the Belle of Lowell," and 1844's "The Mysteries of Lowell."

127 Philadelphia Broadside "The Girl of Yewdall's Mill," cited in *Industrial Gothic* 70. For other examples of contemporary ballads about murders, such as the murder after a wedded week of Mary Ann Wyatt Green in 1845, in a broadsheet ballad *The Murdered Wife*, see Louis C. Jones, "The Berlin Murder Case: In Folklore and Ballad," *New York History* 17:2 (Apr. 1936), 192–205.

128 John Rogers Jewitt, *A Narrative of the Adventures and Sufferings of John R. Jewitt* (Thomas Tegg: 1820), 32.

129 Jewitt, *A Narrative*, 16.

130 Other comic tales: "The Duc de L'Omelette" and "Bon-Bon."

131 See Gustav Gruener, "Notes on the Influence of E.T.A. Hoffmann upon Edgar Allan Poe," *PMLA* 19:1 (1904), 1–25.

132 Quoted in Pochmann, "Irving's German Sources," 480.

133 In *Pym*, 183; compare Kent Ljungquist, "Poe and the Sublime: His Two Short Sea Tales in the Context of an Aesthetic Tradition," *Criticism* 17:2 (1975), 131–51.

134 See J. Gerald Kennedy, "Introduction," Edgar Allan Poe, *The Narrative Of Arthur Gordon Pym and Related Tales* (Oxford World's Classics: 1998), x-xi, and Joseph J. Moldenhauer, "Imagination and Perversity in *The Narrative of Arthur Gordon Pym*," *Texas Studies in Literature and Language* 13:2 (Summer 1971), 267–80.

135 Moldenhauer, *Pym*, 2.

136 Moldenhauer, *Pym*, 61.

137 Moldenhauer, *Pym*, 83, 175.

138 Moldenhauer, *Pym*, 176.

139 See Kennedy, "Introduction," viii; James Southall Wilson, "Poe's Philosophy of Composition," *North American Review* 223 (Mar. 1926), 675–84, Poe quote 680.

140 William Patrick Day, *In the Circles of Fear and Desire* (Chicago: 1985), 60.

141 Compare Arthur A. Brown, "Literature and the Impossibility of Death: Poe's 'Berenice'" *Nineteenth-Century Literature* 50:4 (March 1996), 448–63.

142 Quotes from Lewis A. Lawson, "Poe's Conception of the Grotesque," *Mississippi Quarterly*, 19:4 (Fall 1966), 200–5, 201.

143 Joan Dayan, "The Identity of Berenice, Poe's Idol of the Mind," *Studies in Romanticism* 23:4 (Winter 1984), 491–513, 494.

144 This wasn't the first instance of this horror: an interesting possible precursor is mentioned in "The Man with the Head," a story in the *New Monthly Magazine* on July 1, 1824, that begins "There is scarcely any man that has lived much in the world, who does not know what it is to be haunted" and includes, as an example, that of meeting someone and seeing "the creature open its lips and talk, and talk to *myself*, can be compared only to Hamlet's sensations during his interview with his dead father."

145 For a quite extensive survey on the matter, see Karl Jaberg, "The Birthmark in Folk Belief, Language, Literature, and Fashion," *Romance Philology* 10:1 (1956), 307–42.

146 Compare Richard Brenzo, "Beatrice Rappaccini: A Victim of Male Love and Horror," *American Literature* 48:2 (May 1976), 152–64.

147 An interesting possible precursor to "The Black Cat" is "The Sable Apparition, Or Mysterious Bell Rope," in which the atmospheric terror of the bell rope moving by itself, "the ghost in the shape of a bell-rope" in a "haunted room" ends up being . . . a black cat! See "The Sable Apparition, Or Mysterious Bell Rope," *The Mirror of Taste, and Dramatic Censor* (1810–1811); Apr. 1, 1810.

148 Compare James W. Gargano, "'The Black Cat': Perverseness Reconsidered," *Texas Studies in Literature and Language* 2:2 (Summer 1960), 172–78.

149 *Massachusetts Magazine; or, Monthly Museum. Containing the Literature, History, Politics, Art . . .* June 1794; 6, 6.

150 *Philadelphia Repertory. Devoted to Literature and Useful Intelligence* (1810–1812); July 21, 1810.

151 Compare Natalka Freeland, "'One of an Infinite Series of Mistakes': Mystery, Influence, and Edgar Allan Poe," *ATQ* 10:2 (June 1996), 123–39, esp. 125–26.

152 See J. Rea, "Poe's 'The Cask of Amontillado,'" *Studies in Short Fiction* 4:1 (Fall 1966), 57–69.

153 *Columbian Magazine* (1786–1790); Jan 1790.

154 *North American Review*, 436.

CHAPTER THREE

1 On the complexities of Brown's authorial agency, and the differences between the American and British versions—among others—of his narrative, see Marcus Wood, "'ALL RIGHT!': *The Narrative of Henry Box Brown* as a Test Case for the Racial Prescription of Rhetoric and Semiotics," *Proceedings of the American Antiquarian Society* 107:1 (Jan. 1997), 65–104.

2 Quoted in Wood, *Narrative of Henry Box Brown*, 89.

3 Wood, *Narrative of Henry Box Brown*, 75.

4 Raymond Hedin, "Muffled Voices: The American Slave Narrative," *Clio* 10:2 (Winter 1981), 129–42, 131; Wood, *Narrative of Henry Box Brown*, 74; Milton Polsky, "The American Slave Narrative," *Negro Educational Review* 26:1 (1975), 22–36, 23–24.

5 Herbert Aptheker, "The Negro in the Abolitionist Movement," *Science & Society* 5:1 (Winter 1941), 2–23, 11.

6 See Maurice S. Lee, "Absolute Poe: His System of Transcendental Racism," *American Literature* 75:4 (2003), 751–81.

7 Compare, however, Goddu, *Gothic America*, 81–93.

8 See W. Scott Poole, *Monsters in America* (Baylor: 2011), 49, 59-60.

9 Joseph P. Roppolo, "Harriet Beecher Stowe and New Orleans: A Study in Hate," *New England Quarterly* 30:1 (1957), 346–62, 347.

10 Roppolo, "Harriet Beecher Stowe," quote, 349.

11 Moody E. Prior, "Mrs. Stowe's Uncle Tom," *Critical Inquiry* 5:4 (Summer 1979), 635–50, 635; Richard H. Brodhead, "Veiled Ladies: Toward a History of Antebellum Entertainment," *American Literary History* 1:2 (Summer 1989), 273–94, 276.

12 Quoted in Alexander Grinstein, "'Uncle Tom's Cabin' and Harriet Beecher Stowe," *American Imago* 40:2 (Summer 1983), 115–44, 122.

13 See, for example, the review of his 1856 *Works* in the *North American Review,* Oct. 1, 1856, 427, which states "he is best known, and will be longest remembered, as the author of two brief, but exquisitely beautiful poems, 'The Raven,' and 'Annabel Lee.'" For a provocative suggestion for a precursor to "The Raven," called "Evermore," see George Nordstedt, "Prototype of 'The Raven,'" *North American Review* 224 (Dec. 1927), 692–701. He also suggests the idea of the raven may have come from Dickens's *Barnaby Rudge*.

14 See Monika Elbert, "Alice Cary's Mundane Musings and Rural Hauntings," in Monika Elbert and Rita Bode, eds., *American Women's Regionalist Fiction: Mapping the Gothic* (Palgrave Macmillan: 2021), 235–51. See Rita Bode, "Local Habitations as Gothic Terrain in Rose Terry Cooke," *Regionalist,* 79–96; Rose Mary Cooke, "My Visitation," in *How Celia Changed Her Mind and Collected Stories* (Rutgers: 1986), 14–31.

15 See Nancy Sweet, "The Uncanny Regionalism of Harriet Prescott Spofford's 'Circumstance,'" in *Regionalist,* 19–38.

16 See Jeffrey Andrew Weinstock, "Haunted Homesteads: E.D.E.N. Southworth's Dual Gothic," in *Regionalist,* 137–55, esp. 138–42, quote 138. On Southworth, see Herbert F. Smith, *The Popular American Novel, 1865–1920* (Twayne: 1980), 19–24.

17 Melville, "Hawthorne and His Mosses," in Melville, *Apple-Tree Table and Other Sketches* (Princeton UP: 1922), 53–86.

18 See Newton Arvin, "Melville and the Gothic Novel," *New England Quarterly* 22:1 (Mar. 1949), 33–48.

19 See, for example, Alan Shusterman, "Melville's 'The Lightning-Rod Man': A Reading," *Studies in Short Fiction* 9:2 (Spring 1972), 165–74.

20 Compare Kingsley Widmer, "The Negative Affirmation: Melville's 'Bartleby,'" *Modern Fiction Studies* 8:3 (Autumn 1962), 276–86.

21 Michael Wentworth, "A Matter of Taste: Fitz-James O'Brien's 'The Diamond Lens' and Poe's Aesthetic of Beauty," *ATQ* 2:4 (Dec. 1988), 271.

22 See William Winter, "Sketch of the Author," in *The Poems and Stories of Fitz-James O'Brien* (James R. Osgood: 1881), xv–xxviii; quotes from Frank Wood, "O'Brien as Poet and Soldier," xxxvi–xlvi, xxxvii; and from Stephen Fiske, "O'Brien's Bohemian Days," liv–lviii, quote liv.

23 O'Brien, *Collected Stories,* 106–7.

24 O'Brien, *Collected Stories,* 114–15.

25 Fitz James O'Brien, *Collected Stories* (A. & C. Boni: 1925), 46–47, 52.

26 Statistics from Melville, *Over My Dead Body,* 117.

27 Quote from Melville, *Over My Dead Body* 122.

28 John G. Biel, "The Battle of Shiloh: From the Letters and Diary of Joseph Dimmit Thompson," *Tennessee Historical Quarterly* 17:3 (Sept. 1958), 250–74, 260, 266, 270.

29 Quoted in Randall Stewart, "Hawthorne and the Civil War," *Studies in Philology* 34:1 (Jan. 1937), 91–106, 93. *Septimius Felton* remained unfinished at the time of Hawthorne's death in 1864. See James D. Wallace, "Immortality in Hawthorne's *Septimius Felton,*" *Studies in American Fiction* 14:1 (Spring 1986), 19–33.

30 Quoted in Stewart 96–97; Thomas R. Moore, "Hawthorne as Essayist: *Our Old Home* and 'Chiefly About War Matters,'" *ATQ* 6:4 (Dec. 1992), 263–78, 274–75.

31 Allen Flint, "Hawthorne and the Slavery Crisis," *New England Quarterly* 41:3 (Sept. 1968), 393–408, 393; Jennifer Fleischner, "Hawthorne and the Politics of Slavery," *Studies in the Novel* 23:1 (Spring 1991), 96–106, esp. 97.

32 Dorothy V. Walters, "The Civil War in Song," *Social Studies* 30:5 (May 1939), 208–12, 211.

33 W. J. Holman, "War Prison Experience of a Confederate Officer," *Tennessee Historical Quarterly* 10:2 (June 1951), 149–60, 158. For similar experiences on the opposite side, see James I. Robertson Jr., "Houses of Horror: Danville's Civil War Prisons," *Virginia Magazine of History and Biography* 69:3 (July 1961), 329–45.

34 Gregory J. W. Urwin, "'We Cannot Treat Negroes . . . As Prisoners of War': Racial Atrocities and Reprisals in Civil War Arkansas," *Civil War History* 42:3 (September 1996), 193–210, 197, quotes 201.

35 Image can be viewed at https://www.metmuseum.org/art/collection/search/429261.

36 For the details, see Winter, "Sketch of the Author," xxvi–xxvii; Wood, "O'Brien as Poet," xl–xliv.

37 See Steven Hahn, "'Extravagant Expectations' of Freedom: Rumour, Political Struggle, and the Christmas Insurrection Scare of 1865 in the American South," *Past & Present* 157 (Nov. 1997), 122–58.

38 *Frank Leslie's Illustrated Newspaper,* https://americanantiquarian.org/earlyamericannewsmedia /exhibits/show/news-and-the-civil-war/item/122.

39 I'm grateful to Stefan Dziemianowicz for his comments on this point. See also Goddu, *Gothic America*, 117–30.

40 See Jan Cohn, "The Civil War in Magazine Fiction," *Journal of Popular Culture* 4:2 (Fall 1970), 355–82, esp. 376–77.

41 Edith Abbott, "The Civil War and the Crime Wave of 1865–1870," *Social Service Review* 1:1 (Mar. 1927), 229.

42 See Kleiger, *Trial of Levi Weeks*, 177–78.

43 Kate Holterhoff, *Illustration in Fin-de-Siècle Transatlantic Romance Fiction* (Routledge: 2022), 179–80.

44 D. R. Miller, *The Criminal Classes* (United Brethren: 1903), 28–29.

45 *The Five Fiends, or, The Bender Hotel Horror in Kansas* (Old Franklin Pub. House: 1874), 22.

46 See "Justice Overtakes the Kellys," *The Sun,* Jan. 3, 1888, 1; "Were They the Benders?" *St. Paul Daily Globe,* Jan. 11, 1888.

47 Leonard J. Arrington and Jon Haupt, "Intolerable Zion: The Image of Mormonism in Nineteenth Century American Literature," *Western Humanities Review* 22:3 (Summer 1968), 243–60, quote 244.

48 For a reproduction of the cover, see https://dimenovels.lib.niu.edu/learn/essays/ dimenovelformats.

49 See Edmund Pearson, *Dime Novels, or, Following an Old Trail in Popular Literature* (Little, Brown: 1929), quotes 3, 13–14.

50 Pearson, *Dime Novels,* 33, 46, 49, quote 36.

51 Pearson, *Dime Novels,* 92.

52 Pearson, *Dime Novels,* 105.

53 Quoted in Dara Downey, "Emma Frances Dawson's Urban California Gothic," in *Regionalist,* 287–303, 294.

54 Emma Frances Dawson, *An Itinerant House and Other Stories* (William Doxey: 1897), 30.

55 Harriet Elizabeth Prescott, *The Amber Gods and Other Stories* (Ticknor and Fields: 1863), 12, 14. See Lisa M. Logan, "Race, Romanticism, and the Politics of Feminist Literary Study: Harriet Elizabeth Prescott's 'The Amber Gods,'" *Legacy* 18:1 (2001), 35–51.

56 For a detailed history of the term and concept, see Stanford M. Lyman, "The 'Yellow Peril' Mystique: Origins and Vicissitudes of a Racist Discourse," *International Journal of Politics, Culture, and Society* 13:4 (Summer 2000), 683–747, esp. 695–98.

57 Dawson, *An Itinerant House*, 115. See also, for example, the descriptions on 136.

58 Melville, *Over My Dead Body*, 171.

59 With irony: compare M. E. Grenander, "Bierce's Turn of the Screw: Tales of Ironical Terror," *Western Humanities Review* 11 (1957), 257–64. On consciousness and temporality in the story, see John Kenny Crane, "Crossing the Bar Twice: Post-Mortem Consciousness in Bierce, Hemingway, and Golding," *Studies in Short Fiction* 6:4 (Summer 1969), 361–76, 361–65. Compare, on a compulsiveness characterizing Pierce's fiction, S. T. Joshi, *The Weird Tale* (UT: 1990), 156–57.

60 Ambrose Bierce, *In the Midst of Life: Tales of Soldiers and Civilians* (Chatto and Windus: 1893), 116.

61 Frederick Douglass, "The Color Line," *North American Review* 132:295 (June 1881), quote 574.

62 Frederick Douglass, "The Color Line," 567–77, 567, 568.

63 On Chesnutt's life and work, see Arlene A. Elder, *The "Hindered Hand": Cultural Implications of Early African-American Fiction* (Greenwood: 1978), 147–97, esp. 153–54.

64 Elder, *Hindered Hand* 164.

65 Quoted in Elder, *Hindered Hand*, 174.

66 Emily Dickinson, *Poems* (Methuen: 1905), 121, 64.

67 For historical context, see Carroll Smith-Rosenberg, "The Hysterical Woman: Sex Roles and Role Conflict in 19th-Century America," *Social Research* 39:4 (Winter 1972), 652–78, quotes 657, 662, 677.

68 Quoted in Susan S. Lanser, "Feminist Criticism, 'The Yellow Wallpaper,' and the Politics of Color in America," *Feminist Studies* 15:3 (Fall 1989), 415–41, 417.

69 Kate Chopin, *The Awakening and Selected Stories* (Penguin: 1983), 214.

70 Sandra M. Gilbert, "Introduction," in Chopin, *The Awakening*, 31.

71 Chopin, *The Awakening*, 49.

72 Vorse stories anthologized in Mary Heaton Vorse, *Sinister Romance: Collected Ghost Stories* (Ash-Tree: 2002); Austin's story appears in *Lost Borders* (Harper & Brothers: 1909), 195–209. Compare Lesley Ginsberg, "Mary Austin's California Gothic," in *Regionalist*, 305–22.

73 See Melissa McFarland Pennell, "New England Gothic/New England Guilt: Mary Wilkins Freeman and the Salem Witchcraft Episode," in *Regionalist*, 39–56; and Benjamin F. Fisher, "Transitions from Victorian to Modern: The Supernatural Stories of Mary Wilkins Freeman and Edith Wharton," in Douglas Robillard, ed., *American Supernatural Fiction* (Garland: 1996), 3–42.

74 "The Little Maid at the Door," in Mary E. Freeman, *Silence and Other Stories* (Harper & Brothers: 1899), 238–39, 251.

75 "Silence," in Mary E. Freeman, *Silence and Other Stories* (Harper & Brothers: 1899), 40, 43.

76 See William Gillard, James Reitter, and Robert Stauffer, *Speculative Modernism: How Science Fiction, Fantasy and Horror Conceived the Twentieth Century* (McFarland: 2021), 52–54.

77 Mary Wilkins Freeman, *The Wind in the Rose-Bush: And Other Stories of the Supernatural* (Doubleday, Page & Company: 1903), quotes 78, 81, 82–83, 96–97, 102.

78 Freeman, *The Wind in the Rose-Bush*, 13.

79 "Afterward," in *The Ghost Stories of Edith Wharton* (Scribner: 1973), quotes 58, 59, 63.

80 See Peter Buitenhuis, "Henry James on Hawthorne," *New England Quarterly* 32:1 (January 1959), 207–25, quotes from James's *Hawthorne* 213, 219.

81 See Martha Banta, "Henry James and 'The Others,'" *New England Quarterly* 37:2 (June 1964), 171–84, quotes 171, 172; Ernest Tuveson, "*The Turn of the Screw*: A Palimpsest," *Studies in English Literature* 12:4 (Autumn 1972), 783–800; Pamela Jacobs Shelden, "Jamesian Gothicism: The Haunted Castle of the Mind," *Studies in the Literary Imagination* 7:1 (Spring 1974), 121–34.

82 Hamlin Garland, *The Shadow World* (Harper and Brothers: 1908), iv–v.

83 Quoted in James J. Farrell, *Inventing the American Way of Death* (Temple: 1980), 5.

84 Farrell, *Inventing*, 5.

85 Olivia Howard Dunbar, "The Decay of the Ghost in Fiction,"*Dial*, June 1, 1905, 377–80, quotes 378–79; James quoted in Louis D. Rubin Jr, "One More Turn of the Screw," *Modern Fiction Studies* 9:4 (Winter 1963–1964), 327. See also Burton R. Pollin, "Poe and Henry James: A Changing Relationship," *Yearbook of English Studies* 3 (1973), 232–42.

86 See Rubin, "One More Turn," 314–28, 314; Oscar Cargill, "Henry James as Freudian Pioneer," *Chicago Review* 10:2 (Summer 1956), 13–29, esp. 27.

87 On vision and reflection in the novella, compare Juliet McMaster, "'The Full Image of a Repetition' in 'The Turn of the Screw,'" *Studies in Short Fiction* 6:4 (Summer 1969), 377–82.

88 Turned around, one can see the story as "a tale which exposes the cruel and destructive pressures of Victorian society, with its restrictive code of sexual morality"; see Jane Nardin, "*The Turn of the Screw*: The Victorian Background," *Mosaic* 12:1 (Autumn 1978), 131–42.

89 Quoted in Jean Frantz Blackall, "Cruikshank's *Oliver* and 'The Turn of the Screw,'" *American Literature* 51:2 (May 1979), 161–78, 161.

90 Quoted in Blackall, "Cruikshank's *Oliver*," 162.

91 Dunbar, "Decay of the Ghost," *Dial*, 380.

92 See Joseph J. Firebaugh, "Inadequacy in Eden: Knowledge and 'The Turn of the Screw,'" *Modern Fiction Studies* 3:1 (Spring 1957), 57–63. James wrote thirteen stories that dealt with the dead between 1865 and 1900; on the corpus as a whole, see Banta, "James and 'The Others,'"179–81.

93 See discussion in Louis S. Gross, *Redefining the American Gothic* (UMI: 1989), 15–21.

94 Robert Rogers, "The Beast in Henry James," *American Imago* 13:4 (Winter 1956), 427–54, 428.

95 Compare Shelden's extended reading in "Jamesian Gothicism," 126–34.

96 Gertrude Atherton, "The Striding Place," in *American Fantastic Tales* (Library of America: 2009), 232–37, 237.

97 Quoted in Roger Luckhurst, "Introduction," *Strange Case of Dr. Jekyll and Mr. Hyde and Other Tales* (Oxford: 2006), xi.

98 Arthur Machen, *Tales of Horror and the Supernatural* (Richards Press: 1949), 62.

99 See Felix Taylor, "'Powerful and Sovereign Medicines . . . Virulent Poisons Also': Arthur Machen, Occultism, and the Celtic Revival," in Matthew Cheeseman and Carina Hart, eds. *Folklore and Nation in Britain and Ireland* (Routledge: 2022).

100 Quoted in Catherine Rainwater, "Encounters with the 'White Sphinx': Poe's Influence on Some Early Works of H. G. Wells," *English Literature in Transition* 26:1 (1983), 35–51, 35.

101 Compare discussion in William Gillard et al., *Speculative Modernism*, 22–23.

102 Luckhurst, "Introduction," *Strange Case*, xxix.

103 See Martin Tropp, *Images of Fear* (McFarland: 1990), 110.

104 I'm grateful to Stefan Dziemianowicz for this reference.

105 Crawford, *Wandering Ghosts*, 201, 219.

106 Erik Larson, *The Devil in the White City* (Crown: 2003), 87.

CHAPTER FOUR

1 Larson, *Devil in the White City*, epigraph.

2 Herman W. Mudgett, *Holmes, the Arch Fiend, or a Carnival of Crime*, (Cincinnati: Barclay, 189-), 58, 74–75.

3 Larson, *Devil in the White City*, 31–32.

4 See Eric Solomon, "Stephen Crane's War Stories," *Texas Studies in Literature and Language* 3:1 (Spring 1961), 67–80.

5 Reprinted in Marc Ferrara and Gordon Dossett, "A Sheaf of Contemporary Reviews of Stephen Crane," *Studies in the Novel* 10:1 (Spring 1978), 168–82, 170, 173–74. Compare also Harold Beaver, "Stephen Crane: The Hero as Victim," *Yearbook of English Studies* 12 (1982), 186–93.

6 See Ferenc M. Szasz and Ralph F. Bogardus, "The Camera and the American Social Conscience: The Documentary Photography of Jacob A. Riis," *New York History* 55:4 (Oct. 1974), 409–36.

7 Quoted in Marshall, *Industrial Gothic*, 29.

8 Daniel Bender, "'A Hero . . . for the Weak': Work, Consumption, and the Enfeebled Jewish Worker, 1881–1924," *International Labor and Working-Class History* 56 (Fall 1999), 1–22, 15.

9 Lanser, "Feminist Criticism," 425, 429, 430.

10 Sax Rohmer, *Fu Manchu: Three Complete Novels in One Volume* (PJM: 2008), 171.

11 The original Bible text is from Hebrews 10:31.

12 Robert W. Chambers, *The King in Yellow* (Chatto and Windus: 1895), 96, 10–11.

13 On Zitkála-Ša's life, work, and complicated legacy, see Laura L. Mielke, "Zitkála-Ša's Indigenous Gothicism," *Regionalist*, 339–57, quote 342–43.

14 Zitkála-Ša, *American Indian Stories* (Modern Library: 2019), 34–36.

15 See Rachel Ihara, "'The Stimulus of Books and Tales': Pauline Hopkins's Serial Novels for the *Colored American Magazine*," in Patricia Okker, ed., *Transnationalism and American Serial Fiction* (Routledge: 2012), 127–47, 129–30.

16 See Ihara, "Stimulus," 135, quote 137.

17 Pauline Hopkins, *Of One Blood* (Washington Square Press: 2004), 145.

18 Quotes from Warren Francke, "Sensationalism and the Development of 19th Century Reporting," *Journalism History* 12:3 (Fall 1985), 80–85, 80.

19 *New York Times*, April 19, 1906.

20 Quoted in Francke, "Sensationalism," 84.

21 For two excellent accounts (one in graphic form—literally), see Mark J. Phillips and Aryn Z. Phillips, *Trials of the Century* (Prometheus: 2016), 15–32; and Rick Geary, *Madison Square Tragedy: The Murder of Stanford White* (NBM: 2013).

22 Compare Eugene Arden, "The Evil City in American Fiction," *New York History* 35:3 (July 1954), 259–79, quote 266; Clarence Gohdes, "Wicked Old New York," *Huntington Library Quarterly* 29:2 (Feb. 1966), 171–81, quote 171.

23 Carlos Clarens, *An Illustrated History of the Horror Films* (G. P. Putnam: 1967), 7.

24 Poole, *Monsters*, 84.

25 Clarens, *Illustrated History*, 38.

26 Compare Ivan Butler, *Horror in the Cinema* (A. S. Butler: 1970), 10.

27 Quoted in Roy Huss and T. J. Ross, eds. *Focus on the Horror Film* (Prentice-Hall: 1972), 66.

28 Compare Barry Keith Grant, *100 American Horror Films* (BFI: 2022), 75.

29 Brander Matthews, "Are the Movies a Menace to the Drama?" *North American Review* (Mar. 1917), 205:736, 447–54, 449–50.

30 "Preface," *The Ghost Stories of Edith Wharton*, 8.

31 Kevin Brownlow, "Traffic in Souls," *Griffithiana* 11:32/33 (Sept. 1988), 227–36.

32 Doug Williams, "Concealment and Disclosure: From 'Birth of a Nation' to the Vietnam War Film," *International Political Science Review* 12:1 (Jan. 1991), 29–47, 31.

33 Elder, *Hindered Hand*, 9.

34 See James M. Mellard, "Racism, Formula, and Popular Fiction," *Journal of Popular Culture* 5:1 (Summer 1971), 10–37, quote 25.

35 Quoted in David Brion Davis, "Violence in American Literature," *Annals of the American Academy of Political and Social Science* 364 (Mar. 1966), 28–36, 33.

36 See Williams, "Concealment," 32; Smith, *Popular*, 53–55.

37 James M. SoRelle, "The 'Waco Horror': The Lynching of Jesse Washington," *Southwestern Historical Quarterly* 86:4 (April 1983), 517–36.

38 David Chalmers, "The Ku Klux Klan in Politics in the 1920s," *Mississippi Quarterly* 18:4 (Fall 1965), 234–47, 234–35.

39 Compare John R. Cooley, "*The Emperor Jones* and the Harlem Renaissance," *Studies in the Literary Imagination* 7:2 (Fall 1974), 73–83, quote 75.

40 See Mary E. Jones Parrish, *The Nation Must Awake: My Witness to the Tulsa Race Massacre of 1921* (Trinity UP: 2021). Quote in "Introduction," xv.

41 Quote in Parrish, "Introduction," xvii.

42 See Timothy J. Lyons, "Hollywood and World War I, 1914–1918," *Journal of Popular Film* 1:1 (Winter 1972), 15–30, quotes 18, 19.

43 Cited in Les Cleveland, *Dark Laughter: War in Song and Popular Culture* (Praeger: 1994), 120.

44 Jessica Amalda Salmonson, "The Strange Stories of Alice Brown, New England Mystic," in Brown, *The Empire of Death and Other Strange Stories* (Ash-Tree: 2003), xv, 9, 13.

45 S. S. Prawer, *Caligari's Children* (Oxford UP: 1980), 39.

46 Clarens, *Illustrated History*, 46–47.

47 Clarens, *Illustrated History*, 50.

48 On Browning's biography, see David J. Skal, *The Monster Show: A Cultural History of Horror* (Faber & Faber: 2001), esp. 26–35.

49 Clarens, *Illustrated History*, 70.

50 Walter Kendrick, *Thrill of Fear*, 214.

51 See James Rieger, "Dr. Polidori and the Genesis of Frankenstein," *Studies in English Literature, 1500–1900* 3:4 (Autumn 1963), 461–72, 463.

52 Frances Marion Crawford, *Wandering Ghosts* (Macmillan: 1911), 185, 187.

53 L. Edward Purcell, "Trilby and Trilby-Mania: The Beginning of the Bestseller System," *Journal of Popular Culture* 11:1 (Summer 1977), 62–76, quote 65.

54 See Skal, *Monster Show*, 115–17.

55 Larson, *Devil in the White City*, 35.

56 See Catherine Lester, *Horror Films for Children: Fear and Pleasure in American Cinema* (Bloomsbury: 2022), 3.

57 Clarens, *Illustrated History*, 59–60.

58 Reed Ellis, *A Journey into Darkness: The Art of James Whale's Horror Films* (Arno: 1980), 30.

59 For a more detailed account, see Ellis, *Journey into Darkness*, 35–39 and Drake Douglas, *Horror!* (Macmillan: 1966), 120–22.

60 Compare Elizabeth Young, "Here Comes the Bride: Wedding Gender and Race in 'Bride of Frankenstein,'" *Feminist Studies* 17:3 (Fall 1991), 403–37, esp. 422–24.

61 "Interview with Rouben Mamoulian," *Literature/Film Quarterly* 10:4 (1982), 255–65, 263–64.

62 Frederick Stuart Greene, ed., *The Grim Thirteen* (Dodd & Mead: 1917), xiii–xiv.

63 Archer Jones, "The Pulps—A Mirror to Yearning," *North American Review* 246:1 (Autumn 1938), 35–47, 35.

64 I'm grateful to Jess Nevins for this insight.

65 Jones, "Mirror to Yearning," 36.

66 Herbert Asbury, "Introduction," in Asbury, ed., *Not at Night!* (Macy-Masius: 1928), 10.

67 Glen St. John Barclay, *Anatomy of Horror: The Masters of Occult Fiction* (Weidenfeld and Nicolson: 1978), 84.

68 See the useful essays in Antonio Alcala Gonzalez and Carl H. Sederholm, *Lovecraft in the 21st Century: Dead, But Still Dreaming* (Routledge, Taylor & Francis: 2022); Joshi, *Weird Tale*, esp. 170–79.

69 Quoted in James Campbell, "Cosmic Indifferentism in the Work of H.P. Lovecraft," in *American Supernatural Fiction,* 167–228, 170.

70 Jones, "Mirror to Yearning," 37.

71 I'm grateful to Stefan Dziemianowicz for his comments on this point.

72 Quoted in Wetmore, *Post-9/11 Horror,* 16.

73 See Ian Fetters, "Nuclear Inhumanities," in *Lovecraft in the 21st Century,* 118–31, and Fredrik Blanc, "'It Was the Vegetation': Ecophobia and Monstrous Wildnerness in the Fiction of H.P. Lovecraft," in *Lovecraft in the 21st Century,* 158–71, esp. 160–61.

74 Quoted in Joshi, *Weird Tale,* 194, emphasis Lovecraft's.

75 See Kevin J. Wetmore Jr., "Lovecraft and the Stage: A Recent (Re)Discovery," in *Lovecraft in the 21st Century,* 12–27, 13–15.

76 Ellis, *Journey into Darkness,* 41.

77 Richard A. Oehling, "Hollywood and the Image of the Oriental, 1910–1950, Part I," *Film & History* 8:2 (May 1978), 33–41, 35–36.

78 See William Seabrook, *This Magic Island* (Harcourt, Brace: 1929), 93; A. Langley Searles, "Fantasy and Outré Themes in the Short Fiction of Edward Lucas White and Henry S. Whitehead," in *American Supernatural Fiction,* 59–75, esp. 67–70.

79 Quoted in Rhona J. Berenstein, "White Heroines and Hearts of Darkness: Race, Gender, and Disguise in 1930s Jungle Films," *Film History* 6:3 (Fall 1994), 314–39, 315.

80 William Troy, "Beauty and the Beast," reported in *Focus on the Horror Film,* 104.

81 Compare J. P. Telotte, "The Movies as Monster: Seeing in 'King Kong,'" *Georgia Review* 42:2 (Summer 1988), 388–98, esp. 391–92.

82 See Rhona J. Berenstein, *Attack of the Leading Ladies: Gender, Sexuality, and Spectatorship in Classic Horror Cinema* (Columbia: 1996), 8–10, 186–88.

83 See Clark Ashton Smith, *Out of Space and Time* (Nebraska: 2006), 25–42, 51–99.

84 Quoted in Brian Stableford, "Outside the Human Aquarium: The Fantastic Imagination of Clark Ashton Smith," in *American Supernatural Fiction,* 229–52, 232.

85 Donald Wandrei, *The Eye and the Finger* (Arkham: 1944), 212.

86 Wandrei, *Eye,* 19, 18.

87 Originally for *Unknown Worlds,* July 1942, published in *The Hounds of Tindalos,* (Arkham: 1946), 49–63.

88 Robert Bloch, *The Opener of the Way* (Arkham House: 1945), 248–49.

89 Both in Bloch, *Opener of the Way.*

90 Selma Robinson, "The Departure," as reprinted in Boris Karloff, ed., *And the Darkness Falls* (World Publishing Co.: 1948), 52–57.

91 West, *Miss Lonelyhearts,* 2.

92 West, *Miss Lonelyhearts,* 4.

93 Steven Vincent Benet, "The Devil and Daniel Webster," in *The Devil and Daniel Webster and Other Writings* (Penguin: 1999), 28.

94 See Arlin Turner, "William Faulkner, Southern Novelist," *The Mississippi Quarterly* 14:3 (Summer 1961), 117–30.

95 See William Van O'Connor, "Hawthorne and Faulkner: Some Common Ground," *Virginia Quarterly Review* 33:1 (Winter 1957), 105–23.

96 See David L. Frazier, "Gothicism in 'Sanctuary': The Black Pall and the Crap Table," *Modern Fiction Studies* 2:3 (Autumn 1956), 114–24.

97 See Pat M. Esslinger, "No Spinach in 'Sanctuary,'" *Modern Fiction Studies* 18:4 (Winter 1972–73), 555–58.

98 William Faulkner, *Sanctuary* (Vintage: 2011), 86, 41.

99 William Rossky, "The Pattern of Nightmare in 'Sanctuary,' or, Miss Reba's Dogs," *Modern Fiction Studies* 15:4 (Winter 1969–1970), 503–15, 504–5; Terry Heller, "Mirrored Worlds and the Gothic in Faulkner's *Sanctuary*," *Mississippi Quarterly* 42:3 (Summer 1989), 247–59.

100 Gerald W. Johnson, "The Horrible South," *Virginia Quarterly Review* 11:2 (Apr. 1935), 201–17, 203–4.

101 Quoted in Susan V. Donaldson, "Making a Spectacle: Welty, Faulkner, and Southern Gothic," *Mississippi Quarterly* 50:4 (Fall 1997), 567–84, 567.

102 Manly Wade Wellman, *Who Fears the Devil* (Ballantine: 1963).

103 Charles G. Finney, *The Circus of Dr. Lao* (University of Nebraska: 2002), 64.

104 Eudora Welty, "Petrified Man," in *Eudora Welty: Stories, Essays, and Memoir* (Library of America: 1992), 22–36, quotes 26, 27, 28, 35.

105 See Valerie Levy, "Hoodoo and Voodoo in Zora Neale Hurston's Gothic Stories and Folktales," *Regionalist*, 215–32; Erik D. Curren, "Should Their Eyes Have Been Watching God?: Hurston's Use of Religious Experience and Gothic Horror," *African American Review* 29:1 (Spring 1995), 17–25.

106 Jonathan Lethem, "Introduction," in Nathanael West, *Miss Lonelyhearts* and *The Day of the Locust* (New Directions: 2009), ix.

107 Gloria Young, "*The Day of the Locust:* An Apocalyptic Vision," *Studies in American Jewish Literature* 5 (1986), 103–10, 103.

108 Young, *Day of the Locust*, 61.

109 Stephanie Sarver, "Homer Simpson Meets Frankenstein: Cinematic Influence in Nathanael West's 'The Day of the Locust,'" *Literature/Film Quarterly* 24:2 (1996), 217–22.

110 Bloch, *Opener of the Way*, 173.

111 William E. Berchtold, "The Hollywood Purge," *North American Review* 238:6 (Dec. 1934), 503–12, 510.

112 See William Proctor, "Building Imaginary Horror Worlds: Transfictional Story Telling and the Universal Monster Franchise Cycle," in Mark McKenna and William Proctor, eds. *Horror Franchise Cinema* (Routledge: 2022), 29–50, 34, 37.

113 Quotes in Ellis, *Journey into Darkness*, 70.

114 Ellis, *Journey into Darkness*, 1.

115 Skal, *Monster Show*, 184.

116 A point made in Proctor, "Universal," 43.

117 Bloch, *Opener of the Way*, 178.

118 Quoted in Thomas A. Nelson, "Darkness in the Disney Look," *Literature/Film Quarterly* 6:2 (Spring 1978), 94–103, 95.

119 Compare Steven Watts, "Walt Disney: Art and Politics in the American Century," *Journal of American History* 82:1 (June 1995), 84–110, 89.

120 See Jim McClure, "Murder and Witchcraft: The Incredible Story of York County's Hex Murder," *York Daily Record*, Oct. 14, 2017.

121 Seabrook, *Magic Island*, 265.

122 Seabrook, *Witchcraft: Its Power in the World Today* (Harrap: 1940), 8, 11.

123 Seabrook, *Witchcraft*, 114, 117, 119.

124 See Sharon Russell, "The Witch in Film: Myth and Reality," in Barry Keith Grant, ed., *Planks of Reason: Essays on the Horror Film* (Scarecrow: 1984), 113–25, esp. 117.

125 Clemence Dane, "American Fairy-Tale," *North American Review*, 242:1 (Autumn 1936), 143–52, 148.

126 See William Sloane, *The Edge of Running Water* (Farrar & Rinehart: 1939), 251.

127 William Hjorstberg, "Introduction," *The Cadaver of Gideon Wyck* (Millipede: 2008), 15, 18.

128 Quoted in Wetmore, *Lovecraft in the 21st Century*, 16.

129 See Matthew A. Killmeier, "Aural Atavism: The Witch's Tale and Gothic Horror Radio," *Journal of Radio and Audio Media* 19:1 (May 2012), 61–82.

130 Katherine Anne Porter, *Pale Horse, Pale Rider* (Modern Library: 1939), 188, 232, 264.

131 Dalton Trumbo, *Johnny Got His Gun* (Monogram: 1939), 36.

132 Prawer, *Caligari's Children*, 34.

133 Murry R. Nelson, "An Alternative Medium of Social Education—The 'Horrors of War' Picture Cards," *Social Studies* 88:3 (May 1997), 100–107, 105.

134 Compare Gabriel Eljaiek-Rodríguez, *Baroque Aesthetics in Contemporary American Horror* (Palgrave Macmillan: 2021), 2–3.

135 Anthony Boucher, "The Compleat Werewolf," in *The Compleat Werewolf and Other Stories of Fantasy and Science Fiction* (Simon and Schuster: 1969), 20.

136 Fritz Leiber, *Night's Black Agents* (Neville Spearman: 1947), 5.

137 Fritz Leiber, *Conjure Wife* (Ace: 1984), 66.

138 Boucher, "Mr. Lupescu," in *The Compleat Werewolf*, 140.

139 See David Madden, "James M. Cain: Twenty-Minute Egg of the Hard-Boiled School," *Journal of Popular Culture* 1:3 (Winter 1967), 178–92, quote 180; Dashiell Hammett, ed., *Creeps by Night* (Tudor: 1931), quote "Introduction," 9.

140 Madden, *Egg*, 181.

141 A point made in Alan Spiegel, "Seeing Triple: Cain, Chandler and Wilder on 'Double Indemnity,'" *Mosaic* 16:1–2 (Winter/Spring 1983), 83–101, 87.

142 Reprinted in Karloff, ed., *And the Darkness Falls*, 77–88.

CHAPTER FIVE

1 Joseph Luft and W. M. Wheeler, "Reaction to John Hersey's 'Hiroshima,'" *The Journal of Social Psychology* 28 (1948), 135–40, 136, 137.

2 See George E. Hopkins, "Bombing and the American Conscience During World War II," *Historian* 28:3 (May 1966), 451–73, quotes 451, 457, 459, 462, 463, 469, 470.

3 See Michael J. Yavenditti, "The American People and the Use of Atomic Bombs on Japan: the 1940s," *Historian* 36:2 (Feb. 1974), 224–47.

4 See Michael J. Yavenditti, "John Hersey and the American Conscience: The Reception of 'Hiroshima,'" *Pacific Historical Review* 43:1 (Feb. 1974), 24–49, esp. 47.

5 Peter Schwenger, "Writing the Unthinkable," *Critical Inquiry* 13:1 (Autumn 1986), 33–48, 33.

6 Jack Williamson, *Darker than You Think* (Collier: 1989), 218.

7 See Martin F. Norden, "America and Its Fantasy Films: 1945–1951," *Film & History* 12:1 (1982), 1–8.

8 Karloff, *And the Darkness Falls*, 605; see also Joshi, *Weird Tale*, 4.

9 Charles Addams, *Drawn and Quartered* (Bantam: 1946), 4–5.

10 See Andrew Horton, "Turning On and Tuning Out at the Drive-In: An American Phenomenon Survives and Thrives," *Journal of Popular Film* 5:3 (Jan. 1976), 233–44, 235.

11 Richard Hodgens, "A Brief, Tragical History of the Science Fiction Film," *Film Quarterly* 13:2 (Winter 1959), 30–39, 30.

12 Helen Swick Perry, "Selective Inattention as an Explanatory Concept for U.S. Public Attitudes Toward the Atomic Bomb," *Psychiatry* 17:3 (Aug. 1954), 225–42.

13 Compare Stephen King, *Danse Macabre* (Everest House: 1981), 319.

14 See Richard Matheson, *The Shrinking Man* (Bantam: 1969), 188, 184.

15 Compare Brian Murphy, "Monster Movies: They Came from Beneath the Fifties," *Journal of Popular Film* 1:1 (Winter 1972), 31–44, 35.

16 Jill E. Anderson, *Homemaking for the Apocalypse: Domesticating Horror in Atomic Age Media and Film* (Routledge: 2021), passim.

17 Bradbury, "Homesteading the October Country," in *The October Country* (HarperPerennial: 2011), x.

18 See "Chronology" in Ray Bradbury, *Novels and Story Cycles* (Library of America: 2021), 843–61.

19 See Jon Eller, "*Dark Carnival:* A History," in Bradbury, *Dark Carnival* (Gauntlet: 2001), v-xv.

20 For the poem's text, see https://poets.org/poem/there-will-come-soft-rains.

21 Ray Bradbury, *The Martian Chronicles* (Avon: 1997), 249.

22 See, for example, "Interview with Don Siegel," in William Johnson, ed., *Focus on the Science Fiction Film* (Prentice-Hall: 1972), 75.

23 Bradbury, *Martian Chronicles*, 43–65, under the title "The Third Expedition." Originally published in *Planet Stories* in 1948. See also Jack Finney, *Invasion of the Body Snatchers* (Scribner: 1998), 129, 105, 21.

24 Robert Franciosi, "Screening the Wall: David O. Selznick's 'Lost' Holocaust Film," *Modern Jewish Studies* 12 (2001), 3–11.

25 Martha Gellhorn, *Point of No Return* (Nebraska: 1995), quotes 271, 273, 276, 278, 284.

26 Martin H. Bickham, "Total War and American Character," *Religious Education,* Jan. 1, 1946, 291–94, 292.

27 On the whole phenomenon of horror comics, which was greater than EC, see my *American Comics: A History* (Norton: 2021), and the sources cited there.

28 Published originally in *Haunt of Fear* 22, Nov–Dec 1953, reptd. Graham Ingels, *Accidents and Old Lace and Other Stories* (Fantagraphics: 2021), 15–22, 22.

29 Charles Beaumont, "Open House," in *The Hunger and other Stories* (Valancourt: 2013), 65–76.

30 John Collier, *Fancies and Goodnights* (New York Review Books: 2003), 22, 416.

31 "A GI's Letter Tells Agony of War," *Social Service Review* 26:1 (Mar. 1952), 227–28, 228.

32 Shuji Otsuka and Peter N. Stearns, "Perceptions of Death and the Korean War," *War in History* 6:1 (Jan. 1999), 72–87.

33 See Jonathan Baumbach, "Nightmare of a Native Son: Ralph Ellison's *Invisible Man,*" *Critique* 6:1 (Spring 1963), 48–65, quote 48.

34 See Mary F. Sisney, "The Power and Horror of Whiteness: Wright and Ellison Respond to Poe," *CLA Journal* 29:1 (Sept. 1985), 82–90. (Richard Wright, for his part, writes at the end of the preface of *Native Son*, his classic 1940 novel: "If Poe were alive, he would not have to invent horror. Horror would invent him.")

35 See Richard Kostelantz, "The Politics of Ellison's Booker: *Invisible Man* as Symbolic History," *Chicago Review* 19:2 (1967), 5–26, 8–9.

36 See the discussion in Stephen B. Bennett and William W. Nichols, "Violence in Afro-American Fiction: A Hypothesis," *Modern Fiction Studies* 17:2 (Summer 1971), 221–28, esp. 224–25.

37 Arthur Miller, "Why I Wrote *The Crucible,*" *New Yorker,* Oct. 21/28, 1996.

38 James Gilbert, "Mass Culture and the Fear of Delinquency: the 1950s," *Journal of Early Adolescence* 5:4 (1985), 505–16, quote 505.

39 Gilbert, "Mass Culture," 507.

40 See Bosley Crowther, "The Exception or the Rule? 'Blackboard Jungle' as a Film Raises Grave Questions of Fact," *New York Times* (Mar. 27, 1955); Delmar C. Palm and Gilbert A. Cahill, "Do Blackboard Jungles Exist?" *Social Studies* 48:5 (May 1957), 147–52.

41 Mary I. Preston, "Children's Reactions to Movie Horrors and Radio Crime," *Journal of Pediatrics* 19:2 (Aug. 1941), 147–68, 167–68.

42 I tell this story in significantly greater detail in my *American Comics*, passim.

43 "Usher II," in *Martian Chronicles*, 161–81. A similar story, "The Exiles," appears in Ray Bradbury, *The Illustrated Man* (Avon: 1997), 118–35.

44 "Day After Tomorrow: Why Science Fiction?" reptd. in *Novels and Story Cycles*, 811–17, 812.

45 Bradbury, *Novels and Story Cycles*, 266.

46 "Influence of TV Crime Programs on Children's Health," *Journal of the American Medical Association* 150:1 (Sept. 6, 1952), 37.

47 Bradbury, *Illustrated Man*, 7–25.

48 Proctor, "Universal," 46.

49 See Elena M. Watson, *Television Horror Movie Hosts* (McFarland: 1991), passim.

50 B. Lee Cooper, "Terror Translated into Comedy: The Popular Music Metamorphosis of Film and Television Horror, 1956–1991," *Journal of American Culture* 20:3 (Sept. 1997), 31–42.

51 Tom Weaver, *Interviews with B Science Fiction and Horror Movie Makers* (McFarland & Co: 1988), 10.

52 The Production Code Adminstration had all sorts of objections to filming the novel as written or as it had been adopted, successfully, for the stage. For discussion, see William Paul, *Laughing Screaming* (Columbia: 1994), 275–79.

53 Robert Bloch, *Pleasant Dreams* (Arkham House: 1960), 196, 205.

54 Compare also, for this as a phenomenon in the monster movie more generally, Walter Evans, "Monster Movies: A Sexual Theory," *Journal of Popular Film* 2:4 (Fall 1973), 353–65.

55 Skal, *Monster Show*, 255.

56 Weaver, *Interviews*, 196.

57 This comparison is made in Robert B. Heilman, "The Lure of the Demonic: James and Dürrenmatt," *Comparative Literature* 13: 4 (Autumn 1961), 346–57, esp. 349–50.

58 See Frederick Whiting, "Pedophilia, Pornography, and the Anatomy of Monstrosity in *Lolita*," *American Literature* 70:4 (Dec. 1998), 833–62, 836–37.

59 See Roy S. Simmonds, "Cathy Ames and Rhoda Penmark: Two Child Monsters," *The Mississippi Quarterly* 39:2 (Spring 1986), 91–101. Quote from William March, *The Bad Seed* (Rinehart & Co.: 1954), 182.

60 See Stephen Rebello, *Alfred Hitchcock and the Making of Psycho* (Dembner: 1990), 3.

61 For an excellent, nuanced treatment of the entire Gein case and its coverage, see Ryan Lee Cartwright, *Peculiar Places: A Queer Crip History of Rural Noncomformity* (Chicago: 2021), esp. 87–108.

62 Robert Bloch, *The Scarf* (Dial Press: 1947), 128–29.

63 August Derleth, "Foreword," *Sleep No More* (Farrar & Rinehart: 1944), viii.

64 See Judith Fetterley, "Beauty as the Beast: Fantasy and Fear in *I, the Jury*," *Journal of Popular Culture* 8:4 (Mar. 1975), 775–82, 782.

65 Jim Thompson, *The Killer Inside Me* (Vintage Crime: 1991), 11; *Body Snatchers*, 25.

66 Bloch, *Scarf*, 174.

67 Bloch, *Scarf*, 207.

68 Bloch, *Opener of the Way*, 81, 82.

69 On the ideas of the movie's eclectic style, as an "early example of the 'New American Gothic,'" as containing the "fearful dreaminess, the peculiar cruelty, of the fairy tale," see James R. Fultz, "The Poetry and Danger of Childhood: James Agee's Film Adaptation of 'The Night of the Hunter,'" *Western Humanities Review* 34:1 (Winter 1980), 90–98, 95.

70 Davis Grubb, *Night of the Hunter* (Harper & Brothers: 1953), 21, 261.

71 Bloch, *Scarf*, 128–29.

72 For how it was done, see Moylan C. Mills, "Charles Laughton's Adaptation of 'The Night of the Hunter,'" *Literature/Film Quarterly* 16:1 (1988), 49–57, 53.

73 See King, *Danse Macabre*, 84.

74 Reptd. in Charles Beaumont, *The Magic Man* (Fawcett: 1965), 13–30.

75 Bloch, *Pleasant Dreams*, 116.

76 Richard Matheson, *A Stir of Echoes* (Gauntlet: 2002), 5.

77 Quoted in Shirley Jackson, *The Lottery and Other Stories* (Modern Library: 2000), vi.

78 For an excellent biography of Jackson, see Ruth Franklin, *Shirley Jackson: A Rather Haunted Life* (Liveright: 2016).

79 See Robert Blair St. George, "Witchcraft, Bodily Affliction, and Domestic Space in Seventeenth-Century New England," in Janet Moore Lindman and Michele Lise Tarter, eds., *A Centre of Wonders: The Body in Early America* (Cornell: 2001), 13–28.

80 See also Paulina Palmer, *Lesbian Gothic: Transgressive Fictions* (Cassell: 1999), 13–14.

81 Quoted in Dennis R. Perry, "Imps of the Perverse: Discovering the Poe/Hitchcock Connection," *Literature/Film Quarterly* 24:4 (1996), 393–99, 394.

82 Robert E. Kapsis, "Reputation Building and the Art World: The Case of Alfred Hitchcock," *Sociological Quarterly* 30:1 (Spring 1989), 15–35, 20.

CHAPTER SIX

1 Philip Roth, "Writing American Fiction," *Commentary* 31: 3 (Mar. 1961), 223–33, 224.

2 William Arrowsmith, "Literature and the Uses of Anxiety," *Western Humanities Review*, 1956, 329–30.

3 Quoted in Arrowsmith, *Western Humanities Review*, 325–35, 328.

4 See Robert S. Phillips, "The Gothic Architecture of *The Member of the Wedding*," *Renascence* 16:2 (Winter 1964), 59–73, quote 65.

5 Quoted in David Seed, "Bruce Jay Friedman's Fiction: Black Humour and After," *Thalia* 10:1 (Spring 1988), 14–22, 14.

6 Douglas Day, "Catch-22: A Manifesto for Anarchists," *Carolina Quarterly* 15:3 (Summer 1963), 86–91, 89–90.

7 For a good early reading of Wallant's novel, see Thomas M. Lorch, "The Novels of Edward Lewis Wallant," *Chicago Review* 19:2 (1967), 78–91, esp. 80–84.

8 See Alan Filreis, *1960: The Politics and Art of the Postwar Avant-Garde* (Columbia UP: 2021), 159–60.

9 For Victor LaValle's excellent selection, see *The Best of Richard Matheson* (Penguin: 2017).

10 Lawrence Venuti, "Rod Serling, Television Censorship, the Twilight Zone," *Western Humanities Review* 35:4 (Winter 1981), 349–66.

11 George W. Arndt, "Community Reactions to a Horrifying Event," *Bulletin of the Menninger Clinic* 23:3 (May 1959), 106–11, 107, 108.

12 See Filreis, 12, 50.

13 Glenn Tinder, "The Death of a President and the Problem of Meaning," *Review of Politics* 29:3 (July 1967), 407.

14 Flannery O'Connor, *A Good Man Is Hard to Find* (Harcourt, Brace & World: 1955), 9–29.

15 George Garrett, "Crime and Punishment in Kansas: Truman Capote's *In Cold Blood*," *Hollins Critic* 3:1 (Feb. 1966).

16 Truman Capote, *In Cold Blood* (Hamish Hamilton: 1966), quotes 203, 57, 3.

17 Fawn M. Brodie, "The Political Hero in America: His Fate and His Future," *Virginia Quarterly Review* 46:1 (Winter 1970), 46–60, 47.

18 Jack Finney, *The Third Level* (Dell: 1957), 1, 45.

19 Philip K. Dick, *The Man in the High Castle* (Putnam: 1962).

20 Bradbury, *Novels and Story Cycles*, 781.

21 Gary Morris, *Roger Corman* (Twayne: 1985), 4–5, 89–141; Lester D. Friedman, "'Canyons of Nightmare': The Jewish Horror Film," in Grant, ed., *Planks of Reason*, 126–52, 144; Weaver, *Interviews*, 388–389.

22 August Derleth, "Foreword," in *Dark Mind, Dark Heart* (Arkham House: 1962), vii.

23 Russell Kirk, "A Cautionary Note on the Ghostly Tale," in *The Surly, Sullen Bell* (Fleet: 1962), 232, 236.

24 "Somebody's Trying to Kill Me and I Think It's My Husband: The Modern Gothic," *Journal of Popular Culture* 6:4 (Mar. 1973), 666–84, quote from Terry Carr letter to author on 667.

25 See Harry M. Benshoff, "Resurrection of the Vampire and the Creation of Alternative Life: An Introduction to Dark Shadows Fan Culture," *Spectator* 13:3 (Summer 1993), 50–61; Nina Auerbach, *Our Vampires, Ourselves* (Chicago: 1995), 157–58.

26 See Theodore Sturgeon, *Some of Your Blood* (Millipede: 2006).

27 Kapsis, "Reputation Building," quote 25.

28 Jane Merrill Filstrup, "An Interview with Edward St. John Gorey at the Gotham Book Mart," *Lion and the Unicorn* 2:1 (Jan. 1978), 17–37, quotes 22, 37; Edward Gorey, *Amphigorey* (Berkley: 1972), n.p.

29 Harlan Ellison, "'Repent, Harlequin!' Said the Ticktockman," in *Paingod and Other Delusions* (Pyramid: 1965).

30 I'm grateful to Stefan Dziemianowicz for introducing me to these videos.

31 Richard Meyers, *For One Week Only: The World of Exploitation Films* (New Century: 1983), 71.

32 For other examples of "the sexualized bomb," see Cyndy Hendershot, "The Bomb and Sexuality," *Literature and Psychology* 45:4 (1999), 74–89.

33 David O. Sears and T. M. Tomlinson, "Riot Ideology in Los Angeles: A Study of Negro Attitudes," *Social Science Quarterly* 49:3 (Dec. 1968), 485–503, 489–90.

34 David Ely, *Seconds* (Pantheon: 1963), 24, 92, 86.

35 See Robert A. Rosenstone, "'The Times They Are A-Changin': The Music of Protest," *The Annals of the American Academy of Political and Social Science* 382 (Mar. 1969), 138.

36 Morris, *Roger Corman*, 71–77, quote 77.

37 Reginald Bretnor, "The Children's Crusade," *Modern Age* 13:2 (Spring 1969), 120–22.

38 For a look at Gahan Wilson and some of his blackly comic contemporaries, see Robert Barshay, "The Cartoon of Modern Sensibility," *Journal of Popular Culture* 8:3 (Winter 1974), 523–33; see his *I Paint What I See* (Simon & Schuster: 1971).

39 Harold Schechter, "Kali on Main Street: The Rise of the Terrible Mother in America," *Journal of Popular Culture* 7:2 (Fall 1973), 251–63, quote 258.

40 Rachel Carson, *Silent Spring* (Houghton Mifflin: 1962), 13–14, quoted in Vera L. Norwood, "The Nature of Knowing: Rachel Carson and the American Environment," *Signs* 12:4 (Summer 1987), 740–60, quote 753. See also 752.

41 Compare Kenrick S. Thompson and Alfred C. Clarke, "Photographic Imagery and the Vietnam War: An Unexamined Perspective," *Journal of Psychology* 87:2 (July 1974), 279–92; Chester J. Pach, Jr., "TV's 1968: War, Politics, and Violence on the Network Evening News," *South Central Review* 16:4 (Winter 1999), 29–42.

42 Thomas E. Barden and John Provo, "Legends of the American Soldiers in the Vietnam War," *Fabula* 36 (Jan. 1995), 217.

43 See F. D. Williams, "The Morality of 'Bonnie and Clyde,'" *Journal of Popular Culture* 4:1 (Summer 1970), 299–307, quote 300.

44 Compare, in a different context, Rosenstone, 137.

45 Jeffrey L. Meikle, "'Other Frequencies': The Parallel Worlds of Thomas Pynchon and H. P. Lovecraft," *Modern Fiction Studies* 27:2 (Summer 1981), 287–94, quote 288.

46 Thomas Pynchon, *The Crying of Lot 49* (Penguin: 2012), 165.

47 Donald J. Greiner, "Vonnegut's *Slaughterhouse-Five* and the Fiction of Atrocity," *Critique* 14:3 (Jan. 1973), 38–51; Joyce Nelson, "Slaughterhouse-Five: Novel and Film," *Literature/Film Quarterly* 1:2 (Spring 1973), 149–53; Jerome Klinkowitz, "The Literary Career of Kurt Vonnegut Jr.," *Modern Fiction Studies* 19:1 (Spring 1973), 57–67.

48 Quoted in Charles Derry, *Dark Dreams: A Psychological History of the Modern Horror Film* (A. S. Barnes: 1977), 34.

49 Compare Paul, *Laughing Screaming*, 260.

50 Quoted in Derry, *Dark Dreams*, 65.

51 I am grateful to Adam Lowenstein for this observation.

52 James B. Twitchell, *Dreadful Pleasures: An Anatomy of Modern Horror* (Oxford: 1985), 265.

53 See David D. Galloway, "The Absurd Man as Tragic Hero: The Novels of William Styron," *Texas Studies in Literature and Language* 6:4 (Winter 1965), 512–34, 514; quote from Christopher Metress, "A New Father, A New Home: Styron, Faulkner, and Southern Revisionism," *Studies in the Novel* 22:3 (Fall 1990), 308–22, 311.

54 John Henrik Clarke, ed., *William Styron's Nat Turner: Ten Black Writers Respond* (Beacon: 1968), see vii–viii, 58–65. See also Laurence Shore, "William Styron's *Nat Turner:* The Monster and the Critics," *Journal of Ethnic Studies* 11:4 (Winter 1984), 89–101.

55 Horace Newcomb, "William Styron and the Act of Memory: *The Confessions of Nat Turner*," *Chicago Review* 20:1 (1968), 86–94, 92.

56 Ray Russell, *The Case Against Satan* (Souvenir: 1962), 52.

57 Ira Levin, *Rosemary's Baby* (Random House: 1967), 84.

58 Levin, *Rosemary's Baby*, 211.

59 James Blish, *Black Easter* (Doubleday: 1968), 165, 149.

60 Mark Bernard, "The Texas Chainsaw Massacre: A 'Peculiar, Erratic' Franchise," in McKenna and Proctor, eds., *Horror Franchise Cinema*, 53–65; Lowenstein, *Otherness*, 78–80; Christopher Sharrett, "The Idea of the Apocalypse in *The Texas Chainsaw Massacre*," in Grant, ed., *Planks of Reason*, 255–76, 260.

61 John H. Gagnon and William Simon, "Sexual Deviance in Contemporary America," *Annals of the American Academy of Political and Social Science* 376 (Mar. 1968), 106–22, 107–8.

62 Gross, *Redefining*, 59.

63 John Rechy, "Introduction," *City of Night* (Grove: 2013), 9–10.

64 "'I Both Hate and Love What I Do': An Interview with John Schlesinger," *Literature/Film Quarterly* 6:2 (Spring 1978), 104–15, 108.

65 James Dickey, *Deliverance* (Dell: 1971), quotes 29, 30, 51.

66 See Karen Horsley, *The American Southern Gothic on Screen* (Amsterdam UP: 2021), 15.

67 Jon Corelis, "Kent State Reconsidered as Nightmare," *Journal of Psychohistory* 8:2 (Fall 1980), 137–47, 138.

68 Cited in Harry Russell Huebel, "*Joe* and the Settlers and Indians Formula," *Journal of Popular Culture* 4:3 (Winter 1971), 797–800, quote 797.

69 See figures in J. Hoberman, "Off the Hippies: 'Joe' and the Chaotic Summer of '70," *New York Times*, July 30, 2000.

70 "Wes Craven: An Interview," *Journal of Popular Film and Television* 8:3 (Fall 1980), 10–14, 11.

71 "Wes Craven: An Interview," 12.

72 "'Fairy Tales for the Apocalypse': Wes Craven on the Horror Film," *Literature Film Quarterly* 13:3 (1985), 139–47.

73 John G. Cawelti, "Myths of Violence in American Popular Culture," *Critical Inquiry* 1:3 (Mar. 1975), 521–41, 533.

74 See Douglas Bolling, "The Waking Nightmare: American Society in Rudolph Wurlitzer's *Quake*," *Critique* 16:3 (1975), 70–80; Rudolph Wurlitzer, *Flats* (Dutton: 1970), 9; Rudolph Wurlitzer, *Quake* (Dutton: 1972).

75 Wurlitzer, *Quake*, 17.

76 On Blatty's biography, see Douglas E. Winter, "Casting Out Demons: The Horror Fiction of William Peter Blatty," in Magistrale and Morrison, eds., *A Dark Night's Dreaming*, 84–96, 85–87.

77 Robert West, "Some Popular Literature of Witchcraft Since 1969," *Review of Politics* 37:4 (Oct. 1975), 547–56, 547.

78 "Friedkin Interview," 360.

79 Paul, *Laughing Screaming*, 287.

80 Michael Dempsey, "The Exorcist," *Film Quarterly* 27:4 (Summer 1974), 61–62, 61.

81 "William Friedkin Interview," *Literature/Film Quarterly* 3:4 (Fall 1975), 334–62, 347.

82 Compare the fascinating perspective of Eleanor Johnson in "Exorcising American Domestic Violence: 'The Exorcist' in 1973 and 2023," *Public Books*, Dec. 13, 2023.

83 Ira Levin, *The Stepford Wives* (Bloomsbury: 2000), 2, 82.

84 Quoted in Sarah Cleary, "Horror Heroine or Symbolic Sacrifice: Defining the I Spit on Your Grave Franchise as Horror," in McKenna and Proctor, eds., *Horror Franchise Cinema*, 159–76, 159. The assault happened in 1976.

85 Norman N. Holland and Leona F. Sherman, "Gothic Possibilities," *New Literary History* 8:2 (Winter 1977), 279–94, 281.

86 Stanley Wiater, *Dark Dreamers: Conversations with the Masters of Horror* (Avon: 1990), 136. For the original version, see Richard Matheson, *The Best of Richard Matheson* (Penguin: 2017), 138–63.

87 "*Jaws* Became a Living Nightmare: Steven Spielberg's Ultimate Tell-All Interview," *Vanity Fair*, July 27, 2023.

88 Robert Benchley, *Jaws* (Doubleday: 1974), 54–55.

89 See Jonathan Lemkin, "Archetypal Landscapes and *Jaws*," in Grant, ed., *Planks of Reason*, 277–89, esp. 280–82.

90 Compare Joseph D. Adriano, *Immortal Monster: The Mythological Evolution of the Fantastic Beast in Modern Fiction and Film* (Greenwood: 1999), 17–28.

91 Compare Jane E. Caputi, "*Jaws* as Patriarchal Myth," *Journal of Popular Film* 6:4 (Jan. 1978), 305–26.

92 This is in Benchley's novel, too; see Benchley, *Jaws*, 33–34.

93 Molly Haskell, quoted in Caputi, "Patriarchal Myth," 306.

94 Benchley, *Jaws*, 44.

95 "Ultimate Tell-All Interview," *Vanity Fair*.

96 A point made in J. Hoberman and Jonathan Rosenbaum, *Midnight Movies* (Da Capo: 1983), 11. See also Christy Tyler, Spokane Public Library, in "Our Readers Write," *English Journal* 69:7 (Oct 1980), 60–62, 60. See also, on sexuality, Mark Siegel, "'The Rocky Horror Picture Show': More than a Lip Service," *Science Fiction Studies* 7:3 (Nov. 1980), 305–12; Bruce McDonald, "Semiology Goes to the Midnight Movie," *ETC* 37:3 (Fall 1980), 216–23, 219; and Bruce A. Austin, "Portrait of a Cult Film Audience: The Rocky Horror Picture Show," *Journal of Communication* 31:2 (1981), 43–54.

97 Jasper Lauderdale, "Close-Up: Contemporary Black Horror: 'There Existed an Addiction to Blood': Exhuming the Transtemporal Body," *Black Camera: An International Film Journal* 14:2 (Spring 2023), 275–94, 282.

98 David Morrell, *First Blood* (M. Evans: 1972), 20.

99 *First Blood*, 157, 173.

100 Quoted in Amanda Howell, "Lost Boys and Angry Ghouls: Vietnam's Undead," *Genders* 23 (June 1996), 297.

101 Harlan Ellison, *Approaching Oblivion* (Walker and Company: 1974), 19, 21.

102 See Rachel Manning, Mark Levine, and Alan Collins, "The Kitty Genovese Murder and the Social Psychology of Helping: The Parable of the 38 Witnesses," *American Psychologist* 62:6 (2007), 555–62.

103 Levin, *Stepford Wives*, 7.

104 Thomas Tryon, *Harvest Home* (Open Road: 2018), 16, 136.

105 Richard Matheson, *Hell House* (Viking: 1971).

106 Robert Marasco, *Burnt Offerings* (Delacorte: 1973), 48.

107 Rivers Siddons, *The House Next Door* (Pocket: 2006), 161.

108 See Douglas E. Winter, *Stephen King: The Art of Darkness* (New American Library: 1984), esp. 12–27, for an excellent early biographical essay.

109 Wiater, *Dark Dreamers*, 89.

110 See Sharon A. Russell, *Stephen King: A Critical Companion* (Greenwood: 1996), 2–3.

111 Burton R. Pollin, "Stephen King's Fiction and the Heritage of Poe," *Journal of the Fantastic in the Arts* 5:4 (1993), 2–25, 3; quote Winter, *Art of Darkness*, 18.

112 Quote Winter, *Art of Darkness*, 18.

113 Stephen King, *Night Shift* (Signet: 1979), xxii.

114 Quote Winter, *Art of Darkness*, 26.

115 King, *Night Shift*, 99.

116 An early critic wrote that *Carrie* was "a universal fairy tale, folklore of the last quarter of the twentieth century." Alex E. Alexander, "Stephen King's *Carrie*—A Universal Fairytale," *Journal of Popular Culture* 13:2 (Fall 1979), 282–88, 287.

117 See Mary Jane Dickerson, "Stephen King Reading William Faulkner: Memory, Desire, and Time in the Making of *It*," in Tony Magistrale, ed., *The Dark Descent* (Greenwood: 1992), 171–86.

118 Stephen King, *Carrie* (Anchor: 2011), 63.

119 Quote in Winter, *Art of Darkness*, 30.

120 Quoted in Winter, *Art of Darkness*, 51; see also Tim Underwood and Chuck Miller, eds., *Fear Itself: The Horror Fiction of Stephen King* (Underwood-Miller: 1982), 147–48.

121 Quoted in Winter, *Art of Darkness*, 81.

122 Stephen King, *'Salem's Lot* (Signet: 1976), 150.

123 *'Salem's Lot*, 20, 401. The sheriff suggests one reason: an abundance of gore in the movies.

124 Stephen King, *The Shining* (Pocket: 2001), 41.

125 See King, *Danse Macabre*, 144.

126 Compare Dale Bailey, *American Nightmares: The Haunted House Formula in American Popular Fiction* (Bowling Green: 1999), 54.

127 Lowenstein, *Otherness*, 85–88.

128 For how this complictes the gaze and depictions of male/female desire, see Lowenstein, *Otherness*, 133–34,

129 Tony Williams, "Feminism, Fantasy, and Violence: An Interview with Stephanie Rothman," *Journal of Popular Film and Television* 9:2 (Summer 1981), 84–90, 8.

130 Christopher Sieving, *Pleading the Blood: Bill Gunn's Ganja and Hess* (Indiana UP: 2022), 156–57.

131 Sieving, *Pleading the Blood*.

132 Harlan Ellison, *Strange Wine* (iBooks: 2004), 233–36.

133 Charles L. Grant, *Tales from the Nightside* (Arkham: 1981), 48–62, 90–110.

134 Peter Straub, *Ghost Story* (Coward, McCann & Geoghan: 1979), 205.

135 See Murray Leeder, "If I Were a Carpenter: Prestige and Authorship in the *Halloween* Franchise," McKenna and Proctor, eds., *Horror Franchise Cinema*, 66–80, 67; Robert E. Ziegler, "Killing Space: The Dialectic in John Carpenter's Films," *Georgia Review* 37:4 (Winter 1983), 770–86; and Lowenstein, *Otherness*, 40–43.

CHAPTER SEVEN

1 Whitley Strieber, *The Wolfen* (Morrow: 1978), 144.

2 See Thomas Tessier, *The Nightwalker* (Millipede: 2007), esp. 30–31.

3 Meyers, *For One Week Only*, 194.

4 On Cronenberg, see the useful early essays in Piers Handling, ed., *The Shape of Rage: The Films of David Cronenberg* (Zoetrope: 1983), esp. William Beard's essay "The Visceral Mind," 1–79.

5 See John L. Cobbs, "'Alien' as an Abortion Parable," *Literature/Film Quarterly* 18:3 (1990), 198–201.

6 See Midge Decter, "The Politics of Jonestown," *Commentary* 67:5 (May 1979), 29–34, 30; Steven Stack, "The Effect of the Jonestown Suicides on American Suicide Rates," *Journal of Social Psychology* 119 (1983): 145–146.

7 Carol J. Clover, "Her Body, Himself: Gender in the Slasher Film," *Representations* 20 (Autumn 1987), 187–228, 192.

8 Clover, "Her Body, Himself," 200.

9 Wiater, *Dark Dreamers*, 20.

10 Robert Bloch, *Psycho II* (Wings: 1993), 219.

11 See, for discussion, Marc Di Paolo, "#MeToo and the Filmmaker as Monster: John Landis, Quentin Tarantino, and the Allegorically Confessional Horror Film," in Allan H. Redmon, ed., *Next Generation Adaptation: Spectatorship and Process* (UP of Mississippi: 2021), 185–208, esp. 190–192, and 200–201 regarding *Death Proof* as Tarantino's "stealth apology" to Thurman.

12 Compare Michael A. Arnzen, "Who's Laughing Now? The Postmodern Splatter Film," *Journal of Popular Film and Television* 21:4 (Winter 1994), 176–84.

13 See Skal, *Monster Show*, 315–16.

14 Steven Stack, Jim Gundlach, and Jimmie L. Reeves, "The Heavy Metal Subculture and Suicide," *Suicide and Life-Threatening Behavior* 24:1 (Spring 1994), 15, 18.

15 Véronique Campion-Vincent, "Demonologies in Contemporary Legends and Panics," *Fabula* 34 (Jan. 1993), 238–51, 240.

16 Philip Jenkins and Daniel Maier-Katkin, "Satanism: Myth and Reality in a Contemporary Moral Panic," *Crime, Law, and Social Change* 17 (1992), 53–75, quotes 56, 55, 58, 62.

17 See Bette L. Bottoms and Suzanne L. Davis, "The Creation of Satanic Ritual Abuse," *Journal of Social and Clinical Psychology* 16:2 (Summer 1997), 112–32.

18 Gail Carr Feldman, "Satanic Ritual Abuse: A Chapter in the History of Human Cruelty," *Journal of Psychohistory* 22:3 (Spring 1995), 340–57, 347–48.

19 Marsha Kinder, "Music Video and the Spectator: Television, Ideology, and Dream," *Film Quarterly* 38:1 (Fall 1984), 2–15, 2.

20 David Sanjek, "Fans' Notes: The Horror Film Fanzine," *Literature/Film Quarterly* 18:3 (1990), 150–59, quote 151.

21 See Cosette N. Kies, *Presenting Young Adult Horror Fiction* (Twayne: 1992), 46–59.

22 Martin H. Klein, "The Bite of Pac-Man," *Journal of Psychohistory* 11:4 (Winter 1984), 395–401, 400.

23 Janet Schofield and Mark Pavelchak, "The Day After: The Impact of a Media Event," *American Psychologist* 40:5 (May 1985), 542–48 quote 542.

24 Daniel Wojcik, "Embracing Doomsday: Faith, Fatalism, and Apocalyptic Beliefs in the Nuclear Age," *Western Folklore* 55:4 (Fall 1996), 297–330, 303, 299.

25 Stephen King, *The Dead Zone* (Signet: 1979), 180.

26 See Winter, *Art of Darkness*, 74, and Michael J. Blouin, *Stephen King and American Politics* (University of Wales: 2021), 23–24.

27 J. G. Ballard, *The Atrocity Exhibition* (Re/Search: 1990), 105.

28 Stephen King, *The Mist*, in Kirby McCauley, ed., *Dark Forces* (Viking: 1980), quotes 424, 437, 425, 432.

29 Compare Roger Starr, "The Three Mile Shadow," *Commentary*, Oct. 1980, 48–55.

30 Quoted in Harvey R. Greenberg, "Dangerous Recuperations: *Red Dawn, Rambo,* and the New Decaturism," *Journal of Popular Film and Television* 15:2 (Summer 1987), 60–70, 67.

31 Michael Herr, *Dispatches* (Knopf: 1977), 215–218. See also Marshall Van Deusen, "The Unspeakable Language of Life and Death in Michael Herr's *Dispatches*," *Critique* 24:2 (Winter 1983), 82–87.

32 Quoted in Margot Norris, "Modernism and Vietnam: Francis Ford Coppola's 'Apocalypse Now,'" *Modern Fiction Studies* 44:3 (Fall 1998), 730–766, 731.

33 George Szamuely, "Hollywood Goes to Vietnam," *Commentary* 85:1 (Jan. 1988), 48–53, 49.

34 Compare Greg Smith, "'Real Horrorshow': The Juxtaposition of Subtext, Satire, and Audience Implication in Stanley Kubrick's 'The Shining,'" *Literature/Film Quarterly* 25:4 (1997), 300–306.

35 See Gesa Mackenthun, "Haunted Real Estate: The Occlusion of Colonial Dispossession and Signatures of Cultural Survival in U.S. Horror Fiction," *Amerikastudien* 43:1 (1998), 106.

36 Compare Mackenthun, "Haunted Real Estate," 93–108.

37 Giulia Scarpa, "Narrative Possibilities at Play in Toni Morrison's *Beloved*," *MELUS* 17:4 (Winter 1991–1992), 91–103, 92.

38 See Lowenstein, *Otherness*, 5; Deborah Horvitz, "Nameless Ghosts: Possession and Dispossession in *Beloved*," *Studies in American Fiction* 17:2 (Fall 1989), 157–67; Barbara Offutt Mathieson, "Memory and Mother Love in Morrison's 'Beloved,'" *American Imago* 47:1 (Spring 1990), 1–21, 1; Pamela E. Barnett, "Figurations of Rape and the Supernatural in *Beloved*," *PMLA* 112:3 (May 1997), 418–27; James Berger, "Ghosts of Liberalism: Morrison's *Beloved* and the Moynihan Report," *PMLA* 111:3 (May 1996), 408–20, esp. 414–15.

39 See Carolyn M. Jones, "Southern Landscape as Psychic Landscape in Toni Morrison's Fiction," *Studies in the Literary Imagination* 31:2 (Fall 1998), 37–48.

40 A magisterial overview of this period is Grady Hendrix, *Paperbacks from Hell* (Quirk: 2017).

41 Michael McDowell, *Amulet* (Valancourt: 2013).

42 Quoted in Jacqueline R. Smetak, "Steven Spielberg: Gore, Guts, and PG-13," *Journal of Popular Film and Television* 14:1 (Spring 1986), 4–13, 5.

43 Smetak, "Spielberg," 6.

44 See Lester, *Children*, 48–49.

45 See Barry Keith Grant, "Rich and Strange: The Yuppie Horror Film," in *Journal of Film and Video* 48:1–2 (Spring–Summer 1996), 100, 88.

46 One version of this appears in Noël Carroll, *The Philosophy of Horror* (Routledge: 1990), 207.

47 Quoted Clarens, *Illustrated History*, 69.

48 See Scott Poole, "'Let's Put a Smile on That Face': Trump, the Psychotic Clown, and the History of American Violence," in Victoria McCollum, ed., *Make America Hate Again: Trump-Era Horror and the Politics of Fear* (Routledge: 2019), 19–31, 22–23.

49 King, *Night Shift*, 101; compare Winter, *Art of Darkness*, 163–64.

50 Compare Reynold Humphries, *The American Horror Film: An Introduction* (Edinburgh: 2002), 109.

51 See Robin Wood, *Hollywood from Vietnam to Reagan* (Columbia UP: 1986), 60–69.

52 Julia Epstein, "AIDS, Stigma, and Narratives of Containment," *American Imago* 49:3 (Fall 1992), 293–310, 294.

53 Paul Chodoff, "Fear of AIDS," *Psychiatry* 50:2 (May 1987), 184–191, 184.

54 Harvey Greenberg, "Dracula, Erect (and Otherwise)," *Psychoanalytic Review* 67:3 (Fall 1980), 409–414, 413.

55 See his afterword, "Robert McCammon Tells How He Wrote *They Thirst*," in *They Thirst* (Dark Harvest: 1991), 411–12.

56 Wiater, *Dark Dreamers*, 165, 166.

57 Anne Rice, *Interview with the Vampire* (Knopf: 1976), 15.

58 See Auerbach, *Our Vampires*, 58.

59 See George E. Haggerty, "Anne Rice and the Queering of Culture," *Novel* 32:1 (Fall 1998), 5–18.

60 Les Daniels, in Wiater, *Dark Dreamers*, 48.

61 Edward Guerrero, "AIDS as Monster in Science Fiction and Horror Cinema," *Journal of Popular Film and Television* 18:3 (October 1990), 86–93, 89.

62 Wiater, *Dark Dreamers*, 186.

63 Kies, *Young Adult*, 136–37, quote 137. See also the useful essay by Paul M. Sammon, "Outlaws," in Sammon, ed., *Splatterpunks: Extreme Horror* (St. Martin's: 1990), 272–346, esp. 282–87.

64 Louis J. Kern, "American 'Grand Guignol': Splatterpunk Fore, Sadean Morality and Socially Redemptive Violence," *Journal of American Culture* 19:2 (June 1996), 47–59, 50.

65 Wiater, *Dark Dreamers*, 123.

66 Richard Laymon, *The Cellar* (Leisure: 2006), 187.

67 Wiater, *Dark Dreamers*, 112.

68 Dennis Etchison, *The Dark Country* (Scream/Press: 1982), 107.

69 See, particularly, "Sticks," in Karl Edward Wagner, *In a Lonely Place* (Warner: 1983), 69–94; T. E. D. Klein, "Nadelman's God," in *Dark Gods: Four Tales* (Viking: 1985).

70 Michael Doyle, ed., *Stuart Gordon: Interviews* (UP of Mississippi: 2022), 68.

71 Joseph Payne Brennan, "Can the Supernatural Story Survive?" in *American Supernatural Fiction*, 253–60, 257.

72 See Michael A. Morrison, "After the Danse: Horror at the End of the Century," in Tony Magistrale and Michael A. Morrison, eds. *A Dark Night's Dreaming* (University of South Carolina: 1996), 9–26, 13–14.

73 Quoted in Annalee Newitz, "Serial Killers, True Crime, and Economic Performance Anxiety," *Cineaction* 38 (1995), 38–46, 44.

74 A point made by Newitz passim.

75 Compare also Philip Simpson, "Mystery Rider: The Cultural Construction of a Serial Killer," *Cineaction* 38 (1995), 47ff.

76 Martha A. Schmidt, "Dahmer Discourse and Gay Identity: The Paradox of Queer Politics," *Critical Sociology* 20:3 (1994), 88.

77 Poole, *Monsters*, 150.

78 Schmidt, "Dahmer Discourse," 81.

79 Schmidt, "Dahmer Discourse," 81.

80 Thomas Harris, *Red Dragon* (Penguin: 2000), 69.

81 Arthur Saltzman, "Avid Monsters: The Look of Agony in Contemporary Literature," *Twentieth Century Literature* 45:2 (Summer 1999), 236–52, 236.

82 Straub, "Foreword," in Stephen Jones and Kim Newman, *Horror: Another 100 Best Books* (Carroll and Graf: 2005), xiii–xiv.

83 See discussion in Sara L. Knox, "Made-up and Made-Over: Faking the Serial Killer and the Serial Killer Fake," in Alzena MacDonald, ed., *Murders and Acquisitions: Representations of the Serial Killer in Popular Culture* (Bloomsbury: 2013), 15–32, quote 18–19.

84 Kathleen Margaret Lant, "The Rape of Constant Reader: Stephen King's Construction of the Female Reader and Violation of the Female Body in *Misery*," *Journal of Popular Culture* 30:4 (Mar. 1997), 89–114, 90.

85 Stephen King, *Misery* (Scribner: 2016), 69, 257, 329.

86 See Kumarini Silva and Danielle Rousseau, "Defining Deviance: The Rearticulation of Aileen Wuornos in *Monster*," in MacDonald, ed., *Murders and Acquisitions*, 67–83.

87 Quoted in Betsy Barry, "Forever, in My Dreams: Generic Conventions and the Subversive Imagination in 'Blue Velvet,'" *Literature/Film Quarterly* 16:2 (1988), 82–90, 82.

88 Compare Barry, 87.

89 In Michael Doyle, ed., *Gordon:, Interviews*, 84.

90 Compare Grant, "Rich and Strange," 4–16, esp. 4, 9–10.

91 Compare Christina Lee, "Shopping and Slaying, Fucking and Flaying: Serial Consumption in *American Psycho*," in MacDonald, ed., *Murders and Acquisitions*, 105–122.

92 Quoted in Liam Kennedy, "'It's the Third World Down There!': Urban Decline and (Post) national Mythologies in 'Bonfire of the Vanities,'" *Modern Fiction Studies* 43:1 (Spring 1997), 93–111, 95. "Retrocession": 95. *Bonfire* quotes 96, quoted Kennedy 102.

93 Aviva Briefel and Sianne Ngai, "'How Much Did You Pay for This Place?': Fear, Entitlement, and Urban Space in Bernard Rose's *Candyman*," *Camera Obscura* 13:1 (1996), 69–91, 76, 80.

94 For some discussion, see Joan Hawkins, "Close-Up: Contemporary Black Horror: Vanilla Nightmares and Urban Legends: The Racial Politics of Candyman (1992)," *Black Camera: An International Film Journal* 14, no. 2 (Spring 2023): 252–74, 256; Judith Halberstam, *Skin Shows* (Duke UP: 1995), 5.

95 Tananarive Due, *The Between*, (HarperPerennial: 2021), viii.

96 Lauderdale, "*Close-Up*," 284.

97 Compare Lauderdale, 287.

98 The movie does maintain some ambiguity as to whether Stone's character is the killer. See Celestino Deleyto, "The Margins of Pleasure: Female Monstrosity and Male Paranoia in 'Basic Instinct,'" *Film Criticism* 21:3 (Spring 1997), 20–42, esp. 25–28.

99 Karina Eileraas, "Witches, Bitches & Fluids: Girl Bands Perfoming Ugliness as Resistance," *TDR* 41:3 (Fall 1997), 122–39, 123.

100 Quoted in Eileraas, 129.

101 See Catherine Cookson, "Reports from the Trenches: A Case Study of Religious Freedom Issues Faced by Wiccans Practicing in the United States," *Journal of Church and State* 39:4 (Fall 1997), 723–48.

102 Compare Beth Braun, "'The X-Files' and 'Buffy the Vampire Slayer': The Ambiguity of Evil in Supernatural Representations," *Journal of Popular Film and Television* 20:2 (Summer 2000), 88–94.

103 See Eljaiek-Rodríguez, *Baroque Aesthetics*, 7, which also refers to *True Blood* and *Twilight*.

104 For complexities in the Tara–Willow relationship, see Marshall Moore, "An End to Monstrosity: Horror, Queer Representation, and the Trump Kakistocracy," in McCollum, ed., *Make America Hate Again*, 67–80, 74.

105 See Steven Jay Schneider, "Kevin Williamson and the Rise of the Neo-Stalker," *Post Script* 19:2 (2000), 73–88.

106 Quote in Joe Bellon, "The Strange Discourse of the X-Files," *Critical Studies in Mass Communication* 16 (1999), 140.

107 See Robert Markley, "Alien Assassinations: *The X-Files* and the Paranoid Structure of History," *Camera Obscura* 14:1–2 (May 1997), 75–102; Bellon, "Strange Discourse," 136–154.

108 Compare Lenora Ledwon, "'Twin Peaks' and the Television Gothic," *Literature/Film Quarterly* 21:4 (1993), 260–70.

109 Leslie Anne Perry and Rebecca P. Butler, "Are Goosebumps Books Real Literature?" *Language Arts* 74:6 (October 1997), 454–56.

110 See Perry Nodelman, "Ordinary Monstrosity: The World of Goosebumps," *Children's Literature Association Quarterly* 22:3 (1997), 118–25.

111 See James Kendrick, "A Return to the Graveyard: Notes on the Spiritual Horror Film," in Steffen Hantke, ed., *American Horror Film: The Genre at the Return of the Millennium* (UP of Mississippi: 2010), 142–58.

112 Grant, "Rich and Strange," 100, 20.

113 Jane Roscoe, "Mock-Documentary Goes Mainstream: 'The Blair Witch Project,'" *Jump Cut*, July 2000, 3–8, 3.

114 David C. Banash, "The Blair Witch Project: Technology, Repression, and the Evisceration of Mimesis," *Postmodern Culture* 10:1 (Sept. 1999), 2–12.

CHAPTER EIGHT

1 Guy Westwell, "Acts of Redemption and 'The Falling Man' Photograph in Post-9/11 US Cinema," in Terence McSweeney, ed., *American Cinema in the Shadow of 9/11* (Edinburgh: 2017), 67–88, 73.

2 James Kendrick, "The Terrible, Horrible Desire to Know: Post-9/11 Horror Remakes, Reboots, Sequels, and Prequels," in McSweeney, *American Cinema*, 249–68, 249; Stella Marie Gaynor, *Rethinking Horror in the New Economies of Television* (Palgrave: 2022), 1.

3 See Gray Cavender, Lisa Bond-Maupin, and Nancy C. Jurik, "The Construction of Gender in Reality Crime TV," *Gender and Society* 13:5 (Oct. 1999), 643–63.

4 For.a potential class-based reading of *The Strangers*, see Philip L. Simpson, "'There's Blood on the Walls': Serial Killing as Post-9/11 Terror in *The Strangers*," in MacDonald, ed., *Murders and Acquisitions*, 181–202.

5 See Mark Bernard, "'LOOK AT ME': Serial Killing, Whiteness, and (In)visibility in the *Saw* Series," in MacDonald, ed., *Murders and Acquisitions*, 85–104.

6 On American horror story as "baroque horror," see Eljaiek-Rodríguez, *Baroque Aesthetics*, 56.

7 Glen Hirshberg, *The Snowman's Children* (Carroll & Graf: 2002), 121.

8 See Laura Frost, "Black Screens, Lost Bodies: The Cinematic Apparatus of 9/11 Horror," in Aviva Briefel and Sam J. Miller, *Horror After 9/11* (UT Press: 2011), 13–39, quote 28; Whetmore, "Post-9/11 Horror," 51–55.

9 Compare Catherine Zimmer, "Caught on Tape?: The Politics of Video in the New Torture Film," *Horror After 9/11*, 83–106, esp. 86–89.

10 See Todd K. Platts, "Cut-Price Creeps: The Blumhouse Model of Horror Franchise Management," in *Horror Franchise*, 111–28.

11 See *Selling the Splat Pack* passim.

12 Platts "Cut-Price" 116; *Splat Pack* 188–92.

13 http://hucksblog.blogspot.com/2005/08/snakes-on-motherfucking-plane.html (Aug. 17, 2005).

14 See Richard Hand and Danielle Hancock, "Beware the Untruths: Podcast Audio Horror in Post-Truth America," in McCollum, ed., *Make America Hate Again*, 164–74.

15 Rob Kutner, "The Enduring Appeal of Lo-Fi Horror," *Book and Film Globe*, Feb. 14, 2022.

16 Paul Tremblay, *A Head Full of Ghosts* (William Morrow: 2015), 100.

17 See Andrei Nae, *Immersion, Narrative, and Gender Crisis in Survival Horror Video Games* (Routledge: 2022), passim; Sarah Thomas, "A Match Made in Heaven (Or Hell): Franchise Experiments Between the Horror Film Genre and Virtual Reality Media (2014–2020)," in McKenna and Proctor, eds., *Horror Franchise Cinema*, 206–23, quote 209.

18 See Whetmore, "Post-9/11 Horror," 155.

19 Neil Gaiman, *American Gods* (William Morrow: 2001), 107.

20 On folk horror, see Diane A. Rodgers, "Et in Arcadia Ego: British Folk Horror Film and Television," *Folklore and Nation*, 205–18, 205.

21 Cormac McCarthy, *Outer Dark* (Random House: 1968), 156.

22 Grant, "Rich and Strange," 100, 167.

23 Owl Goingback, *Tribal Screams* (Independent Legions: 2018), quote 47 and "Gator Bait" 77–91.

24 Daryl Gregory, *Revelator* (Vintage: 2024), 311.

25 See Stacy Missari, "Queer Resistance in an Imperfect Allegory: The Politics of Sexuality in *True Blood*," in Barbara Gurr, ed., *Race, Gender, and Sexuality in Post-Apocalyptic TV and Film* (Palgrave: 2015), 87–98.

26 Gaynor, *Rethinking Horror*, 10.

27 For a more powerfully ambiguous treatment of these issues in the 2016 movie *Don't Breathe*, see Dawn Keetley, "Lock Her Up!: Angry Men and the Captive Woman in Post-Recession Horror," in McCollum, ed., *Make America Hate Again*, 97–118, 101–103.

28 For an intriguing gender analysis of King's view of writer/reader dynamic, compare Lant, "Constant Reader," passim.

29 Chuck Palahniuk, *Lullaby* (Doubleday: 2002), 78.

30 For an incisive essay on Kiernan, see Peter Straub, "Afterword," in Kiernan, *Tales of Pain and Wonder* (Subterranean: 2008), 329–337.

31 Rivers Solomon, *Sorrowland* (FSG: 2021).

32 Lowenstein, *Otherness*, 157.

33 Eljaiek-Rodríguez, *Baroque Aesthetics*, 124.

34 See Lowenstein, *Otherness*, 157, 158.

35 Lauren McLeod Cramer and Catherine Zimmer, "Close-Up: Contemporary Black Horror," in Dossier: Spectacles of Anti-Black Violence and Contemporary Black Horror," *Black Camera: An International Film Journal* 14:2 (Spring 2023): 319–63, 320.

36 Quoted in Delphine Letort, "Close-Up: Contemporary Black Horror: Get Out from the Horrors of Slavery," *Black Camera: An International Film Journal* 14:2 (Spring 2023): 295–307, 304.

37 Jonina Anderson-Lopez, *All Kinds of Scary: Diversity in Contemporary Horror* (McFarland: 2023),19.

38 See Anderson-Lopez, *All Kinds of Scary*, passim.

39 See Kimitra D. Brooks, *Searching for Sycorax: Black Women's Hauntings of Contemporary Horror* (Rutgers: 2018), quote 99.

40 Erin E. Adams, *Jackal* (Penguin Random House: 2022), 5.

41 Alma Katsu, *The Fervor* (Putnam: 2022), 40.

42 Katsu, *The Fervor*, 305.

43 Anemona Hartocollis, "At Harvard Dorms, 'House Masters' No More," *New York Times*, Feb. 24, 2016.

44 Tim McGregor, *Hearts Strange and Dreadful* (Off Limits Press: 2021).

45 Scott Thomas, *Kill Creek* (Inkshares, 2017), quote 499.

46 Compare Poole, *Monsters*, 211–14, and Travis Sutton and Harry M. Benshoff, "'Forever Family' Values: *Twilight* and the Modern Mormon Vampire," in *Horror After 9/11*, 200–19.

47 See Gaynor, *Rethinking Horror*, 101–10.

48 Gaynor, *Rethinking Horror*, 32–33, 35–36.

49 Brian Keene, *Earthworm Gods* (Deadite: 2012), 57.

50 Brian Keene, *Dead Sea* (Leisure: 2007), 7.

51 See Jacob Babb, "The Banality of the Apocalypse: Colson Whitehead's Necropolis and Mirthless Parody," in Stefan Rabitsch, ed., *Fantastic Cities : American Urban Spaces in Science Fiction, Fantasy, and Horror* (U of Mississippi: 2022), 85–94. Also racial aspects.

52 On the original 1925 demythologizing novel that is the basis for the movie, see Susan Kollin, "Race, Labor, and the Gothic Western: Dispelling Frontier Myths in Dorothy Scarborough's *The Wind*," *Modern Fiction Studies* 46:3 (Fall 2000), 675–94.

53 See, notably, John Glover, "The Masks of E'Ch-Pi-El: Interpreting the Life and Work of H. P. Lovecraft," in *Lovecraft in the 21st Century*, 57–70.

54 Jeff Vandermeer, *Annihilation* (FSG: 2014), 90.

55 Josh Malerman, *Bird Box* (HarperCollins: 2014), 43.

56 Matt Ruff, *Lovecraft Country* (HarperPerennial: 2016), 13.

57 Victor LaValle, *The Ballad of Black Tom* (Tom Doherty: 2016), 143. See also Kathleen Hudson, "Racial (In)Visibility, Cosmic Indifference," in *Lovecraft in the 21st Century*, 186–200.

58 Elisabeth Vincentelli, "A Festival That Conjures the Magic of H. P. Lovecraft and Beyond," *New York Times*, Aug, 28, 2022.

59 See the essays, esp. by Elisabete Lopes, Stuart L. Lindsay, Suzanne and Richard Albary, and Kevin Corstorphine and Matthew Crofts, in *Lovecraft in the 21st Century*.

60 Kelly Link, *Magic for Beginners* (Small Beer: 2002), 38, 47.

61 Link, *Magic for Beginners*, 156.

62 In Eric LaRocca, *The Trees Grew Because I Bled There* (Titan: 2023).

63 Iain Reid, *I'm Thinking of Ending Things* (Simon & Schuster: 2016), 175.

64 Paula D. Ashe, *We Are Here to Hurt Each Other* (Nictitating: 2022), 32, 131.

65 Joe Hill, *20th Century Ghosts* (William Morrow: 2007), 69–90, quote 86.

66 Bernard, "Peculiar," 60.

67 On "War of the Worlds" as a post-9/11 movie, see Kevin J. Wetmore Jr., *Post-9/11 Horror in American Cinema* (Continuum: 2012), 29, 46–51.

68 See Kendrick, "Remakes, Reboots," esp. 256–57.

69 Gaynor, *Rethinking Horror*, 149–52, quote 150.

70 Compare David Gillota, *Dead Funny: The Humor of American Horror* (Rutgers: 2023), 41.

71 Maureen Dowd, "Ryan Murphy Is Having a Very Happy Halloween," *New York Times*, Nov. 1, 2022.

72 Compare Gillota, *Dead Funny*, 56–58.

73 See Jay McRoy, "'The Kids of Today Should Defend Themselves Against the '70s,'" in *American Horror Film*, 221–33.

74 See Carolina A. Miranda, "RIP 'Los Espookys,' Illicit Lovechild of Pedro Almodóvar and Scooby-Doo," *Los Angeles Times*, Dec. 2, 2022.

75 Brian Keene, *Fear of Gravity* (Delirium: 2004), 18–48.

76 Wetmore Jr., *Post-9/11 Horror*, 106.

77 Quoted in Mark Bernard, *Selling the Splat Pack* (Edinburgh: 2014), 19.

78 Paul Tremblay, *Cabin at the End of the World* (HarperCollins: 2018), 24.

79 Tremblay, *Cabin at the End of the World*, 91.

80 See Anderson, *Homemaking*, 178.

81 See Russell Meeuf, *White Terror: The Horror Film from Obama to Trump* (Indiana: 2022), 1ff; Poole, "Smile," 29; quote in Theresa L. Geller, "Shilling Pennywise: Chump Change in Trump's (Trans) America," in McCollum, ed., *Make America Hate Again*, 32–53, 32.

82 See Stacey Abbott, "When the Subtext Becomes Text: *The Purge* Takes On the American Nightmare," in *Horror Franchise*, 128–42, 131, 135, 138. Meeuf, *White Terror*, 56–60, deals with the racial dimension.

83 For another take on this, see Jake Tapper, "Why Americans Fall for Grifters," *Atlantic* (Nov. 2020).

INDEX